TELEMATIC
EMBRACE

THE PUBLISHER GRATEFULLY ACKNOWLEDGES THE
CONTRIBUTION TOWARD THE PUBLICATION OF THIS BOOK
PROVIDED BY THE ART ENDOWMENT FUND OF THE UNIVERSITY
OF CALIFORNIA PRESS ASSOCIATES, WHICH IS SUPPORTED
BY A MAJOR GIFT FROM THE AHMANSON FOUNDATION.

ROY ASCOTT

TELEMATIC
EMBRACE

VISIONARY THEORIES OF ART, TECHNOLOGY, AND CONSCIOUSNESS

EDITED AND WITH AN ESSAY BY
EDWARD A. SHANKEN

UNIVERSITY OF CALIFORNIA PRESS BERKELEY LOS ANGELES LONDON

UNIVERSITY OF CALIFORNIA PRESS
BERKELEY AND LOS ANGELES, CALIFORNIA

UNIVERSITY OF CALIFORNIA PRESS, LTD.
LONDON, ENGLAND

LIBRARY OF CONGRESS CATALOGING-IN-PUBLICATION DATA

ASCOTT, ROY.
 TELEMATIC EMBRACE : VISIONARY THEORIES OF ART,
 TECHNOLOGY, AND CONSCIOUSNESS / ROY ASCOTT ;
 EDITED AND WITH AN ESSAY BY EDWARD A. SHANKEN.
 P. CM.
 INCLUDES BIBLIOGRAPHICAL REFERENCES AND INDEX.
 ISBN 0-520-21803-5 (ALK. PAPER)
 1. COMPUTER ART. 2. ART AND TECHNOLOGY.
 3. ART—FORECASTING. I. SHANKEN, EDWARD A., 1964-
 II. TITLE.

N7433.8 .A83 2003
700'.285—DC21 2002015444

MANUFACTURED IN THE UNITED STATES OF AMERICA
12 11 10 09 08 07 06 05 04 03
10 9 8 7 6 5 4 3 2 1

THE PAPER USED IN THIS PUBLICATION MEETS THE
MINIMUM REQUIREMENTS OF ANSI/NISO Z39.48-1992
(R 1997) (PERMANENCE OF PAPER).♾

To the memory of my parents
and to the creative futures of my loved ones

CONTENTS

List of Illustrations ix
Preface and Acknowledgments xi

From Cybernetics to Telematics: The Art, Pedagogy,
and Theory of Roy Ascott, by Edward A. Shanken 1

SELECTED ESSAYS OF ROY ASCOTT

1 The Construction of Change (1964) 97
2 Statement from *Control* (1966) 108
3 Behaviourist Art and the Cybernetic Vision (1966–67) 109
4 Behaviourables and Futuribles (1967) 157
5 The Psibernetic Arch (1970) 161
6 Table (1975) 168
7 Connective Criticism (1977) 174
8 Network as Artwork: The Future of Visual Arts
Education (1978) 176
9 Towards a Field Theory for Postmodernist Art (1980) 178
10 Ten Wings (1982) 183
11 Art and Telematics: Towards a Network Consciousness
(1984) 185
12 Concerning Nets and Spurs: Meaning, Mind,
and Telematic Diffusion (1985) 201
13 Art and Education in the Telematic Culture (1988) 212
14 *Gesamtdatenwerk:* Connectivity, Transformation,
and Transcendence (1989) 222
15 Beyond Time-Based Art: ESP, PDP, and PU (1990) 227
16 Is There Love in the Telematic Embrace? (1990) 232
17 Photography at the Interface (1992) 247
18 Heavenly Bodies: Teleconstructing a Zodiac for the
Twenty-First Century (1993) 255
19 Telenoia (1993) 257
20 From Appearance to Apparition: Communication
and Culture in the Cybersphere (1993) 276

21 The Ars Electronica Center Datapool (1993) 284
22 The Planetary Collegium: Art and Education
 in the Post-Biological Era (1994) 310
23 The Architecture of Cyberception (1994) 319
24 Back to Nature II: Art and Technology in the
 Twenty-First Century (1995) 327
25 The Mind of the Museum (1996) 340
26 Weaving the Shamantic Web: Art and Technoetics
 in the Bio-Telematic Domain (1998) 356
27 Art @ the Edge of the Net: The Future Will Be
 Moist! (2000) 363
28 Technoetic Aesthetics: 100 Terms and Definitions
 for the Post-Biological Era (1996) 375

 Appendix I. Roy Ascott's Professional Appointments 383
 Appendix II. Roy Ascott's Publications 387
 Appendix III. Roy Ascott's Art Projects and Exhibitions 395
 Appendix IV. CAiiA-STAR Research Conferences 398
 References 399
 Index 413

ILLUSTRATIONS

1 *Development* (1957) 8

2 LOVE-CODE (1962) 10

3 *Video Roget* (1962) 12

4 *Video Roget* (1962) and *Thesaurus* (1963) 13

5 Untitled diagram (1963) 14-15

6 *Homage to C. E. Shannon* (1964) 27

7–8 *Change Painting* (1959) 29

9 Untitled drawing (1962) 31

10 *Change Map* (1969) 32

11 *Transaction Set* (1971) 33

12 *Table-Top Strategies* (1971) 34

13 *Calibrator for Selecting Human Characteristics* (ca. 1963) 36

14–15 Student behavioural experiments at Ipswich
Civic College, Suffolk (1965) 38-39

16 Curriculum diagram, Ontario College of Art (1972) 41

17 "La Plissure du Texte" (1982) 65

18 "Organe et Fonction d'Alice au Pays des Merveilles" (1985) 68

19 "Aspects of Gaia" (upper level) (1989) 71

20 "Aspects of Gaia" (lower level) (1989) 71

21 *Universe of Discourse* (1977) 87

22 Ascott with *Change Painting* (ca. 1959) 99

23 *Shift* (1963) 101

24 *Blackboard Notes* (1967) 103

25 Leaflet from Ascott's exhibition at the Centre d'Art
Cybernétique, Paris (1964) 125

26 Leaflet from Ascott's exhibition at the Exe Gallery,
Exeter (1970) 153

27 *Hinged Relief* (1960) 162

28 *Cooking Chance* (1978–79) 169

29 Ascott online, Bath (1980) 181

30 "La Plissure du Texte" (1983) 191

31–32 Ascott as Judith, from *Making the Invisible Visible* (1988) 208

33 Information Design Enterprise, project text and sketches
 (1988) 220
34 Planetary network: "Laboratorio ubiqua," Venice Biennale
 (1986) 240
35 "Aspects of Gaia" (lower level) (1989) 243
36 *Telenoia* announcement (1992) 260
37 "Connectivity Model" (1989) 290
38 "Functions and Amenities" (1989) 297
39 *Apollo 13 (Televator)* (1996) 308
40 *Cognitive Map* (1996) 317
41 "Moist Chart" (2000) 364

PREFACE AND ACKNOWLEDGMENTS

Works of art produced by any distinctive creative personality will borrow from and build on prior themes. Similarly, in these essays, Roy Ascott employs a palette of theoretical images drawn from many sources, including Jackson Pollock and Marcel Duchamp, theories of cybernetics, quantum physics, and telematics, and the metaphysical ideas of Pierre Teilhard de Chardin and non-Western cosmologies, which he re-renders and re-contextualizes in original compositions. His theories progressively gain complexity and depth and are always presented in a compelling manner, which is at once poetic and convincing.

Because Ascott's essays are generally quite short, abridgment would in most cases seriously detract from their integrity. Except as noted, the texts selected for this book are therefore included in their entirety. Occasionally, minor editorial alterations have been made to enhance clarity. British spellings have generally been retained, and despite the author's and editor's preference for gender-inclusive language, we also decided to retain the original gendering of pronouns. Ascott's message is one of inclusion and unification, and it is hoped that all readers will feel equally welcome in his telematic embrace.

The introductory essay "From Cybernetics to Telematics: The Art, Pedagogy, and Theory of Roy Ascott" is intended as a basic framework to assist the reader in contextualizing and evaluating the artist's writings, providing a general overview of Ascott's work, briefly describing his intellectual background, and sketching out the problem of artists' writings. It also offers a discussion of cybernetics and telematics and their relationship to Ascott's work as an artist, teacher, and theorist. Roy Ascott is still actively making art, teaching, and writing theory, but I have addressed his work in the past tense in order to retain consistency and provide a proper historical tone.

.

Kristine Stiles sensed that Roy Ascott and I were a perfect match, arranged our meeting in 1994, and encouraged us to pursue this project together. Without her knowledge, dedication, patience, and editorial assistance, my efforts would have amounted to substantially less. My large and extended family has blessed me many times over by supporting my dreams with love and enthusiasm. The Duke University Department of Art and Art History, Graduate School, and Center for International Studies generously supported my dissertation research, a substantial portion of which appears in my essay. A Henry Luce fellowship from the American Council of Learned Societies made an invaluable contribution to the final stages of writing. Thanks are also due to all the artists and critics who offered personal insights into telecommunications art. These include Robert Adrian, Liza Bear, Hank Bull, Peter D'Agostino, Allan Kaprow, Carl Loeffler, Willoughby Sharp, Woody and Steina Vasulka, and Norman White. Eduardo Kac generously edited earlier drafts and provided excellent comments. Deborah Kirshman at the University of California Press embraced this project from the beginning and patiently supported the process that brought it to fruition. Finally, I would like to thank Roy Ascott for the honor of editing this collection of his writings and for the love he has shown by entrusting them to me.

Edward A. Shanken

FROM CYBERNETICS TO TELEMATICS

The Art, Pedagogy, and Theory of Roy Ascott

EDWARD A. SHANKEN

■ INTRODUCTION

Overview: Synthetic Vision

Roy Ascott is recognized as "the outstanding artist in the field of telematics," according to Frank Popper, the foremost European historian of art and technology (Popper 1993, 124). Telematics integrates computers and telecommunications, enabling such familiar applications as electronic mail (e-mail) and automatic teller machines (ATMs). Ascott began developing a more expanded theory of telematics decades ago and has applied it to all aspects of his artwork, writing, and teaching. He has defined telematics as "computer-mediated communications networking between geographically dispersed individuals and institutions . . . and between the human mind and artificial systems of intelligence and perception" (page 232 below). Telematic art challenges the traditional relationship between active viewing subjects and passive art objects by creating interactive, behavioral contexts for remote aesthetic encounters. Ascott's expertise extends beyond his own discipline and has been acknowledged internationally by numerous governmental and institutional organizations for which he has consulted. Synthesizing recent advances in science and technology with experimental art and ancient systems of knowledge, Ascott's visionary theory and practice aspire to enhance human consciousness and to unite minds around the world in a global telematic embrace that is greater than the sum of its parts.

This is the first collection of Ascott's writings to be published in English.[1] The essays selected make available more than three decades of this artist's theories on the relationship between aesthetics and electronics, love and interactivity, and the sense of self and community in a telematic, cyberspacial world. These essays constitute a unique archaeology of ideas and trace the intertwined

cultural history of art, technology, and consciousness from the 1960s to the present. Given the increasing role of the Internet and the World Wide Web (WWW) in the creation of commerce and community, Ascott's writings will benefit artists, entrepreneurs, scholars, policy-makers, and laymen alike. They offer perceptive insights into the past, present, and future implications and possibilities of human-machine relationships, especially with respect to networked telecommunications.

Throughout the 1990s, Ascott's writings addressed the social implications of telematics, nanotechnology (engineering at the atomic level), artificial and post-biological life, and the role of museums in digital culture. In "Telenoia" (1993; chapter 19 below) and "The Architecture of Cyberception" (1994; chapter 23), he explored the relationship between the cybernated individual, the telematic community, and the role of "intelligent architecture" as a medium for the expansion of perception and the exchange of individual and communal information/consciousness, theorizing that the resulting experience of omnipresence and simultaneity transforms conventional notions of space, time, and subjectivity. In "Back to Nature II: Art and Technology in the Twenty-First Century" (1995; chapter 24) and "Art @ the Edge of the Net" (2000; chapter 27), Ascott proposed that from the dry silicon of digital computers, emergent self-organizing systems and nanotechnologies will become increasingly "moist" and more closely related to the wetness of organic biocomputers such as the human brain. He considered, moreover, how the artistic use of post-biological forms of life and intelligence might affect the evolution of organic life. In "The Mind of the Museum" (1996; chapter 25), Ascott noted that cultural institutions must be responsive to these imminent social transformations, which he foresaw as underlying new forms of expression in the future. Such forward-looking theories aspired to push the limits of human consciousness and imagination as part of the ongoing creative process of constructing culture and society.

The futuristic character of Ascott's writings demands that they be described as visionary. By the term "visionary," I mean to suggest a systematic method for envisioning the future. Ascott has described his own work as "visionary," and the word itself emphasizes that his theories emerge from, and focus on, the visual discourses of art. While the artist draws on mystical traditions, his work is more closely allied to the technological utopianism of Filippo Marinetti than to the ecstatic religiosity of William Blake. At the same time, the humanism, spirituality, and systematic methods that characterize his practice, teaching, and theorization of art share affinities with the Bauhaus master Wassily Kandinsky. In the tradition of futurologists like Marshall McLuhan and Buckminster Fuller,

Ascott's prescience results from applying associative reasoning to the serendipitous conjunction, or network, of insights gained from a widely interdisciplinary professional practice. Joining reason and spirit with technique and drawing on diverse ideas from a variety of disciplines and applying them to art, Ascott's work has anticipated and responded to the possibilities and problems of interactivity and networked communications, issues that have become increasingly central to art and culture. The recent growth of widespread commercial, governmental, and public interest in these topics provides a vantage point from which Ascott's early artistic and theoretical research on interactivity, cybernetic art, and telematics now may be interpreted as visionary.

In using the terms "visionary," "prescient," "presaging," and "anticipating," I do not mean to suggest that Ascott wielded supernatural powers that have allowed him to see into the future. What I do mean is that his work as an artist has contributed to the material processes by which ideas from diverse fields feed into one another, subsequently becoming concretized and historicized in particular cultural configurations. I believe that artists play an important role in developing ideas that have broad cultural ramifications, even though the process of historicization generally does not occur in the visual forms of art (which lack cultural authority in such matters and do not "speak" a common language). Rather, using formulae and words, scientific, historical, and other forms of literature are the primary sites where more commonly accepted languages concretize emergent cultural configurations in historical narratives. As a result, scientific and philosophical models are commonly taken to be the precursors to subsequent developments in the visual arts. However, as I hope to show, the process of cultural formation depends on an interrelated exchange of ideas across disciplines such that in many cases it may be spurious to credit one field or another with originating any general concept.

Ascott's synthetic method for envisioning the future is exemplified both by his independent development of interactive art and by the parallel he subsequently drew between the aesthetic principle of interactivity and the scientific theory of cybernetics. His interactive *Change Paintings*, begun in 1959, joined together divergent discourses in the visual arts, along with philosophical and biological theories of duration and morphology. The *Change Paintings* featured a variable structure that enabled the composition to be rearranged interactively by viewers, who thereby became an integral part of the work. In 1961, Ascott began studying the science of cybernetics and immediately recognized its congruence with his concepts of interactive art. The artist's first publication, "The Construction of Change" (1964; chapter 1), reflected an integration of these

aesthetic and scientific concerns, and it proposed radical theories of art and education based on cybernetics. For Ascott and his students, individual artworks—and the classroom alike—came to be seen as creative systems, the behavior of which could be altered and regulated by the interactive exchange of information via feedback loops.

By the mid 1960s, Ascott began to consider the cultural implications of telecommunications, another example of how his interdisciplinary practice presaged subsequent developments in art and culture. In "Behaviourist Art and the Cybernetic Vision" (1966–67; chapter 3), he discussed the possibilities of artistic collaborations between participants in remote locations, interacting via electronic networks. McLuhan's prophetic theories of media had not yet become a technological reality; nonetheless, Ascott's proposals advanced artistic discourses towards the idea of global collaboration. At the same time that the initial formal concerns of conceptual art were being formulated under the rhetoric of "dematerialization," Ascott was considering how the ethereal medium of electronic telecommunications could facilitate interactive and interdisciplinary exchanges.

The sort of electronic exchanges that Ascott had envisioned in "Behaviourist Art and the Cybernetic Vision" were demonstrated in 1968 by the computer scientist Doug Engelbart's NLS "oN Line System." This computer network based at the Stanford Research Laboratory (now SRI) included "the remote participation of multiple people at various sites" (Myers 1996). In 1969, ARPANET (precursor to the Internet) went into operation, sponsored by the U.S. government, but it remained the exclusive province of the defense and scientific communities for a decade.[2] Ascott first went online in 1978, an encounter that turned his attention from making art objects to organizing his first international artists' computer-conferencing project, "Terminal Art" (1980). Since that time, Ascott has been at the forefront of the practice and theory of telematic art, organizing and collaborating on dozens of online projects that have explored the ramifications of networked communication on behavior and consciousness, the consequences of which extend far beyond the realm of aesthetics.

Ascott's early experiences of telematics resulted in the theories elaborated in his essays "Network as Artwork: The Future of Visual Arts Education" (1978; chapter 8) and "Art and Telematics: Towards a Network Consciousness" (1984; chapter 11). Drawing on diverse sources, in the latter essay, he discussed how his telematic project "La Plissure du Texte" (1983) exemplified Roland Barthes's theories of nonlinear narrative and intertextuality. Moreover, noting parallels between neural networks in the brain and telematic computer networks (see,

e.g., Bateson 1972; Teilhard de Chardin 1955; Russell 1983), Ascott proposed that global telematic exchange could expand human consciousness. He tempered this utopian vision by citing Michel Foucault's book *L'Ordre du discours* (1971), which discusses the inextricability of texts and meaning from the institutional powers that they reflect and to which they must capitulate. Consequently, the artist warned that in "the interwoven and shared text of telematics . . . meaning is negotiated—but it too can be the object of desire. . . . We can expect a growing . . . interest in telematics on the part of controlling institutions" (pages 191–92 below).

Science and technology, for Ascott, can contribute to expanding global consciousness, but only with the help of alternative systems of knowledge, such as the *I Ching* (the sixth-century B.C. Taoist *Book of Changes*), parapsychology, Hopi and Gnostic cosmologies, and other modes of holistic thought that the artist has recognized as complementary to Western epistemological models.[3] Ascott's composite and associative way of thinking has challenged conventional systems of knowledge, crossed the boundaries of traditional artistic media and modes of reception, and attempted to merge categories that are commonly considered incommensurable (East and West, science and mysticism, technology and art). Added to the general antipathy of cultural institutions towards electronic art in the 1970s and 1980s, the complexity of Ascott's thought helps to explain why this internationally distinguished artist had not yet received wider acclaim by the end of the century. Indeed, the full ramifications of his ideas can be difficult to comprehend, but in their theoretical richness and compelling purposiveness, his writings offer persuasive insights into the future. As has been the case with many artists and visionaries who ultimately achieved historical recognition, Ascott's importance may not be broadly recognized until the future validates his contribution.

In his combination of science, art, and esoteric knowledge, Ascott sought no unequivocal resolution to seemingly irreconcilable methods of understanding. Rather, the artist recognized the paradoxical nature of knowledge and the contradictions inherent in formal epistemologies. Like an appropriate response to a koan, an enigma that cannot be resolved by any logical formula, his multifaceted theoretical approach to art broadened comprehension of the underlying systems by which visual meaning is culturally constructed. This synthetic and nonhierarchical way of thinking was already manifest in Ascott's art in the early 1960s, and it is made explicit in his essay "The Psibernetic Arch" (1970; chapter 5), where he identifies parallels between scientific and esoteric modes of understanding. In 1982, Ascott's telematic art project "Ten Wings" (chapter 10)

produced the first planetary throwing of the *I Ching* using computer conferencing. More recently, Ascott's contact with Kuikuru *pagés* (shamans) and initiation into the Santo Daime community in Brazil resulted in his essay "Weaving the Shamantic Web" (1998; chapter 26). Here the artist's concept of "technoetics" again acknowledges the complementarity of technological and ritualistic methods for expanding consciousness and creating meaning.

Ascott's theories propose personal and social growth through technically mediated, collaborative interaction. They can be interpreted as aesthetic models for reordering cultural values and recreating the world. As much as these theories depend on the same technologies that support global capitalism, they stand in stark contrast to the profit-motivated logic that increasingly transforms the complexion of social relations and cultural identity into a mirror-reflection of base economic principles.

Throughout the late twentieth century, corporations increasingly strategized how to use technology to expand markets and improve earnings, and academic theories of postmodernity became increasingly anti-utopian, multicultural, and cynical. During this time, Ascott remained committed to theorizing how telematic technology could bring about a condition of psychical convergence throughout the world. He has cited the French philosopher Charles Fourier's principle of "passionate attraction" as an important model for his theory of love in the telematic embrace. Passionate attraction constitutes a field that, like gravity, draws together human beings and bonds them. Ascott envisioned that telematic love would extend beyond the attraction of physical bodies. As an example of this dynamic force in telematic systems, in 1984, he described the feeling of "connection and . . . close community, almost intimacy . . . quite unlike . . . face-to-face meetings" that people have reported experiencing online (pages 186–87 below). Telematics, the artist believed, would expand perception and awareness by merging human and technological forms of intelligence and consciousness through networked communications. He theorized that this global telematic embrace would constitute an "infrastructure for spiritual interchange that could lead to the harmonization and creative development of the whole planet" (page 245 below).

Although not all of Ascott's optimistic prophecies have come to fruition yet, many of his prognoses for the future of art and culture have been validated by the advent of the World Wide Web and the deluge of online artistic experimentation that has resulted in its wake. Ascott's response to these developments was customarily synthetic and visionary. Joining his long-standing concerns with cybernetics, telematics, and art education, he founded the Centre for Advanced

Inquiry in the Interactive Arts (CAiiA). In 1995, CAiiA became the first online Ph.D. program with an emphasis on interactive art. Some of the most prominent international artists in this field have enrolled in its unique curriculum. CAiiA exemplifies the prescience with which Ascott has synthesized cybernetics and telematics with the discourses of art and testifies to the consistency with which he has continued to apply his visionary theories to all aspects of his artwork, writing, and teaching.

Beginnings: Victor Pasmore, Richard Hamilton, and the Synthesis of Art, Pedagogy, and Theory

Ascott's training as a student of Victor Pasmore and Richard Hamilton between 1955 and 1959 offers many insights into his mature work. Both of these leading postwar British artists were actively involved in artistic practice, art theory, art exhibitions, and art education. They passed on their broad-based concern with these overlapping professional interests to Ascott. Although his teachers' approaches to art diverged, both drew on a wide range of aesthetic and non-aesthetic sources. The synthetic quality of their methodologies can also be seen as playing an important role in Ascott's artistic development.

Pasmore and Hamilton were at the center of the movement to reform art education in England in the 1950s. They both taught at King's College in Newcastle upon Tyne, then part of the University of Durham. During 1956–58, along with Ian Stephenson and others, they created the basic design course that Ascott attended. The curriculum was predicated on the principles of biological morphology that the scientist D'Arcy Wentworth Thompson elaborated in his book *On Growth and Form*, which had earlier informed Hamilton's exhibition "Growth and Form" at the Institute of Contemporary Art, London (1951). The course developed a model of how aesthetic forms might emerge from processes akin to organic development. An etching Ascott made in 1957, entitled *Development*, exemplifies this method. Ascott's artistic application of biological metaphors was reinforced by the exhibition "Developing Process" that Pasmore organized at Newcastle and London in 1959 and formalized in his book *A Developing Process in Art Teaching* (1959). The interdisciplinary models of art education that Pasmore and Hamilton developed can be seen as precursors to Ascott's creation of cybernetic and telematic pedagogies.

Pasmore is known as an artist-theoretician, a title that Ascott came to earn for himself as well. In the 1940s, Pasmore had gained an outstanding reputation as a painter for his poetic landscapes and figure studies. His abrupt shift to

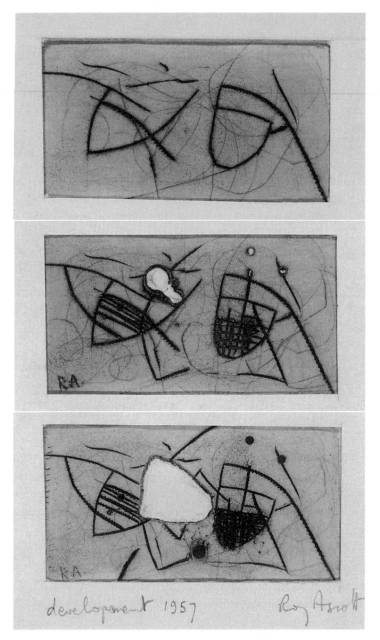

Figure 1. *Development*. 1957. Etching. Three elements, each 2⁷/₈ × 1¹/₂".

abstraction around 1948 has been referred to as "one of the most dramatic events in post-war British art" (Tate Gallery 1965, introduction). In 1951, Pasmore organized the first postwar exhibition of abstract painting and sculpture in London. Later, he became deeply influenced by the constructivist principles of "structuralism" espoused in the American artist/theorist Charles Biederman's seminal book *Art as the Evolution of Visual Knowledge* (1948). Pasmore's work of the mid 1950s was also influenced by the vitalist organic forms of the Alsatian artist Jean Arp. By the time Ascott arrived at Newcastle as his student, Pasmore had abandoned two-dimensional painting and had begun making constructivist relief sculpture. The divergent aesthetic principles of abstract expressionism, constructivism, and vitalism could all be linked through the biological metaphor central to Pasmore's work.[4] Complementing his artistic and pedagogical practices, Pasmore also wrote aesthetic theory. Ascott credited his mentor for "opening up the idea of . . . the artwork as a developing process" and for his insights into "the integration of art, architecture, and technology."[5] Indeed, Pasmore's theoretical approach to art and his agglomeration of diverse aesthetic, philosophical, and scientific ideas foreshadowed the sorts of associations that Ascott would apply in synthesizing his own method.

Hamilton is acknowledged as the father of pop art, and he co-founded the Independent Group in London. His artwork, teaching, and theory have all explored the relationships between art, technology, and popular culture. Works like *Hommage à Chrysler Corp.* (1957) and *$he* (1958–61) integrate a 1950s shapely female figure with the modern design of automobiles, refrigerators, and other mass-produced consumer appliances. These images draw on the heritage of dada to suggest a proto-cyborgian confluence of human and machine. As a curator, Hamilton also organized several highly influential exhibitions, including "Man, Machine and Motion" (Hatton Gallery, Newcastle upon Tyne, 1955) and "This is Tomorrow" (Whitechapel Art Gallery, London, 1956). He also wrote aesthetic theory. Like his artwork and curatorial projects, his theories of art and popular culture anticipated the multidisciplinary writing and research associated with cultural studies. Ascott stated that Hamilton's "intellectual posture, his championing of the place of ideas in art, his questioning of all the certainties, in life as much as art . . . influence[d] me a great deal."[6] Hamilton also increased his sensitivity to the process of art-making and introduced him to the semantic and conceptual complexities of Marcel Duchamp. Duchamp's work had begun to influence Hamilton when he was a student at the Slade School of Art. Like Duchamp, Hamilton and his student (Ascott) were

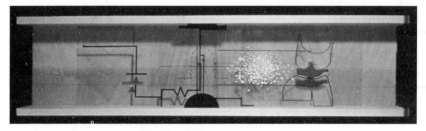

Figure 2. LOVE-CODE. 1962. Diagram box. Cellulose on glass, wood, 13 × 48 × 3". Note the influence of Richard Hamilton's *$he* and Marcel Duchamp's *Large Glass* in Ascott's integration of female and technological forms, and the "seed cloud" between them.

equally fascinated by technology, although each approached it differently. Hamilton incorporated mass media images of technology and popular culture into his canvases (an appropriation of popular imagery into fine art). Ascott later came to utilize mass media technology as the interactive, collaborative "canvas" of telematic art (the appropriation of fine art into popular media). Similarly, Hamilton's abiding interest in formal techniques and finish, as well as his continued adherence to traditional media, diverged from his student's experiments in expanded media, which focused on the conceptual and behavioral aspects of art as an interactive process and system. And, unlike his mentor, Ascott (like Duchamp) fused his interest in technology with esoteric and hermetic forms of knowledge.

After completing his studies in 1959, Ascott was hired by Pasmore as studio demonstrator, a two-year post the favored graduate received as part of a "grooming process." The protégé was expected to spread his mentor's pedagogical principles to other institutions in Britain. In 1961, just before taking a distinguished position Pasmore had secured for him at Ealing College of Art in London, Ascott discovered F. H. George's *Automation, Cybernetics and Society* (1959), Norbert Wiener's *The Human Use of Human Beings: Cybernetics and Society* (1948), and W. Ross Ashby's *Design for a Brain* (1952). The work of these and other authors writing about cybernetics, artificial intelligence, and information theory captivated his imagination, catalyzing what Ascott described as an Archimedean "'Eureka experience'—a visionary flash of insight in which I saw something whole, complete, and entire."[7] Ascott's insight was a sweeping yet subtle vision of the systematic application of cybernetics to art. While still deeply influenced by Pasmore and Hamilton, the young artist's approach to art and to art education had come under the influence of a new way of thinking

about the world, predicated on the ideas of information, feedback, and systemic relationships.

Art and Writing Artists' Writings

Theoretical writing became an integral part of Ascott's artistic practice, as it had been for his teachers Pasmore and Hamilton. Ascott's first publication, "The Construction of Change" (1964), discussed how his work in the classroom complemented his work in the studio. "All art is . . . didactic," he wrote, based on his experience of developing a cybernetic art curriculum at Ealing; the artist's "creative and pedagogic" activities interacted, "each feeding back to the other" (page 98 below). Ascott's theoretical writings reinforced and enriched both his practice and his teaching. Indeed, he came to conceive of these independent elements as increasingly interrelated components of a cybernetic system.

In "The Construction of Change," Ascott renounced the idea that the essence of art could be crystallized in material objects, arguing that art was, rather, characteristic of the behavioral processes by which such objects are generated. For Ascott, art possessed value only to the extent that it enabled a mental, conceptual shift—a transformation of consciousness that altered the relationship of artist, artwork, and audience, thereby changing the behavior of the system they constituted. If art is taken to be a conceptual process manifested in the behavior of the artist within a system of meaning, then Ascott's theoretical work, including the act and process of writing, can be considered part of his artistic oeuvre. This position coincides with the emphasis placed on artistic processes at that time by some other British artists, including John Latham, Mark Boyle, and Gustav Metzger, and by artists working at the intersections of concrete poetry, happenings, Fluxus, and conceptual art.

In the 1960s, Ascott did not conceive of his writings as art per se, but rather, like his teaching, as having a symbiotic relationship with his art-making activity. While writing was part of what he did as an artist, it remained distinct in his mind from his works of art. However, he had begun to consider the processes of ideation and writing as artistic acts. Recalling that period and the liberation that creating texts afforded him, he later observed: "[T]here's nothing you can't do when you're writing as an artist."[8] In relation to other British artists coming of age in the early 1960s, Ascott conceived of his own artistic identity as being that of a "man of ideas."

In 1963, the thesaurus became a primary explanatory metaphor for Ascott's practice as a visual artist, and text became a more integral part of his artwork.

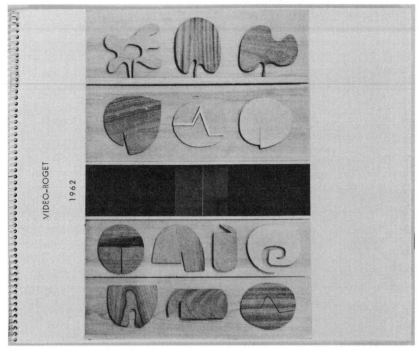

VIDEO-ROGET 1962

Figure 3. *Video Roget*. 1962. Analogue structure. Plexiglas, wood, and glass, 50 × 35". Illustration from Molton Gallery exhibition catalogue (Ascott 1963).

In the catalogue for his exhibition at the Molton Gallery in London that year, *Diagram Boxes and Analogue Structures*, Ascott reproduced his work *Video Roget* (1962). This relief sculpture was inspired in part by Pasmore's mix of constructivist and vitalist teachings, but also incorporated an interactive element that reflected the young artist's commitment to the principles of cybernetics. On the page preceding *Video Roget*, Ascott provided a related diagram on tracing paper, entitled *Thesaurus*. By placing *Thesaurus* over *Video Roget*, words on the former were superimposed on the visual forms of the latter. Together, they suggested relationships between words and shapes, and indicated various feedback loops between them.

Immediately following *Thesaurus* and *Video Roget* in the catalogue, a two-page diagram (drawn like an electrical circuit) declared Ascott's bid to use text in an art context: "This *Thesaurus* is a statement of my intention to use any assembly of diagrammatic and iconographic forms within a given construct as seems necessary" (Ascott 1963). Ascott's *Video Roget* and *Thesaurus* drew an explicit par-

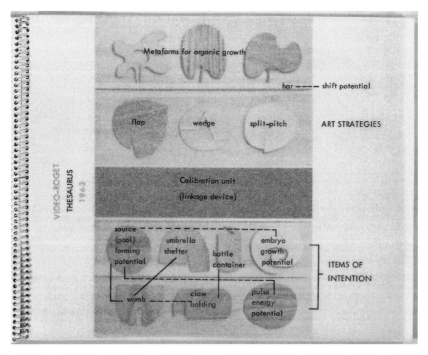

Figure 4. *Video Roget* (1962) and *Thesaurus*. 1963. Tracing paper overlay designed by Noel Forster, in Molton Gallery exhibition catalogue (Ascott 1963).

allel between the semiotics of verbal and visual languages. It proposed that the universe of potential meanings of his art could be derived taxonomically and discursively. In this multilayered process, meaning was contingent on the flow of information between the artist, the object, the semantic systems that govern the reception of works of art, and the actual responses of viewers. Such concepts, including the explicit use of the thesaurus, were concerns that became central to conceptual art, as in Joseph Kosuth's *Second Investigation, Proposition 1* (1968) and Mel Ramsden's *Elements of an Incomplete Map* (1968). Moreover, since *Thesaurus* and the diagram were largely textual, Ascott expressly put in writing his intention to use language in and as art. It must be noted, however, that aside from the catalogue itself, the objects in the exhibition did not contain textual elements, although many of them were diagrammatic.

The discursive relationship between art and text in Ascott's work took on a variety of other forms as well. His "Statement" (chapter 2) published in the first issue of the avant-garde journal *Control* (1966) was designed as a circle, conflat-

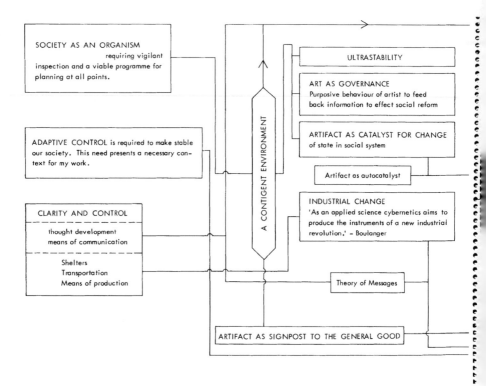

SOCIETY AS AN ORGANISM requiring vigilant inspection and a viable programme for planning at all points.

ADAPTIVE CONTROL is required to make stable our society. This need presents a necessary context for my work.

CLARITY AND CONTROL

thought development
means of communication

Shelters
Transportation
Means of production

A CONTIGENT ENVIRONMENT

ULTRASTABILITY

ART AS GOVERNANCE
Purposive behaviour of artist to feed back information to effect social reform

ARTIFACT AS CATALYST FOR CHANGE
of state in social system

Artifact as autocatalyst

INDUSTRIAL CHANGE
'As an applied science cybernetics aims to produce the instruments of a new industrial revolution.' – Boulanger

Theory of Messages

ARTIFACT AS SIGNPOST TO THE GENERAL GOOD

Figure 5. Untitled diagram. 1963. Illustration designed by Noel Forster, from Molton Gallery exhibition catalogue (Ascott 1963).

ing word and image in a manner parallel to that of concrete poetry. In 1967, the artist produced the manifesto "Behaviourables and Futuribles" (chapter 4) as a broadside, also explicitly utilizing text in a graphic work. Consistent with his perceived artistic role as a "man of ideas," and in recognition of the freedom that writing offers an artist, Ascott strategically expanded the range of what justifiably could be utilized as artistic media to include diagrammatic, iconographic, and textual forms.[9]

Ascott's use of text in an artistic context was arrived at independently of, and yet in tandem with, the development of conceptual art. The first artist to expressly state the idea that language and mathematical systems of notation could be art was the American Henry Flynt. "Since 'concepts' are closely bound up with language, concept art is a kind of art of which the material is language," Flynt observed in his 1961 essay "Concept Art" (Flynt 1975, 125). Experimental artists' books like Mel Bochner's exhibition "Working Drawings and Other

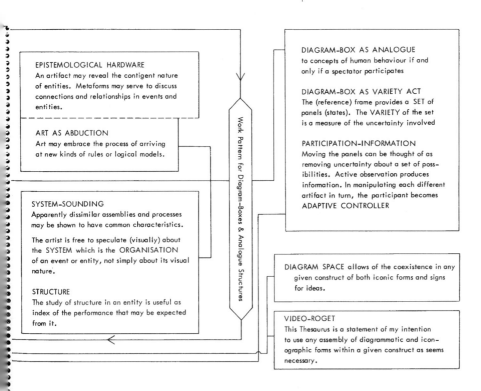

EPISTEMOLOGICAL HARDWARE
An artifact may reveal the contingent nature
of entities. Metaforms may serve to discuss
connections and relationships in events and
entities.

ART AS ABDUCTION
Art may embrace the process of arriving
at new kinds of rules or logical models.

SYSTEM-SOUNDING
Apparently dissimilar assemblies and processes
may be shown to have common characteristics.

The artist is free to speculate (visually) about
the SYSTEM which is the ORGANISATION
of an event or entity, not simply about its visual
nature.

STRUCTURE
The study of structure in an entity is useful as
index of the performance that may be expected
from it.

Work Pattern for Diagram-Boxes & Analogue Structures

DIAGRAM-BOX AS ANALOGUE
to concepts of human behaviour if and
only if a spectator participates

DIAGRAM-BOX AS VARIETY ACT
The (reference) frame provides a SET of
panels (states). The VARIETY of the set
is a measure of the uncertainty involved

PARTICIPATION-INFORMATION
Moving the panels can be thought of as
removing uncertainty about a set of poss-
ibilities. Active observation produces
information. In manipulating each different
artifact in turn, the participant becomes
ADAPTIVE CONTROLLER

DIAGRAM SPACE allows of the coexistence in any
given construct of both iconic forms and signs
for ideas.

VIDEO-ROGET
This Thesaurus is a statement of my intention
to use any assembly of diagrammatic and icon-
ographic forms within a given construct as seems
necessary.

Visible Things on Paper Not Necessarily Meant to Be Viewed as Art" (1966)
emphasized "the ideational processes from which discrete objects emerge" (Stiles
and Selz 1996, 807). High-profile texts like Sol Lewitt's "Paragraphs on Con-
ceptual Art" (1967) and Joseph Kosuth's three-part essay "Art after Philosophy"
(1969) later contributed to the theorization of conceptual art and helped his-
toricize it as a canonical movement in the history of art. In Britain, discussions
between the artists Terry Atkinson and Michael Baldwin in 1966 laid the foun-
dation for the emergence of the Art & Language collective, which published
the first issue of *Art-Language: The Journal of Conceptual Art* in May 1969. Ko-
suth and Art & Language were perhaps the most persistent advocates of the use
of text as a viable medium in visual art.

A useful comparison can be made between the marginal status of media art
(art employing electronic media) within the context of mainstream art institu-
tions, and artists' writings, which have been marginalized within the context of

art history and criticism. Like media art, which is often perceived as too tech-
nological to be appreciated under conventional canons of aesthetics and too artis-
tic to be appreciated according to the scientific methods of engineering, artists'
writings are often perceived as too much like criticism to be appreciated as art
and too artistic to be appreciated as criticism. Working at the intersection of
art and technology, both as an artist and a theorist, Ascott has been especially
subject to these dual prejudices.

Conceptual artists have argued that theory is not the exclusive domain of
philosophers and scientists, and that the written word, or the language of math-
ematics, for that matter, are not the sole legitimate forms of theoretical exege-
sis. It is insufficient to say that works of art can be the plastic embodiment of
philosophical, scientific, or other theories. In both written texts and works of
art (which, again, are not mutually exclusive categories), contemporary artists
have proclaimed their work to be not just highly theoretical but to be theory
itself.[10] At the same time, conceptual art demands that linguistic, mathemati-
cal, and other symbolic carriers of information be regarded as an appropriate
medium for visual art. These theoretical positions interrogate the relationship
between visual and verbal systems of meaning and problematize the categori-
cal distinctness of art and art criticism.

Despite the aforementioned attempts by artists to deconstruct the binary op-
position between art and writings about art, the disciplines of art history and
criticism have tended to preserve this discrete categorical division. As a result,
within the canon of art history, artists' writings occupy an ambiguous position,
straddling the conventional domains of art and theory and lacking authenticity
as either. Joseph Kosuth has identified this "bias against artists who write" as
originating "in the anti-intellectualism of American society" and claims that,
with regard to his own writing, "this conservative mechanism is being exploited
for the purposes of discrediting [my] authenticity as an artist. . . . Artists are ex-
pected to 'stay in their place' and keep to the model of the artist which has been
internalized within modernism: the Expressionist, producer of enigmas."[11]
Artists are thought to lack critical distance from their subject matter, and their
writings have been interpreted as a means of self-promotion. Such objections
are suspicious, for they fail to acknowledge the myriad ways in which the imag-
ined objectivity and "critical distance" attributed to the critic may be just as
clouded by self-promotional impulses.

Texts written by artists have played a central, although underrecognized, role
in the critical and theoretical development of art and its discourses. This is es-
pecially the case in experimental art, where artists often anticipate art histori-

cal and critical appraisal by many years and then serve as uncited references in subsequent writings by critics and historians. Nonetheless, artists' writings occupy a relatively minor and ambiguous position in modern and postmodern art criticism and history. The publication of the collected essays of individual artists—including Kosuth, Robert Morris, Carolee Schneemann, Yvonne Rainer, Allan Kaprow, and now Ascott—and collections of artists' theoretical writings, such as *Blasted Allegories*, edited by Brian Wallis, and *Theories and Documents of Contemporary Art*, edited by Kristine Stiles and Peter Selz, may begin to redress this endemic bias.

▬ CYBERNETICS

The Hungarian-born artist Nicolas Schöffer created his first cybernetic sculptures *CYSP O* and *CYSP I* (the titles of which combine the first two letters of the words "cybernetic" and "spatio-dynamique") in 1956 (Schöffer 1963, 10–17). In 1958, the scientist Abraham Moles published *Théorie de l'information et perception esthétique*, which outlined "the aesthetic conditions for channeling media" (Burnham 1968, 344). Subsequently, "Cybernetic Serendipity," an exhibition curated by Jasia Reichardt in London (1968), Washington, D.C. (1969), and San Francisco (1969–70), popularized the idea of joining cybernetics with art. Not surprisingly, much artistic research on cybernetics had transpired between Schöffer's initial experiments of the mid 1950s and Reichardt's landmark exhibition over a decade later. "A dream of technical control and of instant information conveyed at unthought-of velocities haunted Sixties culture," the art historian David Mellor writes of the cultural attitudes and ideals that cybernetics embodied at that time in Britain. "The wired, electronic outlines of a cybernetic society became apparent to the visual imagination—an immediate future . . . drastically modernized by the impact of computer science. It was a technologically utopian structure of feeling, positivistic, and 'scientistic'" (Mellor 1993, 107). However, these early inquiries into the aesthetic implications of cybernetics took place primarily in Europe, and the United States lagged behind by "five or ten years," the American artist and critic Jack Burnham notes (Burnham 1968, 343).

Evidence of the sentiments described by Mellor could be observed in British painting of the 1960s, especially among a group of artists associated with Roy Ascott and the Ealing College of Art, such as his colleagues Bernard Cohen and R. B. Kitaj and his student Steve Willats, who founded the journal *Control* in 1966. Eduardo Paolozzi's collage techniques of the early 1950s likewise "em-

bodied the spirit of various total systems," which may possibly have been "partially stimulated by the cross-disciplinary investigations connected with the new field of cybernetics" (Kirkpatrick 1971, 19). Cybernetics offered these and other artists a scientific model for constructing a system of visual signs and relationships, which they attempted to achieve by utilizing diagrammatic and interactive elements to create works that functioned as information systems.

The Origin and Meaning of Cybernetics

The scientific discipline of cybernetics emerged out of attempts to regulate the flow of information in feedback loops in order to predict, control, and automate the behavior of mechanical and biological systems. Between 1942 and 1954, the Macy Conferences provided an interdisciplinary forum in which various theories of the nascent field were discussed.[12] The result was the integration of information theory, computer models of binary information processing, and neurophysiology in order to synthesize a totalizing theory of "control and communication in the animal and the machine" (Wiener 1948). Although a collaborative exchange of ideas led to the emergence of cybernetics, it was the American mathematician Norbert Wiener who coined the term from the Greek word *kubernētēs*, or "steersman" (also the root of the English word "governor"). Wiener has been described as the "visionary . . . who articulate[d] the larger implications of the cybernetic paradigm and its cosmic significance" (Hayles 1999, 7).

Cybernetics offered an explanation of phenomena in terms of the exchange of information in systems. It was derived, in part, from information theory, pioneered by the mathematician Claude Shannon. By reducing information to quantifiable probabilities, Shannon developed a method to predict the accuracy with which source information could be encoded, transmitted, received, and decoded (Shannon and Weaver 1949). Information theory provided a model for explaining how messages flowed through feedback loops in cybernetic systems. Moreover, by treating information as a generic substance, like the zeros and ones of computer code, it enabled cybernetics to theorize parallels between the exchange of signals in electro-mechanical systems and in the neural networks of humans and other animals. Cybernetics thus held great promise for creating intelligent machines, as well as for helping to unlock the mysteries of the brain and consciousness. W. Ross Ashby's *Design for a Brain* (1952) and F. H. George's *The Brain as Computer* (1961) are important works in this regard and suggest the early alliance between cybernetics, information theory, and the field that would come to be known as artificial intelligence. The parallels that could be drawn by using a cybernetic

model allowed the theory to be applied to a wide variety of disciplines, including political science, physiology, anthropology, and, in Ascott's case, art.

Indeed, one of the early criticisms of cybernetics was that it was "not really a new science but was merely an extended analogy" (Hayles 1999, 97). This mere analogy, however, effectively challenged essentialist notions of mechanical and biological entities, replacing them with a probabilistic model of relational information systems and feedback loops. Cybernetics has become so entrenched in scientific methodology and social theory alike that many of its underlying principles have come to be taken for granted. It can be seen, moreover, as part of larger epistemological transformations. Acknowledging the historical importance of new scientific models, Wiener called probability theory the "first great revolution of 20th century physics," representing a fundamental shift from conventional Newtonian physics predicated on precision to the "radical . . . new idea . . . that . . . physics . . . cannot escape considering uncertainty and the contingency of events" (Wiener [1950] 1967, 14–15). In this respect, cybernetics is indebted to theoretical physics, such as Albert Einstein's special theory of relativity and Werner Heisenberg's uncertainty principle. Hayles has noted that by replacing an essentialist notion of physical phenomena with one predicated on the contingency of relationality, Wiener's work contributed to a way of thinking about information and knowledge that later became historicized as poststructuralism (Hayles 1999, 91).

While this sweeping generalization remains speculative, a more concrete example of how cybernetics has been applied in practice may help elucidate its general function as well as the significance of its social implications. Wiener offered the following description:

> When the great control rooms at the locks of the Panama Canal are in use, they are two-way message centers. Not only do messages go out controlling the motion of the tow locomotives, the opening and closing of the sluices, and the opening and closing of the gates; but the control room is full of telltales which indicate not merely that the locomotives, the sluices, and the gates have received their orders, but that they have in fact effectively carried out these orders. . . . This principle in control applies not merely to the Panama locks, but to states, armies, and individual human beings. . . . This matter of social feedback is of very great sociological and anthropological interest. (Wiener [1950] 1967, 68–69)

In other words, information in a cybernetic system is dynamically transferred and fed back among its constituent elements, each informing the others of its status, thus enabling the whole to regulate itself in order to maintain a state of operational equilibrium, or homeostasis. As Wiener suggested, cybernetics could

be applied not only to industrial systems, but to social, cultural, environmental, and biological systems as well.

Wiener was deeply concerned about the misuse of science and acknowledged that much research leading to cybernetics, information theory, and computer decision-making was either explicitly or implicitly directed towards (or applicable to) military applications. During World War II, Wiener collaborated with Julian Bigelow on developing an anti-aircraft weapon that could predict the behavior of enemy aircraft based on their prior behavior. After the war, Wiener took an anti-militaristic stance and refused to work on defense projects. The universal applicability of cybernetics also threatened sacrosanct boundaries between the human and the machine. Concerned that his theory would be taken too far, in *The Human Use of Human Beings: Cybernetics and Society,* Wiener advocated the use of cybernetics to improve social conditions and cautioned about the dehumanizing potential of technology. Much to his dismay, cybernetic research and development during the Cold War contributed to the ongoing buildup of the U.S. military-industrial complex.[13] Indeed, the high-tech orchestration of information-processing and computer-generated, telecommunicated strategies employed by the U.S. military suggests nothing short of a cybernetic war machine (Virilio and Lotringer, 1983; Virilio 1991).

To summarize, cybernetics brings together several related propositions: (1) phenomena are fundamentally contingent; (2) the behavior of a system can, nonetheless, be determined probablistically; (3) animals and machines function in quite similar ways with regard to the transfer of information, so a unified theory of this process can be articulated; and (4) the behavior of humans and machines can be automated and controlled by regulating the transfer of information. If phenomena are uncertain and contingent, then it follows that information and feedback are contingent, that the behavior of animals and machines is contingent on their relationships to one another, to the dynamic unfolding of information, and to other environmental elements. There is, in cybernetics, a fundamental shift away from the attempt to analyze either the behavior of individual machines or humans as independent phenomena. What becomes the focus of inquiry is the dynamic process by which the transfer of information among machines and/or humans alters behavior at the systems level.

Cybernetics and Aesthetics: Complementary Discourses

Writing about Ascott's early interactive works shown in the 1961 exhibition "Bewogen Beweging" ("Moving Movement"), Popper noted that, "In the work of

Agam and Ascott, who were perhaps the first to launch an appeal to total participation, the strict antinomy between action and contemplation was entirely abolished."[14] Although Ascott's innovative exploration of the interactive and temporal potentials of art preceded his awareness of cybernetics, his work was not without precedent or parallel in his own discipline. Many twentieth-century artists experimented with process, kinetics, audience-participation, systems, and environment. Cybernetics proposed a universal theory that potentially could be applied to any field, but it was not the cart that pulled the horse. Rather, it articulated a concrete system of knowledge that elegantly united a broad range of disciplinary ideas and methods that had been percolating for many years. However, any common ground that cybernetics and art may have shared at mid-century cannot be attributed to essential underlying qualities. Parallels between them were not manifest, just waiting to be discovered. The bridge between art and cybernetics had to be constructed by creating metaphorical parallels. In other words, the application of cybernetics to artistic concerns depended on the desire and ability of artists to draw conceptual correspondences that joined the scientific discipline with contemporary aesthetic discourses.

The merging of cybernetics and art must be understood in the context of ongoing aesthetic experiments with duration, movement, and process. Although the roots of this tendency go back further, the French impressionist painters systematically explored the durational and perceptual limits of art in novel ways that undermined the physical integrity of matter and emphasized the fleetingness of ocular sensation. The cubists, reinforced by Henri Bergson's theory of *durée*, developed a formal language dissolving perspectival conventions and utilizing found objects. Such disruptions of perceptual expectations and discontinuities in spatial relations, combined with juxtapositions of representations of things seen and things in themselves, all contributed to suggesting metaphorical wrinkles in time and space. The spatio-temporal dimensions of consciousness were likewise fundamental to Italian futurist painting and sculpture, notably that of Giacomo Balla and Umberto Boccioni, who were also inspired by Bergson. Like that of the cubists, their work remained static and only implied movement. Some notable early twentieth-century sculpture experimented with putting visual form into actual motion, such as Marcel Duchamp's *Bicycle Wheel* (1913) and *Precision Optics* (1920), Naum Gabo's *Kinetic Construction* (1920), and László Moholy-Nagy's *Light-Space Modulator* (1923–30). Gabo's work in particular, which produced a virtual volume only when activated, made motion an intrinsic quality of the art object, further emphasizing temporality. In Moholy-Nagy's kinetic work, light bounced off the gyrating object and reflected onto

the floor and walls, not only pushing the temporal dimensions of sculpture, but expanding its spatial dimensions into the entire environment.

By the 1950s, experimentation with duration and motion by sculptors such as Schöffer, Jean Tinguely, Len Lye, and Takis gave rise to the broad, international movement known as kinetic art. Schöffer's *CYSP I*, for example, was programmed to respond electronically to its environment, actively involving the viewer in the temporal experience of the work. In this work, Schöffer drew on constructivist aesthetic ideas that had been developing for three-quarters of a century and intentionally merged them with the relatively new field of cybernetics. In Paris, in 1959, the Romanian-born artist Daniel Spoerri founded Éditions MAT (Multiplication d'Art Transformable), which published affordable multiples of works by artists such as Duchamp, Man Ray, Tinguely, and Victor Vasarely. Vasarely's "participative boxes," for example, included a steel frame and magnetized colored squares and circles that "enabled the buyer to assemble his own 'Vasarely'" (Davis 1973, 52, 55–56). The interactive spirit of kinetic art gave birth in the 1960s to the Nouvelle Tendance collectives. Groups such as the Groupe de Recherche d'Art visuel (GRAV) in Paris and ZERO in Germany, for example, worked with diverse media to explore various aspects of kinetic art and audience participation. Taking audience participation in the direction of political action, after 1957 the Situationist International theory of *détournement* (diversion) offered a strategy for how artists might alter pre-existing aesthetic and social circumstances in order to reconstruct the conditions of everyday life.

Through cross-pollination, the compositional strategy of audience engagement that emerged in Western concert music after World War II also played an important role in the creation of participatory art in the United States. Although not directly related to cybernetics, these artistic pursuits can be interpreted loosely as an independent manifestation of the aesthetic concern with the regulation of a system through the feedback of information among its elements. The most prominent example of this tendency, the American composer John Cage's *4'33"*, premiered in 1952. Written for piano but having no notes, this piece invoked the ambient sounds of the environment (including the listener's own breathing, a neighbor's cough, the crumpling of a candy wrapper) as integral to its content and form. Cage's publications and his lectures at the New School influenced numerous visual artists, notably Allan Kaprow, a founder of happenings (who was equally influenced by Pollock's gestural abstraction), George Brecht, and Yoko Ono, whose "event scores" of the late 1950s anticipated Fluxus performance.

Stiles has noted that the emphasis on the twin processes of artistic creation and reception had become an increasingly central focus of experimental visual art from gestural abstraction to happenings, Fluxus, and minimalism:

> What had begun in the late 1940's as attention to gesture in painting increasingly became a consciousness of how process informs practice at all levels from the studio to the support systems and institutions of art. Through this awareness, artists were able to demonstrate how formal aesthetics and social projects and goals of the modernist avant-gardes formed an inherent synthesis even though they had been theorized as different and independent. (Stiles and Selz 1996, 577)

For example, Robert Morris's *Box with the Sound of Its Own Making* (1961) explicitly incorporated the audible process of the object's coming into being as an integral part of the work. Morris's 1964 exhibition at the Green Gallery featured unitary forms that invoked the viewer as an active component in the environment.

In his provocative essay "Art and Objecthood," the art historian Michael Fried wrote disparagingly of the way minimalist sculpture created a "situation." He interpreted this "theatrical" quality as antithetical to the essence of sculpture (Fried 1967). But as Burnham ironically noted in *The Structure of Art*, such formalist orthodoxy was "tantamount to an archbishop accusing heretics of having . . . forsaken the rules of the Church" (Burnham 1971, 36). Although Fried's criticism has been influential, much of the most interesting art of the postwar period has challenged the categorical absolutism it advocated. Indeed, the interactive quality that Fried denigrated and Burnham supported is at the heart of Ascott's *Change Paintings* and his later cybernetic artworks of the 1960s. These works focused attention on creating interactive situations in order to free art from aesthetic idealism by placing it in a more social context.

By the 1960s, cybernetics had become increasingly absorbed into popular consciousness. Schöffer's work had helped introduce it into artistic discourses. The French artist Jacques Gabriel exhibited the paintings *Cybernétique I* and *Cybernétique II* in "Catastrophe," a group show and happening organized by Jean-Jacques Lebel and Raymond Cordier in Paris in 1962. Gabriel's text published on the poster publicizing the event stated, "L'Art et le cybernétique, c'est la même chose" (Art and cybernetics are the same thing). Also in 1962, Suzanne de Coninck opened the Centre d'Art cybernétique in Paris, where Ascott had a solo exhibition in 1964. Wen-Ying Tsai's *Cybernetic Sculpture* (1969) consisted of stainless-steel rods that vibrated in response to patterns of light

generated by a stroboscope and to the sound of participants clapping their hands.

In 1966, Nam June Paik drew a striking parallel between Buddhism and cybernetics:

> Cybernated art is very important, but art for cybernated life is more important, and the latter need not be cybernated. . . .
>
> Cybernetics, the science of pure relations, or relationship itself, has its origin in karma. . . .
>
> The Buddhists also say
>
> Karma is samsara
>
> Relationship is metempsychosis.
>
> (Paik 1966, 24)

In this short poetic statement, Paik suggested that Eastern philosophy and Western science offered alternative understandings of systematic phenomena. Buddhist accounts of cosmic cycles such as samsara (the cycle of life and death) and metempsychosis (the transmigration of souls) could also be explained in terms of scientific relations by cybernetics. In this respect, Ascott and Paik shared a common understanding of the simultaneously paradoxical and complementary nature of scientific and metaphysical explanations. Neither artist privileged one method over the other; both rather sought to develop insights into how phenomena are systematically interrelated at the most basic and profound levels.

Audio feedback and the use of tape loops, sound synthesis, and computer-generated composition reflected a cybernetic awareness of information, systems, and cycles. Such techniques became widespread in the 1960s, following the pioneering work of composers like Cage, Lejaren Hiller, Karlheinz Stockhausen, and Iannis Xenakis in the 1950s. Perhaps most emblematically, the feedback of Jimi Hendrix's screaming electric guitar at Woodstock (1966) appropriated the National Anthem as a countercultural battle cry. The visual effects of electronic feedback became a focus of artistic research in the late 1960s, when video equipment first reached the consumer market. Woody and Steina Vasulka, for example, used all manner and combination of audio and video signals to generate electronic feedback in their respective or corresponding media. As Woody remarked, "We look at video feedback as electronic art material. . . . It's the clay, it's the air, it's the energy, it's the stone . . . it's the raw material that you . . . build an image with" (Yalkut 1984, 128–30).

Not all artists were so enamored with cybernetics. Whereas Ascott, like Schöffer and others, genuinely believed in its potential as a "practical and in-

tellectual tool," the artists associated with Art & Language were much more skeptical. They applied scientific principles to art in a tongue-in-cheek manner, suggesting a parallel between the dogma of cybernetics and the dogma of modernist aesthetics. For example, in the key to 22 *Predicates: The French Army* (1967), Terry Atkinson and Michael Baldwin offered a legend of abbreviations for the French Army (FA), the Collection of Men and Machines (CMM), and the Group of Regiments (GR). Using logic reminiscent of Lewis Carroll, the artists then described a variety of relationships among these elements as part of a system (of gibberish): "The FA is regarded as the same CMM as the GR and the GR is the same CMM as (e.g.) 'a new order' FA (e.g. morphologically a member of another class of objects): by transitivity the FA is the same CMM as the 'new shape / order one'" (Harrison 1991, 52).

This ironic description—through a looking glass, so to speak—mocked the manner of cybernetic explanations. It reduced to absurdity the systematization of relationships among individuals, groups, and institutions that Ascott employed in defining his theory of a cybernetic art matrix (CAM) in the essay "Behaviorist Art and the Cybernetic Vision" (1966–67). Similarly, in Harold Hurrell's *The Cybernetic Art Work That Nobody Broke* (1969), a spurious computer program for interactively generating color refused to allow the user to interact beyond the rigid banality of binary input. If the user inputted a number other than 0 or 1, the program proffered the message: YOU HAVE NOTHING, OBEY INSTRUCTIONS! If the user inputted a non-number, *The Cybernetic Art Work That Nobody Broke* told him/her that there was an ERROR AT STEP 3.2 (Harrison 1991, 58).

Charles Harrison has interpreted these experiments as "flailing about—products of the search for practical and intellectual tools which had not already been compromised and rendered euphemistic in Modernist use" (Harrison 1991, 56). But they may also be taken as ironic critiques of the technocratic ideology of progress, the incommensurability of science and art, and the rigid confines within which claims for interactive participation might transpire. At the same time, the resistance of Art & Language to the purposeful conjunction of art and technology can be interpreted as a reactionary manifestation of their rejection of media-based art. The unity of art and technology in the 1960s was perceived to be complicit with what Harrison has theorized as the "beholder discourse" of modernism. But this interpretation failed to acknowledge the theoretical intersections and shared goals between such work and the practices of conceptual art and Art & Language (Shanken 2001). Moreover, the cryptic conceptualism of Art & Language arguably constituted an elitism that was equally complicit

in reifying the modernist values of hierarchy and privilege that cybernetic art sought to undermine by involving the audience in interactive encounters.

In this regard, Ascott's work has contributed to vital tendencies of twentieth-century experimental art: to focus on temporality, to put art into motion, to utilize the concept of feedback, and to invoke interaction with the viewer. In general, such art emphasized the artistic process, as opposed to the product, and accentuated the environment or context (especially the social context), as opposed to conventional subject matter or style. These tendencies helped to form a point of convergence between scientific and aesthetic contexts, cybernetics, and art. By constructing metaphorical parallels between the two disciplines, artists were able to utilize cybernetics as a model for aesthetic research, and as a paradigm for reconceptualizing the notion of art itself.

Cybernetics and Ascott's Art

Between 1960 and 1970, Ascott was the subject of eleven solo exhibitions in England and France, and he participated in over twenty-five group exhibitions throughout Europe during the same period. Through his numerous exhibitions, his formulation of a cybernetic art pedagogy, and his theoretical essays on cybernetics and art, Ascott became the British artist most closely associated with cybernetics in the 1960s.[15] At the same time, his work of that period examined the semantic relationships among verbal, scientific, and visual languages. Lucy Lippard prominently quotes his essay "The Construction of Change" (1964) on the dedication page of her seminal *Six Years: The Dematerialization of the Art Object from 1966 to 1972* (Lippard [1973] 1997), placing Ascott in the context of conceptual art.[16]

Cybernetics offered Ascott a new paradigm for his artistic practice and pedagogy. The titles of his works *Homage to C. E. Shannon* (1964), *Analogue Table: Wiener-Rosenblueth* (1964), *Bigelow* (1965), and *Fourier* (1966) honor mathematicians and scientists who contributed to the discipline that played an important role in forming Ascott's first mature aesthetic theory. Art itself became a cybernetic system, consisting of feedback loops that included the artist, the audience, and the environment. This dynamic field of interacting processes and behavior constantly transformed the system as a whole. As he wrote in his 1967 manifesto "Behaviourables and Futuribles": "When art is a form of behaviour, software predominates over hardware in the creative sphere. Process replaces product in importance, just as system supersedes structure" (page 157 below). Ascott envisioned the interactive, systematic processes of cybernetic art as in-

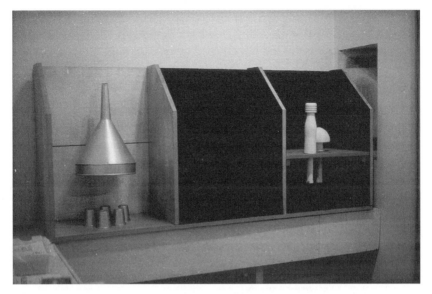

Figure 6. *Homage to C. E. Shannon.* 1964. Painted tin and wood, 24 × 54 × 12".

terconnected components in the larger system of feedback loops that constitute culture. Culture, in turn, he theorized as one of many nodes in the network of feedback loops that constitute society. In this way, Ascott's integration of cybernetics into aesthetics proposed that art, culture, and society were interconnected systems of feedback loops.

Ascott's concern with the temporal aspects of art as a durational process predates his awareness of cybernetics. Some of the artist's earlier conceptual influences help explain the evolution of ideas that ultimately led to his particular formulation of cybernetic art in the 1960s. Wentworth Thompson's biomorphological theories and Bergson's vitalist philosophy are central in this regard. Wentworth Thompson's *On Growth and Form* ([1942] 1968), which illustrates the transformation of biological matter through stages of development, became a sourcebook for artistic approaches to the genesis of visual forms, such as in Ascott's etching *Development* (see fig. 1). Ascott also drew on Bergson's concepts of the *élan vital*—an immaterial animating factor essential to life—and *durée*—the consciousness linking past, present, and future, dissolving the diachronic appearance of categorical time, and providing a unified experience of the synchronic relatedness of continuous change (Bergson 1911).

Although Bergson himself refused to endorse cubism, a number of the movement's leading theorists, including Albert Gleizes and Jean Metzinger, "thought

of themselves as 'Bergsonists,'" Mark Antliff observes (Antliff 1993, 3). In *Beyond Modern Sculpture* (1968), Jack Burnham sketches a critical history of the vitalist (i.e., Bergsonian) tendency in sculpture, identifying its manifestation in the biomorphic work of Jean Arp (an important source for Pasmore) and its particularly strong influence on Henry Moore, Barbara Hepworth, and other British artists beginning in the 1930s. Vitalism also had a strong impact on British art historians such as Sir Herbert Read, and it became a primary inspiration for Ascott, for whom *Creative Evolution* was a favorite philosophical text.

When Ascott was studying art history under Sir Lawrence Gowing, Bergson's ideas influenced his understanding of modern painting, and of the work of Paul Cézanne in particular. Although typically discussed in terms of the construction of space, Ascott suggested Cézanne's paintings were equally evocative of time. As evidence, he identified the simultaneous and shifting points of view from which the artist represented his subject. Drawing on the notions of *élan vital* and *durée*, he concluded that Cézanne's canvases exemplified the constant flux that characterizes the durational phenomenon of consciousness. From this perspective, Ascott extrapolated a general principle for painting in which the essence of reality is embodied in change. "To the painter who is dependent principally upon his visual researches for a greater perception of reality, it is the visual change in the state of things (either in themselves or in his consciousness) which will reveal their essential reality," he wrote (Ascott 1959, 30).

The genealogy from gestural abstraction to happenings and the performative elements of interactive art also offers insight into the growing concern, in the 1960s, with the temporal dimension of art, which Ascott shared. David Mellor has observed that "the notion of the art work as notated event in time underlay John Latham's first theory of the 'event-structure'" around 1954.[17] Another root of this tendency may be traced to the performative aspects of *art informel*, first demonstrated to large audiences by Georges Mathieu in Paris in 1954, and later in various locations around the world, including London at the Institute of Contemporary Arts in 1956 (Stiles 1987 and 1998). Indeed, the work of the New York School, and Jackson Pollock's weblike compositions, in particular, had earned great acclaim internationally by the 1950s. While the abstract expressionist ethos of unbridled expression of the unconscious was too emotional for Ascott's temperament, Pollock's physical, corporeal involvement in and around his paintings established a model for Ascott's research into the process by which art comes into being. In addition, the interconnecting skeins of Pollock's dripped and poured paint came to suggest, for the younger artist, ways in which art functioned metaphorically within connective networks of meaning (see chapter 16).

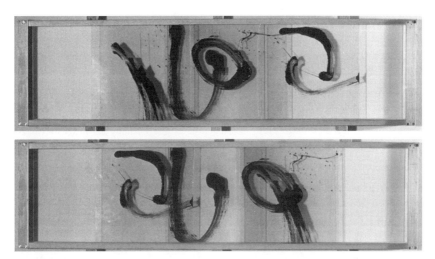

Figures 7-8. *Change Painting.* 1959. Plexiglas, wood, and oil, 66 × 21". Two different states.

"Interchangeable elements, each with an individual identity, may, by the physical participation of the spectator, be brought into a series of relationship, each one adding up to a whole which is more directly related to the manipulator of the parts, than if it were static and at a distance. The act of changing becomes a vital part of the total aesthetic experience of the participant."—ROY ASCOTT, statement from the exhibition brochure Change-Paintings and Reliefs, *St. John's College, York, 1960*

For example, on each plexiglas panel of Ascott's *Change Paintings* was a painterly gesture that the artist conceived of as a "seed" or "ultimate shape." Seeking to capture the essence of the phenomena of potentiality, these morphological art works may also be related to the ideas of organic development described in Wentworth Thompson's *On Growth and Form* and to the ideas of élan vital and durée developed by Bergson. The *Change Paintings* can be seen as an interactive visual construction in which the vital essence of the work can creatively evolve, revealing the multiple stages of its nature (as in the growth of a biological organism), over the duration of its changing compositional states. The infinite combination of these compositional transformations constituted an aesthetic unity, a metaconsciousness, or Bergsonian durée, including all its possible states in the past, present, and future.

Ascott's 1963 solo exhibition at the Molton Gallery in London, "Diagram Boxes and Analogue Structures," offers an early example of how the artist combined cybernetics and art. By this time, Ascott had assimilated cybernetics as a primary theoretical foundation for merging Bergsonian ideas with constructivism and audience interaction, while at the same time employing the use of

diagrams and text as a formal element. In so doing, he developed an original way of applying artistic and scientific theories to generate visual form.

Ascott's "Analogue Structures," such as *Video Roget*, can be interpreted in part as pushing the constructivist legacy to yet another level of complexity. Charles Biederman interpreted the artistic lineage spanning from Monet to Mondrian as systematically freeing color and form from the demands of mimesis. Biederman's structurist works, like the work of the English constructivists, including Pasmore and Nicholson, sought to extend this lineage by freeing form and color from the two-dimensional picture plane and placing it in three-dimensional relief. But whereas their work remained stationary, Ascott's *Change Paintings* and later kinetic works added a durational, interactive element that further liberated form and color by allowing it to move and change over time. Thus, while there are important formal similarities between Ascott's constructions and those of Pasmore and his colleagues,[18] the younger artist disavowed what he referred to as his mentor's "platonic ideals of 'pure form'" and his "refus[al] to link Constructivism with a social context" (Hastings 1963). Like Schöffer's "spatiodynamic" sculptures of the early 1950s, Ascott's work of the early 1960s experimented with placing constructivist principles in a social context by engaging the viewer's active physical and mental participation in determining the composition and meaning of the work.[19] The viewer became an integral part of the artwork, which Ascott conceived of as a cybernetic system, consisting of feedback links between artist, object, and audience.

Ascott's statement in the *Diagram Boxes and Analogue Structures* exhibition catalogue exemplifies how cybernetics had become part of a complex amalgam of aesthetic, philosophical, and scientific ideas that led to his creation of interactive, changeable works of art:

> Cybernetics has provided me with a starting point from which observations of the world can be made. There are other points of departure: the need to find patterns of connections in events and sets of objects; the need to make ideas solid . . . but interfusable; an awareness of change as fundamental to our experience of reality; the intention to make movement a subtle but essential part of an artifact. (Ascott 1963)

In this passage, the artist explicitly stated that cybernetics provided a conceptual framework for interpreting phenomena artistically. His recognition of "change" as fundamental to "the experience of reality" recapitulated a Bergsonian concept he had applied in his interpretation of Cézanne and in his *Change Paintings*. Finally, the "need to make ideas solid . . . but interfusable" suggested

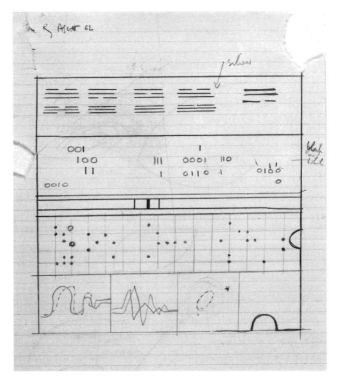

Figure 9. Untitled drawing. 1962. 7 7/8 × 9" approx. Note *I Ching* hexagrams in upper register, followed by binary notation, scatter-plots, and wave-forms. A "calibrator" in the middle suggests the ability to juxtapose or combine various permutations of these systems of information representation.

the modular, concrete aesthetic of constructivism. The "intention to make movement a subtle but essential part of an artifact" reflected a concern he shared with diverse strains of twentieth-century art, which sought to vitalize visual form through motion, enactment, and performative elements.

Ascott extended the parallel he drew between the forms of art and science to include non-Western systems of knowledge as well. The phrase "To programme a programming programme" appears on a 1963 sketch for the 1964 construction *For Kamynin, Lyubimskii and Shura-Bura*, dedicated to the Russian computer scientists. Yet despite the scientific jargon, in this work and others from the 1960s and 1970s, Ascott visually suggests equivalences between *I Ching* hexagrams, binary notation of digital computers, scatterplots of quantum probability, wave forms of information transmissions, and biomorphic shapes.

A similar convergence of methods characterizes works like *Cloud Template*

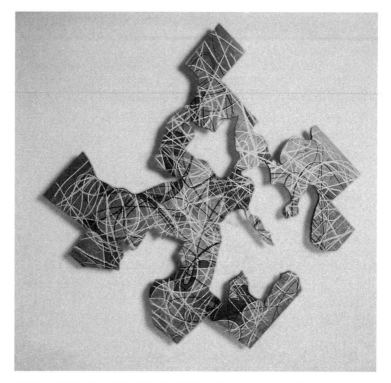

Figure 10. *Change Map.* 1969. Wax and crayon on stained wood, 80 × 80".

(1969; fig. 26) and *Change Map* (1969). Ascott created these sculptural paint-
ings using aleatory methods. By throwing coins (as in casting the *I Ching*) on
top of a sheet of plywood, chance patterns developed. The artist drew lines and
curves connecting the points marked by the coins, then cut through the wood,
progressively removing segments and creating an unpredictable shape. Ascott's
use of chance methods is related both to dada and surrealism and to the tech-
niques of Cage, who determined parameters of his musical compositions by cast-
ing the *I Ching*.

At the same time, the verticality of this method shares affinities with the car-
tographic and horizontal qualities in the work of Pollock and Duchamp. Pol-
lock's decision to remove the canvas from the vertical plane of the easel and paint
it on the horizontal plane of the floor, for example, altered the conventional,
physical working relationship of the artist to his or her work. Similarly, Ascott's
corporeal orientation to his materials became horizontal, whereby the artist
looked down on the canvas from a bird's-eye view. This shift embodied and made

Figure 11. *Transaction Set*. 1971. Found objects, dimensions variable.

explicit the ongoing reconceptualization of painting from a "window on the world" to a cosmological map of physical and metaphysical forces. The random method that Duchamp used for creating *3 Standard Stoppages* (1913–14) also demanded a horizontal relationship between artist and artwork. Duchamp's related *Network of Stoppages* (1914), which can be interpreted as a visual precursor to the decision trees of systems theory, further offered a diagrammatic model for the interconnected visual and semantic networks of Ascott's transparent *Diagram Boxes* (ca. 1962–63).[20] Later, Ascott created interactive works on an explicitly horizontal plane, such as *Transaction Set* (1971), which made use of a table as a "canvas," on which various "table-top strategies" could be played out.

In works like *For Kamynin, Lyubimskii and Shura-Bura* and *Parameter V*, Ascott joined twentieth-century aesthetic concepts of chance, horizontality, and cartographic imagery with Bergsonian notions of vitalism and change, the *I Ching*, cybernetics, and artificial intelligence. For thousands of years the *I Ching* has been consulted on choosing a path toward the future; much more recently cybernetics emerged in part from Wiener's military research, which attempted to anticipate the future behavior of enemy aircraft. Similarly, Ascott's experience as a radar officer in the Royal Air Force may have contributed to his artistic predisposition towards a horizontal bird's-eye view and the use of carto-

Figure 12. *Table-Top Strategies*. 1971. Composite photograph of interactions with a Transaction Set.

graphic forms that triangulated information to predict the future. In this way, Ascott's cybernetic art combined aesthetic, scientific, and mystical models to create his own visionary practice.

Cybernetics and Art Pedagogy

Ascott extended his theory and practice of cybernetic art into his work as an art educator. As head of Foundation Studies at the Ealing College of Art in London (1961–64), he created what might be called a cybernetic art pedagogy. He described how the continuum between his work in the studio and his work in the classroom made the two complementary: "In trying to clarify the relationship between art, science and behaviour, I have found myself able to become involved in a teaching situation without compromising my work. The two activities, creative and pedagogic, interact, each feeding back to the other. Both, I believe, are enriched" (page 98 below).

It is no coincidence that he used the language of cybernetics to suggest how his art practice and pedagogy interacted, "each *feeding back* to the other" in a

mutually reinforcing system. One might even say that the classroom became a cybernetic studio, in which the artist could experiment with behavioral inter-actions among his students, and in which his students could learn some of the most advanced aesthetic theories firsthand, by participating in them. "I do not know of any other artist/teacher who projects such a high incident of integra-tion between his teaching ideas and the art-hardware that he makes," noted the British artist and critic Eddie Wolfram (Wolfram 1968).

Throughout his career, Ascott has held a strong conviction, not just about the role of the educator in teaching art, but about the role of art in teaching cul-ture. In the Foundation Studies curriculum he instituted at Ealing, the study of conventional artistic skills transpired within a context where theoretical con-cerns and the broader implications of art were foregrounded. "All art is, in some sense, didactic: every artist is, in some way, setting out to instruct," he wrote. "For, by instruction, we mean to give direction, and that is precisely what all great art does. . . . Through [the] culture it informs, art becomes a force for change in society" (page 98 below).

This conviction about the positive social function of art as an instrument of education and transformation has been a consistent feature of Ascott's theory, practice, and pedagogy for some forty years. The success of his pedagogical methods and his belief in the role of art in culture in general has led to numer-ous international positions as an arts educator, consultant and administrator (see Appendix I).

In the classroom, cybernetics offered a clear model for reconceptualizing art and education—and their roles in a larger social system—by suggesting the or-ganization of art education curricula in terms of a behavioral system of feed-back and control. The course of study Ascott implemented at Ealing beginning in 1961 focused on these cybernetic principles. Students collaborated together as elements of a system that regulated their artistic behavior as an integrated whole. As Ascott explained, forming groups of six, each student would be "set the task of acquiring and acting out . . . a totally new personality, which is to be narrowly limited and largely the converse of what is considered to be their nor-mal 'selves'" (page 105 below).

Ascott's pedagogy threw into question a student's preconceptions about his or her personality and strengths and weaknesses as an artist, as well as about the nature of art itself. Students were actively encouraged to mature through the experimental adoption of different behavioral characteristics and a rethinking of art-making and art as process and system. Students created aleatory devices, such as the *Calibrator for Selecting Human Characteristics*, in order to determine

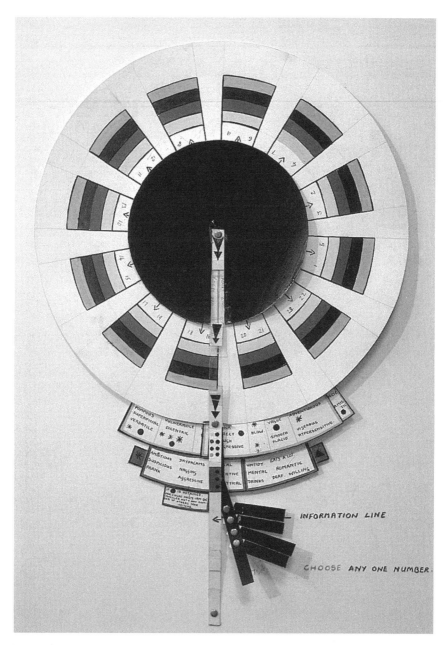

Figure 13. *Calibrator for Selecting Human Characteristics.* Ca. 1963. Student work from Ealing College of Art, London.

behavioral alterations in a random but systematic manner. Because their individual behaviors had to be integrated into a coherent group process, all members would have to be "interdependent and highly conscious of each other's capabilities and limitations" in order to accomplish together the "goal of producing . . . *an ordered entity*" (page 106 below). In one exercise, Peter Townshend (who later founded the rock band The Who) was restricted to transporting himself about the school on a trolley. He and the other members of his group had to compensate for one another's abilities and disabilities in order to make the collective function as an integrated organism. In this way, students learned about the principles of cybernetics as applied to art through their own behavioral interactions in a cybernetic art system in which the controlled exchange of information organized the overall structure.

In Ascott's "Ground Course" (the first-year curriculum for developing foundational artistic skills), students were introduced to other radical artists and intellectuals in a variety of disciplines. Gustav Metzger's presentation of his theory of "destruction in art" is a powerful example of the influence of Ascott's guest lecture program. Townshend has credited Metzger's theory of auto-destructive art with giving him the idea of destroying musical instruments onstage at concert performances by The Who—a performative gesture that visually symbolized the anger of the generation that rebelled against the Vietnam war (Stiles 1987). Stiles has theorized this transference of ideas from Metzger to Townshend as an illustration of the process by which the most advanced and rarified conceptual developments in experimental visual art become assimilated into popular culture. In a similar vein, might not Townshend's experience of immobility in Ascott's cybernetic classroom have inspired the "deaf, dumb, and blind" pinball wizard in his rock opera *Tommy*? Such migrations of concepts from art to culture and society substantiate Ascott's notion that "art is . . . didactic" and that "through culture it informs . . . and becomes a force for change in society" (page 98 below).

Between 1964 and 1967, Ascott was head of the Department of Fine Art at Ipswich Civic College in Suffolk. His emphasis on art as behavior and system resulted in a variety of interesting student exercises. One in particular seems to have anticipated the popular parlor game *Twister*.

Ascott's cybernetic, behavioral art curriculum at Ipswich was as rigorous and challenging as it had been at Ealing. Brian Eno, who was one of his students there and later gained renown as a musician and composer, has provided a firsthand account of his teacher's pedagogical methods and their impact on him:

Figures 14-15. Student behavioural experiments at Ipswich Civic College, Suffolk, 1965. A precursor to the parlor game Twister? Photos by Roy Beston.

> One procedure employed by Ascott and his staff was the "mindmap." In this project each student had to invent a game that would test and evaluate the responses of the people who played it. All the students then played all of the games, and the results for each student were compiled in the form of a chart—or mindmap. The mindmap showed how a student tended to behave in the company of other students and how he reacted to novel situations. In the next project each student produced another mindmap for himself that was the exact opposite of the original. For the remainder of the term he had to behave according to this alternative vision of himself. (Eno et al. 1986, 40–41)

Eno notes that "[f]or everybody concerned this was an extraordinary experience . . . [which] was instrumental in modifying and expanding the range of interaction each student was capable of." He also recounts another educational experiment, later dubbed the "Quadrangle Incident" in which the students were locked in the courtyard by the staff: "They said nothing and would not answer our questions . . . for more than an hour. During this time, our mild amusement at this situation changed to uneasiness and then complete perplexity. We all had an idea that we were expected to do something, but none of us knew what." As Eno's biographer Rick Poynor has noted, this "object lesson in 'the tension that

arises from being plunged into a novel situation' . . . would come to assume increasing importance in Eno's ideas about the function of art" (41).

The reputation Ascott gained as a progressive art educator using experimental methods rooted in cybernetics led to a number of distinguished positions, including those of president and chief executive officer of the Ontario College of Art (OCA) in 1971–72. Coincidentally, and ironically, it was there, in Toronto, the hometown of the visionary media theorist Marshal McLuhan, that Ascott encountered the most serious resistance to his cybernetic art pedagogy. The art education curriculum Ascott attempted to implement at the OCA was predicated on many of the ideas he developed at Ealing, and later at Ipswich and at Wolverhampton Polytechnic, where he was head of Painting between 1967 and 1971. Ascott elaborated his art teaching method in his essay "Behaviourist Art and the Cybernetic Vision" and created an innovative curriculum for OCA based

on those principles, triangulated in a diagram whose components were information, concept, and structure.

The OCA was a beleaguered institution that had "been in constant turmoil" for several years prior to Ascott's appointment. In July 1971, before the revamped curriculum could begin to yield its intended results, tensions were already beginning to mount. An enthusiastic Toronto newspaper headline read, "Revolution at Ontario College of Art." By December, another headline read, "Students and faculty are confused as 'future shock' hits our art college." Ascott ultimately was dismissed in 1972, but his departure met with great resistance, especially on the part of the students. A local art journal reported: "The walls were plastered with posters by the students, 'We want Roy,'" and one student said, "'For the first time we've wakened [sic] up to the WONDER in life. . . . and Roy did it."[21] According to Norman White, an OCA faculty member, Ascott's lasting impact on the school was substantial. Among other influences, he created the innovative Photoelectric Arts Department, where White was still teaching in 1999, and which was still directed by Richard Hill, whom Ascott had appointed during his tenure.[22]

After leaving the OCA, Ascott became head of the Department of Fine Art at the Minneapolis College of Art & Design (1974–75) and then vice president and academic dean of the College at the San Francisco Art Institute (1975–78). In the 1980s, his pioneering research in telematic art (art projects using computer-mediated telecommunications networks as their medium) led to positions as founding head of the Department of Communications Theory at the University of Applied Arts, Vienna (1985–92), and head of the Field of Interactive Arts at Gwent College, Newport, Wales (1991–94). Ironically, ten years after Ascott's dismissal, the OCA participated as one of the nodes in Ascott's art project "La Plissure du Texte." By the mid 1990s, the World Wide Web had made routine the artistic and multidisciplinary collaborations Ascott had been proposing for decades, validating his initiatives to expand art education curricula in unconventional ways. Indeed, the struggle to balance traditional skills and aesthetic concerns with new techniques, media, and values is one of the most difficult issues now facing art education.

In this regard, perhaps Ascott's greatest accomplishment as an art educator was his founding of the Centre for Advanced Inquiry in the Interactive Arts (CAiiA, echoing "Gaia," or Earth) at the University of Wales, Newport, in 1994. In this program, his cybernetic and telematic aesthetic theories have been applied as an integrated pedagogical method. In the 1995–96 academic year, CAiiA gained accreditation for the world's first Ph.D. program focusing on interactive

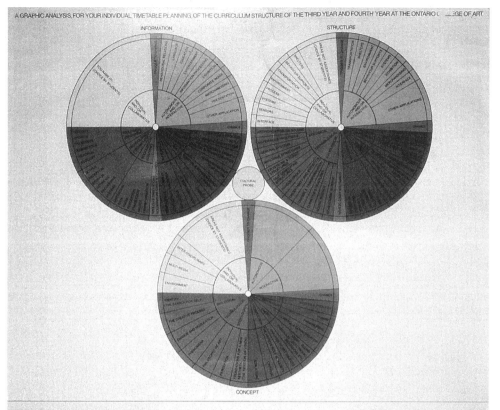

The Ontario College of Art is entering into a new phase of curriculum development. The College will now be structured as an exploratory and speculative organism providing a four year diploma course, comprising a two year ground course common to all students and then two years in which students with tutorial guidance and advice map out an individual learning program relating to three spheres of emphasis plus a centre core cultural probe. Each of these spheres of emphasis: Structure, Concept and Information, provides for exploration and instruction in the areas of analysis, theory, speculation and social application. Students will be encouraged to embrace a spirit of collaboration, participation and of sharing as a basis for creative activity. Each student will have the freedom to operate on and through the widest possible range of physical media and material structures. This will include pigment, steel, electric media, light, sound, fibreglass, plastics, etc. as well as the utilization of such specific processes as television, print, photography, mass production, prefabrication and many others. The exposure and training provided by this unique structure will enable a student to acquire a comprehensive visual education as well as a highly professional background to meet the specific social needs of our time and of the future.

DEFINITIONS OF AREAS OF EMPHASIS IN THE THIRD AND FOURTH YEAR CURRICULUM

STRUCTURE — the relating of elements
INFORMATION — informing through media
CONCEPT — conceived or intuited thought or idea

Each sphere has four quadrants:

ANALYSIS — the *examination* of anything to determine its elements and their relationships
THEORY — *principles* and *methods* as distinguished from practice
SPECULATION — open-ended *consideration* and *development* of an idea
SOCIAL APPLICATION — the *adaptation* of anything for use or purpose in a community

Central to the Curriculum structure is:

CULTURAL PROBE — a search and questioning in: LIFE SCIENCES SOCIAL STUDIES ANALYSIS OF ART SYSTEMS FUTURE STUDIES

Figure 16. Curriculum diagram, Ontario College of Art, 1972.

art—a course of study that has transpired largely online. CAiiA graduates include such internationally renowned artists as Victoria Vesna (U.S., Ph.D. 2000), Bill Seaman (U.S., Ph.D. 1999), Joseph Nechvatal (U.S./France, Ph.D. 1999), Jill Scott (Switzerland/Australia, Ph.D. 1998), and Dew Harrison (U.K., Ph.D. 1998). Other renowned students include Eduardo Kac (Brazil/U.S.), Christa Sommerer (Austria/Japan, Ph.D. 2002), Laurent Mignonneau (France/Japan), Miroslaw Rogala (U.S./Poland, Ph.D. 2001), Marcos Novak (U.S.), and Char Davies (Canada). In the 1997–98 academic year, a joint degree program was developed between CAiiA and the Science, Technology and Art Research center (STAR), in the School of Computing, University of Plymouth. The combined research institute has been named CAiiA-STAR. CAiiA-STAR regularly makes presentations on technology and culture to educational and civic institutions internationally, and has organized an annual "Consciousness Reframed" conference since 1997.

Cybernetics and Ascott's Writings from the 1960s

Two of Ascott's essays from the 1960s exemplify his theories on the application of cybernetics to art: "The Construction of Change" (1964) and "Behaviourist Art and the Cybernetic Vision" (1966–67). In these early publications, Ascott emphasized how the processes of artistic production and reception had come to occupy center stage in his conceptualization of art as a cybernetic system. As noted above, the emergence of this emphasis on "process" may be traced to the gesturalism of postwar painting, and it became an increasingly pervasive area of artistic inquiry in the late 1960s and 1970s. Stiles has suggested, moreover, that this aesthetic shift laid the conceptual groundwork for the popular use of interactive electronic media that would follow:

> In their writings and works, many artists became increasingly aware of how process connects the superficially independent aspects and objects of life to an interdependent, interconnected network of organic systems, cultural institutions, and human practices. However awkwardly these artists' works anticipated the end of a century that witnessed the advent of massive electronic communication systems like the Internet, their research was vital in visualizing process as a means to align art with the future. (Stiles and Selz 1996, 586)

In this context, Ascott's texts of the 1960s are remarkable for the ways in which they not only theorized an artistic project based on the ideas of process and behavioral interaction but also explicitly envisioned the future application of communications technologies (which would not become available for nearly two

decades) to this project. This genealogy of ideas illustrates how concepts that emerged in the liminal space of experimental art often become popularized later in other modes of cultural production. Interactivity, for example, has become a cornerstone of the communications, electronics, and entertainment industries' development and marketing of online services, computer games, and multimedia in the 1990s and 2000s (Stiles and Shanken 2002). And the term "multimedia" has been credited to the Fluxus artist Bob Watts, who coined it in 1958 (Simon 1999, 71).

The types of changes that Ascott identified in "The Construction of Change" and "Behaviourist Art and the Cybernetic Vision" also share many similarities with postmodern discourses that identify themselves as heralding a new epistemological paradigm emerging from the deconstruction of the ideas underpinning modernism. In particular, Ascott's cybernetic aesthetic theory was predicated on the relativism of probabilistic theory, the negotiation of behavior contingent on feedback, the determination of meaning as the result of the dynamic flow of information through a system, and the emphasis on process as opposed to product. All of these ideas are consistent with poststructuralist theories of knowledge and being. These parallels are presented only to suggest that Ascott's aesthetic theory (derived from experimental art, cybernetics, and other sources) reached conclusions that were very similar to those emerging contemporaneously in various critical discourses in diverse disciplines, and which later became historicized under the rubric of postmodernism. There are many differences as well. For example, Ascott was antagonistic to the recycling of historical styles and believed strongly in the possibility and importance of originality, of creating the world anew. But his anticipation of appropriation as an aesthetic strategy indicates how Ascott's thinking was very much at the vanguard of intellectual history in the 1960s.

Ascott's first theoretical text, "The Construction of Change," emphasized the importance of science and technology as models for informing artistic practice in a socially constructive way. It joined Ascott's conceptual roots in Bergsonian concepts of duration and his more recent embrace of cybernetic theory, balancing metaphysical intuition with scientific rationalism. Written while he was teaching at Ealing, the essay asserted the didactic power of art. Ascott observed that technology changes the world, not just by physically altering the objects of experience, but by transforming the way those objects are perceived and experienced. In other words, he suggested that technology alters human consciousness. He argued that artists have a responsibility to comprehend those technologically induced changes so that they can create models of knowledge and

behavior that offer alternative visions and possibilities for shaping the world. "Technology . . . is not only changing our world, it is presenting us with qualities of experience and modes of perception that radically alter our conception of it. . . . The artist's moral responsibility demands that he attempt to understand these changes" (page 98 below). With regard to the artist's role in overcoming the challenges of technological society, he wrote: "The artist functions socially on a symbolic level . . . [and] stakes everything on finding the unfamiliar, the unpredictable. His intellectual audacity is matched only by the vital originality of the forms and structures he creates. Symbolically, he takes on responsibility for absolute power and freedom, to shape and create his world" (page 98 below). In this passage, Ascott asserted that the artist fulfills a social need to take chances, to seek out the unknown, to freely play and experiment with ideas and structures that are unproven and perhaps dangerous but nonetheless a vital source of inspiration and direction for the future.

In "The Construction of Change" Ascott contended that art provides a virtual world in which models of prospective futures may be tested prior to being approved for more general applications, what Burnham later referred to as a "psychic dress-rehearsal" for the future. In this way, Ascott suggested, artistic models can make the transition from ephemeral idea to a transformative behavior that shapes and creates the world. Quoting Goethe, he further claimed that the artist's "'capacity to create what is to be'" takes on a moral imperative, for, "'man's highest merit . . . is to control circumstances as far as possible.'" Such a declaration overstates the case, for Ascott himself had asserted the importance of chance and play as artistic strategies, both in his theoretical writings and in his artworks. But perhaps there is no necessary contradiction between using chance methods to arrive at a form of control. Indeed, the cybernetic art matrix (CAM) Ascott elaborated in "Behaviourist Art and the Cybernetic Vision" prescribed a highly defined and structured system as the precondition for expanding creative play throughout society. Throughout his writings, Ascott has consistently restated his sense of responsibility as an artist to envision alternative futures, overcoming the limited confines of formalist aesthetics, to shape the way people think, live, and interact.

"BEHAVIOURIST ART AND THE CYBERNETIC VISION" (1966-67)

Building on the theories he laid out in "The Construction of Change," in his next major piece of theoretical writing, "Behaviourist Art and the Cybernetic Vision," Ascott attempted to define a way of enhancing creative behavior

throughout society by inventing an educational system according the princi-
ples of cybernetics. This dense and lengthy text was published in two parts in
consecutive issues of the Belgian journal *Cybernetica*. In it, Ascott proposed a
new paradigm of "modern art," which he claimed "differs radically from [the
determinism of] any previous era" and is distinguished by its emphasis on am-
biguity, mutability, feedback, and especially behavior. While hopeful about this
new aesthetic model, Ascott anticipated (with apprehension) the recycling of
artistic styles that would come to characterize certain aspects of postmodernist
art and architecture. He offered a prospective description of interactive artworks
involving human-computer interfaces, and suggested some possibilities of re-
mote artistic collaboration via telecommunications.

In order to promote creative behavior in a technological society, Ascott pro-
posed an educational model that he called the cybernetic art matrix (CAM),
consisting of an elaborate, integrated system for promoting a cybernetic
model of information feedback and exchange throughout culture. Anticipat-
ing a time in which cybernetics and robotics would have created a world in
which human beings had substantially greater amounts of leisure time, Ascott
envisioned that CAM would provide an educational structure in which people
could focus their energies on expanding their intellectual and artistic capabil-
ities and collectively participate in forms of creative behavior that would en-
hance the quality of life.

Behaviorist Art, Cybernetics, and Behaviorism

In "Behaviourist Art" (the first part of "Behaviourist Art and the Cybernetic Vi-
sion"), Ascott sought to differentiate between prior artistic models, and an art
based on ideas from cybernetics and behavioral psychology. In this regard, it is
tempting to draw parallels between the behavioral psychologist B. F. Skinner's
self-proclaimed "technology of behavior" and the roughly contemporary sci-
ence of cybernetics (Skinner 1971). Though Skinner himself might have denied
any connection between the two fields, behaviorism offered an experimental
mechanism for measuring the effect of conditioning on behavioral modifications
that a cybernetician might describe in terms of feedback loops. The methodol-
ogy of behaviorism functioned by bracketing out or, in cybernetic terms, "black-
boxing" the internal mechanisms operating in the organism. In this way, difficult
problems (in psychology or engineering) could be simplified by allowing the
complex internal mechanism inside the "box" to remain unexplained.

Similarly, Ascott conceived of behaviorist art as functioning, in part, like a

cybernetic black box. The transformative potential of the artwork as an input would result in the alteration of the viewer's information and behavior. But whereas the state of the black box of cybernetics or behavioral psychology necessarily was meant to remain unchanged in order to enable predictive control and replicability, Ascott's cybernetic, behavioral artworks were themselves meant to be transformed (within a certain range of possibilities) by the interaction of the viewer with them. It must also be noted that Skinner believed that behavior could be understood on the basis of environmental conditioning alone. As such, he conceived of the organism itself as a black box whose internal processes offered no significant clues to predicting behaviour. Ascott, on the other hand, ascribed great significance to the ability of the internal processes of his artworks and those who participated in them to transform the behavior of the system as a whole. By merging cybernetics and behaviorism, his work countered Skinner's deterministic conception by striking a balance between how internal and external factors affected the behavioral dimensions of art.

The idea of art as a system capable of transforming behavior and consciousness was fundamental to Ascott's paradigm for the art of the future. Such an art had to be interactive, allowing the viewer to become actively engaged with it. In "Behaviourist Art," Ascott claimed that this two-way exchange of information was fundamentally different from the passive one-way path of traditional art:

> The dominant feature of art of the past was the wish to transmit a clearly defined message to the spectator, as a more or less passive receptor, from the artist, as a unique and highly individualised source. This deterministic aesthetic was centred upon the structuring, or "composition," of *facts*, of concepts of the *essence* of things, encapsulated in a factually correct visual field. Modern art, by contrast, is concerned to initiate *events*, and with the forming of concepts of *existence*. The vision of art has shifted from the field of objects to the field of behaviour. . . .
>
> . . . The artist, the artifact, and the spectator are all involved in a more behavioural context. . . . [T]hese factors . . . draw the spectator into active participation in the act of creation; to extend him, via the artifact, the opportunity to become involved in creative behaviour on all levels of experience—physical, emotional, and conceptual. A feedback loop is established, so that the evolution of the artwork/experience is governed by the intimate involvement of the spectator. (Pages 110–11 below)

Contrary to Ascott's strong claim for the radicality of his work vis-à-vis traditional art, it may be argued that works of art have always demanded interac-

tion from viewers and that the networks of signification by which visual forms attain meaning presuppose a two-way exchange of meaning. If what Ascott proposes is not "new" in the sense of offering a fundamentally different model of perception for visual art, then his art and theory may be interpreted as emphasizing and making explicit a bi-directional model of aesthetic information exchange in which the viewer becomes an active participant in determining the work. While Ascott's claims overstate the case and create a binary opposition between conventional art and his own work, that lack of subtlety does not, however, completely undermine his argument for the historical aesthetic shifts he identified. Rather, it suggests that those shifts may be more usefully explained in terms of changes in emphasis and awareness. In this sense, his studio practice and theoretical work can be seen as extending the growing recognition by artists and aestheticians of the active experiential processes involved in creating and viewing art, and in visual perception in general.

A further note on terminology is in order here, because the terms that Ascott used to distinguish between the "art of the past" and "modern art" may now confuse his point. As was customary in the 1960s, Ascott conceived of modern art as new or contemporary art, opposed to prior aesthetic conventions. Over the past forty years, however, the term "modern art" has come to refer to art produced during the historical period of modernism.[23] What Ascott described as the "art of the past" shares principles in common with what scholars now refer to as modern art. And his description of modern art as "forming concepts of existence" and shifting "the vision of art . . . from the field of objects to the field of behaviour" anticipated what became widely recognized as a postmodern artistic and critical strategy: the deconstruction of categorical distinctions such as those between artist, artwork, and audience. At the same time, the reliance of Ascott's argument on binary oppositions (e.g., past vs. present, objects vs. events) and his faith in scientific progress suggest continuities with the liberal humanist values associated with modernism. Since systems of knowledge are hardly univocal or monolithic, such a commingling of values is the inevitable and persistent condition that pertains to the transition, overlap, and negotiation of epistemological models. In other words, Ascott's cybernetic art theories of this period straddle modernism and postmodernism, and manifest the tension between them.

In "Behaviourist Art," Ascott warned that resistance to technology might hinder the social advances he envisioned. He foresaw that if such resistance prevailed, a superficial pastiche of historical styles would come to dominate art:

> This incipient malaise finds its strength in a circular pattern of events, an endless repetition of past styles and artful recombinations of formal traits that have

> already served their purpose for the earlier artists who originated them. Art feeds
> on art, it is true, but the disease results from a preoccupation with the superficial
> visual style of a culture object from the past, and develops out of ignorance of
> the processes of creative thought that produced it. (Page 130 below)

Whether or not one agrees with Ascott's diagnosis of this condition as a "disease," he forecast a significant cultural trend of the subsequent quarter century—an era obsessed with recycling historical styles in art, architecture, music, and fashion. Again, his prescience is notable. For who, in the mid 1960s, could have imagined that artists would achieve art historical fame and commercial success by "appropriating" or copying the images or styles of previous generations of artists?[24] Or that a neo-baroque mélange of historical stylistic references in architecture—what Jean Baudrillard (echoing Walter Benjamin) theorizes as a "procession of simulacra"—would constitute a requiem for the modernist concept of originality and become celebrated as distinctively postmodern?

Ironically, the advent of digital technologies has intensified both the ethos of appropriation Ascott warned of and the ethos of interactivity he promoted. It has accomplished this dual role by facilitating wholesale copying of images, sounds, texts, and other data. Simultaneously, telematic technology has begun to enable the popular and widespread dissemination and transformation of multimedia content, bypassing the conventional corporate structures that control marketing and distribution from the top down.

Significant examples in this regard are the pervasive use of sampling in hip-hop music and the widespread exchanging of music and other media through peer-to-peer file-sharing services such as Napster, recently ruled as a violation of copyright law. Given the complexity of intellectual property law, the financial interests of media producers, and the demand of consumers for free downloads (particularly since the proverbial cat has already been let out of the bag), it is unclear to what extent the utopian goals Ascott foresaw have been realized or will be realized (or curtailed) in the future.

The Cybernetic Vision: The CAM, Computers, and Remote Collaboration

In "The Cybernetic Vision," the second part of the essay, Ascott conceived of the cybernetic art matrix as an interrelated system of feedback loops designed to serve professional artists, as well as the general public. He envisaged that the flow of information and services would be self-regulating throughout the whole. The CAM was intended to provide a variety of functions, including: facilitate

interdisciplinary collaboration among geographically remote artists and scientists, enable a pragmatic art education curriculum for the young, and enrich the lives of "the new leisured class" by offering amenities and modes of creative play. Ascott used symbolic formulae, and numerous acronyms, to identify particular niches within the CAM, and to explain methodically how the various layers are connected to the system. Looking back from a historical distance of nearly four decades, the formulaic structure and scientism of the CAM can be seen as part of its stylistic charm. For along with the overdetermined rigidity of its form and the unmitigated utopianism of its goals, the CAM attempted to employ cybernetic theory in the design of a social system that would solve a practical problem: to serve human needs in the future, when people would be freed from the demands of labor and could focus their energies on developing their intellectual, creative, and ludic capacities.

Ascott envisioned technology as playing a vital role in implementing his cybernetic vision, both as a means to enhance human creativity at the individual level and by enabling collaborative interaction between participants from diverse fields and geographic locations. In this regard, Ascott conceived of the computer and the potential relationship between art and computers in the following terms:

> [The computer] is a tool for the mind, an instrument for the magnification of thought, potentially an 'intelligence amplifier.' . . . [T]he interaction of artifact and computer in the context of the behavioural structure is equally foreseeable. . . .
> The computer may be linked to an artwork, and the artwork may in some sense *be* a computer. (Page 129 below)

Extrapolating from ideas W. Ross Ashby described in "Design for an Intelligence Amplifier" (Ashby 1956), Ascott suggested an unconventional use of computers in an artistic context. Ascott's concept of the artistic application of computers had little in common with the two-dimensional pictures of rigidly geometric computer graphics or the psychedelic organicism of fractal images. Instead, Ascott envisioned the computer as a means for controlling environments and triggering events, regulating a variety of visual parameters, and allowing for audience interaction in real time. Among his artistic models, he cited the work of Nicholas Schöffer, whose studio he visited in Paris in 1957.

By the late 1960s, Ascott's theoretical concerns with audience involvement had expanded from the localized artistic environments of his earlier interactive work, and he began to consider the potential of geographically dispersed interaction. Over a quarter century before the advent of Web-based graphical interfaces, "Behaviourist Art and the Cybernetic Vision" anticipated the emergence

of art created interactively with computers, and remote artistic/interdisciplinary collaborations via telecommunications networks:

> Instant person-to-person contact would support specialised creative work. . . . An artist could be brought right into the working studios of other artists . . . however far apart in the world . . . they may separately be located. By means of holography or a visual telex, instant transmission of facsimiles of their artwork could be effected and visual discussion in a creative context would be maintained. . . . [D]istinguished minds in all fields of art and science could be contacted and linked. (Page 146 below)

In this description, Ascott cited McLuhan's media theories as offering a vision for how electronic media could enable "instant and simultaneous communication . . . [through] electric extensions of the central nervous system . . . produc[ing] a 'global village' of social interdependence" in the realm of art.[25] McLuhan's *Gutenberg Galaxy* (1962) and *Understanding Media* (1964) were already in wide circulation at the time, but Ascott's proposition must nonetheless have seemed like science fiction in the realm of art. Indeed, it would be many years before the artist could gain access to the technology that would make possible such collaborative computer-networking projects, a domain Ascott later dubbed telematic art.

▬ TELEMATICS

Telematics, or the convergence of computers and telecommunications, is rapidly becoming ubiquitous in the developed world. Anyone who has corresponded using e-mail, surfed the World Wide Web, or withdrawn money from an automatic teller has participated in a telematic exchange. The term *télématique*, later anglicized as "telematics," was coined by Inspector General Simon Nora and Finance Inspector Alain Minc in *L'Informatisation de la société: Rapport à M. le président de la République* (1978). Written at the request of President Valéry Giscard d'Estaing, this official government report outlined France's level of development in computerization and telecommunications vis-à-vis other international powers at that time. Nora and Minc further anticipated the directions of future global expansion in these areas and proposed policies for governmental management of technological growth. Comparing telematics with the technologies that fueled the industrial revolution (the steam engine, the railroads, and electricity), the authors described the impending telematic revolution, which they envisioned as follows: "[It] will have wider consequences. . . . Above all,

insofar as it is responsible for an upheaval in the processing and storage of data, it will alter the entire nervous system of social organization. . . . This increasing interconnection between computers and telecommunications—which we will term 'telematics'—opens radically new horizons" (Nora and Minc 1980, 4–5). Although effusive about the potential impact of telematics, Nora and Minc were keenly aware of the desire of governments and other powerful interests to monitor access to technologies strictly in order to control constituencies, and that historically those same constituencies had become increasingly intolerant of such hierarchical control. Of this tension, they asked: "Are we headed . . . toward a society that will use this new technology to reinforce the mechanisms of rigidity, authority, and domination? Or, on the other hand, will we know how to enhance adaptability, freedom, and communication in such a way that every citizen and every group can be responsible for itself?" (10–11).

Which scheme (centralized or decentralized) would come to be realized, they argued, depended on which model of society was desired and chosen. While the question of who would do the choosing remained unanswered in their text, they recognized that it was no more likely that society would spontaneously produce a condition of decentralization than that the government would willingly promote its own demise. Nevertheless, they believed that telematics could help facilitate a productive transformation of the social order. "The challenge," they wrote, "lies in the difficulty of building the system of connections that will allow information and social organization to progress together" (Nora and Minc 1980, 11).[26]

Similarly, Ascott's theorization of telematic art embraced the idea that any radical transformation of the social structure would emerge developmentally as the result of interactions between individuals and institutions in the process of negotiating relationships and implementing new technological structures. This concept reinforced his belief in the artist's "responsibility . . . to shape and change the world." For while Ascott noted some of the potential hazards of telematics, he took as his primary task the development of artistic models for the future, models that parallel Nora and Minc's vision of how telematics could "enhance adaptability, freedom, and communication" in society.

Like a cybernetic system (in which information can be communicated via feedback loops between elements), telematics comprises an extensive global network in which information can flow between interconnected elements. Drawing a parallel between cybernetics and computer telecommunications, William Gibson coined the term "cyberspace" in his 1984 novel *Neuromancer.* Cyberspace applies a virtual location to the state of mind an individual experiences in tele-

matic networks. Telematics implies the potential exchange of information among all nodes in the network, proposing what might amount to a decentralized yet collective state of mind. Whereas cyberspace emphasizes the phenomenology of individual experience, telematics emphasizes the emergence of a collective consciousness.

In this context, Ascott's anticipation of the convergence of cybernetics and telematics in "Behaviorist Art and the Cybernetic Vision" in the mid 1960s is all the more prescient, because in that essay, the artist explicitly articulated plans for utilizing computers and telecommunications in order to enable remote, collaborative exchanges. More than a decade passed before computer networking finally became accessible to artists. When it did, Ascott was one of the first to experiment with how telematics enabled artists at remote locations to collaborate in the creation of electronic artworks that emphasized the immateriality of process rather than the production of objects.

As of now, telematic art is only beginning to gain canonical status. In contrast, Schöffer's joining of art and cybernetics in his *CYSP* series of sculptures has been absorbed into the history of art. This disparity is not surprising, given the relative youth of telematics compared to cybernetics and the challenges that telematic art has posed to aesthetic conventions and institutional practices. Paradoxically, while Ascott's theories of telematic art have proposed the unification of minds in a global field of consciousness, ARPANET (the precursor the Internet, which is the backbone of telematic exchanges) emerged out of the Cold War struggle between the superpowers for technological dominance (Edwards 1996). Given this pedigree, perhaps it is all the more urgent that artists, like Ascott, continue to advocate and experiment with the most collaborative global applications of technologies that were designed to support competition for military superiority.

Definitions of terms such as "telematics," "virtual reality," and "cyberspace" are unstable and overlap in complex, if not confusing, ways. The applications and manifestations of any given technology, like the terminological distinctions that apply to it throughout the course of its use, are highly variable, contextual, and historical. This is especially the case in the so-called information age, when rapid development and production cycles have resulted in the accelerated evolution of technologies and the terminologies applied to them. For example, the integration of computers and telecommunications has become so widespread that the term "telematics" itself can refer to a much wider range of applications than it initially did. Similarly, hybrid forms incorporating telematics, robotics, and virtual reality complicate terminological distinctions. There is also a polit-

ical component to the use of terminology, for the particular definition of any given term may vary to include or exclude elements supporting a personal or institutional agenda (Gieryn 1999). Finally, historians of science and media theorists have questioned the autonomy of technology as a historical agent, pointing out that technological media, such as computer telecommunications, are inextricably related to the political, economic, and cultural contexts in which they emerge and operate. From this perspective, technology possesses no agency independent of the hybrid social practices of which it is a co-constituent (Bolter and Grusin 1999).[27]

Telematics and Art

Telematics enables tremendous artistic freedom. It permits the artist to liberate art from its conventional embodiment in a physical object located in a unique geographic location. Telematics provides a context for interactive aesthetic encounters and facilitates artistic collaborations among globally dispersed individuals. It emphasizes the process of artistic creation and the systematic relationship between artist, artwork, and audience as part of a social network of communication. In addition to these qualities, Ascott argues that a distinctive feature of telematic art is the capability of computer-mediated communications to function *asynchronously*.[28] Early satellite and slow-scan projects enabled interactive exchanges between participants at remote locations, but they had to take place in a strictly synchronous manner in real time; that is, all participants had to participate at the same time. In Ascott's telematic artworks of the same period, information could be entered at any time and place, where it became part of a database that could be accessed and transformed whenever a participant wished, from wherever there were ordinary telephone lines. He anticipated this aspect of telematic art in his 1966 description of a "pillar of information [that would] store and record data . . . available for everyone's use in various areas, [with] links to workshops, studios, . . . exhibition spaces, or . . . directly to the central nervous system of any individual" (page 143 below).[29]

Ascott's telematic art expanded on his theory and practice of cybernetic art and the parallels he had already drawn between science, philosophy, non-Western cosmologies, and experimental art. For example, the asynchronicity of networked exchange—its capability to bend time, so to speak—led Ascott to draw parallels between networked communications and alternative systems of knowledge and divination, such as the *I Ching*, as exemplified in "Ten Wings" (1982; chapter 10). In "Beyond Time-Based Art: ESP, PDP, and PU" (1990; chapter 15),

he expanded on the sorts of connections between cybernetics and parapsychology he had made twenty years earlier in his essay "Psibernetic Arch" (1970), identifying correspondences between telematic consciousness and parapsychology, parallel distributed processing, and the parallel universes theory, in which the processing and exchange of information occur in atypical or anomalous temporal modalities. Like the concomitance of interests that led to Ascott's particular development of cybernetic art in the 1960s, so his practice, pedagogy, and theorization of telematic art, beginning in the 1980s, was the result of a combination of technological and cultural factors that had been percolating for decades. Some of these precursors to telematic art are discussed below, because they raised many of the same conceptual questions that the uses of telecommunications by artists continue to pose to traditional art media and aesthetic values.

Telematic art draws on the heritage of diverse currents in experimental art after World War II, including various strains of art and technology, such as cybernetic art, kinetic art, and video art, happenings and performance art, mail art, and conceptual art. As one might expect, many of the artists who have made telematics an important, if not primary, component of their practice have roots in one or more of these other genres. What, after all, could be more kinetic and performative than an interactive exchange between participants? What could be more technological than computer-mediated global telecommunications networks? And what could be more conceptual than the semantic questions raised by the flow of ideas and creation of meaning via the transmission of immaterial bits of digital information? It is easy to see, as well, how the interactive two-way transfer of information would appeal to video and performance artists alike, and how the immediacy of international exchange could equally open up new frontiers for artists using mail, fax, or television as a medium. This convergence of interests brought great energy and richness to the use of telecommunications for art. By framing Ascott's theory and practice of telematic art within these larger artistic and art historical contexts, the following discussion offers insight into the unique quality of his work, as well as the place of telematic art in a continuity of aesthetic research in the history of art.

PRECURSORS

The first use of telecommunications as an artistic medium may well have occurred in 1922, when the Hungarian constructivist artist and later Bauhaus master László Moholy-Nagy produced the works known as his *Telephone Pictures*. By his own 1947 account, he "ordered by telephone from a sign factory five

paintings in porcelain enamel" (Moholy-Nagy 1947, 79). Whether or not the pictures were, in fact, ordered over the telephone is a matter of dispute. Their commercial method of manufacture, however, implicitly questioned traditional notions of the isolated, individual artist and the unique, original art object. Moreover, by 1925, Moholy-Nagy was writing about the importance of "photo-telegraphy" and "wireless telegraphed photographs" (Moholy-Nagy 1987, 38–39, and Kac 1992). It is not known whether he attached much conceptual significance to telecommunications as an artistic medium in itself (as distinct from his explicitly stated concern with the formulation of a visual idea and its concretion in an image). Nonetheless, collaboration on and exchange of images between geographically dispersed individuals was well within the artist's theoretical realm.

The idea of telecommunications as an artistic medium is made more explicit in Bertolt Brecht's theory of radio. The German dramatist's manifesto-like essay "The Radio as an Apparatus of Communication" (1932) has offered ongoing inspiration not only to experimental radio projects but to artists working with a wide range of interactive media. As Peter D'Agostino has noted, Brecht sought to change radio "from its sole function as a distribution medium to a vehicle of communication [with] two-way send/receive capability" (D'Agostino 1980, 2). Brecht's essay proposed that media should

> [L]et the listener speak as well as hear . . . bring him into a relationship instead of isolating him. On this principle the radio should step out of the supply business and organize its listeners as suppliers. . . . [I]t must follow the prime objective of turning the audience not only into pupils but into teachers. It is the radio's formal task to give these educational operations an interesting turn, i.e. to ensure that these interests interest people. Such an attempt by the radio to put its instruction into an artistic form would link up with the efforts of modern artists to give art an instructive character. (Brecht 1986, 53–54)

Written in the midst of the rise to power of the Nazi dictatorship, Brecht's theory of two-way communication envisioned a less centralized and hierarchical network of communication, such that all points in the system were actively involved in producing meaning. In addition, radio was intended to serve a didactic function in the socialist society Brecht advocated. Ascott has been similarly committed to the pedagogical role of art. Furthermore, in "Art and Telematics" (1984), he began theorizing that the decentralized and nonhierarchical structure of telematic networks was "subversive," in that it "breaks the boundaries not only of the insular individual but of institutions, territories, and time zones" (page 199 below).

As a variant on the two-way communication that Brecht advocated for radio, artists have utilized the postal service. While such work does not explicitly employ electronic telecommunications technology, and reaches a much smaller potential audience, it anticipated the use of computer networking in telematic art. In the early 1960s, the American artist George Brecht mailed "event cards" in order to distribute his "idea happenings" to friends outside of an art world context (Dreher 1995). The precise date when such practices became historicized as the genre known as mail art is not known. However, in 1968, Ray Johnson organized the first meeting of the New York Correspondence School, which expanded to become an international movement.[30] Like telematic art,

> This postal network developed by artists explored non-traditional media, promoted an aesthetics of surprise and collaboration, challenged the boundaries of (postal) communications regulations, and bypassed the official system of art with its curatorial practices, commodification of the artwork, and judgement value. . . . [It] became a truly international . . . network, with thousands of artists feverishly exchanging, transforming, and re-exchanging written and audiovisual messages in multiple media. (Kac 1997)

Mail art was especially important to artists working, not only in remote parts of South America, and even Canada, but in countries where access to contemporary Western art was severely limited, such as those of Eastern Europe. Many such artists also embraced telecommunications technologies, such as fax, which expanded the capabilities of mail art. In Hungary, for example, György Galántai and Júlia Klaniczay founded Art Pool in the mid 1970s in order to obtain, exchange, and distribute information about international art, which was forbidden behind the Iron Curtain. Art Pool maintains an extensive physical and online archive of mail and fax art.

Some of the earliest telecommunications projects attempted by visual artists emerged from the experimental art practice known as "happenings." In *Three Country Happening* (1966), a collaboration between Marta Minujin in Buenos Aires, Kaprow in New York, and Wolf Vostell in Berlin, a telecommunications link was planned to connect the artists for a live, interactive exchange across three continents. Ultimately, funding for the expensive satellite connection failed to materialize, so each artist enacted his or her own happening and, as Kaprow has explained, "imagined interacting with what the others might have been doing at the same time."[31]

Three years later Kaprow created an interactive video happening for "The

Medium Is the Medium," a thirty-minute experimental television program produced by Fred Barzyk for the Boston public television station WBGH. Kaprow's piece *Hello* (1969) utilized five television cameras and twenty-seven monitors, connecting four remote locations over a closed-circuit television network. As Gene Youngblood has described it:

> Groups of people were dispatched to the various locations with instructions as to what they would say on camera, such as "hello, I see you," when acknowledging their own image or that of a friend. Kaprow functioned as "director" in the studio control room. If someone at the airport were talking to someone at M.I.T., the picture might suddenly switch and one would be talking to doctors at the hospital. (Youngblood 1970, 343)

Through his interventions as director, Kaprow was able to provide a critique of the disruptive manner by which technology mediates interaction. *Hello* metaphorically short-circuited the television network—and thereby called attention to the connections made between actual people.[32]

Indeed, many early artistic experiments with television and video were, in part, motivated by a Brechtian desire to wrest the power of representation from the control of corporate media and make it available to the public. In the mid 1970s, Douglas Davis noted that "Brecht . . . pointed out that the decision to manufacture radio sets as receivers only was a political decision, not an economic one. The same is true of television; it is a conscious (and subconscious) decision that renders it one-way" (Ross 1975). Davis's *Electronic Hokkadim* (1971) enabled television viewers to participate in a live telecast by contributing ideas and sounds via telephone. As David Ross wrote in 1974, this work, "linked symbiotically with its viewers whose telephoned chants, songs, and comments reversed through the set, changing and shaping images in the process" (Ross 1974). Davis later commented: "My attempt was and is to inject two-way metaphors—via live telecasts—into our thinking process. All the early two-way telecasts were structural invasions. . . . I hope [to] make a two-way telecast function on the deepest level of communication . . . sending and receiving . . . over a network that is common property" (Ross 1975). Davis's work exemplifies the long and distinguished history of artistic attempts to democratize media by enabling users to participate as content-providers, rather than passive consumers of prefabricated entertainment and commercial messages.

In *Expanded Cinema* (1970), a classic and perceptive account of experimental art in the 1960s, the media historian Gene Youngblood has documented how some of the first interactive video installations also challenged the unidirec-

tionality of commercial media. In works like *Iris* (1968) and *Contact: A Cybernetic Sculpture* (1969) by Les Levine and *Wipe Cycle* (1969) by Frank Gillette and Ira Schneider, video cameras captured various images of the viewer(s), which were fed back, often with time delays or other distortions, onto a bank of monitors. As Levine noted, *Iris* "turns the viewer into information. . . . *Contact* is a system that synthesizes man with his technology . . . the people are the software" (Youngblood 1970, 340). Schneider amplified this view of interactive video installation, saying: "The most important function . . . was to integrate the audience into the information" (342–43). *Wipe Cycle* was related to satellite communications, Gillette further explained: "[Y]ou're as much a piece of information as tomorrow morning's headlines—as a viewer you take a satellite relationship to the information. And the satellite which is you is incorporated into the thing which is being sent back to the satellite" (343). While these works were limited to closed-loop video, they offered an unprecedented opportunity for the public literally to see itself as the content of television.

Significant museum exhibitions in 1969–70 also helped to popularize the use of interactive telecommunications in art. Partly in homage to Moholy-Nagy (who emigrated to Chicago after World War II), the Chicago Museum of Contemporary Art organized the group exhibition "Art by Telephone" in 1969. Hank Bull describes some of the more memorable works: "Artists were invited to telephone the museum with instructions for making an artwork. Dick Higgins asked that visitors be allowed to speak into a telephone, adding their voices to an ever denser 'vocal collage.' Dennis Oppenheim had the museum call him once a week to ask his weight. Wolf Vostell supplied telephone numbers that people could call to hear instructions for a 3-minute happening" (Bull 1993). In 1970, Jack Burnham's exhibition "Software, Information Technology: Its New Meaning for Art" examined how information processing could be interpreted as a metaphor for art (Shanken 1998). "Software" included Hans Haacke's *News* (1969), consisting of teletype machines connected to international news service bureaus, which printed continuous scrolls of information about world events. Ted Nelson and Ned Woodman displayed *Labyrinth* (1970), the first public exhibition of a hypertext system. This computerized work allowed users to interactively construct nonlinear narratives through a database of information. Burnham's exhibition afforded the museum audience an opportunity to interact in an aesthetic context with online data communications and hypertext—two of the key elements that would make possible the construction of the World Wide Web some twenty years later.

On July 30, 1971, the group Experiments in Art and Technology (E.A.T.) or-

ganized "Utopia Q&A," an international telecommunications project consisting of telex stations in New York, Tokyo, Ahmedabad, India, and Stockholm. Telex enabled the remote exchange of texts via specialized local terminals. Participants from around the world posed questions and offered prospective answers regarding changes that they anticipated would occur over the next decade. "Our hope is that this project will contribute to recognition of and contact between different cultures," E.A.T.'s co-founder Billy Klüver noted in one of the early communications posted during the event. "We have chosen a medium which was invented in 1846 which is essentially mechanical, and which was not developed since the late nineteenth century. Like print, its very simplicity provides access. We believe that this is the first worldwide people-to-people project, imagining their future."[33] "Utopia Q&A" poignantly utilized telecommunications to enable an interactive exchange across geopolitical borders and time zones, creating a global village of ideas about the future.

This broad range of artistic activity may have been a catalyst for "the flurry of excitement in the commercial telecommunications world as well as education and government" about the potential of interactive media in the mid 1970s. "A wired nation appeared just around the corner and with it came a promise of a technological promised land in which every home would have a two-way link to virtually unlimited information and entertainment" (Carey and Quarles 1985, 105). Ascott has similarly described telematics as a condition in which "the individual user of networks is always potentially involved in a global net, and the world is always potentially in a state of interaction with the individual" (page 232 below). Indeed, access to computer conferencing and other telecommunications media in the 1980s paved the way for the realization of Ascott's visionary proposals of the mid 1960s.

THE PIONEER DAYS: 1977-1986

Lobbying by grass-roots community organizations enabled limited public access to satellite communications in the late 1970s, just as artists started gaining access to computer-conferencing networks, the backbone of telematics. Given the history of interactive art and the aesthetic goal of utilizing communications media for two-way exchanges, it is no surprise that artists were quick to seize these opportunities. Although communications via satellite, cable, and computer conferencing enable different types of experiences, there is much overlap between them in the development of artists' use of telecommunications in general. As such, each medium must be understood in relation to the other, and as

part of broader aims to create interactive aesthetic exchanges between remote participants. While a few artists had used satellite technology to reach broader audiences (following a traditional, unidirectional telecast model), "the first artists' live, bi-directional, transcontinental satellite transmission" took place in 1977 (Sharp 1980). Two independently conceived and produced projects used satellites to connect artists on the east and west coasts of the United States. These simultaneous efforts suggest how pressing it was for artists in the mid 1970s to utilize advanced telecommunications to support two-way interactive exchanges among remote participants.

As an outgrowth of their "Aesthetic Research in Telecommunications" projects begun in 1975, Kit Galloway and Sherrie Rabinowitz organized the "Satellite Arts Project: A Space with No Boundaries" (1977). With the support of the National Aeronautics and Space Administration (NASA), the artists produced composite images of participants, thus enabling an interactive dance concert amongst geographically disparate performers, two in Maryland and two in California. On video monitors at these locations was a composite image of the four dancers, who coordinated their movements, mindful of the latency, or time-delay, with those of their remote partners projected on the screen. The "Send/Receive Satellite Network" (1977) emerged from Keith Sonnier's idea to make a work of art using satellite communications and Liza Bear's commitment to "gaining access to publicly funded technology . . . [and] . . . establishing a two-way network among artists" (Furlong 1983). Bear brought the project to fruition, orchestrating the collaboration between the Center for New Art Activities and the Franklin Street Arts Center in New York, Art Com / La Mamelle Inc. in San Francisco, and NASA.

Given the proliferation of the Internet and community access cable in the 1980s and 1990s, it may now be hard to imagine how difficult it was for artists to obtain the use of telecommunications equipment, and how it was almost inconceivable for them to consort with NASA in the creation of an artwork.[34] Indeed, Bear was particularly mindful of the sociological import of this aspect of "Send/Receive." This project serves, moreover, to illustrate that the industriousness and agility required of artists who attempt to utilize cutting-edge technologies can result in innovative applications unattempted by industry or the government. The San Francisco coordinator, Sharon Grace, was aided by Carl Loeffler, who helped gain access to a fully equipped studio at the NASA Ames Research Center in Mountain View. In New York, however, Willoughby Sharp and Duff Schweniger were forced to rig a military infrared transmission system between a mobile satellite transceiver (affectionately known as the "Bread

Truck") at the Battery City Park landfill and the Manhattan Cable system down-link at the Rector Street subway station. According to Sharp, this experiment was the first time that a Manhattan Cable downlink box was used to uplink in-formation, a technique the cable provider later used with great commercial suc-cess for live broadcasting of the New York Marathon.[35]

For three and one-half hours, participants on both coasts engaged in a two-way interactive satellite transmission, which was shown live on cable television in New York and San Francisco. An estimated audience of 25,000 saw bi-coastal discussions on the impact of new technologies on art, and improvised, interac-tive dance and music performances that were mixed in real time and shown on a split screen. Of the videotapes *Phase I and Phase II: Send/Receive Satellite Net-work* (1978), produced by Bear and Sonnier to document the event and the or-ganizational hurdles leading up to it, Lucinda Furlong wrote that "*Phase II* re-sembles a cross between a disorganized artists' teleconference and an interactive performance that never really got off the ground" (Furlong 1983). Although the artistic quality may not have been consistent or even very good in this ex-perimental demonstration, Bear has insisted that "the process was paramount." Since they were working with unfamiliar technological media, it was crucial to "let the materials speak for themselves," she added.[36] Here it is important to note that these first satellite works emphasized the primacy of process that As-cott had articulated in the mid 1960s and that has remained central to the theory and practice of telematic art.

The first work of art to use computer conferencing was the "Sat-Tel-Comp Collaboratory" (1978). This multimedia telecommunications art project was or-ganized by the Direct Media Association, an artists' group formed by the Cana-dian artist Bill Bartlett. In 1971, inspired in part by Brecht's theories of media and the potential of an interactive, two-way exchange of information, Bartlett focused his artistic research on promoting "exchange between artists through the 'regeneration, transformation, transportation, communication and trans-mutation of images'" (Bull 1993). Through the Toronto-based artist Norman White, Bartlett gained access to the I. P. Sharp Associates (IPSA) international computer-timesharing network in 1978.[37] Prior to the advent of PCs beginning in the late 1970s, computers were relatively large, expensive, and rare, requir-ing users to share time on them. Early telematic exchanges transpired by log-ging on to such "time-sharing" computers from remote units that had little or no processing or memory capability of their own. The Collaboratory used this precursor to Internet-based e-mail for the telematic exchange of texts between four sites in the United States and Canada. It also used telephone lines for the

transmission of slow-scan video images between the Open Space Gallery in Victoria, British Columbia, and nine sites in Canada and the United States. Slow-scan utilized a picture-scanning device that could send still images over ordinary telephone lines at the rate of one frame every eight seconds.

Also in 1978, Peter D'Agostino proposed using QUBE (Warner Cable's interactive television system) in a video installation that critically interrogated the participation that QUBE claimed to offer users. "The 'interactive' system available to QUBE subscribers takes the form of a console attached to the television set that enables the home viewer to 'participate' in selected programs by pushing one of five 'response' buttons . . . the console feeds a central computer and the results of the home responses are flashed on the screen," he wrote (D'Agostino 1980, 14). D'Agostino noted that in a 1978 program on eggs, "forty-eight percent of the homes had pressed the *scrambled* button." Sarcastically referring to a newspaper headline lauding the QUBE system, he added: "This is how viewers are 'talking back to their television sets.'" Despite claims by Warner Cable's chairman Gustave M. Hauser that, "We are entering the era of participatory as opposed to passive television," D'Agostino argued that such "participation is defined solely by the formal properties of the medium—rather than its content" (15). Given the artist's critical posture regarding QUBE, perhaps it is not surprising that the cable-cast component of his proposal was cancelled "due to 'special programming'" and never rescheduled.

Ascott first experienced telematics in 1978 and organized "Terminal Art," his first telematic artwork, in 1980. Dubbed "Terminal Consciousness" by the press, this three-week computer-conferencing event linked Ascott in Bristol, England, and seven other artists in the United States and the United Kingdom: Eleanor Antin (La Jolla, California), Keith Arnatt (Tintern, Wales), Alice Aycock (New York), Don Burgy (East Minton, Massachusetts), Douglas Davis (New York), Douglas Heubler (Newhall, California), and Jim Pomeroy (San Francisco) (Large 1980). "I . . . mailed portable terminals to a group of artists . . . to participate in collectively generating ideas from their own studios," Ascott later recalled. "Don Burgy chose to take his terminal wherever he was visiting and log in from there" (page 186 below). "Terminal Art" was the first artists' computer-conferencing project between the United States and the United Kingdom, and the first ever to use the Infomedia Notepad System.

As distinguished from telex or electronic mail, which did not offer "control of the conference context or a retrievable group memory," according to the astronomer Jacques Vallée, who founded Infomedia, Notepad was "the first commercial use of a new medium that fully utilize[d] the logical and memory abil-

ities of the modern computer" (Vallée 1981, 5). In addition to being able to re-
trieve and add to information stored in the computer's memory, users could
search the database in a directed and associative manner. The group could, for
example, "tell the computer to turn up any mentions of giraffes and ice cream,"
Ascott explained, adding: "The surrealists could have a field day" (Large 1980).

Because of the diachronic nature and extended duration of this telematic
project, it was possible for conversations and exchanges to develop that could
not have been sustained in the real-time environment of telecommunications
works using satellite. As the media artist and critic Eric Gidney observed, such
"early [telematic] projects manifested an important attribute of this new tech-
nology: the metaphysical feeling of being in touch with a remote group of people,
transcending normal barriers of space and time" (Gidney 1991, 147).

Ascott's earliest attitudes about the experience of telematics and its possibil-
ities as an art medium are reflected in a statement he contributed to "Saturn
Encounter," an interdisciplinary computer-conference hosted by Infomedia that
overlapped with "Terminal Art":

> For the artist, computer conferencing is both a perfect metaphor of intercon-
> nectedness and a new and exciting tool for the realization of many aspirations
> of twentieth-century art: it is a medium which is essentially participatory; it pro-
> motes associative thought and the development of richer and more deeply lay-
> ered language: it is integrative of cultures, disciplines and the great diversity of
> ways of being and seeing. In short, I am very optimistic about the potential for
> art of networking media.[38]

In these early comments, Ascott already identified and theorized how telemat-
ics could help experimental artists create aesthetic encounters that would be
more participatory, culturally diverse, and richly layered with meaning. Signifi-
cantly, Ascott emphasized the ephemerality of computer conferencing, sug-
gesting that the psychical experience of networking was of equal if not greater
importance to a telematic artwork than the discrete texts and images that
emerged from the exchange.

Also in 1980, Kit Galloway and Sherrie Rabinowitz organized "Hole in
Space," a satellite project that connected two storefronts in New York and Los
Angeles. Sharing Ascott's emphasis on the infrastructure and process of tele-
matics, Youngblood explained that in "Hole in Space," "the connecting arma-
ture was important, not the resulting display" (Youngblood 1986, 10). Build-
ing on the prior experience of their "Satellite Arts Project," Galloway and
Rabinowitz purposely displaced the artwork from an art context and put it into

the flux of everyday life, where it became activated when people happened upon it by chance. As Bull has noted of the video documenting the piece, "The results were astounding and often very moving. . . . People sang songs together, played games, even made contact with long-lost relatives" (Bull 1993).

Ascott's "Ten Wings" (1982) was part of Robert Adrian's "The World in 24 Hours," an extraordinarily ambitious telecommunications project commissioned by Ars Electronica, connecting artists in sixteen cities on three continents. As Ascott describes it in "Art and Telematics," participants in "Ten Wings" were invited to join in the first planetary throwing of the *I Ching*. This work was one of many in "The World in 24 Hours" that utilized the ARTBOX network.[39] Adrian enthusiastically recalled his early collaborations with Ascott: "Roy had already been thinking for fifteen years about the possibilities of what artists could do with computer conferencing and had some really great ideas for using ARTBOX."[40]

"The World in 24 Hours" created a global network of artists and artist groups, each of which organized a contribution that made use of any combination of slow-scan, fax, telephone sound, and computer conferencing via ARTBOX. At the time, the high cost of satellite links, international telephone calls, and computer conferencing imposed severe limits on the creative potential of these media for artists.[41] The creation of ARTBOX (and later ARTEX) spearheaded by Adrian, and the corporate sponsorship of these networks by I. P. Sharp Associates, opened a door to artistic experimentation that previously was possible only with substantial funding or at great personal expense.

Ascott's "La Plissure du Texte" ("The Pleating of the Text") project (1983) explored the potential of computer networking for the interactive, collaborative creation of a work of art. The project was produced as part of the "Electra" exhibition organized in 1983 by Frank Popper at the Musée de l'Art moderne de la Ville de Paris. Adrian, then an artist-in-residence at the Western Front art center in Vancouver, organized the ARTEX (Artist's Electronic Exchange) system. Identified by *Leonardo*'s editor Roger Malina as an unsurpassed landmark in the history of telematic art, "La Plissure du Texte" allowed Ascott and his collaborators at eleven locations in the United States, Canada, Europe, and Australia to experiment with what the artist has termed "distributed authorship." Each remote location represented a character in the "planetary fairy tale," and participated in collectively creating and contributing texts and ASCII-based images to the interactive unfolding, or distributed authorship, of the emerging story (see chapter 14 below).[42] Bull, who participated in the event from the Vancouver node, described "the result of this intense exchange" as a "fat tome of Joycean

```
NO.627
FROM BLIX  TO BLIX,NEXUS SENT 16.49 20/12/1983
                              B
                              B
                             LIX
                             LJG
                             HDF
        B                   GHHGG
        B
       LIX                  FHDGFD               B
       LJG                  HJFHHJGJ             B
       HDF                  ULHLKSDHKLJ         LIX
      GHHGG                 FNKGKJGLKJDD        LJG
      UFFFF                 IUHKDHVKJHDFJF      HDF
      HILUHG                IEURUHIVERUIRFFG    IUUFU
      UGGJJGR               OIJGPOJOIJGIOJOIJG  DIGJOIJ
      IIIIIIII        IIIIIIIIIIIIIIIIIIII      IIIIIII
    UIERIHIUHRHUG  GROJRIJIR 8OIGJPIGJIJJ  JOGIJIJGK
    RHHPOGJPOJOPTJRIJGIGJGI  8UGJ9EIO95KJ5O9OG9GK5GG
   P8UGJOPJPGJP4JPGJIGJFOJOI  8UJG4WJGJ5GJIJG5JG59JGGGK
    IIIIIIIIIIIIIIIIIIIIII       IIIIIIIIIIIIIIIIIIIIIIIIIIIII
     IIIIIIIIIIIIIIIII             IIIIIIIIIIIIIIIIIIIIIIIIIIIIIIII
    P8GOFHJOPGIJEPGP8                8OUGPVOJPEGJVPRVJ89PUGJ9PTJT
   IGUKDNGIKIKHDGIKJRGGG              9EGRIOGERPHJP9ERJPJER8JG
  58PEGPEJPOGERJIGJPJPOGJ              5UEPGOPGJPOJRPGIJRGGI
   IIIIIIIIIIIIIIIIIIIIIII               IIIIIIIIIIIIIIIIIIIII
 IIIIIIIIIIIIIIIIIIIIIIIIIIIII            IIIIIIIIIIIIIIIIIIIII
 IIIIIIIIIIIIIIIIIIIIIIIIIII          A    IIIIIIIIIIIIIIIIIIIII
 IUHIRGHIEGIIUGGIUIGUHIUHER          LA     IUGHDFGIHGIRGIERGHGH
  IHOFDGJOEGVOIRGOIJGOIJGOII               8OGJDGJOIOGERJIGJIDJII
   OIGJOGJIJOIJGOIJGIOJIGJIJG  BETE  POUR  8OGJPROJJARGJPJRGJOPI
   PIGVHOIGHVRPGOPGERJIGJROG                KLFVIKGNVIGDIJGIJHGRR
  IGJNLKSGIGHGIHJIGHJGIOJGOI  LE  PETIT     DHJIGRUGHIUHIURHGRIUG
    IIIIIIIIIIIIIIIIIIIIIIII               IIIIIIIIIIIIIIIIIIIIII
     IIIIIIIIIIIIIIIIIIIIII                IIIIIIIIIIIIIIIIIIIIIIIIIII
    IIIIIIIIIIIIIIIIIIIIIIIIII  DE         IIIIIIIIIIIIIIIIIIIIIIIIIIIII
   DHHGGERJOGGIOGOIJGOIJIRIRIR            IGHRJGERJOGEJGERJGRJGIRGIJRIJ
  EUIGHEPGOGOPERJEIJRIOGJEGJRIJG  JEUNER  RHIUHFGIWHFGPGOPGORGJOPGRHUGRR
 IGHDERGIGHIGHIGHFGHIGHIURGHURGHUGG        GEIGFGERPGERGEGDFGOGJOREGJIRJGOIJ
IGUHPGOPGJOGJOGJOGJOGJOPEJGPJOPGTJHIOTJ  POTGJOPJGJOJOGIJOIGJOIJGITJGIJGJGGG
OIHIGUHGIUHGIUHGIUGHIUHGIUHGIUHGUHERIGEIHGIUGIUHIGUUIHGIOGHIUHGIUHEIUHGBGGGG
IOGHIUGHIUHGIUHIUHGIUHIEUGHIUHGIUHITUGHIUHGIUHIHGOPEHGUIHEUIGHIGHUIGHIUHUTTG
IUGHIERPHISGJPEOFGOOPGEPRGIOGJPOOPGPGOJPIJGPJPRTJIGJPOTGJOPJGOITJGOITJGIJGIGJ

NO.630
FROM JKA   TO BOB,NEXUS SENT 18.54 20/12/1983
IMPORTANT MESSAGE !!!
AT PROJECT END, ONCE AGAIN I WILL NEED YOR SIGN-OFF INFO, SO THAT WE CAN
CALCULATE THE COSTS FOR THE PROJECT.  THIS IS IMPORTANT.  IF THESE DATA ARE
NOT GIVEN IN TIME, FULL COSTS MIGHT HAVE TO BE PAYED.
...JOAKIM
(SORRY TO INTERRUPT THE PROJECT, BUT THIS IS THE ONLY WAY I CAN COMMUNICATE
WITH ALL OF YOU AT ONCE.)

NO.628
FROM BLIX  TO BLIX,NEXUS SENT 17.34 20/12/1983
VOR LANGER ZEIT LEBTE IN WIEN EIN MANN, DER ZU EINEM ZAUBERER GING, UM DIE
KUNST DES ZAUBERNS ZU ERLERNEN. ALS ER SCHON 2 JAHRE DORT WAR, STARB DER
ZAUBERER. ER WUSSTE NICHT, DASS SEIN MEISTER EINEN GROSSEN SOHN HATTE, DER
DAS HAUS SEINES VATERS ABREISSEN WOLLTE. DADURCH WURDE ER SEHR BOESE UND
WOLLTE DEN MANN VERFLUCHEN. ER VERWECHSELTE DEN SPRUCH UND VERWANDELTE SICH
SELBST IN EINE FLEDERMAUS. ALS DER SOHN DES ZAUBERERS INS HAUS KAM, FLOG ER
IHM INS GESICHT. DIESER ERSCHRAK SEHR UND RANNTE AUS DEM HAUS. SPETER KAM
ER MIT NETZEN BEWAFFNET WIEDER ZURUECK. ER WOLLTE DAS TIER FANGEN. KAUM
WAR ER IM HAUS, KAM SCHON DER IN EINE FLEDERMAUS VERWANDELTE ZAUBERLEHRLING
ENTGEGEN UND VERKRALLTE SICH IN SEINEM HAAR.
```

Figure 17. "La Plissure du Texte." 1982. Computer printout from International telematic art project, involving "distributed authorship" through remote, interactive exchanges between artists in eleven locations in Austria, the United Kingdom, the United States, Canada, and Australia.

pretensions that delved deep into the poetics of disembodied collaboration and weightless network rambling" (Bull 1993).[43]

The French artist and media theorist Edmond Couchot has noted similarities between the process of distributed authorship and the surrealist game of *cadavre exquis* (exquisite corpse), in which one artist would begin a drawing, and several others, not knowing what preceded them, would continue it (Couchot 1988, 187). Similarly, each "character" in "La Plissure du Texte" could read the latest additions to the story, printed out or displayed by projection or on a monitor, and add to it—all locations receiving these updates electronically. In this way, the story was continuously supplemented with unpredictable twists that, like the surrealists' experiments, "produced remarkably unexpected poetic associations, which could not have been obtained in any other way," and certainly not as the result of a single, organizing mind (Chipp 1968, 418, n. 1). This collaborative process paralleled Ascott's goal of creating a field of consciousness greater than the sum of its parts.

Telematic art projects like "La Plissure du Texte" have challenged both the conventional categories of artist, artwork, and viewer and the traditional opposition of subject and object. At the same time, in such works, the artist retains authorial control and responsibility for defining the parameters of interactivity and for imbuing them with meaning and significance. Aspects of traditional narrative structure may remain, while others are relinquished in order to allow a more open-ended development, fashioned by participants or "participators" (Ascott's preferred term) involved in a multidirectional creative exchange. In this way, Ascott understood telematics as offering the artist new possibilities to create models for the future that would match Nora and Minc's vision of "building the system of connections that will allow information and social organization to progress together." The title "La Plissure du Texte" punningly alludes to Barthes's book *Le Plaisir du texte* (1973). In contrast to the common perception of text as a tissue that simultaneously veils and permits access to the meaning or truth hidden behind it, Ascott drew inspiration from Barthes's emphasis on "the generative idea that the text is made, is worked out in a perpetual interweaving . . . [in which] . . . the subject unmakes himself, like a spider dissolving in the constructive secretions of its web" (Barthes 1975 quoted on page 187 below). Similarly, Ascott's "La Plissure du Texte" emphasized the "generative idea" of "perpetual interweaving," but at the level of the tissue itself, which is no longer the product of a single author but is now pleated together through the process of distributed authorship. Couchot goes so far as to suggest that telematic networks "offer the artist the only medium really capable of breaking

the barriers of time and space, and that will one day set one free of the limits of individual, national, and cultural intelligence" (Couchot 1988, 187).

The potential of telecommunications to allow such individual and cultural freedom was at the heart of "Good Morning Mr. Orwell," a satellite telecast that Nam June Paik organized on New Year's Day, 1984. It was intended, Paik explained, as a liberatory and multidirectional alternative to the threat posed by "Big Brother" surveillance of the kind that George Orwell had warned of in his novel *1984:*

> Orwell only emphasized the negative part, the one-way communication. I see video not as a dictatorial medium but as a liberating one. That's what this show is about, to be a symbol of how satellite television can cross international borders and bridge enormous cultural gaps . . . the best way to safeguard against the world of Orwell is to make this medium interactive so it can represent the spirit of democracy, not dictatorship.[44]

Broadcast live from New York, Paris, and San Francisco to the United States, France, Canada, Germany, and Korea, the event reached a broad international audience and included the collaboration of John Cage, Laurie Anderson, Charlotte Moorman, and Salvador Dali, among others.

Ascott, too, desired to engage a broader public in telematic exchanges. To this end, he created "Organe et Fonction d'Alice au Pays des Merveilles" (Organ and Function of Alice in Wonderland) for "Les Immatériaux," an exhibition curated by Jean-François Lyotard and Thierry Chaput in Paris in 1985. "Organe et Fonction" was accessible to anyone connected to Minitel (the French national videotex system, begun in 1981). Ascott's use of this system enabled a potential audience of thousands to experience the sort of intertextual pleating the artist had initiated in "La Plissure du Texte." "Organe et Fonction" can be interpreted as an archetypal postmodern artwork. Randomly selected quotations from a French translation of Lewis Carroll's *Alice in Wonderland* were juxtaposed with quotations from a scientific treatise entitled *Organe et fonction,* creating unexpected relationships and associations. Conventional notions of originality, authenticity, objecthood, narrative, and style were supplanted by appropriation, duplication, distribution, juxtaposition, and randomness.

Telematic art was embraced by the 1986 Venice Biennale, at which Ascott, Tom Sherman, Don Foresta, and Tomasso Trini were the international team of commissioners responsible for organizing the "Laboratorio ubiqua" (Ubiquitous Laboratory). Part of this project included a variety of telecommunications stations (fax, slow-scan, computer conferencing) assembled under the title "Plan-

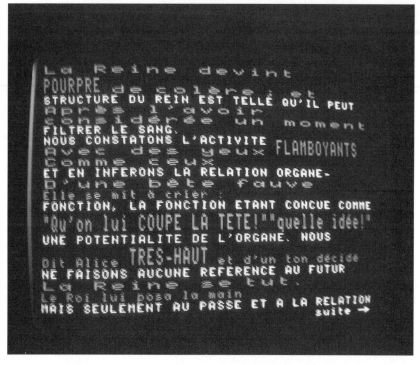

Figure 18. "Organe et Fonction d'Alice au Pays des Merveilles." 1985. Video still from telematic art project using the Minitel network. Part of Jean-François Lyotard's exhibition "Les Immatériaux" at the Centre Pompidou, Paris.

etary Network." Robert Adrian organized the telematic component on ARTEX and traveled around the world to observe the nodes in operation. He later recounted: "The networking of personal computers in BBSs and the increasing presence of FAX and other telephone peripherals in offices and homes made ARTEX and large-scale telecommunications projects superfluous. . . . The pioneer days were over" (Adrian 1995). With entrée into this canonical international exhibition, the pioneer days may indeed have been over. While one senses regret in Adrian's recognition of their passing, technological improvements strengthened the ability of telematic art to develop models of planetary communication and interaction, and to enable a broader audience to experience them. By the late 1980s, public awareness of and interest in computer networking had expanded dramatically, and the newer technologies (and their promotion in the media) were enticing increasing numbers of artists and nonartists alike to participate in telematic exchanges.

EXTENSIONS: TELEMATIC ART AND THE WORLD WIDE WEB

With the proliferation of computer networking in the late 1980s and 1990s, artistic use of the medium likewise expanded, pushing the boundaries of telematic art in new directions. The availability of relatively inexpensive and powerful personal computers, the creation of hypertext markup language (HTML), and the free distribution to consumers of graphical user interfaces (GUI—pronounced "goo-ey"—browsers, such as Netscape Navigator and Microsoft's Internet Explorer), all contributed to enabling the multimedia capabilities of the World Wide Web in the early 1990s. As a result, the number of adults connected to the Internet in the United States and Canada grew exponentially, from 37 million in 1995 to over 90 million in 1999. The WWW is used in many ways that support artistic ends. It serves as a venue for digital exhibitions and as an archive of images. In the tradition of telematic art, it is used as an artistic medium in itself. Moreover, the development of various interfaces that connect remote users to robots, artificial life forms, virtual reality simulations, and other devices and environments extends the domain of telematic art to incorporate hybrid forms of technology.

Many of Ascott's early networking projects (e.g., "Terminal Art" and "La Plissure du Texte") employed computer-conferencing systems to take advantage of the medium's unique qualities, experimenting with remote collaboration and alternative modes of narrativity. Subsequently, many artists have utilized the hyperlinking capability of the Web in order to create nonlinear text and multimedia narratives. Melinda Rackham's "Line" (1997), for example, subtly integrated visual and textual elements. Using a simple and intuitive interface, the seventeen screens of this hypermedia fairy tale about identity in cyberspace incorporated both associative connections via text and random elements via the image. A map allowed the participator to visualize where she or he was in relation to the other screens. Users were invited to submit their own personal views via e-mail, which were incorporated into the work, adding intimacy and complexity.

Paul Sermon, Ascott's student at Newport, created "Telematic Vision" (1994). In this piece, an ISDN line connected two remote sites, each of which was identically fitted with a sofa facing a large monitor with a video camera mounted on top of it. The video images captured at each site were simultaneously superimposed on the two monitors so that people sitting on the sofa at site A could see themselves sitting on the sofa with the people at site B, and vice-versa. The powerful emotional and intellectual impact of this telematic exchange is difficult to grasp unless one experienced it directly. One participant

reported feeling rejected by another at the remote location, who sat next to him virtually on the sofa but would not respond and soon left. In another case, one person wanted to be more intimate than the remote counterpart did. Feeling violated by a phantom image, the less demonstrative participant felt compelled to leave. Because this work functioned in real time, and was not asynchronous, it technically would not fit Ascott's definition of telematic art. However, by its title and conceptual content, Sermon's work, like that of many other artists, paid homage to Ascott's theorization of telematic art, expanding the field in new directions.

Ascott's "Aspects of Gaia: Digital Pathways across the Whole Earth" (1989) combined the disembodied experience of telematics and cyberspace with the corporeal experience of concrete reality in physical space. In this regard, it formed a vital link between the "pioneer days" and subsequent forms of telematic art that have incorporated hybrid technological media. "Aspects of Gaia" brought together a global network of telematic participators to collaborate in the creation and transformation of texts and images related to the British chemist James Lovelock's holistic "Gaia hypothesis," which suggests that the Earth (Gaia) is a unified living organism, and that its climates, atmosphere, geography, plants, and animals have co-developed in a way that sustains the vitality of the planet (Lovelock 1979). Participators could access and contribute information to a global flow of data via several interfaces and on two levels of the Brucknerhaus (the work's central site at the Ars Electronica festival in Linz, Austria). What emerged was a portrait of the Earth "seen from a multiplicity of spiritual, scientific, cultural, and mythological perspectives" (page 241 below).

On the upper level of the Brucknerhaus, a large horizontal screen purposely conflated the conventional vertical orientation of a computer monitor and allowed viewers to gaze down on a data stream of images and texts contributed remotely from all over the world. (This bird's-eye view is related to the horizontal working relationship between artist and the artwork that influenced Ascott's cybernetic works of the 1960s and 1970s.) The horizontal computer screen was set into what Ascott referred to as an "information bar," a metaphorical cocktail lounge, in which the consumption of data was intended to result in greater clarity of mind, rather than an alcohol-induced stupor. The networked images that appeared in the information bar could be altered either by acoustic sensors, which responded to the sounds of the users, or by a computer mouse on the counter.

In the dark, exterior space below the Brucknerhaus, viewers could ride a trolley (also in a horizontal position), which drove past LED screens that

Figure 19. "Aspects of Gaia." Upper level ("Information Bar"). 1989. Video still from telematic art project with multimedia installation. Ars Electronica, Brucknerhaus, Linz. Courtesy Österreichische Rundfunk.

Figure 20. "Aspects of Gaia." Lower level (trolley). 1989. Video still from telematic art project with multimedia installation. Ars Electronica, Brucknerhaus, Linz. Courtesy Österreichische Rundfunk.

flashed messages about Gaia. The viewer became physically engaged in an experience that conveyed ideas about the emergent quality of telematic consciousness as it relates to the Earth as a living organism. As Ascott describes in "Is There Love in the Telematic Embrace?" (1990; chapter 16), the elements of the work co-evolved like Gaia, such that distinctions between artist, viewer, and artwork, nature (Earth), and culture (technology) became blurred as they were united in the unfolding duration of their harmoniously negotiated mutual self-creation.

The idea of combining the ephemerality of telematic exchange with the bodily experience of physical space has subsequently been explored by a number of artists. Like Ascott's "Aspects of Gaia," their work has also challenged conventional relationships between human and nonhuman agents.[45] Eduardo Kac and Stelarc offer compelling examples of two very different approaches to this area of telematic art.

Kac has created numerous "telepresence" works involving the interaction between humans, machines, plants, and animals. He defines "telepresence" as the experience of being physically present and having one's own point of view at a remote location. His "Essay Concerning Human Understanding" (1994), created in collaboration with Ikuo Nakamura, used telematics in a telepresence installation in order to facilitate remote communication between nonhumans, in this case, a canary in Kentucky and a philodendron plant in New York. As Kac explained:

> An electrode was placed on the plant's leaf to sense its response to the singing of the bird. The voltage fluctuation of the plant was monitored through a [computer] running software called Interactive Brain-Wave analyzer. This information was fed into another [computer] . . . which controlled a MIDI sequencer. The electronic sounds [sent from the plant to the bird] were pre-recorded, but the order and the duration were determined in real time by the plant's response to the singing of the bird. (Kac 1996, 137)

Although the work spotlighted the prospect of communication between the bird and the plant, Kac noted that humans interacted with the bird and the plant as well, causing the bird to sing more or less, and the plant to activate a greater or fewer number of sounds. In this way, humans, plant, and bird became part of a cybernetic system of interrelated feedback loops, each affecting the behavior of the other and the system as a whole.

Since commencing his controversial suspension performances in 1976, perhaps no artist has challenged the physical limits of the human body with respect

to technology more than Stelarc. In *Ping Body*, first performed on April 10, 1996, in Sydney, he wired his body and his robotic "Third Hand" to the Internet, and allowed variations in the global transfer of online information to trigger involuntary physiological responses. The artist's arms and legs jerked in an exotic and frightening dance. As he explained:

> The Internet . . . provide[s] . . . the possibility of an external nervous system which may be able to telematically scale up the body to new sensory experiences. For example when, in the *Ping Body* performance, the body's musculature is driven by the ebb and flow of Internet activity, it's as if the body has been telematically scaled up and is a kind of "sensor" or "nexus" manifesting this external dataflow.[46]

Ping Body conflated the standard active-passive relationship of human to machine. While, ultimately, the artist was the master of his work, he permitted his body to be a slave to the more or less random exchange of amorphous data on the Internet. At the same time, Stelarc retained control over a robotic arm activated by muscle contractions in his body. As in most of Stelarc's work, the artist remained the central performer/subject of the piece. This strategy is quite different from Ascott's emphasis on distributed authorship in his telematic projects. However, in *Ping Body*, remote individuals could telematically influence Stelarc's behavior.

As a final example of Web-based art beyond the Internet, "TechnoSphere," spearheaded by Jane Prophet beginning in 1995, combined telematics and artificial life, using the Web as an interface to an evolution simulator that enables users to create their own creatures and monitor them as they grow, evolve, and die in a virtual three-dimensional environment. A series of menus allowed users to select attributes to create an artificial life form that entered the virtual world of "TechnoSphere" and competed for survival and reproduction. Users selected various physical features (eyes, mouths, motility, and so on), chose between herbivorous or carnivorous feeding, and assigned a name to the creature they had parented. The condition and activities of each creature—its weight, battles with other creatures, reproductive success, and so on—were calculated using natural selection algorithms, and the creator was periodically e-mailed updates on his or her offspring's status. "TechnoSphere" shared many concerns in common with Ascott's work over the past four decades, including biological morphology, interactivity, systematic feedback, and telematic connectivity.

Finally, Ascott's creation of "CAiiA-STAR" is worth considering in the context of Web-based art beyond the Internet. Although "CAiiA-STAR" is not a

work of art per se, it constitutes a massive telematic project that supports the creative development of art and artists around the world. Three decades before founding the program, Ascott had stated the fluidity between his artistic and pedagogical practice and had already envisioned international, interdisciplinary exchanges transpiring via telecommunications. The program focuses on developing analytical skills for theorizing and textual articulation of aesthetic ideas related to interactive works of art. It promotes artists' writings and elevates their authorial authority to the Ph.D. level. As a result, "CAiiA-STAR" is helping to dismantle the social misconception of the artist as a "producer of enigmas" and replace it with a concept of the artist as an intellectual with highest academic credentials. In these ways, "CAiiA-STAR" represents a certain culminating point of Ascott's interrelated pursuits as an artist, educator, and writer, extending his research on telematics into social praxis. At the same time, as he describes in "Art @ the Edge of the Net" (2000; chapter 27), "CAiiA-STAR" is itself a stepping stone to his larger conception of a "Planetary Collegium," a global network of centers for advanced research at the cutting edge of art and technology.

Roy Ascott's Theory of Love in the Telematic Embrace

AN INTERDISCIPLINARY EMBRACE OF GLOBAL CONSCIOUSNESS

Reflecting on a decade of telematic art, "Is There Love in the Telematic Embrace?" (1990) integrates many of Ascott's ideas about art, technology, and consciousness in an exceptionally lucid and provocative text. By raising the rhetorical question of whether or not electronic forms of art can possess loving content, Ascott addresses the concern that technology will overwhelm and dehumanize the arts, a last bastion of humanist values. Metaphysical philosophy, quantum physics, and avant-garde aesthetic theories join forces in Ascott's explanation of how telematics extends human perception and creates a form of global consciousness. The artist argues, moreover, that telematics' capacity to cultivate love offers "the very infrastructure for spiritual interchange that could lead to the harmonization and creative development of the whole planet."

"Is There Love in the Telematic Embrace?" welcomes the challenge that telematic art poses to conventional aesthetic values, while maintaining that the electronic medium serves humanist ends. Ascott's argument melds seemingly incompatible systems of knowledge and being, suggesting their complementarity. For example, he asserts a universal principle of love that promotes collaboration and unification in telematic networks. At the same time, Ascott character-

izes his project in Derridean terms as "pure electronic *différance*" (deferral of interpretation). He celebrates telematic art as a "site of interaction and negotiation for meaning" that heralds a "sunrise of uncertainty . . . a joyous dance of meaning . . . [and suggests] a paradigm shift in our worldview, a redescription of reality" (page 235 below). Telematic art in this sense thus embraces both the transcendence of romanticism and the contingency of relativism.

Although he proclaims the inevitability of change, Ascott conforms to neither a modern nor a postmodern epistemological worldview. His insistence on sustaining paradox, on permitting and encouraging the simultaneous coexistence of incongruous modes of thought, is a particularly challenging aspect of his work and arguably one of his important theoretical achievements. This position is consistent with the way artists have imagined the confluence of philosophical rationalism, science, and technology, on the one hand, with metaphysics, intuition, and art, on the other. Ascott belongs, moreover, in the company of those intellectuals and visionaries who have created synthetic methods of constructing alternate ways of knowing and being.

Ascott's notion of telematic love is derived from the theory of "passionate attraction" advanced by the French utopian philosopher Charles Fourier (1772–1837), who described it as "the drive given us by nature prior to any reflection . . . [t]oward the coordination of the passions . . . and consequently toward universal unity" (Fourier [1971] 1983, 216). Ascott similarly defines love as a natural, intuitive force that draws human beings towards one another, transforming multiplicity into unity. He applies the notion of passionate attraction to Marcel Duchamp's *The Bride Stripped Bare by Her Bachelors, Even*, or *Large Glass* (1915–23), which he interprets as embodying love and prophetic of telematic art. Generating energy and emotion from the "tension and interaction of male and female, natural and artificial, human and machine," Ascott writes, Duchamp's vitreous sculpture "always includes both its environment and the reflection of the observer." By observing the work, he explains, the viewer becomes implicated as a participant in it and thus a progenitor of the love that is "contained in this total embrace" (page 235 below).

Ascott's theory of the telematic embrace gained insights from second-wave cybernetics and quantum physics as well. Whereas cybernetics initially considered experimental systems as autonomous entities, second-order cybernetics, as theorized by Heinz von Foerster, raised the question of reflexivity; that is, how to account for the role of the observer with respect to the behavior of a system. Systems came to be understood as contingent on observers and their means of measurement, which influenced the observation of behavior both be-

cause of the subjectivity of interpretation and through the physical alteration of matter at the quantum level (Foerster 1981). In this regard, Ascott cites the physicists John Wheeler and Wojciech Zurek's contention that, "[t]o describe what has happened one has to cross out that old word 'observer' and put in its place 'participator.' In some strange sense the universe is a participatory universe" (Wheeler and Zurek 1983, 6). Similarly, Ascott had long considered art to be a participatory process (as opposed to a discrete object or event), defined not by formal parameters but by behavioral relationships in which artist, observer, and environment (later including global telematic networks) were inextricably integrated into an emergent, distributed, interactive system.

Ascott joined these ideas with the prophecies of global consciousness expounded by the French paleontologist and theologian Pierre Teilhard de Chardin, who theorized the existence of a "noosphere," the British futurologist Peter Russell's speculations about a "global brain," the anthropologist and cybernetician Gregory Bateson's theory of "mind at large," and James Lovelock's "Gaia hypothesis." Such visionary thinking offered Ascott important examples for theorizing how telematics could stimulate the creation of aesthetic models that envisioned a future of heightened global connectivity and consciousness.

TRANSCENDENCE, TRANSPARENCE, AND TELEMATIC ART

Ascott's claim that passionate attraction in telematic systems expands perception and creates a unified global consciousness demands further scrutiny, especially since it is partially based on theories that are not generally accepted. The following critical examination of the artist's concepts of telematic love and consciousness locates his theories of telematics within the context of visual art and the visionary practice of avant-garde artists unrestrained by conventional systems of knowledge.

Teilhard's model of expanded consciousness, the "noosphere" (from the Greek *nous*, or mind) hypothesizes the dawning of a new stage of human evolution. Teilhard reasoned that just as matter gave rise to life (from which consciousness emerged), so consciousness itself would be succeeded by the noosphere, the ultimate stage in human development: "With and within the crisis of [self-]reflection, the next turn in the [evolutionary] series manifests itself . . . a higher function—the engendering and subsequent development of all stages of the mind, this grand phenomenon . . . is the noosphere" (Teilhard de Chardin 1955, 181–82). One may rightly be suspicious of Teilhard's unscientific and teleological explanation of the evolution of consciousness. Nonetheless, his description of the

noosphere as an expanded field of consciousness offered a visionary model for contemplating the future of the human mind in a global context.[47]

Peter Russell built on Teilhard's notion of the noosphere in his "global brain" theory, which also appealed to Ascott, who had theorized in "Behaviourist Art and the Cybernetic Vision" (1966–67) that a "highly interactive network [cybernetic art matrix] on an international level might form the embryonic structure of a world brain" (page 146 below). Based on the trend of data-processing capacity doubling every two and a half years, Russell argued that by the year 2000, the global telecommunications network would equal the complexity of the human brain. He theorized that this global brain (the neurons of which would be individuals, all telematically interconnected, like a neural network) could give rise to an emergent form of consciousness (Russell 1983). According to Russell, this structural system, modeled on that of biological organisms, would provide the essential prerequisites for a new evolutionary level, the emergence of a cyborgian superorganism integrating human consciousness and global computer-networking technology.

Again, as with Teilhard's notion of the noosphere, Russell's theory of the global brain is problematic. For example, it draws parallels between the brain and global telecommunications networks without rigorously considering the material, contextual, and functional dissimilarities between these two systems. Although many scientists and philosophers believe that there are materialist explanations for the operations of the human mind, the role that neuronal complexity plays in the production of consciousness remains subject to speculation.

An expanded form of planetary consciousness, such as the noosphere, may not be attainable, either by evolution or telematics. Computer networks have yet to reach the computational complexity of a global brain and may never achieve the type of consciousness manifested in humans. Criticisms of Teilhard and Russell apply only partially to Ascott's work, however, because art need not comply with the academic conventions of biology, neuroscience, and philosophy. Indeed, conventional scientific methods may not be able to prove or disprove the phenomena of networked consciousness that Ascott reported and conceptualized in an artistic context. But that hardly means they are not possible in fact, much less that they are not meaningful as art and as theory. The concepts of the noosphere and the global brain, like Ascott's theory and practice of telematic art, imagine potentials for the future of consciousness. As a form of experimental research established simultaneously adjacent to, and apart from, other disciplinary protocols, art often utilizes unconventional systems of knowledge that are deemed unacceptable by other fields. Far from lapsing into an irredeemable form of intu-

itionism, however, art exercises this intellectual freedom in order to expand the limits of knowledge and the understanding of human existence.

Such a synthetic, intellectual method apparently was also at work in Duchamp's enigmatic *Large Glass*, which, like Ascott's work, has invoked art historical interpretations running the gamut from mysticism to science. In "Is There Love in the Telematic Embrace?" Ascott proposes the *Large Glass* as a model for the passionate attraction he theorizes as operating in telematic art. He interprets Duchamp's magnum opus as embodying and generating love by drawing viewers into a hybrid field made up of its passionate imagery, its environment, and the viewer's own reflection, and claims that telematic art similarly draws participators into the hybrid field of cyberspace, which they collaboratively create and transform in a process of unification that embodies and generates love. Although much of his discussion of love apropos of the *Large Glass* focuses on its dynamic form, Ascott also identifies the element of attraction in the glass sculpture's sexualized imagery. But alongside whatever attraction might be interpreted in Duchamp's work, the exchange between male and female depicts a proto-cyborgian confluence of mechanical technology and bio-organic aesthetics. The machine-like anonymity and ambivalence of the eroticized intercourse between these aspects might be interpreted as creating a perverse tension rather than a loving embrace.

Like the vitreous surface of a computer terminal, the *Large Glass* resists a consistently transparent view because it includes the reflection of the observer and his or her environment in its image. Ascott advocates this quality for its inclusiveness and claims that it promotes the dissolution of traditional epistemological models based on binary oppositions, in particular the subject-object model of Western art since the Renaissance. Contrary to Ascott's description of the relational intimacy of telematics vis-à-vis the *Large Glass*, skeptics may question whether or not a passionate bond can really be consummated through a computer monitor, which arguably disrupts the total engagement of love. Like Duchamp's transparent sculpture, the eroticism of the telematic embrace is seductive and appealing, perhaps all the more so because of its elusiveness—the impossibility of possessing it; its insistence on keeping the relationship tantalizingly connected, but always at a distance.

While enabling new conditions for, and qualities of, mutual exchange, such hyaline interfaces may equally transform communication into monologue, unification into narcissism, passionate attraction into solitary confinement. Might not the persistent self-reflection one experiences on a computer screen inter-

rupt the mantric union of technological apparatus and human consciousness, network and node? Do not the many delays, bugs, viruses, and crashes to which computer networks are prone remind the telematic participant that she or he is inevitably a perpetual observer, a voyeur whose electronic relationships are subject to autoerotic soliloquy?

Such questions are neither new nor unique to telematics. "The loved object is simply one that has shared an experience at the same moment of time, narcissistically . . . like reflections in different mirrors," Lawrence Durrell writes, and such skeptical assertions have a long history in philosophy and literature (Durrell [1957] 1961, 42). Similar issues have been raised in the context of film theory to interrogate the limits of a viewer's ability to identify with dramatic characters and the unfolding cinematic narrative. Drawing parallels between cinema screens and computer screens, the media theorist Lev Manovich has argued that if, in the context of Western representation, the screen offers the illusion of liberating access into infinite space, it can equally be seen as a prison, because it demands that the viewer be physically present at a precise location.[48]

Ascott has argued that the application of theories about film to the conditions of telematics fails to address the functional dissimilarity of their interfaces, particularly the interactive, relational, multipath potential of computer networks. He rejects the Renaissance idea of art as a window on the world and conceives of it rather as a map of actual and potential relationships. Similarly, Ascott understands computer monitors to be metaphorical "screens of operation," rather than screens of representation. The "telematic screen gives the individual mind and spirit worldwide access to other minds and spirits," he says, enabling expanded "cognitive, affective, and spiritual behavior. It is not at all . . . imprisoning."[49]

Ascott's telematic embrace takes place in the space where love draws together art and technology, where their union becomes consciousness, and where consciousness, in turn, becomes love, allowing the system to cycle and recycle in perpetuity. Indeed, just as he presents telematics as a propositional model merging the instrumentality of technology with the creativity of art, so his concept of love can be seen as a propositional model merging the contingent and the transcendental. If Ascott is correct that the principle of passionate attraction is activated in the form and content of Duchamp's *Bride*, then such love is enigmatic. Similarly, the form and content of telematics are capable both of sustaining life and of violating it; and violation and sustenance are not mutually exclusive. It is this ambiguity that characterizes the dialectical locus of utopian and dystopian visions of the future with respect to technology (Heim 1999).

Toward a Critique of Telematic Art

That emerging technologies extend the hegemony of technocratic institutions, economic systems, and governments is nearly a tautology. As the demands of the evolving military-industrial-media complex push the relationship between human and machine to its limits—not necessarily in the pursuit of any lofty ideal, but in the interests of expanding global control and profit—the question of human values becomes increasingly urgent. Which values are worth keeping? What other types of values might emerge? Ascott proposes perhaps the most obvious, yet unlikely, value—love—as an organizing principle central to telematic culture. Yet, while certain aspects of love may remain stable, others appear subject to change. Similarly, it remains uncertain how the shifts brought about by telematics will transpire and what the costs and benefits will be.

Ascott's polemical query "Is there love in the telematic embrace?" therefore raises further questions: "What will that love be?" "How will it be manifested?" and "Who will benefit from it?" Indeed, the "sunrise of uncertainty" that the artist advocates may not appeal to those whose living circumstances are already tenuous. For no amount of telematic consciousness can result in planetary harmony unless the physical conditions of human life are vastly improved. Moreover, given that only a fraction of the world's population had even a telephone at the end of the second millennium, one must ask how wide the arms of the telematic embrace will be.[50] At the same time, one must remain vigilant that its hugs do not squeeze too tightly.

Cyberspace is a double-edged sword that reproduces the physical world, simultaneously intensifying and dematerializing it. Indeed, online rape, child pornography, terrorism, and computer viruses are part of the economy and structure of the global village, but telematics also offers potential benefits that are unique. Ascott's experiments with interactive art systems, beginning in the 1960s, and with telematic art networks, since the 1980s, can be seen as state-of-the art aesthetic research and design. His early collaborative networking experiments heralded a new paradigm for human interaction that is still in its infancy, the ramifications of which remain a work in progress.

UTOPIAN VALUES AND RESPONSIBILITY

Ascott's theories of telematic art are subject to criticism for their deterministic and utopian attitude regarding technology and the future. However, the artist is keenly aware of the threats that technology potentially poses to society and has expressed concern about how the misuse of technology by empowered in-

stitutions can serve to reinforce the status quo. Perhaps Ascott's service as a radar officer in the mid 1950s, at the height of the Cold War, stimulated his mindfulness of the potency of communications and surveillance technologies. This experience may have influenced his search for alternative scenarios in which these instruments of control promote collaboration, expand perception, and foster more harmonious planetary relations. Indeed, since writing "The Construction of Change" in 1964, he has insisted on the moral responsibility of artists and designers to contribute to shaping society by understanding the implications of technology and envisioning its many cultural possibilities. In this context, Ascott's utopianism is an aesthetic value that reflects his self-defined creative and ethical mission to formulate constructive visions of the future as an inspiration and blueprint for change.

The ethical responsibility of artists' use of telecommunications and the potential ability of art to affect the structure and content of networked communications is a persistent topic of debate (see, e.g., Gigliotti 1993). In general, Ascott has eschewed making explicitly political statements about the potential of telematics. However, in "Art and Telematics," he describes how the aesthetic values of telematic art constitute a subversive paradigm shift that has sweeping ramifications for the social structure:

> . . . [A]rt itself becomes, not a discrete set of entities, but rather a web of relationships between ideas and images in constant flux, to which no single authorship is attributable, and whose meanings depend on the active participation of whoever enters the network. . . .
> . . . [T]here is no centre, or hierarchy, no top nor bottom. . . . To engage in telematic communication is to be at once everywhere and nowhere. In this, it is subversive. It subverts the idea of authorship bound up within the solitary individual. It subverts the idea of individual ownership of the works of imagination. It replaces the bricks and mortar of institutions of culture and learning with an invisible college and a floating museum, the reach of which is always expanding to include new possibilities of mind and new intimations of reality. (Page 199 below)

Here, Ascott theorizes how telematics might promote the development of a society that is essentially different from the inherited model of hierarchical, discrete, centralized, individualistic systems of communication. This telematic model is "subversive," he asserts, in as much as it would "replace the bricks and mortar of institutions." In this distinctly political statement, Ascott sanctions not only the expansion of human consciousness but a reconceptualization of reality that involves the replacement of traditional cultural and social institutions.

Indeed, with the exception of the telephone, industry and government have historically restricted public communication transmissions to a one-way model in which the public has been a passive receiver. In the tradition of Bertolt Brecht, it was artists like Ascott who first offered the public models of interactive global communication among multiple, active participants.

It must be noted that hierarchies are not necessarily evil, and that they often serve vital functions of creating order and differentiation. It is unclear to what extent telematics has challenged the conventional hierarchical structure of society. While peer-to-peer file-sharing may be a thorn in the side of the record industry, and cottage industries have sprung up as a result of the economic benefits of the telematic home office, the fundamental structure of power arguably remains the same. Telematics has not proven the ability to bring repressive regimes to their knees, though a good spam, to say nothing of computer viruses, can cripple a corporate or governmental e-mail server.

Youngblood reiterates the ethical responsibility of artists to utilize telecommunications in a socially constructive manner, but is skeptical of how early telematic artworks merely repeated what had become common commercial practices. "A communications revolution is not about technology; it's about possible relations among people," he observes, arguing that this revolution has the potential to invert extant social relations, transforming the centralized, hierarchical structure of geographically discrete nations into one of decentralized, but politically significant, communities defined by "consciousness, ideology and desire." However, Youngblood warns: "The pretension has been that something done every day in business and industry and by subscribers to computer networks, or employed every evening by network newscasters, becomes special because artists are doing it. In fact nothing is revealed that is not already given, obvious, routine—indeed, already politicized by commercial contexts" (Youngblood 1986, 9).

According to this line of reasoning, the artistic use of telecommunications is "special" (i.e., art as opposed to nonart) only if the media are employed in a way that is not "done every day in business and industry," and therefore "given, obvious, routine, . . . [and] politicized." One could argue, however, that in its nascent stage, even the most mundane use of telecommunications in an art context could have significant meaning. By shifting the context from commerce to art, telematic artists have altered the codes of signification that apply to the dialectic between the medium and the message, form and content. As a historical example of this artistic strategy, Marcel Duchamp's *Fountain* (1917) shifted the context of the reception of a plumbing fixture to the domain of art, thereby endowing the common object with a "new idea," and abruptly changing West-

ern aesthetic conventions in the process. Similarly, the use of telecommunications media in the context of art not only imparts a new idea to that technology but raises significant challenges to artistic traditions.

Robert Adrian has also addressed the important process of decentralized exchange, expressing skepticism about the ability of artists to alter the form of telematics, while asserting confidence in their capacity to impart significant content to computer networking. "It is in the ephemeral immediacy of the exchange that the meaning of the work exists," Adrian writes, noting, however, that "the network implicit in the use of such systems ought not to be seen as originating with the technology but rather as the refinement of an existing network" of decentralized artists (Adrian 1979). In other words, the structure of computer networking remediates extant relationships between artists. It is too late for artists "to really change the direction of design development" of electronic media, Adrian has observed, although maintaining that "we can try at least to discover ways to insert human content into [the] commercial/military world floating in this electronic space. And this is where artists are traditionally strong in discovering new ways to use media and materials, in inventing new and contradictory meanings for existing organizations and systems in subverting self-serving power-structures in the interests of nearly everyone" (Adrian 1982).

Although he doubts that artists can influence the structural form of computer networks, Adrian remains optimistic that they might nonetheless use them in unprescribed ways and contribute provocative, and potentially subversive, material. In contrast to Youngblood and Adrian, Ascott's position is closer to Nora and Minc's view that the very structure of telematics holds the potential for a subversive reordering of social relationships and values. Ascott's theories of telematic art emphasize how the structure and process of asynchronous, decentralized, and collaborative interaction results in the transformation of consciousness on a global scale.

Also addressing the question of responsibility in telematic art, Kac questions the ability of telematics to change the conventional relationship between artist and viewer. Kac asks rhetorically whether the artists who produce such works do not "restore the same hierarchy they seem to negate by presenting themselves as the organizers or creators of the events they promote—in other words, as the central figure from which meaning irradiates." Arguing that they do not, Kac explains that the telematic artist creates a context in which networked telecommunications transpire, "but without fully controlling the flux of signs through it." This position closely parallels Ascott's assertion twenty-five years

earlier in "Behaviourist Art and the Cybernetic Vision" that "[w]hile the general context of the art experience is set by the artist, its evolution in any specific sense is unpredictable and dependent on the total involvement of the spectator" (page 111 below). Kac concludes that the artist working with telecommunications media "gives up his or her responsibility for the 'work,' to present the event as that which restores or tries to restore the responsibility (in Baudrillard's sense) of the media" (Kac 1992, 48).

In his essay "Requiem for the Media," the French sociologist Jean Baudrillard theorizes media "responsibility," not in psychological or moral terms, but as a "personal, mutual correlation in exchange . . . restoring the possibility of response" (Baudrillard 1981, 169–70). In contrast to McLuhan's proposition that telecommunications is creating an interconnected global village, Baudrillard insists that the formal qualities and institutional conditions of media embody "*what always prevents response*" and therefore what implicitly undermines any liberatory potential that might be imputed to telecommunications on the basis of its structure. He dismisses, as uncritical and retrograde, the utopian dreams to "liberate the media, to return them to their social vocation of open communication and unlimited democratic exchange," claiming that "what we have here is an extension of the same schema assigned, since time immemorial, from Marx to Marcuse, to productive forces and technology: they are the promise of human fulfillment, but capitalism freezes or confiscates them. They are liberatory, but it is necessary to liberate them." For Baudrillard, the potential for revolution in the media lies in "restoring [the] possibility of response." But he adds that "such a simple possibility presupposes an upheaval in the entire existing structure of the media" (168–70).

Baudrillard's critique of the structural limits of media challenges Ascott's assertion of the liberatory potential of telematics. The media historian and theorist Douglas Kellner has noted some of the shortcomings of Baudrillard's argument, offering a critique that supports Ascott's position with respect to the transformative capabilities of telematic media. Kellner argues that Baudrillard's position is technologically deterministic; it confers potency exclusively on the formal aspects of media, while evacuating their content of significant meaning (Kellner 1989a, 1989b). Like the utopian global village prophesied in McLuhan's *Understanding Media*, the dystopic account of technology in "Requiem for the Media" fails to acknowledge the dialectic between the medium and the message as co-determining elements of social practice. Moreover, because, for Baudrillard, media vitiate the possibility of response, he is unable to entertain the potential of alternative media structures (such as two-way radio and telematics)

to enable response, much less to constitute an "upheaval in the entire existing structure of the media." Finally, Kellner points out that the sociologist's nostalgia for a primitive form of direct response naïvely imagines that communication could be unmediated in some pre- or post-technological context. Ascott has himself repudiated this notion. "Human communication has never been . . . beyond mediation," he wrote, "since it is clear that the constraints and limited range of our biological systems of perception, and the ordering of experience by our languages, involve us in a continual process of constructing our world" (page 268 below). Indeed, communication is arguably always mediated, whether it transpires face-to-face or modem-to-modem, so technological media cannot be isolated out for criticism on this basis.

These various perspectives point to the problematic relationship between form and content in telematic art. D'Agostino and Adrian emphasize the importance of content, while Youngblood and Baudrillard emphasize formal concerns. Kac and Kellner attempt to strike a balance between form and content as inextricably connected components of communication. Ascott's work emerges from an aesthetic tradition that, at least in part, undermines the terms of this polemic.

FORM, CONTENT, PROCESS, AND TELEMATIC AESTHETICS

The relationship between form and content has been a problematic issue throughout the history of art. The practice, theorization, and criticism of telematic art have not refrained from adding to the fray. As noted above, there are divergent opinions regarding form and content in telematic art. However, I believe that telematic art exemplifies the intrinsic interrelatedness of form and content, and, as a result, has made a valuable contribution to the broader art historical discourses on this issue. For example, while Ascott's theories have clearly emphasized the formal aspects of telematics, the subject matter of projects like "La Plissure du Texte," "Ten Wings," and "Aspects of Gaia" all belie the importance of content in his work and in telematic art in general. In these works, form and content are inseparable and mutually co-determining parts of the overall meaning produced.[51]

One must also recall Ascott's emphases—for some forty years—on process, on the phenomenology of interactive participation in aesthetic encounters, and on the discursive production of meaning as the result of information exchanges within systematic contexts. For such concepts transcend the binary theoretical construct of form and content, offering a far richer basis for understanding the relationship between technological media and artistic expression. Form and con-

tent in telematic art can neither be considered in isolation from each other nor outside of considerations of process and context. Form is not a receptacle for content, and content is not an armature for form. The processes by which technological media develop are inseparable from the content they embody, just as the developing content of technological media is inseparable from the formal structures that embody it. Moreover, form, content, and process must be considered within the particular contexts of their creation and interpretation. The telematic embrace does not embody love by virtue of its formal structure, any more or any less than by virtue of the sensitivity and caring that it potentially communicates. If there is love in the telematic embrace, that love emerges as a dialogical process of interaction in which exchanges of information create bonds through shared systems of meaning and value.

In addition to the concerns of form and content, process, interactivity, and the semiotics of meaning in computer networks, there is also a conceptual component to telematic art, which, although it rarely goes unnoticed, has not been given sufficient consideration. Ascott's artistic practice since the early 1960s has shared significant theoretical alliances with what has since become historicized as conceptual art, including a strong emphasis on questioning the way in which art accrues meaning through the interplay of semantic systems. Ascott's interactive constructions have been equally concerned with how a "universe of discourse" can be derived as a result of the exchange or transaction of signifiers between the participant(s) and the work. Ascott's theory and practice of telematic art can be interpreted, then, as an extension of his theory and practice of a form of proto–conceptual art (Shanken 2001). Whereas conceptual art deemphasizes the materiality of art objects to interrogate the semiotic basis of visual meaning, telematic art asks how the semiotic structure of computer networking offers alternative forms of authorship, meaning, and consciousness in the electronic ether of cyberspace.

If telematic art is interpreted as an extension of conceptual art, then a significant aspect of a telematic artwork will be embodied in its own idea. Opposition to what has been termed the "techno-utopian rhetoric" of telematic art may be responsible, in part, for the occlusion of this point (Penny 1995, 47–73). While such critical challenges are important, this so-called rhetoric may, in and of itself, be considered a significant aspect of the art form. In other words, the conceptual idea of Ascott's telematic art—that electronic telecommunications technologies may contribute to the creation of a networked consciousness that is greater than the sum of its parts—is an integral part of his work and the history of the genre.[52]

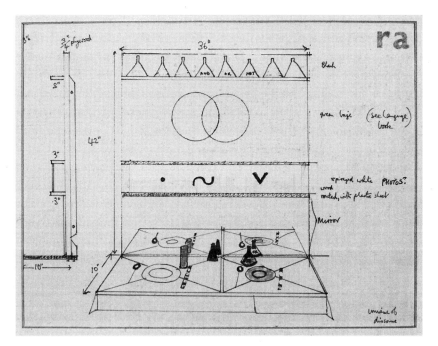

Figure 21. *Universe of Discourse*. 1977. Pen, crayon, and tape on paper, approx. 10 × 14". Note mirror panel indicated above table, and faint drawings of Transaction Tables partially hidden under tape above above it. The words "and," "but," and "or" suggest the conjunctive relationality of discursive interactions.

"Language, mathematics, and systems are an integral part of conceptual art," observes Carl Loeffler, whose involvement with satellite and telematic projects beginning in the late 1970s grew out of his interest in conceptual art. "To take the beauty of a good idea—conceptualism—and to apply it to a computer network is an exploration of language, systems, technology and, what became increasingly important over time, the idea of public art and the social context."[53] Indeed, telematic art, as it emerged in the work of Ascott, Loeffler, and other pioneers, was bound up in the concerns of conceptual art. This common ground is reflected in artistic activities that include the creation of alternative spaces, the impulse to involve the public in a more integrated manner with art, and a general rethinking of the relationship between art and society. Telematic art involves an ideology of interactive collaboration and global connectivity. As such, it both embodies utopian aspirations and constitutes a model for achieving them.

Mindful of both utopian and dystopian attitudes towards technology and the

future, Ascott's theories of telematic art envision "*life-as-we-know-it* in the larger context of *life-as-it-could-be*," as the artificial life researcher Christopher Langton has so eloquently written.[54] In this sense, Ascott's praxis bears a striking affinity to the strategic convictions of avant-garde artists throughout history: the perception, conception, envisioning, and representation of alternative realities and systems of meaning. Ascott's theory and practice of telematic art can most usefully and thoughtfully be considered in the context of avant-garde art. Indeed, the reasoned impulse to imagine alternative futures as a precursor to building them in the present shapes Ascott's desire for a telematic embrace.

The telematic embrace draws on the social force of art as an ally of technology. Unencumbered by the destructive history of technology and the demands of rational epistemology, perhaps the discipline of art—as the cultural convention charged with the embodiment and maintenance of the loftiest of human ideals and the rigorous questioning of them—can offer alternatives to military and commercial applications of new technologies. Telematic art offers an artistic meta-perspective capable of embodying paradox, dismantling convention, and constructing new visual forms that employ emerging technologies in ways that redefine knowledge and being. For over four decades, Ascott's artistic theory, practice, and pedagogy have offered such alternative models of "life-as-it-could-be," inspiring the collective imagination to create it in the present.

NOTES

1　A collection of Ascott's writings has been published in Japanese as *Art and Telematics: Towards the Construction of a New Aesthetics*, trans. Erimi Fujihara (Tokyo: Nippon Telephone and Telegraph Publishing Co., 1998).

2　The Advanced Research Projects Agency (ARPA) was founded in 1958 by the U.S. Department of Defense in response to the successful launching of Sputnik by the USSR. ARPANET, the precursor of the Internet, was an ARPA project initiated in the midst of the Cold War space race to enhance the ability of U.S. researchers to quickly exchange vital scientific and military information. See Myers 1996.

3　The late American composer and mycologist John Cage is probably the most famous artist in the postwar period to merge Eastern mysticism and Western technology and aesthetics. He studied Zen with D. T. Suzuki and used a computer to consult the *I Ching* in order to determine aspects of his musical compositions. See Cage 1961.

4　Charles Biederman's analysis of modern art was predicated on an evolutionary model in which color was progressively freed from form. Arp's organic forms and the developmental process of their creation can be likened to Wentworth Thomp-

son's models of biological morphology. Abstract expressionism relied on the unconscious to create visual forms that resembled the complexity of nature, and could also be interpreted by the structuralist model as freeing color from form.

5 Roy Ascott, "Interactive Art" (unpublished manuscript), 2.

6 Roy Ascott, e-mail correspondence with the author, June 25, 1997.

7 Roy Ascott, interview with the author, Bristol, May 25, 1995.

8 Roy Ascott, interview with the author, Montreal, September 20, 1995. Subsequent quotation from same source.

9 In retrospect, the artist acknowledges that an interpretation of his writings as works of art is justified, given the conceptual framework he had established at the outset for his artistic behavior, which included teaching and writing, and which he has maintained vigilantly since the early 1960s. Roy Ascott, interview with the author, New York, February 13, 1996.

10 See, e.g., Kosuth 1991 and Max Bill, "Concrete Art" (1936, rev. 1949) and "The Mathematical Approach in Contemporary Art" (1949), excerpted in Stiles and Selz 1996, 74–77.

11 Joseph Kosuth, "Vico's Appliance: The Historian as Artist and the Crisis of Certainty" (paper delivered at Duke University, April 1996), 4. See also Kosuth 1996. According to Kosuth, the art historian Benjamin Buchloh, along with his associates at the influential art journal *October*, of which Buchloh is editor, have persistently attacked his work, attempting to undermine the historical importance of his contributions to art and criticism. Kosuth's reply and Buchloh's rejoinder can be found in *October* 57 (Summer 1991): 152–57, 158–61.

12 The Josiah Macy Jr. Foundation "put into practice the belief that discoveries in one field of scientific activity can often result from information gained in quite another, that the increasing isolation of the different branches of science is a serious obstacle for progress" (Stewart 1959). The Macy Conferences on the topic of cybernetics were an outgrowth of its 1942 conference on "Cerebral Inhibitions." Organized by the Macy Foundation's medical director, Charles Fremont-Smith, and chaired by the neurophysiologist Warren McCulloch, the first of these small, invitational meetings, entitled "Feedback Mechanisms and Circular Causal Systems in Biological and Social Systems," took place in March 1946. In 1949, after Norbert Wiener published *Cybernetics*, the meetings became known as the Macy Conferences on Cybernetics.

13 For more on the political and sociological aspects of the development of computers and cybernetics in the context of the Cold War, see Edwards 1996.

14 Popper 1975, 10. The famous "Bewogen Beweging" exhibition was organized by Daniel Spoerri, K. G. Pontus Hultén, and Jean Tinguely at the Stedelijk Museum in Amsterdam. Ascott has claimed that he did not know of other artists who worked with interactive media until he exhibited in that show with Agam. Roy Ascott, interview with the author, Montreal, September 25, 1995.

15 Despite his prominence in this area, Ascott was not included in Reichardt's "Cybernetic Serendipity" exhibition at the Institute of Contemporary Arts in London in 1968. This oversight can be explained in part by the fact that his art, although manifesting a complex, metaphorical relationship with scientific ideas, did not explicitly utilize technological apparatus. Reichardt was aware of Ascott's work with cybernetics in the early 1960s. The artist's theoretical approach to the application of cybernetics to art as process and system did not, however, match Reichardt's vision for "Cybernetic Serendipity," which involved the juxtaposition of art and nonart, and emphasized the use of technological apparatus either as an object or as a means for producing objects. Jasia Reichardt, interview with the author, London, July 30, 1998.

16 Ascott's anticipation of, and contribution to, the formation of conceptual art in Britain has not received proper recognition, perhaps because his work was perceived as too closely allied with technology. See Shanken 2001.

17 Mellor 1993, 19. Mellor dates Latham's theorization of "event structure" to 1959. Latham claims to have conceived of it much earlier, and certainly prior to Georges Mathieu's performance at the Institute of Contemporary Arts in London in 1956. John Latham, interview with the author, Los Angeles, February 8, 1998.

18 In 1962, Ascott was included with Pasmore, Ben Nicholson, and Kenneth and Mary Martin in an exhibition of British constructivist art. See *The Geometric Environment* (exhibition leaflet), A.I.A. Gallery, London, May 10–31, 1962.

19 On the relationship of Schöffer's spatio-dynamic and cybernetic sculptures to constructivism, see Popper 1968, 134–40.

20 Similarly, Duchamp's *Large Glass* (1915–23) has been interpreted as a visual map of the structural foundations of Western art history and the internal semiological functioning of art objects through a diagrammatic and transparent form. See Burnham 1974.

21 See Wolfe 1972 and 2001, as well as *Art* (Journal of the Society of Canadian Artists) 3, 11 (Spring–Summer, 1972): 25.

22 Norman White, telephone interview with the author, October 2, 1998.

23 As H. H. Arnason notes: "Various dates are used to mark the point at which modern art supposedly began. The most commonly chosen, perhaps, is 1863, the year of the Salon des Refusés in Paris . . . [although] other and even earlier dates may be considered . . . even 1784, when . . . in Neoclassical art a fundamental Renaissance tradition was seriously opposed for the first time—the use of perspective recession to govern the organization of pictorial space." More recently, some scholars, such as Joseph Koerner, have located the dawning of modernity in the Renaissance, which they interpret as the moment when artists began to self-consciously and self-reflexively express their identity and role as artists in a critical manner. See Arnason 1986, 13, and Koerner, 1993. See also Harrison 1996.

24 In recycling media images (an original artistic gesture in the early 1960s), even pop artists like Hamilton, Rauschenberg, and Warhol were bound up in creating a personal style, thus perpetuating the modernist value of originality.

25 Here Ascott quotes McLuhan 1964. See also McLuhan 1962.

26 The French response to this dilemma was to put the development of telematics in the hands of the civil service bureaucracy, which was deemed less malignant than corporate interests. See Feenberg 1995, 144–66.

27 Bolter and Grusin (1999) discuss the problem of technical determinism and writing about media, noting: "It is difficult . . . to hold in relief all the aspects of a technology at any one rhetorical moment" (75–78). They suggest that statements that impute autonomous agency to media (e.g., "digital media are challenging the status of television and film") be treated as shorthand for more "lugubrious" descriptions that acknowledge the hybridity of agency with respect to media (e.g., "the individuals, groups, and institutions that create and use digital media treat these media as improved forms of television and film"). I have followed this approach in my text.

28 Roy Ascott, e-mail correspondence with the author, October 11, 1998.

29 Thirty years later, it was reported that doctors at Emory University had succeeded in planting an electrode in the brain of a paralyzed mute stroke victim, which enabled him to communicate directly with a computer. "Implant Transmits Brain Signals Directly to Computer," AP, *New York Times* on the Web, October 22, 1998, <http://www.nytimes.com/library/tech/yr/mo/circuits/articles/22brai.html>.

30 According to Klára Kiss-Pál (1997), "People put various dates to the inception of the NYCS. Mike Crane dates it from 1962; according to Johnson, it already functioned in the fifties. But the name, given by Ed Plunkett (New York Correspondence School), gained recognition only at the end of the sixties, mostly due to the increasingly regular meetings organized by Johnson . . . between 1968 and 1983."

31 Allan Kaprow, telephone interview with the author, July 23, 1998. According to Kaprow, Minujin's happening took place at a television studio. Video clips, ostensibly of the happenings going on simultaneously in New York and Berlin, were displayed on monitors. Although apparently no deception was intended, the audience and the press in Argentina believed that they actually were seeing an interactive, transcontinental performance in real time.

32 In 1971, Kaprow expounded an expanded vision of the possibilities of such communication/noncommunication systems, a combination of video arcade and Internet cafe, which he described as, "A global network of simultaneously transmitting and receiving 'TV Arcades' . . . [e]ach equipped with a hundred or more monitors. . . . A dozen automatically moving cameras . . . will pan and fix anyone or anything that happens to come along or be in view [and] send the same images to all other arcades. . . . Thus what happens in one arcade may be happening in a

thousand, generated a thousand times. . . . Everybody in and out of touch all at once!" ("The Education of the Un-Artist," in Kaprow 1993, 106–7).

33 Transcript of "Utopia Q&A," E.A.T. archive, Getty Research Institute for the History of Art and the Humanities, Los Angeles.

34 The Public Interest Satellite Association (PISA) helped to orchestrate this event with NASA and to obtain use of the jointly owned U.S./Canadian "Hermes" CTS satellite. Liza Bear, telephone interview with the author, October 26, 1998.

35 Willoughby Sharp, telephone interview with the author, September 24, 1998.

36 Liza Bear, telephone interview with the author, October 26, 1998.

37 White had a free account on the IPSA network through his friend Bob Bernecky, who worked there as a systems programmer. The problem for White was that he didn't know any other artists who had access to the network. White and Bartlett met in 1977 or 1978 at a conference on art and technology in Toronto and discussed the possibility of using the IPSA network for an art project. Norman White, telephone interview with the author, October 2, 1998. This conference may well have been the Fifth Network Conference, where Bartlett and Adrian met in 1978.

38 Vallée 1981, entry 34, October 16, 1980. *Saturn Encounter* was organized by Vallée, Stan Kent, and Ren Breck on the occasion of the *Voyager*'s encounter with the planet Saturn on November 11–12, 1980.

39 The history and evolution of ARTBOX is noteworthy, because it was a major technological achievement that enabled many text-based telematic art projects in the 1980s. Adrian (1995) explained that

> In the summer of 1980, Bill Bartlett and I began to put pressure on IPSA [I. P. Sharp Associates] to develop a cheaper and more user-friendly e-mail program for noncorporate and non-institutional users. This resulted in the creation, by Gottfried Bach, of ARTBOX—a cheap and simple version of the IPSA "Mailbox." ARTBOX went through a number of versions until about 1983 when it became formalised as ARTEX—the Artists' Electronic Exchange program—a "user-group" on the IPSA network. ARTEX had about 30 members [including Ascott] and was used for the organization of global projects and as a medium for art projects as well as for personal contact. It existed until about 1990 when IPSA was purchased by Reuters and eventually closed down.

40 Robert Adrian, interview with the author, Plymouth, U.K., December 13, 1999.

41 It is reputed that Bartlett dropped out of telecommunications art after being left to foot a bill he could not afford to pay. This story was independently corroborated by Hank Bull (telephone interview with the author, September 17, 1998) and Robert Adrian (interview with the author, December 13, 1999).

42 The roles were: Alma, Quebec—"beast"; Amsterdam—"villain"; Bristol—"trickster"; Honolulu—"wise old man"; Paris (Roy Ascott)—"magician"; Pittsburgh—"prince"; San Francisco—"fool"; Sydney—"witch"; Toronto—"fairy godmother"; Vancouver—"princess"; Vienna—"sorcerer's apprentice." A

transcript of "La Plissure" compiled by Norman White at the Toronto node is available online at <http://www.bmts.com/~normill/artpage.html>.

43 Bull further clarified this description, stating: "It was like live radio or performance—that the value lay more in the event, the process, the shared experience of the project, than in the literary quality of the final outcome. Nevertheless, a good writer could no doubt make an interesting job of editing it for publication." Hank Bull, e-mail correspondence with the author, September 23, 1998.

44 Nam June Paik quoted by Laura Foti in Lynette Taylor, "We Made Home TV," *Art Com* 6, 23 (1984), cited in Lovejoy [1989] 1997, 220–21.

45 For more on the subject of agency in telematic art, see Shanken 2000.

46 Stelarc, interview with Jeffrey Cook and Gina Fenton, Sydney, October 26, 1996, in Stelarc 1997.

47 It is interesting to note that Teilhard has been resuscitated as a model for networked consciousness and spirituality. See, e.g., Mike King, "Concerning the Spiritual in Twentieth-Century Art and Science" *Leonardo* 31, 1 (February 1998): 21–31, and Jennifer Cobb Kreisberg, "A Robe Clothing Itself with a Brain," *Wired* 3, 6 (June 1995).

48 Lev Manovich, "An Archeology of a Computer Screen," *Kunstforum International* 132 (November 1995–January 1996): 124–35. If the screen is perceived as a prison, however, one wonders what apparatus could not, in some sense, be so conceived of. The term "prison" lapses into a generality in which it begins to lose its significance. Nonetheless, Manovich's point, following the film theorist Jean-Louis Baudry (Baudry 1974–75), is well taken, because the screen certainly demands and restricts behavior as it offers and supplies information.

49 Roy Ascott, e-mail correspondence with the author, January 6, 1999. I have re-ordered this quotation for clarity.

50 Even if everyone were connected, there is no guarantee that cyberspace would be any less hierarchical than any other space. Licklider and Taylor 1968 anticipated this concern, and it remains a current topic of debate.

51 Two divergent explanations may help illuminate, albeit dimly, the discrepancy between Ascott's theories and artistic practice: (1) the difficulty of maintaining a logically consistent position during times of great cultural and social transition; and (2) Ascott's logically consistent position that "consistency" is an overrated value.

52 That is not to say that artists using telematics as their medium could not, or do not, create work that is critical of that ideology. Certainly Web-based works such as *Jodi* and Julia Scher's *Securityland* are deeply critical of techno-utopianism and make explicit the dangers of telematic surveillance. Indeed, Scher's work is critical of any sort of utopianism, neither utilizing the collaborative potential of telematics nor attempting to offer artistic models for creating desirable alternative futures. But such work is also not the type of artistic application of telematics that would be a relevant model for an international, process-oriented exchange among

art students, unless they wanted to explore the process of being the surveyed and the surveyor within a closed system.

53 Carl Loeffler, interview with the author, September 16, 1998. See also Mark J. Jones, "Email from Carl" (e-mail interview with Carl Loeffler), *Cyberstage* 1, 2 (May 1995), <http://www.cyberstage.org/archive/cstage12/carl12.htm>.

54 Langton 1989, quoted by Ascott, page 311 below.

SELECTED ESSAYS OF
ROY ASCOTT

THE CONSTRUCTION OF CHANGE

1964 ▬ **ART AND DIDACTICS**

While the creative process demands acts of synthesis that defy verbal description and that only the work of art itself can define, there are some aspects of artistic activity that can be examined and set down rationally. They are both empirical and analytical and involve forays into unfamiliar conceptual territories. Very often scientific ideas can reinforce or extend what is uncovered. To discuss what one is *doing* rather than the artwork that results, to attempt to unravel the loops of creative activity, is, in many ways, a behavioural problem. The fusion of art, science, and personality is involved. It leads to a consideration of our total relationship to a work of art, in which physical moves may lead to conceptual moves, in which behaviour relates to idea.

Art, for me, is largely a matter of freely developing ideas and creating forms and structures that embody them. Whatever ideas I may pursue—and in art, the entire universe is open to investigation and reconstruction—behaviour is an important reference in my considerations of space, time, and form. I make structures in which the relationships of parts are not fixed and may be changed by the intervention of the spectator. As formal relationships are altered, so the ideas they stand for are extended. I am conscious of the spectator's role. Once positioned in relation to a work, he may become totally involved—physically as well as intellectually or emotionally. To project my ideas, I set limits within which he may behave. In response to behavioural clues in a construction (to push, pull, slide back, open, peg in, for example), the participant becomes responsible for the extension of the artwork's meaning. He becomes a decision-maker in the symbolic world that confronts him. My *Change Paint-*

Originally published in *Cambridge Opinion*, January 1964.

ings and kinetic constructions are intended not only to discuss and project ideas but also to function as analogues of ideas—structures that are subject to change and human intervention in the way that ideas themselves are. It is predominantly the experience of change and the concept of power that lie behind our control and prediction of events that hold my attention at present.

In trying to clarify the relationship between art, science, and behaviour, I have found myself able to become involved in a teaching situation without compromising my own work. The two activities, creative and pedagogic, interact, each feeding back to the other. Both, I believe, are enriched. The didactics of art, set against the discoveries of science, have concerned many artists in the past. It is useful to turn to the writings of, for example, Leonardo, Seurat, or Paul Klee, but they cannot go all the way towards dealing with the problems and experiences that face us today.

All art is, in some sense, didactic; every artist is, in some way, setting out to instruct. For, by instruction, we mean to give direction, and that is precisely what all great art does. Art shapes life. It is a force; only the aesthete makes a refuge of it. Through his work, the artist learns to understand his existence. Through the culture it informs, art becomes a force for change in society. It seems to me that one should be highly conscious of the didactic and social role of one's art today. Society is in a state of enormous transition. The most extensive changes in our environment can be attributed to science and technology. The artist's moral responsibility demands that he attempt to understand these changes. Some real familiarity with scientific thought is indispensable to him. It is not enough to accept our condition, or simply to enjoy it. Acceptance can only lead to a "murderous easy-goingness," as Thomas Mann puts it. "It would take a new society in order for art to become innocent and harmless again."

Culture regulates and shapes society. The artist functions socially on a symbolic level. He acts out the role of the free man par excellence. Having chosen the symbolic field within which he will act, and setting material limitations for himself with which he is familiar, he sets out to discover the unknown. He stakes everything on finding the unfamiliar, the unpredictable. His intellectual audacity is matched only by the vital originality of the forms and structures he creates. Symbolically, he takes on responsibility for absolute power and freedom to shape and create his world. He demonstrates, perhaps ritualistically, man's "capacity to create what is to be. . . . Man's highest merit, after all, is to control circumstances as far as possible" (Goethe). In this context, the artist's *activity* is as significant as the artwork he produces.

Creative leaps are also taken in science. Science seeks to reduce the unpre-

Figure 22. Roy Ascott with *Change Painting*. Ca. 1959.

dictable to measurable limits. While it may have a symbolic or ritualistic function, it is generally seen to operate in practical works in consort with practical power. By prediction, it reduces our anxiety about the unknown future. By control, it reduces the contingent nature of events and orders them to our advantage. By comparison, the artist plays, but it is play "in deep seriousness" (Mann). The culture to which art contributes, although it works without practical power, is responsible to a considerable extent for the direction in which society moves. The artist's activity serves to set before his fellow men the symbolic pattern of an existence in which, given absolute choice and responsibility and the power to take incalculable risks, the world and his own identity are shaped to his will. It stands for that optimum of control and creativity to which man's practical life constantly aspires.

▬ SCIENCE AND A DISCIPLINE FOR ART

Culture has been well defined as "the sum of all the learned behaviours that exist in a given locality." The work of art occupies a pivotal point between two sets of behaviour, the artist's and the spectator's. It is essentially a matrix, the

substance *between*. It exists neither for itself nor by itself. Consequently, the artist would do well to examine with some precision the nature of the special activity that gives rise to his own art. "An organism is most efficient when it knows its own internal order" (Claude Bernard). He might direct his attention to those sciences that measure behaviour, scrutinise biological processes, and explore the internal systems of communication and self-regulation. He may ask how the human organism interacts with its environment; what relation knowledge has to perception. A consistent and thorough enquiry might lead to the forming of a discipline. But the behavioural sciences alone can hardly supply the total backbone to one's art. Some real understanding of the world to which we respond and with which we have commerce must be obtained. Traditionally, the artist relies on visual observation, intuitive judgement, and day-to-day experience for this. But to fully orientate himself in the modern world, the artist must turn to science as a tool and reference. I recommend that he turn to cybernetics.

Science as a whole works on many fronts—too many highly specialised fields, in fact, for the artist to consult them all, except casually. Cybernetics, however, is essentially *integrative*, drawing many disparate sciences together. It ranges over many territories of scientific enquiry. It is a coordinator of science, as art is the coordinator of experience. Cybernetic method may be characterised by a tendency to exteriorise its concepts in some solid form; to produce models in hardware of the natural or artificial system it is discussing. It is concerned with what things *do* and how they do them, and with the process within which they behave. It takes a dynamic view of life, not unlike that of the artist. Phenomena are studied in so far as they do something or are part of something that is being done. The identity we give to what we perceive is always relative, yet it presupposes a whole. Everything changes ceaselessly; we investigate our world best by first seeing the system or process before evaluating the "thing." Cybernetics is concerned with the behaviour of the environment, its regulation, and the structure that reveals the organisation of its parts. "Control and communication in animal and machine" is a proper study for the artist.

Linked to technology, cybernetics is responsible for unprecedented changes in the human condition. Cybernation is bringing about a total industrial revolution, which will have far reaching social consequences. This science of control and communication is leading to new concepts of urban planning, production, shelters, transport, and learning methods. The ball has started to roll. The artist cannot ignore this creative force, which is changing his world. Moreover, cybernetics deals with concepts of information, perception, translation, logic, and chance that are singularly relevant to his art.

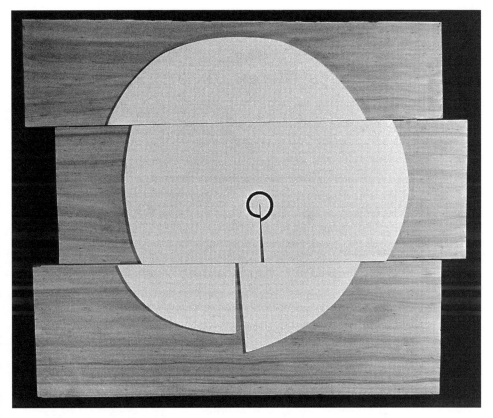

Figure 23. *Shift.* 1963. Wood, 38 × 36".

And man's relationship to his environment has changed. As a result of cybernetic efficiency, he finds himself becoming more and more predominantly a controller and less an effecter. The machine, largely self-regulating and highly adaptive, stands between man and his world. It extends his perception into furthest space and deep into the finest particles of matter; physical labour is replaced by accurate, tireless automata; in many situations, the machine can gather, store, and process required information and act on it more swiftly and reliably than man himself can. Man perceives the world through the excellent artificial systems he has devised. Cybernetics is not only changing our world, it is presenting us with qualities of experience and modes of perception that radically alter our conception of it.

Science can inform a discipline for art, then, not to produce a scientific work but to substantiate our empirical findings and intuitions with clear analysis and

reason. The final stage is beyond theory; only creative synthesis can produce the coordinating matrix for ideas that is art.

To praise science, however, is not to praise a spurious scientism; I mean that tendency in art to use images and notations found in the *products* of science with no understanding of the concepts behind them— a "scientific" style; a romanticism of machines and laboratories, micro-photographs and unidentified cross-sections; the furniture of science, the props. This attitude is often accompanied by a sentimental nostalgia for the past. To ignore the theory, the process, the demonstration must be a contradiction of science, and, indeed, of a forward-reaching art. Anti-science in art is equally to be criticised. It is an attitude that derives from a fear of the vitality of modern life, its technological advance, its scientific daring. It is hostile to reason and clarity of purpose, it is irresponsible and vague.

Great art symbolises our will to shape and change the world and also puts forward the particular aspirations of its time. What is our symbol of faith? We may find that it will embody a concept of power realised in our capacity for highly adaptive control, subtlety of communication, and the boldness of our investigation and planning at the most complex biological and environmental levels.

▬ A GROUNDCOURSE FOR ART

But no matter what our aspirations or intentions in art, we must prepare a discipline, a groundwork for creative activity. When I emphasise that my art and didactics are one, I am suggesting that the artist's discipline and experience can usefully be extended to the student. One can help him to win an outlook and to construct the groundwork for his own unique creative identity. But one artist is not enough. A wide diversity of artists and scientists, suitably coordinated, must confront the student. He, in turn, must be sufficiently uninhibited to respond. Out of the flux, a many-sided organism may evolve.

Such an organism, so to speak, is in the course of evolution at the Ealing School of Art in London. This two-year "Groundcourse" [initiated and directed by Roy Ascott—Ed.] is a microcosm of a total process of art education stretching from general secondary education to the graduate levels of professional art and design training, and it occupies the pivotal point in it. It takes students from secondary school and prepares them for subsequent professional training. I would like to describe the Groundcourse very broadly. My collaborators on the course have included a deliberately varied selection of painters, sculptors, de-

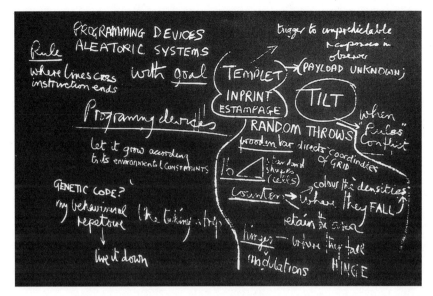

Figure 24. *Blackboard Notes.* 1967. Screen print. The blackboard, symbolic of a pedagogical context, here became the ground for representing Ascott's fusion of studio and classroom practice.

signers, and scientists.[1] Each one has expanded his own given area of teaching with ideas fresh from his studio or study. These areas interact and suggest new fields of study and the need for new kinds of personalities. Ideas grow and exercises proliferate as teachers discuss and dissect one another's attitudes and pedagogic methods. So many exercises and methods of presenting them are thrown up in this creative milieu, even in the course of one week, that it would be impossible to list them here. I shall describe the general areas of study and a few examples of specific problems students may be set.

The first-year course has many facets. Empirical enquiry in response to precise questions is balanced by scientific study; irrational acts by logical procedures. At the core is a concept of power, the will to shape and change. Cybernetics and behavioural sciences are studied regularly.

The new student's preconceptions of the nature of art and his own limitations ("Art is Van Gogh"; "Art is what my teacher said it was to get me through my art exam"; "I am no good at colour"; "I am the class clown"; "I am thick, but good at patterns and posters") must first be severely shaken and opened up to his close scrutiny. His disorientation is contrived within an environment that

is sometimes unexpectedly confusing, where he is faced with problems that seem absurd, aimless, or terrifying.

The nature of drawing is questioned. Example 1. Draw the room in reverse perspective. What information is lost? If any, find a way of adding it to your drawing. 2. Time-drawing of the model. Draw her hair in three seconds, face in three minutes, left hand thumbnail in three hours, legs in six seconds, right ankle in two days. 3. Draw her with acute earache. 4. Draw the room using only rubbings from surfaces in it. Copy the drawing precisely with line and tone.

The values of perspective and mechanical and architectural drawing are practised and tested against problems of space—scanning and design.

Perception studies examine the modes of human perception and their coordination and include the search for visual/plastic equivalents. Surface gesture, mark, colour, and volume are investigated, always within some context. Example 1. Imagine you wake up one morning to find that you are a sponge. Describe visually your adventures during the day. 2. List the sense data of an umbrella or a hot water bottle. Visually restructure the parts to form a new entity. Ask your neighbour to identify it. 3. If fifteen ragged criss-cross lines stand for a cough, how would you draw the BBC time signal? 4. Use only solid shapes to discuss your perception of: a bottle of ink; fish and chips; a police siren; ice hockey. 5. Show how zebras disguise themselves. 6. Invent a typewriter bird and show the kind of tree within which it could most successfully hide.

In the workshop, the student acquires skills in joining, moulding, separating, and transforming wood, metals, and various transparent, reflective, and flexible materials. Example 1. Make a sculpture in plaster of interlocking units, such that when a key piece is removed, the rest falls apart. Allot colours to the separate pieces (a) to indicate the key, (b) to facilitate reassembly. 2. Using only wood, sheet aluminium, string and panel pins, construct analogues of: a high-pitched scream, the taste of ice cream, a football match. Kinetic structures are built and studied. Concepts can be formed and developed by visual means. This might be seen as the third leg in the learning process, where, for some reason, verbal or numerical systems are inadequate. Unlike the latter symbolic systems, however, the visual ABC and syntax have to be reinvented for every problem. In visual terms, students set about analysing and inventing games, logical propositions, idea sequences, and matrices. Visual polemic is induced, and codes are designed and broken.

Natural growth and form in the context of, say, scale, reproduction, and simultaneity are analysed with meticulously detailed drawings. Example 1. Analyse

and dissect a section of a pomegranate. Discuss with precise drawing its three-dimensional cellular structure. 2. Examine a plant in minute detail; design a new plant based upon the principles of growth you have observed. 3. Discuss visually the movements of a hungry, caged lion; then those of a frightened squirrel.

In the light-handling class, students control a limited environment with lights, coloured filters, grids and lenses, moving screens, and prefabricated items. A theatre-play situation emerges, in the course of which students rehearse a variety of social and archetypal roles and explore the relationship of illusion to identity in terms of colour and light. The registration of environmental changes on light-sensitive paper introduces photography.

Concepts of behaviour, environment, and identity find their way into practical classes. Example 1. Draw a man, machine, or animal. Cut up the drawing into seven sections (e.g., arm, head, wheel, handle, etc.). Put the pieces with everyone else's in a box. Pull out another seven at random; logically construct a new entity. Draw the environment in which you might expect to encounter it. 2. Show, with line and colour, the potential function of: the studio door, a water tap, an elephant, the window blind. Attempt to describe what they might have in common. 3. Invent two distinctly different animals, imagine them to mate, and draw the offspring. 4. Make the illusion of, say, a bun or sausage in three dimensions and on paper. Show it being submitted to various events: run over, squeezed dry, soaked in acid, minced, perforated by a shotgun. Measure the real against the metaphoric. 5. Create a world on paper with major and minor structural systems. Show a fault occurring in the minor one; design a repair centre to put it right. 6. Entropy may be described as a constant drift in the universe towards a state of total undifferentiation; pockets of resistance are organising continuously. Discuss this proposition, limiting yourself to six visual elements.

In this first-year course, the student is bombarded at every point with problems demanding total involvement for their solution. Ideas are developed within material limitations and in the abstract. For the teachers, the formulation of problems is in itself a creative activity; the above examples give a general indication of the kind of questions they have set.

In the second year, the situation changes radically. The general direction is programmed, but beyond that students must find their own problems. Students are set the task of acquiring and acting out for a limited period (ten weeks) a totally new personality, which is to be narrowly limited and largely the converse of what is considered to be their normal "selves." They design "calibrators" to

read off their responses to situations, materials, tools, and people. They equip themselves with handy "mind-maps" for immediate reference to their behaviour pattern as changes in the limitations of space, substance, and state occur.

They form groups of six. These sexagonal organisms, whose members are of necessity interdependent and highly conscious of one another's capabilities and limitations, are set the goal of producing an *ordered entity* out of substances and space in their environment.

The limitations on individual behaviour are severe and unfamiliar. The student who thinks himself "useless" with, say, colour, machine tools, or objective drawing may find himself with the sole responsibility for these things in his group. The shy girl must act out an easy sociability; the aggressive youth must become cooperative. One student may be limited to transporting himself about the school on a trolley; another may not use paper, numbers, or adhesive substances.

The subsequent "ordered entities" are as diverse as the composite personalities of the organisms they reflect. Totems, time machines, sense boxes, films, sexagonal cabinets, and cages have been produced out of the flux of discussion and activity.

Students are then invited to return to their former personalities. They must make a total visual documentation of the whole process in which they have been engaged. They must search for relationships and ideas unfamiliar to art (e.g., spatial relationships are familiar). They use, at first, every possible expressive means: film, collage, graphic processes, wood, plaster, metal, cloth, glass, ready-mades, rubber, paint, and so on. They work on a huge scale at one point and in miniature at another, sometimes with kinetic structures, sometimes with static relationships.

In the process, and reflecting upon their previously contrived limitations of behaviour, they become aware of the flexibility of their responses, their resourcefulness and ingenuity in the face of difficulties. What they assumed to be ingrained in their personalities they now tend to see as controllable. A sense of creative viability is being acquired.

They move progressively into problems of their own; one set of ideas is preferred to another, exploited and pushed to an extremity of thought or technique. They also begin to choose specific limitations of material within which to work. They are moving towards the point of deciding within which professional field they will act. They are becoming aware of their special creative identity. Analysis and experiment are beginning to lead to synthesis. This is a report of work in progress; it can be little more than a brief summary of an evolving situation. It is difficult to do justice to the vitality and sense of purpose that the

course engenders. What has been proposed is not a rigid system but a flexible structure within which everything can find its place, every individual his way. It is an art that does not eschew science. It enables the student to become aware of himself and the world, while enabling him to give dimension and substance to his will to create and change.

NOTE

1 Kenneth Adams, Anthony Benjamin, Adrian Berg, David Bindman, Dennis Bowen, Bernard Cohen, Harold Cohen, Noel Forster, B. French, N. Johnson, R. B. Kitaj, Stephen McKenna, J. Morris, J. Nerichov, George Popperwell, Peter Startup, William Suddaby, Brian Wall, and Brian Wright.

STATEMENT FROM *CONTROL*

1966

To control ones
environment is to assert ones
existence. In controlling my identity
I define it. The Free Man has control of every
aspect of his world and creates his role within it
("remakes himself" in Nietzsche's terms). Although
through science we strive for this total freedom, it may
never be attained. Art, however, provides the means to win
this freedom and to act it out—symbolically. In Art the will to
control is expressed through processes of restricting experience
and of creating in familiar relationships within a universe of visual
discourse. In this way the Artist becomes the Free Man. Just as my
own artwork feeds back to affect my subsequent behaviour, so in
society generally the artist activity may function as some kind of
ritual control mechanism. Both individual artworks and cultural
clumps can act as behavioural triggers. But the cultural force not
only controls a Social Situation it constantly assigns to it fresh
goals. This is not a steady state control—it is one affecting a
changing, fluid field. This is one kind of value, amongst others, that
I want my public art to have. It requires the New, unfamiliar forms
and unpredictable relationships. These come only out of
creative behaviour—unlearned, non-routine constantly shaken
up. It involves taking risks, stretching the intuition. There
is a splendid paradox in Art that often the wildest,
most far out, random unprogrammed activity can
in the end produce work which may exercise
the most profound and fruitful control
on the human situation.
ROY ASCOTT

Originally published in *Control* 1, no. 1 (1966).

**BEHAVIOURIST ART
AND THE CYBERNETIC VISION**

1966-67 The purpose of this essay is twofold: *(a)* to bring into focus the emergence of a cybernetic vision in art, characterised by an evolving behavioural tendency in the artistic attitudes and forms of this century; and *(b)* to make provisional recommendations for a Cybernetic Art Matrix (CAM) that would provide a technological and social framework for the furtherance of this vision, without in any way inhibiting the essentially anarchic nature of the processes of creativity and cultural interaction.

▬ THE BEHAVIOURAL TENDENCY IN MODERN ART

By "modern art," I mean the cultural continuum of ideas, forms, and human activity that not only differs radically from the art of any previous era but is both expressive and formative of the attitudes and conditions of our time. To describe it as a continuum may seem to contradict its accepted identity. It is popularly seen as an anarchic, highly diversified, and chaotic situation, which loses as much in coherence and continuity as it gains in novelty and imagination.

Now, it is undoubtedly anarchic, but in the good sense that interaction between artists is free and not constrained by aesthetic canons or political directives. The diversity of images, structures, and ideas that it engenders is far greater than at any other period in history. And it may well seem chaotic; a common cultural consciousness is not readily apparent today. But it is my purpose to demonstrate that modern art is fundamentally of a piece, that there is unity in its diversity, and that the quality that unifies it is in dis-

This two-part article first appeared in *Cybernetica: Journal of the International Association for Cybernetics* 9 (1966) and 10 (1967) and is reprinted with permission.

tinct contrast to the essential nature of the art that went before it. I describe this quality as "behavioural," and I shall show how it evidences our present transition from the old deterministic culture to a future shaped by a cybernetic vision.

The analysis of this behavioural tendency will be largely confined to one broad area, that of the visual/plastic arts, since it seems to be most marked there, but in a more general sense I shall discuss the arts as a whole, illustrating their convergence and interaction in this context. I shall demonstrate how this unity of approach may be potentially part of a larger unity, an integral culture, embracing modern science and technology. And I shall warn how this unity, and the incipient cybernetic vision in art, may be inhibited by artistic attitudes that, out of ignorance and fear, are opposed to radical creative change and view a cybernated society with indifference or hostility.

The General Characteristics of Modern Art

The dominant feature of art of the past was the wish to transmit a clearly defined message to the spectator, as a more or less passive receptor, from the artist, as a unique and highly individualised source. This deterministic aesthetic was centred upon the structuring, or "composition," of *facts*, of concepts of the *essence* of things, encapsulated in a factually correct visual field. Modern art, by contrast, is concerned to initiate *events*, and with the forming of concepts of *existence*. The vision of art has shifted from the field of objects to the field of behaviour, and its function has become less descriptive and more purposive.

Although in painting and sculpture, the channel of communication remains largely visual, other modalities—tactile, postural, aural—are increasingly employed, so that a more inclusive term than "visual" art must be found, and the one I propose is "behavioural." This behavioural tendency dominates art now in all its aspects. The artist, the artifact, and the spectator are all involved in a more behavioural context. One finds an insistence on polemic, formal ambiguity and instability, uncertainty, and room for change in the images and forms of modern art. And these factors predominate, not for esoteric or obscurantist reasons, but to draw the spectator into active participation in the act of creation; to extend him, via the artifact, the opportunity to become involved in creative behaviour on all levels of experience—physical, emotional, and conceptual. A feedback loop is established, so that the evolution of the

artwork/experience is governed by the intimate involvement of the spectator. As the process is open-ended, the spectator now engages in decision-making play.

CREATIVE PARTICIPATION

The boundaries between making art, the artifact itself, and the experience of the work are no longer clearly defined. Or, more precisely, the tendency for this to be so is evident. There are still in this transitional period many artists who contrive to force the new sensibility into old moulds, just as in technology there are many industrialists who attempt to squeeze cybernation into a nineteenth-century structure of operations.

The participational, inclusive form of art has as its basic principle "feedback," and it is this loop that makes an integral whole of the triad artist/artwork/observer. For art to switch its role from the private, exclusive arena of a rarefied elite to the public, open field of general consciousness, the artist has had to create more flexible structures and images, offering a greater variety of readings than were formerly needed in art. This situation, in which the artwork exists in a perpetual state of transition, where the effort to establish a final resolution must come from the observer, may be seen in the context of games. One can say that in the past the artist played to win and so set the conditions that he always dominated the play. The spectator was positioned to lose, in the sense that his moves were predetermined and he could form no strategy of his own. Nowadays, art is moving towards a situation in which the game is never won, but remains perpetually in a state of play. While the general context of the art experience is set by the artist, its evolution in any specific sense is unpredictable and dependent on the total involvement of the spectator.

Where once the function of art was to create an equilibrium, establish a harmony on the public level of relatively passive reception, art is now a more strident agent of change, jolting the whole human organism, a catalyst that sets up patterns of behaviour, of thought, and of emotion that are unpredictable in any fine sense. The paintings of Nicolas Poussin, for example, wish to fix a set of relationships in the spectator's consciousness, to reinforce these absolutes by the stability of the formal composition; he communicates, but by a one-way channel. The modern artist, on the other hand, is primarily motivated to initiate a *dialogue*, to set feelings and ideas in motion, to enrich the artistic experience with feedback from the spectator's response.

This cybernetic process of retroaction generates a constant stream of new and unfamiliar relationships, associative links, and concepts. Each artwork becomes a sort of behavioural Tarot pack, presenting coordinates that can be endlessly reshuffled by the spectator, always to produce meaning. This is achieved principally in one of two ways: either the artifact has a definitive form, but contains only a small amount of low-definition information; or its physical structure is such that its individual constituent parts can change their relationships, either by the direct manipulation of the spectator, by his shifting viewpoint, or by the agency of electrical or other natural power. The active involvement of the spectator can be thought of as removing uncertainty about a set of possibilities. Deep involvement and interplay produces information. The "set" of the artwork has variety only in so far as the observer participates. The variety of the set is a measure of the uncertainty involved. An important characteristic of modern art, then, is that it offers a high degree of uncertainty and permits a great intensity of participation.

As to the artist's role, it can be said to function on two levels simultaneously, the private and the social. In the first case, the primacy of a total behavioural involvement in the activity or *process* of making art is apparent. The artist is not goal-directed in the sense of working towards a predetermined art object. The artifact is essentially the result of his creative behaviour, rather than the reason for it. The growth of a painting or sculpture or environment is of more importance than the achievement of its final form. Indeed, unlike classical art, there is no point at which it can be said to have reached a final form. From the social point of view, the artist's behaviour is a ritual in which he acts out the role of the free man controlling his world by taking endless risks as he plunges into the unknown territories of form and idea. It is a paradigm of a condition to which the human being constantly aspires, where freedom and responsibility combine to reduce our anxiety about the unknown and unpredictable, while enlarging our experience of the unfamiliar and irresistible.

At this early stage of a radically new culture, the artist is doing little more than explore his new relationship to the spectator. He is searching for new ways of handling ideas, for more flexible and adaptive structures to contain them; he is attempting to generate new carrier-waves for the modulations of contemporary experience; and he is searching the resources of technology to expand his repertoire of skills. His concern is to affirm that dialogue is possible—that is the content and the message of art now; and that is why, seen from the deterministic point of view, art may seem devoid of content and the artist to have nothing to say. The modern means of communication, of feedback and viable

interplay—these are the content of art. The artist's message is that the extension of creative behaviour into everyday experience is possible.

The message is timely and apposite at a period in which one can anticipate the reduction of labour to a minimum and expect the creative use of leisure time to be the main preoccupation of people's lives. And even if the artist were to have fully explored the new channels of communication and thoroughly exploited the media and techniques of modern technology, it is unlikely that his attitude would change. He would continue to avoid the limitations of an aesthetic geared to the transmission of finite messages or the formulation of fixed attitudes and absolute values. He will continue, instead, to provide a *matrix* for ideas and feelings from which the participants in his work may construct for themselves new experiences and unfamiliar patterns of behaviour.

The Deterministic Vision and the Transition to the Modern Era

The deterministic vision in painting and sculpture was based upon an interest in human beings and things seen as discrete entities, subject to the immutable laws of a Newtonian universe residing in a Euclidean space of constant and measurable dimensions, from which time had been banished. The artist projected his ideas, feelings, and fantasies in sets of absolute, fixed relationships; the completeness of his compositions indicated his intolerance of the ambiguity of uncertainty in the message that they embodied or were expected to transmit. Each work was absolute unto itself: a universe of visual discourse bounded in painting by a framework of perspective, and in sculpture by the demands of an immediate realism. The insistence on perspective as a screen through which to view the world so dominated the painting of five centuries that even nowadays there is a popular belief that this is really the way we see the world. It was more than a stylistic convention: the mandatory use of a vanishing point and the constant gradations of aerial perspective implied a rigidly mechanistic belief in the essential predictability of a causal universe. This deep-freeze vision, with its resultant sets of static relationships, required little more of the spectator than that he should step into the artist's shoes and observe, more or less passively, his exclusive view of the world. This meant, in effect, adopting the artist's identity and, although it might lead to the re-enactment of the artist's original imaginative activity, it nonetheless implied a basically restricted and confined field of operation. This is not to say that this restricted field did not produce art that was deeply satisfying and illuminating to its public, because we know the contrary to be the case; but it was a vision restricted by the deterministic thought of its time.

THE TRANSITION

The perception of our own times is more inclusive and panoptic; the simultaneity of events and their endless changeability have called for a depth of field that zooms from the microscopic to the macroscopic. It is a perception as much tactile as visual; indeed, it engages all the senses in a way we can best describe as behavioural. The transition from the old sensibility to the new reflects the impact of indeterminism on science, of the analytic method on psychology and of phenomenology on philosophy (Philip Mairet), and is seen to evolve slowly from the middle of the nineteenth century, becoming more apparent in the early years of the twentieth.

A comprehensive documentation of the seeds of modern art goes far beyond the scope of this essay; it would call for the breakdown of an intricate mosaic field of events embracing symbolist poetry, Wagnerian opera, Bergsonian philosophy, the introduction of still and ciné photography, and political and economic factors, no less than developments in painting itself, such as the techniques of Manet, Pissarro, or Monet, the theory of Seurat, and the examples of Van Gogh and Gauguin. It will be sufficient however to focus now on the achievement of one individual, the painting of Paul Cézanne.

THE EXPRESSION OF CHANGE

The emergence of the new sensibility was signalled by an awakening of the sense of time and of the event, which are measured visually in terms of movement. But physical movement, especially in the mechanistic ways that Degas or Seurat chose to depict it, is simply the superficial expression of change, "the incessant movement of life, the always present, changing, becoming now" (Bergson 1911). It is the intuitive and forceful expression of change that marks Cézanne's oeuvre as the decisive influence in the course of modern painting. His work is pivotal both to the pictorial art of the past and to the more behavioural forms of the present.

Whereas the world of Renaissance-based art could only be viewed at a distance, through a window let into the wall, as it were, Cézanne's paintings seem to derive from a process of building up from the canvas, out into the space we inhabit, in an implicitly organic way. For the spectator, his work hints at the possibility of a shift from the predominantly contemplative relationship to an artwork to a more active involvement in its evolution. His late paintings (1892–1906), and in particular the watercolours, are visual expressions of pure change. Their subtle spatial compositions are elastic; they constitute a supple-

ness of construction that, by its very imprecision, is full of possibilities of rhythmic passages. Instead of presenting a final, fixed equilibrium, a rigid construction, these later works are as if not yet come to rest. The spectator becomes involved, he can construct a final equilibrium for the composition out of a variety of possibilities of relationship. "Ce que le peintre suggère, le tableau le dit, le spectateur achève. Mais cet achèvement offre une multitude de possibilités dont chacune n'est valable que pour un instant," Liliane Brion-Guerry observes.[1]

In the last phase of his work, human figures, trees, clouds, and bushes are indistinguishable from one another, caught up in a flux of colour. This "tendency to break up volumes, to arrive almost at a refusal to accept the unity of each object, to allow planes to move freely in space" (Fry [1927] 1952) is the essence of Cézanne's expression of the new easel painting, of Cézanne's intention: "Je voudrais peindre l'espace et le temps pour qu'ils deviennent les formes de la sensibilité des couleurs."[2]

The way was prepared for the modern artist to deal with human experience in the space-time continuum; to describe the dimensions of change and the parameters of events; and to create images of the changing identity of objects through the perception of their behaviour. In this, the artist was no longer a passive observer. Rather than view his motif from a fixed point of view, he began to move around it or through it, or to set it in motion. Here was the fundamental and radical change of interest in art: a concern not with what things *are*, in some absolute sense, but with what they *do*, how they behave, and what they have done to them. This behavioural interest could only find expression in an unstable and uncertain visual structure that invited the participative behaviour of the spectator to resolve the equilibrium.

This concern with the behaviour of the observed world, with events, movement, and change, was synthesised into distinct forms by the two principal art movements of the beginning of this century, namely, cubism and futurism. It is a concern that constitutes one aspect of the behavioural tendency of modern art, which we shall now examine more closely.

Six Aspects of the Behavioural Tendency in Modern Art

In order to establish a provisional framework in which to examine modern art, I shall propose six coordinates or aspects of the underlying behavioural tendency. They are arbitrary in the sense that art can never be categorised in any fine sense, but they may be useful to indicate the main issues involved. There are as many categories as there are artists, but nevertheless certain general attitudes and cur-

rents of thought can be distinguished, and grouping them into a tentative frame-work may provide us with a tool to understand the directions in which modern art is flowing. Inevitably, the citing of specific examples of artists and work must be unsatisfactory, in the sense that no artist is tied down to one category, nor can one category, in fact, be established as rigidly separate from any other. Inevitably, too, many important artists must be omitted, and I limit myself here to those who most clearly and unambiguously illustrate the general ideas involved. The mosaic of modern art will be observed, then, from six points of view, six aspects of the behavioural tendency. Art as:

a behavioural analogue;

a behavioural trigger;

a behavioural environment;

a behavioural structure;

a behavioural ritual;

a total behavioural synthesis.

THE BEHAVIOURAL ANALOGUE

A central quality of the work of the cubist and futurist painters is a sense of involvement in some behavioural situation. These artists were interested in visual phenomena of a kind familiar to traditional art, such as still life objects, the human figure, and the furniture of urban life (buildings, vehicles), but in a behavioural context. On their canvases, Picasso and Braque reconstructed the space-time experience of a still life group; of moving around it, of viewing innumerable facets, even, in a sense, of penetrating its mass. Similarly, the Italian futurists were concerned to make analogues of the dynamism of the city, of machines and living organisms. Giacomo Balla's painting *Dog on a Leash* (1919), for all that it resorts rather naively to the use of a quasi-stroboscopic notation, is significant in its attempt to express a *process* (canine locomotion) rather than the discrete *object* (the dog). The event replaces the fact.

The quasi-stroboscopic technique to discuss a behavioural situation was successfully used by Marcel Duchamp in the painting *Nude Descending a Staircase, No 2* (1912). Richard Hamilton suggests that Duchamp had investigated E.-J. Marey's scientific research, which used the superimposed exposures of stages of movement on the photographic plate. Earlier, in 1911, Duchamp demonstrated his interest in the behaviour of a machine *(Coffee Mill)*. Kasimir Malevich's painting *Knife Grinder* (1912) is another early example of a behavioural analogue of

the man/machine interaction. But it is in Duchamp's *Large Glass, The Bride Stripped Bare by Her Bachelors, Even* (1915–23) that the behavioural analogue aspires to a monumental form—the result of considerable preparatory research (notes, diagrams, and studies, later collected and published as *The Green Box* [1934]).

Paul Klee's notebooks reveal a dedicated and extensive enquiry into processes of growth and movement, not only in natural events but in the construction of a painting. He "takes a line for a walk" or, through the interaction of cellular colour units, creates an analogue of the process of blooming, *Blooming* (1934). Another aspect of the study of natural behaviour is found in the sculpture of Brancusi. His monumental forms, such as *Cock* (1924), *Bird* (1925), and *Fish* (1927), distilled from a search for greater purity and simplicity of expression, bear little resemblance to their natural structure, but are a poetic synthesis of the behavioural qualities that characterise each.

These brief examples illustrate one thread in the modern movement, the analogical restructuring of a behavioural situation that the artist has observed, which he has already experienced. Now we turn to another major aspect, where the artist is concerned not with past events but with the possibility of creating new behavioural situations through the agency of the artifact.

THE BEHAVIOURAL TRIGGER

Every artwork draws some response from the observer. But where a central and explicit concern of the artist is to spark off an event, to elicit a series of responses in his public, his work may be described as a behavioural trigger. It may be effective on one or a number of biological or social levels of response.

On the other hand, there is the artifact, which makes certain physical demands on the spectator; on the other, there is the art object, which triggers a polemical response, a reconstruction or questioning of attitudes and values, which is intended to result ultimately in changes in the observer's social or intimate behaviour.

Physical Response

Optical: a high intensity of retinal activity induced by visual stimuli creating flicker, after-images, spatial ambiguity and illusion, and uncertainty of figure-ground relationships, such as in the work of Victor Vasarely and Bridget Riley or the earlier "precision optics" of Duchamp (*Rotary Demisphere* [1925], etc.).

Manual: the nature of the art structure (usually a wall relief) is such that the spectator is induced to alter the position of its parts manually into new sets of

relationships, as, for example, in the "transformables" of Yaacov Agam, Bruno Munari, and the boxes of Karl Gerstner.

Postural: without becoming free-standing environmental sculpture, the artifact solicits a postural change or shifting position of the observer, as a result of which images merge and transform, visual vibrations are set up, or changing relationships of fixed forms in relief are experienced, as, for example, in the relief objects of the constructivist and Nouvelle Tendance groups; and of Agam, Jesus Rafael Soto, Victor Pasmore, and Anthony Hill.

Polemic and the Social Response

The work of the dadaist and surrealist painters and poets was essentially polemical. The form of the art object was conditioned almost entirely by its required effects—that is, the displacement of concepts, the revision of values, the destruction of inhibitive preconceptions, the creation of psychological frisson, or simply a general need to "épater le bourgeois." The technique was to induce change in individual or group behaviour through the shock of the unfamiliar, absurd, horrifying, or obscene qualities in their imagery. The process was to destroy and to question—a tradition continued in the present work of Jasper Johns, for example, and the "soft sculpture" of Claes Oldenburg.

On the other hand, while still working within the context of change in social and personal behaviour, there is a line of development concerned with the more sober, dialectical construction of form represented by Vladimir Tatlin, Naum Gabo, Piet Mondrian, Théo van Doesburg, and in the didactic programmes of the Bauhaus.

THE BEHAVIOURAL ENVIRONMENT

There is another strong current in modern art, which deals with human behaviour on what might be called the environmental level; it functions to increase or alter one's awareness of the environment—either by means of an object, painting, or sculpture, or by the construction of a totally artificial container or arena within which the observer can react.

Painting

Influential examples are found in the work of Mark Rothko, Barnett Newman, Clyfford Still, and Kenneth Noland. The nonassociative and parsimonious, or "cool," quality of their painting, coupled with an outfacing, largeness of scale, and often of size, forces the observer to readjust his relationship to a canvas and

his response to the environment that contains them. By means of the interaction of large areas of pure colour (vide Matisse), the surrounding environmental space is reactivated; rhythms set up in the painting extend as ripples into the actual space beyond.

Sculpture

From early experiments in open form (i.e., planar, spatial volume) of the Obmokhu exhibition (1920), of Antoine Pevsner and Naum Gabo, through the Groupe Espace of the 1950s, to the present decade, sculpture has moved away from the pedestal to become free-standing in space, calling for a more total, environmental level of response in the observer—to walk round it, through it, to touch it, bang it, sound it. David Smith (1906–65) brought into effective use the coloured plane and the reflective surface; the one affecting its environment, the other responding to changes of light and colour in it. Examples of the further development of a behaviour-oriented sculpture can be seen in the work of Brian Wall and Anthony Caro.

Environment

A range of experiments in a total artificial environment stretches from the *Merzbau* of Kurt Schwitters to the New Babylon of Constant Nieuwenhuys; from the room to the world. Within this spectrum, there is a wide variety of projects, such as the Groupe de Recherche d'Art Visuel's *Labyrinth*, with its unwritten instruction "Handle and Cooperate!" Victor Pasmore's *Exhibit*, a maze of transparent, reflective, and opaque plastic panels; the colour-shaped *Environment* of Maurice Agis; and the "Fun House," Chicago. Unlike painting and sculpture, most environmental experiments rarely come to the public's notice; there is, however, a great deal of research in this field at present in many parts of the world. Joan Littlewood's "Fun Palace Project," which is still at the design stage, has a team of biologists, mathematicians, sociologists, and artists, led by Dr. Gordon Pask and the architect Cedric Price, working on plans for a highly diversified behavioural environment to answer the urban need for fun and edifying diversions.

All the examples cited in this section in some good sense lean towards architecture, which is, of course, the art of behavioural environments par excellence.

THE BEHAVIOURAL STRUCTURE

By this term, I literally mean "structures that behave," that is, art forms that articulate their parts in response to the promptings of their internal or external

environments. This type of work is generally grouped under the term "kinetic art," which also includes certain tendencies we have already considered as behavioural triggers of the optical, manual, and postural kind.

Internally Controlled Structures

On one hand, there are the articulated sculptures of Nicolas Schöffer; the spatiodynamic "Chronos" series, and the sound-equipped luminodynamic *Tower* at Liège. The behavioural quality of some of Schöffer's structures constitutes a "spectacle" in the sense of theatre, and they physically interact with human dancers (e.g., *CYSP I* [1956]), the variable patterns of movement being cybernetically controlled. More subtle and limited behaviour is displayed by the reliefs of Pol Bury, the formal elements of which punctuate space and time with slow, relentless rhythms. The tele-magnetic sculpture of Takis employs other means to achieve a shifting structure.

Internal control may lead, on the other hand, to the behaviour of light on a two-dimensional screen, projected out towards the observer. Frank Malina, Gregorio Vardanega, and John Healey, for example, work with internally lit structures. Stephen Willats experiments with subliminal techniques to reinforce the observers' responses.

László Moholy-Nagy pioneered the field of light and movement, as, for example, in *Licht-requisit* (*Light-Space Modulator* [1922–30]). He also expressed the goal of those who researched the projection of coloured forms into space and onto surfaces (e.g., the colour organs of Thomas Wilfred, Wallace Rimington, and Adrian Klein) when he wrote of "systems of powerful light generators, enabling the artist to flood the air—vast halls, or reflective walls of unusual substances, with brilliant multicoloured light visions in motion" (Moholy-Nagy 1934).

Externally Controlled Structures

I have referred to those artworks that depend upon manual intervention.

The mobile is a suspended structure whose patterns of behaviour depend upon the impact of air currents on the fins and vanes of its parts. Alexander Calder devoted himself to this kind of behavioural structure, "chaque élément pouvant bouger, remuer, osciller, aller et venir dans ses relations avec les autres éléments de son univers."[3] Earlier objects of this kind were made by Man Ray, such as *Object of Obstruction* (1920). The "screw" mobiles and "link" and "reflector" mobiles of Kenneth Martin have added further dimensions to the field.

P. K. Hoenich experiments with direct sunlight and wind-driven motors as media and power for his "Robot" art forms. The behaviour of the natural elements shapes the behaviour of the artifact. Another possibility for the behavioural structure is a built-in ability to grow (see below) or to destroy itself. Jean Tinguely favours a dramatic and relatively rapid disintegration, accelerated by wild and random behaviour of the parts (*Hommage à New York*, 1960); while Gustav Metzger adopts a more dialectical stance.

THE BEHAVIOURAL RITUAL

Action

The term "action painting" should be self-explanatory. It refers to an approach to art in which the *act of making* is all important; the canvas being the arena within which the artist creates. The act of painting thus becomes ritualised, and the high priest of this ritual was Jackson Pollock. The consistency of his approach has been identified by Lawrence Gowing with "the natural graphic consistency of America . . . the new, unknown consistency of human behaviour let loose in an immense and empty space." Pollock has come to symbolise the artist totally liberated from the constraints of traditional technique, free to explore the extremes of creative behaviour.

Chance

The surrealists claimed a degree of freedom in technique with their utilisation of chance effects and events—images and words found at random and arranged automatically according to the laws of chance could constitute works of art. Jean Arp's experiments with chance forms in collage and wood relief contribute to a sense of the ritualisation of random artistic behaviour, for example, *Selon les lois du hasard* (1916).

Choice

The idea of *l'objet trouvé* and the "ready-made" are related to the area of chance, but the latter is charged with more significance than that of a mere *acte gratuit*, or gratuitous act. The ready-made concept, originated by Duchamp in 1916, provides for an art that dispenses with the artist's active intervention in its "making." It is essentially dependent upon the act of choosing and nominating a ready-made object as "art." The act of choosing becomes ritualised in Duchamp's stance, to the extent that finally it becomes almost everything.

Event

Once the action, the event, the process becomes as important or more important than the resultant artifact, there will be inevitably a tendency for some artists to treat the "happening" as an art work in its own right. People interacting freely in groups, producing unfamiliar situations, motivated and directed only from within the assembly, can become art. Or, by extension, the very choice of some unpremeditated event as "art" endows an individual with a ritualised sense of creativity, as, for example, in the happenings initiated by Wolf Vostell, John Latham, Oldenburg, Andy Warhol, John Cage, and the Japanese group Gutai.

THE BEHAVIOURAL SYNTHESIS

As the behavioural tendency increases in art, so the boundaries between its fragmented and specialised areas become less distinct (i.e., between painting, sculpture, literature, dance, music, theatre, and so on). There is no reason to suppose that a behavioural synthesis will mean that these boundaries will cease to exist altogether, in the sense that every artist will employ all these modes together, all the time; the demands of specific skills and imaginative focus alone, quite apart from genetic or conditioned preferences, will mean there must always be a tendency towards one area or another. But I am concerned to emphasise the probability of a greater degree of interplay between these areas, in such a way that the ratio of sensory modalities in our perception leads to a more inclusive experience, and so that our engagement with art is of a more integrally behavioural kind.

I have tried to show that the modern tendency in art is such as to reinforce the following factors:

(a) the deep participative involvement of the spectator in an open-ended situation;

(b) the primacy of process and event in the artist's work, rather than object and fact;

(c) the extensive exploration of media for more flexible structures and more inclusive forms;

(d) a polemical concern to ask questions, to find problems rather than provide absolute answers;

(e) the organic interaction of random and ordered elements in the creative act.

To some extent, these factors apply to all the arts now, in some good sense, and although this essay is centred on painting and sculpture and their behavioural

extensions, we should glance briefly at related experiments in music, literature, and other fields.

Music

I shall limit my description of the behavioural tendency in this field to John Cage's contribution, which is marked by extensive and varied experiment. This may be indicated best by quoting directly from his "musical scores" and from conversations he has [had] with Roger Reynolds [Reynolds 1962]:

> If music is conceived as an *object*, then it has a beginning, middle and an end, and one can feel rather confident when he makes measurements of time. But when it (music) is *process*, those measurements become less meaningful, and the process itself, involving if it happens to, the idea of Zero Time (that is to say no time at all), becomes mysterious and therefore eminently useful.
>
> . . . finally that process has to be seen as subjective to each individual.
>
> . . . We must arrange our music . . . so that people realise that they themselves are doing it, and not that something is being done to them.
>
> I use the word experimental to mean making an action the outcome of which is not foreseen.
>
> . . . the most important thing to do with electronic music now is to somehow make it theatrical . . . by introducing live performance elements. That is to say, people actually doing things . . . [and] the actual, visual manipulation of the machines, to begin with; the distinct giving to the audience of the impression that something is happening then which is unique to that particular experience.

COMPOSITIONS

Water Music (1952), 6 minutes

For a pianist, using also radio, whistles, water container, deck of cards; score to be mounted as a larger poster.

The composing means were chance operations derived from the I-Ching.

The notations are in space equal to time, the musician using a stopwatch in performance.

Music for Amplified Toy Pianos (1960)

This is a composition indeterminate of its performance. There are eight sheets of transparent material. Two have points that refer to the key or rods of the pianos. Two have circles that refer to the piano amplification. Two have points

within circles that refer to noise. A graph read vertically refers to the pianos (any number), read horizontally refers to time, regular or irregular. All sheets are superimposed in any way for a single reading. Any number of readings may be taken for a given performance.

Cage's use of unorthodox sound sources and the creation of totally unfamiliar musical structures have caused the composer to invent new forms of composition and notation. They have an emphatically visual/tactile quality, often on sets of interchangeable sheets, some transparent, which call for an intensive participation from the performer in the composition of the form of the work. To the audience, in many compositions, involvement in the behaviour of performers and the musical "machines" is as necessary as the reception of the sound.

Literature

Experiments with the form of poetry and the written word generally in relation to an open structure and closer reader participation have accompanied a number of movements in painting, such as the cubists, surrealists, futurists, dadaists, the Bauhaus, and so on. They led to a more tactile and dynamic use of typography, a more creative deployment of information, forming a bridge between poetry and painting.

Retroaction, in the form of reader response, can be found on the level of syntax and narrative, in the work of James Joyce and William Burroughs, for example. On one hand, as in [Joyce's] *Ulysses*, there is the use of the complex, multilevel pun and the semantic that combine to induce a vigorous involvement in the reader, such that each word or phrase must be approached from all angles in order to shake out the last drop of meaning. Layers of association and reference endlessly unfold as long as this active participation is continued. Participation produces information. On the other hand, as in [Burroughs's] *The Naked Lunch*, the superimposition of data equates with the simultaneity of events, in which relationships shift in and out of focus and the sequence of events is random. Any resolution of the indeterminacy and uncertainty of the narrative line must come from decisions made by the reader. Similarly in film, Jean-Luc Goddard, for example, uses rapid jump-cuts, sudden frozen frames, blurred images, and random sequences.

Electric Media

In *The Gutenberg Galaxy* [1962], Marshall McLuhan argues that in a purely literary culture, mechanical type and the printed word led to a fragmented soci-

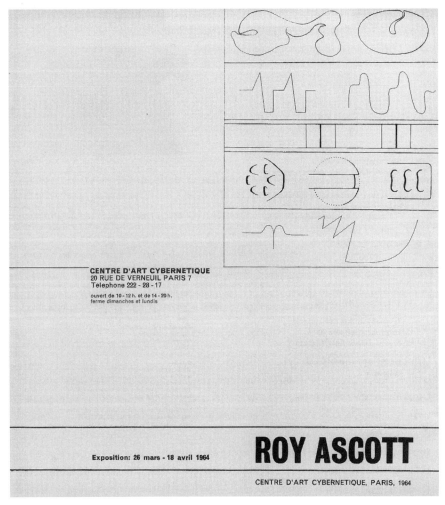

Figure 25. Leaflet from Ascott's exhibition at the Centre d'Art Cybernétique, Paris, 1964.

ety: a linear, deterministic culture. He claims, moreover, that the extensive development of "electric media," of instant and simultaneous communication (TV and electric extensions of the central nervous system) produces a "global village" of social interdependence and deep involvement.

Experiment and development in the arts generally, and particularly in painting and sculpture, are of a kind that suggests that a behavioural synthesis is evolving. We now turn to discuss how this tendency may relate to the cybernated so-

ciety that is rapidly forming, and to define what is meant by the cybernetic vision in art.

[The first part of this essay concludes here in the journal *Cybernetica*, volume 9 (1966). The second part of the essay resumes in volume 10 (1967).—Ed.]

■ THE CYBERNETIC VISION IN ART

By this term, I neither mean "the art of cybernetics" nor refer to an art concerned to illustrate cybernetics, nor yet an art embodying cybernetic machines or robot art—although any one of these things might be involved at some point, or, again, might not.

I am referring to the spirit of cybernetics, which may inform art and in turn be enriched by it. I contrast the cybernetic vision in art to the deterministic vision of the past, which has already been outlined. I say of cybernetics that, before it is a method or an applied science, it is a field of knowledge that shapes our philosophy, influences our behaviour, and extends our thought.

We are moving towards a fully cybernated society (see Diebold, George, etc.), where processes of retroaction, instant communication, and autonomic flexibility will inform every aspect of our environment. In that forming society, of which we are a part, the cybernetic spirit finds its expression in the human sciences and in environmental technology, the two poles between which we act out our existence. It is the spirit of our understanding of life at its simplest and most complex levels and a large measure of our ability to control it.

The economic and social effects of automation in the cybernated society will be profound. The effects of our transition to that future state are already being felt, particularly in the United States. Matters of leisure, class formation, and political and economic power have already called for revision and new thinking. Cybernetics already dominates our more advanced concepts of transport, shelter, storage, and other day-to-day matters of control and communication and has caused the radical transformation of many industrial and commercial procedures. The effect of the computer on human thought is currently the subject of vigorous discussion in academic circles; the man/computer relationship is seen to be as much a question of identity as of methodology.

Fundamentally, cybernetics concerns the idea of the perfectibility of systems; it is concerned in practice with the procurement of effective action by means of self-organising systems. It recognises the idea of the perfectibility of man, of the possibility of further evolution in the biological and social sphere. In this,

it shares its optimism with molecular biology. Bio-cybernetics, the simulation of living processes, genetic manipulation, the behavioural sciences, and automatic environments together constitute an understanding of the human being that calls for and will in time produce new human values and a new morality.

How does the artist stand in relation to these radical changes? On the level of opinions or concepts, he is and will be free to accept or reject them. But on the level of deep human experience, they will "alter sense ratios or patterns of perception steadily and without resistance," as Marshall McLuhan observed in *Understanding Media* (1964). The artist is faced with two possibilities; either to be carried along in the stream of events, mindlessly, half-aware, and perhaps bitter and hostile as a result; or he can come to terms with his world, shape it and develop it by understanding its underlying cybernetic characteristics. Awareness of these underlying forces will sharpen his perception; the utilisation of new techniques will enlarge his powers of thought and creative action; he will be empowered to construct a vision in art that will enhance the cybernated society as much as it will be enriched by it. Understanding and awareness, in short, are the conditions for optimism in art.

There is reason to suppose that a unity of art, science and human values is possible; there is no doubt that it is desirable. More specifically, I propose that an essentially *cybernetic* vision could unify and feed such culture. The grounds for supposing that art has anticipated this integral situation and is prepared for it can be found in the emphatically *behavioural* tendency that it displays. Cybernetics is consistent with behaviourist art; it can assist in its evolution, just as, in turn, a behavioural synthesis can embody a cybernetic vision.

Cybernetics and Behaviourist Art

It is necessary to differentiate between *l'esprit cybernétique*, as I have tried to describe it above, and cybernetics as a descriptive method. Now, art, like any process or system, can be examined from the cybernetic point of view; it can also derive technical and theoretical support from this science—as in the past it has done from optics or geometry. This is not unimportant, since the artist's range can be extended considerably, as discussed below, in relation to the Cybernetic Art Matrix (CAM). But it is important to remember that the cybernetic vision in art, which will unify art with a cybernated society, is a matter of "stance," a fundamental attitude to events and human relationships, before it is in any sense a technical or procedural matter.

Behaviourist art constitutes, as we have seen, a retroactive process of human involvement, in which the artifact functions as both matrix and catalyst. As matrix, it is the substance between two sets of behaviours; it exists neither for itself nor by itself. As a catalyst, it triggers changes in the spectator's total behaviour. Its structure must be adaptive, implicitly or physically, to accommodate the spectator's responses, in order that the creative evolution of form and idea may take place. The basic principle is *feedback*. The artifact/observer system furnishes its own controlling energy: a function of an output variable (observer's response) is to act as an input variable, which introduces more variety into the system and leads to more variety in the output (observer's experience). This rich interplay derives from what is a self-organising system in which there are two controlling factors: one, the spectator is a self-organising subsystem; the other, the artwork is not usually at present homeostatic.

There is no prior reason why the artifact should not be a self-organising system, an organism, as it were, which derives its initial programme or code from the artist's creative activity and then evolves its specific artistic identity and function in response to the environments it encounters. The artist's creative activity is also dependent on feedback; the changes that he effects in his immediate environment (or "arena") by means of tools and media set up configurations that feed back to affect his subsequent decisions and actions. Modern art, with its fundamental behavioural quality, is thus the art of the *organisation of effects*. And when all the control factors, including the artwork itself, are effectively homeostatic, art will be concerned with the automatic control of effects. Cybernetics, of course, is the science of the organisation of effects, and of the automatic control of effects, as Pierre de Latil has noted.

Equally, there is no a priori reason why the artwork *should* become a self-organising system; the basic feedback process of behaviourist art operates within the conventions of painting and sculpture, provided that they display low definition, multiple associations, and indeterminate content, within parameters that are, at least implicitly, flexible. And, as I have already suggested, this is nowadays the case—even to the extent of providing a more or less empty receptacle (the canvas) into which the spectator can project his own imaginative world (e.g., as in the artwork of Yves Klein, Ad Reinhard).

The Computer and Growth Systems

However, historically it has been a characteristic of the artist to reach out to the tools and materials that the technology of his time produces, just as his per-

ception and patterns of thought have tended to identify with scientific and philosophical attitudes of the period. If the cybernetic spirit constitutes the predominant *attitude* of the modern era, the computer is the supreme *tool* that its technology has produced. Used in conjunction with synthetic materials, it can be expected to open up paths of radical change and invention in art. For it is not simply a physical tool in the sense that an aluminium casting plant or CO_2 welding gear are tools—that is, extensions of physical power. It is a tool for the mind, an instrument for the magnification of thought, potentially an "intelligence amplifier," to use H. Ross Ashby's term. The interaction of man and computer in some creative endeavour, involving the heightening of imaginative thought, is to be expected. Moreover, the interaction of artifact and computer in the context of the behavioural structure is equally foreseeable.

Experiments are already taking place. I have cited Schöffer's use of a computer in some of his structures. In music, Iannis Xenakis has made extensive use of an IBM 7090—a process in which he "specifies the duration and density of sound events, leaving the parameters of pitch, velocity and dynamics to the computer" [Xenakis 1963]. The "Light-Harp" project of Arnold Haukeland and Arne Nordheim, an environmental sculpture emitting sound in relation to the quality of local light, with sound sources changing position within the structure, calls for a highly sophisticated control and communications system within it.

The computer may be linked to an artwork, and the artwork may in some sense *be* a computer. The necessary conditions of behaviourist art are that the spectator is involved and that the artwork in some way *behaves*. Now, it seems likely that in the artist's attempt to create structures that are probabilistic, the artifact may result from biological modelling. In short, it may be developed with the properties of growth. Cybernetics already furnishes models that could assist in this development, such as Stafford Beer's fungoid systems and research into chemical and chemical-colloidal computers. F. H. George concurs that the potential for the future is enormous.

As to the amplification of human intelligence by means of computers and the possibility of artificial creative intelligence, I defer further discussion to the section dealing with the CAM/LIGA concept below.

The cybernetic vision not only shapes modern science and technology, integrating and bridging disparate fields of knowledge and improving artificial control and communication systems by the understanding of complex natural processes; it can be expected to find expression and enlargement in art as well. It can assist in the evolution of art, serving to increase its variety and vigour.

The Advancement of Creativity and Its Inhibition

The first part of this essay has been diagnostic of the recent past in order to come to some understanding of the present, since it is from the present that we can view the future. I am not concerned to predict what art will be—only the practice of art, the interplay of creative minds will determine what art will be. But I am concerned to construct certain proposals for the advancement of creativity, having determined the necessary conditions and directions within which art is likely to flourish. There is historical evidence to show that the perpetual vitality of art cannot be taken for granted. Social practices, economic factors, and political regimes can and do inhibit creative evolution in art.

My diagnosis of modern art has purposely omitted inhibitive factors that, nonetheless, are currently active. Compared to the apparent energy and diversity of the current scene, they may seem to be scarcely worthy of attention. But they are noteworthy because their importance may grow with the advent of a fully cybernated society and, in their opposition or indifference to it, they may inhibit the realisation of an integral culture and lead to a demoralised decline of art into the decorative and decadent.

This incipient malaise finds its strength in a circular pattern of events, an endless repetition of past styles and artful recombinations of formal traits that have already served their purpose for the earlier artists who originated them. Art feeds on art, it is true, but the disease results from a preoccupation with the superficial visual style proper to cultural forms of the past and develops out of ignorance of the processes of creative thought that produced it. Art is thus in danger of becoming an endless synthesis of faded glories, a collage of old ideas. Now, no vitally personal and original development or continuity can take place under these conditions; and sensing this, the artist may use other means to give it an apparent coherence. He devises a trademark. Commercial pressures reinforce this expedient. The art trade, while it has and does support radical experiment (without which, very often, experiment would be unable to continue for some artists), in many cases tends to operate like the "rag trade"; that is, it depends for its viability on fashion. This quick turnover of novel and amusing products is a process that can only maintain the financial value of an artist by the slick promotion of his trademark.

The competitive drive of the artist in his attempt to secure some measure of financial freedom to go on working tends to force him to consider his artwork, however obliquely, as a marketable commodity—indeed, it may induce him to "finish" it and package it in the smartest Madison Avenue fashion. But, in gen-

eral, it seems that the artist is not unaware of the paradox of a constrained creativity, of an art shaped by commerce. He may acquiesce pleasurably, gratified by momentary success or by the acquisition of an instant art identity. Or his bitter frustration may lead him to cultivate an ironic pose of mindless acceptance. This acceptance and acquiescence can and does become total, and it embraces without question other products of commercial enterprise—the detritus of mass-produced uniformity in supermarkets and buildings, advertising and popular entertainment.

Now, it is certain that this bitterness will lead to pessimism and hostility to the cybernated society, a retreat to an ivory tower, if the potential of the new society is seen only as an extension of the weakness of the present transitional period. It is a common fallacy to equate an automated world with the old industrial era, holding that cybernation is merely mechanisation intensified. However, there is a difference not merely in degree but in kind, both in the processes involved and in the results for society. Cybernation will mean the most radical change in more or less every aspect of human life and experience. Socially and politically, it presages a more fluid state of control and intercourse, where, by instant communications and rapid feedback, the old rigid hierarchies of power are rendered obsolete and give way to more viable and adaptive procedures; to what might become, in short, a cybernetic-politic.[4] Another mistaken fear is of an increase in the uniformity of the environment due to mass production, but the very nature of automation is such as to facilitate the production of the unique and the custom-built at assembly-line cheapness and speed. Whereas the mechanical age led to a high degree of consumer-orientation, the cybernated society will be emphatically producer-oriented. Participation of a more direct kind in all aspects of social organisation and design, entertainment and learning, will replace mere acceptance and consumption.

But this is not easily understood by many artists, whose attitudes have been conditioned by the desperate need to be on the crest of the next wave of fashion or by a cosseted infancy in the nineteenth-century atmosphere of an art school. And the remedy is certainly not to attempt to overtly enlighten the "formed" artist in this respect—his response is likely to be one of bewilderment or boredom. And in the education of the young artist and designer, the teaching of "cybernetics" as an academic study is unlikely to be more than marginally useful. What is required, it seems, is that the early formative years of an artist's development and education should be imbued with a *cybernetic spirit*: "Il est plus exact de parler de la formation à l'esprit cybernétique que d'enseignement de la Cybernétique."[5]

At the same time, to combat the insidious complacency that attaches to the delusions of creativity of what Victor Vasarely referred to as "the false and moderate avant-guard," a platform of vigorous polemic and stringent criticism must be established. If it cannot arrive spontaneously in the course of events, and it evidently has not arisen, then it must be artificially induced. The important point is that it should exist and that it should be effective.

Ignorance of the cybernetic vision in science and society is usually accompanied by ignorance of the breadth of modern technology; however, access to that hardware is likely to be an even greater problem. A solution is to be found in pooling technical resources—that is, computers, communications services, media-handling facilities, data storage, synthetic materials processing, and so on.

These factors, demands of polemic, learning, and technological centralisation, call for some kind of practical framework that, linked to other requirements of the cybernated society (creative leisure activity and the cultural education of the young), lead to the proposal for a Cybernetic Art Matrix, the provisional description of which occupies the second part of this essay.

▬ THE CYBERNETIC ART MATRIX

Three principle functions are required of any framework designed to assist in the advancement of creativity in our forming cybernated society. The Cybernetic Art Matrix (CAM) is designed as a framework concerned with:

(a) servicing the needs of professionally committed artists;

(b) providing amenities for creative play for the new leisured class;

(c) formulating pragmatically a process of "art" education for the young.

(a) I have already indicated very broadly what the needs of the highly committed artist are likely to be: instant access to new ideas in all fields, a platform for polemic, and extensive technical facilities were instanced.

(b) The new leisured class, with its subclasses, can be expected to swell in numbers as automation becomes more totally applied to society's productive activities. The main body of this class will comprise workers, employed in industry, commerce, and other services on a part-time rotational basis, doing about three five-hour days' of work per week in the short term, and probably even less at a later stage, as W. Gordon has suggested. The opportunity for "creative play" will consequently be considerable, although the *demand* for it may not be very noticeable initially. We can expect a continuance at first of the present trend to-

wards "recreational buying"—the consumption of goods for the activity and pleasure of buying—and the use of established commercial forms of entertainment. But there will be a growing need for amenities that provide for social and intimate participation in creative activities of new and stimulating kinds.

(c) For the young, a more integral, inclusive, "behavioural" process of education is required. Existing forms of art education are often either incarcerated in highly deterministic modes of operation or else fragmented into an uncoordinated "liberal" sprawl. In general education, art is usually treated as a fringe activity, involving more play than thought, and strictly marginal to the academic learning modes of numeracy and literacy; but a third branch of the general learning programme might be developed, involving the "behavioural" mode.

The interaction within one framework of these three variables—artists, new leisured class, and students—could only be rewarding to each of them. The unique experience, knowledge, and skills of each individual would feed in to enrich the general awareness and variety of the whole organism. CAM would need to be a self-organising system, a highly retroactive organism. Further necessary input would come from scientists, as well as a constant stream of information, via communication satellites, from the world at large.

It would be absurd to think of such an organism as a socially isolated entity, conscious only of itself and its own internal state (although that consciousness would be of a high order). The feedback between the energetic core of creative activity and its environment would constitute an effective mechanism of social control, responsible for the formulation of human values and for the design of new facets of the urban scene. And it may not be too far fetched to imagine a network of CAMs so deployed that they would constitute the creative element in a "world brain."

CAM: General Characteristics

The framework so far described is that of a matrix within which creative behaviour is generated and developed in the spirit of the cybernetic age—in short, a Cybernetic Art Matrix. The polarity of the CAM that I shall describe is visual/tactile, or "behavioural," in the sense that I have given the term, and its identity is consistent with the evolution of modern art, especially of painting and sculpture and their extensions. References to music, film, literature, or dance, for example, will thus not be frequent (which is not to say that they will not in some good sense be included). Other CAMs with other polarities could be envisaged, and no doubt, at some future time, a fully comprehensive CAM-like

structure might evolve. Certainly, some kind of integral unit such as I shall discuss will be formed, perhaps spontaneously and biologically, as it were, to counterbalance the forces of science and industry in a future society. But the immediate necessity for at least an embryonic CAM-network is forcefully apparent. At the same time, its design should be provisional and general, rather than absolute and specific. The purpose of my proposals for CAM is to initiate new lines of thought and experiment; I am not concerned to present a paradigm but a catalyst to action and change.

Thus the specifics of CAM cannot be predicted, since they will be contingent upon the state of information in the system; that is, such variables as the human beings involved in its geographical location, economic strength, and so on. The changing demands for hardware and environmental amenities will call for an adaptive, flexible architectural container. But general consideration can be given in advance to those factors that may be expected to be constants in the CAM system. I shall discuss them under four general headings:

(1) Learning procedures	(CAM/L)	Education
(2) Information handling	(CAM/I)	Communications
(3) Generative processes	(CAM/G)	Development
(4) Amenities	(CAM/A)	Hardware

CAM/LIGA, elaborated as a programme, could be expected to provide an organic framework of procedures and conditions that would bring into being a Cybernetic Art Matrix. CAM/LIGA serves as a sort of genetic code for the nascent organism CAM, which, while retaining certain hereditary characteristics, will evolve its unique form in response to changes in its internal and external environments.

In this provisional description of CAM/LIGA, I shall codify the principal factors in order to reveal the formation of the structure more distinctly.

CAM/L EDUCATION

A function of CAM is the provision and development of educational processes, learning procedures, which would be available to every type of individual passing through the matrix. The first requirement of an initial specification of CAM/L is a codified description of the probable needs of individuals in order to set the initial parameters. CAM will be required to accommodate a large and varied input of people, each an individual with unique demands. These indi-

vidual demands are unpredictable in any fine sense, and the initial codification must therefore deal with broad classes of input types. By describing the general needs of each type, we arrive at a preparatory and simplified set of instructions for a rudimentary CAM/L.

Codification:

Input Types

There will be three general types of input:

T_1 The highly committed artist

T_2 A member of the new leisured class

T_3 The full-time student

Learning Net Coordinates

The three coordinates of the learning net may be classified as:

C_1 Identity

C_2 Media

C_3 Concepts

C_1 concerns matters of personal identity, of role searching/playing, and the social relationship of the individual to his environment. C_2 concerns material, physical conditions and processes, and the limitations and possibilities inherent in them. C_3 concerns the formulation of concepts and the examination of ideas.

Learning Procedures

Learning procedures will be classed as either high order (Ho) or low order (Lo). Ho involves an intensive one-to-one relationship between the individual and tutor (human or adaptive machine). Lo involves group learning and social exploration of less intensity (with or without supporting hardware).

Learning Contexts

Learning can take place within the context of creative activity, or exploratory play, or under conditions of operant conditioning. For the purpose of general education, all three factors need be present, but in certain specialised cases, one or more may be required to be intensified:

iC intensify creativity

iP intensify play

iO intensify operant conditioning

Mobility between Input Types

While the input types can be defined and a general description of their needs can be codified, it is important to remember that any individual is *free to chose to identify himself with any type* and to shift from one type to another. His general needs will change, but those of each input type remain constant (relatively). The movement between types would not be irreversible, as it tends to be in the hierarchic structure of traditional education. The "educational ladder" becomes the "educational switch-back" within the CAM learning net. Thus, an individual's first passage through CAM may be as T_2; he might then decide upon a period of intensive learning as T_3, or perhaps commit himself to intensive work as T_1. Similarly, T_1 might want to relax in CAM as T_2, or T_3 might want to act out the role of artist or designer T_1. Freedom of choice, freedom of mobility, and the concomitant personal responsibility are essential features of CAM.

Codified Instructions

The general needs of each input type can be codified as follows:

$T_1/C_{23}/Ho/iCiO$

$T_2/C_{12}/Lo/iP$

$T_3/C_{123}/LoHo/iPiOiC$

These simplified instructions are useful for the initial rudimentary structuring of CAM/L, but it is understood that as a more measurable insight into each unique individual's requirements becomes available, so the degree of factorisation would be greater and, through this progressive sophistication, more efficient.

Coordination of Requirements

A coordinating element in CAM/L, some sort of human/machine system, will be required to detect the variable T needs, to ensure a state of readiness in respect of instructors, human catalysts, hardware, communications, tools and materials, and teaching programmes. Thus it will be necessary to know the quantity of each T passing through CAM/L during any given period of time; each

individual will be required to inform the coordinating system of the T he has elected to adopt and the length of time or number of occasions that he will pursue its path. In this way, the total learning environment will adapt itself to the changing needs of the individuals in it, rather than the student limiting himself to a rigid, fixed set of procedures. CAM/L is seen as a highly adaptive and complex environmental teaching machine, an organism in which the interaction of variables determines its state at any time. The variety of output is likely to be greater than that of hierarchical pedagogical systems, which are structured in terms of graduating filters.

Elaboration of Codified Instructions

The paths of each T through CAM/L will be branching, rather than linear, and they will from time to time intersect or converge. This will make for a rich mixing of personalities and can be expected to produce ideas for new lines of direction. In this sense, CAM/L will display the property of growth.

In proposing possible elaborations of the codified instructions (codins) for each T, I have drawn on my experience of art in the way of professional practice and practical experiment in a number of teaching situations (see appendices to this chapter).

First of all, I discuss the situation relating to the full-time student.

T_3/C_{123}/LoHo/iOiPiC

This codin to CAM/L reads: full-time student requiring both low order and high order learning procedures in matters concerning identity, media, and concepts, with variable intensification of operant conditioning, play, and creativity. This codin is then broken down in terms of three (or in some cases four) phased subcodes. There are certain general observations to be made before I elaborate the subcodes.

T_3 CODIN: General Observations

We are dealing here with a form of "art education," but unlike the conventional model, it aims to relate to the needs and conditions of radical change in society and to accelerate our transition to the cybernetic future. I have said that I foresee cores of creative activity ultimately springing up in all urban areas as leisure time increases and the need for creative social happenings becomes more acute. These cores will embrace all modes of action and expression, involving music, dance, theatre, visual art forms, and all kinds of intellectual stimulants,

puzzles, games, and pursuits. These cores of ICAMS (Inclusive Cybernetic Art Matrices) would grow to meet most needs of creative social intercourse—in place of the socialising function of work tasks and employed labour of today.

But the present CAM is limited, for the reasons I have given, to a more specifically visual/tactile polarity, relating to behaviourist art in painting, sculpture, and design. Thus the full-time student of the present CAM/L is in effect an "art student."

Redundancy of Overspecialisation

The general tendency in conventional art education is geared towards quite intensive specialisation at an early stage in the student's "professional" course of study. Many programmes allow a first year of general grounding but then leap into a highly vocational form of instruction (in design) and a well-defined area of specialisation in fine art. The criteria of success tend to revolve around predetermined and well-established stylistic canons, which are held to be good by the examining judges. This operates in terms of series of graduated filters, each of which is designed, in effect, to perpetuate the standards and bias of the examiners. This cramped and inverted process of intensive fragmentation merely equips the student with an overspecialised repertoire for a world that increasingly requires a broader more inclusive artistic vision and design practice. Education for architecture, graphics, and industrial design, as well as fine art, is in need of serious reappraisal and rethinking. The absence of keen public debate or intensive professional investigation in this matter is symptomatic of a cultural blockage, where design is confused with styling and the hit-or-miss application of an artistic "flair." Although, from time to time, minor modifications are made in design education and blatantly superficial modifications are applied to fine art education, there is no real understanding of the need for radical change in these fields and certainly very little speculation on what the nature of the change might be.

The Aesthetic of System and Process

The basic concept that underlies CAM/L in respect of design procedures is that the student should be more concerned with creating *systems* than with the styling of *objects* or products. Nowadays, most of the actual handling of materials and decisions about specific forms can be computed automatically by machines. The creative work of the designer is required at the level of systems, or of programming machines (or man/machine units); this means generating ideas for

such systems as human shelters, goods circulation, consumer direction, and domestic functions. The specification of units within the system, i.e., house, package, leaflet, appliance, can be left to the computer to relate to the total demands of the designer's created system. The initial programming of computers for this task would require of an artist a great deal more than the vague artistic flair that he often relies on at present.

This purposes a decisive shift of emphasis in our aesthetic sensibilities. A shift that is endorsed by the observed behavioural tendency of modern art; a shift, in short, towards an art of system and process. This implies that our appreciation of the beautiful, and the delight, stimulation, satisfaction, and regeneration that it induces in us, resides in our perception and awareness of a system rather than an object. There is no reason to suppose that the art of process should be any less visual or poetic or musical than the art object or art of object. Beauty can reside in relationships of structured processes, as well as in the traditional relationships of fixed parts in a product's structure. Beauty thus defined, in which space is shaped by time and form relates to function, is the beauty of a cybernetic vision.

In practical design terms, this means that for automobile design, for example, a study is made of transport systems and automotive processes, from which coordinates are produced to define the parameters within which the computer can design, subject to each set of special cases (individual consumer demands). The mass production of a style line becomes obsolete as fully automated plants linked to the design computer swiftly and cheaply produce unique, custom-built automobiles—or, if the situation calls for it, fleets of them.

Learning for Twenty Years Hence

Education for designers today should equip them for practice twenty years hence, for the time when automation is more or less total and the definition of the cybernated society is more advanced. Fashion and style-oriented design training renders the designer obsolete almost from the time of graduation.

CAM/L in relation to T_3 is expressly concerned with education for the future.

Phasing of Studies

The flow of study and work in the CAM/L art/design "school" will pass through three phases (and, for a minority of students, four phases) or subprogrammes, namely:

C_1/Lo/iP C_{23}/Ho/iO C_{23}/Lo/iC and C_3/Ho/iC

that is, it is initially a low order, group environment learning process, which is essentially exploratory, pragmatic, inventive, and "playful," the general context being of a behavioural visual/tactile kind, focused on creating process and system without any reference to known existing models in natural or artificial situations. High order teaching of skills with operant conditioning techniques then follows—wherever possible using technological instrumentation to release teachers for their own creative work (and more social involvement in the lives of their students). This covers skills with media and concepts. The third phase entails a more social, low order learning continuum, involving group studies in applied systems design in fairly general but concrete areas, such as shelter, containers, and signs systems. From here, a student would be prepared to move into the world at large with a broad role, open to varieties of specific tasks (unlike the tendency today to release graduates capable of a set of specialised tasks that restrict their social roles). Graduates would continue to draw upon and add to their original CAM, or others in the network, by participating as T_1 or possibly T_2 inputs. Some would remain in CAM/L as T_3 concerned with more advanced and largely conceptual creative work (possibly related to highly sophisticated programming for design computers).

Elaboration of Phases

(a) $T_3/C_1/Lo/iP$: Low Order Exploratory Play. The greatest problem for students entering CAM/L or any conventional art school is one of identity coupled with complacency. Certain examination systems (e.g., the GCE, or General Certificate of Education, in England) tend to reinforce complacency in one way or another. A pass in a subject is often taken by the student to mean that he knows what art, literature, or whatever "is all about." A failure in a subject is usually taken by the student to mean that it is an area he should leave alone. Either way, his relation to various fields of knowledge and experience tends to be defined by examination results. This limiting form of certainty in the student's idea of himself is coupled with a profound uncertainty about his approaching adulthood. The tension of complacency versus uncertainty produces a tendency to form rigid preconceptions about unexperienced situations as a form of security. Ideas about what art is, what an art teacher should be, what "good" drawing is, and which artists are best are all formed as fixed symbols of security.

The most dangerous rigid conception the student can form is that of his own identity, of his limitations and abilities.

The first requirement is to break down these preconceptions, where they are seen to be inhibitive, and to instigate a total rethink. This demands a contrived ambiance of total security of the kind that the unreal, fantasy world of theatre provides. An artificial world is required, a kind of stage, on which the student *as actor* (i.e., exempt from the inhibiting standards of skill and talent in the real world) can act out, try out, and turn inside out every kind of role, identity, and human relationship he wishes. The permissiveness in terms of role-playing leads him to attempt techniques and skills with materials and ideas he might have thought himself inadequate for in the "real" world, and leads him into further sequences of exploratory activity. The student may then take on a severely restricted role (possibly defined with a situation-response programme, or "mind-map," as described in Appendix B to this chapter), which calls for interdependence and cooperation with a group of other students, who are also limited in various ways. Each group may set about building a fully differentiated "universe" (in response to some generally defined goal), using whatever materials are available and creating their own systems, processes, structures, and qualities of human experience. In short, they create a microcosm of fully interrelated events and self-contained purposes. Once completed, the "universe" of their playful involvement can then exercise the student in analysis, visual notation, image making, form building, and system perfection based upon a world that he knows intimately—because he has created it in its entirety—with little or no relation to established methods of analysis or notation, that is to say, with a kind of pristine perception. At the same time, this artificial play situation has been such as to encourage him to display an unusual breadth of behavioural response and a noticeable flexibility of identity.

(b) T_3/C_{23}/Ho/iO: Operant Conditioning of Skills with Media and Concepts. There are far too many specific programmes and exercises involved here for any detailed description in this essay, and they will in any case depend entirely on the teacher/student variables involved. The areas involved are motor, perceptual, analytical, and concept-forming skills.

This covers media-handling; tool techniques; matching; rhythm; colour-valuation; space scanning; form development; detail-observation; memory reinforcement; classification; selection; study of natural structure; systems study of growth, genetic coding, tropisms, mutation, and breeding; inductive reasoning; logic; language; visual and plastic syntax; notational methods; symbology; principles of communication and control; history of social/cultural events;

and knowledge of intentions/achievements in earlier art and design. These are simply some examples of "skills" that can be "taught," in the sense of initiating the student into carrying on teaching himself.

(c) $T_3/C_{23}/Lo/iC$: Group Projects Related to Concrete Problems. The student is now involved in making creative decisions through the imaginative handling of natural and synthetic materials, using all types of techniques of forming, moulding, joining, colouring, and so on, with electronic elements of control, and sound, light, printed media, and so on, *as a member of a group* working under conditions of competition, danger, deadlines, and budgets in the pursuit of solutions to a given brief. Briefs would relate to general systems design, covering such areas as urban communications design, controls and interface design, transport, storage systems, entertainment environments, and domestic appliances. In respect of painting and sculpture and derivative forms, the student will experience a polemical interchange with other group members, while maintaining an exploratory probe into materials and new sources of experience; he will be given concrete problems to solve, in the sense of being presented with specific contexts for ideas that he must *question* through his work. He pursues his art as a process of question-asking and problem-seeking; and his completed structures, whether in two or three dimensions, must be such as to put the spectator in a questioning position as well.

Criticism and learning come out of group discussion, and the responses to problems (art/design systems) are tested within the groups.

(d) $T_3/C_3/Ho/iC$: Advanced Creative Work. Some students may prefer to continue in CAM/L at a more intensive level of creative thought, learning more sophisticated skills in computer programming and production processes, with deeper research in the behavioural "fine art" area (symbols, syntax, behavioural fields of interplay, new materials-handling possibilities, etc.). More practical problems could centre on local urban community design-systems requirements, as well as application to the needs of CAM generally. Design problems would centre on more specialised systems, such as those involved in space exploration (capsules, containers for instruments, humans, data, etc.); underwater shelters; communications; sign systems and conduits for ground effect machines; aerial-approach formats; and so on.

With a broad background in the processes of design and an intimate familiarity with the possibilities of materials/machines in this respect, the "postgraduate" student will concentrate on creative work at the conceptual level,

designing programmes for machines to display creative behaviour or producing algorithms for computers linked to processing plants or human groups.

In this area, there will be a great deal of interaction with professional artists and designers (T_1) producing new ideas and perspectives.

We should now discuss the CODINS of T_1 and T_2.

(a) $T_1/C_{23}/Ho/iCiO$: The Highly Committed Professional Artist Designer. The CODIN reads: artist/designer seeking learning in media and concepts by means of both operant conditioning and creative participation.

Matters of identity would be dealt with by the artist outside the framework of CAM/L. And while he may have a social (Lo) interest in CAM generally, his use of CAM/L will be of a high order intensity. In terms of $C_2/Ho/iO$, this means learning new techniques with new materials and understanding new processes in any field relevant to his work; further learning in this respect will, of course, take place as he applies the new skills to creative situations (iC).

$C_3/Ho/iO$ will mean the acquisition of new concepts in science and general access to new ideas; biology, space research, and history of culture are examples of the areas in which he may require instruction.

On the other hand, $C_3/Ho/iC$ implies an intensive involvement in polemical discussion, criticism, and interlearning through the exchange of ideas at the most creative level. The crossing of "paths" here, both for T_1 in general and in the sense of $C_3/Ho/iC$ intersecting $T_3/C_3/Ho/iC$, will make for mixing areas of rich creative consistency.

(b) $T_2/C_{12}/Lo/iP$: The New Leisured Public. The context of CAM learning for this input type will be that of play rather than operant conditioning or intensive creativity, since both the latter demand levels of commitment that cannot be accommodated within the more *casual* involvement of the public.

Low order learning of a general kind about subjects too numerous to cite, and too variable to predict, would undoubtedly be required; but this would be provided in the amenities of the pillar of information (see CAM/A). The general public T_2 requires access to diverse kinds of information rather than *learning* in any continuous or structured sense.

As for media, C_2, they are included in the T_2 CODIN in relation to iP, play. That is to say that T_2 activity will be exploratory of all kinds of materials, including paint, synthetic resins, light, and elementary manipulation of tools and technological instrumentation. Exploration in itself, regardless of any deep-seated creative problems, will be the meaning of iP, self-rewarding play activity.

The problems of identity C_1 are likely to be acute for this input type. Resolution may be found in group play situations that allow them to act out therapeutically a variety of roles within artificially created environments; this amounts to providing games that allow individuals *as actors* to overcome fear of the absurd, the unfamiliar, and the unorthodox by acting out roles within these contexts—a kind of self-governed psycho-drama.

General Demands for Irritants and Variety

In so far as the instruction iC is concerned (creativity), the concept of irritants must be introduced into CAM/L procedures. While operant conditioning and play (iO, iP) require contexts for activity that are relatively easy to predict and provide, the context for intensifying creativity is less straightforward to define. Beyond the draw of a given problem in itself, this will depend on the artist's responses to the irritants he encounters in CAM/L. The design of irritants of a sensory, intellectual, and social kind will be a major task of instructors and catalysts in CAM/L (see Appendix B to this chapter on the irritation of the learning organism).

The other general requirement in CAM/L is that the level of variety be maintained at a high point. The constant variability of input and the free interaction and mobility of individuals will promote a rich variety in the system, but constant environmental changes will also be called for.

CAM/I INFORMATION-HANDLING AND COMMUNICATIONS

Principles of Information Flow

Five principles are likely to govern the flow of information in CAM and through its links with the exterior environment:

IP$_1$ Reciprocity of information

IP$_2$ Intensification of social interaction

IP$_3$ Extension of human perception

IP$_4$ Magnification of human thought

IP$_5$ Viability of internal control

Internal and External Communications Channels

All links are reciprocal.

External channels:

ECC₁ CAM to CAM within the network

ECC₂ CAM to the world at large

ECC₃ CAM to specialised centres of research and knowledge

Internal links:

ICC₁ Person to person

ICC₂ Place to place

ICC₃ Person to specialised zone

Control of Channels

RS Continual random switching from channel to channel to create an incessant flow of variable information from all kinds of sources, transmitted to multiple projection points (in various media) throughout the CAM.

DC Direct control, multichannel selection of all kinds of transmission and reception, with personal or group participation as required. All persons in the CAM have uncensored access to all channels input/output.

Principles of Information Flow Elaborated

IP₁ What is done with or to "received information" must become new information and must be fed back, in some sense, into the communications net. All channels of communication must be kept active with two-way flow. Information is the lifeblood of the CAM and maintains its vitality within society.

IP₂ Creativity is most efficiently maximised in the CAM system by intensification of the transfer of ideas from person to person. Speed of transfer and variety of media are imperatives.

IP₃ All technological and biochemical aids to perception are involved. The CAM may also, in this sense, be a laboratory and testing ground for medical research.

IP₄ This involves research and development in the man/computer relationship.

IP₅ Feedback from CAM participants adjusts the parameters of the system. The CAM produces its own controlling energy.

Demands and Effects of the Communication Net

CAM/I is only concerned with the general principles involved; the elaboration of these in terms of hardware, environments, tools, and so on is dealt with in CAM/A.

ECC₁ (DC). CAMs may learn from each other. A highly interactive CAM network on an international level might form the embryonic structure of a world brain, or at least a subsystem of such a structure, since each individual CAM would be the most sensitive perceptor of changes and needs in its immediate urban locality and, at the same time, the most creative cell in the community.

ECC₂ (RS). The uncensored flow of information between the CAM and the world at large would reduce the chances of it becoming an overspecialised, inbred society. Random switching maintains a steady influx of visual and verbal information from all kinds of sources of human activity: hospital wards, holiday centres, clubs, automatic factories, outer-space locations, marine environments, shopping centres, sports meetings, and so on. The material would come without shaping or editing, instantly and directly from its sources all over the world, and indeed the universe.

ECC₃ (DC). Specialised centres will provide up-to-date information as it is specifically demanded, by direct control to, for example, university libraries and laboratories, scientific research establishments, national computer grids, zoological gardens, space laboratories, industrial centres, and so on.

ECC₄ (DC). Instant person-to-person contact would support specialised creative work and study in depth. An artist could be brought right into the working studios of other artists by TV link, however far apart in the world or across the country they may separately be located. By means of holography or a visual telex, instant transmission of facsimiles of their artwork could be effected and visual discussion in a creative context would be maintained. Depending on time availability, distinguished creative minds in all fields of art and science could be contacted and linked.

ICC₁ (DC). In smaller CAMs, the direct confrontation of persons would be possible, but larger complexes would require artificial communication systems; for example, an artist might communi-

cate with a group of T_2 or T_3 direct from his work area without unduly interrupting his flow of work.

ICC₂ (RS). Every part of CAM would be switched into every other part at all times.

ICC₃ (DC). A Pillar of Information [see below] will store and record data required by the CAM and will be available for everyone's use in various areas, with links to workshops, studios, projection booths, seminars, exhibition spaces, discussion plazas, and "happenings" arenas, or, with more sophisticated techniques, direct to the central nervous system of any individual.

Instant communication, simultaneity of events, multidirectional references and associations, incessant stimulation of all the senses, and the active participation of each human being are factors that constitute an energetic core of creative activity. Only a fully automated society, or a society in process of being shaped by a cybernetic vision, would require this degree of artificially supported creative intensity; and only the cybernetic era could be expected to maintain it.

The rich diversity of experience and the high rate of information flow throughout the Cybernetic Art Matrix indicate that the two principal requirements of a creative situation are present, namely, variety and irritation.

Before concluding this essay with some general consideration of the ways in which a Cybernetic Art Matrix might generate its own growth and development (CAM/L), it is necessary to specify the kinds of amenities that will be required to support the organism.

CAM/A AMENITIES: HARDWARE AND ENVIRONMENTS

If the CAM is to adapt to the needs of the human beings who pass through it, rather than its participants being squeezed into behavioural moulds by the rigid fixity of a predetermined structure, its specification must be rudimentary. Consequently, to list amenities in any detail would contravene the requirements of a CAM specification. I shall limit the description of hardware and environments to very broad generalities; in some instances, science and technology may not yet be able to supply the required elements.

(1) Pillar of Information. This not only stores data, artefacts, equipment, and so on, but records the details of withdrawals and patterns of use of information, acting in effect as the memory of the whole CAM organism. Access to it might be direct or via a videophone, and information might be received in

a number of modes: relayed into viewing/reading booths, transmitted to workshops, or retrieved manually. Some types of information it might contain are: local community archives; canned entertainment; film/book/music teaching programmes, games, puzzles, play themes, simulated systems, academic and scholarly source material in the arts and sciences, and generalised data concerning achievements in biology, physics, space exploration, and so on.

(2) Tools to extend perception. In addition to the familiar hardware of laboratories and dissecting tables, chemical aids to perception should be employed on a controlled basis.

(3) Thought amplifiers (computer availability).

(4) Electric communications: TV, visual telex, radar, and so on.

(5) Light-handling facilities: photographic darkrooms; movie units; light and sound projection theatre.

(6) Controlled environments—exterior. Highly adaptable large zones with movable panels, winches, sound-mixing units, light generators, gantries, and modular construction units to enable T_2 (and possibly T_3) to create play environments. Similarly adaptable zones would be useful to the professional for experimental projects.

(7) Controlled environments—internal. Chemical and electrical modifications to the central nervous system can create whole new worlds, artificial internal environments within the mind, leading to unfamiliar and strange experience and sensations. Examples include lysergic acid, mescalin, other hallucinogens, and controlled experiments with electrical stimulation of various parts of the brain (with attendant sensation cabinets and zones for contemplation and meditation).

(8) Facilities for materials handling—for welding, laminating, casting, firing, coating, and generally shaping materials of all kinds: synthetic resins, wood, metal, and so on. These would be service areas adjacent to private and group studio units.

(9) Copying unit. For the reproduction of visual and aural information, particularly creative experimental work: transparencies; videotape; xerography; holography; screen printing coupled to a photographic printing unit; typographical workshop; offset litho, etching, and other graphic processes, colour ciné film, and so on.

(10) Identity bar. For T_2 usage and role playing arenas (see also 6 above). The creation and selection of roles and identities, and the general context

of "play," would be aided by an identity bar, from which items of clothing (symbolic headpieces, ritual-wear, novel forms, and tactile sensations) could be selected in relation to the development of "play." (Paper clothes would be easily disposable.)

(11) The nature of "happenings" is that they occur spontaneously anywhere, but the possibility of quite large group events calls for large plazas (the size of which can be rapidly modified) for discussions on a formal level, exhibition, demonstrations, parades, pageants, and displays, as well as other unpredictable forms of social activity.

(12) Facilities for physical modification of the individual. Permanent and temporary changes in one's physical make-up, and cybernetic machine extension of skills (cf. cyborg concept of Manfred Clynes and Nathan S. Kline).

CAM/G: THE GENERATION OF CREATIVITY AND THE GROWTH OF CAM

The vitality generated by an initially small number of CAMs might lead to a proliferation of various kinds of CAM complexes in a network linking many countries, which in turn might lead to the free flow of information and maintenance of creative behaviour throughout the world community.

The characteristic of CAM growth is that it progressively defines itself, or redefines itself, in relation to the changing needs of its internal participants and of its outer social environment. It does not impose stringent rules, laws, or moral or ethical codes on its participants; rather, free interaction is likely to evolve new human values, rituals of behaviour, and a kind of legality useful in the day-to-day world of events.

The proposal for a Cybernetic Art Matrix has come out of necessity, and out of necessity it might be adopted. It would continue to function only as long as a community required it: a disposable structure rather than a permanent institution. The assumption that the CAM might be realised in some physical sense can be based on two factors:

(a) the emphatically behavioural tendency in modern art;

(b) the flexibility of control and communications, and the possibilities for extending human experience that a cybernetic society offers, coupled with the need for an integral culture.

Whatever the future of the CAM may be, one thing is certain: the interaction of creative human beings and artificial cybernetic systems is likely to bring

new, exciting, and totally unpredictable dimensions of experience to human culture.

▬ APPENDIX A

The author's personal relationship to what he terms "Behaviourist Art" is not that of an observer but of a contributor, that is, a working artist. Many of the attitudes expressed in this essay derive from visual/plastic "thinking" in his studio. Some of the work is now described with his supporting statements from various exhibition catalogues.

(1) Change-Paintings and Hinged Reliefs (1959-61) [figs. 7–8, 27]

Interchangeable transparent panels (supporting purely formal images) that slide behind each other within a rectangular framework by the manipulation of the spectator. Structures (wall reliefs) with hinged flaps that can be altered, again by the observer's manipulation.

Statement from the catalogue to the Bewogen Beweging ("Moving Movement") exhibition at the Stedelijk Museum, Amsterdam, 1961: "Change is fundamental to our experience of reality. Interchangeable elements, each with an individual identity, may, by the physical participation of the spectator, be brought into a series of relationships, each one adding up to a whole which is more directly related to the manipulator of the parts, than if it were static and at a distance. The act of changing becomes a vital part of the total aesthetic experience of the participant" [Ascott 1961].

(2) Analogue Structures and Diagram-Boxes (from 1962)

Wall relief constructions in various materials (wood, glass, perspex, cellulose paint) that combine features of behavioural analogue and trigger. Analogues were made either of systems involving association and identity or systems discussed by C. E. Shannon, Norbert Wiener, A. G. Pask, and others, including, for example, the Russian group of V. Kamynin, E. Lyubimski, and M. R. Shura-Bura.

Homage to Shannon (1963), 61 × 137 × 30 cm [fig. 6], was an analogue of the simple information flow: input (mode A) → noise → output (mode B) where the message transmitted concerned the concept of "containers."

Video-Roget (thesaurus) (1962), 130 × 89 cm [figs. 3, 4], set out the contexts for shapes and form referents in the associated works:

(a) metaforms for organic growth;

(b) formal strategies (flap, wedge, split-pitch);

(c) items of intention (womb/source/goal/bottle/container/umbrella/shelter/embryo) (growth potential); pulse-waveform (energy potential); claw (holding potential).

A "calibration unit" (a sliding perspex panel that provided a linear link between layers of shapes) divided the board into two parts.

Behaviour triggers with no reference to specific systems, but visually discussing the idea of identity also were produced. For example:

Locomotion Board (1963), 122 × 91 cm, provided elements of distant identities that the spectator could manipulate into a variety of pre-set and random relationships by plugging in, rolling along a track and positioning a stand-up cut-out form.

Kiosk (1962), 61 × 46 × 23 cm. Manipulation was in the form of goal-less "measurement" and sifting through papers in a built-in drawer that were visual comments on the structure that contained them.

One-man exhibitions of this work were held at the Molton Gallery, London, 1963; Suzanne de Conninck (Centre d'Art cybernétique), Paris, 1964; and Queens University, Belfast, 1964.

The catalogue provided a diagrammatic statement of intention [figs. 14–15] including certain definitions of terms, such as:

"Diagram Box": (rectangular framework with sliding transparent panels carrying diagrammatic information), as analogue to concepts of human behaviour, if and only if a spectator participates.

"Diagram Box as Variety Act": The (reference) frame provides a set of panels (states). The variety of the set is a measure of the uncertainty involved.

"Participation–Information": Moving the panels removes uncertainty about a set of possibilities. Active observation produces information. In manipulating each artefact in turn, the participant becomes adaptive controller.

Concepts of "art as abduction," "epistemological hardware," "system-sounding," and "diagram space" (icons and signs) were also discussed.

Work of this period was foreworded by a brief statement in the catalogue to the exhibition *Britische Malerei der Gegenwart*, at the Kunsthalle, Düsseldorf (subsequently touring Germany), 1964: "In my work I aim to relate Behaviour (of both spectator and artwork) to Idea. My discipline is reinforced by reference to Science—especially Cybernetics and Behavioural Science. In manipulating my constructions the spectator (as decision-maker) is symbolically acting out a concept of power and realising a concept of change."

(3) Cut-Outs and Templates (1965) [e.g., figs. 10, 26]

In a one-man show at the Hamilton Galleries in London in 1965, certain other directions were taken up, concerned with the synthesis of low definition content and an *implicitly* flexible container, or, more precisely, a formal condition in which the *container was the content.*

The structures were of large format (e.g., 178 × 178 cm, in some cases, and 150 × 300 cm in others), large cut-out fields of washed colour (on blockboard, each a single colour). The use of washed colour reinforced the linear quality of the cuts (where opaque colour would have made them the edges of forms). These were essentially *linear* analogues discussing and creating ideas of *modulation* in terms of wave forms, fretted profiles, vector diagrams, and oscillating edge-rhythms.

Fourier, a blue square with wave-form edges, turned first inwards diagonally and then outwards towards the spectator. The large blank areas of stained board served as *receptacles* for spectator ideas, with the general context shaped by the linear configurations that contained them.

The works are also records of certain random actions and motions with a powered fretsaw, where sawing around a large board becomes a way of demarcating one's "arena." This topological tracing of paths with a saw across a field at times generates new goals, which come out of the process.

Present experiments with behavioural structures include the use of the spectator's *approach and proximity* to the work to cue changes and movement within the artifact (photoelectric cells, etc.) as well as flip-flop units in environmental situations and other ideas.

▬ APPENDIX B

Practical experiments that have led up to the CAM concept have been conducted by the author and his colleagues within the art teaching situation during the

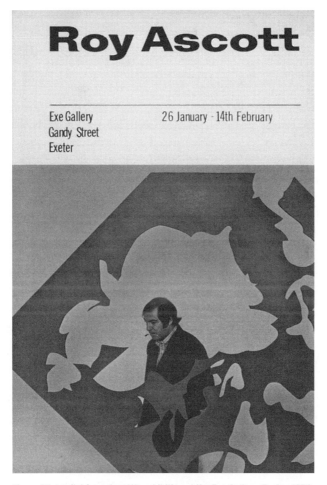

Figure 26. Leaflet from Ascott's exhibition at the Exe Gallery, Exeter, 1970, showing Ascott behind *Cloud Template* (1969; stained wood, 80 x 80").

past six years at Ealing School of Art, London, 1961–64, and at Ipswich School of Art, Suffolk 1964–66.

As director of studies in both places, it was possible for me to experiment with the *total* teaching programme (at Groundcourse and fine art levels, but not with vocational studies for graphics, industrial design, and so on). And so, in addition to artists, designers, and an architect, it was possible to bring into the regular staff a biologist, a cybernetician, a behavioural psychologist, an engineer, a sociologist, and a linguist—to work not only in the lecture hall or seminar but in the practical environment of studio and workshop. Casual interaction within

this varied staff led to intensive discussion and developments in the creative thought of both scientists and artists involved. In "The Construction of Change" [chapter 1 above], I described it thus: "Each [teacher] has expanded his own given area of teaching with ideas fresh from his studio or study. These areas interact and suggest new fields of study and the need for new kinds of personalities. Ideas grow and exercises proliferate as teachers discuss and dissect each other's attitudes and pedagogic methods. So many exercises and methods of presenting them are thrown up in this creative milieu, even in the course of one week, that it would be impossible to list them all." This essay was published in an issue of *Cambridge Opinion* entitled *Modern Art in Britain*, which included an account of the growth of "Groundcourse—Ealing," some details of teaching methods developed there, and their cybernetic/behavioural orientation.

Some detailed mention is required of "Behavioural Studies" as it has been called at Ealing and Ipswich, which is referred to in this essay under CAM/L T_3/Ci/Lo/iP (i.e., exploratory play). The following brief, given to second-year Groundcourse students at Ipswich, will help to define the process:

> Students will first consider the relationship between man and environment. This will lead to the study of the behaviour of human organisms, particularly with regard to creative behaviour. Information collected during these studies will be used in the design of a "calibrator" [fig. 13] which can give instructions concerning programmed responses (in the human being involved) to situations, environment, materials, etc. Groups will be formed and readings taken by each person from the calibrators in order to design and compile "mind-maps" (giving limited behaviour patterns and a limited identity, both contrary to evident and assumed characteristics of each group member).

The mind-maps (a small-scale design problem in themselves) provide immediate reference to the behavioural responses that are demanded as changes occur in terms of space, tools, media, and social situations.

Members of each group (about five to a group) are of necessity interdependent and highly aware of each others' imposed limitations and potential. The groups are given a goal, a general problem that, in past years, has been: (1) to produce out of available materials and studio space an unspecified ordered entity; (2) to create and enact a ritual based on a specific natural system (e.g., the human digestive system, the spreading of a contagious disease); (3) the devising of a three-dimensional "ontological" game. The resultant constructions and artificial environments are dependent upon the constituent, imposed limitations and opportunities of the group member; for example, a stu-

dent may be limited to transporting himself about the school on a trolley, and others may not be able to use paper or nails or numbers or, possibly, human speech.

Not only resourcefulness, ingenuity, and a sense of social interdependence and responsibility result from these limitations, but, perhaps most important to creativity, a sense of flexibility of thought and attitude and an *open* quality of personal identity.

The descriptions that various groups of students have given to the products of this process may provide some idea of the diversity of activity and form that it tends to engender: time machine; sense maze; process board; sense box; net and wire mosaic field; icon cabinet; mosquito ritual; grid-climbing game; evolution game. The general intention of Groundcourse was summarised (out of joint discussion by its members) in the Prospectus for 1963/64 at Ealing:

> The Groundcourse places the student at the centre of a system of visual education designed to develop in him awareness of his personal responsibility towards idea, persons and the physical environment such that he may contribute to a social context within which his subsequent professional activity may become wholly creative and purposive.
>
> The intention of the Groundcourse is to create an organism which is constantly seeking for irritation. The term "organism" may be applied to both the individual student and to the Groundcourse as a whole.
>
> The irritation of the organism is applied in three different directions:
>
> (a) towards the social relationship of the individual to his environment;
>
> (b) towards the limitations implied in material situations;
>
> (c) towards conceptual possibilities, the physical embodiment of which is unimportant.
>
> This self-regulating system, except in one particular, cannot be predetermined. The exception, basic to all creative activity, is the necessity of a concept of power.

NOTES

1 Brion-Guerry [1950] 1995: "What the painter suggests, the picture states, the spectator achieves. But this achievement offers a multitude of possibilities, each of which is valid only for an instant."—Ed.

2 "I would like to paint space and time so that they become sensible forms like colors."—Ed.

3 Calder [1932] 1968: "each element being able to move, stir, oscillate, go and come in its relations with the other elements of its universe."—Ed.

4 Whereas art has had difficulty claiming its effectiveness as a force for "realpolitik," Ascott claims here that art can play a vital role in "cybernetic politic" because the cybernation of society implicitly alters the political structure.—Ed.

5 Couffignal 1964: "It is more precise to speak about forming a cybernetic spirit than about teaching cybernetics."—Ed.

BEHAVIOURABLES AND FUTURIBLES

1967 When art is a form of behaviour, software predominates over hardware in the creative sphere. Process replaces product in importance, just as system supersedes structure.

Consider the art object in its total process: a behaviourable in its history, a futurible in its structure, a trigger in its effect.

Ritual creates a unity of mood. We need a grand rite of passage to take us from this fag end of the machine age into the fresh new world of the cybernetic era.

Just as our environment is becoming more and more automatic, so our habitually automatic behaviour becomes less taken for granted and more conscious and examined.

Now that we see that the world is all process, constant change, we are less surprised to discover that our art is all about process too. We recognise process at the human level as behaviour, and we are beginning to understand art now as being essentially behaviourist.

Object hustlers! Reduce your anxiety! Process culture and behaviourist art need not mean the end of the object, as long as it means the beginning of new values for art. Maybe the behaviourist art object will come to be read like the palm of your hand. Instead of figuration—prefiguration: the delineation of futuribles. Pictomancy—the palmistry of paintings—divination of possible futures by structural analysis. Art as apparition? Parapsychology as a Courtauld credit?

Originally produced by Roy Ascott as a poster-sized manifesto in 1967. Subsequently published in *Control* 5 (1970).

Cézanne's structuralism reflected a world flooded with physical data. Our world is flooded with behavioural data. How does that grab you?

Social inquisitiveness is a factor we would like to reinforce.

All in all, we are still bound up with the search for myths. But the context will be biological and behavioural—zooming through the micro/macro levels. Get ready for the great biomyths, visceral legends.

Imagine this game. Groups of people with highly constrained artificial behaviours moving through zones with different functions (like magic, camouflage, enlargement, reversal, disparity). Gives you zone shifts, time shifts, identity shifts. No light pen needed to work out that potential.

Dare we talk about art and social modelling?

We are very much concerned with generating futuribles—maybe that's because the more we can dream up alternative futures, the more changeable the present can become. And change is what we are all about—change for its own sake. That is the essence of behaviourist art, and generating change is the aim of the behaviourist artist.

We could talk about the levels of resolution for examining two classes of art system—the discrete and the continuous. That's like classical and behaviourist art.

How about the notion of secret reciprocity?

Cybernetics will have come of age when we no longer notice the hardware, where the interface is minimal. Same goes for art?

The cybernetic age is an age of silences. Same goes for music?

Artist on the campus. We can create new rituals in the centres of learning. We can introduce art as visual matrix for the varied discourse of a university. To hell with commissioned monuments!

Is it useful to discuss the thermodynamics of an artwork? An artwork is hot when it is densely stacked with information bits, highly organised, and rigidly deter-

mined. Hot artwork admits of very little feedback in the system artifact/observer, it's really a one-way channel; pushing a message from the artist, out through the artwork into the spectator.

Call it cool when the information bits are loosely stacked, of uncertain order, not clearly connected, ambiguous, entropic. Then the system allows the observer to participate, projecting his own sense of order or significance into the work, or setting up resonances by quite unpredicted interaction with it. We must also consider the cut-out mechanism that operates when an artwork overheats; when it is too hot, too densely stacked with an overburdened accumulation of bits, a sort of infinitely inclusive field. Then the system switches to a very cool state and feedback of a high order is possible.

Behaviourist art has two principle aspects—the biological and the social. It will be more or less visceral, more or less groupy.

Great art sets up systems of attitudes that can bring about the necessary imbalance and dispersal in society while maintaining cultural cohesion. For a culture to survive, it needs internal acrimony (irritation), reciprocity (feedbacks), and variety (change). Enter art.

With heart-swopping behind us, what about behaviour transplants?

The process structuring of artworks must inevitably reflect the substructure of behaviours in our cybernated ecology. Gives you video analogues of processes that may trigger new behaviours.

Art now comes out of a passionate affair with the future. Let's take into account ESP, astrology, divination by tarot, the whole psychic scene, and work out scenarios for the astral plane. Let the mediums give the message. Remember! Black and white magic is easily reproduced.

If we are to keep art schools, let them be structured as homeostatic organisms, living, adaptive instruments for generating creative thought and action. But first—more artists and scholars—fewer clerks and boy scouts. No more phoney-liberal blindman's-buff. Within a behaviourist framework, the creative interplay of reason, passion, and chance can take place.

The Cybernetic Art Matrix concept is essentially a futurible—anticipatory and speculative, depending for its viability on an understanding of the past. As a projection of our behaviour-based culture, it is intended to be a scenario that is neither surprise-free or definitive. It is an alternative. The idea of the alternative or multifold alternatives is becoming the very core of art as it progresses. As in science and sociology, to which it aspires from time to time to relate, generating alternative futures seems to be essential to the internal development of art.

Art creates mythic futures. The mythology of change and uncertainty and the ritualisation of the will to form combine in behaviourist art. "Only through myth and the structures it requires can we combine the necessary paradox of definition and ambiguity, of order and uncertainty, of the tangible and the infinite" (Lévi-Strauss).

In the post-industrial society, it is not technology that will carry us through so much as psychotechnology. That may take us beyond Skinner's behavioural engineering into the shadow lands, the futuribles, the speculative, astrological, dreamed-up, out-of-body, future behaviours. We may not have reached the frontiers of parapsychology, but when we do—wham! Instant communications with no media. Total telepathy, waves of alternative behaviours surging on from creative impulses of the mind. A hardline software culture, always being rerouted, conditioned only to branch.

Art is now a form of behaviour.

Message ends.

THE PSIBERNETIC ARCH

1970 If writing about art has any value at all at a time when art works and processes are themselves polemical, it can only be to discuss alternative futures. Futurology, the business of generating scenarios that are projections into the future from variables of the present, is a game indulged in by economists, sociologists, and astrologers from New York to Delhi [see, e.g., International Future Research Conference 1969]. Their aim, whether via statistics or the occult, as the case may be, is to produce "surprise-free" predictions for their clients. For the artist, there is no client—at any rate, in advance of the assembly of his ideas—and so, for us, the generating of futuribles is essentially a far less constrained affair and may become a creative act.

My interest is in discussing, not a range of specific futuribles or a detailed scenario in a given location, but a general model of the factors that will operate on culture over the next twenty-five years. The model takes the form of an arch bridging two apparently opposed spheres: cybernetics and parapsychology. The west and east sides of the mind, so to speak; technology and telepathy; provision and prevision; cyb and psi.

There seems to me to be a very beautiful set of correspondences and potential interactions between these fields of activity. A rainbow arch unites them. A general systems approach would enable us to investigate the two aspects of a whole system of prediction, control, and communication. This arch could support a whole artistic culture. Extra-sensory perception, in so far is it has been shown to exist in terms of telepathy and clairvoyance, is the most perfect form of communication and social feedback imaginable, although its manifestation is erratic. Applied cybernetics, on the other hand, which

Originally published as an untitled contribution to *Studio International*, April 1970.

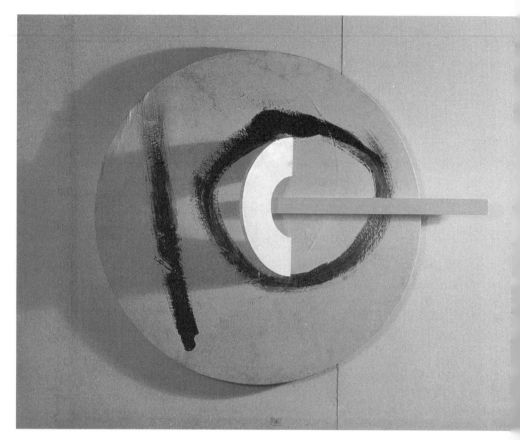

Figure 27. *Hinged Relief.* 1960. Wood, 27" diameter.

is efficient and reliable, contributes to an idea of the perfectibility of systems, which due to the limitations of media, it can never hope to attain absolutely. ESP is instant, but sporadic. Cybernetics is universal, but entropic.

It is interesting to note that in the Soviet Union an advanced study of parapsychology is carried out in the Laboratory of Biological Cybernetics at Leningrad University. If its work is less popularly known than that of Dr. J. B. Rhine of Duke University, North Carolina, this is probably because it was suppressed for many years under Stalin, when L. L. Vasiliev, the great exponent of psychic behaviour, was prevented from research and writing by the Soviet Academy of Sciences. The end of suppression of psi research corresponds in time to the end of the ban on cybernetics. The political theorists of the USSR were, for at least ten years, unable to reconcile the implications of cybernetic theory with Marxist-Leninist doctrine.

All the while, engineers, biologists, and mathematicians were struggling to have cybernetics admitted to their fields of research. When the ban was lifted in 1958, the floodgates opened. Journals, books, and papers on the subject, which had mushroomed in the United States and Europe since the publication of Norbert Wiener's *Cybernetics* in 1948, poured into the Soviet Union, knocking over the prejudices of the Soviet Academy of Sciences and galvanizing research workers in many disciplines. The establishment of the USSR, having prevaricated for so long, woke up to the enormous importance of the subject and with astonishing foresight, the Twenty-Second Congress of the Communist Party of the Soviet Union in 1961 decreed that it should be applied to the whole Soviet system. Seeing it as a means of obtaining the economy of abundance, and that "automation is a universal law of development," they have effectively redefined cybernetics as the science of government, which was the meaning the French physicist A.-M. Ampère intended when he coined the word, many years before Norbert Wiener. Russia had come a long way from the pejorative definition of cybernetics given in a 1954 Soviet dictionary of philosophy: "a form of reactionary pseudoscience originating in the United States after World War II . . . a form of contemporary mechanisation."[1]

This is worth mentioning, I think, since now all aspects of Soviet government— shelters, storage, transport, agriculture, production, medicine, defence, research, and so on—are to be linked into one master cybernetic system, with the capability of correlating behaviours, trends, and needs from minute to minute across the entire country. The "Unified Information System" is scheduled for completion during the 1970–75 period [Ford 1966; Mikulak 1966]. Apart from economic prediction and scientific future studies, the research institutes for para-

psychology and biological cybernetics will gain a great deal. At once we see that the scope of statistics of psychic behaviour will be immense, providing the opportunity for the first time of comparative psychic research on a gigantic scale. The feedback of all this on our thinking is likely to be considerable. Art will no doubt adjust its parameters in response.

In the West, also, research on psi has been consistent, if limited. But, recently, work with a machine that automatically generates random events has yielded valuable results, enough for the *New Scientist* to have finally accepted the validity of the ESP hypothesis, where formerly much controversy has reigned.[2] Dr. Helmut Schmidt who did the work at Boeing Scientific Research laboratories in Seattle has now joined Rhine's laboratory. However, it is Herman Kahn at the Hudson Institute, New York, who has captured the public's imagination with his predictive systems [Kahn and Wiener 1967]. These rely, not on psychic perception or clairvoyance of an occult kind, but on raw Cartesian procedures of assembling hard facts and extrapolating into the long-term future scenarios that have a real economic and political value to the U.S. government and the big corporations. His task is not to predict the future but to sketch alternative futures.

Prediction, control, and communication; human behaviour; process and system; organisation and entropy. What does this all add up to, and how is it relevant to art?

We have read a great deal in recent years about the qualities of feedback in visual culture; of interaction between artwork and audience. I have myself contributed the idea of a general behavioural quality in twentieth-century art that admits of cybernetic analysis. We have also seen the underlying cybernetic structure of art misunderstood, or simply made fashionable with large-scale exhibitions of what is effectively cybernetic camp—creaking hardware and antique concepts—simply out to capture public attention at a trivial level. But however it is grasped, with or without imagination or insight, with or without financial support, there is no doubt that the cybernetic era—perhaps we should call it the *psi*bernetic era—is upon us, and that art, however obscurely, has anticipated the fact.

I want to suggest that art has anticipated something more, the real value for human beings of a cybernated culture: the leisure and abundance to choose and anticipate. Art has anticipated *anticipation:* the ability to predict, to sketch for oneself all kinds of alternative futures. Unlike the past, when poverty and shortage caused science to be used merely to mitigate a certain future of hardship and anxiety, the future economy of abundance will mean life of personal choice

and invention. Given raw materials and automatic processing, we are free to elaborate and realise our dreams. This is the promise of advanced technology with which the United States, a post-industrial society, and the USSR have already come to terms. In art, the action is where the power is. In Western art, this has usually been so whether the power was temporal or spiritual. In the future, the power will be with the post-industrial societies, and we can expect to see the psibernetic culture engendered within their constraints.

Electric technology is the artificial supporting redundancy for psychic systems. ESP is more instant than instant electronic communications, because it involves no media. Finally, it can mean a kind of instant global sympathy, a galactic sympathy perhaps. Out-of-time behaviour, clairvoyance, and psychokinesis are, for example, the only real hope of travel around the galaxy and beyond.

It is a prediction, then, that art will become, and is perhaps already beginning to be, the expression of a *psi*bernetic culture in the fullest and most hopeful sense: the art of visual and structural alternatives.

We are familiar with an abstract art that is the restructuring of past experiences at a general level; with an impressionistic art that distils experience at a more specific level; and with an art of the real, of now, of the moment. The art I am pointing to is an art of predictive or anticipatory structure, which creates alternative futures, a distillation in pure visual energy of what could be the case. The art of futuribles.

Because it will develop, in my view, upon an arch of cybernetic technology and psychic behaviour, this does not necessarily mean that it needs to employ the media of either. Neither advanced hardware nor elaborate ectoplasm need be involved! Indeed, we see much evidence in art now of the futility of trying to compete with technology at its own level. After all, the creativity in technology is to be found in its own advance. Art is concerned to give expression to process and system underlying technological culture, and it will be increasingly concerned to ally this with the expression of behaviour at the psychic level. It's worth noting that as with TV, so with ESP, the medium is the message.

So I want an art that reads like the palm of your hand. I would like the critics to have a chance of being useful again. Instead of judging and interpreting with their eyes in the backs of their heads, they could begin to look out front, exercising the pineal gland for a change; interpreting alternative futures from the configurations thrown up by the artist. The critic as seer would be involved in seeing again, in an entirely fresh light, a visionary rather than a merely visual art. An art that sets you off dreaming; ambiguous, uncertain; non-specific; certainly not literary or merely arcane; *pre*figurative painting perhaps, or

*pro*spective modelling! I am pointing to an art that is formed reaching, antici-patory, that triggers you outside of time.

Ambiguous, uncertain, indeterminate—these are qualities to be found in the art forms of today. The germs of the new culture have formed, but the issues need to be clarified—they are not, at present, simply vague and cloudy, but con-fused. The vision of our time must be seen as a prevision; a function and pur-pose can be restored to art, where there now appears to be only aimlessness and lassitude. The future of art is with the futuribles.

In my painting, with which these ideas are consistent, I find it necessary to operate at what amounts to the level of trance. I mean that kind of open, un-constrained but intense process of working that can be induced by random be-haviour, open systems of play with marks, colours, and gestures interacting with a deliberate grid. This intimate level of operation is for me an analogue of pos-sible processes at the social level, mirrored in fact in the blueprint for a Cyber-netic Art Matrix [CAM; see chapter 3 above], where free and infinitely variable human behaviour interacts with a matrix of hardware and environmental ameni-ties adaptive to the needs of inducing and reinforcing creative behaviour in a community. In this microcosm/macrocosm relationship, there is much to be learned from Tantric art.

At this personal level, there is a stage of working where actions become au-tomatic (in the sense of automatic writing). The board I work on can become the arena for any kind of force, just as the ouija board seems to elicit informa-tion from a deep psychic level of the participants. In the CAM also, subsystems tend to become automatic as the level of complexity overall rises, and a psychic consciousness of the human group within it evolves. So the board, the analogue structure as futurible, offers feedback facilities for dragging up visual configu-rations from a deep level of consciousness, which in turn generate anticipated future structures and relationships. I would like the board to be read like the palm of the hand—"pictomancy"—a kind of non-figurative, all-at-once tarot. The crystal ball rolled out and transferred on to the flat surface of the board like some kind of cartographical projection of the world, not the world geo-graphically described, but an alternative future structured in terms of pure vi-sual energy.

Other levels of work, apart from the intimate and the social (the studio and the cybernetic art matrix), are called for, and experiments have begun. Psychic systems for generating instructions for creative behaviour have been set up re-cently with a group of associates, using four or five ouija boards simultaneously, for example. We are planning to feed instructions from a planchette on a wired

table (on/off switches replace the circle of letters and numbers normally used) within a domed structure linked to an electronic system of light and sound located on the exterior of the structure—a kind of system with a psychic brain. The implications for art of ESP and clairvoyant channels as media are very great. There is room for fascinating speculation on the possibilities of linking a sensitive clairvoyant to a computer so that it can acquire a psychic repertoire and in turn amplify the subject's messages and images.

It can be argued that the rainbow arch between psi and cybernetics has hardly formed. Maybe it is a futurible, but I think not, there is too much evidence to suggest that the structure is forming. Maybe it is finally a dream, but as Montaigne said, defending in anticipation, no doubt, the futurible syndrome: "It is pricing life exactly at its worth, to abandon it for a dream" [Montaigne 1958].

NOTES

1 *Kratkii filosofskii slovar*, ed. M. M. Rozental' and P. Yudin (Moscow: Gos. izd-vo polit. lit-ry, 1954).

2 Editorial, "Quantum Processes Predicted," *New Scientist*, October 16, 1969.

1975 Each person's house is a received or created analogue of his/her per-
ceived or wished-for universe. The table is the analogue of the
house. The table enables us to sit around our universe of discourse
and to transact with one another in that universe.

The components of the domestic day, the behaviours of trans-
forming, unpacking, laying out, switching on and off this or that
system, are analogues of behaviours in the wider universe. In the
kitchen, a fork, a funnel, a container, a grater, a sieve are all *pure
ideas*, realised in hardware, and in using them we bring into con-
junction new assemblies of ideas.

The preparation of a meal is always a ritual analogue of our ways
of dealing with the world, the ways we transmute raw matter, stuff
of our daily physical existence, into new forms, concepts, and expe-
riences. Functionally central to the kitchen, seen in these terms, is
the table. This arena has its own semiotic. All our behaviours exist
and have meaning on many levels simultaneously, they contain
bonded meanings. To use domestic utensils and materials, for exam-
ple, is to be involved at the same time with psychic instrumentation.

A table exists, just as a house exists and our universe exists, only
in so far as it is the arena for behaviours. But the particular behav-
ioural frame governing the most general class of table affords a de-
gree of alienation sufficient to ensure that we are never entirely *in*
a table, only *at* a table. To participate in table behaviour is to stand,
or more generally sit, at a table, somewhat apart from it, while en-
tering into transactions with people or objects across this arena. The
table is a medium of exchange, the space between behaviours and
states, the grounds for change. A table is very properly a matrix (and
so at all levels).

Originally published in *House: The Journal of the London Architecture Club* 1, no. 1
(1975), and reprinted with permission.

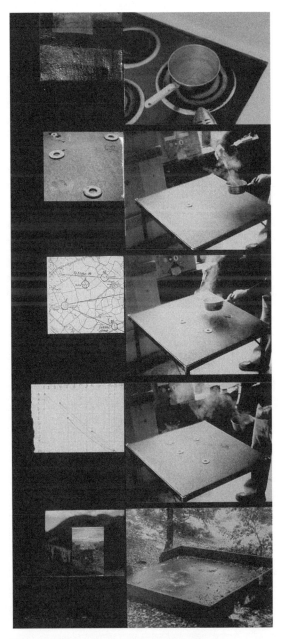

Figure 28. *Cooking Chance.* 1978-79. Photocollage.

Just as the table is the symbolic arena upon which all the behaviours of the house are enacted by analogy (signifying the organisations of the house, domestic transactions), and equally those of the entire universe of the group inhabiting the house, so also can the table provide the arena to construct and rehearse alternative behaviours, structures, and organisations. The table is then a device for divination, a sounding board for new relationships within the house or the universe, a test-bed for change.

Some rooms are devoted to their table, the table is all. In other rooms, the table is just one of a variety of arenas for transaction—its historic role as the analogue board for exchange is not seen clearly by the inhabitants of the house. But what can replace a table even when conditions are unfavourable for a solid structure? The soft table is employed in the Middle East, for example, and at picnics in the West; it is then essentially a temporary spread but still a horizontal surface for transaction. The sense of removing the corporeality of the table to a mere slip of cloth, a shadow of a table, has its own delights. To bring the table-top literally to the surface of the earth, the mediating arena in touch with the immediate ground, is in itself an exceptionally rich symbolic act.

Parenthetically, it is interesting that Sufi culture, which is concerned with maintaining a continuous daily awareness of the bonded meanings of all acts, a cosmic corporeality, should be found predominantly in that part of the world, the Middle East, in which the table as a spread on the ground, pure table-top so to speak, is traditionally one of the preferred table modes.

Nor can we ignore, in any structural analysis of table-top behaviours, the physical conditions governing each particular table. The shape, height, position, and proportion of the table, relative to the room it is in, are factors that speak to us and participate in our existential dialogue with the world.

Such physical conditions may be conducive to certain classes of discourse and may inhibit or prevent others. It is proper to ask if, say, an oval, polished mahogany table admits of the same analogue modelling as a square vinyl-topped table. What classes of table-top behaviours are generated in each instance? The function of the table in myth and in religion is clear. It is always the matrix of transformation and transfer, of change and exchange, between two poles, two worlds (of discourse), between two cultures, states of awareness, good and evil; the dialectical surface is necessarily horizontal. What church or religious arena is without its table, its altar, the sacred horizontal that stands between the vertical polarities of heaven and earth. In religion, the table is the mystical matrix.

The esoteric tradition finds its most generative system in the tarot, a universe of discourse that creates new universes of possibilities with each spread. The

metaphysical table-top is its whole arena. Its own most generative card, number one of the major arcana, the magician, has at its centre the table. Only a table can support the co-ordinates of the minor arcana system—the sword, wand, pentacle, and cup—since it provides the arena for their free interaction, that is, without containing (limiting or defining) their behaviours. Tarot is the most metaphysically refined of table-top behaviours.

In spite of the timeless history of the table-top, its semiotic was repressed during the Renaissance with the advent of perspective and its principal raison d'être, which was to demonstrate man's isolation from the universe, to close down mystical transactions. The horizontal plane of the table-top was abandoned in favour of the vertical plane of the rectangle on the wall. This change was of the utmost significance, since it signalled the change of Western culture's conception of its relation to the universe: instead of it being, by analogy, horizontal (reflecting the cosmos, offering a bird's-eye or holistic viewpoint), it became at that time vertical (reflecting only [man] himself, an isolated viewpoint). "Mirror, mirror on the wall . . ." was the way folk culture dealt with this aberration.

Indeed, the concept of art "mirroring" life not only demanded the format of the rectangle on the wall but ensured that the metaphysics of the table-top would become as moribund for Renaissance culture as the holistic and integrative worldview that its doctrine of the vanishing point was intended to obliterate. The mirror on the wall demands a fixed viewing point. It thus immobilises the viewer, fixes him/her in one stance, or a succession of stances. The fixed viewpoint does not enable the viewer to see layers of meaning, view upon view. Bonded meanings are actually denied by the convention of the mirror or picture on the wall. At the same time, the picture on the wall is always totally alienating, always separate and apart from the viewer, guaranteeing his/her isolation. "Mirror, mirror on the wall, who is the fairest of them all"; this apotheosis of the vertical plane, the isolated rectangle reflecting only ourselves and talking to us only one at a time, quite separately, is the archetypal convention of a whole culture of separation, competition, self-love. As such the picture on the wall, the painting, has been the pre-eminent signifier of Western culture for as long as the values of alienation, competition, and narcissism have dominated our society. As those values recede, so does the importance of painting as a "mirror-on-the-wall" signifier.

The social and cultural failure of television as either entertainment or art is largely due to it being viewed, and produced to be viewed, on the vertical plane. Indeed, the very separation of entertainment and art, so-called, is a consequence

of this verticality. On the one hand, we expect to be diverted and amused by this mirror of life, reflecting what we "know" is the case and that, in consequence, is reassuringly familiar: entertainment by watching the stream of life. On the other hand, we attempt to go through the looking glass, to invert our values or anticipations: a "higher level" entertainment is presumed, in fact, masquerading as art. The bankruptcy and irrelevance of "video art" are assured just as long as the convention of the monitor screen on the vertical plane is maintained. Only when video is created to be viewed on the horizontal, table-top plane, seen all round without top or bottom, will it have the possibility of contributing to our holistic consciousness. Let us get our images out on the table, where a fuller disclosure is possible than in the "mirror" on the wall. We know we are not the fairest of them all.

As an arena for disclosure and analysis, the table is well employed, be it round table, board table, or high table. Disclosure and analysis require human transaction, the transfer of feelings, thoughts, and information from one to another. Reciprocity generates trust and sympathy. This is particularly appropriate when we are concerned with disclosure of the inner self, as in art. The table-top enables us to float out our intangible dreams and intimations on a secure and substantial surface. Whether for psychoanalysis or for art, the dream table is a prerequisite, absolutely replacing the analyst's couch of the previous era. Typically, the couch only permitted a one-way line of communication, from patient to analyst. The hierarchic arrangement was such that the doctor remained hidden, disclosing nothing of himself, giving nothing of his interior world. Without reciprocity and transaction, change and growth of either patient or analyst were impeded. The dream table, unlike the couch, has infinite lines of communication, enabling transactions to occur between the inner worlds, the dreams or inventions of all those placed around it. The whole process can be amplified and extended by employing psychic instruments, whether specially made objects or things "borrowed" from their everyday contexts (fork, funnel, knife, platter).

The context of art now is set within concepts of behaviour, transaction, process and system. Our worldview is holistic and integrative. Our vision is cybernetic. We are no longer locked into the moment, we resist the partial view. Within the table-top, a horizontal creative arena, we can fully engage in analogue modelling, speculative restructuring of systems, contemplation of the rich interconnections of events and the infinite pathways between bonded meanings. Table-top behaviour enables us to invent and rehearse alternatives, to exploit the fecund ambiguity of new relationships and the dynamic uncertainty of movements of meanings. The table-top not only encourages interaction between ob-

servers attending it but focuses into this mediating plane all the psychic energies of the individuals involved.

Art, clearly established in our present culture as a form of behaviour (rather than a simple array of images or objects), now takes on the quality of a transaction. Art aspires to the condition of exchange. There is consequently no final outcome, no ultimate climax, no absolute resolution or irreversible conclusion in art now, as in life. The table-top supports an open system, in which only the intervention of observers can generate meaning and value. Art, then, resides not on a surface or within material objects alone, but between the behaviours of all parts of the system.

CONNECTIVE CRITICISM

1977 There is a need for a Center for Critical Inquiry in the United States. The critical analysis of art receives scant attention in our journals and institutions, although there is much facile description and anecdotal commentary about art served up in the press. If there is a crisis in criticism, there is certainly a crisis in the understanding of art. Its purposes, meanings, functions, and even its sources are obscure. Some feel that to probe these dark corners would be detrimental to art. Others choose to limit their examination to matters of style and form. But for those of us seeking a more comprehensive insight there is a shift of interest from form to function. Rather than limiting our inquiry to the *what* or *how* or art, we wish to pursue the *why*.

At a time of crisis, all the resources of the human mind must be brought into play. How can we ignore the paradigms of science, the researches of psychology, the structures of language, social and economic theory, the intimations of metaphysics, or the propositions of philosophy?

Though criticism in many ways appears to be moribund, there are pockets of highly specialized inquiry into art currently being pursued which, within their narrow terms of reference, are extremely valuable. How much more valuable would these studies be if they could combine their resources into a unified field of inquiry. Such intersection would constitute a field of *connective criticism*, which would not only contain the ambiguities, polarities, and contradictions of these separate approaches, but would identify correspondences, similarities, and new relationships.

Other critical disciplines will be encouraged to lend their con-

Statement prepared by Roy Ascott for a conference he organized at the Center for Critical Inquiry, San Francisco Art Institute, 1977. Previously unpublished.

ceptual frameworks and methodologies to the search for such a *metacritique*. Whether a unified field of critical inquiry will emerge and whether the interconnection of disciplines will lead to creative synthesis cannot be predicted. But to seek to "reforge the broken links between creation and knowledge, art and science, myth and concept," as Northrop Frye has exhorted us to do, is a necessary function of criticism at this point.

This is not the only role of criticism. Art is a system and finds its form in the interaction of many parts. The role of criticism in this system, like the role of the viewer or participant, is formative. The critical analysis of art not only clarifies but augments the many contexts within which it can be experienced and understood. Critical inquiry is a part of the making of art.

There is another sense in which criticism, properly employed, does more than elucidate and explain. It has a vital cultural function as the agent of speculation and change, pointing to future possibilities for the artist, perceiving new social needs, new sources of ideas, paths to awareness, and areas of interaction. *Speculative criticism* acts as a springboard to further dimensions of creative work, triggering new behaviors and attitudes of mind.

Art is a starting point; by its very nature, it is open-ended. Criticism must be as well. A definitive critique is a contradiction in terms, just as there are no limits to the experience and ideas an artwork can generate for the observer when he can *participate* in its evolution. Art is an open system. But for a fully creative culture, in which meanings, values, and realities can freely unfold and blossom, the participants must be informed, with access to ideas and attitudes from many dimensions of knowledge and experience. A Center for Critical Inquiry can serve to connect a diversity of disciplines, initiating probes and researches which may further the understanding of art and its future possibilities.

The Future of Visual Arts Education

1978 The future of art education at the post-secondary level must be ex-
amined in a post-institutional context. Mobility and networking will
become important constraints in educational theory and on cur-
ricular planning. Curriculum design in visual arts learning will not
be based on rigid compartmentalization and specialization (depart-
ments of painting, sculpture, etc.), although skill banks allowing for
media-specific instruction will remain. Instead, a learning landscape
will be available to the student that will be global in scope and call
on information and amenities from many disciplines and pursuits.

The necessary reconceptualization of the learning net will be
based on the idea of an exploratory and speculative field with po-
larities of information/structure/concept and probes into cultural/
technological/noetic areas. Each of these interconnected areas will
be approached by the student from the point of view of analysis,
theory, speculation, or social application. Such implied access and
interaction will dissolve the fine art/applied design dichotomies and
antipathies that currently exist at the professional level.

Through travel and teleconferencing, students will access a global
index of resources suited to their individual needs. This behavior
will become the norm, attendance at the college with a 9:00 to 5:00
schedule of classes becoming quite redundant. This will lead to
fewer permanent, monolithic buildings for art education, fewer
permanent institutions. A pattern of leasing, adapting to locally
available resources and short-term structures will emerge. Muse-
ums, too, will tend to physically disintegrate, becoming instead ex-
hibition systems. Art centres (New York, London, etc.) as a con-
cept and a marketplace will be replaced by moving centres.

Abstract for the World Future Society Education Section Meeting, University of Hous-
ton, Clear Lake City, October, 1978. Previously unpublished.

These tendencies will also bring about greater connectivity between artists, designers, and other professionals, breeding new hybrids: quantum artists, bio-aestheticians, and video-planners, for example. More holistic thought and images will occur; the currently emerging mode of participation in art will develop further, leading to a connective, network paradigm for art and art theory, calling for a connective criticism. These developments in art will call for and eventually bring about radical changes in the way we approach arts education.

TOWARDS A FIELD THEORY FOR POSTMODERNIST ART

1980

I would like to look at the attributes of a paradigm for art, a field theory that would replace the formalist modernist aesthetic. It takes as its focus not form but behaviour; not an information model of the sending/receiving of messages in a one-way linearity but the interrogation of probabilities by the viewer; it looks at a system in which the artwork is a matrix between two sets of behaviours (the artist and the observer), providing for a field of psychic interplay that can be generative of multiple meanings, where the final responsibility for meaning lies with the viewer.

To understand this paradigm, it is first necessary to know what formalist modernism was not. It was not connective, inclusive, transactional, associative, referential, interactive, changeable, discontinuous, multilayered, impure, ambiguous; it ignored autobiographical data and questions of personality. Postmodernist art, by encompassing these qualities, presents a connective paradigm, which in turn demands a connective criticism. This art we call "postmodern" recognizes time and periodicity, but, rather than being tied to one-way time series, it can move back and forth in time and can be associated in its reversibility with the new physics. It moves across and through different areas of knowledge, and in this networking, it can be associated with cybernetics.

It contains layers of possible meanings, all existing simultaneously but inertly until negotiated by the viewer, and can be associated with both new linguistics and the old Sufi thought. It mixes the left and right hemispheres and employs both reason, passion and chance. In comparison, formalist modernism employs a very restricted code.

Paper delivered on the panel "Towards Post-Modernist Form," College Art Association Annual Conference, New York, February 1978. Originally published in *Leonardo* 13, no. 1 (February 1980). © 1980 by the International Society for the Arts, Sciences and Technology (ISAST). Reprinted by permission of MIT Press.

The insistent linearity in time of formalist modernism was tied to the idea of progress and the future; the styles and the modes of the modernist aesthetic were linked almost causally in a straight line, on which there was no going back, for it was thought that to look to the past could only be regressive. I wish to point instead to a cyclical universe of interactions in space, time, and consciousness, where past, present, and future mingle, where the objective and subjective find their operational link in probability and indeterminacy, where we can explore the matrix of matter and psychism. Ambiguity, associative linkages, the boundary regions of art and consciousness, crossing the lines between individual dreams, memories and events, between cultures and histories: this is the prospectus for postmodernism.

Art does not reside in the artwork alone, nor in the activity of the artist alone, but is understood as a field of psychic probability, highly entropic, in which the viewer is actively involved, not in an act of closure in the sense of completing a discrete message from the artist (a passive process) but by interrogating and interacting with the system "artwork" to generate meaning. This field provides for transactions to take place between the psychic system "artist" and the psychic system "viewer," where both are, to use Umberto Eco's phrase, "gambling on the possibility of semiosis" [Eco 1976].

Thus the viewer/observer must be a participator and is of operational importance in the total behaviour of the system. A field theory of art must pay much attention to the participator.

Formalist modernism saw itself moving through time like an arrow, directed to the future with simple, clear, and direct messages on its shaft or, naively, with no messages at all, as if human consciousness were in any way disposed to abandon its prime function—the creation of meaning—in favour of a bland and passive contemplation of "pure" form. This idea of art always moving on, eyes set only on the future, with never a thought for previous events, is found also in biology and the theory of evolution, both tied up with the notion of development and irreversibility.

The claim of formalist modernism to have dispensed with the Newtonian worldview was correct only to some extent within its own formal terms (e.g., rejection of classical perspective), but the simplest analysis of its cultural form shows a totally Newtonian structure. Formalist modernism was explicitly a one-way street, stylistically irreversible, always rushing for the future, while insisting on maintaining an overall "modernist" orthodoxy. Even in its own terms, then, it was "faux modernist."

Werner Heisenberg's great contribution to physics and to epistemology in

general was to understand the limitations of this purely linear time-series view. There are no absolute outcomes to be predicted in quantum physics. All we can anticipate is "the distribution of possible futures of [a] system."

Norbert Wiener recognized the prime concept of semantic *alternatives*, seeing the transmission of information as "impossible save as a transmission of alternatives." In both physics and cybernetics, the importance of the observer as participator in creating meaning is recognized. The physicist knows that his observational behaviour and consciousness are a part of what he is observing. "The apparatus includes the consciousness of the participators." Equally, the artwork as matrix provides for an interlock of previously unrelated psychic fields—the artist and observer, which jointly provide the possibility for generating meaning.

The new understanding of art calls for new terms, a new language, a new set of metaphors. We shall not find these terms in formalist modernism; we shall not find them among "art" terms at all. One reason for this is the paradigmatic shift from an information model for art, which moves from "intentionalist" theory of messages to an *associative* form of communication. One model available to us in this sense is found in psi research and "paranormal" experience, which, as Jacques Vallée has intriguingly argued recently in *Co-Evolution Quarterly*, links in a sense with the way a user interacts with database software.

Just as the search by Vallée and others for a physics of information ("probing the reality of information handling by the brain from the point of view of associative constructs") can yield valuable insights for art, so links between quantum physics and Eastern spiritual models of consciousness (as in Fritjof Capra's popular *The Tao of Physics* [1975]) can be employed in the connective process of establishing a field theory for art.

Studies of cultural influences on perception are also useful and the work, for example, of F. H. Allport (1955) and F. T. Kilpatrick (1961) concerning the transactional hypothesis of perception (although now rather overlooked in favour of a more neurophysiological bias) can usefully amplify our understanding of the role of the viewer/observer/audience/participator of art. This area has long been ignored by formalist modernism.

We are in transition from materialist culture to one in which value is put upon the full dimensions of personal, psychic, and social life. In moving towards the spiritual in art, the postmodernist artist is simply closing the loop to the early aspirations of formalist modernism before it became trapped in a preoccupation with materialism.

In my own work, I recognize the primacy of the arena, the horizontal surface, and most specifically the table-top, as the focus for the processes of mod-

Figure 29. Roy Ascott online, Bath, 1980.

elling, imaging, and transacting that constitute my art. The horizontal surface mediates, symbolically and structurally, in the artist/viewer interaction, more directly than the vertical plane of painting. Whatever its content, the painting plane for me can never quite overcome its identification with "Mirror, mirror on the wall, who is the fairest of them all"—it seems best suited to the process of affirmation and answer giving—a contained set of bits of information—in short, a fixed message. Clearly, there are many examples to show that the vertical surface can provide sufficient possibility for ambiguity and, thus, greater viewer participation, but there is much potential in the open-endedness—*inconclusiveness*—of unfixed, changeable objects and elements on the horizontal surface, whether table-top or, on a larger scale, the arena. While the painting on the wall looks back only at us, reflecting given values, assertive of orthodoxy (especially the orthodoxy of formalist modernism), the arena and the table-top have a more cosmic outlook, facing up, not only to us, but to the whole universe. From the viewer's position, it offers a bird's-eye view, a more holistic, open perspective. But most valuable is the opportunity it provides for transactions between people across or upon its surface.

I wonder how video, for example, might change and break out of its formal prison if, rather than aping painting in the vertical, it were made to be viewed on the horizontal plane, with its technology extended to permit a more trans-actional, participative behaviour on the part of the observer.

This essay identifies a search for a field theory of art, which should perhaps be called a field theory of art and consciousness. Its terminology frequently em-ploys ideas of transaction, interplay, net, web, reversibility, association, psychism, multiple meaning, and connectivity. It will call for a connective criticism to be developed. It demands awareness of time, a reaching out to other disciplines and other operational modes of consciousness.

But, finally, like this essay, any field theory of art must be inconclusive. I have not sought to tie up loose ends, so much as to lay out the threads for a multidi-mensional network of ideas. Networking is the antithesis of reductionism, and to be inconclusive in this sense is the essence of the postmodernist condition.

1982 SHARP APL SERVICE

ARTBOX: ARTISTS PRIVATE MAILBOX SYSTEM
FOR DETAILS TYPE <DESCRIBE>
MESSAGE ID: ASCOT 33
MSG TITLE: ARS ELECTRONICA TEN WINGS PROJECT
DATED: SEPTEMBER 26, 1982
DISPLAY (Y/N): Y

TEN WINGS
A PROJECT FOR ARS ELECTRONICA 1982, INITIATED BY ROY ASCOTT
IN CONSULTATION WITH I CHING, THE BOOK OF CHANGES.

YOU ARE INVITED TO PARTICIPATE IN THE FIRST PLANETARY CONSUL-
TATION OF I CHING. THERE WILL BE TEN PLAYERS INVOLVED AROUND
THE PLANET, HENCE: "TEN WINGS". TEN WINGS IS ALSO THE NAME
ATTRIBUTED TO THE OLDEST EXPOSITION OF THE BOOK OF CHANGES.

THE PROJECT:
IT IS ESSENTIAL YOU RESPOND TO THIS CALL.
TO MAINTAIN PLANETARY BALANCE IN THE READING, AS SOON AS YOU
RECEIVE THIS MESSAGE, PREPARE TO PARTICIPATE AS FOLLOWS:
TAKE THREE COINS OF EQUAL SIZE. ASCRIBE NUMERICAL VALUES TO
EACH SIDE OF THE COINS. HEAD: THE VALUE 3. TAIL: THE VALUE
2. WHEN YOU ARE GIVEN THE SIGN TO DO SO, SHAKE THE COINS IN
YOUR CUPPED HANDS, LET THE COINS FALL SIMULTANEOUSLY.
RECORD THE SUM TOTAL OF EACH FALL.
FOR EXAMPLE: TWO HEADS: 3-3 AND A TAIL: 2 — THE SUM OF 8.
MAKE THREE THROWS OF THE COINS AND RECORD THE SEQUENCE OF
TOTALS FOR EACH THROW, FOR EXAMPLE: THROW 1: 8; THROW 2: 6;
THROW 3: 7. THEN IMMEDIATELY PLACE THIS INFO INTO YOUR TER-
MINAL ADDRESSED TO <ASCOT> ON IPSA ARTBOX.

PLEASE NOTE: THE SIGN FOR YOU TO BEGIN THE THROWING OF
COINS WILL BE THE FIRST SIGHT YOU HAVE OF A BIRD OR INSECT
IN FLIGHT: EITHER IN REAL SPACE, ON TV OR IN PRINT.

THE INFO RECEIVED FROM ALL POINTS WILL GENERATE TRIGRAMS
AND HEXAGRAMS WHICH THROUGH THE MEDIUM OF MY COORDINATION
WILL YIELD A MASTER HEXAGRAM. THIS WILL PRODUCE A "WORLD

A proposal for a telematic art project for Robert Adrian's "The World in 24 Hours,"
Ars Electronica exhibition, Linz, Austria, 1982.

QUESTION". KEEP THIS "WORLD QUESTION" VERY MUCH AS THE FOCUS OF YOUR
ATTENTION AS SOON AS YOU RECEIVE IT BACK FROM ME VIA ARTBOX. THEN RE-
PEAT THE PROCESS OF THROWING COINS THREE TIMES AS SHOWN ABOVE AND IM-
MEDIATELY SEND THE NEW SEQUENCE OF TOTALS TO ME ADDRESSED <ASCOT> AS
BEFORE. BY THE SAME PROCESS OF DIVINATION A JUDGEMENT, A COMMENTARY
AND AN IMAGE "IN TEXT" WILL BE GENERATED AND TRANSMITTED BACK TO YOU
AND TO THE ARS ELECTRONICA CENTER FOR DISPLAY.

ON RECEIPT OF THE FINAL TEXT AS ANSWER TO THE WORLD QUESTION, COL-
LATE ONTO A CARD, IN BLACK AND WHITE, FIVE IMAGES OF THE FIRST, RE-
PEAT THE FIRST FIVE OBJECTS, PEOPLE, THINGS OR PLACES WHICH RELATE
IMMEDIATELY IN ANY WAY TO THE "IMAGE" SUGGESTED BY THE TEXT AND MAIL
WITHIN 24 HOURS TO ROY ASCOTT, ART ACCESS/NETWORKING, 16, BLOOMFIELD
RD, BATH, ENGLAND. A DOCUMENTATION OF THE EVENT WILL BE MAILED TO ALL
THE PARTICIPANTS AND INTERESTED PARTIES. IS ALL.

THANKS.
ACCEPT (Y/N): Y
MSG ACCEPTED: ASCOT 33

ART AND TELEMATICS

Towards a Network Consciousness

1984 In Mill Valley, California in the spring of 1978, I got high on networking. I had anticipated the condition some seventeen years earlier in my rather wintry studio in London, where I was visited with a cybernetic vision of art after reading the works of Norbert Wiener and Ross Ashby [Wiener (1950) 1967; Ashby 1952], formulating a prospectus for creative work that could, as I saw it, raise consciousness to a higher level.

My work, on gallery walls and in colleges of art both in England and abroad (especially at Ealing, London, and at the Ontario College of Art [OCA], Toronto) attempted to create analogues of the cybernetic vision that I had committed to publication [see chapter 3 above], but one crucial element was missing. It was not simply that computer access was difficult to arrange, although that certainly was the case at that time, but that some link between the computer and the means of communication was (in my experience) lacking. I remember well how at the OCA in Toronto, the matrix: information/ concept/structure (a curricular triangulation we introduced to replace the antique departmentalised and constraining structure then and always to be found in orthodox art education) was thwarted by an overload of interactions, like those busy post offices that, while swamped with customers, insist on completing all the written transactions by hand. I knew that some crucial element in the available technology was missing.

More broadly, in my mind, the concept of a global creative network, a cybernetic art matrix, was clear, but not until some fifteen years after I had first digested the significance of integrative systems

Originally published in *Art + Telecommunication*, edited by Heidi Grundmann (Vancouver: Western Front, 1984), and reprinted with permission.

did I come upon the technology that could effect these transformations of culture I had so eagerly anticipated.

If that sounds unduly personal and autobiographical for an essay on art and telecommunications, that's nevertheless how it was. Networking invites personal disclosure. But to know of a brand-new technology is not necessarily to be able to get your hands on it.

It took me eighteen months to get funds and access to a network system. In 1980, thanks to an award from the National Endowment for the Arts in Washington, D.C., and Jacques Vallée's Infomedia Notepad computer conferencing system, I set up my first international networking project, mailing portable terminals to a group of artists in California, New York, and Wales to participate in collectively generating ideas from their own studios. One of the group, Don Burgy, chose to take his terminal wherever he was visiting and log in from there.

The possibilities of the medium began to unfold. Later that year I joined a group of scientists in SATURN ENCOUNTER, a global computer conference that, in electronic space, accompanied NASA's *Voyager II* probe of Saturn. The high remained.

As my contribution to Bob Adrian's "World in 24 Hours" event in Ars Electronica [1982], I had players at their terminals around the world toss coins for the first planetary throw of the I Ching [see chapter 10 above]. As I recall, we got close to eighth hexagram, PI (holding together/union), but the bottom line of the lower trigram was unbroken, which transformed the reading into the third hexagram, CHUN (difficulty at the beginning), which was undoubtedly true. In fact, looking at the emergence of networking for art, the offspring of this momentous convergence of computers and telecommunications, the commentary on CHUN is particularly apt: "Times of growth are beset with difficulties. They resemble a first birth. But these difficulties arise from the very profusion of all that is struggling to attain form. Everything is in motion: therefore if one perseveres there is the prospect of great success" [*I Ching* 1950, 16].

Over the past three years, I have been interacting through my terminal with artists in Australia, Europe, and North America once or twice a week through I. P. Sharp's ARTBOX. I haven't come down from that high yet, and frankly I don't expect to. Logging on to the network, sharing the exchange of ideas, propositions, visions, and sheer gossip is exhilarating; in fact, it becomes totally compelling and addictive. It was Don Burgy, in the first project, whose twenty-sixth entry confided: "Guess I'm hooked because I just got up and the first thing I did (after brushing my teeth) was to log in."

A new user coming online even for the first time senses a connection and a

close community, almost intimacy, which is quite unlike initial face-to-face meetings. For anyone not involved in networking, it is probably hard to imagine how a computer-based medium could possibly be convivial and friendly or how indeed working at a data terminal could lead to interconnections between human beings at any real level of meaning at all. The very term "information technology" sounds cold and rather alienating, like the outer offices of some Kafkaesque institution.

In fact, the opposite is the case, and computer-mediated networks, in my view, offer the possibility of a kind of planetary conviviality and creativity that no other means of communication has been able to achieve. One reason may be that networking puts you, in a sense, out of body, linking your mind into a kind of timeless sea. It is a more precise condition than the oceanic feeling that Jung describes in proposing a collective unconscious, and that is because it deals with more than feeling—with particular ideas and associations, too. These ideas, being generated from a diversity of scattered locations, set in widely different cultural contexts and channelled, of course, through uniquely different individuals, may become densely layered in meaning and implication. Networking produces an interweaving of imaginations that gives the term "associative thinking" the most amplified interpretation.

The metaphor of weaving is especially potent in current thought. The physicists Fritjof Capra and David Bohm attest to the seamless web of interconnected events detectable at the quantum level of reality. Bohm writes of the unravelling of an implicate order in the universe, and Capra finds it entirely fitting to interlink his exposition of contemporary physics with the Taoist metaphysics [Bohm 1981; Capra (1975) 1977]. (*Tantra*, meaning weaving, is the Buddhist denotation of cosmic interconnectedness.) Earlier, Marshall McLuhan alerted us to the cultural transfusion in which "[e]lectric circuitry is Orientalizing the West. The constrained, the distinct, the separate—our Western legacy—are being replaced by the following, the unified, the fused" [McLuhan 1964].

Significant, too, especially at this stage of technological development, when the telematic dissemination of text is more advanced and a good deal cheaper than interactive networking of images, are the observations of Roland Barthes:

> Text means tissue; but whereas hitherto we have always taken this tissue as a product, a ready made veil, behind which lies, more or less hidden, meaning (truth), we are now emphasising, in the tissue, the generative idea that the text is made, is worked out in a perpetual interweaving; lost in this tissue—this texture—the subject unmakes himself, like a spider dissolving in the constructive secretions of its web. [Barthes 1975, 64]

In more practical terms, Jacques Vallée, a pioneer with Robert Johansen of the FORUM computer conferencing system, developed at the Institute for the Future, and foremost in the field of technological application of networking to commercial, industrial, and educational needs, has pointed out the uniqueness of the medium: "Computer conferencing is the first medium of human interaction that uses the computer as its base of support. The telephone was based on simple knowledge of electric currents. Radio and television use electromagnetic waves. (Networking is) a medium that fully utilises the logical and memory abilities of the modern computer. . . . The long term consequences are incalculable" [Johanesen et al. 1979, 148]. In the context of weaving and linking minds, during the Saturn Encounter Project, Vallée made the following point: "In any other medium (and even in the marvellous television pictures [of Saturn] we are seeing from Voyager) the sense of time and space is always present. Not so in computer conferencing since we truly link minds wherever they are, and the sense of time is lost rapidly in the group interaction that transcends it" [Vallée 1981].

There seem to me to be two seminal essays on the significance of computerised telecommunications for society as a whole. One is by Daniel Bell of Harvard, who has coined the phrase "the information society" [Bell 1979]; the other is a report to the president of France entitled *L'Informatisation de la société (The Computerisation of Society)* by Simon Nora and Alain Minc, who introduce the term "telematics." According to Nora and Minc, telematics is the "springing to life born of the marriage between computers and communications networks, which will culminate in the arrival of universal satellites, transmitting images, data and sounds" [Nora and Minc 1980, 13].

Around this new medium, a wealth of terms and neologisms have been generated, none of which have yet achieved universal acceptance. In *The Network Nation: Human Communication via Computer,* Starr Roxanne Hiltz and Murray Turoff cite the terms "computerized conferencing" (USA), "computer-mediated interaction" (Canada), and "teleconferencing" [Hiltz and Turoff 1978]. Anthony Oettinger has advanced the neologism "compunications" [Oettinger et al. 1977]. I prefer to use the terms "networking," for the activity, and "telematics," for the medium as a whole.

This is no place to trace the history of telematics, even though it is an exceedingly brief history, compared even to the relatively recent emergence of its two component parts—telecommunications and computers. But what I do want to show, or propose, is that the convergence of these two, in themselves vastly powerful media, constitutes a paradigm change in our culture and, without be-

ing foolishly optimistic, I hope, what may amount to a quantum leap in human consciousness. I am certainly not alone in this, and I propose to cite a variety of writers from a variety of disciplines who collectively contribute to a vision of the future of the human condition that is rather hopeful. At the same time, I shall try to make it clear that for art, telematics—while being the product of considerable technological innovation—can equally be seen to carry forward an aesthetic of participation and interconnectedness implicit in the developing strands of art practice during this century. Indeed, it in many ways constitutes a return to values expressed in the culture of the very distant past.

Initially, however, I want to refer to the telematic networking of text. Currently, to apply telematic processes of distributed authorship to the generating of images is extremely expensive and virtually inaccessible for any sustained creative enterprise. The text is both cheaper and easier to process. When I first used it, I saw it very much as a secondary medium and not capable of serving as the central component of my art practice. However, my experience of the past three years has led me to feel that the text can, in its own right—seen as it emerges, hot off the roll of a thermal printer, so to speak; or, especially, inhabiting the electronic space of a VDU (visual display unit; *console de visualisation* is more poetic)—have primary significance in my work. Not, as I had previously used it, as a vehicle for analysis or explication, or (as usually is the case, I'm afraid, with artists like myself) for rhetoric, but distinctly a thing in itself, a concrete entity with its own space—a space that was new to me and that remains enigmatic, mysterious, and wondrous. To extend the video output by data projector to a large screen format only further enhances the palpable presence of the text in this non-localised, timeless space.

My belief in this new order of the text, actually a new order of discourse, and my wish to exercise and celebrate the participatory mode of dispersed authorship that networking affords, led me to devise a project wholly concerned with the interweaving of textual inputs from a global distribution of artists. This became "La Plissure du Texte" in the exhibition "Electra" 1983 at the Musée d'Art moderne de la Ville de Paris.

The title of the project alludes, of course, to Roland Barthes's book *Le Plaisir du texte*; but pleating (*plissure*) is not intended to replace pleasure (*plaisir*), only to amplify and enhance it. Barthes's book is rich in insights into what we do when we enjoy a text. It is a wonderful book and, along with his *Writing Degree Zero*, *S/Z*, and *Mythologies*, pumps blood into the otherwise colourless body of semiological thought and is prodigiously fertile in ideas for the artist. But the text Barthes writes about is not "telematic text" as I experience it, and the au-

thorship he analyses is not the "distributed authorship" of networking. So that when he celebrates the *jouissance* that text stimulates—which is best understood as "coming" or "knowing" (biblical) or "spending" (Victorian)—it seems to be very much a solitary act that Barthes describes. Telematic text by contrast, rather than affording a *jouissance solitaire*, offers the means of a "coming to-gether." It is a distributed but not dissipated jouissance; metaphysically strange (at first) since the act is indifferent to the geographical location of its contrib-utors, as it is to the time or sequence of their interventions. It constitutes a "bliss" that is visited on every point of the system that generated it. The processes of coming and going of information is wavelike, and without wish-ing to stretch the metaphor beyond credibility, at the full intensity of interac-tion in a creative networking project, these waves can extend to the most pro-longed stage of jouissance.

Some people would feel that the text is most satisfying when it is the most precise; that the certainty of the message, an underlying determinism of the un-folding discourse is what is most sought in its production and consumption. But to be involved with creative work in the telematic mode is to search for and to play with uncertainty and ambiguity rather than to strive for semantic outcomes of the finite kind. To "understand" what is going on in the transactional pro-cess of network art is to merge into the waves of planetary inputs, the modu-lation of ideas passed around the multiplicity of terminals, and to identify with the patterns of change that surge through the lines of communication. It can feel, not just like an extension of mind, but like an extension of the body. There can be this sense of out-of-body experience, joining up with others in the aetheric, electronic, and totally timeless space. There are high tides and low tides of these wave motions, these ripples of meaning; greater or lesser densities of textual loadings. I do not mean to imply that the medium is the message, but that the interwoven texture of the messages in the telematic medium certainly informs and contextualises the artist's engagement with it.

But whether with the text or the visual image, telematic networking gener-ates discourse—discourse of an order unlike speech or writing, but discourse none the less, which exists in relation to desire and power just as the other or-ders do. In examining this, we can be guided by Michel Foucault's *L'Ordre du discours* (although in no way does he refer to the telematic process or to distrib-uted authorship) [Foucault 1971].

I have mentioned already the addictive itch to log on to the network that users quickly acquire. The conviviality of the medium (Terry Winograd has written usefully on this [Winograd 1979]—if only Ivan Illich would welcome electronic

Figure 30. "La Plissure du Texte." 1983. Students in the Music Gallery, Ontario College of Art, Toronto.

systems of at least this kind into his inventory of social tools!) invites frequent
returns to the keyboard, to reach out to others in the "field" who are at once to
be woven into a text. Compared to the towering achievements of the art of pre-
vious eras, networking must appear puny and insignificant. Foucault points out
that speech, similarly, may be of little account in appearance, but that the pro-
hibitions surrounding it soon reveal its links with desire and power: "This should
not be very surprising, for psychoanalysis has already shown us that speech is
not merely the medium that manifests—or dissembles—desires; it is also the
object of desire." Interwoven and shared text of telematics is a form of discourse
for which we have no name. It is not speech, nor is it writing as we know it in
the book. Authorship is distributed, meaning is negotiated—but it too can be
the object of desire. To continue in Foucault's Nietzschean vein, networking
can be seen as an issue of the "will to truth," since its form, spreading over the
whole planet, invisible in a sense, promises to evade those systems set up for the
control and delimitation of discourse: "In any society, the production of dis-
course is at once controlled, selected, organised, and redistributed according to
a number of procedures whose role is to avert its powers and its changes, to
cope with chance events, to evade its ponderous, awesome materiality."

We can expect a growing and close interest in telematics on the part of the

controlling institutions in our society. At present, most timesharing systems are in the hands of the multinational corporations and the military, in any case, but there is general agreement that over the next ten years, telematic networks will spread over the whole earth, the growth of data banks will be exponential, and information processing will acquire priority status in most countries. Japan's total national commitment to acquire world leadership in knowledge information processing systems (KIPS) by the 1990s, and the intensity of effort to sustain ICOT, the Institute of New Generation Computer Technology, gives further significance to the notion of a "telematic imperative" in culture [Feigenbaum and McCorduck 1983].

In his 1978 report to the French president, Simon Nora draws attention to the inevitable spread of networks:

> Today any consumer of electricity can instantly obtain the electrical power he needs without worrying where it comes from or how much it costs. There is every reason to assume that the same will be true in future of telematics. Once the initial connections are made, the network will spread by osmosis . . . thus, within a relatively short time, the debate will focus on interconnectability. . . . In the past, the stakes in the computer game were limited—they were commercial, industrial or military. Now, with data processing dispersing into a limitless variety of small machines and disappearing behind a network with infinite branches, it is drawing society as a whole into its net.

I considered identifying some of the ambitious experiments in interactive VIDEOTEX that are currently being pursued, for example, in Canada, where Sask-Tel has been running its PATHFINDER trials, using Telidon to link up a small but scattered community in Saskatchewan, or the wiring of Velisie, an urban community outside Paris, for a complete range of interactive systems. But I need reach no further than this morning's mail to give an example of the proliferation of commercial telematics.

Here on my desk is a postal solicitation from a savings and loan company to do business with them through a home terminal that they will be happy to provide me with at virtually no cost. I can invest, borrow, or transfer funds, pay bills, do my teleshopping, and access 250,000 pages of PRESTEL information. More important, I can interact with anyone else in the system and initiate messages, which will be stored until they are ready to be accessed. If I wish to display as "artwork" some visual/textual mosaic for public viewing, I can rent a page in the PRESTEL files. It may lack the subtlety and flexibility of the more advanced computer-mediated networks, but it is here now on the domestic doorstep.

However, even the most rudimentary overview of experiments in computerised telecommunications in the broad social context would be lacking if it failed to mention the enormous imaginative effort that has gone into the proposals for a *carrefour*, or crossroads, of telecommunications—the International Centre for Communications at Tête Defense in Paris. This is planned to be a test bed for new information technology, a public access point for the newest developments in interactive media, a museum, an art space, a language research centre and a kind of creative technological and intellectual switching unit for the whole telecommunications field. The background papers for this initiative, along with Elaine Kerr and Starr Roxanne Hiltz's study *Computer-Mediated Communication Systems*, for the Computerised Conferencing and Communications Centre at the New Jersey Institute of Technology at Newark, together provide essential reading for anyone, and particularly artists, wishing to fully understand the scope of the medium [Kerr and Hiltz 1982].

Though we can expect both regional and international regulatory bodies to proliferate in consort with network expansion, the particular nature of telematic discourse makes it less amenable to control. For the artist, its out-of-body, asynchronous, dispersed, interactive, and semantically layered qualities make the medium less vulnerable to cultural constraint than earlier modes of expression.[1]

Foucault speaks of "fellowships of discourse" that have operated to preserve orders of discourse and their secrets within a closed community, in which "roles of speaking and listening were not interchangeable." But he warns us not to be deceived into thinking that (widely) published discourse is free from secret appropriation and non-interchangeability: "The separateness of the writer, continually opposed to the activity of all other writing and speaking subjects, the intransitive character he lends to discourse, the fundamental singularity he has long accorded to 'writing' . . . all this manifests in its formulation . . . the existence of a certain 'fellowship of discourse'" [Foucault 1972].

I want to propose, perhaps naively and without caution in the light of society's relentless determination always to institutionalise and contain creativity by any means, that telematic discourse can exist outside such closed systems, or that a much more inclusive, indeed, planetary, "fellowship of discourse" can be created, lying outside and circumnavigating the institutional management of discourse as it now exists in book production, conventional telecommunications, and entertainment media structures.

The visual discourse of art, embodied in painting, sculpture, film, and photography, has its own closed fellowship. For all the apparent freedom from constraint cherished in the mythology of the avant-garde, the ways of addressing

artwork (either as "sender" or "receiver") constitute a set of rules, the learning of which permit entry into the permitted discourse. The control, selection, organization, and redistribution of art must be understood as part of the large ordering processes in society, where art is the subset of a wider discourse, subject to the institutional management of desire and power.

Telematics does not only generate a new order of art discourse but demands a new form of criticism and analysis. The theory of this mode of art will have its technical, philosophical, and communications aspect bound up within a larger cybernetic framework, which Gregory Bateson has called "ecology of mind" [Bateson 1972]. This in turn will produce a re-evaluation and fresh interpretation of older art forms, since it can be argued that meaning has never in reality been created by a one-way dispatch, nor do new ideas of images originate in the solitary mind. Individual genius was the invention of an era that chose to delimit and contain the subversive power of art within fixed, identifiable boundaries. The field of communications-network analysis is especially relevant here, and the major shift of emphasis within this field of research in recent years points up the dialectic between the telematic model and the older paradigm of art discourse. As E. M. Rogers and D. L. Kincaid have noted:

> Communications research in the past has almost always followed a linear, "components" model of the human communication act. Such research mainly investigated the effects of communication messages from a source to a receiver, in a one-way, persuasive-type paradigm that is not consistent with our basic conception of the communication process as mutual information-exchange, as sharing meanings, as convergence. [The new approach] is guided by a convergence model of communication based on a cybernetic explanation of human behaviour from a systems perspective. [Rogers and Kincaid 1981, xi]

This may sound a far cry from the poetics of *télématique*, but we should remind ourselves that the ordering of ideas supporting the cardinal concept of perspective in the formative period of Renaissance art called equally for rigours of thought and measurement that were at least as demanding. *La bella prospettiva* after all kept Uccello from his lady's bed night after night.

Perspective underwrote a mode of visual discourse that separated out both the individual artist and the solitary viewer: a one-way view of the world calling for a one-way reading of the visual field. It called for a head-to-toe consistency with human viewing that was at once isolating and alienating.

As McLuhan noted: "The view of renaissance art is systematically placed out-

side the frame of experience. A piazza for everything and everything in its piazza. The instantaneous world of electric information media involves all of us, all at once. No detachment of frame is possible" [McLuhan 1967]. In telematic discourse, meanings are not asserted and consumed in one-way linearity, but negotiated, distributed, transformed, and layered in multiple exchanges, where the authorial role is decentralised and scattered in space and time.

But "vertical field viewing" in visual art began to give way at the beginning of this century to a more inclusive "bird's-eye view" of the world that sought a more composite, holistic patterning of events. Some would nominate Marcel Duchamp as the most vital force at that time in this radical shift in art, which finds its expression in the tilt of the picture plane from the vertical to the horizontal. As Leo Steinberg has pointed out, Duchamp's *Large Glass* or his *Tu m'* is no longer the analogue of a world perceived from an upright position, but a matrix of information conveniently placed in a vertical situation. Steinberg goes on to show how

> something happened in painting around 1950—most conspicuously (at least in my experience) in the work of Rauschenberg and Dubuffet. We can still hang their pictures—just as we tack up maps and architectural plans . . . yet these pictures no longer simulate vertical fields, but opaque, flatbed horizontals. They no more rely on a head to toe correspondence with human posture than a newspaper does. The flatbed picture plane makes its symbolic allusion to hard surfaces such as table tops, studio floors, charts, bulletin boards—any receptor surface on which objects are scattered, on which data is entered, on which information may be received, printed, impressed—whether coherently or in confusion. The pictures of the last fifteen to twenty years insist on a radically new orientation, in which the painted surface is no longer the analogue of a visual experience of nature but of operational processes. [Steinberg 1972]

Perhaps the most powerful visual metaphor of telematic interconnectedness that painting of that transitional period could offer is to be found in Jackson Pollock's work. Here the horizontal arena is both celebrated and actually employed in the production of the painting. Pollock creates "fields" of intertwining, interweaving, branching, joining, crossing, linking lines of energy, creating an "all-overness" and "all-at-onceness" that is the very epitome of telematic networking. His space is inclusive and inviting, in a sense providing for a kind of anonymity of authorship that embraces the viewer in the creation of meanings. The metaphysical promise of Pollock's work is made technologically explicit in telematic systems, where the dichotomy of artist/viewer or sender/receiver of

the earlier era is resolved into a unitary "user" of the creative system. Pollock's painting surface was an "arena," a meeting place, of behaviour, myth, and idea. The computerised network is another kind of meeting place, an electronic arena for creative work.

I see this shift to the horizontal as a renewal as much as "the new," a return to very ancient values belonging to a more holistic worldview.

Many of the behaviours of transaction, negotiation, even interconnectedness, can be understood in terms of the table-top. It is a compact meeting place, a microcosm of larger fields of interaction. Claude Lévi-Strauss has taken particular note of the structure of table manners in the mythical texts of the native people of America. The table-top and its required forms of exchange constitute an ethical process to unify the inner life of man and the external world of nature. In our own culture, he points out, we have simply been concerned with control of the external world, where the events of nature and of other people are seen as a continual threat to be mastered [Lévi-Strauss 1978]. Is there some connection between the insistent verticality of viewing in art and the aggressive, alienating stance of a society? The re-emergence in our culture in recent decades of interest in the psyche, in co-operative human action, in a more holistic approach to the planet, seems to be all of a piece with the impulse towards "flatbed" inclusiveness in contemporary cultural forms.

Telematic networks can provide an extensive electronic meeting place for culture, a non-localised table-top for the most intimate and inclusive dialogue and exchange. One of the earliest experiments in electronic remote conferencing was called the "electronic round table," I seem to recall, although at that time the idea of computer mediation was no more than a dream. The dream has become realised now, with vast dimensions and implication in the telematic domain. Two of the principal components, machine memory and artificial intelligence (AI) have hardly begun to be investigated by the artist. On our agenda must be the inquiry into the extent to which, through its internal "semantic network," calling upon memory and intelligence, the computer can itself contribute to our artistic strategies. Can the information matrix, this electronic meeting place of minds, itself generate ideas from its experience of the ideas it mediates? The extent to which a telematic network can learn itself is a question only a fifth-generation system will be able to begin to answer. But in human learning, and I have in mind especially the education of artists, telematics offers enormous scope. Unlike the orthodox media, telematic systems are unlike any other technological applications to learning. On the prospects of networking for education, Vallée notes,

they involve group interaction *through* the technology. And this interactive capability means they do not have to be impersonal, authoritarian or boring. Learning via teleconferencing does not require pre-packaged instruction programs as does television or programmed learning. The electronic seminar is as possible as the electronic lecture. Furthermore, with media like audio or computer-based conferencing, it is possible for students to put together their own learning networks and call upon people who, because of geographical location, might otherwise be inaccessible. Education might become student-centered rather than institution-centered. [Vallée 1981]

Telematics has arisen from an ethos of cross-disciplinary science and is set within a cybernetic perspective of the world. Numerous writers have attempted to describe the enormous changes they see occurring in human awareness, which some see as a kind of planetary consciousness. Teilhard de Chardin imagined a noosphere, a thinking layer, enveloping the biosphere of the earth. Peter Russell has more recently advanced the hypothesis of the emergence of a planetary brain that may put us onto "the threshold of a completely new level of evolution, as different from consciousness as consciousness is from life and life is from matter." He further suggests that this process will result in "a global brain which will result in a shift in human ego-centred awareness to a unified field of shared awareness" [Russell 1983].

Russell sees this occurring as a result of the exponential rate of information processing and global telecommunications. In comparing planetary networking to the emergence of multicellular organisms a billion years ago, he takes his theory to the point where, "as communications networks increase, we will eventually reach a point where the billions of information exchanges shuttling through the networks at any one time can create patterns of coherence in the global brain, similar to those found in the human brain." He goes on to argue that "[a]dvances in each of the technologies involved accelerate progress in all the others. The cross-catalyzing effect of these technologies suggests we are in the midst of a phase that has no evolutionary precedent."

However inflated his expectations may seem to be, there can be little doubt that the engagement of creative minds in telematic systems will affect human consciousness and transform our culture.

To the unconvinced, the artist who commits himself or herself to networking as a primary medium is playing with dreams. But it was, after all, the most grounded of men who said "it is pricing life exactly at its worth, to abandon it for a dream." Montaigne would have been in tune also, I suspect, with Hazel Henderson's description of networking in the real world:

> Out of all our current social ferment, organisations are slowly learning that if they and our society are to survive, they will need to reformulate their goals and restructure themselves along less pyramidal, hierarchical lines. Such participatory, flexible, organic, and cybernetic design is now mandatory in the face of cataclysmic changes. . . . In fact the ultimate organisations already exist although they are metaphysical. They are most often referred to as networks. . . . Few theorists have yet studied networks because they are evanescent, ebbing and flowing around issues, ideas and knowledge. Luckily, networks are linked by the mimeograph machine, the postal system and the telephone—all decentralised technologies accessible to individual users. . . . Networking cross hatches all existing structured institutions and links diverse participants who are in metaphysical harmony . . . networking is the most vital, intelligent, integrative organisational mode on our turbulent social scene . . . it may even augur the next revolutionary step in developing human consciousness. [Henderson 1978, 234–35]

I have concentrated here on the nature of telematic networking in its structure, scope, and possible cultural consequences, rather than citing examples of the specific content of specific art projects in the medium. This is because, whether interacting in the textual or visual mode, the specific data generated can only be understood in the totality of the transactional experience.

Work at the interface of the network, at a console with keyboard, VDU, printer, or plotter is, in itself, sensuously satisfying: the rhythm of the printer, the unrolling of the paper, the glow of the CRT, the secret stillness and precision of the software, the immaculately delicate responsiveness of the keyboard, the whirring and bleeping of control signals can induce moods that can excite enthusiastic expectancy or a meditative tranquillity. The electronic space of the video output that the text and image inhabit is a new kind of space, not at all that of the projected space of film or the illusionary space of photography. It is more ethereal and metaphysical than paint, though no less palpable. It coalesces on a two-dimensional screen, but its depth is infinite. With appropriate software, the text can be deconstructed, disassembled, redeployed, inverted, withdrawn, squashed, stretched, removed, recalled, cut, chopped, twisted. The field of the text is mosaic; but, if scrolled, it can be set rolling for eternity. There need be no beginning and no end to the text. It can be generated by a multiplicity of participants, or transferred privately to a targeted interlocutor. The space is negotiable space; it invites interrogation.

It is that rare medium in which errors of input, whether clumsy typing or mistaken insertion of extraneous material, are somehow instantly acceptable and accommodated by your collaborators in the network; rather as, when you are

working entirely alone, you not only accept mistakes but so often find within them the seeds of new, totally unexpected ideas for development. There is always this sense of community, the presence of your collaborators is all about you, albeit in another space, telematic space, present but silent unless summoned up through the matrix you all share.

Networking is a shared activity of mind and a form of behaviour that is both a dance and an embrace. It brings about a convergence of ideas from scattered sources, which, then, amplified, platted or stacked, diverge out into branching pathways of meaning. This darting to and fro of ideas and images (let's call it creative data), colliding, emitting new combinations, absorbing each other, virtual, real, in a state of continual transformation, puts me in mind of Gary Zukav's description of the dance of subatomic particles, "which never ends and is never the same" [Zukav 1979, 232].

That, I would see, as the grand aspiration of networking in art, where the artwork, the transformations of "creative data," are in perpetual motion, an unending process. In this sense, art itself becomes, not a discrete set of entities, but rather a web of relationships between ideas and images in constant flux, to which no single authorship is attributable, and whose meanings depend on the active participation of whoever enters the network. In a sense, there is one wholeness, the flow of the network in which every idea is a part of every other idea, in which every participant reflects every other participant in the whole. This grand reciprocity, this symmetry of sender and receiver, is such that a mirror image is exchanged, in which sender is receiver and receiver sender. The observer of the "artwork" is a participator who, in accessing the system, transforms it. The physicists who attempt to explain the quantum view that all particles exist potentially as different combinations of other particles often cite the Buddhist parallel view of the world, expressed in the metaphor of Indra's net: "In the heaven of Indra, there is said to be a network of pearls, so arranged that if you look at one you see all the others reflected in it. In the same way each object in the world is not merely itself but involves every other object and in fact *is* everything else."[2]

The creative use of networks makes them organisms. The work is never in a state of completion, how could it be so? Télématique is a decentralising medium; its metaphor is that of a web or net in which there is no centre, or hierarchy, no top nor bottom. It breaks the boundaries not only of the insular individual but of institutions, territories, and time zones. To engage in telematic communication is to be at once everywhere and nowhere. In this, it is subversive. It subverts the idea of authorship bound up within the solitary individual. It subverts

the idea of individual ownership of the works of imagination. It replaces the bricks and mortar of institutions of culture and learning with an invisible college and a floating museum, the reach of which is always expanding to include new possibilities of mind and new intimations of reality.

NOTES

1 On the concepts of acausality and synchronicity (in the sense of the atemporal quality that Ascott ascribes to telematics), see Jung 1973. Jung's theory was predicated in part on the parapsychological research of J. B. Rhine at Duke University.—Ed.

2 Sir Charles Elliot, *Japanese Buddhism* (1933; New York: Barnes & Noble, 1969), 109, quoted in Capra [1975] 1977.

CONCERNING NETS AND SPURS

Meaning, Mind, and Telematic Diffusion

1985 The first part of this title comes from the ninth-century Byzantine scholar Photius's summary of Dionysios of Aegeae's book "Concerning Nets," a text related to the creation of mortals;[1] we are reminded that Plato likened the intertwining of the nerves, veins, and arteries to "the network of a basket." This model is part of a larger project in ancient thought that sought to establish the weaving of networks as an essential metaphor of creation in the universe and in human action. It is a metaphor, as we shall see, that equally informs the most recent ideas about the universe in quantum physics and in models of the brain and of mind at large as it is diffused by computerised telecommunication networks over the face of the planet and out into space.

The second part of the title of this essay is provided by Jacques Derrida's book *Éperons: Les Styles de Nietzsche* (translated as *Spurs: Nietzsche's Styles* [Derrida 1979]), standing metonymically for that corpus of texts by Roland Barthes, Michel Foucault, Derrida, and the poststructuralist, deconstructive practice they have advanced. "Spurs" gives us those hooks into images and texts that enable us to unravel meanings, while at the same time spurring us on to weave new semantic networks from the threads we have unpicked.

The whole poststructuralist project can be seen as the necessary (and perhaps inevitable) correlative to the emergent communications technology that is so radically and rapidly affecting our ways of human interaction, the diffusion and integration of ideas, and our understanding and use of memory, language, and even human identity. This supports a prospectus for a post-aesthetic practice that, with the full cooperation of computer intelligence, seeks to weave

Originally published in *Artificial Intelligence in the Arts*, edited by Richard Kriesche (Graz: Steirischer Herbst, 1985), and reprinted by permission of Richard Kriesche and Kulturdata.

new images and texts, a new "order" of image text, out of the strands of ideas and experience so long unconnected and separated into exclusive orders of things: "science," "art," "philosophy," and "technology," so as to more thoroughly articulate and advance our desires for a more holistic relationship between ourselves and the universe.

The rubric "telematics" not only refers to the convergence of computers and telecommunications systems but qualifies a whole class of consciousness and culture in which new modalities of knowledge and the means of their distribution are being tested and extended. Telematics implies interaction, negotiation, and collaboration amongst human beings and intelligent machines. Telematic process involves ambiguity, uncertainty, and incompleteness; meaning is not given but negotiated, endlessly reconstituted and redefined; truth, always relative, does not lie in an absolute location but is embedded in process, is telematically inscribed in the networking that is human behaviour at its most liberated.

How, then, are images, ideas, text, and data brought together, kept ready for our immediate engagement, regardless of their place or time of origin, by that vast world memory, computer memory, or set of submemories linked together by networks in a way that constitutes planetary memory, mind at large?

Computer memory works by associative search; it can range over information regardless of the kinds of categories that, in books or on library shelves, would previously keep ideas apart. Set to search for, say, "nets," it will immediately gather references from a multitude of previously unconnected categories of knowledge. The computer searches associatively, as our brain searches associatively—or as our brain "can" search associatively (creatively, artistically, inventively) when it is not repressed by linear thinking, that Cartesian constriction of thought so systematically imposed in our schools and institutions of higher learning.

Nothing is totally new, but whether we view the direction of human "development" as circular or spiral, it may be instructive to look briefly at some ancient expressions of network consciousness, obviously devoid of modern communications technology but drawing from the same mythic and psychic ground.

Advanced technology is not innocent or value-free; it carries a psychic charge such that to interact with it is to change the psyche. When the whole planet engages with a technology as widespread as telematics, then a sea-change in world order can be expected. To understand the deep-rooted insights, the human meaning, implicit in this technology is important, and much work must be done

on this. It is an enterprise that cannot be trusted either to artists and poets alone or to scientists and philosophers. It calls for a new order of investigation, a collaboration that may in time reveal new myths, archetypes, and resonant world images, or a new understanding, a telematic relevance, of the ancient ones.

What, then, are these ancient myths that give to these images of nets, networking, and weaving their potency as metaphors of such far-reaching significance? They combine the notion of cosmic creativity and the knitting together into one mantle of a new order of knowledge—a mantle that is not only thrown over the old order but is used to ensnare it and put it down.

In his book *Orpheus* [1896], G. R. S. Mead pointed out the early Greek undertaking to identify weaving with creativity: "the work that Kore performs is that of weaving; she plies her shuttle in the 'roaring loom of time,' and weaves out the universe. Proclus tells us that Kore-Proserpine 'weaves the diacosm of life' and Claudianus speaks of a goddess weaving a web for her mother, 'and in it she marks out the procession of the elements and the paternal seats with her needle, according to the laws whereby her mother Nature has decreed.'" We learn also of Proserpine "weaving a robe for Zeus" and Minerva weaving a mantle marvellously interwoven with pictures of the sky and sea, like the robe Plutarch describes as the "image of the cosmos and heavenly phenomena."

Giorgio de Santillana and Hertha von Dechend, too, have shown the potency of the network metaphor, not just in reference to the weaving together of elements into a new pattern, but as an instrument to ensnare old ideas and "pull down the structure." In *Hamlet's Mill: An Essay on Myth and the Frame of Time* [1969], they show how "in many myths the destruction of the building is linked with a net." The building represents an edifice of ideas, values, beliefs. The Hamlet (Amlethus) of the medieval Danish historian Saxo Grammaticus reappears at the banquet set by the king for his own supposed funeral (burial of new ideas). He throws the knotted carpet net prepared by his mother over the drunken crowd and burns down the hall. Similarly, in the fall of the House of Atreus, Clytemnestra throws a net over the king struggling in his bath.

New ideas are woven together from the threads of the old and provide a net or mantle to cover over and demolish the old order. In Saxo and Claudianus, the pattern from which the net is woven comes from the "mother," the matrix or model of new ideas. For Santillana, that matrix was in the sky: "What that net could be is known from the story of Kaulu [who] wanting to destroy a she-cannibal, flew up to Makalii the great god, and asked for the nets, the Pleiades and the Hyades, into which he entangled the evil one before he burned down the house."

It is not in the stars alone but in the "cosmic web" within us, within matter at the deepest energetic level, that the myth of network connectedness becomes the science of quantum physics.

Equally, in art, a new matrix or mode, consistent with the emergence of telematic technology, resistant to the status quo, deconstructive of tradition, informs poststructuralism, absorbing it while destroying it. Here the nets are invisible or at least "immaterial," to draw on the title of a significant exhibition organised by Jean-François Lyotard and Thierry Chaput at the Centre Pompidou in Paris, "Les Immatériaux," which registers the dissolution of the old orders of thought based on aesthetics, the legitimacy of the object and the fixity of individual identity. The structural metaphor of network pervades the organisation of the exhibition: "Instead of walls, we have a system of webbings that will stretch from floor to ceiling" [Lyotard and Chaput 1985].

Lyotard has taken the root "mat" of the title of the exhibition to derive five poles around which everything in it is conceptually ordered: "Matériaux," "Matrice," "Matière," "Matériel," and "Maternité." In an interview [Lyotard 1985], he observes that "all of the progress that has been accomplished in the sciences, and probably in the arts as well, is strictly connected to an ever closer knowledge of what we call objects (which can also be a question of objects of thought). And so analysis decomposes these objects and makes us perceive that, finally, they can only be considered to be objects at the level of the human point of view; at their constitutive or structural level, they are only a question of complex agglomerates of tiny packets of energy, or particles that can't possibly be grasped as such. Finally there's no such thing as matter, and the only thing that exists is energy; we no longer have any such thing as materials, in the old sense of the word that implied an object that offered resistance to any kind of project that attempted to alienate it from its primary finalities."

Many of the ideas that inform Lyotard's position—ideas of energy, information, transformation, and interconnectedness—spring from the ground that also shapes modern physics and, in fact, led to cybernetics, systems theory, and, subsequently, telematic networks.

If Santillana shows how in ancient myth the demolition of the building is linked with "nets," Fritjof Capra has equally made plain how in physics the classical concepts of solid objects have been demolished by quantum theory: "as we penetrate into matter, nature does not show us any isolated 'basic building blocks,' but rather appears as a complicated web of relations between the various parts of the whole. These relations always include the observer in an essential way" [Capra (1975) 1977, 57]. "Quantum theory has shown that particles are not iso-

lated grains of matter, but are probability patterns, interconnections in an inseparable cosmic web" [188–89].

Capra shows the relation between physics and eastern myth. He quotes from the Buddhist Avatamsaka Sutra, in which the world is described as a perfect network of mutual relations where all things and events interact with each other in an infinitely complicated way. The cosmic web is central to Tantric philosophy, where the Sanskrit root of *tantra* means "to weave," referring to the interwovenness and interdependence of all things and events.

There are many examples cited by Capra of the similarity between the "network or web philosophy" of Eastern thought and the model of interconnectedness in quantum physics, but his book *The Tao of Physics* is too well known to require any further citation here. However, he does make an important point about language that links us to another principal attribute of telematic inscription—the layering and pleating of meanings, interconnected and dispersed authorship, and the unending reconstitution of image and text. "[The Eastern mystics] . . . [b]eing well aware of the essential interrelationship of the universe . . . realize that to explain something means, ultimately, to show how it is connected to everything else" [189]. (Does this find a parallel in the "intertext" of deconstructive theory and confirm its insight that all texts and meanings are part of a continuous field?) "Both Buddhists and Taoists speak of a 'network of words,' or a 'net of concepts,' thus extending the idea of the interconnected web to the realm of the intellect" [281]. With the eventual symbiosis of artificial and human intelligence that we now foresee, this network of ideas is likely to expand exponentially.

The physicist David Bohm, whose book *Wholeness and the Implicate Order* defines a "seamless order of unbroken wholeness" in the universe, alerts us to "the defects of the ordinary mode of using language, with its implication that it is not restricting the world view in any way" [Bohm 1981]. We must be aware of the worldview implied in each form of language. We have come to the end of the usefulness of language derived from the Enlightenment, with which modernism was continuous.

Telematic discourse is generating new language, uncertain, ambiguous layerings of meanings, which, however, form an integral whole through the dynamic interconnection of its many sources. To attempt to use telematic networks creatively is to become aware of the profound questions regarding the nature of originality, the individual, literal meaning, and signification that this form of communication raises.

But before looking at the relevance of poststructuralist ideas to these ques-

tions, we should look at an earlier example of the seminal fusion of some of these questions in the work of Marcel Duchamp.

Quantum physicists are currently searching for super particles that will support the idea of a super symmetry needed to produce a grand unified theory of the four forces ruling the universe. Super symmetry calls the basic units of both matter and energy "strings," and holds that the various fundamental particles correspond to the ways these strings vibrate; this is the modern metaphor of strings or threads woven together to form the fabric of the universe.

It was Duchamp's use of threads that produced the work *3 Stoppages—étalon*, which he later described as "in itself not an important work of art but for me it opened up the way—the way to escape from those traditional methods of expression long associated with art. I didn't realise at the time exactly what I had stumbled on . . . for me the *3 Stoppages* was a first gesture liberating me from the past" [Duchamp 1973]. In making the piece, he was concerned to "associate the idea of a perpendicular thread falling by chance to make its own 'deformation.'"

"Stoppage" means "invisible mending" (seamless whole), and needle-weaving. The metaphor is clear and it is not surprising that he went on to make *Reseaux des stoppages* (Network of Stoppages).

It was Duchamp, too, who was first and most instructive amongst visual artists in the liberation of the text. In his work, the text is not secondary or merely explicative. He saw the notes for the *Large Glass* "to be quite as important as the visual material." He thus anticipates the telematic mode, in which text and image interrelate on a plane that may even exclude the signified. His text is multilayered, ambiguous, and frequently a "re-projection" or reconstitution or, perhaps, a deconstruction of other texts—mostly notably, as Craig E. Adcock has pointed out, those by the mathematicians Henri Poincaré and E.-P. Jouffret [Adcock 1981].

Duchamp also well understood the new role of the "spectator" in modern thought. Heisenberg, who formulated the Uncertainty Principle in quantum mechanics, at the same time noted that "what we observe is not nature itself, but nature exposed to our method of questioning." "The Cartesian partition between I and the world, between the observer and the observed, cannot be made when dealing with atomic matter" [Heisenberg 1958].

Duchamp understood that the work of art does not reside in the object alone, but in a system, a negotiation between artist and spectator in the creation of meaning: "All in all the creative act is not performed by the artist alone; the spectator brings the work into contact with the external world by deciphering and interpreting its inner qualifications and thus adds to the creative act" [Duchamp 1973].

It is in Duchamp that we first encounter the decisive rupture in Western art, from the passive pleasure of the contemplation of the beautiful to the "exegetical/eisegetical" relationship of all parties involved in the creative process: the reading of meaning into and the reading of meaning out of this new mode of image/text.

Telematics is the system of systems in which these principles can most clearly be manifested. Telematic networks can carry images and texts in new forms of conjunction, mediated by computer process in a flux of meanings in which there are no "senders" and "receivers" (as in the old models of information theory) but only "users," whose intervention will be more or less creative depending on the degree of their participation in the system. In telematic networks, the screen of transformations replaces the mirror of reflections, providing the branching, interacting pathways through which telematic process can discharge its creative collisions and conjunctions of inputs and, as for particles in a cloud chamber, provide a planetary field for the dance of data—much as Nietzsche saw thinking itself: a dance of concepts and the pen.

This brings us to the spur of our subject: an assault on meaning, a reconsideration of individual identity, the nature of originality, and an ensnarement and demolition of language, which structures a reality composed only of discrete objects set in a strict causality. Here it may be worth quoting at length from Nietzsche's *Twilight of the Idols:*

> Change, mutation, becoming in general were formerly taken as proof of appearance, as the sign of the presence of something which led us astray. Today, on the contrary, we see ourselves as it were entangled in error, *necessitated* to error, to precisely the extent that our prejudice in favour of reason compels us to posit unity, identity, duration substance, cause, materiality, being. . . . The situation is the same as with the motions of the sun: in that case error has our eyes, in the present case our *language* as a perpetual advocate. Language belongs in its origin to the age of the most rudimentary form of psychology: we find ourselves in the midst of a rude fetishism when we call to mind the basic presuppositions of the metaphysics of language—which is to say of *reason*. It is *this* that sees everywhere deed and doer; this that believes in will as cause in general; this that believes in the "ego," in the ego as being, in the ego as substance, and that *projects* its ego-substance on to all things—only thus does it *create* the concept "thing."
> [Nietzsche 1974, "'Reason' in Philosophy," pt. 5, 37–38]

Telematic process, coupling together by satellite, cable, and threads of optical fibre a vast diversity of world-wide inputs, celebrates the death of the "individual," "original" author of images or texts. It brings into being, instead, a new

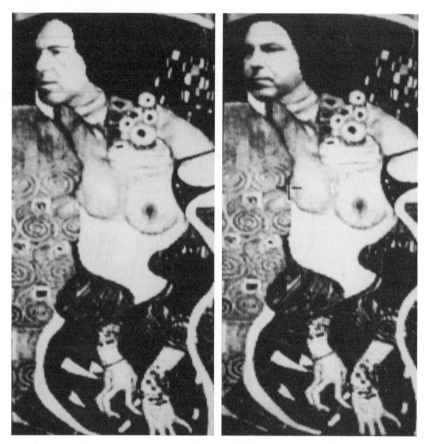

Figures 31-32. Roy Ascott as Judith. 1988. Slow-scan images in which the artist created a video composite of his own portrait and Gustav Klimt's *Judith* (1909); from *Making the Invisible Visible*.

"dispersed authorship" generating massive variety within the virtual "immateriality" of the networks. In the space of the computer memory, this endless activity of inputs, retrievals, and regroupings of creative data constitutes an image/intertext. Telematics brings a new order of discourse into being that embodies and amplifies Barthes's earlier insight: "We now know that the text is not a line of words releasing a single 'theological' meaning (the 'message' of an 'Author-God') but a multidimensional space in which a variety of writings, none of them original, blend and clash. The text is a tissue of quotations drawn from innumerable centres of culture" [Barthes 1975].

Following Barthes, Derrida puts a spike in the wheel of modernism. It is in Nietzsche's styles that we see the prospectus for the postmodernist concept of

inconsistency of method and manner, and the deconstruction of its own rhetorical motives. "Nietzsche, like Barthes and Derrida, deploys every means of resisting this drift towards interpretation in its various tradition forms. His plurality of styles and cultivation of paradox are strategies intended to arrest understanding, as far as possible, at the level of the text where signification has not yet congealed into meaning or concept" [Norris 1982]. And in this writing in *Deconstruction, Theory and Practice*, Christopher Norris goes on to connect the image of "the dance of the pen" with Derrida's free play of sense.

The dance of data and free play of sense are attributes that telematic process can only amplify. The "blend and clash" of images and text from innumerable inputs, in innumerable locations, reflecting innumerable cultures and contexts, has the potential to bring about an epiphany of creative mind.

All this is to look at the future, but it is not far from us. The cracks in the old order of art and knowledge have become fissures in those cases where the ram (*éperon*) has been pushed in with great force. Two particularly forceful spurs to change in this context that prefigure the semantic diversity of the telematic mode are curiously linked (not causally but associatively) by their titles: Derrida's book *Glas* [1974] and the *Large Glass* of Marcel Duchamp. In both, we find the invention of form through the appropriation of form from other contexts: puns, quotations, enigmas, styles. Both carry the trace of massive rupture:

Duchamp, horizontally across the Glass; Derrida right down the middle of *Glas*. *Différance*, Derrida's portmanteau term, which in its anomalous spelling carries multiple meanings of "difference," which language depends on, and the "deferral" of ultimate meaning and postponement of presence, can equally be applied to the attitudes and approach of Duchamp. Just as the bride and her bachelors are separated out in the Glass, so "Hegel" and "Genet" are opposed in *Glas*. And with mind/body, left/right hemisphere, a vast alternation of modes of reference and representation invite endless exegesis.

What Geoffrey Hartmann has to say about *Glas* can be applied equally well to the image/text project of the *Large Glass:* "[I]t is not only hard to say whether *Glas* is 'criticism' or 'philosophy' or 'literature', it is hard to affirm that it is a book. *Glas* raises the spectre of texts so tangled, contaminated, displaced, deceptive that the idea of a single or original author fades" [Hartmann 1981].

The fading of the idea of a single or original author gives way to the idea of multiple authorship and ownership of images and forms in the telematic process both through the reconstitutive "pleating" or montage of "existing," material and through the interactions or collaborations of multiple users widely dispersed through the network systems. But the creative potential of telematic networks

will only be realised to the extent that artists resist the monopolisation and colonisation of electronic space by multinational business and the military.

Artists also must be vigilant in seeing that as the Third World is brought into the "information embrace," the voices of its own authentic artists can be networked into the emergent telematic consciousness.

The pervasiveness of the new information technology and the application of artificial intelligence to all the coordinates of social life will produce structures of thought and forms of expression entirely consistent with the impulses to a new order noted in postmodernist and poststructuralist endeavours. At the end of 1983, the first large-scale telematic project involving the generating of text by artists and writers distributed over three continents was set up through a computer time-sharing network. The project, called "La Plissure du Texte" (in homage to Barthes's *Le Plaisir du texte*), was presented in the context of the extensive ELECTRA exhibition at the Musée d'Art Moderne de la Ville de Paris. With terminals in eleven cities, the network grew to include local networks of artists, friends, and random members of the general public who would happen to be visiting the museum or art centre where the terminals were located. Over the three-week period of the project, hundreds of "users" became involved in a massive intertext, the weaving of a "textile," which could not be classified, even though ostensibly the project was to generate a "planetary fairy tale." Each participant or group of participants in the process could interact with the inputs of all others, retrieving from the vast memory store all text accumulated since they last logged on. The textual interplay was complex, working on many layers of meaning, witty, bawdy, clever, academic, philosophical, entertaining, inventive, shocking, amusing—assimilating the great diversity of cultural contexts, value systems, and intellectual interests of participants located in Honolulu, Pittsburgh, San Francisco, Paris, Vancouver, Vienna, Toronto, Bristol, Amsterdam, Alma, Quebec, and Sydney.

Satellite, telefacsimile, slow-scan TV, ham radio, videotex, interactive graphics systems, teleconferencing, and computer networking have all been used over the past ten years in the search for ways to find a new kind of creativity in electronic space, essentially to find human meaning in the new planetary technology of high-speed computers, artificial intelligence, and telecommunication systems. A whole new field of consciousness is forming, and every aspect of human activity is at stake: language, philosophy, economics, education, even the very sense of what it is to be human.

The artist has a role to play in the expression of this consciousness and in the exploration of modes of presenting the new human relationships and sense of

identity in post-industrial society. But this will no longer be a solitary or iso-lated pursuit of the "individual genius"; it will call for a huge amplification of intellect and imagination, a great diversity of experience, a huge combination of dreams, visions, and desires that only the telematic process, pervading the planet with its network of interactive systems, linking mind to mind, can hope to achieve.

NOTE

1 Photius, *Bibliothèque*, trans. and ed. René Henry (Paris: Les Belles Lettres, 1960), summaries of the *Diktuaka* of Dionysios of Aegeae, vol. 2, no. 185; vol. 3, no. 211. "Cet ouvrage curieux ne nous est connu que par Photius et nous n'avons aucun élé-ment qui permette de situer son auteur," René Henry notes (2: 200). See also *Paulys Real-Encyclopädie der classischen Altertumswissenschaft*, ed. Georg Wissowa (Stuttgart: J. B. Metzler, 1893–1963), vol. 5 (1905), col. 975, Dionysios, no. 124.—Ed.

**ART AND EDUCATION
IN THE TELEMATIC CULTURE**

1988 It was Simon Nora who coined the term *telematics* to describe the
new electronic technology derived from the convergence of com-
puters and telecommunications systems. The report he and Alain
Minc submitted to the president of France in 1978, *L'Informa-
tisation de la société* [Nora and Minc 1980] is perhaps one of the
most influential documents in this field to have been published in
Europe—influential in that it led to the swift establishment by the
French government of the Programme Télématique, which has re-
sulted in the transformation of many aspects of French culture.
This process of telematisation is most dramatically seen in the
ubiquitous and rapid spread of Minitel, the public videotex system
that enables widespread interaction between users and databases
across an enormous range of services. Nowadays, on the Paris
Métro, for example, it is enough to see a poster of an island in the
sun, a new household appliance, or racehorses pounding the turf,
inscribed with a seven-figure sequence of numbers, to know that
another Minitel service is being advertised. At home, at one's Mini-
tel terminal (distributed by the PTT in place of the volumes of
telephone directories previously provided), one can interact in
electronic space with friends, colleagues, institutions, and organi-
sations of all kinds. Artists, too, have not been slow to assimilate
the medium.

Interactivity is the essence of the videotex system, as it is of all
telematic systems, giving us the ability to interact in electronic space,
via computer memory and beyond the normal constraints of time

Originally published in *Leonardo* 21, supplemental issue (1988). © 1988 by the Inter-
national Society for the Arts, Sciences and Technology (ISAST). Reprinted by per-
mission of MIT Press. The "Appendix: Statement on Art Practice and Pedagogy" has
been omitted here, because Ascott's telematic projects have been described elsewhere
in greater detail. See, for example, chapters 11, 16, and 19 in this volume.

and space that apply to face-to-face communication. The concept of interactivity also has an important place in recent theories of communication, in contrast to the one-way linearity of older models. The new approach is found, for example, in the network analysis of Everett M. Rogers and D. Lawrence Kinkaid and in research into biology and cognition by Humberto R. Maturana and Francisco J. Varela. Neither of these studies is centrally concerned with electronic systems or telematic technologies. Both, however, deal with human interaction, language, meaning, and memory, which is of value in our understanding of the potential of telematic systems to enrich visual culture.

Let me quote from both of these studies:

> Communication research in the past has almost always followed a linear "components" model of the human communication act. Such research mainly investigated the effects of communication messages from a source to a receiver, in a one-way, persuasive type paradigm that is not consistent with our basic conception of the communication process as mutual information exchange, as sharing means, as convergence. [The new approach] is guided by a convergence model of communication based on a cybernetic explanation of human behaviour from a systems perspective. [Rogers and Kincaid 1981]

> According to the metaphor of the tube, communication is something generated at a certain point. It is carried by a conduit (or tube) and is delivered to the receiver at the other end. Hence there is something that is communicated, and what is communicated is an integral part of that which travels in the tube. Thus, we speak of the "information" contained in a picture, an object, or, more evidently, the printed word. According to our analysis, this metaphor is basically false. It presupposes a unity that is not determined structurally, where interactions are instructive, as though what happens to a system in art interaction is determined by the perturbing agent and not by its structural dynamics. It is evident, however, even in daily life, that such is not the case with communication: each person says what he says or hears what he hears according to his own structural determination . . . communication depends on not what is transmitted, but what happens to the person who receives it. And this is a very different matter from "transmitting information." [Maturana and Varela (1987) 1992]

In both cases, we see that meaning is created out of interaction between people, rather than being "something" that is sent from one to another. If there is an author of this "meaning," then it may be the system of interaction itself, in all its particulars, that should be described as the author, or we might want to refer to a "dispersed authorship," covering all those involved in negotiating for meaning in a given context. Where the context includes artificial memory in a telematic system, the potential for the creation of meaning is greatly enlarged.

And when such systems are activated globally, in an art context, we can expect to see quite richly layered fields of "meaning" being created.

We can see art as a whole, regardless of what media may be employed, as constituting such a system; and where, in any given practice, art objects are involved—for example, paintings or sculptures—we can recognise them as parts of a system in which a flux of meanings can be generated, dependent upon the variety of interactions that arise within it. Art does not reside in the object alone, nor is meaning fixed or stable within the physical limits of the artist's work. Art is all process, all system. If, in the past, we have thought otherwise—for example, that art is an object, or that the artwork "carries" a definitive meaning "created" by the artist and received by the viewer—this can perhaps be understood in the light of our Renaissance heritage. The ordering of space in Renaissance painting, with its absolute rules of representation and of viewing, a space subject to the authority of the vanishing point, which also positioned the viewer in relation to the "world" and established control of a reality consisting of separate and discrete parts (everything in its place and a place for everything), can be seen as the perfect metaphor of the ordering of parts in the societies to which it gave expression. Renaissance space is authorised as "real" space by many of those societies in which information flows one way, from the apex of the social pyramid to the base, where it informs the thinking, the orthodoxies, the rules of conduct of a culture. This one-way despatch fashions consciousness and enforces a dominant scientific paradigm, just as the vanishing point and rules of representation determine, within the pyramid of space based at the picture plane, a coherent view of a world presented as "reality." Under these circumstances, the art object could well be understood as embodying not only unambiguous meaning and beauty but also absolute truth. This form of representation and this status of the object as art continues today, of course, in some quarters and has to some extent been automated by the photographic process. Its persistence is well understood given the seductive nature of the apparent certainty and coherence it claimed to depict.

But the art of our time is one of system, process, behaviour, interaction. As artists, we deal in uncertainty and ambiguity, discontinuity, flux and flow. Our values are relativistic, our culture is pluralistic, and our images and forms are evanescent. If it is processes of interaction between human beings that create meaning and consequently cultures, then those systems and processes that facilitate and amplify interaction are the ones that we shall employ in order for more richly differentiated cultures and meanings to emerge. This is precisely

the potential of telematic systems. Rather than limiting the individual to a narrow, parochial level of exchange, computer-mediated cable and satellite links spanning the whole planet open up a whole world community, in all its diversity, within which we can interact. Telematic networks are ubiquitous and can be accessed from virtually any location—the home, public institutions, libraries, hospitals, prisons, bars, beaches, and mountain tops, as well as studios, museums, galleries, academies, and colleges—anywhere, in fact, that is reached by telephone, including mobile telephones in cars, trains, ships, and planes. The primary effect of creative interaction within such networks is to render obsolete the distinction in absolute terms between the artist and viewer as producer and consumer, respectively. The new composite role becomes that simply of participant in a system creating meaning seen as art. This contrasts forcibly with the Renaissance paradigm of the artist standing apart from the world and depicting it and the observer standing outside of the artwork and receiving this depiction. It was a paradigm that placed the scientist, also, outside the world, looking in, and in turn led to all kinds of alienation and separateness in society.

Our assertion of *network* as the metaphor for the emerging culture appears to find support in fields beyond art. Quantum physicists, for example, speak of an "undivided wholeness" at the quantum level of reality, of indeterminate behaviour, of non-local connectivity in the subatomic field, of the laboratory experiment being a part of the field of consciousness of the observer as participant. In literary theory and criticism, the status and identity of the "author" is under scrutiny; the text is seen as a space within which the reader actively generates meanings, rather than as a container of messages and stable form. And in art it was not Duchamp alone who brought the power of context and new position of the observer as participant to our attention. The mobile viewpoint, montage, and performance work all have contributed in various ways to breaking down the barriers, towards creating whole systems.

One effect of these holistic strategies in art and science, perhaps most evident in telematic systems, is to give credence to the idea of mind at large. In their various contributions to a science of wholeness, the new generalists—Gregory Bateson, with his idea of an ecology of mind, and Ludwig von Bertalanffy, with his general system theory—have perhaps done most in recent decades to reject the idea of the individual as an isolated entity, separate from his environment and other individuals. And it is the holistic view we must surely take when we consider art in relation to a telematic culture. Bateson argued that human plus computer system plus environment constitutes a thinking system.

Just as he challenged the idea of separate, isolated mind that could be differentiated from body and from the individual's environment, so he showed that the lines between human, computer, and environment are purely artificial and fictitious. They are the lines across the pathways along which information passes and within which meaning is created; they are not boundaries of the thinking system. With the convergence of computers and telecommunications, the "thinking system" becomes planetary.

"Isolation" and "convergence" are terms that encapsulate what could be seen as the problem and the remedy in our considerations of visual art in the electronic culture. The current problem is one of isolation through a rather crude differentiation between centres of operation in visual culture, inherited largely from the previous century. Despite some notable exceptions, we find for the most part a rather clear separation between atelier, museum, library, concert hall, and academy. They are, by and large, autonomous entities, independent systems housed in distinctly separate physical structures. In many museums, as in academies, the flow of communication is usually one-way. Art is identified with objects; architecture is designed to support the consumption of culture rather than actively to participate in its creation. With electronic media, its flow of images and texts, and the ubiquitous connectivity of telematic systems, this isolation and separateness must eventually disappear, and new architectural structures and forms of cultural association will emerge. And in this emergence, we can expect to see, as we are beginning to see, new orders of art practice, with new strategies and theories, new forms of public accessibility, new methods of presentation and display, new learning networks—in short, whole new cultural configurations.

Within the planetary scope of these new configurations, however, we shall want to do everything to avoid a homogenisation of culture. Telematic systems, through the massive memory of computers involved in their articulation, support great diversity and variety of input, such that all the differences of individual experience, local culture, and regional attributes can be preserved. The aim of a telematic culture cannot be to homogenise experience and unify ideas or conventionalise images but to generate *difference* in the multiplicity of viewpoints, preferences, dreams, and concerns—spiritual, political, intellectual—that a whole planetary community can be expected to provide. At the same time, the richness of input that might be expected as creative collaboration around the world increases, and the profusion of images and meanings that could be generated to flow across the planet, will probably lead to a greater awareness of the world as a "whole."

It is as if the planet is at the *stade du miroir*, the point in its development where Jacques Lacan theorizes the infant sees in its newly reflected image its own unique identity and gains a sense of self (in this case, provided by astronauts and remote sensors in space beaming images of the whole earth back to us). Is it too fanciful to suppose that we are approaching the next stage of planetary awareness—global consciousness? As Peter Russell [1983] has pointed out, although it is far from equalling the trillions of synapses through which human nerve cells interact, our global interaction through telecommunication networks, mediated by the hugely increased capability of parallel processing in the next generation of computers, seemingly is reaching a level of complexity and interconnectedness in which we can no longer perceive ourselves as isolated individuals or cultures.

Given the accelerated telematisation of culture, not only can we expect institutions to converge, but we are probably in the position of having to revise all our assumptions about our field of enquiry—that is to say, a complete revision of art in all its roles, institutions, behaviours, codes, protocols, methods, funding, and so on. Our inherited conventions of, for example, practice, display, conservation, and education in art may soon progressively come to be seen as irrelevant and redundant.

Even a cursory examination of the art academy will show that, while here and there significant changes are taking place, the curricula for the most part contain curious anomalies. Let us take, for example, the case of life drawing. While computer systems and other electronic media are moved in, and new paradigms of design and analysis are presented to students, the life drawing class in many cases remains not as a historical curiosity but as central—sometimes the anchor—to the practical curriculum. And yet, this is not where the living processes of the body are examined; it is often merely where archaic codes of representation are rehearsed and, in fact, assimilated into the students' consciousness. There we find the body immobilised, without mind; is that not the ideal of all repressive cultures? The practice of life drawing, sometimes called "objective drawing," is defended as offering a complex structure against which hand-to-eye coordination can be perfected. But is it not hand-to-mind coordination we should seek? Students are frequently misled into thinking that the life drawing class is where they will confront "reality" and can acquire a skill to master its representation. The human eye is insufficient to reveal the whole complexity of the living person. The mind, not the eye alone, knows it to be a complex organism, made up of systems within systems, a subtle and continuous transformation of energy and matter. If visual observation in the life draw-

ing class is to reach maturity, it requires technological extensions of the senses to give access to the microscopic processes and macroscopic environments by which the "life model" is maintained. There are many other strategies, in science and in mysticism, for example, that offer us ways into a more holistic understanding of ourselves. It is no longer enough, one might think, to rely on a stub of charcoal and specious historical precedent. For, despite recent marketing of a nostalgic classicism, presented in the guise of a (misunderstood) postmodernism, the project of the art of our century has been essentially to make the invisible visible. Art has progressively sought to be in touch with unseen forces and fields, systems, relationships, connections, and transformations and to make them visible.

And it is the computer that is the matrix through which the abundance of data in all its modes can pass, from remote sensors, scanners, metering devices, and difference machines of all kinds. Digitisation can be the lingua franca of an enormous range of visual and notational systems reporting on, recording, and analysing the world, as well as a device through which our dreams, fantasies, speculations, and assertions can find expression. The computer is simply a universal machine that can facilitate new modes of communication of desire and of anxiety.

As a matrix, it is much more than a stand-alone generator of images, for it extends enormously the capability of the artist to integrate and work between diverse media—film, video, photography, graphics, paint, print, and text—as well as plotting performance in "virtual" space and "virtual" time. This universal machine similarly is spawning output media of considerable variety: electronic image and synthesised sound coexist with print media, cybernetic structures, and complex interactive environments. Computer-aided manufacture is also open to investigation by the artist.

On the screen we have the power to summon up colour, to draw, erase, recall, mix, split, overlay, and reverse images and texts; we can digitise, juxtapose, enlarge, shrink, stack, cut, fuse, file, and retrieve material of our own making or made by collaborators—or even made by others unknown to us whose work may be available in a variety of archival sources. The digital mode can lead to endless metamorphoses, realignments, new associations, conjunctions, and assimilations of ideas and images.

And let us not forget that this is just the beginning of a technology, despite its exponential growth in the past few decades. Unless we are unusually privileged, we have yet as artists to play with touch-sensitive, high-definition, wall-size computer screens. We are for the most part still tapping keyboards, scratch-

ing with light pens, and playing with mice. We are at the "horseless carriage" stage in the development of the artist-friendly interface.

Apart from telematic networks and the computer as the matrix of creative work, we also have to consider the environment. As artists, we inhabit physical as well as electronic space, of course, and electronic architecture, the information city, is part of our concern. In this regard, Japan's national technopolis strategy for the planning of a series of high technology research cities is both comprehensive and visionary, and the design brief and supporting portfolio for the 1986 International Concept Design Competition for an "advanced information city" at Kawasaki were breathtaking in the scope of their concerns and the issues they raised. As the Japanese "fifth generation" [of computers] becomes our generation, it is conceivable that the technopolis could become a town-planning standard (although it is doubtful that it will become an export commodity on the Tokyo stock exchange). It is clear in any case that many ideas currently being developed through the agency of MITI [the Japanese Ministry of Trade and Industry] concerning the design of living environments to support innovation and creativity will find their way to the West.

In all of this, the artist and the creative participant in telematic systems will find a place, but that place can be defined properly only with the active involvement of the artist at the outset of the planning process. And this seems to me to be the case whether we are discussing such advanced concepts as MITI is proposing or more discrete projects, such as academies or museums. To start with, we probably need to find new terminology to avoid the cultural baggage that the old vocabulary carries. Our first questions should probably be, in every case, what creativity and contact, what creative interaction, can the new institution as system be expected to generate and support? And then, as a subsystem of a larger whole, what other subsystems must we plan to interact with? These are obvious questions to be sure, and yet how often today in our culture do we see new buildings put up ostensibly to serve art while actually they stand alone, physically alienated and alienating in their indifference to the larger processes and systems with which we expect them to integrate? The problem is even greater if we take the view that they are institutions that will increasingly need to serve an emerging culture radically unlike the culture from which they are derived.

The popular conception of high technology, we are told, is that of a sterile, inhuman and emotionless environment. And yet those of us who know of the sheer conviviality of communication in electronic networks and have come to realise the sensitivity and receptivity towards the generating of images of which

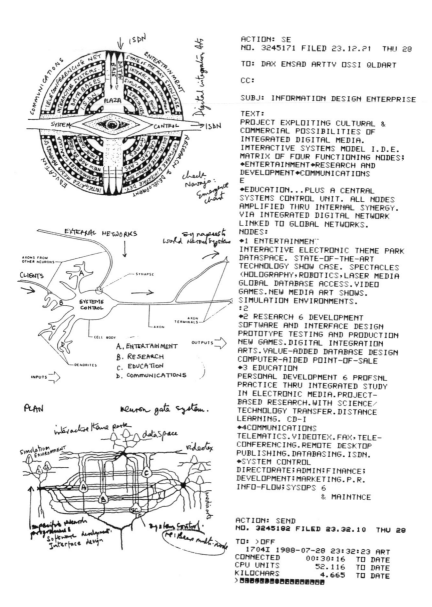

Figure 33. Information Design Enterprise by Ascott and collaborators at the University of Applied Arts, Vienna, 1988.

the computer is capable will seek to change this perception. "Garbage in, garbage out" is, I suppose, the phrase to invoke here. That is to say, the universal machine—which the computer is—can contain as much creative thought and express as much emotion as we put into it. There is no doubt, though, that if used merely as tools of production, telematic networks and computer systems will certainly and very effectively promote sterility and alienation in the culture. If we seek wisdom from the past, I imagine it should be to Socrates rather than to Cato that we should turn, particularly insofar as the education of the artist is concerned. The principles of Socrates—critical reflection, personal development, and sustained enquiry—must not be undermined in this new technological environment by the principles of Cato, which estimate everything by what it produces.

In my view, we might anticipate the dematerialisation of academies, galleries, and museums, or at least their fusion into pervasive and wide-reaching networks. While the physical presence of material artworks will always be valued in experience, electronic storage and distribution of these works, apart from the purposes of archival research, will come to be enjoyed also as electronic "traces." In addition, the ability of students, quite apart from artists themselves, to communicate through telematic networks with skill banks, data banks, artists, and experts and professionals in all fields, to participate in world-wide electronic seminars, and so to engage from any location at any time of night or day, would add considerably to their current face-to-face contact with a meagre handful of teachers and technicians (however well informed and dedicated) with depleted resources and an inadequate physical plant, housed in buildings designed to support a Beaux Arts culture and scarcely attended to since their construction.

Our cultural participation in intelligent telematic networks has long-term implications that we can scarcely imagine. The symbiosis of computers and human beings and the integration of natural and artificial intelligence will be realised in forms and behaviours the understanding of which is beyond our present conceptual horizon. There is a need, however, for artists, designers, architects, museum directors, educators, philosophers, scientists, technologists, and politicians throughout the world to work together to create cybernetic systems that will support new forms of art practice, new means of public access, and the involvement of a wider range of participants.

1989 Networking provides the metaphor for late twentieth-century culture: it speaks of interactivity, decentralisation, the layering of ideas from a multiplicity of sources. Networking is the provenance of far-reaching connectivity; and, mediated, accelerated, and intensified by the computer, it leads to the amplification of thought, enrichment of the imagination, both broader and deeper memory, and the extension of our human senses. Computer networking means the linking of person to person, mind to mind, memory to memory regardless of their dispersal in space and their dislocation in time. In its global reach, in its complexity of idea processing, in its flexibility of output (image/music/text and articulation of remote cybernetic systems, structures and environments) and in its capacity to accommodate a great diversity of input modes, all of which are digitally treated in universal data space, networking is particularly suited to take on the great challenge of late twentieth-century art, which can be seen as the overarching project of our time: to make the invisible visible. That is, to bring to our senses, to make available to our minds, within the human constraints of space and time, what is otherwise beyond our reach, outside of our perceptual range, the far side of the mind.

This is not simply to speak of the complexities of chaos science, those infinite sequences of order and disorder that defy comprehension and representation within the computational range of the human brain—that fractal structuring of the world that the computer alone seems able to reveal. Nor is it only a matter of recognising how computer-mediated communication systems provide us

Originally published in German in *Kunstforum* (Cologne) 103 (1989). Descriptions of Ascott's telematic art projects have been omitted here, because these works have been described elsewhere in greater detail. See, for example, chapters 11, 16, and 19 in this volume.

with the remote sensing capability to probe far out into cosmic space and deep into matter at the most profound quantum level. Neither is it enough to understand how dependent for image enhancement, data treatment, and graphic reconstruction we are on parallel data processing, with the rapid updating that implies, for us to negotiate a universe made up of transformations of energy operating at wavelengths or intensities far beyond the capability of our meagre sensory system to apprehend.

It is much more than all of this but its implications for human growth and creativity can be stated quite simply: computer networking provides for a field of interaction between human and artificial intelligence, involving symbiosis and integration of modes of thinking, imagining and creating, which, from the point of view of art, can lead to an immense diversity of cultural transformations, and which, in science and philosophy, can yield enriched definitions of the human condition. Computer networking, in short, responds to our deep psychological desire for transcendence—to reach the immaterial, the spiritual—the wish to be out of body, out of mind, to exceed the limitations of time and space, a kind of biotechnological theology.

When people interact, when minds interpenetrate, a proliferation of ideas are generated. When sensibilities from diverse cultures from all parts of the globe interweave, collaborate, conjoin, and become restructured, new cultural forms emerge, new potentials for meaning and experience are brought forth. This is the scope and ambition of networking. This is to speak of superconnectivity, the production of a multilayered culture, planetary culture, a holistic world art. It is not to be confused with homogenisation, or neutralisation of cultural, regional, or individual difference. What this offers in effect is the opportunity for us not only to construct new realities but to enter into the realities of others, the interpenetration of parallel universes of discourse.

Our immersion in electronic global networks can lead to a re-evaluation of the status of reality; to an understanding of its provisional nature, as one of many co-existing realities, all of which are constructed—"virtual" in a sense—and dependent upon our active participation for their construction. When we recognise the centrality of the computer in this process of production (and indeed it has become central to both the construction as well as the dissemination of knowledge, and therefore of experience), it is easy to see a comparison to quantum physics. That is, replace the term "quanta" with "data" and a physics of information is invoked. For it is in the quantum world that reality is the production of observation. The apparatus we use, the measuring system we employ, and the language we articulate, all condition the nature of the reality we per-

ceive. It is in a sense a conspiracy. From the ground of undifferentiated wholeness we construct virtual realities, knowing that they are transient, impermanent, ephemeral constructs of mind. That they may be internally coherent and consistent only furthers the illusion of permanency.

In philosophy, Bergson and Nietzsche in their different ways have pointed to this way of thinking about reality and cognition. In science, Heisenberg and Schrödinger, and more dramatically John Bell and Alain Aspect, for example, have theorized and demonstrated its physical manifestations as well. The principle of indeterminacy and uncertainty holds dominion. Strict causality operates only within a limited stratum of events. Our perception of space and time is not the frame of reality but an aspect of an undivided whole within which an infinity of separate realities, parallel universes, can endlessly be constructed. How quickly this science moves into metaphysics and brings us back to theology, mysticism, and mythology! It is in this richness of value systems, world models, cultural constructs, and virtual realities that the networking artist operates. In this s/he is never alone. To network is to be engaged with mind at large, to amplify individual thought and imagination through the dynamic interaction with others in the network. In this enterprise, "others" includes artificial intelligences, sensing systems, and memory stores, as well, of course, as human beings from an enormous diversity of personal and cultural contexts. It is through computer networking that we can deal creatively with relativism and with pluralism, providing a radically constructive repudiation of the negative pessimism in so much postmodernist thought.

The subject of quantum physics is the transformation of energy, and quanta are its object. The subject of computer science is the transformation of information, and data are its object. Data exist in streams; data flow is ephemeral, transient, shifting. Data is everywhere and nowhere. A physics of information would talk about the phase space, the virtual space that data occupy. Processed in time—the beat of the computer's pulse measured in nanoseconds—data are nevertheless time-free and time-resistant in so far as their transformation within computer networking is concerned. That is to say that the user of such networks can access and interact and collaborate with other users independently of the constraints of time or place. In this sense, data are asynchronously managed and networking becomes a non-linear creative medium. And, as with quantum behaviour, data are discontinuous; they "jump" between semantic states. In this way, they model, as well as support, creative behaviour, which is always non-linear, indeterminate, and uncertain, just as, with brilliant graphic clarity, the

computer reveals nature's capacity to jump unpredictably to new levels of order from chaos, the stochastic leap.

If the project of our time is to render the invisible visible, to bring directly into our consciousness the direct apprehension of the processes and systems, forces and fields, dynamic and transformative relationships of life that elude our everyday perception and lie beyond the capture of our senses, then we must recognise the necessity of making the currently very visible computer invisible. The computer as thing—as object, as apparatus, as machine—is too much with us, too dominant. It is not transparent, it is not understood as pure system, universal transformative matrix. The computer is not primarily a thing, but a set of behaviours. Its purpose is not only computation but transformation; not only storage but dissemination. It is the agent of the data field, a construct of data space. Where it is seen simply as a screen presenting the pages of an illuminated book, or as an internally lit painting, it is artistically valueless. Where access to its transformative power is constrained by a typewriter keyboard or the gestural configurations of a "mouse," it is culture-bound; the user is forced into the posture of a clerk. The power of the interface cannot be overestimated; the role of the user must be clearly defined. Rather than seeing the computer interface as a membrane separating out the computer as a discrete object from ourselves, we should see it and design it as a doorway into data space, a synaptic interval in a human-computer symbiosis. To see the computer as no more than screen and keyboard—to use it as no more than the apparatus of the accountant—is to be condemned to produce art of the "bottom line"; that is to say, an art of finalities, of completion. To do so is to deny, in other words, the essential qualities of open-endedness, nonlinearity, and fecund incompleteness that are the great distinguishing potential of computer-mediated art practice. Similarly, our gathering of images, music, and texts, for example, from the endlessly flowing data stream of creative interactions with networks around the world, should be understood as a kind of data harvest, a form of accessing and selecting and displaying that will not confuse the identity or role of the interface with that of a painting, book, or film screen—for they propose quite different aesthetics.

The essence of the interface is its potential flexibility; it can accept and deliver images both fixed and in movement, sounds constructed, synthesised, or sampled, written texts, speech. It can be heat-sensitive, body-responsive, environmentally aware. It can respond to the tapping of the feet, the dancer's arabesque, the direction of a viewer's gaze. It may not only articulate a physical environment with movement, sound, and image, it *is* an environment in the sense

that it actually constitutes an arena of data space in which art comprising this human-computer symbiosis can be acted out. The computer interface is, in each individual case, an aspect of a holographic unity. To be in or at any one interface is to be with all the interfaces throughout the network of which it is a part.

Increasingly, as artists, we are impatient with single modes of operation in data space. We search for synthesis of image, sound, text. We wish to incorporate human and artificial movements, environmental dynamics, and ambient transformations all together into a more seamless whole. We search, in short, for what I call, in German, *Gesamtdatenwerk*, or "integrated data work," echoing the *Gesamtkunstwerk*, or "total artwork," conceived by Richard Wagner. Whereas Wagner's *Gesamtkunstwerk* was performed in an opera house, however, the site of the *Gesamtdatenwerk* must be the planet as a whole, its data space, its electronic noosphere. The duration of the work will, of course, ultimately, be indeterminate, since this must be a work in flux and flow, permitting an infinity of interactions, inputs and outputs, collaborations and conjunctions between its many participants. Since reciprocity and interaction are of its essence, such work cannot differentiate between "artist" and "viewer," producer and consumer. To participate in such a network is always to be involved in the creation of meaning and experience. The roles cannot be separated out. One can no longer be at the window, looking in on a scene composed by another, one is instead invited to enter the doorway into a world where interaction is all. We are a long way from the *Gesamtdatenwerk*. The computer industry is slow in releasing those technologies that will facilitate a seamless interface emerging, although research departments, most notably, for example, the Media Lab at MIT, are investigating and creating interface environments of considerable subtlety. Ultimately, it is a matter of artists and technologists collaborating, with or without institutional support, to bring the interface into the full sensorium of human experience and engagement.

BEYOND TIME-BASED ART

ESP, PDP, and PU

1990 Time flows forward or backward, or is discontinuous any way up, depending on who is using it, looking at it, or playing with it. Time may be about to disappear. At all events, I'm with Saint Augustine, who said, "If you ask me what time is, I don't know the answer. If you don't ask me, I do." Or, to put it another way, if it takes five hundred million nanoseconds to clap one's hands, what is the time of one hand clapping?

For the artist, tracking down the paradoxical, opening up uncertainty, and stalking the ambiguous is in the nature of the creative act. Bringing two ideas together may be good for comparative studies, or oppositional polemic, but the classical dialectic will not get us very far in trying to locate Time. I propose to use the non-analytical creative process to locate it, by employing a form of triangulation. The three coordinates, threads of ideas, I want to bring together I shall call ESP, PDP, and PU. They refer to what I see as the three most powerful areas of action and speculation currently shaping our culture, namely, media, computer science, and quantum physics. Separately, in their own right, they each constitute a formidable force in our thinking; brought together—in a word, triangulated—they define a zone of understanding that provides new insights into the nature of time and new awareness of the human potential for creative consciousness.

I have used the term ESP to point to media because of its layered meaning. The initials are popularly employed to designate Extra-Sensory Perception—those ways of knowing, perceiving, and acting that transcend or lie outside the Cartesian-Newtonian frame of being: time-shifts, future affecting the past, dislocation of conscious-

Originally published in *New Observations*, no. 76, *Special Issue: Navigating the Telematic Sea*, edited by Bruce Breland (1990), and reprinted with permission.

ness, clairvoyance and out-of-body states. But the initials are also those of Edwin S. Porter, who first discovered that time can be compressed, expanded, or reversed, albeit in the medium of film, by means of the technique of editing. It is a long way from *The Life of an American Fireman*, which he made in 1902, to the computerised hypermedia of the late 1980s, but the principle remains. Similarly, David Griffith's parallel editing technique (1908) of expanding time by showing simultaneous action in response to a single event and, with freeze-frame, stopping time altogether, leads us quite directly to the mosaic screen of digital discontinuity, of the layering and associative interweaving of data, which we are now beginning to exploit through telematic media.

"Telematics" means—beyond its technical designation of the convergence of computer and telecommunications systems—effectively out-of-body, out-of-mind. That is to say, *asynchronous connectivity*, whereby individuals can communicate (negotiate for meaning) through electronic networks, regardless of where they are located in the world or at what "real" time they log on to the digital, free-flowing continuum of computer-mediated interactions. Through telematic networks, intelligence is amplified, authorship is dispersed, and memory becomes time-free and global in its dimensions.

The second strand in the process of triangulating to locate time is PDP, parallel data processing. The power of the computer in processing images, sound, and text—actually assisting symbiotically in their creation—is well known, not least by artists. Link one computer to another in a global system, or at least into something greater than a local area network, and the potential for world culture is enormous. Time, the new time, a kind of schizo-time, dominates the process. Time has special meaning for the computer scientist. Turing's man—to take J. David Bolter's phrase—is the first man who actually "works *with* time." Every digital computer has clocks built into its central processor— the timer releases electrical charge at intervals, setting the pulse of the computer's operations: the interval can be measured in nanoseconds—that's one-thousand-millionth of a second. "For the computer, the passage of time is not a continuous flow . . . time passes as a series of discrete units, marking off the progress of the machine. Nothing is instantaneous, it takes time for a signal to move from point to point on a silicon chip—the electronic clock provides the measure of sequences." The computer, then, processes time itself by transforming billions of electronic pulses into instructions that will manipulate data, thereby transforming microseconds and nanoseconds into information. But "the enormous speed of this transformation puts the computer operation into a temporal world that is outside human experience such that events

in the computer are simply beyond the range of human senses" [Bolter 1984, 101, 103].

The computer is an extra-sensory device dealing invisibly with the invisible; that is, with all the connections, systems, fields, and forces—all those transformations, chaotic assemblies, and higher orders of organisation—which lie outside the rather gross level of material perception afforded by our natural senses. Totally invisible to our everyday perception is the dance of electrons, the discontinuous quantum jumps, tunnelling, and transformations of energy that the new physics presents. It is these patterns of events—non-linear, non-local, layered, and discontinuous—that the computer can simulate. It is through the computer that we can hope to glimpse the unseeable, to grasp chaos and the secret order in the disordered. Through the computer, we can call a halt to entropy, bending time round, tying it, in effect, in a butterfly bow, to bring distant, separate events and minds into new conjunctions, to weave in digital space that seamless universal web of which, previously, only mystics and madmen would speak.

There are many paradoxes in quantum physics. How can a single electron in a hydrogen atom, for example, be in more than one place at one time? By getting rid of time, it seems. The relativity of space-time provides for nothing moving, nothing standing still. Photons spend no time in our world. These zero-time particles exist only in the gap between the tangible and the potential, the virtual, or rather they occupy both places simultaneously. Within this field, it is the many-worlds theories of parallel universes (PU) that, I believe, resonate most sympathetically with our current sensibilities. PU transforms our view of both time and the production of realities in ways that mirror the new understanding of the creative process in telematic culture. Equally, it brings a new place in the order of things to lucid dreaming, schizophrenia, and other black holes of human consciousness. Although, in art, the postmodern prospectus has been assailed by a profound pessimism and despair, its essential impetus, to play with time, to layer experience, to mix and match tropes and codes in imaginative discontinuities, has not been entirely exhausted. To pursue these aspirations in deep data space, in the digital space-time of the computer, fully PDP and networked, is to bring art into resonant co-existence with physics. The one field maps inspiringly onto the other. The models and even the terminology of quantum physics can be put to work in the development of new descriptions of art practice in the telematic environment.

Certainly UP—Heisenberg's Uncertainty Principle and his description of the observer effect, that is, the sudden change in the property of subatomic matter

when that property is observed—intriguingly models the poststructuralist description of the reader/viewer as author/artist set in a context of semantic indeterminacy, where the meaning horizon is always as ultimately unreachable as the event-horizon is to the physicist. There is a black hole at the end of both rainbows. An infinite amount of time is predicated in both cases.

In a telematic network, with PDP memory and processing clusters linked to personal terminals all over the planet, there is a flow of data from which an observer, logging on to the system, can radically transform that data; that is, become an active participant in the process of constructing images, sound, and textual meaning, and activating what may effectively come to be seen as a global consciousness. In the theory of parallel universes as surveyed by Fred Alan Wolf, for example, drawing on the work of John Wheeler, Hugh Everett III, and Bryce DeWitt, it is the observer who creates the reality of the act by observation and choice of measuring apparatus or viewing frame [Wolf 1988]. Just as Benjamin Lee Whorf has argued that specific language produces a specific worldview [Whorf 1967], and as Jakob von Uexküll has proposed a distinct *Umwelt* for each different species, so virtual universes are immanent, relative to observer intervention [Uexküll 1934].

In all this indeterminacy, how, then, should time be continuous, uniform or consistent?

As artists, we move through parallel universes, shifting in and out of time-frames, phase shifts, tunnelling through one set of realities into other worlds: like Schrödinger's Cat, neither precisely here nor there, actual or virtual. In our evolving symbiosis with the computer, in our telematic augmentation, these attributes are magnified. All is in transition, art and meaning constantly shift fleetingly between resolutions. To insert oneself into the flow of data as a user of an art-directed telematic system ("user," i.e., neither autonomous creator nor passive viewer) is never to interact with the same set of data (images, text, sound) twice. Like Heraclitus, the philosopher of Ephesus, we can never put our foot into the same river twice. In the context of art, networking involves us no longer with an art object discretely to be identified in time and space, nor a sequence of (moving) images to be experienced in linear progression, nor yet a melange of space-time juxtapositions to be received as a complete, pre-ordered, and autonomously coherent entity. Time used in such production implies a fixed point in a perceiving system, a self-standing intelligence. Time becomes something other when our intelligence is dispersed, when the perceiving system is global in its gaze, and when interactions between parts of the network are asynchronic rather than serial or simultaneous. In short, schizo-time, layered phase-space,

discontinuous periodicity takes us into hyper time, the branching time-pathways of parallel universes.

The orthodoxies of time and space in the production of artworks of the old order contributed to the overarching drive in art towards representation. Art concerned with representation makes demands on art as object and on a fixed separation of creator and observer of the work. Representation demands coherence in space and time between the work itself and the subject of its representation. Representation demands work that is determinate, coherent, and consistent. It produces an art of assertion, a subscription to an assertive (aggressive, consuming, demanding) culture, in which the observing subject must be essentially passive, both in reception of the aesthetic messages that culture sustains and within its linguistic orthodoxies. In its insistence on clarity and coherence, representation always masks the inherent instability, the chaos, of process in the world. Principles of uncertainty, indeterminacy, flux and flow, have no place in an art of representation.

Telematic art rejects representation in favour of simulation. In seeking to simulate in its digital space-time the unstable, chaotic, fleeting, and numinous quality of its subject, telematic art rejects the mode of assertion in favour of negotiation, participation, collaboration. The art of the old order led inexorably to representations of representation itself, a suicidal art of solipsistic inversion, deconstructivist postmodernism.

Thus telematic art, moving beyond object art and time-based art, uses simulation to render what is invisible visible, to bring the virtual, the potential, the unseen, and unrealised into view. In this process, a multiplicity of viewpoints, of worldviews, is required and provided by networked perception and intelligence. Various, and often incompatible and certainly discontinuous, timeframes are invoked. In place of the aesthetic deprivation and semantic nihilism we have come to associate with the deconstructive pessimism of late postmodern art, we can hope for the emergence of a radically constructive art, moving from the older frame of time and representation to the multiple and layered frames of parallel time-worlds, creating the ceaselessly bifurcating semantic pathways of virtuality and simulation.

CHAPTER 16 **IS THERE LOVE IN THE TELEMATIC EMBRACE?**

1990 The past decade has seen the two powerful technologies of computing and telecommunications converge into one field of operations, which has drawn into its embrace other electronic media, including video, sound synthesis, remote sensing, and a variety of cybernetic systems. These phenomena are exerting enormous influence upon society and on individual behaviour; they seem increasingly to be calling into question the very nature of what it is to be human, to be creative, to think, and to perceive, and indeed our relationship to one another and to the planet as a whole. The "telematic culture" that accompanies the new developments consists of a set of behaviours, ideas, media, values, and objectives that are significantly unlike those that have shaped society since the Enlightenment. New cultural and scientific metaphors and paradigms are being generated, new models and representations of reality are being invented, new expressive means are being manufactured.

"Telematics" is a term used to designate computer-mediated communications networking involving telephone, cable, and satellite links between geographically dispersed individuals and institutions that are interfaced to data-processing systems, remote sensing devices, and capacious data storage banks [Nora and Minc 1980]. It involves the technology of interaction among human beings and between the human mind and artificial systems of intelligence and perception. The individual user of networks is always potentially involved in a global net, and the world is always potentially in a state of interaction with the individual. Thus, across the vast spread of telematic networks worldwide, the quantity of data processed and the density of information exchanged is incalculable. The ubiquitous efficacy of the telematic medium is not in doubt, but in human terms,

Originally published in *Art Journal* 49, no. 3 (Fall 1990): 241-47.

from the point of view of culture and creativity, the question is: What is the content?

This question, which seems to be at the heart of many critiques of art involving computers and telecommunications, suggests deep-seated fears of the machine coming to dominate the human will and of a technological formalism erasing human content and values. Apart from all the particulars of personal histories, of dreams, desires, and anxieties that inform the content of art's rich repertoire, the question, in essence, is: Is there love in the telematic embrace?

In the attempt to extricate human content from technological form, the question is made more complicated by our increasing tendency as artists to bring together imaging, sound, and text systems into interactive environments that exploit state-of-the-art hypermedia and that engage the full sensorium, albeit by digital means. Out of this technological complexity, we can sense the emergence of a synthesis of the arts. The question of content must therefore be addressed to the *Gesamtdatenwerk*—the integrated data work—and to its capacity to engage the intellect, emotions, and sensibility of the observer.[1] Here, however, more problems arise, since the observer in an interactive telematic system is by definition a participator. In a telematic art, meaning is not created by the artist, distributed through the network, and received by the observer. Meaning is the product of interaction between the observer and the system, the content of which is in a state of flux, of endless change and transformation. In this condition of uncertainty and instability, not simply because of the criss-crossing interactions of users of the network but because content is embodied in data that is itself immaterial, it is pure electronic *différance*, until it has been reconstituted at the interface as image, text, or sound. The sensory output may be differentiated further as existing on screen, as articulated structure or material, as architecture, as environment, or in virtual space.

Such a view is in line with a more general approach to art as residing in a cultural communications system rather than in the art object as a fixed semantic configuration—a system in which the viewer actively negotiates for meaning [see Maturana and Varela (1987) 1992]. In this sense, telematic networking makes explicit in its technology and protocols what is implicit in all aesthetic experience, where that experience is seen as being as much creative in the act of the viewer's perception as it is in the artist's production [see Barthes 1977]. Classical communications theory holds, however, that communication is a one-way dispatch, from sender to receiver, in which only contingent "noise" in the channel can modify the message (often further confused as the meaning) initiated at the source of transmission [see Shannon and Weaver 1949]. This is the model

that has the artist as sender and therefore originator of meaning, the artist as creator and owner of images and ideas, the artist as controller of context and content. It is a model that requires, for its completion, the viewer as, at best, a skilled decoder or interpreter of the artist's "meaning," or, at worst, simply a passive receptacle of such meaning. It gives rise to the industry of criticism and exegesis, in which those who "understand" this or that work of art explain it to those who are too stupid or uneducated to receive its meaning unaided. In this scenario, the artwork and its maker are viewed in the same way as the world and its creator. The beauty and truth of both art and the world are "out there" in the world and in the work of art. They are as fixed and immutable as the material universe appears to be. The canon of determinism decrees prefigured harmony and composition, regulated form and continuity of expression, with unity and clarity assured by a cultural consensus and a linguistic uniformity shared by artist and public alike.

The problem of content and meaning within a telematic culture gives added poignancy to the College Art Association [New York] panel "Computers and Art: Issues of Content" for which this essay was developed. "Issue" is open to a plurality of meanings, no one of which is satisfactory. The metaphor of a semantic sea, endlessly ebbing and flowing, of meaning constantly in flux, of all words, utterances, gestures, and images in a state of undecidability, tossed to and fro into new collusions and conjunctions within a field of human interaction and negotiation, is found as much in new science—in quantum physics, second-order cybernetics [see, e.g., Foerster 1981], or chaology [see, e.g., Gleick 1987], for example—as in art employing telematic concepts or the new literary criticism that has absorbed philosophy and social theory into its practice. This sunrise of uncertainty, of a joyous dance of meaning between layers of genre and metaphoric systems, this unfolding tissue woven of a multiplicity of visual codes and cultural imaginations was also the initial promise of the postmodern project before it disappeared into the domain of social theory, leaving only its frail corpus of pessimism and despair.

In the case of the physicists, the radical shift in metaphors about the world and our participation in its creation and redescription mean that science's picture window onto reality has been shattered by the very process of trying to measure it. John Wheeler uses this analogy succinctly:

> Nothing is more important about the quantum principle than this, that it destroys the concept of the world "sitting out there," with the observer safely separated from it by a 20 centimetre slab of plate glass. Even to observe so minuscule an object as electron, he must shatter the glass. He must reach in. He must

install his chosen measuring equipment. It is up to him whether he shall measure position or momentum . . . the measurement changes the state of the electron. The universe will never afterwards be the same. To describe what has happened one has to cross out that old word "observer" and put in its place "participator." In some strange sense the universe is a participatory universe. [Wheeler and Zurek 1983, 6]

In the context of telematic systems and the issue of content and meaning, the parallel shift in art of the status of "observer" to that of "participator" is demonstrated clearly if in accounts of the quantum principle we substitute "data" for "quanta." Indeed, finding such analogies between art and physics is more than just a pleasant game: the web of connections between new models of the theory and practice in the arts and the sciences, over a wide domain, is so pervasive as to suggest a paradigm shift in our worldview, a redescription of reality and a recontextualization of ourselves. We begin to understand that chance and change, chaos and indeterminacy, transcendence and transformation, the immaterial and the numinous are terms of the centre of our self-understanding and our new visions of reality. How, then, could there be a content—sets of meanings—contained within telematic art when every aspect of networking in data space is in a state of transformation and of becoming? The very technology of computer telecommunications extends the gaze, transcends the body, amplifies the mind into unpredictable configurations of thought and creativity.

In the recent history of Western art, it was Marcel Duchamp who first took the metaphor of the glass, of the window onto the world, and turned it back on itself to reveal what is invisible. We see in the work known as *The Bride Stripped Bare by Her Bachelors, Even*, or *Large Glass*, a field of vitreous reality in which energy and emotion are generated from the tension and interaction of male and female, natural and artificial, human and machine [see Duchamp 1973]. Its subject is attraction, in Charles Fourier's sense,[2] or, we might even say, love. The *Large Glass*, in its transparent essence, always includes both its environment and the reflection of the observer. Love is contained in this total embrace; all that escapes is reason and certainty. By participating in the embrace, the viewer comes to be a progenitor of the semantic issue. As "ground," the *Large Glass* has a function and status anticipating that of the computer monitor as a screen of operations—of transformations—and as the site of interaction and negotiation for meaning. But it is not only through the *Large Glass* that we can see Duchamp as prophetic of the telematic mode. The very metaphor of networking interaction in a field of uncertainty, in which the observer is creator and meaning is unstable, is implicit in all his work. Equally prophetic in

the *Large Glass* is the horizontal bar that joins the upper and lower parts of the work and serves as a metaphor for the all-around viewing, the inclusive, all-embracing scope of its vision. This stands in opposition to the vertical, head-to-toe viewing of Renaissance space, embodied in the Western pictorial tradition, where the metaphor of verticality is employed insistently in its monuments and architecture—emblems often as not of aggression, competition, and dominance, always of a tunnel vision. The horizontal, on the other hand, is a metaphor for the bird's-eye view, the all-over, all-embracing, holistic systems view of structures, relationships, and events—viewing that can include the ironic, the fuzzy, and the ambiguous. This is precisely the condition of perception and insight to which telematic networking aspires.

Perhaps the most powerful metaphor of interconnectedness and the horizontal embrace in art before the advent of telematic media is to be found in the work of Jackson Pollock [see Frank 1983]. Here the horizontal arena, a space marked out on the surface of the earth is the "ground" for the action and transformation that become the painting itself. Pollock created his powerful metaphors of connectedness by generating fields of intertwining, interweaving, branching, joining, colliding, crossing, linking lines of energy. His space is inclusive and inviting; his imagery carries a sense of anonymity of authorship that embraces the viewer in the creation of meaning. Nothing in painting could be more emblematic or prophetic of the network consciousness emerging with the telematic culture.

This provenance of telematic culture, as spiritual or transcendent in its force as the Navajo sand painting to which it, in turn, owes allegiance, is perhaps more readily understood if we are able to see the ubiquitous spread of computer communications networks across the face of the earth as constituting what in many esoteric traditions of both East and West would be called a "subtle body" [Tansley 1977]—a psychic envelope for the planet, a telematic "noosphere" [Teilhard de Chardin 1964], or "mind at large" [Bateson 1972]. Peter Russell describes the emergence of a planetary consciousness: "As communications networks increase, we will eventually reach a point where the billions of information exchanges, shuttling through the networks at any one time, can create coherence in the global brain, similar to those found in the human brain" [Russell 1982]. This suggests equally the need for a redescription of human consciousness as it emerges from the developing symbiosis of the human mind and the artificial thought of parallel distributed processing (PDP) [Rumelhart et al. 1986, vol. 1].

One of the great rituals of emergence into a new world—that of the Amer-

ican Indian Hopi—is centred around the sacred *sipapu* that connects to the Underworld of power and transformation, and our emergence into the new world of telematic culture similarly calls for celebration at the interface to those PDP systems that can link us with super connectivity, mind to mind, into a new planetary community. And just as the Hopi seek to exploit the full measure of their expressive means by joining image, music, chant, and dance into a holistic unity, so we too now seek a synthesis of digital modes—image, sound, text, and cybernetic structure—by which to recontextualize our own world, that numinous whole of all our separate realities.

The emerging new order of art is that of interactivity, of "dispersed authorship";[3] the canon is one of contingency and uncertainty. Telematic art encompasses a wide array of media: hypermedia, videotex, telefacsimile, interactive video, computer animation and simulation, teleconferencing, text exchange, image transfer, sound synthesis, telemetry and remote sensing, virtual space, cybernetic structures, and intelligent architecture. These are simply broad categories of technologies and methodologies that are constantly evolving—bifurcating, joining, hybridising—at an accelerated rate.

At the same time, the status of the art object changes. The culturally dominant objet d'art as the sole focus (the uncommon carrier of uncommon content) is replaced by the interface. Instead of the artwork as a window onto a composed, resolved, and ordered reality, we have at the interface a doorway to undecidability, a data space of semantic and material potentiality. The focus of the aesthetic shifts from the observed object to participating subject, from the analysis of observed systems to the (second-order) cybernetics of observing systems: the canon of the immaterial and participatory. Thus, at the interface to telematic systems, content is created rather than received. By the same token, content is disposed of at the interface by reinserting it, transformed by the process of interaction, back into the network for storage, distribution, and eventual transformation at the interface of other users, at other access nodes across the planet.

A telematic network is more than the sum of its parts, more than a computer communications web. The new order of perception it constitutes can be called "global vision," since its distributed sensorium and distributed intelligence—networked across the whole planet as well as reaching remotely into galactic space and deep into quantum levels of matter—together provide for a holistic, integrative viewing of structures, systems, and events that is global in its scope. This artificial extension of human intelligence and perception, which the neural nets of PDP and sophisticated and remote-sensing systems provide [Curran 1985], not only amplifies human perception but is in the process of changing it.

The transformation is entirely consistent with the overarching ambition of both art and science throughout this century: to make the invisible visible. Even now, it must be recognised that our human cognitive processes (whether involving linear or associative thought, imaging, remembering, computing, or hypothesizing) are rarely carried out without the computer being involved [Graubard 1988]. A great proportion of the time that we are involved in communicating, learning, or being entertained entails our interaction with telecommunication systems [Kobayashi 1986]. Similarly, with feeling and sensing, artificial, intelligent sensors of considerable subtlety are becoming integral to human interaction with the environment and to the monitoring of both internal and external ecologies. Human perception, understood as the product of active negotiation rather than passive reception, thus requires, within this evolving symbiosis of human/machine, telematic links of considerable complexity between the very diverse nodes of the worldwide artificial reticular sensorium.

Telematic culture means, in short, that we do not think, see, or feel in isolation. Creativity is shared, authorship is distributed, but not in a way that denies the individual her authenticity or power of self-creation, as rather crude models of collectivity might have done in the past. On the contrary, telematic culture amplifies the individual's capacity for creative thought and action, for more vivid and intense experience, for more informed perception, by enabling her to participate in the production of global vision through networked interaction with other minds, other sensibilities, other sensing and thinking systems across the planet—thought circulating in the medium of data through a multiplicity of different cultural, geographical, social, and personal layers. Networking supports endless redescription and recontextualization, such that no language or visual code is final and no reality is ultimate. In the telematic culture, pluralism and relativism shape the configurations of ideas—of image, music, and text— that circulate in the system.

It is the computer that is at the heart of this circulation system, and, like the heart, it works best when it becomes invisible. At present, the computer as a physical, material presence is too much with us; it dominates our inventory of tools, instruments, appliances, and apparatus as the ultimate machine. In our artistic and educational environments, it is all too solidly there, a computational block to poetry and imagination. It is not transparent, nor is it yet fully understood as pure system, a universal transformative matrix. The computer is not primarily a thing, an object, but a set of behaviours, a system, actually, a system of systems. Data constitute its lingua franca. It is the agent of the data field, the constructor of data space. Where it is seen simply as a screen presenting the

pages of an illuminated book, or as an internally lit painting, it is of no artistic value. Where its considerable speed of processing is used simply to simulate filmic or photographic representations, it becomes the agent of passive voyeurism. Where access to its transformative power is constrained by a typewriter keyboard, the user is forced into the posture of a clerk. The electronic palette, the light pen, and even the mouse bind us to past practices. The power of the computer's presence, particularly the power of the interface to shape language and thought, cannot be overestimated. It may not be an exaggeration to say that the "content" of a telematic art will depend in large measure on the nature of the interface; that is, the kinds of configurations and assemblies of image, sound, and text, the kinds of restructuring and articulation of environment that telematic interactivity might yield, will be determined by the freedoms and fluidity available at the interface.

The essence of the interface is its potential flexibility; it can accept and deliver images both fixed and in movement; sounds constructed, synthesised, or sampled; texts written and spoken. It can be heat-sensitive, body-responsive, environmentally aware. It can respond to the tapping of feet, the dancer's arabesque, the direction of a viewer's gaze. It not only articulates a physical environment with movement, sound, or light; it is an environment, an arena of data space in which a distributed art of the human/computer symbiosis can be acted out, the issue of its cybernetic content. Each individual computer interface is an aspect of a telematic unity, such that to be in or at any one interface is to be in the virtual presence of all the other interfaces throughout the network of which it is a part. This might be defined as the "holomatic" principle in networking. It is so because all the data flowing through any access node of the network are equally and at the same time held in the memory of that network: they can be accessed, through cable or satellite links, from any part of the planet at any time of day or night, by users of the network (who, in order to communicate with each other, do not need to be in the same place at the same time).

This holomatic principle was well demonstrated during the Venice Biennale of 1986, when the "Planetary Network" project had the effect of pulling the exhibition from its rather elite, centralised, and exclusive domain in Venice and stretching it out over the face of the globe,[4] the flow of creative data generated by the interaction of artists networking all over the world was accessible everywhere. Set within the interactive environment "Laboratory Ubiqua," a wide range of telematic media were involved, including electronic mail, videotex, digital-image exchange, slow-scan TV, and computer conferencing. Interactive videodiscs, remote-sensing systems, and cybernetic structures were also included.

Figure 34. Planetary network: "Laboratorio ubiqua." 1986. XVIIth Venice Biennale.

On a simpler and publicly more accessible level, the telematic project devised by Art Accès for the exhibition "Les Immatériaux" at the Centre Pompidou in Paris in 1985 can be cited for its effective use of a domestic terminal interfacing a public videotex service. It involved the use of the French national Minitel system as the network for on-line interaction between artists "in" the exhibition and the large population of Minitel subscribers distributed throughout the greater Paris region. In this case, the cultural interface had developed from its humble beginnings as an on-line telephone-directory terminal (installed free for PTT subscribers in place of the traditional and costly annual issue of printed directories), through its accelerated development as a consumer and marketing tool, to a games machine, a reference library, a dating service, and now an instrument of new art.

Earlier, in 1983, for the exhibition "Electra" at the Musée d'Art Moderne de la Ville de Paris, the interface for the international telematic project "La Plissure du Texte" (a planetary fairy tale created by means of a "dispersed authorship" through electronic networking) involved little more than the orthodox computer terminal and keyboard [Ascott 1983]. A data projector carried the text to a public dimension, dramatising its electronic presence, which was at once ephemeral and concrete. With many participants on-line throughout America,

Europe, and Australia, this was a perfect vehicle to involve both artists and public in the layering of texts and in the semantic ambiguities, delights, and surprises that can be generated by an interactive authorship dispersed throughout so many cultures in so many remote parts of the world. Like most telematic projects of the early 1980s, however, the project was limited to the text for technical and financial as much as for conceptual reasons.

A more elaborate and complex multimedia interface was created for the project "Aspects of Gaia: Digital Pathways across the Whole Earth" as part of the Ars Electronica Festival of Art and Technology in Linz, Austria, in 1989. The transmission of digital image and sound by file transfer and the computer storage of telefacsimile material via modem, by this time economically feasible, invited the creation of a more dramatic and engaging environment for public participation. Invitations to participate in the project were e-mailed, faxed, or airmailed to "artists, scientists, poets, shamans, musicians, architects, visionaries, aboriginal artists of Australia, native artists of the Americas." The subject of the project was the many aspects of the earth, Gaia, seen from a multiplicity of spiritual, scientific, cultural, and mythological perspectives. An energising stream of integrated digital images, texts, and sounds (a *Gesamtdatenwerk*) would then constitute a kind of invisible cloak, a digital noosphere that might contribute to the harmonisation of the planet. In accessing the meridians at various nodes, participants became involved in a form of global acupuncture, their interactions endlessly transforming and reconstituting the worldwide flow of creative data.

Congruent with the structural form of the Brucknerhaus (site of the festival) as a metaphor of curving space-time, the public interface installation in Linz was on two levels, reflecting the layering of material that the project was intended to generate. The upper level investigated the potential of the digital screen seen on the horizontal, large-scale format, rather than the more familiar vertical monitor presentation. Giving the public a bird's-eye view of images networked in from all over the planet, the large horizontal screens were set into "information bars," around which viewers could sit—on high stools, as if at a cocktail bar—gazing not into an alcoholic haze but into pure data space. The networked images that appeared were then changed by means of acoustic sensors fed to appropriate software (in the form of small microphones set on the countertop of the bar) or were modified with line and colour by means of a mouse manipulated by the viewer across the countertop. Thus, interaction by voice and gesture led to the creation of new images, which could then be retrieved by the computer and stored pending their eventual insertion back into the planetary network.

The interface on the lower level involved a railway track curving through a long, low tunnel that flanked the building, carrying a flatbed trolley (upholstered not unlike an analyst's couch), which enabled each participant to glide effortlessly through a darkened acoustical space, looking up at a series of flickering LED signs scrolling texts drawn from the network of inputs all over the world. This was Gaia's womb, a kind of telematic Neolithic passageway.

The design and production of the interface as a whole—involving the collaboration of artists and technicians working with digital sound and image, electroacoustical and mechanical structures, and software design—was achieved "remotely" by computer-conference networking among their widely dispersed geographical locations. The same telematic process of design and consultation through international networks was involved in the preparation of "La Plissure du Texte" for "Electra" and of the "Planetary Network" and the "Laboratory Ubiqua" in Venice. It is a process that is at the centre of much research, development, design, production, and presentation in many fields of artistic and scientific endeavour [Brand 1987]. It is also a process that can include the client, consumer, user, or viewer from the very start. In the telematization of the creative process, the roles of artist and viewer, designer and consumer, become diffused; the polarities of maker and user become destabilized. This will lead ultimately, no doubt, to changes in status, description, and use of cultural institutions: a redescription (and revitalisation, perhaps) of the academy, museum, gallery, archive, workshop, and studio. A fusion of art, science, technology, education, and entertainment into a telematic fabric of learning and creativity can be foreseen.

To the objection that such a global vision of an emerging planetary art is uncritically euphoric, or that the prospectus of a telematic culture with its *Gesamtdatenwerk* of hypermediated virtual realities is too grandiose, we should perhaps remind ourselves of the essentially political, economic, and social sensibilities of those who laid the conceptual foundations of the field of interactive systems. This cultural prospectus implies a telematic politics, embodying the features of feedback, self-determination, interaction, and collaborative creativity, not unlike the "science of government" for which, over 150 years ago, André-Marie Ampère coined the term "cybernetics"—a term reinvigorated and humanised by Norbert Wiener in this century [Wiener 1948]. Contrary to the rather rigid determinism and positivism that have shaped society since the Enlightenment, however, these features will have to accommodate notions of uncertainty, chaos, autopoiesis, contingency, and the second-order cybernetics of a fuzzy-systems

Figure 35. "Aspects of Gaia." Lower level (trolley). 1989. Telematic art project with multimedia installation. Ars Electronica, Brucknerhaus, Linz.

view of a world in which the observer and observed, creator and viewer, are inextricably linked in the process of making reality—all our many separate realities interacting, colliding, reforming, and resonating within the telematic noosphere of the planet.

Within these separate realities, the status of the "real" in the phenomenology of the artwork also changes. Virtual space, virtual image, virtual reality—these are categories of experience that can be shared through telematic networks, allowing for movement through "cyberspace" and engagement with the virtual presence of others who are in their corporeal materiality at a distance, physically inaccessible or otherwise remote.[6] The adoption of a headset, data glove, or other data wear can make the personal connection to cyberspace—socialisation in hyper reality—wherein interaction with others will undoubtedly be experienced as "real," and the feelings and perceptions so generated will also be "real." The passage from real to virtual will probably be seamless, just as social behaviour derived from human-computer symbiosis is flowing unnoticed into our consciousness. But the very ease of transition from "reality" to "virtuality" will cause

confusion in culture, in values, and in matters of personal identity. It will be the role of the artist, in collaboration with scientists, to establish not only new creative praxes but also new value systems, new ordinances of human interaction and social communicability. The issue of content in the planetary art of this emerging telematic culture is therefore the issue of values, expressed as transient hypotheses rather than finalities, tested within the immaterial, virtual hyper realities of data space. Integrity of the work will not be judged by the old aesthetics; no antecedent criteria can be applied to network creativity, since there is no previous canon to accommodate it. The telematic process, like the technology that embodies it, is the product of a profound human desire for transcendence: to be out of body, out of mind, beyond language. Virtual space and data space constitute the domain, previously provided by myth and religion, where imagination, desire, and will can reengage the forces of space, time, and matter in the battle for a new reality.

The digital matrix that brings all new electronic and optical media into its telematic embrace—being a connectionist model of hypermedia—calls for a "connective criticism." The personal computer yields to the interpersonal computer. Serial data processing becomes parallel distributed processing. Networks link memory bank to memory bank, intelligence to intelligence. Digital image and digital sound find their common ground, just as a synthesis of modes—visual, tactile, textual, and acoustic environment—can be expected to "hypermediate" the networked sensibilities of a constellation of global cultures. The digital camera—gathering still and moving images from remote sensors deep in space, or directed by human or artificial intelligence on earth, seeking out what is unseen, imaging what is invisible—meets at a point between our own eyes and the reticular retina of world-wide networks, stretching perception laterally away from the tunnel vision, from the Cartesian sight lines of the old deterministic era. Our sensory experience becomes extrasensory, as our vision is enhanced by the extrasensory devices of telematic perception. The computer deals invisibly with the invisible. It processes those connections, collusions, systems, forces and fields, transformations and transferences, chaotic assemblies, and higher orders of organisation that lie outside our vision, outside the gross level of material perception afforded by our natural senses. Totally invisible to our everyday unaided perception, for example, is the underlying fluidity of matter, the indeterminate dance of electrons, the "snap, crackle, and pop" of quanta, the tunnelling and transpositions, non-local and superluminal, that the new physics presents. It is these patterns of events, these new exhilarating metaphors of existence— non-linear, uncertain, layered, and discontinuous—that the computer can re-

describe. With the computer, and brought together in the telematic embrace, we can hope to glimpse the unseeable, to grasp the ineffable chaos of becoming, the secret order of disorder. And as we come to see more, we shall see the computer less and less. It will become invisible in its immanence, but its presence will be palpable to the artist engaged telematically in the world process of autopoiesis, of planetary self-creation.

The technology of computerised media and telematic systems is no longer to be viewed simply as a set of rather complicated tools extending the range of painting and sculpture, performed music, or published literature. It can now be seen to support a whole new field of creative endeavour that is as radically unlike each of those established artistic genres as they are unlike each other. A new vehicle of consciousness, of creativity and expression, has entered our repertoire of being. While it is concerned with both technology and poetry, the virtual and the immaterial as well as the palpable and concrete, the telematic may be categorised as neither art nor science, while being allied in many ways to the discourses of both. The further development of this field will clearly mean an interdependence of artistic, scientific, and technological competencies and aspirations and, urgently, on the formulation of a transdisciplinary education.

So, to link the ancient image-making process of Navajo sand painting to the digital imaging of modern supercomputers through common silicon, which serves them both as pigment and processor chip, is more than ironic whimsy. The holistic ambition of Native American culture is paralleled by the holistic potentiality of telematic art. More than a technological expedient for the interchange of information, networking provides the very infrastructure for spiritual interchange that could lead to the harmonisation and creative development of the whole planet. With this prospectus, however naively optimistic and transcendental it may appear in our current fin-de-siècle gloom, the metaphor of love in the telematic embrace may not be entirely misplaced.

NOTES

1 Cf. the German word *Gesamtkunstwerk*, used by Richard Wagner to refer to his vision of a "total artwork" integrating music, image, and poetry. [Ascott's neologism *Gesamtdatenwerk* applies this concept to telematic art. See chapter 14.—Ed.]

2 Charles Fourier (1772–1837) proposed a "system of passionate attraction" that seeks universal harmony. See Fourier 1996.

3 The term "dispersed authorship" was first proposed in Roy Ascott, "Art and Telematics: Towards a Network Consciousness" (1984; chapter 11 above).

4 See Ascott 1986. The international commissioners for the 1986 Venice Biennale were Roy Ascott, Don Foresta, Tom Sherman, and Tomaso Trini.

5 Telematic art project by Roy Ascott in collaboration with Peter Appleton, Matthias Fuchs, Robert Pepperell, and Miles Viseman.

6 VPL Research, Inc., of California demonstrated "shared virtual reality" and "walk-through cyberspace" at Texpo '89 in San Francisco, June 1989.

PHOTOGRAPHY AT THE INTERFACE

1992 There has been a long-running debate about the relationship be-
tween photography and the real, which for many has meant fak-
ing faith in its power to represent adequately, or even at all, the
true nature of things seen, or the reality of surfaces encountered,
while for others, it has meant a faith in fakes, photographic de-
ception in the service of power. Some have argued that photogra-
phy has used the alias of truth to impose its fictions. It's now more
than ten years since Stewart Brand saw the Giza pyramid move.[1]
To that generation of photographers, contemplating the sins of dig-
ital retouching, it meant endless (and for some, wearisome) self-
questioning, moralising, and fretting about truth to appearance,
and confusion about truth and reality. But now, who cares? *Did the
pyramids move for you, darling?* We don't care—because our virtual
worlds allow us to construct pyramids in all kinds of data space,
because we have no trust whatsoever in either journalism or art as
purveyors of reality, because, like Marshall Blonsky, we've had close
encounters with semiotics of the third kind, "not the representa-
tion, or meaning, but the way the meaning is announced" [Blon-
sky 1985, xviii].
 Now this disbelief, merited towards the media whenever cor-
ruption and dissimulation are its editorial intent, which is mostly,
is not a reproach to art. It is rather a recognition that art has grown
to embrace, in addition to its continuing critical concern with rep-
resentation, and on-again, off-again flirtations with simulation, a
computer-mediated virtualisation. (From the light and shade of the
mimetic, through the trough of deconstruction, towards the radi-
ance of a radical constructivism, might be one way to put it [Wat-

Originally published in French in *Digital Photography,* edited by Annick Bureaud
(Paris: Centre national de la photographie, 1992). The original English was published
in *Electronic Culture: Technology and Visual Representation,* edited by Tim Druckrey
(New York: Aperture Foundation, 1996), and is reprinted with permission.

zlawick 1984].) Undeveloped as this view may be, we are sufficiently self-aware to know that reality is built by us, to fit our psychic and sensory specifications and to satisfy our conceptual longings. It's all tied up with the role of the viewing subject (in the world, in the laboratory, in art) on the one hand, and with the technology of cognition on the other. The field of digital photography plays its part in this prospectus, and the artists in this exhibition, "Digital Photography" [see Bureaud 1992], play a leading role within this field.

The golden age of the electronic, post-biological culture may be far ahead, but the world of digital photography is opening up, just as the world of analogue photography (as it has been practiced) is, if not closing down, then being absorbed within the digital discourse. This is not a debate about the relative merits of gold and silver. It's a matter of attitude, both of the artist and of the viewer. We are at the beginning of the era of post-photographic practice. The work here presented by Paul Berger, Carol Flax, Manual, and Esther Parada testifies vigorously to this overture. It is not that these artists are no longer focused on things seen, or that they no longer want to make images that fix our attention into a composite moment, although it is true that their various interests are evidently and potently invested more in what cannot be seen at the surface level of reality, in what is invisible, fluid, and transient: human relationships, systems, forces, and fields as they are at work in nature, politics, and culture. It's that photography as a stable medium is giving way to a practice that celebrates instability, uncertainty, incompleteness, and transformation. And I don't just mean semantically. What these artists have taken on board is the radical change in the technology of image emergence, not only how the meaning is announced but how it comes on stage; not only how the world is pictured, or how it is framed, but how frameworks are constructed from which image worlds can emerge, an open-ended process.

This post-photographic technology captures images ("seen" images from still, video, and other cameras), constructs images ("unseen" data from remote sensors and data banks), and generates images (from raw numbers); it treats them, stores them, associates them, disburses them, and transmits them into a media flow that is—in every serious sense—unending and ubiquitous. Or, to put it more comfortably for those still chemically connected to image production, and for the present anyway, it is a technology that allows us to do so, if we wish. What has changed, though, from the old economy of the image is that the processes of transformation I have described are now in the hands of the viewer as much as the artist. Or are *implicitly* so. And, just around the corner, not yet

playing peek-a-boo but close to doing so, is the artificial observer, the eye of the neural net, the artificial intelligence that will surely become a part of the observing system. But that's for the future.

Here and now in the domain of popular culture (of 1992), the world takes its photographic negatives to the neighbourhood photo shop, slips them the 35mm roll, and later collects a compact disc ready to view . . . on the TV screen. "CD killed the video star" is likely to be the refrain for this decade. And the CD-ROM, compact discs with read-only-memory, will, of course, eventually give way in the mass market to interactive discs, CD-I, allowing the public not only to interact with the (photo) data at their disposal, to travel through it with their own connective patterns of viewing, but to interfere with the images themselves, to distort, collage, dismember, fractionise, and in every way transform the image at will. Coupled with the easier availability of scanners, no photographic images from Walker Evans to *Playboy* centerfolds will be immune to violation or domestication. This "opening" of the image and the distribution, across time, of authorship at the public level will doubtless have unprecedented effects both on the perceived legitimacy of the photograph and on the perceived authenticity and cultural status of the photographic artist.

The combination of complexity in capturing, constructing, storing, and accessing data, combining those data at various levels of resolution, in a variety of sensory and semantic modes—image, text, sound—places digital photography in a kind of virtual space, on the road to hypermedia.[2] It is an important component of the complex ensembles that these new media sustain. This route, actually consisting of many personal pathways, is being opened up by artists to whom silver is no longer precious—significant among them, the artists presented in this exhibition. For them, data space is infinitely layered, and data images exist always and at all times in a sea of interdata, just as the hypertext exists within the boundless domain of the intertext, where Ted Nelson meets Roland Barthes, or where Apple makes a non-intuitive, natural bid to be regrafted onto the tree of knowledge.[3]

"The computer has provided the technology to facilitate the representation of the multi-dimensional and layered aspect of my ideas," writes Carol Flax. It is this need, to model, reflect, contain, and distribute complexity (in life, in personal experience, in politics) that leads her, as with the other artists in this exhibition, to employ the complex systems of new technology, "never thinking of them," as she says, "simply as painting tools, but always as communications devices." Similarly, as Esther Parada shows, these mixtures of text and image, lay-

ering and montage, can serve distinctly critical ends, allowing for the revisioning, reworking, and reconstructing of racial, political, and cultural myth and mendacity in earlier photographic practices.

For the viewer, it's the difference between absorption and immersion. In classical photography, we wanted to absorb as much as we could of the beauty of the image, its content, its politics, its culture. The photograph always lingered between *documentum* and *monumentum*, between the official piece of evidence and the legitimised record; between sighting and reminding, collecting and storing. That is, between process and substance, activity and object. It is salutary to remind ourselves that the provenance of documentum lies in *docere*, to teach, to give proof, but also touches on *decere*, to be fitting and decent, and, if *docere* is to work, docile. There is a sense that much photography has underwritten, if not official reality, then an ideologically coherent one, set very much *as if* in the here and now.

There has always been a pull in photography, towards "normal" viewing, the "real" language of seeing: photographic reality is after all a synonym for ordinary reality, couched in ordinary language. "[T]his pull towards ordinary language was often, is often, a pull towards current consciousness: a framing of ideas within certain polite but definite limits," Raymond Williams observes [Williams 1980]. "By itself photography cannot deal with the unseen, the remote, the internal, the abstract," Neil Postman has pointed out. "It does not speak of 'Man', only of 'a man'; not of 'tree', only of 'a tree'. You can only photograph a fragment of here and now. The photograph presents the world as object; language, the world as idea. There is no such thing in nature as 'man' or 'tree.' The universe offers no such categories or simplifications; only flux and infinite variety" [Postman 1985].

Absorption in the here and now is re-enacted in a more focused, compact, bounded, and therefore more intense way by means of the photograph. The context is one of empathy. The transfer of feeling. But photography easily lulls us into a false sense of reality, a reality reaffirmed by its familiarity. The routines of seeing. In this regard, the philosopher Paul Feyerabend wrote: "Life seems clear enough as long as it is routine, i.e. as long as people remain docile, read texts in a standard manner and are not challenged in a fundamental way. The clarity dissolves, strange ideas, perceptions, feelings raise their head when routine breaks down" [Feyerabend 1991].

Just as our interest nowadays is less in *what* photographs mean than in *how* they mean, so empathy with an artwork's evocation of a given state, or a given fragment of the here and now, is of less importance to us than a vivid involve-

ment, through our interaction with the photo-data image, in the construction of a reality, of multiple realities. In post-photographic practice, the lust for verisimilitude gives way to the love of modeling.

In post-photographic practice, the routine to which Feyerabend referred breaks down. The metaphor for this practice is emphatically aquatic, notwithstanding the necessary computers, imaging peripherals, and optical and magnetic storage devices. The hypermedia systems in which photo data float call for sensory immersion and conceptual navigation on the part of the viewing subject: immersion in the images which are brought up from the database into our realm of seeing; and navigation through the layers of data, the multiplicity of (HyperCard) routes and (SuperCard) passages, within which the images are enfolded.

Thus the new photographic discourse, both within its stereographic virtuality and its hypermedia potentiality, must put as much emphasis on the behaviour of the viewing subject, her *inter-action* with the apparatus and the image, as on her introspective *re-action*. The window onto a world of analogue actualities gives way to the doorway into a world of digital potentialities. It is a process of creation that invites collaboration and cooperation both by those who, as artists, instigate the process and those, as viewers, who respond to the process in the public arena. Collaboration and participation in the construction of the digital photograph is initiated at the very point of conception in the practice of the artist Manual. Their practice is insistently and paradigmatically collaborative, but whereas this partnership is seamless in its process of production, it is concerned to reveal the divisions of digital and analogue media employed, and to make transparent their composite structures, as a strategy in presenting the overall problematics which the work poses. Paul Berger, similarly, seeks to visualise something of the conflict that exists between the competing information vehicles of computer interface, mechanical hand-drawing, and camera-based imaging systems.

But it would be false to set up the different aspects of photography, digital or analogue, in complete and total opposition. And these artists are certainly not doing that. It's simultaneously a case of both "both/and" as well as "either/or." All strategies are open to deployment. Photography both affirms gravity and gravitates around immateriality. As for its relationship to the real, and to truth, it is as relativistic, and can be as pragmatic, as those current discourses which have replaced philosophy as the echo or guide of artistic practice. "Contingency, irony, and solidarity" play their part in its formation, despite Manual's witty allusion to Americans being "irony-bored" (and "over-pressed" by the media, one might add) [Rorty 1989]. Just as, in his contributions to radical constructivism,

Paul Watzlawick asks how we know what we believe we know, so photography has the potential to show how realities are constructed, and with digital photography, to admit us, as participating viewers, into the process of construction [Watzlawick 1984].

Hypermedia, which provides the layered space for digital photography, is a site of interactivity and connectivity in which the viewer can play an active part in the transformation or affirmation of the images the photographer provides. But once flowing in data space, stand-alone meanings and conceptual linearities disappear. A world of fuzzy ambiguities, darting associations, shifting contexts, and semantic leaps opens up. This is the second order of reproduction, a stage beyond Walter Benjamin's "work of art in the age of mechanical reproduction" [Benjamin 1969]. This is the stage of co-production. First, we understood a co-production between the photographer and the viewing subject in the realm of meaning; now we see a technology of co-production and transformation of the image itself.

Where there was once a photography that always ended up with its back to the wall, or pressed between the covers of a book, impenetrable by other media, now we are seeing the emergence in digital photography of a permeable data field, whose sources may well be photographic, focused on a photonic given, but whose image is a lightly woven structure, open to other image sources, other insertions into the purity of the photographic field. Esther Parada sees it as "an electronic loom . . . into which I can weave other material . . . an equivalent to Guatemalan textiles, in which elaborate embroidery plays against the woven pattern of the cloth."

As photography moves along the path to hypermedia, to a place on the CD-I disc so to speak, it can be seen that the permeability of the photographic image is not solely due to the flooding of the silver grains by digital pixels, nor just to the expansion from the single frame to a multiplicity of layers, nor from the image frozen in time to the image flowing in time, but also to the repositioning of the viewer, to her empowerment as a manipulator of that image, as the one in whose hands the destiny of the image may lie. "Once digitized," writes Paul Berger, "the image, which on the screen resembles a very clean video freeze-frame, can be endlessly manipulated, recombined with other elements, and transformed."

So, to the question, naively but frequently asked: "What is the difference between digital photography and regular photography other than the fact that lies and dissimulations may be inserted more seamlessly into the veridical space of

its image?" we can answer: "Its object lies in a virtual space, and in an implicit world that evolves within the flow of hypermedia—layered, relational, and constantly shifting in content and context, depending on the behaviour and consciousness of the viewer." The answer cannot be simply that it lies in the difference between the material image on paper and the immaterial apparition at the computer interface, nor that the one depends upon perception by the physical and organic machine and the other on perception by the technological machine. It lies finally in the opportunity for its further transformation by the viewing subject.

As digital photography moves towards the scene of hypermediated transactions, the ink-jet printer is as much a metaphor as an instrument. All contradictions, it is the very precision of the printing process that allows the artist to postulate a semantic uncertainty, and it is the crisp certainty of its defined images that allow the photo image to reveal its fuzzy shifts in meaning. Visions, dreams, and illusions, however tenuous and imprecise, are given a clarity of form and a critical density of image. Due to their digital provenance, the destiny of these images, apparently anchored on a surface in real space, is as likely to be realised in the evanescence of a television screen, the embrace of a stereographic display, embedded in an LCD screen, projected, holographed, or illuminated, as on a wall or in a book.

These artists, whose work brings American digital photography to France for the first time, have opened the door into data space and stepped into the future. But although they have closed the shutters on the picture-window view of reality, they are very grounded in the present. Their themes of family, ecology, political oppression, and cultural discontinuity are made more vivid rather than diminished by the high technology they have employed. They confound those critics of the electronic age who see only a technoculture of progressive dehumanisation. Photography is now at the interface, and these artists have taken up the challenge that the new complexity of technological systems and diversity of media present. They bring us images and issues of a subtle sensibility and the assurance that the computerization of photographic practice is profoundly human at base.

NOTES

1 The *National Geographic*, February 1982, "digitally moved" a pyramid to accommodate the design needs of its front cover. See Brand 1987.

2 Hypermedia provides for a nonsequential inputting and navigation of multimedia data (photo, graphics, text, video, audio).

3 Ted Nelson is the inventor of Hypertext and of "Xanadu," the vision of a globally connected knowledge network. Apple plans to market an interface with user-friendly sensory modes that will replace the keyboard and mouse.

HEAVENLY BODIES

Teleconstructing a Zodiac for the Twenty-First Century

1993 *Note: Time is the essential ingredient of this project.*
Every input/output must be strictly scheduled and precisely observed.

▬ OBJECTIVE

To construct twelve new signs of the zodiac by remote collabora-
tion. Each sign of the zodiac consists of twelve actual, mythical, or
artificial animal/human parts, which have been created and trans-
mitted by the participants with instructions for their place in the
overall configuration of the sign. All accompanied by divinatory
texts and music of the spheres.

▬ STRUCTURE

Graz is the interface between twelve groups of participants, each of
whom is online in strict rotation with videophone and fax. Each in
turn receives data from the interface. Each group sends one image,
text, and sound-bite package within each one-hour transmission
period. Each group will thus send twelve such packages over the
twelve transmission periods.

The transmission periods can occupy twelve continuous hours
within one day, or be spread across several days according to Graz
program requirements, e.g., two transmission periods each evening
for six days.

There will be six transmission points communicating with the
Graz Interface Zone: Santa Monica, Toronto, Paris, Den Bosch and
Utrecht in Holland, and Gwent, Wales.

A proposal for a telematic art project for Graz, Austria. Originally published in
Teleskulptur III, edited by Richard Kriesche (Graz: Kulturdata, 1993), and reprinted by
permission of Richard Kriesche and Kulturdata.

Two artists (or two groups) will send from each transmission point. There will be twelve transmission phases (P1, P2, . . . P12). Each transmission phase lasts sixty minutes. Each transmission phase consists of twelve transmission bursts (P1.1, P1.2, etc.). One transmission burst is sent every five minutes.

— PROCESS

Each transmission burst will result in the transmission to the interface of a video image, a sound bite, and a fax message from one participant group. The image will consist of a part of an actual, mythical, or artificial creature. The sound bite will be a three-second synthesized sound structure. The text will be divinatory, prophetic, or anticipatory in register.

— EXAMPLE

A video single-frame image is sent with a grid reference. The videophone receiving the video image is placed on the actual wall grid according to the frame reference. The videophone's audio broadcasts the sound bite. The videophone holds the image for the remainder of the hour. The image is also stored on videotape. In the course of an hour, images will appear in each of the twelve videophones hung on the North Wall grid, as an illuminated celestial map, configured overall according to the grid references sent with each image.

At the same time a brief text message is received by fax. The fax message is loaded into an LED sign to be displayed as a scrolling text. In the course of an hour, twelve divinatory texts will emerge on the LED signs. At the end of the hour, the whole configuration will be loaded into the main computer, reduced to a linear figure, and placed in the evolving circle of zodiac signs. To reduce the videophone configuration to a linear figure, the position of each videophone on the grid will be treated as a point to be joined by a straight line to the next incoming point. The resultant linear configuration will constitute the new zodiacal sign. The transmitted parts will also be graphically joined in such a way that the image of a zodiacal creature will be created.

The twelve received sound bites will be synthesized to produce a sound structure (harmony of the spheres) to accompany the new zodiacal sign.

At the end of the hour, a videotape is made of each transmission burst and replayed on the monitors under each digital clock, as appropriate to each sending location.

1993 I would like to start by confronting two questions that are often put to me concerning art in the telematic culture: "Can computer-communications technology sustain art?" and "Will telematic systems destroy the humanness of human communication?" Well, first, what do we mean by "telematics"?

Telematics, being the fusion of computers and telecommunications systems, is both a technology and a medium. As a medium, it is at the heart of interactivity, of diffusion with reciprocity, of telepresence and informatic negotiation. As a technology, it is concerned with sustaining systems and processes of all kinds, artistic and cultural just as much as biological, commercial, or industrial. Telematics can certainly sustain art, and as I hope to show you, can extend it into unprecedented forms. But whether art, in the sense in which we have chosen to define it over the past hundred or so years (I'm thinking of romanticism and modernism, of course), is capable of sustaining itself into the twenty-first century, *with or without* technology, is quite another matter.

My feeling is that it probably is not capable of doing so, and that we can well do without it. By that I mean that we can do without an art that reinforces ideologies of repression and conservation rather than bringing into the world new metaphors to enhance life. It's a bit like the institutionalisation of religion: as its power and relevance decline, we can see that, historically on balance, probably more bad than good has been done in its name. There's much rhetoric about wholeness and transcendence, but the overarching effect has been to strengthen alienation, sectarianism, and strife. Much romantic and modernist art often celebrated, as much as it

Originally published in *On Line-Kunst im Netz*, edited by Robert Adrian (Graz: Steirischen Kulturinitiative, 1993), and reprinted by permission of Richard Kriesche and Kulturdata.

epitomised, the alienation of experience and the solipsism of consciousness to which we were doomed in the industrial age. The secrecy and suspicion sustained by the paradigm of paranoia, which is what the smokestack culture engendered, was well reflected in a lust for power in the citadels of culture and scholarship (and too often the two were thought to be synonymous), by the advancement of hermeneutics and the control of representation. The control, that is, of *meaning*.

Well, we want to put all that behind us. We played along as artists in that era unknowingly, unconsciously, because we never took the trouble to examine critically just what it was, just what kind of cultural war machine we were feeding. Who would imagine in the heady years of the 1960s in New York or London that the private gallery was a Sherman tank, that *Artforum* fired missiles, that the Museum of Modern Art was a military installation? We should have known, since our language was full of avant-gardisms. We failed to see the structural connection between the supreme individualism of art and the supreme individualism of business and speculation. Nor did we recognise how our notion of artistic leader mapped so precisely onto the notion of captain of industry, or how the great artistic indifference to the world beyond the ego mirrored the entrepreneur's indifference to the world beyond the stock exchange.

Let's look at the assumption that seems to lie behind the second question, "Will telematic systems destroy the humanness of human communication?" This begs the further question, "Communication between whom and about what?" Do we mean the top-down communication of the political state, the one-way communication of institutionalised teaching and learning, the circulation of information within universes of discourse that prided themselves on their total separateness and isolation from one another? All these qualities seem to me properly to describe social communication in the pre-telematic era. After all, language, so-called "natural language," is technology—a tool for shaping perception, limiting and defining worldviews by its structures, its registers and tropes, every bit as much as the metaphors it licenses. Those who control language, which is to say *representation*, control our consciousness, even as we recognise that they control our actions.

What is so breathtakingly lovely about a networked world, the telematic culture, is that it is beyond representation, or rather that, in the congregation of representations that it sustains, an ebb and flow of meanings, semantic transformations, uncertainties, and ambiguities are made possible. In the world as net, we can play with meaning, "play in deep seriousness" (as Thomas Mann defined art), which empowers us to de-authorise meaning just as it enables us

to reconstruct the world. The reconstruction is a model, to be sure, creating a virtual world, from which other worlds can emerge. The potency of virtual reality technology can thus be understood in its power to transform the world, just as it can be seen to open up the inevitable pathway to our co-evolutionary development of artificial life.

In November of 1992, I coined a word that was intended both to identify a specific networking project and to stand for the nature of the telematic process in general. The project was initiated at the V2 Organisation in s'Hertogenbosch in Holland. It was an intensive twenty-four-hour, global event involving bulletin boards, e-mail, computer conferencing, file exchange, fax, and videophone. And, although it generated a massive amount of data (images, texts, music), was highly interactive, and involved many artists dispersed throughout Europe and America, it is not possible properly to mediate the experience of the event on videotape, in slides or by text, although such documentation has been made. This is so, essentially, for all telematic projects, since the processes of interaction can only be felt and understood from *inside* the network. Unlike a painting, sculpture, or other artifact of the pre-telematic culture, whose surface is absolutely intended to be viewed, whose very purpose is to externalise meaning, a work of telematic art generates meaning through our intimate participation in its evolution. It cannot be viewed, from the outside, as a discrete entity.

The word I coined to describe both the means and the meaning of this process is "telenoia," from the Greek roots *tēle*, "far off," and *nous*, "mind." Telenoia is networked consciousness, interactive awareness, mind at large (to use Gregory Bateson's term). And although it's a new word, I think you might agree that its meaning has a very old provenance, in that it perhaps should have been the very first word to be uttered as we emerged into our humanness, as we evolved our distinctiveness amongst the primates, signalled by the emergence of shared consciousness, from which I suppose our sense of society and social responsibility grew. But if, in the beginning, the Word was Telenoia; it is evident now that we lost it, perhaps in inverse ratio to our gain in verbal intelligence, or at any rate in the cultural prioritisation of linear, mechanical thinking, which was especially accelerated during our recent history of deterministic industrialisation. Certainly, we abandoned right hemisphere thinking—visual, mosaic, all-at-once-thinking—long ago. The left hemisphere of our brain (controlling the right side of our body, and instrumental in the "right" kind of social acts) had acquired dominance over the right hemisphere, just as patriarchy replaced matriarchy. The stately progression of logic, step by step, has won for it an authoritative

ROY ASCOTT

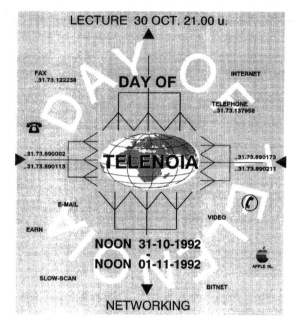

V2_MUNTELSTR. 23_'S-HERTOGENBOSCH (NL)_tel 073-137958

Figure 36. *Telenoia.* 1992. Announcement for telematic art project, V2, 's-Hertogenbosch, Holland. Courtesy V2 archive.

gravity, which discredits the dazzling speed of intuition. The non-linear, intuitional, fast-as-lightning distributed mind of networks, whether on the vast scale of the whole planet or as infinitely small as your average, down-home neural network are equally distrusted by institutionalised authority.

Telenoia is what we invoke as artists involved in networking, it is what cultural telematics is all about. The implications of digital networking—for culture, for the social order, indeed, for many of our established behaviours—are quite radical. Networking is a subversive activity of extreme potency. It is turning the world upside down, inside out. It is actually erasing space, destabilising location, and investing time with qualities of reversal and compression with a

relational order much closer to that of aboriginal cultures than to the strict linearity of the old modernism.

We are creating a culture in which the "artist" becomes a complex and widely distributed system, in which both human and artificial cognition and perception play their part; an art that is emergent from a multiplicity of interactions in data space. It is from telematics in art that we have the concept of "distributed authorship." I coined this term in 1983 to describe the process of creativity involved in my project for Frank Popper's exhibition "Electra" at the Musée d'Art Moderne de la Ville de Paris.

The title of the project, "La Plissure du Texte: A Planetary Fairy Tale," alludes to Roland Barthes's book *Le Plaisir du Texte*, a famous discourse on authorship, semantic layering, and the creative role of the reader as writer of the text. But in my title for the project, *plissure* (pleating) is not intended to replace *plaisir* (pleasure), only to amplify and enhance it. The project used the I. P. Sharp timesharing global computer communications network to create a virtual community of co-authors, interacting in data space to write a planetary fairy tale. There were fourteen principal nodes, spread across four continents, each node in turn linked to a local regional network of groups and individuals. Each node represented a character, an archetype from the repertory of characters in fairy tales: Honolulu was the "Wise Old Man," Pittsburgh "the Prince," Amsterdam "the Villain," San Francisco "the Fool," Toronto "the Fairy," Vancouver "the Princess," Vienna "the Sorcerer's Apprentice," Alma, Quebec, "the Beast," Sydney, Australia, "the Witch," and Bristol "the Trickster," while I, with the role of "the Magician," set the whole thing in motion from Musée d'Art Moderne in Paris. The story developed as each node inputted text into the net, which was then stored in I. P. Sharp's central computer in Toronto until other nodes came online, outputted the developing story and added further twists and turns to the tale. Needless to say, the emerging texts were multilayered, insightful, witty, wise, and inventive in turn. The story was non-linear, indeterminate, branching, and unforeseeable at every point. The process continued night and day for three weeks. It existed in the data space until retrieved, transformed, reprocessed, and restructured by a node coming online. Most nodes offered access to the network to the public, who were encouraged to participate in the writing of the fairy tale.

During this period in Paris, I experimented with another "Plissure du Texte" within an interactive system of a more public kind, this time, however, pleating the texts of two authors from two quite different spheres within the (then) newly developed interactive system known as Minitel, the public access videotext sys-

tem that has since become so hugely popular and pervasive in French communications culture. The texts were randomly selected from Henri Bué's translation into French of Lewis Carroll's *Alice in Wonderland* and *Organe et fonction*, a scientific treatise by two theoretical biologists in Montreal. The piece, "Organe et Fonction d'Alice aux Pays des Merveilles," was part of Jean-François Lyotard's 1984 postmodern exhibition at Beaubourg, "Les Immatériaux," which existed not in the building as such, but throughout the data space of the Minitel network, allowing for participation at home by the public wishing to play with the piece's "meaning."

In all telecommunication projects, whether involving computer conferencing networks, interactive videotext like Minitel, bulletin boards, or e-mail systems, each individual interface is an aspect of a telematic unity, such that to be at any one interface is to be in the virtual presence of all other interfaces throughout the network to which it is online. This might be defined as the "holomatic" principle. This principle was well demonstrated during the Venice Biennale of 1986, when the "Planetary Network" (which I initiated as an international commissioner of the Biennale) had the effect, through its worldwide network of artists, of stretching the location of the Biennale from its traditional base in Venice to extend over the whole face of the globe. As with "La Plissure du Texte," the flow of information generated, transmitted, manipulated, distorted, transformed, and reciprocated was rich in poetry, visions, stern political realities, beauty, fantasy, and facts. In this faster-than-light, stratospheric atmosphere, a group of well-grounded Aussies were always there in the network ready to bring us back to earth. But whatever the content in all its diversity, the data flow at any one point was the data flow at all other points in the system, and as it changed, through online interaction at any one point, so it changed at all other locations.

The same was the case with a multimedia interactive project I initiated for the Ars Electronica Festival in Linz, Austria, in 1989, "Gaia: Digital Pathways across the Whole Earth," which was addressed to "artists, scientists, poets, shamans, musicians, architects, visionaries, aboriginal artists of Australia, native artists of the Americas" [see also chapter 16 above—Ed.]. It involved over a hundred artists, from all parts of the planet, sending and receiving images, texts, and music files by computer communications and fax. The interface at Linz was on two levels. The upper part presented data horizontally displayed on interactive screens; the lower part, Gaia's womb, constituted a dark "data tunnel" through which the spectator rode (on an electronically driven flatbed trolley), passing a series of LED signs displaying incoming messages networked from all parts of the world.

But these were earlier works. Now that the technology of computer-mediated communications, telepresence, and multilayered, multimedia interactivity is more advanced, the stakes are higher, and, equally, the objectives are becoming clearer to me. Gaia has become *Caiia* for me, the big *C* calling for our participation as artists in the connectivity and computerisation of Gaia.

CAiiA stands for the Centre for Advanced Inquiry in the Interactive Arts, which is the base, set in the Newport School of Art and Design at Gwent College of Higher Education in Wales [now known as the University of Wales College, Newport—Ed.], from which we are planning to develop a community of artists and scientists dedicated to explore this expanding field of art: a network community, living and working online, in virtual space, in the data field. I describe this base as a "data garden," since it must grow to embrace both hard and soft, smart and neural, engineered and biological developments in the art of the twenty-first century. Of course, similar initiatives are appearing in other parts of Europe, as well as in North America and Japan. One node of the evolving world net is incorporated in quite dramatic structures at Futuroscope in Poitiers, France.

The network creativity emerging from these worldwide initiatives is not only ignoring the boundaries of geography and region, and of culture and gender, but contributes, along with new scientific and philosophical insights, to the erasure of the established boundaries of the material body—established, that is, within a Cartesian, medical orthodoxy specific to Western cultures. The concept of the body in many Eastern cultures is quite other.

This erasure leads, however, not to a disembodiment of the person, nor to an immateriality, but to the rematerialisation, the redescription, reconstruction—in short, the reinvention of the human being. But it is a human being made ready to fly, outward bound for the stars, rather than to be eternally earthbound. Our perspectives are beginning to shift away from the earth, out into the cosmos. Our eyes are set on the stars. We see Gaia now more as a friend than as a mother, more as a space platform than as a host body.

Herein lies the cultural transformation that we feel so keenly and in so many ways. It may account for our profound neglect of the earthbound condition, our propensity for nomadism, our apparently callous indifference to homelessness, to the disintegration of society. While we are certainly open to moral censure in all these respects, we cannot be satisfied with the simplistic proposition that selfishness and greed are totally responsible. We have always been selfish and greedy, but in past eras, we have loved dearly, even excessively, the earth and the human condition, as represented in its body; think only of the history of art:

canvas upon canvas of landscapes, of nature, of the earth, and in sculpture, pedestal upon pedestal of human figures. While obscene greed and selfishness are still with us, I sense now a quality of indifference born of longing. The longing to escape the earth, to escape the body, to reframe ourselves, to recontextualize our lives. This longing has brought us not simply to a point of cultural transition but to an enormous rupture from the past, indeed from history itself. The same longing brought forth the very technologies that have provoked this rupture. Telematic technology is the technology of consciousness; it is spiritual before it is in any way utilitarian.

This rupture with the past, this erasure of the old models of mind, body, and world is marked by three cardinal factors:

- the growing together of minds, witnessed in the exponential growth of the technology of communications, that is, of telematic connectivity;
- the fragmentation and dispersal of the body, witnessed in the technologies of presence, that is, of telepresence;
- and the extension of the environment, witnessed in the ascendancy of artificial life and the technology of space exploration.

Fundamental to this whole cultural transition is the displacement of the body. In one sense, we were never as aware of the body as we are now. It is glorious, we celebrate it, we nurture it, exercise it, cosset it. Our technological prostheses extend it, amplify it, enrich it. We know its innermost workings, its cycles and seasons, its changes, its autonomous systems and ecological dependencies. The body has been rediscovered, re-evaluated, brought into its own. We love it with the intensity we show to those we must leave behind, forever. The body frames the mind; our mind is now embarked on a project to reframe itself, to reconfigure its housing, to remodel and relocate. Thus we are moving not so much out-of-body as out-of-frame, recontextualising ourselves on the cosmic plane rather than the earthly plane. We can't wait to go, we need lift-off, and we need it now! This is currently most dramatically felt both in the fantasy worlds of drug culture (which may also contain a shamanic reality) and in our real experience of telepresence, in our ability to view, hear, and generally sense the world remotely, to communicate with each other in electronic, immaterial, virtual spaces, to be distributed across remote and extended locations, to be both here and there, in many places at one and the same time.

The individual human presence of the individual human self, a unitary and

undivided personality, has become the multiple, distributed presences of a set of many selves, of multileveled, complex, diverse personalities—*l'homme éclaté*, as Paul Virilio has called it. The explosion of the one and the connectivity of the many is perhaps the single most important effect of the telematisation of our culture. It could be argued that the appearance of the zero in Western thought has been equalled in importance only by the *dis*appearance of the one, the single and solitary, whose boundary and isolation was hermetically complete. Our impulse is that of connectivity. Connectivity is a significant feature of the evolutionary process. The undivided unity we seek is in mind at large. The complexity of personality we generate demands more than one single body or a solitary, permanent presence could support. Psychology is unprepared to deal with the exigencies of telepresence in a telematic society. In this respect, the computer scientist Hans Moravec has more to offer us than Freud; his vision of a consummate downloading of personality from wetware to hardware offers us more promise of liberating ourselves from history and the chains of trauma than Freud's closet consciousness could ever hope to do.

And we can no longer accept death: we transfer our allegiance from an art that seeks immortality through the residue of the artwork-as-object to an art that joins forces with the poets and visionaries of advanced robotics, artificial life, nano-technology, and born-again bionics. For let us be clear, human presence is now a technological matter, just as human evolution is in step with the evolution of nanosystems and bio-engineering. To be in the telepresence of another, of others who in turn feel your own telepresence close to themselves, is to define community in a quite radically different way. Love in the telematic embrace is a many-splendoured thing, or in the light of the multimedia involved, a multi-splendoured thing! And I haven't begun to discuss, yet, the scope of cyberspace; that is of interactivity in virtual reality. Cybersex and virtual affection are qualities of human relationship we are only beginning to define.

Telenoia is thus set to replace the paranoia of the isolated, alienated self of the old industrial society. The cult of the individual was always accompanied by the cult of the unified, indivisible human being, one body, one soul, one self. Since the divided self was a threat to the established order, P. D. Ouspensky's claim that we are each composed of many selves [see, e.g., Ouspensky (1950) 1974] has been taken to be a sign of outright lunacy, and schizophrenia is viewed as the sign of the utmost otherness.

The technologies of presence are preparing us for connectivity with artificial life, the creation of a cyborg culture. If we are leaving the old, classical, earthly

body for another, it is not in order to dematerialise but to inhabit a new corpo-reality, which is almost totally artificial, bionic, prosthetic. Just as the artist is concerned no longer with the creation of content but with the construction of a context (the goal is a hypercontext), so, too, the brain seeks its hypercontext in the hyperbody. This is to talk about the post-biological body as interface. Where the user of the body has volitional control over various electronic de-vices directly from nervous system signals, creating what Hugh Lusted, Ben-jamin Knapp, and Anthony Lloyd call "biocontrollers," a technology provid-ing direct information channels between the human and computer (from muscle, eye, and brain signals). And it is the interface to networks, to systems of con-nectivity and interactivity, that is our primary concern. Interface is all context, just as content is all interactivity between the viewer and the interface-as-art. It is in this sense that I say that the artist is a system by which, and in interac-tion with which, meaning is generated. The degree to which the system is "hu-man" is of very little significance. The human value of the meaning generated resides in the intervention of the (human) viewer or user of the system.

Let me then, if rather simplistically, review the principal factors contribut-ing to the cultural rupture in which we are so profoundly implicated:

· Electronic, computer-mediated, and post-biological systems are now a fun-damental part of our daily life and are playing a significant role in the trans-formation and globalisation of culture.

· Artists working with these systems are seeking the means to increase our cognitive and sensory immersion in the data spaces and data structures they create.

· Interactivity is a quality more and more sought by the public in all aspects of production, transportation, entertainment, education, planning, and archi-tecture, as well as art.

· Interactivity empowers the individual to participate fully in the workings of a system, whether that system operates at the conceptual, behavioural, or en-vironmental level, and whether it is utilitarian or artistic.

· The public is becoming increasingly aware of the value of electronic space as a space for personal transformation, for communication, play, learning, and gaining information.

· Older cultural institutions cannot adapt to the needs of the new post-biological, electronic, and online arts—radical rethinking is needed to guar-antee public involvement and cultural viability.

· Connectivity, immersion, interaction, transformation, and emergence are thus key elements in our cultural transition.

> *Connectivity* of people, places, ideas, media, systems
>
> *Immersion* of the viewer in the data space of the artist
>
> *Interaction* with elements of the systems that are encountered
>
> *Transformation* of media and of the consciousness of the viewer
>
> *Emergence* of new data, images, forms structures and systems

It is the concept of network that integrates the progression of these elements; it is the global Net of telematic networks within which this great transition will be played out. These key tendencies mark what I would describe as the five-fold path towards telenoia, towards a convivial and constructive life in the Net.

Marge Piercy has written evocatively on the Net in her 1991 novel *Body of Glass:*

> The Net was a public utility to which communities, multis, towns, even individuals subscribed. It contained the mutual information of the world, living languages and many dead ones. It indexed available libraries and offered either the complete text or précis of books and articles. It was the standard way people communicated, accepting visuals, code or voice. It was also a playing field, a maze of games and nodes of special interest, a great clubhouse with thousands of rooms, a place where people met without ever seeing one another unless they chose to present a visible image—which might or might not be how they actually looked.

As an aside, it's worth noting that Richard Branson has listened closely to Ms. Piercy, introducing his own version of "a great clubhouse" in Virgin Atlantic's new airport lounge at London Heathrow: British Telecom has contributed its VC7000 videoconferencing system; the CF2000 fax capable of using ISDN's higher data rates is there, along with a remote surveillance system; the new BT Relate 2000 videophones linked into the world, as well as a PhoneDisc CD-ROM. The world is made visible to travellers by means of a computerised analysis system called Earthview, running on a Mac Quadra 950, taking signals from satellites in a variety of orbits, allowing them to see the earth at different angles and degrees of magnification. It's essentially interactive, offering much choice of viewing angles, image enhancement and manipulation, including animation in QuickTime. The games room is equally richly endowed with state-of-the-art distractions. While telepresence is limited, net life is certainly present, though in this case, strictly "upper class," as Branson's top fare

category is called. But the coffee is said to be good, and much telecommunication takes place, so he has no doubt been listening to talk of the Electronic Café as well![1]

Marge Piercy is serious business. She has enormous empathy for a telematic culture. It is in such post-feminist literary, critical, and cultural writing that we can best take stock of the changes in which we are involved and the trail that we are blazing. Marge Piercy's novel is an insightful and viable narrative, much more profoundly aware of the radical changes in human sensibilities and relationships in the "cyborg era" than William Gibson's unidimensional punks could ever be [see Gibson 1984 and Cavallaro 2000—Ed.]. It seems to me that when Richard Rorty calls for the novel to replace philosophy in communicating the new pragmatism [Rorty 1989], Piercy's work must be seminal in our study of the new relationships between human and artificial consciousness that life in the Net will mean for all of us. Similarly, Donna Haraway's collection of essays *Simians, Cyborgs and Women*, and in particular her "Cyborg Manifesto," provides me with more wisdom concerning the telematic condition of our species than I have encountered in most of the many (male-dominated) conferences and congresses on technoculture over the past ten years [Haraway 1991].

There is a message here, that scenarios of future states must be radically more than comfortable modifications of the forms and institutions of the earlier eras, with muffled yearnings for the old order, simply tinkering with change. That's why phrases like "to save something of what once was communication" fill me with foreboding, the fear that we shall lose the telenoic potential of our evolving world Net in yearning for a supposed, passed (and quite mythical) golden age of "natural" human interaction and communication. Human communication has never been "natural," any more than man or nature has ever been "natural"—if by natural we mean beyond mediation, since it is clear that the constraints and limited range of our biological systems of perception, and the ordering of experience by our languages, involve us in a continual process of constructing our world.

"Nature" itself is a product of this process. Perhaps *Umwelt* [i.e., milieu; see also chapter 15 above and Uexküll 1934] is a more useful term, as long as we continue to recognise that its definition is always species-dependent. Our species is changing, as a result of increasing bionic, molecular intervention. And not just externally with add-ons and peripherals, but "internally" at the cognitive level of metaphor-processing and meaning-making. Communication is no more imprecise, fuzzy, indeterminate, and subject to negotiation than it ever was, or will be. The human organism is structurally coupled to its

"environment," and communication—whether verbal, gestural, chemical, or electronic—will always be a process of negotiation, of modelling, and of shared construction.

Radical reconstruction, redescription, and redefinition are called for of our world, of our relationships, and of ourselves. And therefore high on the agenda is education as interface, interface as education. Here, too, the telematic rule that context must supersede content applies. It must be the mission of education to provide the space, no doubt a data space, within which the student can be empowered to *navigate* his own pathways through knowledge. Here we see a merging of functions: of the school, the museum, the library, and even the domestic hearth. All of these once monumentally separate institutions are now to be seen commonly as a matrix within which creativity can evolve through public interactivity. Such a matrix will not be in any way the same as a traditional museum, or school, workshop, studio, production facility, or art centre.

The electronic and post-biological arts of the 1990s will increasingly embody qualities of open-endedness, of sensory immersion of the viewing subject, of intensive interactivity and connectivity, from which new material will emerge and from which a new art will evolve. The new cultural space is the global Net: digitally informed, but interfaced to increasingly "smart" materials and "intelligent" applications. The new institutions we need must constitute networks of fluid, flowing systems, supporting the qualities of open-endedness and emergence, and encouraging connectivity at all levels. They will be dynamic organisms rather than fixed and static structures. They will have to be seeded, data-fed, technologically sustained, and allowed to grow and blossom.

It is important here to make some reference to the impact of this new thinking on the field of industrial design. The designer practising in the telematic culture is a "distributed" designer, a paragon of connectivity, whose technical expertise, imagination, and conceptual skill will be found spread throughout the networks rather than embodied in a single individual. Just as with the artist, the designer becomes a system that includes both human and artificial intelligence. The telematic design process calls for the networking of a constant flow of transient hypotheses. Here are some aspects of the requirements of the design process in the telematic mode:

· The overarching need is to design a world fit for telepresence—a fulfilling life in the Net.

· Evolution of the *teleconducer* (the online consumer-producer) will result from increasing consumption and production in the electronic marketplace.

- Mind markets, requiring designed products for mental life, will call for close collaboration between the designer and the cognitive scientist. Projects such as the design of bionic interfaces to the world Net and instruments for person-to-person communication in the nanosphere will have to be considered.
- Smart materials, adaptive physical systems, and intelligent building components will have to be developed, calling for new architectural initiatives.
- Communication systems within and between artificial life forms will have to be designed.
- New instruments and systems will have to be designed to enable us to access telememory and the virtualisation of the past.
- An architecture for online communities will have to be developed, and this in turn will call for new concepts of domestic living such as the data hearth and ISDN furniture.
- Virtual reality has as its interface the total body, and new communications costumes and tele-wear will be required for lounging by the datapool: leisure wear inspired by cyberpunk street fashion.
- Zones of tele-meditation will have to be designed to service the increasing need for psychic and spiritual growth within the telematic culture.

Perhaps one of the more useful metaphors to describe what is required is the "datapool," a term I coined as a consultant for the new Ars Electronica Centre in Linz, Austria [see chapter 21 below]. The datapool is that into which, and within which, data in all its modes flows—endlessly transformed through human interaction—and from which it emerges, art-in-flux, flowing on into other domains, other pools, other tributaries of the data sea. This and other such cultural organisms call for new behaviours on the part of the viewing public: no longer to observe, stand back, look from a distance and judge, but to plunge into the datapool, immerse themselves in its fluid changeability, share in its swirling transformations, navigate its knowledge bases, dive to its depths of meaning. This is to call for new standards in public access to art, art not as finite object but as process and system, a fluid, moving stream of data configurations, embodied in networks, on screens, in material structures, in installations and environments, endlessly open to transformation and change.

The Ars Electronica project is a museum of the twenty-first century. But it can also be seen as the college of the future: not reactive but anticipatory, not imposing perspectives on the history of art but opening up a pool of possibilities that emerge as the prospect for the future of art. It will work at the forward

edge of contemporary culture, as an agent of cultural change, as a cause of art practice rather than simply as a cultural effect. To take the plunge, to dive into this data world requires a new understanding of art. Just as in the academic world, the computerisation of knowledge means that children must acquire new attitudes to learning, and teachers new attitudes to their teaching, so in art the public need to enjoy new approaches to the electronic environment, learning to immerse themselves in the data field, to interact with the elements it contains, and navigate through its many layers and networks of media and meaning.

Just as contemporary art—in coming to terms with new digital multimedia and the technologies of perception, cognition, and behaviour—builds upon and absorbs the art movements of the past (Cézanne's mobile viewpoint, the cubist interpenetration of space and time, futurist dynamics, Duchampian conceptualism, Jackson Pollock's actionism, kinetic art, intermedia, performance, film, photography, video, and early computer graphics), so we can expect, as we approach the twenty-first century, the evolution of entirely new forms, ideas and media, grounded in the art of today. For this reason, the museum/academy of the twenty-first century must be designed to create a context of development for the post-biological arts, for the replacement of artifice with artificial life, and a frame for their cultural evolution in the data sphere. The museum/academy must provide a setting for art from which new visions, new initiatives, new methods can grow. Thus it is a seedbed for the future, a test-bed of present inquiry and experiment, and a fertile ground of historical reference.

The governing perspective within which the evolution of new cultural organisms is viewed is not that of the machine, however, despite our evident reliance on the technological sustenance of computers, systems, and electronic engineering. But, just as the conceptual position of many artists in the techno-culture of 1980s was fuelled by metaphors drawn from quantum physics, chaos science, and cosmology, often deconstructionist and inevitably postmodern, so the new metaphors likely to govern the evolution of art in the decade leading us into the twenty-first century will come from the new biology, molecular engineering, smart materials, artificial life, neural networks, cognitive science, and radical constructivism. Not that these two frames are worlds apart. They converge at many points, not least in their challenge to representation as the dominant function of art. Despite the recent popularity of computer simulations of the external surfaces of the world, and of the virtual image, we are witnessing the end of an art in which the mimetic and symbolic were central. Its role in providing representations of the world is shifting to that of creating worlds, of inventing alternative realities, a process in which the observer of art becomes

an active participant, a process from which art emerges. The attempt is no longer to imitate life but to emulate it, as part of the co-evolution with nature that is our contemporary goal. We are entering the post-biological era, and it is the intricately woven fabric of telematic networks that will both clothe and carry forward our endeavours.

The new biological perspective is replacing the role of art as representation, just as it is replacing the model of the mind as mirror of the world. There is no little screen within the brain from which some inner homunculus reads out the reflection of the world. Instead, we have Humberto Maturana and Francisco Varela's fecund notion of "structural coupling" of the human organism with its environment, the autonomous, self-creating organism that constructs its world and its reality [Maturana and Varela 1980, xx ff.].

The computer is also bypassing the screen by beaming laser data directly onto the retina. I was introduced to this by Paul Berger (whose work, along with that of Carl Flax, Manual, and Esther Parada, I had the pleasure to introduce in the catalogue to the first major exhibition of digital photography in Paris, at the Palais de Tokyo [see chapter 17 above]). While discussing this retinal imaging technology with Tom Furness, director, and William Bricken, principal scientist, at the Human Interface Technology Laboratory at the University of Washington in Seattle recently, it became plain to me that alongside this very advanced scientific research, in the heart of these laboratories devoted to the most cutting-edge technology, ideas about education, culture, and social relationships are also evolving, and doing so infinitely more richly than in most of the ateliers and academies of art that I have visited.

The computer has also become biological, as I also learned during that trip. The video artist Tom Sherman, who was my companion on part of the journey, introduced me to the research of Robert Birge, director of the Center for Molecular Electronics at Syracuse University in Syracuse, New York. As we need more and more memory and more and more speed, so we find that semiconductor circuits and disks have little more to give. We look to molecular electronics to quicken the pace of computer operations by 100,000 times and store information to equal a dozen sets of encyclopaedias in a cube that will fit in the palm of your hand. Birge is experimenting with the molecule bacteriorhodopsin, a light-harvesting protein, encoded by laser light. Memories using the bacteriorhodopsin in three dimensions can become five times faster than our present-day fastest mass-storage memories—with the memory storage medium little more complicated than a few tablespoons of jelly in a glass. A cube two cen-

timetres on each side might store the entire catalogued holdings of the Library of Congress. By genetically engineering this protein, Birge's 2 × 2 × 2 cm cube might eventually hold 500 billion bytes. That's far from the 1,000 billion bytes of the human brain, but Birge's memory in a cube has considerable implications for the emergence of artificial consciousness in the Net, and for the enhancement of associative thought, just as it can lead to a richer complexity in our processes of structural coupling with the world.

Similarly, George Gilder, a leading American commentator in the field of computer development and technological innovation, alerts us to the confident prediction in the research community of one billion transistors being laid on a single chip within the next ten years [Gilder 1993]. That's the power of sixteen Cray supercomputers (currently costing some $320 million) on a chip costing less than $100.

Well, of course, we can brush aside such prognostications, if we will (and in Britain we most certainly shall), although it is easily seen that if only a half of that is achieved, the consequences for human behaviour will be enormous. Less easy to ignore, however, is the infrastructure that already is being set out to link minds, machines, data banks, and production facilities in an awesome global connectivity. Here I am referring to the same evolutionary leap that President Clinton and Vice President Al Gore refer to in the letter that everyone on the Internet received from them on June 1, 1993, about the ACE programme, "Americans Communicating Electronically." The political implications of all that, both in the United States and Japan, where "high fibre" is taken seriously (and not as a dietary supplement), and in Europe, particularly the United Kingdom, where our clinging to copper wire is almost pathological, is one thing. But it is difficult to see how the eventual ubiquity of optical fibre, particularly the almost infinitely data-capacious "dark fibre," can, in any evolutionary sense, be resisted. In case you are not familiar with dark fibre, I'll quote George Gilder: "Fibre comes in threads, as thin as a human hair, as long as the British Isles, fed by lasers as small as a grain of salt and as bright as the sun. A single fibre thread can potentially hold all the telephone calls in the United States at a peak moment of Mother's Day. Fibre is not really a replacement for copper (wires) . . . it's a replacement for air" [BBC 1993]. As Paul Green of IBM's Advanced Optical Networking Research Division says, "Dark fibre, lit with different colours for different protocols will deliver one thousand times our present total broadcasting capacity" [Green 1993]. Oh, yes, and by the way, given that our political leaders and policy-makers will most certainly ignore all this, the invention

that has released optical fibre from the erstwhile bottlenecked, logjam of information flow (suffered by its reliance on electronic amplification), that of the Erbium Doped Amplifier, which will send an infinity of messages through glass on wings of light, has been developed by a British scientist, David Payne of the Optoelectronics Research Centre at Southampton University. Payne notes that, "We have created the communications engineer's Holy Grail—the dream communications system, capable of communicating over vast distances with huge information capacity. The next question is, what do we actually do with it?" [BBC 1993].

That, I am sure you will agree, is at the top of our agenda as artists. It is *within* the net that any human and creative answer must be found. In other words, it's a matter of total immersion in this cobweb of light, this honeycomb of illuminated colour. It is from the complexity of interactions within the Net, that the new "art" can be expected to emerge.

But this "art" is becoming so fundamentally different from the art of the past that it seems to constitute an entirely new *field* of creative endeavour. That is why many of us involved in this field think it would be best if a new word could be found to describe it. The term "art" is too heavy with the meanings given to it by both romanticism and classicism, as well as, of course, by modernism, and too deeply embedded in the notion of the individual creator and the reactive rather than interactive viewer, for us to feel properly represented by it. It's not that we think we have redefined art in its totality or that the art with its roots in those earlier orders is no longer practised with vigour and with contemporary relevance. Only society can determine that. But we feel that we cannot go on much longer having to define our terms every time we engage in conversation about art, to make it plain that it is *this* art, the art of interactivity and of intelligent systems, that we are discussing; not *that* art, the art of established orthodoxies and practices. Maybe we should try to avoid using the term "art" as far as possible, in these circumstances, and use the term "connectivism" when we are referring to telematic art practice. All art practice involving computer-mediated systems and electronic media of any given complexion is by definition telematic; connectivity is at its core. Maybe all artists engaged in the field should be called "connectivists." On second thoughts, maybe not! We've had too many "-ists" and "-isms" this century. But the term would provide a happy, although perhaps rather facile, complementarity to the "connectionists" who are developing the very neural nets that the next generation of artists will most certainly employ.

Just as the "artist" is fast becoming a complex and widely distributed system,

in which both human and artificial cognition and perception play their part, so art is no longer primarily a matter of representation but of emergence, ordering itself from a multiplicity of chaotic interactions in telematic data space, within the structural coupling of what we know as human evolution. The key to our understanding of this evolution lies within the domain of consciousness. It is my belief that the quality of telenoia in our structural relationships with the world and between one another will define the new qualities of art in the technological culture.

NOTE

1 Ascott refers here to the Electronic Cafe International, a prototype cybercafe founded by artists Kit Galloway and Sherrie Rabinowitz in Santa Monica in 1984.—Ed.

FROM APPEARANCE TO APPARITION

Communication and Culture in the Cybersphere

1993
"The mod does two things . . . it stops me collapsing the wave function; it disables the parts of the brain that normally do so. But the mod also allows me to manipulate the eigenstates—now that I no longer clumsily, randomly, destroy all but one of them."

"So what should we call it?"

". . . neural linear decomposition of the state vector, followed by phase shifting and preferential reinforcement of eigenstates." She laughs. "You're right: we'd better think of something catchier, or the whole thing will end up being grossly mis-reported."

—GREG EGAN, *QUARANTINE*

Schrödinger's Cat has to be the most celebrated creature in the bestiary of science, and the paradox it proposes is perhaps the most complex in our understanding of consciousness and reality. It describes the problem of measurement at the quantum level of reality, the level of subatomic particles, atoms and molecules. This gruesome thought experiment involves a black box containing a cat and radioactive material positioned so as to trigger the cat's death if the particle decays. The process is quantum mechanical, and so the decay can only be predicted in a probabilistic sense. The whole boxed system is described by a wave function that involves a combination of the two possible states that the cat can be in; according to quantum theory, the cat is both dead and alive until we observe or measure it, at which point the wave function collapses and the cat will be seen to be in either one state or the other. And just as the electron is neither a wave nor a particle until a measurement is made on it, so the cat is neither dead nor alive until we get to take a look

Originally published in *FISEA: Fourth International Symposium on Electronic Arts*, edited by Roman Verostko (Minneapolis: MCAD, 1993), and reprinted with permission.

at it. We are dealing here with observer-created reality. To look is to have the system jump from a both/and situation to an either/or outcome, the quantum jump producing what is known as the eigenstate. But there is no agreement among physicists about precisely where, in the chain of events in this wave-function collapse, the measurement result is ultimately registered.

Greg Egan places the point of collapse, the point at which reality is created, right in the brain. By proposing a technology that could be inserted in the brain to modify this eigenstate effect, to block it and thereby prevent the collapse of the wave function, his scenario gives a post-biological context to the idea that reality is constructed. Egan speaks the language of the coming decade. His 1990s science fiction addresses issues of the neuro-cognitive sciences with the pre-science that William Gibson showed towards computer communication developments in the 1980s. And just as Gibson's *Neuromancer* [1984] correctly identified cyberspace as an important cultural construct of the late twentieth century, so Egan's *Quarantine* identifies the issues likely to preoccupy us at the turn of the millennium. The question of consciousness, the technology of consciousness, the transcendence of consciousness will be the themes of twenty-first-century life. Fundamental to this evolution is the development of a telematic art in the cybersphere, and fundamental to that art are the experiments, concepts, dreams, and audacity of artists working today with telecommunications systems and services.

Questions of consciousness and the construction of reality are at the centre of any discussion of the status, role, and potential of art in the emerging cyber-culture. The fundamental question is this: Can an art that is concerned, as Western art has always been, with *appearance*, with the look of things, with surface reality, have any relevance in our systems-based culture, in which *apparition*, emergence, and transformation are seminal? Can representation co-exist with constructivism? The overarching concern with appearance and representation that has hitherto characterised Western art has made it the servant of ideologies of both church and state. Its concern with appearance has kept it in line with classical science, looking no further into things than their outward forms allow, making of the world a clockwork machine of parts whose movements are regulated by rigid determinism, and seeing man as little more than a material object. It is the art of appearance that is purveyed in boutiques, galleries, museums, and on the pages of chic art magazines. It is international art. And it is dying, because it is no longer relevant to a culture that is progressively concerned with the complexity of relationships and subtlety of systems, with the invisible and immaterial, the evolutive and the evanescent, in short, with apparition.

Questions of representation no longer interest us. We find no value in representation, just as we find no value in political ideologies. We do not wish to keep up appearances.

The telecommunications of cyberspace, on the other hand, offer the contemporary artist the means of interaction (both his own and that of the viewing subject) with dynamic systems, with creativity in process, with the emergent properties of an art of transformation, growth, and change. It is for this reason also that the narratives and technology of artificial life are so important to us at this time. Cyberspace is the space of *apparition*, in which the virtual and real not only co-exist, but co-evolve in a cultural complexity. Apparition implies action, just as appearance implies inertia. Apparition is about the coming into being of a new identity, which is often, at first, unexpected, surprising, disturbing. If appearance is claimed as the face of reality, of things as they are, apparition is the emergence of things as they could be. However, our insight into the ways in which reality is constructed in our consciousness leaves us in no doubt that the processes of apparition are authentic and that appearance is a fraud. Representation in art was always essentially mendacious, illusory, and counterfeit. The mirror always lies.

More and more artists now take global networks, virtual reality, and high speed computing for granted. These technologies are no longer seen as simply tools for art; they now constitute the very environment within which art is developing. Given this increasing familiarity, artistic questions now are not so much concerned with these data worlds per se as with the interface between them, between us, between our own minds and that larger field of consciousness we call the world.

Whether or not Egan's fictive brain modifier gets to be developed, the fact is that our technologies of perception, cognition, and communication—the interface to the complex computer systems that both mediate our consciousness and construct our reality—are moving closer and closer to the body and into the brain. Just as the keyboard and mouse are being consigned to history, so, too, the head-mounted display, the data glove, and even the data suit will soon be consigned to the museum. Conceptually, they already are. We want the systems interface set within our brain. We want the boundaries between "natural" and "artificial" to be as redundant technologically as they are becoming conceptually and spiritually. This is to talk about the post-biological body as interface.

Progressively, we artists want to be creative in cyberspace by controlling computer-mediated systems through biological input sensors and biocontrollers

in our own nervous systems responding directly to signals from the brain, eye, and muscles. However, while the advent of neural interfacing will certainly have enormous consequences for the development of art in the Net, and as much as it fascinates our speculative nature, it is not the most fundamental question at present for artists in the cyberculture. More important to us now are the conceptual implications of the shift taking place in art from appearance to apparition, from object to process. Art, which was previously so concerned with a finite product, a composed and ordered outcome, an aesthetic finality, a resolution or conclusion, reflecting a ready-made reality, is now moving towards a fundamental concern with processes of emergence and of coming into being. This raises critical, theoretical, and aesthetic questions that we can no longer avoid. In an important sense, the issue is political: it concerns the democratisation of meaning as much as the democratisation of communications—that is to say, a shared participation in the creation and ownership of reality.

The revolution in art that prompts these questions lies in the radically new role of the artist. Instead of creating, expressing, or transmitting *content*, he is now involved in designing *context*: contexts within which the observer or viewer can construct experience and meaning. The skill in this, the insight, sensibility, feeling, and intelligence required to design such contexts, is no less than that demanded of the artist in classical, orthodox art. But the outcome is radically different. Connectivity, interaction, and emergence are now the watchwords of artistic culture. The observer of art is now at the centre of the creative process, not at the periphery looking in. Art is no longer a window onto the world but a doorway through which the observer is invited to enter into a world of interaction and transformation. The importance in all of this of telematic networks—of the inherent connectivity of cyberspace—cannot be overestimated. These ubiquitous networks are themselves undergoing significant augmentation with the capacity and speed now available in the so-called dark fibre. As George Gilder explains: "Dark fibre, lit with different colours for different protocols, will deliver one thousand times our present total broadcasting capacity. The recently developed Erbium Doped Amplifier, which will send an infinity of messages through glass on wings of light, is the communications engineer's Holy Grail—the dream communications system, capable of communicating over vast distances with huge information capacity" [BBC 1993]. So, dark fibre, boxed cats, and biocontrollers are directly relevant to the development of art in the cyberculture, this domain of apparition in which natural intelligence and artificial life can interact creatively. Whatever the dominant media, whether electronic, optical, or genetic, the art of the cyberculture is generically interactive.

This interactive art is characterised by a systems approach to creation, in which interactivity and connectivity are the essential features, such that the behaviour of the system (the artwork, network, product, or building) is responsive in important ways to the behaviour of its user (the viewer or consumer). More than simply responsive, it constitutes a structural coupling between everyone and everything within the Net. This kind of work is inherently cybernetic and typically constitutes an open-ended system whose transformative potential enables the user to be actively involved in the evolution of its content, form, or structure.

Science fiction such as Egan's is not alone in positing scenarios in which human consciousness is seen as the instrument for creating reality. Outstanding among philosophers from the point of view of cyberculture is Paul Watzlawick, whose contributions to radical constructivism can be seen as directly relevant to the interactive art aesthetic [Watzlawick 1984]. Radical constructivism is as incompatible with traditional thinking as interactive art is with traditional art. As early as 1973, the cybernetician and biomathematician Heinz von Foerster gave his classic lecture "On Constructing a Reality," showing how the environment, as we perceive it, is our invention, describing the neurophysiological mechanisms of these perceptions and the ethical and aesthetic implications of these constructs.

What both the art and technologies of cyberculture are able to show is that there is a radical shift in our perceived relationship with reality, where the emphasis has moved from appearance to apparition; that is, from the outward and visible look of things to the inward and emergent processes of becoming. In this culture, neither the precise state of art nor its cultural status can be fixed or defined; it is in a constant state of transformation. This is not a state of transition between two known and fixed definitions or destinations, rather, it is transformation itself as a defining characteristic, as intrinsic to the identity of interactive art as the composed and finite object was to its classical predecessor. Interactive art is art in a state of endless becoming. It is art in flux. This is so at present both in stand-alone systems, whether hypermedia or multimedia in format, and in the Internet, with its global multiplicity of inputs and outputs.

A culture concerned with appearances bases itself on certainties, a definitive description of reality. Uniformity of dogma, uniformity of outlook and goals, cultural continuity and consensus, semiotic stability: these are its distinguishing features. Within this larger frame, aesthetic changes, when they occur, are merely cosmetic; the basic conformity to an approved model of reality remains. There have been paradigm shifts in art, just as in science, but it could be argued

that the canon of Western art has maintained a much longer consistency and continuity than science, since numerous scientific revolutions have come and gone, while art's preoccupation with appearance, with the surface image, with ready-made reality, has held for millennia.

In contrast, a culture concerned with apparition bases itself on the construction of reality, through shared perceptions, dreams, and desires, through communication, and on the hybridisation of media and the *celebration* of semiotic instability. The shift in art towards apparition and construction as its primary concerns is a paradigmatic shift. We now realise that an art dedicated to appearance simply gives the lie to whatever is the case, since the retinal gaze can penetrate very little of the material state and almost nothing of the spiritual state of things. The surface of the world hides more than it discloses. Science in the twentieth century has been based largely on what is invisible to human retinal vision, since it has always attempted to comprehend the forces, fields, and relationships underlying "our" visual world. In the earlier art of the twentieth century, this also to some extent was true; Kandinsky, Duchamp, and Pollock distinguish themselves, in their radically different ways, by their attempts to reveal the invisible, and construct their separate realities. Of these, it was Pollock whose intimations of connectivity, in swirling, circulating, linking confluences of line and colour, brought to modern painting the great commanding images of a networked world. It was Pollock who first brought the tight-framed picture window of painting off the gallery wall and onto the surface of the Earth, marking out an arena for action and interactivity, and thereby laying the groundwork for holistic ways of viewing, imaging, and constructing an entirely new *attitude* towards art and aesthetics, of which we in our digital space are the principal heirs and benefactors.

But until the effects of cyberculture were felt, until the radical implications for art of the new technologies had begun to be recognised and adopted, those artists whose practice, complicitly or unthinkingly, upheld the old orders of perception and knowledge, aided and abetted by the de facto controllers of representation and consciousness—curators, critics, historians, and dealers—resisted the radicalism of these pioneers. It is to the great shame of American scholarship that Pollock has never been properly appreciated or understood. Neither, as Tim Hilton has noted in reviewing the current [1993], disastrous Royal Academy exhibition "American Art in the 20th Century," has he ever been given a serious full-scale retrospective or a fully sympathetic book. "America wishes him to be a dead movie-star rather than an artist."[1] And yet Pollock first created the *aesthetic* possibility, in a sense, the historical permission, for our own

radical constructivism in the cybersphere to come into being. Because, at base, working with networks is a matter of attitude before it is anything to do with machines. Telematic art is conceptually driven, not technologically led. The fundamental concepts of art as action, interaction with the art-in-process, the artwork as arena, art as transformation, change, flux and flow, these are in origin Pollock's—with the acknowledged provenance, of course, of Navajo art and the visual culture of Native America. If there is any link whatsoever between the art of cyberculture and the art of the pre-telematic era, it lies in the painting of Pollock. The link is one of sensibility, not style, of attitude, not form.

The collapse of the New York School, the market rise of resurgent German expressionism, the despairing floundering of postmodernist solipsism, the dismal return to nineteenth-century academicism, figuration, and narrative, the whole miserable confusion, demoralisation, and splintering of art at the fag end of this century is evidence of the major paradigm shift that we are undergoing. Nothing is spared in the process: galleries become redundant, museums have to be rethought and redesigned, academies have to be abandoned and reconstituted, the patronage, placement, and perpetuity of art are all to be reconsidered.

In our present understanding of the world, nothing is sufficiently stable for us to wish to give a permanent form to its representation. Nor do we wish it to be. We are on an evolutionary spiral that has returned us to a more Taoist desire for flux and flow, for change and transformation. No eternal verities present themselves as worthy of consecration in manuscripts or monuments. We want an art now that *constructs* new realities, not one that represents a preordained, finite, and ready-made world. We want an art now that is instrumental rather than illustrative, explicatory, or expressive. Rather than to simply embellish the world and add to its ornamentation, the artist of the cyberculture wishes to engage in its renewal and reconstruction.

Above all, we no longer need those cultural theorists, critics, and academics who winge and wince at technology, who wag endlessly their disapproving and despairing fingers at the daring perceptions and dazzling innovations of science, hovering like vultures at the periphery of the old order of art. Such "cultural theory" was often little more than ideological determinism dressed up in pretentious rhetoric, show without action, ideally suited in these latter years to preside over the demise of the old order of art, the art of appearance.

Art in the cybersphere is emerging out of the fusion of communications and computers, virtual space and real space, nature and artificial life, which constitutes a new universe of space and time. This new network environment is ex-

tending our sensorium and providing new metaphysical dimensions to human consciousness and culture. Along the way, new modalities of knowledge and the means of their distribution are being tested and extended. Cyberspace cannot remain innocent. It is a matrix of human values. It carries a psychic charge. In the cyberculture, to construct art is to construct reality, the networks of cyberspace underpinning our desire to amplify human cooperation and interaction in the constructive process.

NOTE

1 Tim Hilton, review in the *Guardian*. [The release of Ed Harris's film *Pollock* (2000), hot on the heels of the painter's blockbuster retrospective exhibition at MOMA and the Tate (1999), simultaneously challenges and reinforces Hilton's point.—Ed.]

THE ARS ELECTRONICA CENTER DATAPOOL

1993 ■ **THE ARS ELECTRONICA CENTER**
The Situation

Electronic, computer-mediated, and post-biological systems are now a fundamental part of our daily life and are playing a significant role in the transformation and globalisation of culture.

Artists working with these systems are seeking the means to increase our cognitive and sensory immersion in the data spaces and data structures they create.

Interactivity is a quality more and more sought by the public in all aspects of production, transportation, entertainment, education, planning, and architecture, as well as art.

Interactivity empowers the individual to participate fully in the workings of a system, whether that system operates at the conceptual, behavioural, or environmental level, and whether it is utilitarian or artistic.

The public is becoming increasingly aware of the value of electronic space as a space for personal transformation, for communication, play, learning, and gaining information.

Older cultural institutions cannot adapt to the needs of the new electronic arts—radical rethinking is needed to guarantee public involvement and cultural viability.

Connectivity, immersion, interaction, transformation, and emergence are the key elements of the electronic arts in the 1990s:

· *connectivity* of people, places, ideas, media, and systems

· *immersion* of the viewer in the data space of the artist

· *interaction* with elements of the systems that are encountered

Originally published in German in *Ars Electronica Center Projektstudie*, vol. 3, *Einzelstudien* (Linz, 1993).

- *transformation* of media and of the consciousness of the viewer
- *emergence* of new data, images, forms, structures, and systems.

The Need

There is a need for an institution that reflects these changing cultural attitudes, which will function essentially as a matrix within which artistic work can evolve through public interactivity. This will not be in any way the same as a traditional museum, or school, workshop, studio, production facility, or art centre. The electronic arts in the 1990s embody qualities of open-endedness, of sensory immersion of the viewing subject, and of intensive interactivity from which new material emerges and from which the new art evolves. Thus the institution that is required must constitute a fluid and flowing system, supporting these qualities of open-endedness and emergence, and encouraging connectivity at all levels. This is to describe a dynamic organism rather than a fixed and static institution. The proposed Ars Electronica Center [AEC] in Linz will be this organism—a museum of the twenty-first century.

The Datapool

Perhaps the best metaphor to describe this new Center is that of a "datapool" into which and within which data in all their modes flow, endlessly transformed through human interaction, and from which they emerge, art-in-flux, flowing on into other domains, other pools, other tributaries of the data sea. This in turn calls for new behaviours on the part of the viewing public: no longer to observe, stand back, look from a distance, and judge, but to plunge into the datapool, immerse themselves in its fluid changeability, share in its swirling transformations, navigate its knowledge bases, dive to its depths of meaning. AEC is thus setting a new standard in public access to art, art not as finite object but as process and system, a fluid, moving stream of data configurations, embodied in networks, on screens, in material structures, in installations and environments, endlessly open to transformation and change.

This is a museum of the twenty-first century. Not reactive but anticipatory, not imposing perspectives on the history of art but opening up a pool of possibilities emerging as the prospect for the future of art. It is working at the forward edge of contemporary culture, as an *agent* of cultural change, as a cause of art practice rather than simply a cultural effect. To take the plunge, to dive

into this data world requires a new understanding of art. Just as in the academic world, the computerisation of knowledge means that children must acquire new attitudes to learning, and teachers new attitudes to their teaching, so in art the public need to enjoy new approaches to the electronic environment, *learning* to immerse themselves in the data field, to *interact* with the elements it contains, and *navigate* through its many layers and networks of media and meaning.

The datapool metaphor reminds us of the parallel between the emergence of proto-organisms from primeval rock pools and the emergence of the constituents of a post-biological culture from the pools of data forming on the planet today.

A New Context for Art

Just as contemporary art, in coming to terms with new digital multimedia and the technologies of perception, cognition, and behaviour, builds upon and absorbs the art movements of the past—the cubist interpenetration of space and time, futurist dynamics, kinetic art, intermedia, performance, film, video, and early computer graphics, so, as we approach the twenty-first century, we can expect the evolution of entirely new forms, ideas, and media, grounded in the art of today. For this reason, AEC is designed to create a context of development for the electronic arts and a frame for their cultural evolution in the data sphere. While its museum role as archive, reference, and repository of works of excellence and of historical significance is maintained (although with a technology of access, cross-reference, and display that is state-of-the-art), AEC essentially provides a setting for art from which new visions, new initiatives, and new methods can grow. Thus it is a seedbed for the future, a test-bed of present inquiry and experiment, and a fertile ground of historical reference.

The governing perspective within which the evolution of AEC is viewed is not that of the machine, however, despite our evident reliance on computers, technological systems, and electronic engineering. But, just as the conceptual position of many artists in the technoculture of 1980s was fuelled by metaphors drawn from quantum physics, chaos science, and cosmology, often deconstructionist and inevitably postmodern, so the new metaphors likely to govern the evolution of art in the decade leading us into the twenty-first century will come from the new biology, artificial life, neural networks, cognitive science, and radical constructivism. Not that these two frames are worlds apart. They converge at many points, not least in their replacement of the representational function

of art. Despite the recent popularity of computer simulations of the external surfaces of the world, we are witnessing the end of the era of mimetic art. Its role in providing representations of the world is shifting to that of *creating* worlds, of inventing alternative realities, a process in which the observer of art becomes an active participant, a process from which art *emerges*. The attempt is no longer to imitate life but to emulate it, as part of the co-evolution with nature that is our contemporary goal. We are entering the post-biological era.

Public Partnership

The building offers its public the opportunity to share, to collaborate, and participate in this process of cultural emergence. The public, whether schoolchildren, artists and designers, engineers, shopkeepers, or industrialists, will have a stake through AEC in the future of culture. For this reason, AEC must be transparent in its structures, its goals, and its systems of operation at all levels: architectural, curatorial, and administrative. It should be an intelligent building with its own memory, a building that reacts to us as much as we interact with it. It will be a radical departure from conventional museums and a unique response to the new cultural momentum.

Thus the visitor will enjoy the role of partner in the evolution of the art at AEC—experiencing the electronic arts from the inside out and from the bottom up. Each visitor to AEC, whether from Linz or further afield—must have a sense of ownership of the art that is experienced there, and that in part has been shaped through his or her active involvement. Similarly, as a major node of international telematic networks, AEC extends the opportunity for participation to an even wider artistic community.

We think that [most of] our visitors, in-house and online, will be demographically representative of ages between eight and thirty, [although] at the same time recognising that neither the middle-aged nor the more elderly public are unaware of technology or indifferent to it in their cultural life, and that initially curiosity will draw many into the centre. We are confident that the excitement and rewards of an immersion in this environment will be a positive inducement for them to return. The video recorder is almost as familiar to these generations [now] as the phonograph or transistor were in their youth. Virtual reality has had a widespread press. The programmes of Ars Electronica at the Brucknerhaus and on TV and radio have prepared the population of Linz as well as the international community for an informed and open participation in the new Center.

Opening Doors

For that is the mission of AEC: to break down the mystique of high art, and remove unnecessary barriers to the experience of innovative, experimental work, to allay public fears of computerised electronic systems and cybernetic structures, by presenting such work without compromise but in an environment of accessibility and participation, in which room for informed reflection, access to historical precedent, and the skilful coordination of architectural resources make the encounter an enriching rather than a forbidding experience. Not that such work is without humour, wit, or charm, in any case, or that it fails to address issues of world importance and of personal interest. But there are many public preconceptions about the computer and much misunderstanding of its powers.

AEC wants to open the doorway into data space—to share with its visitors the new sensations and paradoxes of events in electronic space, the experience of telepresence, cyberspace, of being online to a global community, of being both here and somewhere else at the same time. Where once this could only be achieved in art projects and museum performances at the level of spectacle, with the audience distanced, feeling its way into telematic experience only through the surrogate actions of a performer, we are now witnessing the domestication of real-time video conferencing, bulletin boards, databanks, and e-mail networks, bringing the creative possibilities of telepresence and computer collaboration to the individual. More and more, artistic enterprise is being invested in interactive systems (CD-I is a current example), and the desktop multimedia environment will allow for very direct and personal involvement by each visitor.

Tensions and Strengths

Our vision for AEC does not ignore the contradictions and tensions that its cultural ambitions raise:

- it is oriented to the general public, but it presents advanced and challenging work
- it is rooted in the community, but its networks reach out to the world
- its references are technological and scientific, but its ethos is poetic and spiritual
- it is dedicated to serving local culture but committed to art at the international level
- its media orientation is electronic, but its perspective is biological

- it takes artistic risks, but its financial and commercial attitudes are sound
- its processes are digital, but its attitudes are profoundly human
- its output is fluid and immaterial, but its engineering and construction are precise
- it uses the technology of power, but its effects are democratic and integrative

However, these oppositions are in fact complementary, and the tensions are energising. It is this complementarity and energy that will fuel the internal dynamic of the Center and give it cultural cohesion and artistic significance.

The Structure of the Center

Seedbed, and test-bed, set in the fertile ground of artistic achievement . . . how is this reflected in the organisation of the building?

The artistic achievement upon which future evolution of interactive art lies is encountered as soon as one passes through the osmotic membrane, separating the Center from the street, into the ground floor of the building, where all that is newest, most challenging and, at the same time, most inviting in the current world of electronic arts is encountered, including prize-winning works from Ars Electronica, installations, and performances. New products and state-of-the-art technology are shown here. It is a space also where the individual's orientation to the City of Linz can be mapped out in cyberspace, and where the role of being a free-floating cybernaut can be enjoyed.

On the floor below there are multimedia accounts of the origins of interactive systems in art, and an audio visual environment proposing the origins of the twenty-first century; a videotheque where past achievements of Ars Electronica can be viewed; an installation space for hypermedia; and a digital cinema. On the far wall, there are portholes through which video simulations and submarine fantasies can be enjoyed.

The televator or the interactive stairs can take us up past the ground floor, to the level of experimentation [see fig. 39]. Here we encounter cyberspace, telepresence, radio art, experiments with sound and light, holography, and a space for the manipulation of video and computer images on the broad floor level surface of the "datarena." There is access to worldwide networks, to data banks, and online telecommunications projects: in short, a teleport, whose extensive links are as likely to attract innovative business minds just as much as artists. This is the territory of events: projects for probing and prodding the limits of electronic art, searching for the furthest possibilities of artistic innovation

ARS ELECTRONICA CENTER
CONNECTIVITY MODEL

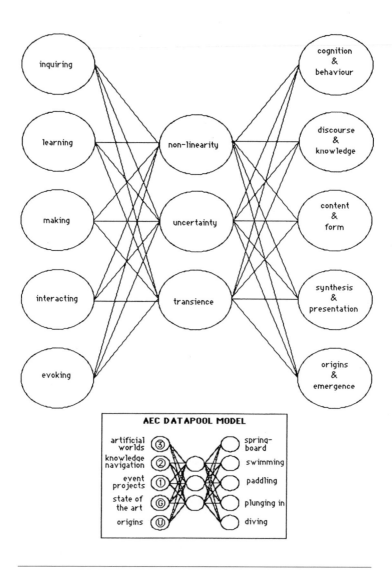

Figure 37. "Connectivity Model." Ars Electronica Center, Linz.

in electronic space. At the same time, the social impact of electronic networking, particularly the global imbalances it can create with the Third World, will not be overlooked, and initiatives designed to address these issues will be prominent.

The next floor above is concerned with inquiry and learning: navigating knowledge, ordering and reshaping ideas, exploring the many levels of human and machine perception, acquiring and developing techniques of communication. It is the interface also to the archive, doorway to other times and other cultures. It is the schoolroom of the twenty-first century—postmodern technology for the postmodern mind. Here the tools and techniques of computer graphics and animation, hypermedia and databasing, virtual reality systems, and digital editing are available. Here schoolchildren of Linz and young people generally, as well as AEC fellows, researchers, and artists will gather together, to learn about, to create, analyse and discuss in a working situation, the newest means of imaging, visualising, rendering, virtualising, and transforming reality, the recording of natural processes and events in the world, and the restructuring of knowledge. Links will be made electronically, principally through e-mail to other academic centres in Linz and further afield.

The top floor makes publicly accessible everything of recent research that concerns cognition, perception and behaviour as they relate to electronic, biological, and post-biological systems. Here is a zoo set in artificial nature, a menagerie of "animats," "progranimals," and other artificial life forms existing in the space of a computer screen or as robots crawling around at our feet. Here we encounter the intelligence of neural nets and complex sensing systems. Here, too, bionic and body metering devices, prostheses, and telerobotic systems will be available. The artistry of scientific visualisation—turning facts and mathematical models into stunning computer images, making all that is invisible in the world visible. And here too, close to the sky, is a zone for telemeditation, a kind of data-dream lab and a possible site for telematic healing. Certainly, the relationship between technology and consciousness is on the agenda here. And the windows offer a view that is superb—and changeable. The Danube and the city of Linz alternate with simulations of other landscapes, other worlds, alternative realities brought about in these very windows by LCD, holography, video projection, and other means. Here, too, is space for those meetings of minds, in conferences and seminars, where issues relevant to the new emerging culture can be argued and discussed.

There is a further level, which is as potent as it is invisible—the telematic level. It is the alias of all other levels of the building, consisting of all those func-

tions, events, projects and performances that come to exist within the web of far-reaching digital networks of which AEC will be a major, generative node.

Connectivity

Since the building is organised in layers—"Artificial Worlds," "Knowledge Navigation," "Origins," and so on, the physical and conceptual separation will call for an electronic central nervous system; that is, adequate cabling for voice, video, and data to ensure a high degree of connectivity between all its parts. The classification of the layers is no more than provisional and cannot wholly reflect the relational complexity of the field of interactive arts in all its technological, media, and conceptual diversity. Since AEC is an organism of some considerable internal complexity, its conceptual and physical systems will have to be monitored, serviced, and developed regularly. To enable the visitor to grasp this complexity and to exploit it with confidence and pleasure, the system is served by a number of amenities, such as an interactive staircase, a televator, touchscreen event-menus, a personal electronic rucksack, and videophone booths.

The activity inside the building will be manifested outside the building, either by digital wall screen, video projection, or laser, so that there will be a constant flow of data from the datapool to the city. Similarly, in the immediate urban area, telephone and cable connections will allow for the output of this material to a variety of public places. AEC should be active twenty-four hours a day.

The Commercial Context

In stressing the cultural and social service that AEC will provide, we should not overlook its commercial potential. Individuals and groups from the Linz and the immediate region are likely to become regular visitors since the convivial atmosphere of user-friendly architecture and constantly changing events will be irresistible. The international community, not simply people from the surrounding countries, but also from North America and Japan, are likely to visit the Center in sizable numbers. They will be students, artists, collectors, researchers, writers, architects, planners, designers, technologists, teachers and . . . cultural tourists. Entrance fees for all or part of the Center will be levied. A smart card will be the most effective way of giving and withholding access to levels, services, and exhibits.

Apart from the obvious attractions of its unique design and innovative programmes, including its integration and cooperation with the Prix Ars Elec-

tronica, and access to so much that is significant in the field of interactive arts, it will also be a vitrine, a platform, for the presentation of ground-breaking designs of hardware and software, technological invention, and product development in the spheres of design, entertainment, and education. It will quickly come to be in demand as a site for prestigious conferences, meetings, and presentations by business, professional, and public bodies, as well as a teleport and teleconference centre. Similarly, the technical facilities of image processing, cybermapping, and interactive laser disc design, for example, will represent a local resource of some substance, both for prototype development and for short training courses.

All of these aspects are potential sources of revenue that, along with shop sales, information services, and copyrights of archival material, will yield income of some significance to the financial viability of the centre. Industrial and commercial sponsorship of projects, programmes (e.g., the Sony Diskman museum guide), and specific parts of the building (e.g., the Apple Electronic School Room) will also be sought.

Working at the Forward Edge

AEC is oriented towards the future, as a place of cultural emergence, and as its identity and reputation as a world centre of electronic and post-biological inquiry, experimentation, and achievement in the arts quickly become established, it will become increasingly attractive to industries and corporations wishing to exhibit and promote their newest technological products and services. The potential in terms of sponsorship by means of capital equipment gifts and loans, programme and fellowship endowments, matching grants, and advertising revenue is considerable. This must be offset against the necessity of upgrading or replacing equipment and systems every two years, and ongoing development of in-house software. The costs are not inconsiderable. But this field is identified as much with technological as with artistic and cultural innovation, and anything less than a state-of-the-art environment would be inappropriate and detrimental to the advanced standing of the Center.

And it is from the point of view of income-generation, as much as social responsiveness, that the Center will be well advised to establish an educational provision that capitalises on its unique interdisciplinary and technocultural orientation and resources, in a way that will employ more than the obvious strategy of establishing short training courses, educational visits, or familiarisation workshops for teachers, necessary and useful as they will be. Europe needs, and

the Center will be uniquely able to deliver, a summer university of the arts that is set in the context of the post-biological, telematic culture. Colleges and academies of art are neither physically equipped nor intellectually able to offer a learning environment such as the Center envisages. Students, on the other hand, are increasingly in search of contemporary relevance and meaning in their education and training. Proper promotional strategies will also ensure that fee-paying students in significant numbers are recruited from Japan, Europe, and America. From this perspective, a programme of online education through the electronic networks will also be developed. European satellite education is an obvious target in this respect.

The Linz Academic Network

It is clear that both on the level of teaching and on that of research and development, close ties must be established with appropriate university departments, science and technology institutes, art and design, music, and other academic centres in Linz. The trade-off will be very much two-way, since in addition to the programmes, exhibitions and archives of the Center itself, AEC will be attracting and presenting distinguished artists and experts in many fields.

Ars Electronica

Works of excellence from all categories of the Prix and from the Festival will, of course, be found, for longer or shorter periods, in most parts of AEC on all five levels. The following section of this report lists examples of such work. The relationship with Prix Ars Electronica, however, should also extend to including project areas in the competition brief (e.g., teleconference and networking, digital sound, interactive environments, datarena, cyberspace, televator, and simulation portholes). This will have two effects: to broaden the range of interactive works submitted to the jury and to give prospective contributors a concrete goal for the realisation and installation of their proposals.

Swimming Towards the Future

The datapool metaphor should serve us well, since in addition to reminding us of the fluid, flowing, and endlessly transformational aspects of the art and behaviour we wish to evolve, it allows us also to keep humour in the perspective. Splashing, paddling, plunging, wading, diving, fast crawl and dog paddle all have

their place in AEC as descriptions of the variable degrees of physical, intellectual, and emotional engagement each visitor may wish to invest in the experiences we offer. We hope that the design and programmes of AEC will be such that every toe dipped in to test the water will find the artistic temperature warm enough and fresh enough to invite further immersion in the datapool.

▬ STRUCTURE OF THE ARS ELECTRONICA CENTER
References to Artists and Work

In order to indicate the range, balance, and dynamism of work that AEC would support, the following section gives examples of artists and individuals whose work could be available to experience were the Center operational at this time. *They are intended to serve as no more than indications of the kind of work that might appear in a given section.* There are, of course, many, many more such examples of originality and excellence in the field that could have been chosen.

For easy reference, I have included a bracketed number alongside most names and titles of works mentioned. The number before the point refers to the publication from the list below, and the number after the point refers to the page number—for example, Troy Innocent, "Iconworld" (2.124) can be found in *Der Prix Ars Electronic* (1992) on page 124.

Publications

(1) Ars Electronica, *Die Welt von Innen* — ENDO & NANO = *The World from Within* — ENDO & NANO, ed. Karl Gerbel et al. (Linz: PVS Verleger, 1992).

(2) *Der Prix Ars Electronica: Internationales Kompendium der Computerkünste*, ed. Hannes Leopoldseder (Linz: Veritas, 1992).

(3) *Leonardo* 25, 1 (1992).

(4) *Der Prix Ars Electronica: Internationales Kompendium der Computerkünste*, ed. Hannes Leopoldseder (Linz: Veritas, 1991).

(5) *Der Prix Ars Electronica: Internationales Kompendium der Computerkünste*, ed. Hannes Leopoldseder (Linz: Veritas, 1990).

(6) *Art Press Spécial*, no. 12 (1991), *Nouvelles technologies*.

(7) *Leonardo*, supplement, 1988, *Electronic Art*.

(8) ARTEC, First International Biennale, Nagoya, Japan, 1989.

(9) *Art Journal* 49, 3 (1990), *Computers and Art*.

(10) *Leonardo* 24, 2 (1991), *Connectivity.*

(11) Steward Brand, *The Media Lab: Inventing the Future at MIT* (New York: Viking Penguin, 1987).

▬ Third Floor

Cognition, perception, and behaviour as they relate to electronic, biological, and post-biological systems.

ARTIFICIAL LIFE

Data creatures growing, interacting, and evolving in data space.

Chris Langton, Santa Fe Institute
John Conway, "Life"
Louis Bec, France, "animats"
Michael Travers, Media Lab, MIT
Norman Packard and Mark Bedau
Peter Oppenheimer, New York Institute of Technology
David Jefferson, UCLA, "programinals"
Rebecca Allen, UCLA
Carl Sims, Thinking Machines
Walt Disney, animal animation
William Latham, IBM, U.K.
Luv Stills, AI, Brussels, virtual robot ecology

ROBOTICS

Interactive, "intelligent" artificial creatures.

Jean-Marc Matos, "Talos" (6.131)
Chico MacMurtrie and Rick Sayre, "Tumbling Man"; MacMurtrie, "The Trees Are Walking" (4.128)
Jim Pallas, "Nose Wazoo" (4.150)
Hans Moravec, CMU, proposed "Bush Robot"
Rodney Brooks, Mobile Robot (Mobot) group, MIT, "Creatures," "Genghis" foot-long cockroach, "Allen," vacuum-robots, "Herbert," "Attila"
Jonathan Connell, Mobot, "Tom & Jerry"
Randell Beer, CWRU, "Periplaneta computatrix"
Stuart Wilson, "animats"
Robert Collins & David Jefferson, "Antfarm"

FUNCTIONS & AMENITIES

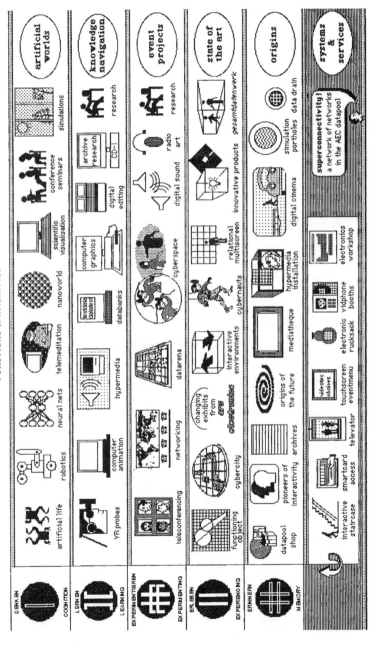

Figure 38. "Functions and Amenities." Ars Electronica Center, Linz.

Onno Onnen, Fachhochschule, Karlsruhe, Mechatron VI robot
Norman White, "Helpless Robot" (5.179)
Harold Cohen, UCSD, drawing machine [AARON]
Stelarc, videotapes of performances

COMPUTER ANIMATION

Keith Hunter, "Power Surge" (2.88)
Follow progress of Alan Kay's MIT Vivarium project

NEURAL NETS

PDP Group, UCSD, videotapes
Carver Mead, Synaptics Inc., eye/ear prototypes
Asahi Chemical Industry Co., Japan, speech recognition
Prof. Teuvo Kohonen, Helsinki

NANOWORLD

Troy Innocent, "Iconworld" (2.124)
Jean-Marc Philippe, smart materials sculpture
Foresight Institute, Palo Alto, videotapes on molecular engineering

SCIENTIFIC VISUALISATION

Digital visualisation of complex systems.

Michael Tolson, "Wet Science" (4.110)
Charlie Gunn and Delle Maxwell, "Not Knot" (2.54)
Donna Cox, online to research laboratories, Linz University (supercomputer access)
Remote sensing images—pulled off from weather satellite

SEMINAR SPACE

Simultaneous translation system
Light catering facilities

SIMULATION WINDOWS

Screen conversions of the windows on this level employing projected video/data and holographic techniques. *Development note:* Large, flat wall screen colour TV

by 1996 MITI programme (liquid crystal display). Trial 1995, prototype 40"—
bigger later.

Computer animation: Alan Norton, "Free-for-All" (2.92), Yoichiro Kawaguchi
"Eggy" (4.89)
Holography: Michael Snow, John Perry, Dieter Jung (6.47), Setsuko Ishii (6.58),
Rudie Berkhout

TELEMEDITATION

Experimental resource for new meditation techniques, techno-healing, and
dreamwork.

Brian Eno, "Datalounge"

■ Second Floor

*Inquiry and learning: navigating knowledge, ordering and reshaping ideas, exploring
the many levels of human and machine perception, acquiring and developing techniques
of communication.*

THE ELECTRONIC SCHOOLROOM

Much of the equipment listed will be used in conjunction with experimental
teaching techniques and systems. Examples of current practice are

(1) "Virtual Classroom": group communications and work "spaces"; software
by Star Roxanne Hiltz at the Computerized Conferencing and Communi-
cations Center, New Jersey Institute of Technology, Newark

(2) Brenda Laurel: alternative curriculum at Mill Valley High School, Mill
Valley, California

(3) "A Living Library": network of interactive life frames—culture/ecology,
by Bonnie Sherk (10.223)

(4) Hennigan School, MIT (includes LEGO/logo software) (11.119)

VIRTUAL REALITY KIT

VPL Eyephone and Dataglove; Reality Built for Two (RB2)—needs real-time
rendering on Silicon Graphics computers
Virtual Worlds educational software includes: cognitive science test-bed, med-
ical database, simple molecule kit, creative arts

HYPERMEDIA FACILITY

Desktop video, MIDI—sound, hypertext, graphics interface
Wide range of educational, artistic, and scientific software available for Mac II
and Amiga

COMPUTER ANIMATION

Resource to include real-time 3D if online access to university supercomputer
is arranged.

Maurice Benayoun, "Notes about Quarxs" (4.95)
Christiane Geoffroy, "Geo-Genetic" (5.105)
Alan Norton, "Tipsy Turvy" (5.101)
Hirofumi Ito, "Imaginary Proteins" (6.163)
Simon Frazer University choreographic programme "Compose"
Software: "Life," "SimCity," "After Dark," "Eliza," "PacMan," "Star," "Colos-
sal Cave," VisiCalc (non-active) virus programmes (1.191)

DATABANK ACCESS

Both the techniques of using databanks and of constructing them will be taught
here. This is also the access point for all searches into academic databases.

Henry See, "A Memory Project" (2.128)

COMPUTER GRAPHICS

Educational workstations and interface for research.

Richard Greene, "Light Strokes" interface (5.202)

DIGITAL AND VIDEO EDITING

Resource for teaching, programme preparation, and research.

ARCHIVE RESEARCH

CD-ROM, CD-I

Ref: Titus Leber

DATARENA

Video/data back projection (LCD screens when available).

For all work, especially with children on this level, involving human interaction with a horizontal floor screen. Tapes and computer programmes can be shown and may be controlled for interactivity with the images/texts, given development of appropriate software.

RESEARCH
Space and resources for two art/science researchers.

■ First Floor

Cyberspace, telepresence, radio art, experiments with sound and light, holography, and a space for the manipulation of video and computer images.

TELECONFERENCING
ISDN (Integrated Services Digital Network)

ISDN is a network architecture using digital technology to support integrated voice, data, and image communications. It works over standard interfaces using typical twisted pair telephone wire. It is over 600 percent faster than a high-speed modem (1 MB file transmits in two minutes). The sort of high volume of data, text, image, and sound we shall need to receive and distribute is made possible by a dial-up service over the public telephone network. By the time that AEC becomes operational, ISDN is expected to be available more widely in Austria. Current interlinks are with the United Kingdom, France, Germany, Belgium, the Netherlands, Japan, Hong Kong, the United States, Singapore, Australia, and Scandinavia. There are two levels: ISDN 2 provides just two lines for interactive work; ISDN 30 provides thirty lines. Much more expensive, but much wider bandwidth, and thus more versatile.

Development note: By late 1993, British Telecom and Motorola will market a multimedia communications chipset for face-to-face conferencing by ISDN. This will be for broadcast-quality video conferencing and transfer of very large graphic files.

SATELLITE SERVICES
Uplink/downlink station facility unit is too expensive ($66,000), but we should have the capability to receive public satellite broadcasting.

Development note: VSAT—very small aperture terminal.

NETWORKING

Using a modem to link the computer to public telephone lines will put users of
AEC in touch with data banks, electronic mail, and computer-conferencing net-
works across the world.

AEC's research and teaching function will qualify it for access to EARN, the
European Academic Research Network (either as an independent node or con-
nected to the University of Linz node). Brussels has also created the (free) ac-
ademic research network COSINE.

AEC will also make fax available for projects and events.

We will create an online "virtual AEC." This will be curated, designed, and
developed in parallel with the AEC programmes.

EARN, the European Academic Research Network, has hosts in Austria and
every Western European country, plus Yugoslavia, Cyprus, Turkey, Israel, Al-
geria, Ivory Coast, Morocco, Tunisia, Egypt (India is an associate), Bulgaria,
Hungary, and Russia: 600 hosts in 500 institutions, and 30,000 users. With AEC
in EARN, it will have gateways to JANET UK, EUnet (which includes MCVAX
Holland and UNIDO Germany). EARN is based on the X.25 PTT networks.
It will give AEC access to Bitnet and Internet in the United States. Through
ACONET—Akademisches Computer Netz—most Austrian higher education
and research institutes connect to EARN, EUnet, Datex-p, and through them
to rest of the world. These networks carry special interest user groups for e-mail,
bulletin boards, and art and music communications projects such as:

ZEROnet (Graz)
NETJAM (UC Berkeley) collaboration on musical compositions MIDI inter-
face, compression, etc., via the Internet; EcoNet and EarthNet (connecting
with NEC PC-Van in Japan and the Institute for Networking Design, Tokyo)
FAST, the Fine Art, Science & Technology Bulletin Board; Art Com, The Well

Networking and teleconferencing services will be at the heart of AEC Data-
pool development. An operations manager and systems operator will be needed
from the start of AEC operations.

Development note: European Community networking and database ser-
vices. The Community seeks Eurowide ISDN and digital nets. With good in-
frastructure and network integration, AEC could offer itself to RACE (Research
& Development of Advanced Communications Technology in Europe) as an
experimental node within any Austrian development.

The University of Linz is part of the Networks of Excellence, concerned with
new discipline areas, e.g., robotics, speech and natural language, computer-in-

tegrated manufacturing; human/computer interfaces; neural networks. AEC research areas should have access to the network.

STAR is concerned with special telecom action for regional development in Europe: telematics and equipment.

Exploratory research [will be] conducted on advanced data transmission systems to sectors such as education.

DATARENA

Video/data back-projection (LCD screens when available). This was the original "datapool," conceived of as a horizontal screen for all communications activity—input/output—of networking projects.

For work involving human interaction with the floor screen, tapes and computer programmes can be shown and may be controlled for interactivity with the images/texts, given development of appropriate software.

CYBERSPACE

Virtual reality data wear and communications software (e.g., VPL's "RB2" software). Projects involving interactivity between players and virtual objects and environments. Autodesk has software for cybertheatre.

Robert McFadden, "About Five Idylls" (2.120)

DIGITAL SOUND

MIDI interface—synthesisers, samplers, mixing boards, and instruments for live electronics.

Philippe Ménard, *Synchoros* (7.63)
Ref: Laurent Bayle, IRCAM (Institut de Recherche et Coordination Acoustique/Musique, Paris) (6.66)
David Rosenboom, *On Being Invisible* (7.121)
Ale Guzzetti, *Suoni di plastica* (4.138)
Mathias Fuchs (10.145)
David Eagle, *Traces for Flute and Computer* (4.134)

RADIO ART

Facility (and licence) for direct broadcast out. Preparation of tapes for transmission in other countries. Presentation of incoming tapes curated: e.g., *Radiolabor*, Austria (1.203).

▬ Ground Floor

All that is newest, most challenging and, at the same time, most inviting in the current world of electronic art.

FUNCTIONAL OBJECT

Multipurpose event space. Ref: Art + Com.

CYBERCITY

Art + Com VR walkthru of Linz. Test-bed for other architectural walk-thru and mapping software/interface (W Industries, AutoDesk, Division Ltd.).

INTERACTIVE ENVIRONMENTS

Computer-mediated systems of transformation of images, acoustics, structures.

Jean-Louis Boissier, "Le Bus" (6.41)
Nola Farman, "Lift" (4.136)
Barry Treu, "Wind and Light Machine" (3.151)
Joan Truckenbrod, "Expressive Reflections: Reflective Expressions" (7.101)
Luc Courchesne, "Portrait One" (2.118)
Christian Möller, "Der Spielraum" (1.155)
Jeffrey Shaw, "Virtual Museum" (5.187)
Myron Krueger, "Videoplace" (5.171)
Agnes Hegedus, "Handsight" (1.101)
Joachim Sauter and Dirk Luesebrink, "Zerseher" (2.106)
Ed Emshwiller, "The Blue Wall" (8)
Edmond Couchot, "La Plume" (6.146)
David Rockeby, "Very Nervous System" (4.132)
Philippe Prevot, "Le Corps sonore" (8)
Lynn Hershman, "Deep Contact" (9.253)
Sara Roberts, "Margo" (9.253)
Jane Veeder, "Warp It Out" (9.253)

GESAMTDATENWERK

Multimedia installation and performance: video, computer, sound, robotics, CD-I, sensing systems, light, human performer.

Georges Dyens, "Big Bang" (6.48)
IMmediaCY, a technological theatre

Will Bauer and Mark Bell, "(PoMo CoMo), Canada" (1.226)
Robert Mulder and Kristi Allik, "Electronic Purgatory" (4.156)
Stephen Wilson, "Inquiry Theatre" (4.148)
Paul Sermon, "Texts, Bombs and Videotape" (4.123)
Gerhard Pakesch, "Sonata per Guitarra Electrica Preparata No. 1" (5.93)
Jean-Marc Matos, Nicole and Norbert Corsino (6.131)

HOLOGRAPHY SUBSET

Bruce Evans, Michael Page, Sesuko Ishii, Doris Vila, Philippe Boissonet, Andrew Pepper (6)
Stephen Benton, projected hologram (11.84)

RELATIONAL MULTISCREEN

Wall of computer-programmed video screens.

(1) Simultaneous screening of short video and computer animation material of different genres, e.g., Roberto Matta (6.99); Mathew Brunner, Mario Buendia, Jerome Estienne, and Xavier Duval, "Fantôme" (2.66); Cecile Babiole (6.82); John Lasseter, Steve Goldberg, and Eihachiro Nakamae (5.113).

(2) Constantly changing mosaic of computer graphics images, e.g., Arthur Schmidt, Bill Woodward, Yoshiyuki Abe (4.0), Manfred Mohr, Charles Csuri, and Scott Howe (5.00).

(3) (Software) development of interactive selection *by association* via CD-I storage.

(4) Projects specifically designed for the Relational Multiscreen.

CYBERNAUTS

Appropriate virtual reality equipment and software gives the illusion of free-fall in space to suspended players.

Matt Mullican, "City Project" (6.177)
Monika Fleischmann and Wolfgang Strauss, "Home of the Brain" (2.100)

INNOVATIVE PRODUCTS

Vitrine for state of the art hardware and software, consumer products, transport designs, intelligent architecture systems. The space should also periodi-

cally display innovative design from students associated with learning programmes at AEC.

Future Systems, "The Drop" (8.)

CHANGING EXHIBITS

Smaller objects, sculptures, and related work from Ars Electronica Prix and Festival.

Martin Spanjaard, "Adelbrecht" (2.133)
Mark Madel, "Universal Time Piece" (4.142)

■ Lower Floor

Multimedia accounts of the origins of interactive systems in art, and an audiovisual environment proposing the origins of the twenty-first century.

PIONEERS OF INTERACTIVITY

An interactive maze giving video and hypermedia presentations of the artistic, scientific, and technological roots of the interactive arts.

ORIGINS OF THE FUTURE

An installation presenting fifty individuals nominated as setting the foundations of the twenty-first century. Mini-portraits made by outstanding video/computer artists, displayed on mini-monitors.

MEDIATHEQUE

Large Sony monitors [showing] videotapes from around the world covering all aspects of the electronic arts, including documentaries of performances, events, artist interviews, and curated showings (programmed by, e.g., country, artist, genre, subject, technique, and season).

DIGITAL CINEMA

Video/data projection on large screen in the Vortragssaal.

N. Magnenat and Daniel Thalman, *Rendez-vous à Montréal* (7.55)
Pascal Young, *The Invisible Man in Blind Love* (4.113)
Peter Krieg, *Suspicious Minds* (4.140)

Nicolas and Kular, *Sub Ocean Shuttle* (2.90)
Eduard Oleschak, *Move-X* (4.109)
Peter Claridge, *The Castle* (4.97)
James Duesing, *Maxwell's Demon*
Philippe Andrevon, *Star Life* (5.87)

SIMULATION PORTHOLES

These will be porthole apertures set in the wall that is nearest (though underground) to the Danube. Works (submitted in competition to Prix Ars Electronica) will be projected to simulate external environments.

DATA DRAIN

This feature is at the bottom of the public space of the datapool. It will carry computer/video images of "waste data" leaving the system. This will be activated by the visitor. It is envisaged that an artist such as Peter d'Agostino (5.203) might be commissioned to create the tapes.

HYPERMEDIA

HyperCard, SuperCard. Desktop interactive, image/text/sound.

Ed Tannenbaum, "SYM-ulation" (9.255)
Beverly and Hans Reiser, "Life on a Slice" (2.126)
Rajinder Chand, "House II" (2.116)
Bill Seaman, "The Exquisite Mechanism of Shivers" (2.110)
Paul Sermon, "Think about the People Now" (4.121)
Christopher Burnett, "The Information Machine" (9.255)
Benjamin Jay Britten, "je suis (un readymade)" (5.191)

ARCHIVE STORE

[This will] be [a] database for all that relates to interactive arts and electronic arts.
Ref. Titus Leber.

Systems & Services
INTERACTIVE STAIRS

Ref.: Art + Com. (architectural firm, Berlin).

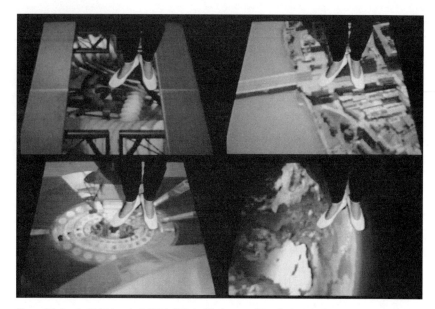

Figure 39. *Apollo 13 (Televator)*. 1996. Video stills from multimedia installation. Interactive elevator "Televator" permanently installed at the Ars Electronica Center in Linz. The screen in the floor of the elevator gives the impression of the museum, Linz, Austria, Europe, and the planet Earth slipping away as the elevator ascends, and vice versa on descent. The ceiling monitor Ascott proposed was not realized.

TELEVATOR

Flat-screen video monitor inset in ceiling and floor of the house elevator.

The screen in the ceiling of the elevator carries videotaped astronomical remote-sensing images; the floor screen gives the impression of the museum, Linz, Austria, Europe, the planet Earth slipping away as the elevator ascends, and vice versa on descent.

TOUCHSCREEN EVENT-MENU

Located on all levels, including the external face of the main entrance.

In-house interactive videotex using commercial software. Updated daily, showing building plan, permanent features, temporary exhibits, performances, programmes, biographical and technical information.

ELECTRONIC RUCKSACK

Ref.: Art + Com. (architectural firm, Berlin).

VIDPHONE BOOTHS

Internal telephones at each level with online capability, (a) for prepared Europe-wide projects; (b) regular PTT communications as the product becomes publicly available.

SMARTCARD ACCESS

Public access to different levels, sections, or programmes of the house by card purchased on arrival. Sophisticated add-ons to the access system include voice response with name identification. The same system would be employed for security and staff access.

PAPER AND ONLINE NEWSLETTER

To keep the public informed of AEC plans and development and to act as a forum for ideas related to the Center's field of operations.

DATABASE

Due to its unique identity and function, AEC will need to write a special programme for its institutional database. This must include graphics (or objects) but object-oriented database systems are still only in the research arena. They are likely to be available by the time that AEC starts operations. There will be an initial financial outlay, but it will become a valuable resource, for which we should charge user fees.

ELECTRONICS LAB

A small but comprehensive resource for house technicians and visiting fellows.

CHAPTER 22 **THE PLANETARY COLLEGIUM**

Art and Education in the Post-Biological Era

1994
In order to touch the right buttons in navigating our hyperstack of ideas and options for art education in the post-biological age, we should perhaps start by identifying the right icon. But the icon for turn-of-the-century art education is not yet defined. A hundred years ago, the icon would have been the canvas on its easel, with the artist and his model as the standard mise-en-scène. Now we are dealing essentially with the invisible, with transformative systems, with interactivity. The icon must speak of collaboration, the integration of minds, of media and of skills, as well as the almost chaotic proliferation of variable meaning and transient identity. That's some icon! Most likely, it will be found among the metaphors of artificial life and the cognitive sciences. I think it will be found there because the narratives these sciences offer are more likely to illuminate our practices in art, and its associated field of education, than anything the culture crunchers, the theorists, and art analysts, are likely to throw up. Looking back now, in this century, it perhaps was always so. D'Arcy Wentworth Thompson's *On Growth and Form* and Norbert Wiener's *Cybernetics* have more lasting relevance to the advancement of our field than many of the art-specific publications of high modernism or those of the even higher, you might say stratospheric, ambitions of postmodernism [Wentworth Thompson (1942) 1968; Wiener 1948].

What is this "artificial life" that it should offer such relevance to where we are now? Let me use the words of Chris Langton, whose vision and energy have been instrumental in identifying the integration of a number of otherwise disparate scientific disciplines into this wholly new field of inquiry:

Originally published in *ISEA94: Proceedings of International Symposium for Electronic Art* (Helsinki: UIAH, 1994). This revised version appeared in *Artlink* (Adelaide) 16, nos. 2-3 (1996), and is reprinted with permission.

Only when we are able to view life-as-we-know-it in the larger context of life-as-it-could-be will we really understand the nature of the beast. Artificial Life (AL) is a relatively new field employing a synthetic approach to the study of life-as-it-could-be. It views life as a property of the organization of matter, rather than a property of the matter which is so organised. The "key" concept in AL is emergent behavior. Natural life merges out of the organized interactions of a great number of non living molecules, with no global controller responsible for the behavior of every part. Rather, every part is a behavior itself, and life is the behavior that emerges from out of all the local interactions among individual behaviors. It is this bottom-up, local determination of behavior that AL employs in its primary methodological approach to the generation of lifelike behaviors. [Langton 1989, 2]

Is it not this very "bottom-up, distributed, local determination of behavior" that precisely describes the art we practice, an art of connectivity and interactivity, mind-to-mind collaboration through computer-mediated telecommunications systems. An art in which the artist or author is a complex and often widely distributed system, in which both human and artificial cognition and perception play their part. An art that is emergent from a multiplicity of interactions in electronic space, the bottom-up process of creation replacing the classical top-down imposition of ideology or aesthetic. Let me remind you of the five defining features of our art—intrinsic to this bottom-up process—that so conspicuously differentiate it from the art of earlier eras:

connectivity: of part to part, person to person, mind to mind

immersion: into the whole, and the dissolution thereby of subject and ground

interaction: as the very form of art, such that art as the behaviour of forms has become art as a form of behaviour

transformation: perpetual flux of image, surface, and identity

emergence: the perpetual coming into being of meaning, matter, and mind

Artificial life will increasingly affect our thinking about the development of telematic culture and computer-mediated art practice, such that the place of education within our strategies for the advancement of creativity must urgently be revised. Our pedagogical practices in this context must reflect the increasing digitalisation of society and the grass-roots processes of environmental and political transformation that we are seeking to establish. In the networked, non-linear universes of discourse in which multimediated knowledge is dispersed, academic roles, if not reversed, are radically changed. Who does what, where, how, and why are all on the agenda. Traditional art education, at this point of

its terminal decline, has shown itself to have nothing to offer the demands of the emerging culture. Moreover, our current fascination with the theatre of the virtual has obscured the true destiny of virtual reality (VR). Its importance lies in its role not as a stage for the re-enactment of renaissance perspectives, but as a cultural phase space, the test-bed for all those ideas, structures, and behaviours that are emerging from our new relationship to the processes of evolution and growth, the challenge of artificial life. This, as Kevin Kelly has recently reminded us, is a two-way process: in as much as we promote the engineering of biological systems as extensions of technology, so, too, we apply the principles of biology to our technological systems [Kelly 1995].

The defining metaphor in art practice of *electronic flow*—which in recent years has replaced the aesthetic of the material object—is now giving way to the metaphor of *emergence*. Unbounded neural networks, in an infinite connectivity, dominate our imagination. The fuzziness they support well suits the instability of our cultural field. An instability we wish to celebrate. Nothing has become more unstable than the premises upon which teaching itself has been grounded, where truth has become relative, where reality is seen as the product of human negotiation and construction, and where the viewing subject, hitherto a passive observer of art, now negotiates and navigates what is largely a world of her own making. Instead of providing content and meaning, directing passion and pre-empting feeling, the artist now creates contexts and systems, within which the viewer is instrumental in manipulating his own universe of experience and insight. No wonder the old institution of art education is in tatters, its insolent subjectivity turned in upon itself, its adoration of the object enfeebled and derided. No amount of modularisation, bureaucratic modification, or curricular meddling can stem the attrition of the atelier. The students aren't there. They are half in school and half in cyberspace. They live between the virtual and the real. They are on the Internet more often than out of it. This is the advent of inter-reality (IR), the space we are all most likely to inhabit for the next many years.

(There are perhaps some thirty million people using the Internet as a whole. The Internet Society says there are now 3.2 million reachable machines on the Internet, and 1 million new hosts were added during the first six months of 1994, this in more than 80 countries.)

Of course, being a student, or at any rate learning, spending much of your time seeking information, making conceptual connections, and acquiring cognitive skills is no longer limited to the traditional demographically convenient 18-to-23 age group. Everybody wants to learn now, and more and more people

are finding their own ways to do so. Many universities are largely indifferent to the telematic culture and will therefore be the last place anyone is going to turn to. While they are right to spurn such institutions, which they see as tombs of irrelevance, tarnished ivory towers, there is a danger that this thirst for learning, this desire to connect in wider communities of mind will be satisfied by others even less qualified to do so. The danger can simply be summed up as a shift from the world of learning, research, and creativity to the opportunistic corporate world of commerce and business. Of course, it is now often said that all too many universities and academies have themselves become big business, where the financial bottom line frequently replaces all questions of imagination, excellence, and insight. But I have no doubt that the big corporations are turning their attention to global education as the next big market. This was made public by a number of leading figures in the media and communications industries speaking at the Seybold Digital World Conference in Los Angeles (June 1994).

There are 5 billion adults in the world seeking education in one form or another. That form will predominantly be on-line. CD-ROM is migrating to big disks at a server near you. But just as the future of education lies in the function of integrated multimedia telecommunication services, so that future could be solely in the hands of big business, which simply sees "content" as the "value-added" component it has to include to get "market share." You can easily foresee a completely crazy take-over of education by these commercial telecommunications industries unless we can provide models of on-line collaborative creativity and learning whose originality, effectiveness, and appeal outshine the more cynical manipulations of the market.

Many political, technological, scientific, and artistic agendas are beginning to merge into multilayered, multicultural, transdisciplinary creative environments. Not without pressure in some cases, pain in others. The inertia of the university structure often defeats the energy of its most enterprising staff to bring art and science, or technology and poetry, together. But the eventual telematisation of learning and digitalisation of creativity is not in doubt.

I believe that the learning organism most suited to our needs, our technologies, and our consciousness is taking root within the Internet itself.

In calling this emergent organism the Planetary Collegium, I want to invoke the sense of a global community in which each member has more or less equal power and authority both in access to knowledge and in the means of its reconfiguration and distribution; a community concerned with art and the advancement of learning through collaborative inquiry and shared experience. It

is a Collegium that will, by definition, be non-hierarchical, non-linear, and intrinsically interactive; a gathering together, a connecting, an integration of art, people, and ideas. Combining cognition and connectivity, what better creative learning organism could serve our unfolding telematic culture. Such an organism cannot be planned and implemented top-down. It is already emerging, bottom-up from the infinity of interactions within the Internet. We need to cultivate this new organism as it emerges, to feed it, support it, nourish it.

Such a Planetary Collegium would be a paradigm of the twenty-first-century interversity. Its birth is chaotic, informal, even random. Chaos, or non-linearity, has the effect that tiny changes in the initial conditions of a system create massive differences at later stages. This will certainly be so in the World Wide Web of telematic systems. No one can foresee the eventual outcomes of thousands of minds interacting so intimately all over the planet.

Of course, the very thought of a digital artistic culture fills many people in art education with terror, especially among those who pull its strings. But the entry of the academy into cyberspace need not be traumatic. Education at its best is always a matter of opening doors, discovering new perspectives, making the invisible visible. Eventually, however, what we, as a more or less minority group, a terrorist group even, understand today to be necessary and inevitable, will tomorrow become widespread in the art educational establishment. That may just be too late. The bird will have flown; the students, the new extended learning public will have moved away from the very notion of a fixed academy, of art education in a box. They will instead be nomads of the Internet, navigators of the data seas. If the context of creativity is to be a shifting context, if everything is culturally in flux, if there is world-wide media flow, if all our hypotheses (both scientific and artistic) are transient hypotheses, then the essential medium for such creative connectivity is the network.

In ways that have been both inhibiting and mystifying, the computer has been treated as a kind of magic wand in the art school, a means of extending past practices, supplying a range of chic appliances—the electronic paintbrush, the digital notebook, the handy word processor. It has generally not been understood as environment. In electronic space, the old artistic canons no longer apply, the old values and criteria collapse. The aesthetics of composition, completion, and finality of form and meaning are wholly and irreversibly redundant. Art education in the era of digital systems, if it is to exist at all, has to be reconstructed from the bottom up. This can only be done with the full assistance of those most in tune with the new culture, those for whom there is no surprise in communicating with a whole galaxy of disembodied personalities and

minds; for whom the inevitabilities of linear narrative are grossly tedious and torpid; for whom "edutainment" and "infotainment" are generic rather than hybrid; for whom any medium that is bounded, discrete, and unconnected to other media is grotesquely inadequate to interface with the complexities and dynamism of their experience; for whom chaos is a form of coherence. That is the very generation the art school desperately wishes to attract. The tables have turned. In most cases, students should be recruited to the academy to teach the teachers.

Similarly, the tools are changing. While the printed book will continue to be employed, the question becomes how and for what purpose, since it is clear that hypermedia is in many areas set to replace it. The book has come to be the embodiment of authority and its obsolescence as a primary academic tool will cause considerable problems in the academic world. The book is a medium that is fixed and frozen, while interactive media are fluid. Postmodernism, with its relativist doctrine of layered realities and the slippage of codes, has prepared us for the shifting uncertainties of authority, indeed of authorship and ownership of ideas, whatever they might constitute, either in science or in art. But the scripting, negotiation, and critical evaluation of hypertext present demands for revolutionary pedagogical change.

Four new ways of being and doing, I would suggest, are arising within our telematic culture and will contribute to our conception of a planetary collegium:

Telenoia: computer-mediated, distributed mind-at-large: asynchronous global connectivity. Not paranoia!

Cyber-estate: the interfaces, networks, circuits and sensors of telematic educational structures. Not real estate!

Inter-Reality: a fuzzy state between the virtual and the real in which our everyday social, cultural and educational interactions take place. IR is located between VR, AL, and natural systems. Not phoney reality!

Cyberception: emergent human faculty of technologically augmented perception/conception. Not natural deception!

The interim question is how, given the market pressures and the challenge of on-line services, the academy as we know it now is going to react. It could simply go "open university" and join the interactive TV lobby, devolving ultimately to a set-top box, a TV operating system, an on-line look and listen machine, video on demand, with a few optional buttons. It is not difficult to see that the traditional institutions could easily become ghettos of mandarin refinement if

they do not undergo fundamental redescription and restructuring. What students need now is not so much intensity of instruction as ease of navigation in the knowledge fields. The bit stream is replacing the structured discourse. Being on-line to a critical community can be more rewarding than being in line for infrequent and brief face-to-face tutorials. The dissolution of the university as real estate will not occur overnight. University investment in cyber-estate is only just beginning. But our plans as educationalists must be anticipatory. We need to show our administrators the way culture is moving and the speed with which it is getting there.

What will be the consequences for art and for education when the digital image is no longer box-dependent? When we no longer have to sit up and beg for information with a typewriter keyboard and TV set? When whole walls of buildings inside and out can be digitally flooded with sound, colour, and light, images and texts flowing in endless transformations, when whole environments respond to our body movements and the articulations of our voices? When the printed page no longer regiments our thinking into orderly rows of linear data? If the poets, artists, and musicians of the world are not ready with strategies to effect this environmental and ecological digitalisation, the politicians, merchants, and entrepreneurs will. In this context, art schools have a clear necessity to put up or shut down.

The curriculum must be highly mobile, transient, emergent. This is not a time for prescription, but I would like, by way of illustration, to point to some elements in the mapping of a telematic consciousness to which a transient curriculum might contribute:

While reading Francisco Varela, Evan Thompson, and Eleanor Rosch's book *The Embodied Mind* [(1991) 1993] and Barbara Maria Stafford's *Body Criticism* [1991], which I would characterise as the two poles—radical constructivism and non-linguistic representation—between which our electronic arts can be calibrated, I encountered a new text, *The Muse in the Machine,* by David Gelernter [1994]. Varela brings the Buddhist concept of the non-unified, decentralised self to our emergent, distributed telematic culture and to our sense of self-creation; the view that cognition has no ground beyond its history of embodiment, seeing the mind as an emergent and autonomous network, rather than an information-processing input-output device. "Structural coupling," mutuality between ourselves and environment, has important implications for the evolution of our "interactive art," just as Stafford's "aesthetics of almost" usefully proffers a perceptual and affective model of knowing.

For me, Gelernter can be usefully triangulated with Varela and Stafford be-

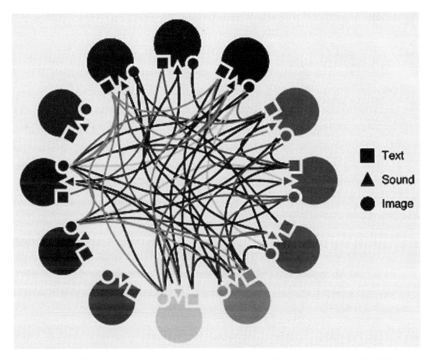

Text
Sound
Image

Figure 40. *Cognitive Map.* 1996. Digital image designed by Ascott as an interface for the Web-based project "Identity in Cyberspace." Sponsored by the Commission of European Communities. Ascott created this pilot program of the European Cyberspace Collegium, which included artist groups based in Dublin (ARTHOUSE), Barcelona (CEDIM), and Newport, Wales (CAiiA).

arts — sciences

cause of his project to build a spiritual computer. An emotional computer. Gelernter has valuable things to say about computers and creative thought. "A computer that can't feel can't think," he argues. His new book speaks our language. He "rejects the traditional academic subject divisions" and feels "especially at home in the no man's land between art and science." Professor Stafford must feel the same, navigating between aesthetics and medicine to chart the emergent revolution in seeing and imaging. Equally, Francisco Varela is not fettered by academic boundaries and roams over an extensive cultural terrain, combining neuroscience with Buddhist theory and speaking to issues in art as much as in society.

Finally, the quality of coming-into-being, of apparition, is replacing the quality of representation, of appearance, which has for so long been the defining characteristic of Western art. It's not simply that many colleges are haunted by the ghosts of culture past, but that apparitions of the future are emerging on

for "Haunting"

every screen, in every network. These apparitions are the constructions of dis-
tributed mind, the coming-into-being of new forms of human presence, half-
real, half-virtual, new forms of social relationships, realised in telepresence, set
in cyberspace. They are challenging the old discarded forms of representation
and hermeneutics, which still haunt the lecture halls. The students are begin-
ning to treat the university as an interface to inter-reality, as a doorway to a
radical constructivism, a way into building their own world. They are begin-
ning to understand that there are no more finalities. This applies as much to
our own identities as to configurations of the world. Art has a place in this cul-
tural reformation. It can bring new values and new understandings of our post-
biological condition and assist in defining the new responsibilities we carry for
our own bionic evolution.

In art education, we cannot turn (yet again!) to the industrialised materiality
of the Bauhaus. Klee, Schlemmer, and Gropius, for all their ingenuity and charm,
cannot sustain us any more. The twentieth century is passing. New practices
are forming, new values have to be forged. The Planetary Collegium may be-
come the matrix from which these transformations can emerge.

THE ARCHITECTURE OF CYBERCEPTION

1994 ■ **CYBERCEPTION**

Not only are we changing radically, body and mind, but we are becoming actively involved in our own transformation. And it's not just a matter of the prosthetics of implant organs, add-on limbs or surgical face-fixing, however necessary and beneficial such technologies of the body may be. It's a matter of consciousness. We are acquiring new faculties and a new understanding of human presence. To inhabit both the real and virtual worlds at one and the same time, and to be both here and potentially everywhere else at the same time, is giving us a new sense of self, new ways of thinking and perceiving that extend what we have believed to be our natural, genetic capabilities. In fact, the old debate about artificial and natural is no longer relevant. We are only interested in what can be made of ourselves, not what made us. As for the sanctity of the individual, well, we are now each of us made up of many individuals, a set of selves. Actually, the sense of the individual is giving way to the sense of the interface. Our consciousness allows us the fuzzy edge on identity, hovering between inside and outside every kind of definition of what it is to be a human being that we might come up with. We are all interface. We are computer-mediated and computer-enhanced. These new ways of conceptualising and perceiving reality involve more than simply some sort of quantitative change in how we see, think, and act in the world. They constitute a qualitative change in our being, a whole new faculty, the post-biological faculty of "cyberception."

Cyberception involves a convergence of conceptual and perceptual processes in which the connectivity of telematic networks

Paper first presented at ISEA94 in Helsinki and originally published in *Leonardo Electronic Almanac* 2 (1994). Reprinted by permission of MIT Press.

plays a formative role. Perception is the awareness of the elements of environment through physical sensation. The cybernet, the sum of all the interactive computer-mediated systems and telematic networks in the world, is part of our sensory apparatus. It redefines our individual body, just as it connects all our bodies into a planetary whole. Perception is physical sensation interpreted in the light of experience. Experience is now telematically shared: computerised telecommunications technology enables us to shift in and out of one another's consciousnesses and telepresences within the global media flow. By "conception," we mean, among other things, the process of originating, forming, or understanding ideas. Ideas come from the interactions and negotiations of minds. Once locked socially and philosophically into the solitary body, minds now float free in telematic space. We are looking at the augmentation of our capacity to think and conceptualise, and the extension and refinement of our senses: to conceptualise more richly and to perceive more fully both inside and beyond our former limitations of seeing, thinking, and constructing. The cybernet is the sum of all those artificial systems of probing, communicating, remembering, and constructing that data processing, satellite links, remote sensing, and tele-robotics variously serve in the enhancement of our being.

Cyberception heightens transpersonal experience and is the defining behaviour of a transpersonal art. Cyberception involves transpersonal technology, the technology of communicating, sharing, and collaborating, the technology that enables us to transform our selves, transfer our thoughts, and transcend the limitations of our bodies. Transpersonal experience gives us insight into the interconnectedness of all things, the permeability and instability of boundaries, the lack of distinction between part and whole, foreground and background, context and content. Transpersonal technology is the technology of networks, hypermedia, and cyberspace.

Cyberception gives us access to the holomatic media of the cybernet. The holomatic principle is that each individual interface to the net is an aspect of a telematic unity: to be in or at any one interface is to be in the virtual presence of all the other interfaces throughout the network. This is so because all the data flowing through any access node of a network are equally and at the same time held in the memory of that network: they can be accessed at any other interface through cable or satellite links, from any part of the planet, at any time of day or night.

It is cyberception that enables us to perceive the apparitions of cyberspace, the coming into being of their virtual presence. It is through cyberception that we can apprehend the processes of emergence in nature, the media flow, the in-

visible forces and fields of our many realities. We cyberceive transformative re-
lationships and connectivity as immaterial process just as palpably and imme-
diately as we commonly perceive material objects in material locations. If, as
many would hold, the project of art in the twentieth century has been to make
the invisible visible, it is our growing faculty of cyberception that is providing
us with X-ray vision and the optics of outer space. And when, for example, the
space probe *Cassini* reaches the dense nitrogen atmosphere of Saturn's satellite
Titan, it will be our eyes and minds that are there, our cyberception that will
be testing and measuring its unknown surface.

The cybernet is also the agent of realisation and construction, embracing a
multiplicity of electronic pathways to robotic systems, intelligent environments,
and artificial organisms. And in so far as we create and inhabit parallel worlds
and open up divergent event trajectories, cyberception may enable us to become
simultaneously conscious of them all, or at least to zap at will across multiple
universes. The transpersonal technologies of telepresence, global networking,
and cyberspace may be stimulating and re-activating parts of the apparatus of
a consciousness long forgotten and made obsolete by a mechanistic worldview
of cogs and wheels. Cyberception may mean an awakening of our latent psy-
chic powers, our capacity to be out of body or in mind-to-mind symbiosis with
others.

So what differentiates cyberception from perception and conception? It's not
just the extension of intelligence promised by Cal Tech's silicon neurons, the
implications of the molecular computer, or the consequences of Bell AT&T's
electro-optic integrated circuit that will compute in one billionth of a second.
The answer lies in our new understanding of pattern, of seeing the whole, of
flowing with the rhythms of process and system. Hitherto, we have thought and
seen things in a linear manner, one thing after another, one thing hidden be-
hind another, leading to this or that finality, and along the way dividing the world
up into categories and classes of things: objects with impermeable boundaries,
surfaces with impenetrable interiors, superficial simplicities of vision that ig-
nored the infinite complexities. But cyberception means getting a sense of a
whole, acquiring a bird's-eye view of events, the astronaut's view of the earth,
the cybernaut's view of systems. It's a matter of high-speed feedback, access to
massive databases, interaction with a multiplicity of minds, seeing with a thou-
sand eyes, hearing the earth's most silent whispers, reaching into the enormity
of space, even to the edge of time. Cyberception is the antithesis of tunnel vi-
sion or linear thought. It is an all-at-once perception of a multiplicity of view-
points, an extension in all dimensions of associative thought, a recognition of

the transience of all hypotheses, the relativity of all knowledge, the impermanence of all perception. It is cyberception that allows us to interact fully with the flux and fuzz of life, to read the *Book of Changes*, to follow the Tao. In this, cyberception is not so much a new faculty as a revived faculty. It is us finding ourselves again, after the human waste and loss of the age of reason, the age of certainty, determinism, and absolute values. The age of appearance.

Cyberception defines an important aspect of the new human being whose emergence is further accelerated by our advances in genetic engineering and post-biological modelling. The originating of a life, biological conception, should now also be called post-biological cyberception, since the decision to initiate and process the birth of children is shifting from the so-called imperatives and constraints of "nature" to the will and desire of individuals, in consort with new technologies and regardless of their age or sexual performance.

We are at the dawn, not just of a new body, but of a new consciousness, which in turn will demand a wholly new environment, massive urban transformation, a reconsideration of every aspect of the zones of living. Cyberception impels us to a redefinition of how we live together and where we live together. In this process, we must start to re-evaluate the material matrix and cultural instrument of society that we have for so long taken for granted: the city.

▬ CITY

The problem with Western architecture is that it is too much concerned with surfaces and structures and too little concerned with living systems. There is no biology of building, simply the physics of space. What we might call the "edificial" look is all. The city is seen as a battle zone in which this or that architectural genre or idiomatic impulse fights to survive. It's a matter of relative inertia, the classicists wishing to protect the total inertia, political and cultural, of a stylistic past, and the modernists protecting the privileged inertia of a stylised present. No one is interested in radical change or intimations of the future. Edificial images, superficial surfaces, define the contemporary city. But to its everyday users, a city is not just a pretty façade. It's a zone of negotiation made up of a multitude of networks and systems. What are needed are designers of such spaces who can provide forms of access that are not only direct and transparent but enrich the city's everyday business and everyday transactions. The language of access to these processes of communication, production, and transformation is more concerned with systems interfaces and network nodes than with traditional architectural discourse. And, without the fundamental under-

standing on the part of planners and designers of the human faculty of cyber-ception and its implications for transactional behaviour, cities will remain the arid and unwelcoming tracts of modernist glass and concrete or tacky post-modernist folly that we are generally forced to endure. We need to reconcep-tualise the urban strategy, rethink architecture; we need bring into being the idea of zones of transformation, to accommodate the transpersonal technolo-gies that are shaping our global culture.

Cities support and embody the interactions of people, and the arts add value to such exchange. Today, it is predominantly electronic systems that facilitate our interaction and connectivity, and the art of today is based on such systems. Cities can be dynamic, evolving zones of transformation, just as interactive art itself is about transformation and change. And just as cities can offer rewarding complexities of buildings and streets to navigate, leading to surprises, delights, mysteries, and beauty, and are, at their best, about human dreams and human fulfilment, so interactive art urges you to navigate its many-layered multimedia realities. It invites you to immerse yourself in its cyberspace, to get on-line to its global networks. If it is through recent innovations in art and science that we have become aware of cyberception, it will be cyberception at the level of city planning and architecture that will lead us to the city of the twenty-first century. Art is no longer about appearance, and certainly not about represen-tation, but is concerned with apparition, the coming into being of what has never before been seen or heard or experienced.

Cities that are no more than a set of representations function badly. Their buildings may speak "hospital," "school," "library," but unless they articulate these meanings within integrated, cybernetic systems, they lie in their teeth. And too many buildings lie in their teeth. Their monuments, unless they invite the recreation of the past by means of interactive media, are no more than inert wit-nesses to the duplicity of official history.

Cities work best when they are constructed to empower their citizens to find fulfilment. Such urban aspirations call for the support of an art that is less con-cerned with representation and expression and more concerned with radical con-struction and imaginative realisation. This is the art that is presently emerging out of the fusion of new communications and computer media. It builds on the complexity and diversity of dreams and desires that our multicultural, multi-media world brings forth. Just as we call this art *interactive*, the enriching envi-ronment that our cities must become should be based on the same principles of interaction and connectivity.

The city in the twenty-first century must be anticipatory, futures-oriented,

working at the forward edge of contemporary culture, as an *agent* of cultural prosperity, and as a *cause* of profitable innovation, rather than simply as an *effect* of the art and products of a former time. It should be a test-bed for all that is new, not just in the arts but in entertainment, leisure, education, business, research, and production.

A city should offer its public the opportunity to share, to collaborate, and to participate in the processes of cultural evolution. Its many communities must have a stake in its future. For this reason, it must be transparent in its structures, its goals, and its systems of operation at all levels. Its infrastructure, like its architecture, must be both "intelligent" and publicly intelligible, comprising systems that react to us as much as we interact with them. The principle of rapid and effective feedback at all levels should be at the very heart of the city's development. This means high-speed data channels criss-crossing every nook and cranny of its urban complexities. Feedback should not only work but be seen to work. This is to talk about cyberception as fundamental to the quality of living in an advanced technological, post-biological society.

Just as architects must forget their concrete boxes and Disneyland decorations and attend to the design of everything that is invisible and immaterial in a city, so they must understand that planning must be developed in an evolutive space-time matrix that is not simply three-dimensional or confined to a continuous mapping of buildings, roads, and monuments. Instead, planning and designing must apply connectivity and interaction to four quite different zones: underground, street level, sky/sea, and cyberspace. Instead of the planner's talk of streets, alleyways, avenues and boulevards, we need to think of wormholes, to borrow a term from quantum physics, tunnelling between separate realities, real and virtual, at many levels, through many layers. Similarly, the paradigms and discoveries of artificial life science must be brought into play. The architect's new task is to fuse together material structures and cyberspace organisms into a new continuum. Architecture is the true test of our capacity to integrate the potential of the material world, the new consciousness, and virtual realities into humanly enriching zones and structures. In this enterprise, many traditional ideas must be jettisoned, ideas whose inherent instability was always implicit in the dichotomies by which they were expressed: urban/rural, city/country, artificial/natural, day/night, work/play, local/global. The boundaries of these ideas have shifted or eroded altogether.

The city as an amalgam of systems interfaces and communications nodes is likely to be much more supportive of creative lives and personal fulfilments than the grossly conceived and rigidly realised conurbations of the industrial age. In

place of their dense and intractable materiality, we can expect the environmental fluidity of faster-than-light pathways, intelligent surfaces and structures, and transformable habitations. The end of representation is nigh! Semiology is ceasing to underpin our structures. Buildings will *behave* in ways consistent with their announced function, rather than speaking their role by semiological implication. Appearance is giving way to apparition in art, and notions of unfolding, transformation, and coming into being are suffusing our culture. It will only be with the understanding that buildings must be planted and "grown" that architecture will flourish. It's a growbag culture that is needed, in which *seeding* replaces designing. Architectural practice should find its guiding metaphors in horticulture, rather than in warfare. Ultimately, we can perhaps talk about pollination and grafting.

Buildings, like cities, should grow. But without cyberception, the traditional architect and urbanist have no idea whatsoever of what we are proposing. To see that technology changes, that building methods, economies, and planning systems change, but to fail to recognise that human beings also are radically changing, is a grave error. Perhaps classes in consciousness and gardening should replace the study of classical orders and historical canons of style and genre that stultify architectural education!

Where is there a building, much less a city, that supports a cyberculture, that sees cyberception as central to human sense and sensibility? Where is there an urban space in which we can fully celebrate "telenoia," the product of networked consciousness, interactive awareness, thought at a distance, or "mind-at-large" (to use Gregory Bateson's term). Where is there an architectural school that is, as a whole, united body, *determined* to create the conditions for the proper evolution of a truly twenty-first-century city? Where in architecture and planning are connectivity and interaction taken as primary principles of the design process? The debate in architecture should not be a matter of either/or. Either classical or modern, either new or old, either idealistic or pragmatic, either functional or frivolous. Between idealism and pragmatism, between conception of the desired and perception of the possible, lie the evolutive initiatives of cyberception.

As a frustrated HyperCard programme might say, "Where is Home?" Where will we cybernauts of the turning millennium live? What is the nature of community and cohabitation in a telematic culture? How is cyberspacial transience to be accommodated? Where are those zones that we can cyberceive as beautiful and fulfilling? We inhabit material forms with psychic dimensions set in the limitless boundaries of cyberspace. We are networked to the universe,

our nervous systems are suffusing the cosmos. We navigate inner and outer space. We don't need buildings so much as we need ourselves to be built, or rebuilt from genetic foundations that we are rapidly re-evaluating and may soon restructure.

Perhaps the most radical challenge to the old ideas of architecture comes from the consequences of telepresence, the disseminated self. When human identity itself is undergoing transformation, the collaborative mind and the connected consciousness replacing the unitary mind and solitary consciousness of the old order of Western thought, architecture must look to new strategies if it is to bring useful ideas about living and interacting in the world. Telepresence is the province of the distributed self, of remote meetings in cyberspace, of on-line living. Telepresence means instant global interaction with a thousand communities, being in any one of them, or all of them, virtually at the same time. Telepresence defines the new human identity perhaps more than any other aspect of the repertoire of cyberculture.

Contemporary architecture and shopping have become more or less the same thing. Architecture, having turned its back on the need for radical responses to the realities of the teleself and distributed presence, constitutes little more than a shopping cart world of boxed packages, wheeled around the sterile zones of a mall culture. Each building is a prettified and packaged product, each component mail-ordered from a catalogue. The "have a good day" code of building practice has put the appeasement of tradition before collaboration with the future. But the need for an architecture of interfaces and nodes will not go away. We shall increasingly live in two worlds, the real and the virtual, and in many realities, both cultural and spiritual, regardless of the indifference of urban designers. These many worlds interconnect at many points. We are constantly on the move between them. In the creative zone, transience and transformation identify our way. Hi-tech chic and Bauhaus bluff will not fool our keen cyberception. Change must be radical. The new city, both in its visible immateriality and its invisible construction, will grow into a fruitful reality only if it is seeded with imagination and vision. It is artists who can become the sowers of these seeds, who can take the chances needed to allow new forms and features of the new city to grow. It is their cyberception that equips them with the global awareness and conceptual dexterity to re-see, rethink, and rebuild our world.

BACK TO NATURE II

Art and Technology in the Twenty-First Century

1995 It's well known that we have lost touch with nature. It is not so much that nature has retreated, or that we have dismissed it, destroyed it, or denied it. It is simply that the metaphors that it has long supported no longer hold. Nature is, of course, all metaphor: the good, the pure, the unadulterated, the whole. It speaks of innocence, a kind of blessed naiveté, as well as the wild, the unspoilt, and the instinctive. We should perhaps first agree that it has never as such existed, or that it has existed in different ways for different societies. It is the first virtual reality—in which the pure data of an undifferentiated wholeness are programmed, shaped, and categorised according to our language, fears, and desires. We have always placed it in opposition—to culture, the city, technology. Its strength has lain in this opposition, as much a refuge as a force. But now the binary opposition of town and country, for example, is disappearing. With the ubiquity of telematic networks, the city is no longer the necessary site of commerce, learning, or entertainment, while the advance of artificial systems of synthesis and replication in the biological sciences means that the country can no longer claim a hegemony of pure and authentic natural processes. The country was the environment within which or against which the city was set, but with high technology as the environment, neither country nor city can be distinguished as an object to be foregrounded or privileged. As we move into the twenty-first century, we shall need to create new metaphors to house the complex interacting systems of biological, technological, and social life that we are developing.

The shelf life of all metaphors, great and small, is limited, and nature seems to be past its "sell by" date. It has served us well in

This essay first appeared in *Convergence: The Journal of Research into New Media Technologies* 1, no. 1 (Spring 1995), and is reprinted with permission. An earlier, shorter version appeared in German as "Zurück zur (künstlichen) Natur," in *Kultur und Technik im 21. Jahrhundert*, ed. G. Kaiser, D. Matejovski, and J. Fedrowitz (Frankfurt: Campus Verlag, 1993), 341-55.

many respects. The ultimate appeal, for example, in questions of justice, to human behaviour, as in those of representation and figuration in the arts, has always been: *Is it natural?* Thus the popular icon of the visual culture of the epoch has been Van Gogh (a value to be measured in hard yen) and, for higher brows, Cézanne; both of whom we are reminded spent most of their time in the fields, *immersed* in nature. This scenario conveniently ignores Cézanne's comment that "all things, particularly in art, are *theory* developed and applied in contact with nature" [Cézanne 1941, 228]—an insight curiously parallel to which is found in the new physics, as exemplified in Werner Heisenberg's dictum that it is the experimental apparatus (which includes the observer's consciousness) that determines a particle's "natural" behaviour [Heisenberg 1958]. And it is from Cézanne that we first understood the consequences for painting of the artist's *mobile* viewpoint, his focus restlessly scanning a world in flux.

Nature—classical, pastoral, secret, god-given nature—has suffered considerably at the hands of physicists during the twentieth century, and molecular biologists have not given it much peace either. Science, whether reductionist or holistic, has irreversibly altered the common view of nature; on the one hand, tearing it up into little pieces, on the other, attempting to unify it into wholly new configurations. By the twenty-first century, it will be dead. Scientific inquiry, aided by advanced computing, imaging, and telemetry systems, is yielding up to us an entirely new kind of nature—its transformations of energy, its evolutive, emergent behaviours, its order in chaos, the birth and death of galaxies, molecular life, and quantum events, even mapping the movement of consciousness in our own brains—none of which is observable directly by the human eye, and none of which had previously been observed by human beings in the whole of recorded history. All of which presents a picture of nature quite unlike that "staged" for our viewing by Western artists and writers for the past five hundred years.

Contrary to the popular view of art's relationship to nature, it is these technological and computerised systems that are providing us with a threshold, an open *doorway* into the natural world; whereas landscape and figure painting— the faithfully realistic and naturalistic painting of Western culture—have kept us separated from it. Painting produced a cultural *membrane* that kept us distanced from the processes of nature (and nature is all process), thereby affecting our relationship to it on more than the purely aesthetic level. That membrane was the window, the proscenium arch within which the artist "staged" nature, framed it in a timeless immobility. In the search for "naturalism," the wonder is not that the camera obscura and optical machines of the seventeenth

and eighteenth centuries led to "naturalistic" photography and film in the nine-teenth century, but that artists failed for so long to respond in their painting to the dynamic processes of life revealed by the microscope, and so blindly pursued the representation of nature as a series of theatrical sets. Zacharias Jansenn's compound microscope was invented in 1590, but it was not until our own century that any serious attempts were made by artists to deal with nature as it is perceived below the immediate level of the senses, expressing "the invisible which moves and lives beneath the gross forms" as Umberto Boccioni put it.

Sir Kenneth Clark, one of the last apologists of the old order, rejected such artists, particularly Paul Klee, as having merely "refurnished their repertoire of forms from the laboratories [which] does not in any way compensate for the loss of intimacy and love with which it was possible to contemplate the old an-thropocentric nature. *Love of creation cannot really extend to the microbe*, nor to those spaces where the light which reaches our eyes has been travelling to meet us since before the beginning of man" [Clark (1953) 1979, 141; emphasis added]. While earlier, with the same patrician certainty, Bernard Berenson, in trying to account for the "living force" that he found in the painting of Giotto, asserted that "there must exist surely a *viaticum* which bears its possessor to our own hearts, across the wastes of time, some secret which Giotto possessed. . . . What is this life-conserving virtue—in what does it consist? The answer is brief—*in life itself*. If the artist can cunningly seize upon the spirit of life and emprison it in his paintings, his works . . . will live forever" [Berenson (1897) 1903, 32].

These two texts, sentimental and superstitious in turn, spoke for both the confusion and the desires of a culture at its turning point, in confronting the questions: how do we *realise* nature and *evoke* life, in what do they consist, how may they be re-created and transmitted? These questions of realisation, evocation, re-creation, and transmission remain those that we artists prioritise now, just as much as they drive research in the sciences. But the transformations in our models of the world and the accelerated increase on our technological powers of manipulation in recent years suggest that a cardinal question for artists in the twenty-first century will instead be, "What might nature *become?*" And as knowledge and perception are increasingly mediated by computer-based systems, the question "What is reality?" is being replaced by "How do we interact with a proliferation of separate realities?" We connectivists feel that the conceptual foundation for dealing with these questions in art is beginning to take shape, and that our work in *electronic space* today is properly preparing us to participate creatively in *molecular time* in the future, in the twenty-first-century return to nature.

How could it be that our inhabiting electronic space, communicating in electronic space, creating art in electronic space, can bring us back to nature? How is it that the most advanced technologies, electronic and molecular, the very epitome of the artificial, could bring us back to nature? For that is what I propose. I want to suggest that the logical outcome of our working in electronic space is to redefine our living in natural space. The logical outcome of the *immateriality* of the information society is the reinstatement in the twenty-first century of a natural *materiality*. I am not, of course, wanting to invoke the old metaphors of nature in this assertion, but seeking to identify the metaphors of a new nature, second-order nature, emergent nature, Nature II, a new creativity whose "engines of creation" will embrace artificial life. In his book *Engines of Creation* [1986], K. Eric Drexler gives a visionary and authoritative account of the consequences for " nature" of new technological developments, particularly of nanotechnology, the engineering of molecular computers that can self-assemble and replicate within human cells or build complex structures in outer space, which contains for artists some of the most radical implications since Norbert Wiener's *Cybernetics* [1948].

Wiener's ideas effectively led to the computer revolution, the information society, and telematic culture. It may very well be that Drexler's writing signals the stirrings of a twenty-first-century revolution, the *molecular revolution*, the first shots of which have already been fired with the synthesis of chemicals with internal moving parts, a prototype of the molecular machine that will lead us in a matter of decades to optical molecular computers that may make our present "electronic space" an obsolescent environment. But following Marshal McLuhan's idea that the content of a new medium is the medium that preceded it, the rear-view mirror effect, we telematic artists can be optimistic that the molecular society of tomorrow will realise *with ease* the ideas of telepresence, connectivity, distributed authorship, and interactivity that we are working with today. The difference will be that in addition to the processes of *virtualisation* that epitomise our current concerns, we shall see the emergence of new processes of *materialisation*. In this respect, it is an amusing aside to consider how psychic phenomena have previously been resorted to in order to satisfy the desire for transcendence that is now reflected in our attitude to new technology: table rapping and disembodied voices followed by radio; clairvoyance by TV; telepathy by telematics; remote viewing by remote sensing; out-of-body experiences by virtual reality (VR)—and now, coming soon to a séance near you, materialisation by nanotechnology.

Just as mid-century cybernetics led, in important ways, to the development

of AI (artificial intelligence), AL (artificial life), and IA (interactive art), so the course of cybernetics itself over the past fifty years provides a useful parallel to the evolution of our relationship with nature. Cybernetics, the study of control and communication in living and artificial systems, found itself inadequate to the study of such systems until it included the observer of a system *as a part of the system itself.* Thus was born second-order cybernetics, which recognised the boundaries around all its objects of study as being intrinsically fuzzy, permeable, uncertain, and transformable, and utterly dependent on the position, attitude, and intention of the observer involved in such study. This insight, applicable as much to the quantum level of experiment as to the social, cultural, or even aesthetic level of experience, redefines our relationship with nature, so that rather than being outsiders looking in on nature or antagonists opposed to nature, we become *participants* in the creative processes of nature. This means, of course, not an inert, passive, or genetically programmed participation but a conscious involvement in the evolution of those forms and emergent behaviours that we identify with life, and that, as our powers of intelligent collaboration and participation increase, will come to constitute the new nature: Nature II.

There is a superstition, theme of countless myths and legends, that such participation (or *intervention*—a far greater crime!) in the emergent behaviours of planetary life, certainly any attempt to synthesise life, to create new forms of life and intelligence, constitutes *hubris*, a sin against the gods! New life, new language, and new behaviour all constitute a new relationship to the cosmos— if this is hubris, then it is a sin that besets new religions and new movements in art as much as science and technology. Moreover, such innovation, such renewal of vision, such need to create the new, to invent the future, is at the same time profoundly traditional, as Maurizio Calvesi has pointed out with regard to the Italian futurists, whose manifestos in many respects previsioned today's interactive arts of intelligent systems. "The Futurist *hubris* of a radical *novitas* is the most traditional element of Futurism! Every Gnosis . . . , is obsessed with breaking away from the past, with rebelling against *traditum* . . . the Christian language reveals an unheard-of message which shocks and surprises man. . . . St. Iranaeus sums up this aspect of the gnostic mentality by saying it leads to an absolute *contrarietas et dissolutio praeteritorum* . . . this *contrarietas* [in futurist writing led to] *broken* time . . . the word liberated from the 'army' of syntax . . . a language that dissolves the past and burns the old, that frees the field ('Giiive me a brooom!' cries Marinetti) from the gods of death, paralysis and gravity" [Pontus Hultén 1986].

Broken time, the liberated text, the embrace of life, speed, anti-gravity—these

are themes from our own late twentieth-century physics, poststructuralist lin-
guistics, nanotechnology, space exploration. We now have the brooom in our
hands. But this is not hubris! Our development as a species towards playing an
increasingly direct part in the evolution of life and of consciousness grows out
of our increased connectivity with the processes of nature, both in conceptual
modelling and practical intervention. Second-order cybernetics and second-
order nature share in what can be called the *connectivist paradigm*, which holds
that everything is connected, everything interacts with and affects everything
else. It is an idea as old, as *traditional* as oriental religions and as new as the quan-
tum physics of David Bohm, John Stewart Bell, and Alain Aspect [see Herbert
1985]. This connectedness, this undivided wholeness, unmediated action-at-a-
distance, capable of transcending the laws of space and time with non-local in-
teraction, is reflected in the telematic environment of computer-mediated net-
works of data transfer, interactive videoconferencing, remote sensing, and
telerobotics, where communication can also in a sense be "non-local" and asyn-
chronous, although in different ways and with different outcomes. Equally, the
connectivist paradigm is at work in the modelling of human intelligence and
theorising about the mind. These explorations into the microstructure of cog-
nition, known as connectionism, parallel distributed processing, or neural net-
works, have developed out of a re-evaluation of some of the earliest ideas of cy-
bernetics, of neural nets [see Rumelhart et al. 1986] and the Perceptron,
rejecting the linear, symbolic systems of the old AI. They will lead to the mod-
elling of the complexities of many interconnected *physical* as well as cognitive
behaviours, ultimately, of multisensory systems and perhaps emotional mental
states also. The connectivist paradigm thus embraces both *connectionism* in sci-
ence and what it is appropriate to call *connectivism* in art.[1]

Within the systems metaphor, everything connects. The self is a complex sys-
tem that interconnects with all other systems in a way that renders the line be-
tween natural and artificial systems meaningless. We are all becoming, to a
greater or lesser extent, bionic. Drexler's account of the consequences of nano-
technology and Hans Moravec's vision of advanced robotics attest to this rap-
idly and radically evolving interdependency and connectedness of the natural
and artificial in our development [Moravec 1988]. Our prostheses not only am-
plify and extend the body and its five senses but also augment cognition and
memory and subtly transform the personality. The psyche is certainly affected
by interactions in the electronic space. Our relationship to time as well as space
is altered. We are learning to measure memory and experience in nanoseconds
as positron-emission tomography and other computer-aided systems show us

shimmering patterns of sensation shifting almost instantaneously across the brain's grid of tens of billions of nerve cells. Telematic communication systems and molecular engineering mean that nature and technology become inextricably linked. Just as space becomes "electronic," so time is becoming "molecular." Gilles Deleuze has recently returned us to Bergson's project concerning time and duration with reference to "the new lines, openings, traces, leaps, dynamisms, discovered by a molecular biology of the brain" [Deleuze 1988, 117]. I use the term "molecular time" to denote that bundle of meanings and interpretations of time provided in different but connected ways by cognitive science, neurobiology, computer science, and quantum physics, each of which recognises the variable rates, jumps, delays, phases, and reversals of time that exist both within our consciousness, in our interactions with artificial memory and intelligence, and in the world of quantum events.

As we move into the twenty-first century, the interface between ourselves and the outer environment (at best always a fuzzy boundary) is becoming increasingly digitalised. Our perception is increasingly computer-mediated; our information at the broad level of human affairs increasingly mediatised. We are less interested in representations of the world than in its virtualisation. We no longer tend to "encounter all things through a rigorous story line," which, as McLuhan has pointed out, is one of the penalties paid for literacy and a high visual culture [McLuhan and Parker 1968]. Linear systems, rigid causality, and analytical certitude have given way to a more playful interaction with non-linear systems, layered language, the navigation of meaning, heightening intuition, and self-creation. Connectivism, which calls for interactivity, reciprocity, and negotiation in the act of communication, gives rise to the idea of *implicate meaning*, to adapt David Bohm's notion of implicate order. In telematic art, each quantum of meaning is many-layered, carrying within it a multiplicity of possible semantic trajectories, depending on the participating viewer, reader or listener.[2]

Thus while one feature of connectivism is the explosion of meaning into an infinity of fragments, each particle embodying the principle of implicate meaning (leading perhaps to the *semantic reseeding* of the planet with the new metaphors of life that we so urgently need), the material substrate of this new art is incorporating sound, image, text, structures, and movement in increasing synthesis. In the ratio of the senses, sound is perhaps coming to count for as much as image, auditory space is more pervasive than visual space, in the electronic present. Our visual focus is becoming more inclusive, as language becomes more inclusive, as we come to recognise the essentially *metaphoric* construction of our knowledge and interpretation of reality. We move increasingly

freely in the data space opened up by the computer-mediated systems of perception, modelling, and simulation that render the invisible visible.

Acoustic experience will become more focused as the environment becomes more intelligent and responsive to us. Once environments and their component parts (the buildings, furniture, vehicles, and tools with which we interact) can *intelligently* recognise the direction and intention of our gaze or the meaning in our voice, they may learn to talk back to us, to respond with verbal as well as visual information focused on our individual needs. Personalised interactive systems and services set in acoustic space, linking us within the continuum of sound to an essentially intelligent and responsive built environment, may replace the visual barrage of signs, signals, and messages that pollute the urban landscape.

There can be little doubt that databasing will also lead to new cultural behaviours, widely in the domain of home entertainment, if more narrowly with those involved in creative exploration. There are (in 1994) already in the world some 4,500 distinct databases available through 650 real-time information services. Increasingly, streams of personal or collective memories, dreams, and speculations will feed into this ocean of data. Networking with these vast resources of image, text, and sound material will call for entirely new artistic strategies in the next century. Collaborative networking, interfacing in and out with the flux and flow of such data, rather than the attempt to construct the old form of artistic finalities will clearly be a dominant mode of artistic expression. But however we interact with the electronic and digital systems that now bind us to the world, until we master the technological problem of *internalising* the interface to such systems; that is, within our bodies, the cultural symbiosis that we seek will evade us. Nothing impedes the subtle integration of human, natural, and artificial systems more than the present crudity of our technological interfaces—whether keyboard, screen, or data suit or visor. Since the optical system is that part of the brain best understood by us at present, this presumably will be the site of our first forays into the bionic internalisation of the computer interface.

Telematic culture is leading us to new behaviours, new ways of relating to one another and to the planet, new metaphors and new values. Many of these behaviours, relationships, and metaphors are already formed, but we may not yet be able to recognise them readily or employ them effectively, since attitudes and values of the old culture linger within the sclerosis of protected institutions and practices. Post-institutional thought is needed urgently; new landscapes of learning and creativity must be constructed. Connectivity is a principle of life, and the telematisation of consciousness on the planet is carrying us all forward to another level of evolutionary development. Con-

sciousness itself is in question—our sense of presence in the world and our relationship to reality. The question is, which world and which reality? Therein lies the schizophrenia of our condition. Telematic systems of global networking in virtual realities allow us to be both here and elsewhere at the same time. Increasingly, over the coming years, we shall become familiar with dealing with others *and with ourselves* as virtual presences in virtual spaces. Here and not here. Here and there, telematically, often without our knowledge or awareness of where we are being encountered or by whom, at which interface or communications node. In this process, human presence becomes virtualised and the individual self is distributed; space becomes virtualised and place becomes distributed. Moreover, there is inherent in all the research that currently surrounds the sciences of mind, advanced AI, AL, molecular engineering, robotics, and complex systems, the potential for consciousness to evolve beyond the human organism, and to a degree that perhaps only silicon-based life could accommodate, in "entities as complex as ourselves, and eventually into something transcending everything we know—in whom we can take pride when they refer to themselves as our descendants" [Moravec 1988]. Art may come to constitute a form of mediation between human and post-human consciousness, just as, in past cultures, it has been used to mediate between mankind and the gods.

These ideas are seen by many people as threatening or confusing, but we artists using telematic media are exhilarated and inspired by this new existential potential, responding to it enthusiastically as an attribute of the human condition that has long been anticipated and keenly desired. These are ambitions that religions have sought to satisfy, and that parapsychology seeks to address: to be out of body, to transcend our physical limitations, to participate in mind at large, to be in a state of *virtual presence* beyond the constraints of Euclidian space and Newtonian time—or, to employ a less lofty set of metaphors—to swim, sail, snorkel, and surf in the limitless semantic sea! All of which recognises the self and human presence as ongoing dynamic processes rather than as a material finality.

Art has always concerned itself with human *presence*, by seeking to celebrate it, conserve it, invoke it, or mourn its passing. In religious art, it has been the presence of the gods; in classical art, of heroes and notables; in romantic art, the presence of the artist ; in abstract, non-figurative art, the presence of presence itself. In the art of the telematic culture, set in electronic space, we artists are no longer concerned either with magic or representation, but with virtualisation, our presence distributed across the connection matrix, which may be any one or more of a variety of telematic systems.

This question of the transformation of the self within electronic space and molecular time—that is to say, in the context of advanced telematics and nanotechnology—will dominate the art of the next century. The alteration in our individual understanding of body-mind is enormously accelerated in the electronic environment. In the old print culture, for example, the separation of books and mind, in questions of memory and information storage, was clear-cut. But with electronic technology, associative memory, once the privilege of the human mind alone, is now an attribute of computer systems. To think is more and more to interface with such systems. At the same time, the conceptual foundations of personal, individual, and original thought have been attacked by post-structuralist ideas of authorship and intertextuality.

There is no doubt that this is a critical period for art. The confusions and contradictions of postmodernism alone attest to the reactionary and arid banality of much contemporary production. This is not simply to say—although we connectivists think that the description is accurate—that a great deal of art involving computers is little more than a replay of older art forms: a kind of digital conversion of video, film, painting, sculpture, even the book. Nor is it to ignore the massive *technical* achievements in image synthesis, animation, and simulation. But this work is not connectivist in its attitudes, and it is not telematic in its use of media. The computer is still too much *contained*, finitely *located*, isolated as a black box, as a clever screen, or as an instrument, and until it is released, let loose in the world, into *nature*, into essentially living systems, the new art form's future will not emerge. The spirit of connectivity has been released by the ubiquity of computer communications systems, but until the capacity for *intelligent* response and creative collaboration lies within the environment in all its parts, the connectivists' dream of planetary transformation will not be realised.

At present, we are in a kind of cultural holding pattern. The computer screen is no more than an interim contrivance: it allows us to *model* possibilities, just as VR allows us to *model* scenarios and test them out in virtual conditions. But think of the Hollywood movie *Ghost* (1990), in which a "passed over" personality is projected into another *organic agency*, in this case a "sensitive"—a psychic medium. Its success as a movie lay in the fact that it tapped into precisely the contemporary consciousness of *personality transfer*, our contemporary understanding of mental acts as patterns of behaviour in virtual machines, the wetware that drives the body hardware. Patterns of cognitive organisation that we feel could be transferred between organisms, between machines. Patterns of ourselves that could be transferred across the networks. We cannot overestimate

the potency of the image of the hacker, Case, the protagonist of William Gibson's *Neuromancer*, jacked into a custom cyberspace deck that "projected his disembodied consciousness into the consensual hallucination that is the matrix" [Gibson 1984].

Another important aspect of the connectivist paradigm is to be found in the ideas of Rupert Sheldrake, specifically his concept of a "morphic resonance" by means of which

> the form of a system, including its characteristic internal structure and vibration frequencies, becomes *present* to a subsequent system with a similar form. Analogous to the sympathetic vibration of stretched strings in response to appropriate sound waves, or the tuning of radio sets to the frequency of sound waves given out by transmitters . . . morphic resonance takes place between vibrating systems (note that in the body, including the brain, all our parts are in ceaseless oscillation). Morphic resonance takes place through morphogenetic fields. Not only does a specific field influence the form of a system, but also the form of this system influences the field. [Sheldrake 1981]

Twenty-first century connectivists will want to tap into these morphogenetic fields, to influence the resonance of these vibrating systems. Sheldrake's is a science of metaphor, anti-reductionist, holistic, and intuitive. Like James Lovelock's Gaia hypothesis of an organic, self-regulating planet [Lovelock 1979], morphic resonance offers a vision of reciprocity and connectivity in the world to which the telematic art of our time aspires. Personality transfer, idea transfer, telepresence, the creation remotely, through distributed authorship, of images, forms, sound, and movement in totally synthesised ensembles, the *virtual* realisation of concepts that address the unknown and the hitherto unknowable, that make the invisible visible, that can inhabit *intelligent* systems, that can come into the world in the form of an open-ended, transformable, interactive, responsive, *organic materiality*—that is the prospectus for art in the next century.

This rematerialization of art, this creativity involving natural systems with artificial life, will come about as a convergence of the two apparently divergent trajectories of contemporary technology: the one essentially electronic, concerning computerised perception and intelligence, virtualisation, telematic communication; the other biological, involving nanotechnology, molecular engineering, the organisation of matter and emergent behaviour. A marriage of the immaterial and the material leading to a transcendence over the gross materiality of "natural," unmediated life. Put simply, for the connectivist, this is a question of creating an interactive art of intelligent systems set within intelligent environments. The early twenty-first century may see some success in this en-

deavour. We shall then have moved beyond the information society, beyond the frontier of electronic space, back to nature—but to a nature radically revised—an holistic environment of mind and matter, as much spiritual as material, in which "natural" transformations of nature take their place with our conscious participation and collaboration within a culture of creative complexity.

None of this, however, can be achieved in cultural isolation. Artists must reach out to those scientific and technological disciplines that speak a similar language. In neural networks, we certainly find one such discipline, and nanotechnology as it develops will undoubtedly be another. A whole new field of bio-telematics waits to be created, a whole new field of art is preparing to participate in its emergence. We can at this time feel a special resonance with the metaphors and aspirations of artificial life. Here we see a concern with

> *life-as-we-know-it* in the larger context of *life-as-it-could-be*. It views life as a property of the *organisation* of matter, rather than as a property of the matter which is organised. . . . The key concept in AL is *emergent behavior*. Natural life emerges out of the organized interaction of a great number of non living molecules, with no global controller responsible for the behavior of every part. Rather, every part is a behav*ior* itself, and life is the behav*ior* that emerges from all of the local interactions among individual behav*iors*. It is this bottom-up, distributed, local determination of behavior that AL employs in its primary methodological approach to the generation of lifelike behaviors. [Langton 1989]

For "life," read "art"! By replacing the word "life" with the word "art" in the above passage, we can see the parallelism between AL and IA. Telematic culture shares this bottom-up, distributed, local determination of its art, with no global controller responsible for the behaviour of every part.

Whilst it is often true that life imitates art, we have here a situation in which art in the twenty-first century may very well come to parallel in important ways the aspirations of artificial life. This convergence set in electronic space and molecular time may well point us to a path leading back to nature, the sequel to nature . . . Nature II.

NOTES

1 As I note in "Telenoia" (chapter 19 above), the term "connectivism" suggests yet another "ism," another art movement for the history books. We know that this is not so. Art within the telematic culture is so fundamentally different from the art of the past as to constitute an entirely new *field* of creative endeavour. That is why many of us involved in this field think it would be best if a new word could be found

to describe it. The term "art" is too heavy with the meanings given to it by both romanticism and classicism, as well as, of course, by modernism, and too deeply embedded in the notion of the individual creator and the reactive rather than interactive viewer, for us to feel properly represented by it. It's not that we think we have redefined art in its totality or that the art with its roots in those earlier orders is no longer practised with vigor and with contemporary relevance. Only society can determine that. But we feel that we cannot go on much longer having to define our terms every time we engage in conversation about art, to make it plain that it is *this* art, the art of interactivity and of intelligent systems, that we are discussing; not *that* art, the art of established orthodoxies and practices. So it may be useful for a while to avoid using the term "art" as far as possible in these circumstances, and to use the term "connectivism" when we are referring to telematic art practice. All art practice involving computer-mediated systems and electronic media of whatever complexion is by definition telematic, thus all artists engaged in the field are connectivists.

2 We might want to call this the "many meanings" hypothesis in complementarity to Hugh Everett's "many worlds" interpretation of quantum mechanics—the observer as participant generating a rich profusion of parallel worlds/parallel meanings. See DeWitt and Graham 1973.

THE MIND OF THE MUSEUM

1996 In the past few weeks I have been both in Linz, where the Ars Elec-
tronica Center, a digital museum of the twenty-first century, is now
up and functioning, and to Tokyo, where the NTT InterCommu-
nication Center is about ready to move in its machines and install
its systems. I had a hand in the design of the former and am involved
in a number of ways with the evolution of the latter. I know them
both to be state-of-the-art, and, in their different ways, as advanced
as a contemporary digital museum could be. But I would like here
to set the debate on the museum ahead by a few years, to sketch out
the scenario for the future—what I believe to be the very near fu-
ture. Those few years may give us the critical distance to begin to
rethink the museum as it might be engendered in the first decades
of the twenty-first century. There's a pragmatic as well as a vision-
ary reason for this. Museums, of whatever complexion, require seven
or more years of gestation, an enormous investment of money, spe-
cialized effort, and political will. To build a museum that serves only
the present and has no anticipation of the future is foolish. I'd like
to be a little outrageous here and tell you I have seen the future—
and it's moist. It's where artificial life and artificial consciousness
meet our own wet biology and our telematic society of mind.

However, before I develop a post-museum scenario, I would like
to raise the question: what was the space of the museum before the
museum existed? I mean in the deep past. I presume it was the site
of collective memory; the site of celebration, even of hedonism; the
site of creative imagination, danger, and daring. The site of trans-
formation, especially spiritual transformation, played out in images
that transformed the body. Somewhere along the line, I believe, the

Keynote address for "The Total Museum: An Interactive Multimedia Conference" at
the Art Institute of Chicago, October 1996. Previously unpublished.

museum lost that heritage. It got to be exclusive, conservative, even cautious. It got to validate more than to value, to certify rather than embrace uncertainty. Not always and not everywhere. It went wrong when it adopted the values of the old industrial culture, a culture of exclusivity, compartmentalization, of the unified self, of anxiety, alienation, excessive individualism, privacy and secrecy, a society of paranoia. I hope here to evoke the new society, the society of connectivity, open-ended creativity, collaborative consciousness, which celebrates the very opposite of paranoia, what I call "telenoia," from the Greek roots *tēle*, "far off," and *nous*, "mind," or consciousness-at-large.

I want to talk about a museum that has a life of its own, that thinks for itself, that feeds itself, takes care of itself, anticipates and participates fully in the chaos and complexities of culture, that contributes constructively to the world in the exigencies of its paradigmatic transformation. I want to talk about a museum that is as much emotional as instrumental, as intuitive as ordered. I want to get inside the mind of the museum, and I want a museum that can get into my mind. I want a seamless interchange between the imagination and poetry of the individual artist's mind with the imagination and poetry of mind at large, the community of mind for which the Net, still primeval but powerfully emergent, is the substrate. I want my neural network to be synaptic with the artificial neural networks of the planet. As far as the museum is concerned, in this moment of its grave uncertainty and possible demise, I want a chip in my brain rather than a chip on my shoulder. The exploration of mind, both human and artificial, perhaps unmediated by visual forms and representation, seems to me to be the prospect for twenty-first-century culture. To put my cards on the table from the outset, I see the consequences of everything that has occurred in the art of this century, the strands of art based in technology and scientific metaphor, intertwining with the strands of art dedicated to the spiritual and to the conceptual, as preparing us for the emergence of what I call technoetic culture (*technē* + *noetic*, as I just defined it, concerning mind and consciousness). To use Gilles Deleuze's phrase (in his discussion of Nietzsche), the "game of images is over" [Deleuze 1983]; our concern now is with conceptual strategies, ideas and cognitive behaviour, and with the emergence of new consciousness.

The "museum" is now a more or less empty sign, at least in everything that concerns digital, interactive, immaterial as well as re-materialized (I mean artificial life–based), art. We could abandon the word with the concept it contained. Or at least relegate it to its own semiotic solipsism. Or we could attempt to recuperate the term, transforming it slightly to mark the shift in its provenance from the muse to the mind. I suppose it would trivialize my thesis to sug-

gest a change from museum to "mindeum." But, more seriously, to remain viable in the emerging technoetic culture, the museum must adopt the strategies of the human brain and adapt to the techno-evolution of the human brain. Rather than "educating" our perception, it must learn the cultural consequences of our newly acquired faculty of cyberception, the technologically amplified faculties of perception and cognition. In short, the museum must become intelligent, must get smart.

Please do not misunderstand me. I am not talking simply about "intelligent architecture," smart interfaces, responsive interiors, or interactive fixtures and fittings, as welcome as these features would be in the otherwise bland inertia of contemporary museum design. I am talking about the museum as a brain, richly embodying the associative thought of its own, very tangible cortex, what properly should be called its hypercortex, the cognitive nexus of all those ideas, forms, structures, and strategies that are generated in interspace, the associative cognition, the hyperlinks of a profound connectivity, that constitute the field of becoming between the virtual and the real that is our global domain.

Please also understand that I am appealing here to pragmatism rather than to metaphor. We are no longer in the realm of the dream and the analogy of great visionaries such as, say, Pierre Teilhard de Chardin and Gregory Bateson. The field of consciousness engendered by the intensive hyperconnectivity of minds on the Internet is now palpably a part of our reality.

We have to stop thinking *for* the museum and allow it to think for itself. We need to be less concerned with what it should be doing, what art it might contain, what policies it should embody, even what architectural form it should take, and concern ourselves with what art might emerge, what ideas might come into being, what forms might grow. It's not just that the model for the museum must be the model of the brain, although it is readily apparent that it shares with our own mentation the need to serve the functions of memory, thought, reality-building, non-linear narrative, consciousness, and dreaming. It is that we must apply all our thinking about the emergence of cognitive structures to the building of brains, specifically those selected for culture, actually to assist at the birth of artificial consciousness.

In this, we shall be reflecting the attitude and behaviour of the artist as she contemplates the emergence of a technoetic art. For the role of the artist is changing from active to passive, just as the role of the viewer changed from passive to active in interactive art. It is not, however, an inert passivity that the artist must adopt vis-à-vis the new forms and new meanings emerging from the internal hyperconnectivity of the Internet, but rather a dynamic, contained, Zen-

like awareness, or condition of preparedness. This emergent hyperconnectivity is no longer just between human minds but between our artificial agents, indeed between artificial life forms whose adaptive complexity can be expected to evolve into an artificial consciousness. It may well be that artistic process may be initiated by artificial agents and auto-constructed entities; they might become artistic identities, whether in silicon or in the moist terrain of artificial life as it integrates with our own wet biology.

Let me turn briefly to the question of the museum's role in the context of education. The debate concerning the museum's role in education is set between what the French pragmatically call *formation* and what Humberto Maturana and Francisco Varela call "autopoeisis" [Maturana and Varela (1987) 1992]. That is, on the one hand, an institution forming or shaping the consciousness and behaviour of its constituents—a process hidden in the English language by the euphemism "training"—and, on the other, self-creation, which involves as much the building of reality as the structuring of one's authentic identity, or, as I would say (invoking telepresence) ident*ities*. But more of that later. The reason that museums have in the past received such enormous support from both public and private funds is doubtless due to the efficacy of their ability to "form" rather than inform the viewer. And here I take issue with those who assert that the museum's function is simply to control information, since I believe that in truth it serves and has always served to control meaning, actually to assist in the dissemination of ideology, to shape consciousness. With some well known and outstanding exceptions, many education programmes are little more than cosmetic, serving only to obscure the deep processes of cultural control that are always at work in the semiology of [museum] architecture, the despotism of commission and omission of the paintings on the wall.

To echo the artist Myron Krueger's disenchantment with curatorial myopia concerning early interactive art, the same blind spot in the policy of museums has overlooked telematic art, art in the Net which has been with us for over a decade. Artists have been working with computer networks as their medium since at least 1980. But, effectively (and there are exceptions in the museum world, as in any other regime where the anxiety of demise leads to uncharacteristic charity), no museums then took up the responsibility to present this dynamic, living, emergent culture to their public. Meanwhile THE public, and actually the museum's future public—if, indeed, it is to have a future—was discovering games and gimmicks on its own PCs, just as, in recent years, it has found its way into the delirious disorder of the Internet.

The role that some museums have adopted as Johnny-come-lately, pretend-

ing that [a museum's] website can carry the voices of the artists rather than echo the ringing of its own cash registers, is not admirable. Listen, I'm waving not whinging. I'm signalling to the museum to wake up to the realities of cyborg life and telematic consciousness, to the advent of technoetic culture. Website design and postvideo production is not enough. Radical revision, visionary restructuring, is not just an option; it's the only survival strategy. The first kind of museum, where those with the leisure to do so could hang out with the muse, is past. What we might call museums of the second kind, where the materiality of art, in all its glorious and discrete objecthood, could be transposed into its virtual other, won't work. I'm talking about the museum of the third kind, where the close encounter of minds with minds, cortex to hypercortex, virtual with the actual, leads to interactivity at the level of the spirit. Some will cynically argue that it's in the nature of things that the museum of the old kind was always many steps behind the artist. Judgment, discernment, selection, rejection, sifting, and sorting takes time. Particularly if you have absolutely no idea what is going on, with no criteria, no values, no consensual base relevant to the new digital phenomena to make judgments from. Such are the despair, the delays, and the doubts that have overcome the museum in our relativistic culture.

Actually, it was long thought that for your average affluent middle-class punter, art was a more rewarding distraction, and even maybe more marginally uplifting and intellectually improving, than science. But in recent decades, especially with the advance of digital visualization techniques and new concepts of modelling, science is providing both entertainment of a high order and metaphors of great power to an increasingly large public. In art itself, art criticism and commentary has largely given way to a discourse concordant with scientific ideas. Who can doubt the value and, indeed, inspiration to artists involved with interactivity that the ideas of the early quantum physicists and, more recently, Charles Wheeler or David Bohm have provided. Of course, their ideas are scandalously metaphysical at heart. And, unlike the classical physicist, they are all heart. I mean, they have introduced subjectivity into science, which further implicates them in our own creative process. The threads of science and spirituality, technology and consciousness, are often so closely intertwined that clear differentiation of them is not possible.

From the ironic scientism and Taoist "indifference" of Marcel Duchamp to the engineering optimism and theosophical bias of the Russian constructivists and the technological dynamism and spiritual acuity of Umberto Boccioni, for example [see Coen 1988], there are few generative moments at the roots of twentieth-century art that do not celebrate the metaphors of science and tech-

nology, while also reaching for the spiritual in art. And although psychology could never pass for an exact science, even surrealism owed much to that discipline's cognitive precepts and prescriptions. What, after all, was Alfred Jarry's pataphysics [see, e.g., Jarry 1996] but a tangential distillation of all those yearnings? And now as technology itself increasingly aspires to the condition of biology, to bio-engineering and bio-electronics, so art involves itself with issues of emergence, evolution, the "growth of form" (to adapt D'Arcy Wentworth Thompson's phrase), and Madame Blavatsky's growth of consciousness.

Traditionally the plastic arts, with the complicity of the museum, directed us to the surface appearance of things and their representation, but our attention is now turned towards the invisible, to the generative processes of chaos and complexity, the coming into being of consciousness, the ways in which form and meaning can emerge. Thus, post-biological systems, the ubiquitous Net, intelligent architecture, and artificial life are significant elements in a new paradigm that opens up unprecedented pathways for development in art and science, as well as demanding new moral and ethical values for the kinds of worlds we can envisage and will eventually construct. Equally, they challenge the immutability of human identity, offering the prospect not only of personal transformation but of the distribution of the self. Our potential in cyberspace for telepresence— for being both here and there, in effect, everywhere simultaneously—coupled with our acquisition of a kind of teleprescience, the ability to anticipate faster and foresee further, means that we can both release and articulate the many inflections of self, indeed, the many co-existing selves, which the Western model of a unitary personality has for so long denied and prohibited.

In the world at large, the history of these changing attitudes lies more with developments in science and technology than in philosophy or political theory. But it is within the open-ended and creative framework of art, in alliance with digital systems and advanced technology, that new models of our post-biological behaviour can best be engendered and refined. Our cultural immersion in interactive, transformative systems and hyperlinked structures, set in virtual spaces, with world-wide connectivity, may lead to the next step—maybe a quantum leap—in our evolution. Increasingly, all fields of knowledge are becoming permeable as all systems connect. The paradox is that after the relentless materialism of the industrial age, it is now technology and science themselves that are foregrounding issues of consciousness, mind, and spirit, and it is in consort with a telematic and radically constructive art that, I believe, we shall see the emergence of a new culture. Now the museum, radically redefined and restructured, could assist in this process. But the simple conversion of real estate to the vir-

tual state will not do. The adaptation of the boxed-in museum space to the open nodal structures of the Internet is not easily achieved. In my view, rather than to adapt and convert museum buildings, we need to start over. This time, we shall not design and build the "museum" top-down but create a cultural and economic and social ecology in which it can grow bottom-up. What to do with the old museum? I think our only option is to *museumize* it itself. To put it in cultural parentheses, to put the museum, in other words, in the museum. To give it its place in history.

It's been over thirty years since Marshall McLuhan, contemplating the advent of electronic computer telecommunications, wrote: "[W]e are suddenly threatened with a liberation that taxes our inner resources of self-employment and imaginative participation in society. This would seem to be the fate that calls men to the role of artist in society. Men are suddenly nomadic gatherers of knowledge, nomadic as never before, informed as never before, free from fragmented specialism as never before—but also involved in the total social process as never before" [McLuhan 1964, 358]. The acceleration of these media over the intervening years, and especially since the turn of the 1990s, has been exponential, and the effects have been culturally explosive, not least in the area of art practice, and, above all, on the nature, status, and role of the gallery and the mediation of art. The implications and effects of all this find their realization in the territory of the Net. On-line artistic inter-production not only institutes and confirms a new cultural process but can be seen to prefigure a new kind of social process. The variety of attitudes, issues, and techniques involved in telematic art parallels the complexity and interrelationship of issues in contemporary life: political censorship, the ambiguities of telepresence, transcultural semiosis, the interpenetration of artistic modalities and notations, non-linear narrative, urban mythology, the new sense of self, and the variability of personal identity, all set within a truly global perspective in which the category limits between knowledge and play, science and subjectivity, and construction and emergence are triumphantly stretched and exceeded.

The website is a site of cultural compression, a sort of time hologram, in which any one part, approached at any one time from any one location, leads to all other parts in all other places: both interstitial and inter-sited. Here is to be found the redefined "gallery" or museum whose internal structure and order are "implicate." Implicate, in the sense that artists, the originators of each processive art line, continued to add and amplify their creations, to enfold and entwine them in denser and denser connections and associations, and implicate also in the sense of creating a potential for the unfolding of an infinity of trajectories,

according to the myriad interactions and interventions of the world-wide view-ing public. This is the very paradigm of a Net art gallery. Against the conven-tional sequencing of works on the wall that the traditional gallery would pro-vide, here we get a collection of deseriated works, whose order of viewing and interconnection, both semantically and experientially, is wholly open, observer-dependent, and interactive.

Social life is the concretisation of consciousness, and Net art is the product of the connectivity of minds before it is anything else. Noetic process precedes social process: in engaging with art in the Net, we are taking the first steps in a new way of being and a new way of ordering our experience and of shaping the world. It requires a new kind of perception, cyberception. Even the flow of time has to be reconsidered. Bandwidth alone (or its limitations) demands that we learn to access and interact at variable rates and speeds. I am reminded of Greg Egan's book *Permutation City*, in which virtual human copies have a "model-of-the-brain" that runs seventeen times slower than the real thing. Accessing is never that slow, but the bandwidth overload of busy periods can keep you hanging around, just as long queues can keep you from getting to see popular exhibitions in a conventional museum.

The delays of downloading can induce a trance state; the rhythms of down-loading, especially at a busy site, can become a mantra. The "time" of conscious-ness is never regular or continuous, and in telematic mind, this is particularly so. To bring the Net gallery into the world, a world that can only associate mean-ing with materiality, and thus museums with ownership, space with security, walls with certainty, is to demand radically new cultural behaviour and to initiate, how-ever tentatively, a new social process.

Is it too early to speak of spiritual journeys in Net space? Certainly, I engage in a noetic voyage as I navigate the Web. It is more than simply engaging with other artists' sound, images, movies, and messages; I enter their space of con-sciousness. Walter Benjamin was right about art's loss of aura in the age of me-chanical reproduction [Benjamin 1969]. But Benjamin had no intimation of the age of telematic production. Here the work of art does indeed have an aura, but it is the aura of noetic potentiality rather than heroic personality.

I cannot offer a critical analysis of art in the Net, so much as a kind of poet-ical analysis operating from an understanding that while art can be informed by ideology, much that is worthwhile in art lies beyond ideology, in what I would call the state of poetic emergence. There is no "absolute reality" to set ideol-ogy against, there is only poetic emergence, a semiotic coming into being out of the undifferentiated whole. The richness of art on the Internet is that while

many artists plant seeds of poetic indeterminacy, others seek to harvest the unforeseen creativity of its chaotic instability.

There I go again, flying off into hyperspace, recklessly speculating with irresponsible optimism! So let me get back to nuts and bolts, concrete and glass, and try to rethink the museum.

Let us start from the point of view that all is metaphor, that there is no ground of reality on which perceptions are based, or that is mediated by language; that, in short, we talk the world into being, that our descriptions are its becoming. The museum, then, harbours its metaphors of reality from a raging semantic sea. Its fragments of past realities (shards of pottery, bones of dinosaurs) and its authorized metaphors of truth and beauty (scientific models, paintings, sculpture) all claim privilege as true representations of the past (or past representations of the truth), sanitized metaphors of worldviews.

It is time to release the metaphors from their cages, to let loose upon the world these tight concentrations of hypotheses. We don't need museums; the world itself is constantly being museumized as we engage in language, scientific discourse, and philosophical debate. The realities and worlds we construct by means of metaphor are thus fixed, taken out of the flux of dynamic transformations that constitutes life, and folded back in their concreteness as specimens, objectified, whose province then is the past. In seeking to explode the museum out of its cultural fortress into the world at large, we should attempt to plant gardens of hypotheses and grow forests of metaphors, as real, physical sites to inhabit, as an alternative to the tenements of reason, squares of certainty, and office blocks of determinism that congest our cities. Since the world is all metaphor, let us build metaphors of alternative realities in the midst of our material environment. As the museum dematerialises, we might then see new metaphors of what it is to be human materialize all around us.

If, a century ago, Henri Bergson, philosopher of change and process, had been appointed director of French museums, our debate today would not take place, or at any rate would be of an entirely different nature. We would have had a century of musing on evidence of "becoming" rather than collections of artifacts of what has passed. As it is, Mickey Mouse has taken world leadership in conserving the archaeology of urban culture. Now Europe, home of the museum, benefits directly from the care and consideration of Messrs. D. Duck and M. Mouse, in privileging France with a Disneyland. Just as the old museum, with its formula of display cases and cabinets, pedestals and diorama, endlessly reproduced itself, colonizing the planet with its ideology of The Past, so Disneyland is everywhere now, in essence, in a state of franchise-readiness to re-

play myth and history. All it takes is a population of sixty million within a two- •
hour radius of a site, and it will be there.

It is not simply that the theme park has become the definitive twentieth-
century museum, but that the museum itself now aspires to the condition of a
micro-theme park, complete with gift shop, restaurant, guided tours, fancy light-
ing, gluts, and glamour. All of which simply masks the fact that the past cannot
be re-presented. In simulating the past, we simply create an alternative present.
In this process, simulation is more satisfying than representation, because it is
less arid, juicier, more engaging. Now, the theme of a park is not entirely irrel-
evant in the search for the redefinition of the museum. After all, it suggests not
only activity but all those ideas of radical constructivism in an art allied to
artificial life and wholesale participation in the creation of meanings. In place
of museums we need to re-plough and re-seed the ecology with new metaphors
and hypotheses, just as in the search for new forms and new structures, of both
behaviour and meaning, we need to set in motion adaptive complex systems and
engineer new genetic strategies.

But just as art in the past was thought to be concerned with authoring (the
one-way channelling of meaning), so museums saw their business as that of au-
thorizing (a one-way system of validating and valorising). The idea was not that
we might participate in creating our past but that The Past could teach us a
thing or two. There can be a moral insistence about the museum that is odious.
Museums have been not so much concerned with viewing as with viewpoints.
I foresee curatorial obsolescence: we don't need our histories or our cultures to
be shaped by others, which is to say that we do not need history unless it fur-
nishes us with a present. History is a medium not a message. In using the
medium, we create our own content.

In so far as official art has been concerned with controlling meaning (and there
is surely little else it has ever been concerned with, since beauty and even dec-
oration have never been semantically innocent, value-free or without significant
form—every canvas, mural and architectural ornament being soaked in semi-
osis), and in so far as the museums have housed art, they have been veritable
maisons closes of metaphor, keeping the best, most shapely, most intelligent and
seductive metaphors and meanings for our delight. Museums have always en-
abled us to go whoring after culture. Indeed, if I think of those edifices of cul-
ture and learning built in the nineteenth century (and still very much with us),
with their use of decoration—chandeliers, rich carpets, patterned tiles, sump-
tuous staircases, carved panels, gilded frames, velvet wall hangings, luxurious
drapes, padded couches—each one has the appearance of the greatest little

whore-house in the world. It leads us to think of the ancillary behaviour that supports such enterprises: the pimping with art dealers and antiquarians. Jean Genet's *The Balcony* could as well have been set in a museum as in a bordello.

What fails to fit with our contemporary sensibility is not so much the privilege and authority that museums seek to invest in the metaphors and hypotheses their collections of objects and specimens are thought to carry, but that they present material artifacts (concrete instances) at all. Ours is increasingly an immaterial world, a scenario in constant flux, with little or no consensus reality. The planet is a densely layered, multifaceted network of interacting personal, social, economic, cultural, political, and spiritual differences. We hold few hypotheses valid for any more than the microseconds in which their contexts transform themselves. Change is the root of our condition, all is subject to constant revision, re-alignment, reconstruction, re-interpretation, reformulation. Unlike the butterfly of the museum lepidopterist, we shall not be pinned down. We resist analysis. Indeed, the butterfly provides a useful metaphor of contemporary consciousness. We fly from metaphor to metaphor, from point of view to point of view, settling but for an instant. Not for us those all-to-solid beliefs, those in-depth visions of the Age of Reason, with its robust certainty and Cartesian assurance. For us, all is surface, surface upon surface. Not for us a single steady gaze or its tunnel vision. Ours is a holistic, bird's-eye view of events and of ourselves, even of our body.

Although we can see its inner processes, we live increasingly outside the body, beyond the body, just as our mind is now mind-at-large. This means, not that we are junking the body, or that we are careless about the body, but that we do not accept the definition of the body in the orthodoxy of its Western meaning. To escape the body is to escape the meanings that it carries. The technology of cyberception causes us to ask: What is the body, what really are its limits? If we are not to have a separation of the material and spiritual, is it not time to create new metaphors of embodiment? Indeed, is it not time to reconsider the notion of the disembodied self in order to reach a better understanding of who we are and what we may become? Who will claim the authority to describe the definitive body? The foregrounding of the body in much contemporary digital discourse is driven by anxiety, not of loss but of uncertainty of meaning. The materialist description is inadequate. All this is exemplified, not just by the widespread appeal of interpersonal psychologies, fascination with the paranormal, postmodernist theory, or poststructuralist philosophy, but also by new developments in new technologies, the infrastructure of the Net through which we re-see, re-think, and re-create the world and ourselves. Thus, we are not only

leaving our bodies, the old definitions of "body," we are leaving behind embodiment as the primary measure and sign of reality. Through telematic networks, our presence is distributed. We are both present and absent, here and elsewhere, all at the same time. It seems that embodied representation is giving way to disembodied reconstruction of ourselves.

In this immersion in the immaterial, which constitutes a culture of computer-mediated events, fuzzy logic, principles of uncertainty, undecidability, and chaos, what place do repositories of old pots and pans, sticks and stones, bones and baubles have in our consciousness? What useful role can be played in storing, classifying, and representing material "evidence" of objectified hypotheses in this immaterial culture? Cannot traces be stored in databanks, for realization in virtual reality when demanded, allowing the user to access cultural, historical memories as he will, creating his own associations, conjunctions, reconstructions and meanings? Michel Foucault, from the centre of European culture [Foucault 1970], and Donald Horne, from its antipodes [Horne 1984], have both exposed the autocratic subtext of museum mediation. First, in its proposing that there is a past to which we should attend, or within which we should expect to find coherence. Then, that we should read its authorized meanings. Museums store material objects whose meanings they create in the supposed context of truth or accuracy or authenticity. They bear witness to the past, to evidence of the past, as repositories of truth and meaning in past events—an assertion that the universe, in other words, makes sense. This supports the dream that there might be meaning and truth in the present, and that with the state apparatus of culture, of which the museum is a part, we might identify what is true and meaningful "out there" within the chaos and contingency of life. Such pious hope stemmed from an age that saw itself as Enlightened, that tried through its institutions and discourse to create a fixed, methodical and durable present, wise in age-old truths, full of reason, certainty, based on absolute and eternal verities. The world as museum.

How at odds that is with our current sensibility: we celebrate the uncertain, the shifting, the transitory. We invest our world in the technologies and systems of the immaterial, the fluid and fleeting, the fragmentary, layered, and discontinuous. Our hypotheses are transient and transformative. The cultural paradigm is shifting. No longer is art, for example, the product of a solitary, individual point of view—a unique, singular or discrete picture of the world—a framed and fixed finality of form or content. Too many codes and texts crowd in on its formation. In fact, the artwork may not necessarily exist as a material commodity. It can exist as a provisional assembly of elements in a media flow,

as transient "différance" in data space, although always as "difference that makes the difference" to use Gregory Bateson's phrase [Bateson 1972]. The commanding metaphor of art shifts from that of a window onto the world to that of a doorway into negotiable (data) space, a space in which we can create our own shared realities. In that space, all sensory modes can be engaged. Images, texts, sounds, and gestures co-exist in this hypermedia. To enter the media flow is to change it. The user is the content, the interface creates the context, always to be renegotiated.

But within this transcendental, out-of-body, mind-at-large scenario of consciousness technology and virtual spaces, we should not forget Mickey Mouse. Back in the old country, there is a real fear that Europe could be rendered into one huge theme park, a vast virtual space for the entertainment of visitors from the rest of the world. A vast coast-to-coast museum of rotting antiquity and quaint charm: English villages, French cathedrals, Bavarian inns, and Viennese waltzes, the whole of European culture as a vacation experience, a total entertainment. But perhaps Europe *is* a theme park, a virtual reality, in any case— its universities, hospitals, and banks no more than worn-out metaphors of learning, health, and order, with no reality principle there. Perhaps even these eternal verities themselves are simply linguistic constructs without "essential" meaning or reality. If everything is subject to the rule of relativism, the shelf life of any metaphor is limited. Museums often prevent us from relinquishing metaphors that have outlived their usefulness. Conserve, protect, curate a metaphor for too long, and it may become a truth, an evidential fact, a part of the jigsaw that can make up the whole picture. Such fictions are seductive.

Against the museum, we must press the necessity of constantly redescribing and reconstructing reality, the many realities that are ceaselessly created within our universe of metaphor and meaning. For the artist, whose job this is (and everyone can take this role on—no special genetic endowment is required), the world is all *interface*, awaiting meaning. All worlds are virtual worlds, everything is in a state of becoming. Museums are merely the traps and cages of imprisoned metaphors. Let them roam freely in gardens of hypotheses, float out in the semantic sea that surrounds us, reside on the Internet that connects us.

Instead of museum buildings, we could plant knowledge landscapes—gardens of hypotheses that will be found, on various scales, within and around cities, laid out in the interspace between the virtual and the actual. Gardens of hypotheses could be planted all over the planet and in our cities in space, subject to cycles of intellectual growth and change, reflecting our shifting perspectives, values, and ambitions. The garden of hypotheses is to the technoetic culture and

to the world of artificial life and artificial consciousness, to the hypercortex and to human cyberception, what the neo-Georgian and postmodern boxes of the old museum were to the Cartesian conformity of classical culture.

Within this post-biological frame, there is an art, and one that I admire deeply (the work of Christa Sommerer and Tom Ray springs to mind, for example) that treats artificial life as a conduit for art, as a context in which forms and structures can grow, through the interaction of the viewer with the apparatus of the work, or even autonomously, as it were, through the interaction of its internal elements and agents. I should perhaps here remind you of Christopher Langton's initial description of artificial life as behaviour that emerges from "bottom-up, distributed" interactions, "with no global controller responsible for the behavior of every part" [Langton 1989].

You will, I hope, readily see the parallelism between artificial life and interactive art. It is within its telematic dimension, within the implicate art of the Internet, that we find this same "bottom-up, distributed," local determination of art, "with no global controller responsible for the behavior of every part." And it is here, in the Net, that my focus as an artist lies. My personal concern as an artist is with the art that has as its substrate the Net, a field-generating, field-active art that takes as its domain the space of consciousness. When I work in the Net, every fibre, every node, every server is a part of me. As I interact with the Net, I reconfigure myself. My "Net-extent" defines me, just as my material body defined me in the old biological culture. I am weightless and dimensionless in any exact sense. I am measured by my connectivity. My passion is planting conceptual seeds in the substrate of the Net and watching them grow; watching the Net with a Zen-like attentiveness as new forms emerge, as the creative energy of connectivity brings forth new ideas, new images, new life. Emergence is the key behaviour in the Net. It is the key to understanding what art on the Net is all about.

Of course, artists using digital media are creating an enormous range of artistic strategies, and in the resonance between the real and the virtual, between the "transience of materiality" and the "embodiment of connectivity," there is a rich and fecund complexity. To reiterate my contention, there are three principal coordinates that it is necessary to triangulate in the search for the location of culture at this turning of the millennium:

· *technoetics* (everything that concerns cyberception and the technology of consciousness)

· *artificial life* (everything that concerns the emergent processes of nature)

· *intelligent architecture* (everything that concerns qualities of anticipation and adaptation in environmental systems and structures)

Just as the electronics revolution, which led from telecommunications to the computer, is now taking place in the human brain, so artificial life, engendered in silicon, may increasingly take on a moister reality, eventually integrating with the wet reality we call nature. We can expect this to occur precisely at the point where the Internet itself connects with a chip in the brain to effect a seamless interchange between artificial consciousness and our own neural networks.

I earlier referred to the value of scientific metaphor in advancing the theory of our art. Let me finally turn to the metaphor that brings together the past, the present, and the potential of the future: I mean the origins of art in the ancient shamanic tradition, art on the Internet of today, and art set in the space/time navigation of the future. I'm referring to the metaphor of the wormhole. The shaman could shift at will across the barriers of space and time, a kind of wormhole in consciousness. The telematic links and hypermedia of the Net allow us to wormhole effortlessly between sites, nodes, places, people, images, and texts. As for the future, our dream of wormholing in the universe is getting closer: wormholes tunnelling in quantum foam, or, as Kip Thorne describes them, handles in the topology of space, connecting two widely separated locations in our universe, affording the rapid transit of particles and people from one layer of reality to another, from one galaxy to another [Thorne 1994].

Although tunnelling through quantum foam may seem distantly theoretical, wormholes in the mind, a kind of cognitive tunnelling through what might be called "data foam" on the Web, from one hyperlinked layer to another, from one telepresence to another, from one mind to another, is a very present reality. And so with architecture. To facilitate our passage between real and virtual spaces, and between natural and paranatural worlds, the wormhole will be an essential requirement of the urban system. That brings us back to the museum, the architecture of the museum, its place in the fabric of the city, and its role in the changing shape of society. The museum must be riddled with wormholes, a hyperstructure that links us seamlessly between the nodes of experience, the interstices of events, and the convergences of mind and behaviour that we shall doubtless continue to call art. The museum must become a wormhole to facilitate our passage between worlds, worlds in whose construction and meaning we all can collaborate and cooperate.

That sounds a funny note to end on, that the museum must become a rift in space/time, a hole in space. Well, maybe it's appropriate to invoke that phrase,

since the "Hole in Space" [1980; see page 63 above] was the seminal work of my friends Kit Galloway and Sherrie Rabinowitz, founders of Electronic Cafe in Santa Monica, in which, by satellite connectivity, folk in one place, in one mental state, in one social and cultural condition, could communicate in real time and in virtual presence with folk in quite another situation across the other side of the continent. Whether or not the metaphor of the wormhole will stick, will be useful, or will quickly die is of no great issue. But it is imperative to find new ways, new terms and descriptions, to transform our thinking about what the museum could or should become.

It is imperative because art now inhabits both the interspace between material and immaterial worlds and the interstices of the many disciplines of mind and body. It deals with apparition rather than appearance, initiating and managing the emergence of realities rather than the expression of a given reality. For many artists, it is a time of complexity and confusion, brilliant insight and crass banality. To deal only superficially with science and technology is more destructive than to leave it alone entirely. To rearrange the furniture of the museum or replace the fittings will not solve the problem. The way forward requires transdisciplinary dialogue. Just as the Net can be the agent of this discourse, so art on the Net can initiate the seeding, evolving, and disseminating of new cultural forms. It is by the Net that we apprehend the future. It is through the Net, in the interspace between the real and virtual, that the new museum, like our new reality, and our new definitions of self, will be re-embodied and grow. It is in the Net that we are beginning to live the behaviours and procedures, the practices and protocols of life in the new millennium.

Art and Technoetics in the Bio-Telematic Domain

1998

What is more ubiquitous than consciousness? What is less under-stood than mind? The telematic adventure in art has brought the question of consciousness and of distributed mind to the forefront of the new aesthetic, a technoetic aesthetic, so named because I be-lieve we need to recognize that technology plus mind not only en-ables us to explore consciousness more thoroughly but may lead to distinctly new forms of art, new qualities of mind, new forms of cog-nition and perception.

In both art and science now, the matter of consciousness is high on the agenda. Science is trying hard to explain consciousness, with distinctly limited success. It seems to pose the most intractable of problems. For the artist, consciousness is more to be explored than to be explained, more to be transformed than understood, more to be reframed than reported. As for conscious experience in itself, there is nothing we know more closely than our inner sense of be-ing, and there is nothing we can experience with less comprehen-sion than the conscious states of another. It may be that only the profound empathy of mutual attraction, "love," if you will, can break this barrier, but neither reductionist science nor the postmodern aes-thetic could possibly countenance such an assertion. Fortunately, there are signs that science is becoming more subjective, and post-modern pessimism is on the wane. There is no doubt that both sci-entists and artists are curious about the ways that advanced tech-nology can aid in the exploration of mind. And advanced technology itself is calling into question our definitions of what it is to be hu-man and what might constitute an artificial consciousness in the emergent forms of artificial life.

Revised from the original French publication, "The Shamantic Web: Art et techologie de la conscience," trans. Myriam Bloedé, in *Pour une écologie des media: Art, cinéma, vidéo, ordinateur*, ed. M. Klonaris and K. Thomadaki (Paris: ASTARTI, 1998), 88-104.

It is my contention that not only has the moment arrived in Western art for the artist to recognize the primacy of consciousness as both the context and content of art, and the object and subject of study, but that the very provenance of art in the twentieth century leads, through its psychic, spiritual, and conceptual aspirations, towards this technoetic condition. I need perhaps only point to the examples of Duchamp, Kandinsky, Klee, or Boccioni, early in the century, to indicate the roots of this tendency. It is equally clear that the impact on art practice of technology, especially digital and communications technology, has been to reduce art in many cases to a form of craft in which polished technique or skilful programming, leading to dazzling special effects, have come to replace the creation of meaning and values. A resonance with William Morris's nineteenth-century Arts and Crafts movement springs to mind. There was then the same process of dumbing down from art to craft, in which the authoring of technique took primacy over the authoring of ideas, a pandering to the luxury market covered by a veneer of social conscience.

A more optimistic view is that our concern in telematic art with whole systems—that is, systems in which the viewer or observer of art in the Net plays an active part in the work's definition and evolution—represents at the very least a yearning to embrace the individual mind by a larger field of consciousness. By this account, the employment of telematic hypermedia is no less than a desire to transcend linear thought by reaching for a free-flowing consciousness of associative structures. It then becomes the artist's imperative to explore every aspect of new technology that might empower the viewer through direct physical interaction to collaborate in the production of meaning and the creation of authentic artistic experience. I would like to return to the theme of interactivity in art, particularly in the Net, at a later stage, since I see it as both emblematic of the desire for shared consciousness and problematic in its assumed resolution of the object/process and observer/participant dichotomies.

But first, I want to address the notion of double consciousness and its relationship to art. By "double consciousness," I mean the state of being that gives access, at one and the same time, to two distinctly different fields of experience. In classical anthropological terms, this is to describe the shamanic "trance" in which the shaman is both in the everyday world and at the same time navigating the outermost limits of other worlds, psychic spaces to which only those prepared by physical ritual and mental discipline, aided often by "plant technology," are granted access. In post-biological terms, this is mirrored by our ability, aided by computer technology, to move effortlessly through the infini-

ties of cyberspace, while at the same time accommodating ourselves within the structures of the material world.

To research this apparent parallelism between shamanic space and telematic space, and the double consciousness that seems to be a part of both fields of experience, I have spent time immersed in the virtual reality of advanced computer systems and in the traditional reality of a native Indian tribe; that is, under the influence of the computer and of the plant, albeit an extremely powerful computer and a particularly potent plant (ayahuasca, the "vine of the soul"). My access to virtual reality was at locations on both sides of the United States, at the Human Interface Technology Laboratory in Seattle and at the University of North Carolina at Chapel Hill Virtual Reality Laboratory. My introduction to the psychic world was in the very heart of Brazil, with the Kuikuru *pagés* (shamans) of the Xingu River Region of the Mato Grosso and through my initiation into the ritual of the Santo Daime community in Brasilia.

The shaman is the one who "cares" for consciousness, for whom the navigation of consciousness for purposes of spiritual and physical wholeness is the subject and object of living. Consciousness occupies many domains. The pagé is able to pass through many layers of reality, through different realities. In his altered states of awareness, he engages with disembodied entities, avatars, and the phenomena of other worlds. He sees the world through different eyes, navigates the world with different bodies. In parallel with technologically aided cyberception, this could be called "psi-perception."[1] In both cases, it is a matter of the double gaze, seeing at once both inward realities and the outward surfaces of the world.

The double gaze and double consciousness are related. In my experience of ingesting the ayahuasca, I entered a state of double consciousness, aware both of my own familiar sense of self and of a totally separate state of being. I could move more or less freely between these two states. Similarly with my body: I was at one and the same time conscious of inhabiting two bodies, the familiar phenomenology of my own body sheathed, as it were, in a second body made up of a mass of multicoloured particles, a million molecular points of light. My visual field, my double gaze, alternated, at choice, between the coherent space of everyday reality and a fractal universe comprising a thousand repetitions of the same image, or else forming a tunnel in space through which I could voluntarily pass with urgent acceleration. I could at any point stop and review these states, moving in and out of them more or less at will.

Not only do many shamanic tribes enhance their psi-perception by drinking ayahuasca on a regular basis, but their culture, by adoption, has given rise to a

ritualised practice known as Santo Daime, which has spread to most parts of Brazil, not least in its urban and metropolitan areas. In addition to the ritual drinking of ayahuasca, Santo Daime has precise architectural and social codes. The design of the building that houses the ritual, the ordered placing of participants in that space, the rhythmic structure of the music, the pungency of the incense, the repetitive insistence of intoned phrases, punctuated by extended periods of absolute silence, the recurrent demand to stand or sit, one's own inclination to move into and out of the new field of consciousness that the ceremony and the drink together induce, leads one's awareness to fluctuate between the two realities. The importance of this organizational structure raises the question, of course, of the way in which specific protocols and conditions control or construct a given reality, and leaves unanswered the question of where or how or indeed if a ground of reality might be identified or even be said to exist in the absence of such structures.

This immersion in a controlled environment affects sight, touch, taste, smell, and hearing respectively. It confers on the mind the ability both to induce and create new conceptual and sensory structures (in philosophical jargon, new "qualia"), while at the same time giving the freedom to step aside from the visionary experience, back into the "normal" field of experience. In many respects, this ancient ritual mirrors our contemporary artistic aspirations using digital technology, as, for example, in Virtual Reality, hypermedia, multimedia installations, and, with its superimposition of cognitive schemas on real world situations, the fast developing field of augmented reality.[2]

In both cases there is a kind of rehearsal of the Sufi injunction to be in the world but not of the world, although the original context of that phrase is more emphatically spiritual than many artists would perhaps want to acknowledge. Here technology plays an important part in the experience of "double consciousness," just as it is clearly integral to our emergent faculty of cyberception and the double gaze. It is as if, through our bio-telematic art, we are weaving what I would call a "shamantic" web, combining the sense of shamanic and semantic, the navigation of consciousness and the construction of meaning.

Historically our command of the material world has been such that we have had little option but to keep the worlds of our double consciousness in separate and distinct categories, such as the real, the imagined, and the spiritual. The advent of the artificial life sciences, in which I include both dry (pixel) and moist (molecular) artificial organisms and the whole prospectus of nanotechnology, points to the possibility of eroding the boundaries between states of mind, between conception and construction, between the internalisation and the reali-

sation of our desires, dreams, and needs of our everyday existence. Let me give you an example, which can be found in our cyberception of matter at the atomic level. The scanning tunnelling microscope (STM) enables us not only to view matter at this level, but also to image individual, single atoms. However, the real significance of this process does not end there. Not only can we select and focus on individual atoms, but we can, at the same time, manipulate them, one by one, atom by atom, to construct atomic structures of our own choosing from the bottom up.[3]

The ramifications of this condition are profound. In an important sense, the prosthesis of vision can be at one and the same time instrumental in constructing what is envisioned. To see in the mind's eye is to realize in the material world. The worlds of double consciousness, supervenient as they are on the processes of the double gaze, become less distinctly separate. The immaterial and material lose their categorical distinction. Cyberception is as much active and constructive as it is receptive and reflective. As this kind of double technology develops—and it is doing so at an accelerated rate—artists, no less than the philosophers and neuroscientists, must increasingly turn their attention to what I shall call "techno-qualia," a whole new repertoire of senses, and to a new kind of relationship between the tools of seeing and building.

Let me, at this point, return to the question of interactive art. At the moment, by its structure, placement, and presentation (which is generally in a traditional museum or gallery space), the work of networked interactive art presupposes, in spite of itself, an audience of more or less passive observers, just as much as it proposes a participant in open-ended interaction with its interface. In this sense, the total system, including the participant viewer, however dynamic a process it may be, is actually incarcerated within the very status it despises, that of pure object—an envelope, bracketed in space and time, to be viewed by a second observer. This creates a dichotomy between the aspiration toward open-ended evolution of meanings and the closure of an autonomous frame of consciousness, a contradiction that necessitates the removal of the second observer and the phantom audience from the canon of telematic art.

Here, by way of contrast, the shamanic tradition may usefully be invoked. All the activity of the pagé, and of those who interact with him in image-making, dancing, chanting, and making music, is performative but *is not intended as a public performance*. It is never played to an audience, actual or implicit. No one is watching or will be expected to watch what is being enacted. This is not a public performance but a spiritual *enactment*, which entails the structuring or restructuring of psychic forces. To paint the body elaborately, to stamp the

ground repeatedly, to shake the rattle, to beat the drum, to circle round, pace back and forth in unison, is to invoke these forces, to conjure hidden energies. This is an enactment of psychic power, not a performance or cultural entertainment. This perspective, although seen at a great distance from our current hypermediated culture, may be of value in our consideration of the function of works of interactive art, thereby avoiding the double observer, the phantom audience. Art as an enactment of mind implies an intimate level of human interaction within the system, which constitutes the work of art, an art without audience in its inactive mode. Eschewing the passive voyeur, the traditional gallery viewer, this technoetic aesthetic speaks to a kind of widespread intimacy, closeness on the planetary scale.

So what, then, is the role of the artist in an art that increasingly sees its content and meaning as created out of the viewer's interactions and negotiations on the Internet? An art that is unstable, shifting, and in flux? An art that parallels life, not through representation or narrative, but in its processes of emergence, uncertainty, and transformation? An art that favours the ontology of becoming, rather than the assertion of being? An art moving towards a post-biological re-materialization? An art of enactment, without audience? An intimate art, the free-flowing outcome of interaction between participant viewers within networks of transformation? An art, in short, that reframes consciousness, articulating a psychic instrumentality, exploring the mysteries of mind?

These are the questions that will take us into the next century, and artists working at the furthest edge of the technoetic aesthetic are already beginning to ask them. One answer may be found in the deep past, in the remotest parts of the planet, or simply within the double consciousness to which we all have access. It may be found in the role of the shaman, re-contextualised in the bio-telematic culture but re-affirmed in its capacity for the creation, navigation, and distribution of mind. It may be as the conservator of what emerges from the complexity of interactions in the Net or from the self-assembling processes of artificial life. Whatever may be the case, one thing seems certain: the technoetic principle will be at the centre of art as it develops, and consciousness in all its forms will be the field of its unfolding.

NOTES

1 Note the parallels here between Ascott's 1970 notion of psibernetics described in "The Psibernetic Arch" (chapter 5 above), his 1994 concept of cyberception in "The

Architecture of Cyberception" (chapter 23 above), and the concept of psi-perception described here.—Ed.

2 See, e.g., <http://se.rit.edu/~jrv/research/ar>.

3 An aspect of this process can be viewed at the IBM website <http://www.almaden .ibm.com/vis/stm/lobby.html>.

ART @ THE EDGE OF THE NET
The Future Will Be Moist!

2000 MOIST MANIFESTO

MOIST SPACE is where dry pixels and wet molecules converge
MOIST ART is digitally dry, biologically wet, and spiritually numinous
MOIST REALITY combines Virtual Reality with Vegetal Reality
MOIST MEDIA comprises bits, atoms, neurons, and genes
MOIST MEDIA is interactive and psychoactive
MOIST LIFE embraces digital identity and biological being
MOIST MIND is technoetic multiconsciousness
MOISTWARE erodes the boundary between hardware and wetware
MOIST MANUFACTURE is tele-biotic, neuro-constructive, nano-robotic
MOIST ENGINEERING embraces ontology
MOIST DESIGN is bottom-up, seeded, and emergent
MOIST COMMS are bio-telematic and psi-bernetic
MOIST ART is at the edge of the Net

Just as the development of interactive media in the past century
transformed the world of print and broadcasting, and replaced the
cult of the objet d'art with a process-based culture, so, at the start
of this century, we see a further artistic shift, as silicon and pixels
merge with molecules and matter. Between the dry world of virtu-
ality and the wet world of biology lies a moist domain, a new in-
terspace of potentiality and promise. Moistmedia (comprising bits,
atoms, neurons, and genes in every kind of combination) will con-
stitute the substrate of the art of our new century, a transformative
art concerned with the construction of a fluid reality. This will mean
the spread of intelligence to every part of the built environment,

Revised and expanded from the keynote address "Wired, Wet, Moist: Art @ the Edge
of the Net" for the conference "Invenção: Thinking the Future," ITAU Cultural Center,
São Paulo, August 26, 1999. "Moist Manifesto" was originally published in *Kunst, Wis-
senschaft, Kommunikation: comm.gr2000az/,* ed. Helmut Konrad and Richard Kriesche
(Vienna: Springer, 2000) and is reprinted by permission of Springer Verlag.

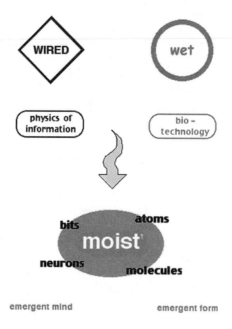

from the immaterial to the re-materialisation of art

WIRED

wet

physics of
information

bio-
technology

bits atoms

moist

neurons molecules

emergent mind emergent form

post-biological culture

Figure 41. "Moist Chart." 2000. Originally published in *Kunst, Wissenschaft, Kommunikation: comm.gr2000az/*, ed. Helmut Konrad and Richard Kriesche (Vienna: Springer, 2000) and used by permission of Springer Verlag.

coupled with recognition of the intelligence that lies within every part of the living planet. This burgeoning awareness is technoetic: *technē* and *gnōsis* combined into a new knowledge of the world, a connective mind that is spawning new realities and new definitions of life and human identity. A mind that will seek new forms of embodiment. At the same time as we seek to enable intelligence to flow into every part of our civilization, we recognise that nature is no

longer to be thought of as over there, to be viewed in the middle distance, benign or threatening as contingency dictates. It is no longer to be seen as victim or ecology, fragile or fractious, according to our mode of mistreatment. Technology is providing us with the tools and insights to see more deeply into its richness and fecundity, and above all to recognise its sentience and to understand how intelligence, indeed, consciousness, pervades its every living part.

So, as multimedia give way to moistmedia, and interactive art takes on a more psychoactive complexion, consciousness remains the great mysterium, just as intelligent artificial life remains the great challenge. For some years now, artists working at the edge of the Net have been exploring the nature of consciousness and the potential of artificial life. Compared to the art of previous eras, the work is inevitably more constructive than expressive, more connective than discrete, and considerably more complex both semantically and technologically. Within this complexity, I foresee the insertion of a new but very ancient technology, that of the psychoactive plant. A sort of cyberbotany may arise, for example, around the instrumentality of such plants as the shamanic liana, ayahuasca *(Banisteriopsis caapi)*, the vine of the soul. It is my contention that vegetal reality and virtual reality will combine to create a new ontology, just as our notions of outer space and inner space will coalesce into another order of cosmography. My project ayahuascatec.net is designed to explore this field.[1] Cyberbotany covers a wide spectrum of activity and investigation into the properties and potential of artificial life forms within the cyber and nano ecologies, as well as the technoetic dimensions and psychoactivity induced by such plants as the ayahuasca and other vegetal products of nature.

▬ CONSTRUCTIVE LANGUAGE AND VISIONARY PRAGMATISM

The key to understanding this new state of being is language: the understanding that language is not merely a device for communicating ideas about the world but rather a tool for bringing the world into existence. Art is a form of world building, of mind construction, of self-creation, whether through digital programming, genetic code, articulation of the body, imaging, simulation, or visual construction. Art is the search for new language, new metaphors, new ways of constructing reality, and for the means of redefining ourselves. It is language embodied in forms and behaviours, texts and structures. When it is embodied in moistmedia, it is language involving all the senses, going perhaps beyond the senses, calling both on our newly evolved cyberception and our rediscovered psi-perception. Moistmedia are transformative media; moist systems are the

agencies of change. The moist environment, located at the convergence of the digital, biological, and spiritual, is essentially a dynamic environment, involving artificial and human intelligence in non-linear processes of emergence, construction, and transformation.

Through the languages it creates, art serves to reframe consciousness. It can only be evaluated by the new language it produces. For the artist simply to re-iterate received language, uncreatively and uncritically, is to renounce the idea that we can rethink ourselves and our world, and to accede to the notion that in matters of reality, our minds are made up for us. In Richard Rorty's words: "To create one's mind is to create one's own language, rather than to let the length of one's mind be set by language other human beings have left behind" [Rorty 1989, 27]. Rorty is a philosopher who challenges the very category in which the world would place him. His pragmatism eschews the sanctity of philosophy in favour of the artist's visionary impulse and search for metaphor that leads to the continual construction of reality and of the self, thereby denying the passive acceptance of any canonical description. Similarly, many artists escape the constraints of artistic identity by straying freely into the speculative zones of science and technology, mysticism and philosophy. Breaking free of categories both intellectually and emotionally and creating new realities, new languages, and new practices—that is what art is about.

When the visionary impulse is combined with pragmatism of the kind that Rorty espouses, we have a description of what it is that artists do, or seek to achieve, and have done throughout cultural time. This *visionary pragmatism*, as I shall call it, is about flying with your feet on the ground. It's about working with the future in the present. It is living life acausally but not casually. At its most efficacious, it combines, within the artistic domain, the perennial wisdom of shamans and gnostics with contemporary insights of scientists, engineers, and philosophers. Visionary pragmatism finds in moistmedia its creative ally, with its triad of computational exactitude, biological fluidity, and technoetic complexity. Visionary pragmatism is an attribute to be fostered in all aspiring artists. It is a quality least understood but most in need of support. Visionary pragmatism is guided by the need to bring dreams to earth. In the case of the digital culture, it has led to what is known as ubiquitous computing, where intelligence spreads throughout the network and into every facet of the environment, into every product, every tool, every system. At the same time, it is visionary pragmatism that has pushed the consequences of a screen-based, immaterial world into the *re-materialisation* of culture involving molecules and atoms, nanotechnology and neurons. It corners the nihilism and despair of late postmodernism

and springs forth into the post-biological culture with a radical constructivism. It's a case of "bye-bye Baudrillard" and signals a reversal of the sense of terminal decline that characterised art at the end of the preceding millennium.

▬ THE PLANETARY COLLEGIUM

The Planetary Collegium [see chapter 22 above] is an example of visionary pragmatism that seeks to develop advanced research in the interspace between artistic, technological, scientific, and spiritual disciplines. As such it is inherently moist, a paradigmatic embodiment of the nascent moist culture. It sees its influence spreading from the research domain to engender new forms of creativity and learning at all levels, at all stages of an individual's life, in a variety of cultural settings. It presents a dynamic alternative to the orthodox university form of advanced research while producing outcomes of comparable rigour, innovation, and depth. The Collegium was first proposed in 1994 at the International Symposium on Electronic Art in Helsinki. The Planetary Collegium concept has evolved in step with the success of CAiiA-STAR to create a dynamic and harmonious community of doctoral and post-doctoral researchers of high calibre whose work transcends orthodox subject boundaries and whose practice is at the leading edge of post-biological art.

I established CAiiA, the Centre for Advanced Inquiry in the Interactive Arts, in 1994 at University of Wales College, Newport. Three years later I was invited to set up a similar centre for research, STAR, the Science Technology and Art Research Centre, in the School of Computing, University of Plymouth. I structured the two centres into one integrated research platform. CAiiA-STAR combines online research in cyberspace with periodic face-to-face sessions in different parts of the world. Specifically, this means that all members of the research group meet three times a year for intensive ten-day "composite sessions" of seminars, tutorials, critique, and public conferencing. Most research is undertaken at the researcher's home base, while maintaining regular telematic communication with the group. The composite sessions are spent either in residence in the host universities, at Newport or Plymouth, or by invitation at media centres or universities in various parts of the world. These have included Art House, Dublin; La Beneficia Cultural Centre, Valencia; Les Triches, Marseilles; the Federal University, Rio de Janeiro; and the College of Fine Arts, University of Arizona, Tucson; and are forthcoming in Paris, Turin, Los Angeles, and Nagoya [see Appendix IV]. Doctoral candidates enrol in either one of the two universities and receive their Ph.D. from that university, but in every other respect

the programme is common to all candidates, and the intellectual, academic, and technological resources of each university are available to all. Appropriate high-level supervision and advising involve the development of an online network of mentors, who are experts in a variety of scientific and arts fields.[2] CAiiA-STAR can be said to create and explore spaces triangulated by issues of art, technology, and consciousness. A major international conference, "Consciousness Reframed," which is convened annually at Newport to address these issues, attracts over one hundred presentations by researchers coming from some twenty-five different countries [Ascott 1999].

The Planetary Collegium, having been developed, tested, and proven within the limits of the university framework, is now ready to cut loose from the Mothership and move out into a world in which many other long-established institutions and practices are becoming culturally redundant, commercially ineffective, and financially unviable. Just as historically the church as the centre of learning had to give way to the secular university, so now the university has to give way to new forms of learning set within the domain of cyberspace and moist-media. It may mean taking the Collegium to the new transnational marketplace of e-commerce in order to find the kind of investment and support for it that radically new practices require to grow. Despite the rather hysterical climate of the current world of start-ups and IPOs, this prospect is not as awesome as it might have been earlier, in the twentieth century, when investment in education was more generally to be seen at the level of bricks and mortar, rather than behaviour and communication. "Distance-learning" curricula hardly begin to address this central problem of the university in the telematic age. Habitual investment in physical real estate stands in the way of educational development in interspatial cyber estate, with all the implications of a fluid architecture, networked organisation and lateral structure that would support—and be supported—by it.

Within the framework of CAiiA-STAR, I have drawn together an international, transdisciplinary group of artists and theorists, each of whom represents a generic strand in the emergent field of the interactive, digital, post-biological arts.[3] The Planetary Collegium is the evolutionary projection of this late twentieth-century university venture into the post-institutional space of the twenty-first century—a century in which the old academic orthodoxies have to be replaced by creative research organisms fitted to the telematic, post-biological society. It combines the necessary face-to-face transdisciplinary association of individuals with the nomadic, transcultural requirements of a networking community.

The Planetary Collegium will initially have seven physical sites, each strategically located across the planet, each serving as a residential node, the architecture of which constitutes an ecologically responsive, technologically informed environment. Each node has its parallel place in cyberspace, with its own server guaranteeing state-of-the-art connectivity. Each node is required to support some twenty researchers, with a support network of research advisors emerging with the development of individual and collective research trajectories. Following the efficacy of CAiiA-STAR practice, each group will come together for intensive ten-day, face-to-face sessions, three times a year, meeting at one or other of the seven nodes on a periodic basis. At the same time, each researcher is charged with the responsibility of creating a personal network of associates and experts with whom regular communication is maintained in cyberspace. Through this process, an extensive planetary research network will emerge. At the successful completion of their research, researchers will be awarded formal recognition commensurate with the Ph.D. in traditional universities, but more closely related to the twenty-first-century context of knowledge creation and transdisciplinary understanding. By virtue of international agreements, the Collegium will be able to guarantee the negotiable value of the award.

In time, the model offered by the Collegium may prove itself worthy of public adoption on a wider basis, but at present much work has to be done within academia to sweep away the accumulated errors and conventions of previous eras before meaningful structural change can take place. Initially, in order to ensure its coherence, integrity, and independence from both university and government sectors, the proper development of the Planetary Collegium will require considerable private investment. The potential of the Collegium for informing the creation of other kinds of moist institutions and curricula, at other educational and life-style levels, presents a variety of investment opportunities. Equally, each residential site will be available commercially for retreats and seminars by corporate and other bodies wishing to be identified with the research ethos of the Collegium. Periodically, both by way of public dissemination and as a source of revenue, the Collegium will provide public conference presentations, streamed online and at its nodal locations, by researchers drawn from the planetary network.

The Collegium would build first on the approach to advanced research already established by CAiiA-STAR. The first zone, then, will focus on practices that constitute clearly defined genres of emergent fields of creativity. A second zone will be introduced to enable the research and preparation of those destined to act instrumentally within the post-biological culture, as advisors, con-

sultants, and planners, in global, national, and regional organisations. Their role would be to seed change, to initiate new urban, cultural, artistic, and educational structures, bottom-up. Using models and methods thus developed, a third zone would be introduced, concerned with learning and self-creation in a transdisciplinary context, offered within a matrix of concept, communication, and construction. (This tripartite structure parallels the curriculum diagram I designed at the Ontario College of Art nearly thirty years ago, in which the triad of concept, information, and structure was intersected by a quadrant of speculation, social application, theory, and analysis [see fig. 16].) While recognising that there are individuals and groups who can be distinguished as prime movers in the emergence of new practice and theory, a lateral rather than hierarchical relationship between the three zones is envisaged. In this way, synergy is maximised, and the cumulative, global effect of the collegiate organism as a whole can be beneficial socially, culturally, and, perhaps, spiritually.

■ THE TRANSFORMATIVE VOCATION AND THE TELEMATIC EMBRACE

The ambition to work without boundaries, beyond categories of learning, to build new realities, new language, and new practices, redefines the work of the artist and gives those practices relevance in the social context. It replaces the historical sense of the artist's role as an "honourable calling" with the idea of such work as a "transformative vocation"—a concept that is central to the theory of society of the Brazilian thinker and Harvard professor of law Roberto Mangabiera Unger. His programme for social reconstruction shows how, against the idea of work as purely instrumental or as an honourable calling, a third idea of work has appeared in the world. "It connects self-fulfilment and transformation: the change of any aspect of the practical or imaginative settings of the individual's life." In order to be "fully a person" one must "engage in a struggle against the defects of the limits of existing society or available knowledge," according to Unger. "The dominant institutional and imaginative structure of a society represents a major part of this constraining biographical circumstance, and it must therefore also be a central target of transformative resistance" [Unger 1997].

The imaginative structure and constraining institutions that Unger identifies are losing their dominance and appear everywhere to be crumbling. The value of interactive and telematic media in the context of transformation is immediately apparent, since the widespread diffusion of ideas and the enrichment of

individual and collective work are the defining attributes of such media. And it is in art practice that these attributes have been most imaginatively explored and where new models of communication, construction, and, indeed, resistance have been most subtly modelled. Here both the concept of emergence and the principle of uncertainty must be evoked, since the processes involved are neither prescriptive nor deterministic—all is open-ended, incomplete, and contingent, awaiting always the intervention and constructive collaboration of the viewer. The telematic embrace releases feelings of solidarity and co-operation, just as it raises those issues that previously isolated cultures, social groups, or individuals left hidden and unanswered. We are only now moving from the industrial age of paranoia into the telenoia of universal connectivity and transparency.

These issues of mind/body, spirit/matter, and concept/form are tied up with questions of identity, of self-definition, of what it is to be human. Do we possess creativity, or does creativity possess us? Should the artist firmly claim the meaning of his work, or is its semiosis invested in the viewer? Is not art, like knowledge itself, always on the edge of instability, oscillating between certitude and indeterminacy, just as the quantum world seems to be? Since the meaning of an artwork is a product of the viewer's negotiation with the system, is the artist responsible for its content, or is it his role to provide contexts from which meaning can arise? These are the enduring questions that follow us into the twenty-first century. They apply as much to architecture as to art, as much to narrative as to performance. Our double consciousness simultaneously constructs and navigates a world that is at once virtual and actual: a technoetic fabric of minds, set in a moist ecology. We are at home in this indeterminacy.

▬ THE BUILDING OF SENTIENCE

Architecture provides a useful focus of visionary pragmatism, since its practice resonates in a number of pertinent contexts: building in both hardware and code, terrestrial and in cyberspace; intelligent environments; and nano-construction at both biological and industrial levels. While Euclidean space appeals primarily to the physical body, cyberspace appeals primarily to the mind. The body loves surfaces, solidity, resistance; it wants its world to be limitless but safely ordered, open to the clouds but protected from indeterminacy. Above all, the body wants its senses put in perspective. In twentieth-century architecture, the body ruled. But in our new century, architecture progressively will embody mind; technoetics will be at the foundation of practice. The mind seeks connectivity

and complexity, uncertainty and chaos. It knows reality to be layered and am-
biguous, constantly collapsing and reforming, observer-dependent, endlessly in
flux. In reflecting these attributes, twenty-first-century architecture will be like
nothing the world has ever known. Distributed mind, collective intelligence,
cybermentation, connected consciousness, whatever we choose to call the tech-
noetic consequences of the Net, the forms of telematic embodiment likely to
emerge will be as exotic to our present conception of architecture as they will
be protean. Stylistic and functional diversity will increase exponentially as the
practical consequences of nano-engineering kick in. In turn, our frustration with
the limitations of our own bodies will demand prostheses and genetic inter-
vention of a high order. We realise that the body, like our own identity, can be
transformed, indeed must become transformable. The many selves hypothesis,[4]
like the many worlds hypothesis of physics, is not only compelling but also nec-
essary to life and liberty in the moist culture.

Increasingly, the attitude of the mind towards the body is post-biological. Its
view is cybernetic, seeking always the perfectibility of systems. The hypercor-
tex, mind in the Net, needs shelter. Human bodies and artificial agents need
common habitats. At the point where cyberspace and post-biological life meet,
an entirely new kind of social architecture is required. A truly anticipatory ar-
chitecture must prepare itself for this marriage of cyberspace with moistmedia,
combining self-assembling structures and self-aware systems. Visionary prag-
matism, in architecture as in other creative practice, must embrace the antici-
patory design science advocated by Buckminster Fuller. Indeed Fuller's entire
oeuvre provides valuable grounding for development in this respect [see Vesna
1998].

As the century advances, the paradigmatic change in architecture will be reg-
istered at the level of behaviour rather than form. To give just one simple ex-
ample, the twentieth century's exaggerated interest in what a building looks like,
its mere appearance, will give way to a concern with the quality of its gaze, how
it sees us, how it perceives our needs. Questions of the physical structure of build-
ings will be overshadowed by ambitions for their dynamism and intelligence,
their ability to interact with one another and with us, to communicate, learn
and evolve within the larger ecology. Engineering will embrace ontology. Time
will become more dominant than space, system more significant than structure.
Seeding, as I have argued earlier,[5] will become at least as important as design-
ing, and design will be a bottom-up process, always seeking short-term evolu-
tionary gains. The goal will be the building of sentience, a moist architecture

that has a life of its own, that thinks for itself, feeds itself, takes care of itself, repairs itself, plans its future, copes with adversity. It will be an architecture that is as much emotional as instrumental, as intuitive as ordered. We shall want to get inside the mind of such architecture and shall demand an architecture that can get into our own minds, such that our neural networks can be synaptic with the artificial neural networks of the planet. If the building of sentience is the challenge to architecture in the twenty-first century, the emergence of moist-media will be the manifestation of its radical restructuring.

■ INCLUSION

Since this essay is intended as a textual portal to the future, there is no end or closure to these issues, and my final remarks will be inclusive rather than conclusive. The Planetary Collegium is clearly a moist project, bringing together nodes located in cyberspace and at physical locations across the planet. More than a matter of intelligent architecture, its design treats the Collegium as a brain, developing a connective intelligence and connective tissue that embodies the associative thought of its own hypercortex. The structure should be emergent, growing bottom-up from the interactions within its community. One would not plan *for* the Collegium so much as expect it to plan for itself. Then the focus could be on its own sentience, how consciousness might arise within its internal system, how ideas could come into being, and how forms could emerge from the human/artificial complexity of the whole community.

In this way, it will find its place within the larger self-organising, self-aware, planetary environment that it is in large measure the artist's responsibility to plant, grow, and cultivate. The notion of cyberbotany thus extends from the wise application of plant technology, in the technoetic context, to the creative employment of horticultural metaphor in envisioning outcomes at the material level of construction: hyperculture seen as horticulture, the moist synthesis of artificial and natural systems.

Visionary pragmatism is perhaps the most useful way to inform the artist's participation in building worlds we would want to live in. Visionary pragmatism can take the love inherent in the telematic embrace and create new relationships, new societies, and new culture. Just as art in the next hundred years will be not only interactive but also psychoactive and proactive, so human affairs will benefit from closer connectivity, distributed intelligence, and spiritual solidarity. As the unfolding years of this new century will show, the media best

employed to effect these changes will be moistmedia, the networks that sustain them will be technoetic, and the cyberperception of the planetary society as a whole will reflect a growing sense of optimism and telenoia.

NOTES

1 See chapter 26 above, "Weaving the Shamantic Web." The project seeks to link a number of *ayahuasceros* telematically and telepathically (employing their double consciousness to navigate both psychic space and cyberspace) with spiritual guides who always appear as helpers to those in advanced use of the psychoactive brew. This builds on my experience with Santo Daime and the Kuikuru Indians during my visit to the Mato Grosso in 1997. The aim is to bring these disembodied entities into communication with human users and their artificial agents on the Internet, thereby constructing a "Psibernetic Arch," as first envisaged in 1970 (see chapter 5 above). This involves my establishing an infrastructure for the project in Brazil throughout the fall of 2000, in communion with the members of the União do vegetal and Amerindian tribes.

2 For example, Tom Ray, John L. Casti, Carol Gigliotti, Linda Dalrymple Henderson, Roger Malina, Kristine Stiles, and Francisco Varela.

3 They include, online, Peter Anders, Donna Cox, Char Davies, Elisa Giaccardi, Pamela Jennings, Eduardo Kac, Jim Laukes, Laurent Mignonneau, Marcos Novak, Niranjan Rajah, Miroslaw Rogala, Gretchen Schiller, Thecla Schiphorst, and Christa Sommerer; on-site, Jon Bedworth, Geoff Cox, Gillian Hunt, Kepa Landa, Dan Livingstone, Kieran Lyons, and James Norwood; graduates, Jill Scott, Dew Harrison, Joseph Nechvatal, William Seaman, and Victoria Vesna; post-doc, Tania Fraga; on-site co-ordinators, Michael Punt (Newport) and Mike Phillips (Plymouth).

4 As noted in chapter 19 above ("Telenoia"), Ascott derives the "many selves hypothesis" from P. D. Ouspensky, but the latter by his own admission adopted it from the teachings of G. I. Gurdjieff (see, e.g., Ouspensky, *In Search of the Miraculous* [New York: Harcourt Brace, 1949], pp. 239–40).—Ed.

5 Roy Ascott, "The Architecture of Cyberception" (1994), chapter 23 above.

1996 **Art** While traditionally focused on the appearance of things and their representation, art is now concerned with processes of inter-action, transformation, and emergence.

Art gallery The artist's window on the world now becomes a door-way into data space. As the gallery changes from showcase to operations centre, the museum must become collaboratory.

Artist The creator of contexts for noetic navigation and of open-ended, evolutive systems in the Net.

Behaviour Classical aesthetics dealt with the behaviour of forms; the new aesthetic deals with forms of behaviour.

Biohaus Instead of Bauhaus bluff, we need a biology of building. Seeding should replace designing; buildings must be planted and allowed to grow.

Bio-myths We are still bound up with the search for myths. The context now is biological and behavioural—zooming through the micro/macro levels. Get ready for the great bio-myths, A-life legends.

Bionicity Synchronicity is the convergence of disparate events into a unified time. Iconicity is the convergence of disparate data into a unified image. Bionicity is the convergence of artificial and living systems into a unified consciousness.

Bio-telematics As biological implants connect us seamlessly to the Net, the matter of consciousness becomes prioritised, and art both defines and inhabits the bio-telematic domain.

Body Previously the property of nature; now the site of bionic transformation at which we can recreate ourselves and redefine what it is to be human.

Originally published in Japanese in Roy Ascott, *Art & Telematics: Toward the Con-struction of New Aesthetics*, trans. E. Fujihara (Tokyo: NTT Publishing Co., 1998).

Computer arts and crafts As with William Morris's nineteenth-century Arts and Crafts movement, we can see a dumbing down from art to craft in digital art, when the authoring of technique takes primacy over the authoring of ideas.

Connectitude Moral messaging, correctness of behaviour in the Net.

Connectivity Connectionism is the way of cognitive scientists; connectivism is the way of the technoetic artist. They converge where the artificial collaborates with the natural in a new synthesis of being.

Cross-sectoral sensibility A new creative practice, unnamed and unbounded, crosses the domains of art, science, technology, and philosophy, but is centred in none. Its principal concern is with mind, states of being, and the process of becoming.

Cyberpower Virtual reality corrupts and absolute reality corrupts absolutely, whenever the constraints and limitations of its construction are preordained, predefined, or pre-set.

Cyberception The emergent human faculty of technologically augmented cognition and perception.

Cyberself We are each made up of many selves: de-centred, distributed, and constructively schizophrenic. We are the embodiment of technoetic relativity.

Cyberstress Induced by inertia in fast-flowing streams of transformation and translocation.

Cyburbs We shall all move from the city to the cyburbs, wormholing effortlessly between real and virtual locations, meeting with real bodies and telepresences in the same continuum.

Dark matter It is not the dark matter of outer space that interests us so much as the dark matter of consciousness. Maybe it's the same thing.

Data foam Wormholes are found tunnelling in quantum foam—connecting widely separated locations in the galaxy. We tunnel through data foam from hyperlink to hyperlink, across our planetary web.

Datapool A metaphor for the digital museum into which data flows, endlessly transformed through human interaction, and from which it flows on out into the data sea. Post-biological life forms grow in these datapools just as proto-organisms emerged from primeval rock pools.

Design Design was always a top-down affair with blueprints, master plans, and models. Now it's a bottom-up process, its algorithms growing from a telematic substrate.

DMT (digital media toxin) Unlike the natural hallucinogen dimethyltryptamine (DMT) in the shaman's brew *ayahuasca*, digital media toxin is a synthetic hallucinogen that is poisonous if taken in excess. Ayahu-ascii could be one example, joining the vegetal mind expansion of *ayahuasca* with the silicon mind expansion of ASCII characters.

Double consciousness The state of being that gives access, at one and the same time, to two distinctly different fields of experience: psychic space and cyberspace, the material world and the virtual, in an artwork and outside of it.

Double gazing We see, hear, and feel in ways unknown to biological man, just as the environment increasingly hears, sees, and feels us. With retina-tracking lasers, the artist's gaze is returned; the walls have ears, and buildings will speak volumes.

Edificiality A weakness of Western architecture that shows too much concern with surface and too little concern with transformative systems.

Enactment Just as a shamanic ceremony is not a public performance but a spiritual *enactment*, entailing the structuring of psychic forces without an audience, so interactive art should involve an enactment of mind, immersed in an intimate system.

Evolutionary environment It will be the mutations in design and the randomness in bottom-up construction that will make artificial environments become complex and clever.

Farming on-line Cyberspace is where we seed concepts and plant images. Their growth depends on cybersynthesis rather than photosynthesis.

FDS and OES FDS are finite data sets: action within pre-designed limits, presented as either a unitary or a so-called interactive experience, with the artist in control.

OES are open-ended systems: interaction within networked or evolutive systems that put the user or the environment in control.

Feral networking How quickly computer-based art can be tamed and domesticated! The wild cats are relatively few, but their presence in the Internet jungle is our only guarantee against complacency.

Fivefold path The Tao of telematics has five steps: connectivity, immersion, interaction, transformation, and emergence.

Gaiatronics The technological amelioration of planetary life.

Gardens of hypotheses Museums imprison metaphors. Gardens of hypotheses are to the technoetic culture what the neo-Georgian museum was to classical culture.

Hermeneutic error In the pre-telematic era, we thought the world was full of meaning, a text to be interpreted, a great book waiting to be read. Now we see that we write our own reality and negotiate for meaning through interaction.

HMD Heel-mounted display for bottom-up viewing of emergent processes!

Holomatics The holomatic principle is that each network interface is an aspect of a telematic unity: to be at any one is to be in the virtual presence of all others throughout the network.

Horhizome The event horizon of the Net.

Hypercortex The global network of collective cognition. Superthought comes from its community of mind, wisdom from its hyperstructure of experience.

Hyperdata Data converging from scattered sources, split into uncertain trajectories of meaning. This darting to and fro of data, colliding, emitting new combinations, and absorbing each other is a kind of quantum behaviour.

Hyper-hiker This is Kerouac's *On the Road* with software. The hyper-hiker charts a different highway from the old Beat generation. Upbeat, downloaded, empowerbooked, and taking every branch of the digital highway.

Immateriality The dematerialisation of art, telemedia, and virtual reality leads inexorably to the re-materialisation of culture in the form of artificial life.

Implicate process Where the artist's enfolding of ideas and images in a density of Web connections is accompanied by the unfolding of links and trajectories created by the user's interactions.

Interactivity The trivial form is a closed system with a finite data set. The non-trivial form has the open-ended capacity to accommodate new variables.

Interneticity As plasticity was to the visual arts, so interneticity is to the telematic arts.

Interspace Found between the virtual and the actual, where reality is renegotiated and the new consciousness is embodied.

Interstitial practice Art located at the meeting point of bio-electronics, nano-engineering and the science of consciousness.

Ki Consciousness in artificial systems, self-aware machines, and intelligent architecture. The Japanese know this spiritual energy to be intrinsic to advanced technology.

Mars The only place left to go if bottom-up structures and cultures are to have untrammelled freedom to evolve. To achieve any kind of gravity of purpose, visionary free-fall is first required.

Mind-altering technologies Surgeon-General's warning: Digital dependency can seriously endanger your health.

Mind-city As neural networks meet planetary networks and make the connection, so our brain will invade the city and the city will enter our brain.

Mystemics The systems study of mystical consciousness, in architectural, iconic, and ritualistic form.

Nano-navigation Our present multimedia explorations will go progressively further and deeper as we penetrate the nano-level of particle consciousness. Our bodies will host the chips that process these navigations.

Nature II Our direct involvement in the evolution of artificial life, assisted by bio-telematic connectivity, is leading to the replacement of the old authorised nature by Nature II.

Net-extent Our net-extent defines us in telematic space just as the material body defined us in the old biological culture. We are now weightless and dimensionless in any exact sense. We are measured by our connectivity.

Neuro-cosmology Artificial neural networks are merging with planetary networks in a new space of consciousness. We shall chart the mind as we chart the sky, creating new cognitive constellations, noetic zodiacs.

Noetic networks Our personal neural networks merge with global networks to create a new space of consciousness.

Non-linear identity I connect, therefore I am multiple.

Notitia immaturana Underdeveloped, unformed ideas about the nature of reality.

Paramentation The cerebral activity of collective intelligence.

Paranature Absorbs, recontextualises, and goes beyond nature, technologically assisting in its many inadequacies. Paranormal experience, suppressed in industrial society, is reintegrating into everyday life.

Phantom audience A passive, voyeuristic, phantom audience is often implicit in the very art that claims to have rejected the inert viewer in favour of the interactive user. This is due largely to the persistence of the museum culture.

Photomutation In the multimedia culture, the silence of the lens dies the death of the early movies: mute images mutate to the sonic state.

Phreno-fractals Freud is dead and the myth of the unified individual has been destroyed. We are each made up of many selves: de-centred, distributed, and tele-schizophrenic. Our minds have an infinity of phreno-fractals constantly creating alternative realities.

Planetary Collegium Promotes web wisdom and online learning. Just as the monastery gave way to the university in mediaeval Europe, so now the university will give way to the Planetary Collegium.

PoBio city An architecture of systems interfaces and network nodes informing the conjunction of cyberspace and built environment. The antithesis of the PoMo architecture of façade and style.

Post-biological era The old disputes between modernism and poststructuralism, grand narrative and semantic negation dissolve before the prospect of post-biological life.

Post-photographic practice The digital camera is a tool for constructing reality, the mechanical camera a tool for reflecting it.

Psibernetic phenomena The human desire for transcendence takes many forms: telepathy, telekinesis, out-of-body experience. Now we have telematics, telepresence, and the aesthetics of apparition.

Psiborg Psychically extended organism, human but with vastly increased powers of psychic perception.

Radical constructivism/Radical connectivism The radical constructivism of post-biological philosophy joined with the radical connectivism of telematic art can provide a scenario of living in which we take on responsibility for the construction of our own identity and the reality it inhabits.

Replocator At the molecular level, a replicator is an entity that causes certain environments to copy it. At the mirror site, a replocator is an environment that causes certain entities to copy it.

Sentient Net The conscious Net is the feeling Net. In artificial systems, only emotional intelligence can produce truly augmented thought.

Shamantics Foregrounding the semantic aspect of shamanism in the technoetic context.

Sipápuni The ritual hole in Hopi kivas that represents the place of emergence from the previous world into this one. By creating *sipápuni* in cyberspace, we can wormhole into other realities.

Smart architecture To support the realities of cyborg living, the distributed self, and our technoetic ecology, architecture will have to become more conscious, anticipatory, and responsive.

Software, passion, chance These are the three vectors of techno-creativity. No one of them is sufficient alone.

Spiritual software The soul of the machine.

State-of-the-heart Only when computers are able to love will they be able to think.

STMs In scanning tunnelling microscopes, imaging and manipulation of molecular construction combine, thus making the STM the new tool for pico-sculpture and interface design.

Structural analysis Psychotherapy for intelligent buildings may be more appropriate than putting ourselves in analysis. Think of all the psychotic and schizophrenic places you know.

Subtle, intimate, ubiquitous The three conditions to which all interactive art aspires.

Supervenience Mind is supervenient on the activity of its interfaces, whether organic or telematic, and although mind is ubiquitous and always present, it requires matter to become manifest.

Technoetic aesthetics The classical concern with the surface image of the world gives way to the technoetic aesthetics of creative consciousness and artificial life.

Techno-formalism A pixel is a pixel is a pixel.

Technostic Having esoteric, occult, spiritual knowledge revealed through technology.

Techno-qualia The philosophy of the senses must recognise that the human sensorium is expanding to include entirely new sensations and perceptions.

Teleclonics Dolly the lamb reminded us that the geographical dispersal of clones around the world is mirrored by our own distribution in telepresence throughout cyberspace.

Telemadic Where the ancients were nomadic, we are restlessly telemadic, our minds traversing the vast interspaces of the worldwide networks of technology and consciousness.

Telematic Imperative When there are no more geographical boundaries, territorial aggression is as irrelevant as polarized politics. The only imperative is to connect. Nowadays even the self is permeable.

Telenoia Telenoia celebrates the networked consciousness of global connectivity. It replaces the anxious, alienated, secretive, and neurotically private paranoia of the old industrial culture.

Teleprescience In cyberspace our consciousness accelerates to a higher state of prescience: teleprescience. It means that we anticipate faster, and foresee further.

Telepresence Art has always concerned itself with presence: of gods in religious art, heroes in classical art, the artist in romantic art; of presence itself in abstract art. In telematic art, our telepresence is distributed throughout the Internet. We are both here and there, out-of-body and reembodied, dematerialised, and re-configured at one and the same time.

T-space Traditionally, art was constructed in 2-space or 3-space. The digital arts occupy telematic space that both collapses classical space and deterritorialises time.

Turing test Turing the Net, hitting the hot spots, visiting exotic sites. The challenge of turism in cyberspace. Are you who I think you are? Am I where you think I am?

Values New values, new politics, and new ways of living are emerging from our global connectivity.

Variable reality Dry reality is found in the arid spaces of VR.

Wet reality is the nature that we nurture.

Moist reality emerges from the biotechnology of artificial life.

World-mind Planetary self-awareness and cognition arising from the technoetic Web.

Wormhole Intrinsic to hypermedia in cyberspace, the wormhole also is as essential a requirement of urban systems as of galaxies, facilitating our passage between real and virtual spaces and between natural and paranatural worlds.

Zen The new necessity in art is watchful preparedness: standing back in a Zen-like state of readiness to allow new ideas and forms to emerge from the hyper-connectivity of the Net, then to cultivate, nurture, and reseed them.

PROFESSIONAL APPOINTMENTS

Academic Appointments

1959–61 Studio demonstrator in fine art, King's College, University of Durham, England

1961–64 Head of Foundation Studies, Ealing School of Art, London

1964–67 Head of Department of Fine Art, Ipswich Civic College, Suffolk, England

1967–71 Head of Department of Painting, Wolverhampton Polytechnic, England

1968–71 Visiting lecturer in painting, Slade School of Fine Art, University College, London

1971–72 President, chief executive officer, Ontario College of Art, Toronto

1973–74 Visiting tutor in sculpture, Saint Martin's School of Art, London, and Central School of Art & Design, London

1974–75 Professor, chair, Department of Fine Art, Minneapolis College of Art & Design, Minneapolis

1975–78 Vice-president and Dean of the College, San Francisco Art Institute, San Francisco

1980–93 Head of Fine Art, Newport School of Art & Design, Gwent College of Higher Education, Wales

1985–92 Professor for communications theory, head of the Department of Communications Theory, University of Applied Arts (Hochschule für angewandte Kunst), Vienna

1991–98 Visiting lecturer, Diplôme d'Études supérieures transdisciplinaires, CETEC, UER Économie appliquée, Université Paris-Dauphine, Paris

1994– University of Wales professor of interactive arts, founder and director of the Centre for Advanced Inquiry in the Interactive Arts (CAiiA), University of Wales College, Newport, U.K. (See appendix IV).

1997– Professor of technoetic art, director of the Science Technology and Art Research Centre (STAR), School of Computing, University of Plymouth, England

2000– Adjunct professor, School of the Arts, University of California, Los Angeles

Advisory and Editorial Appointments

1964–65 Chair, Form and Amenities Committee, Joan Littlewood's Fun Palace project, London

1969–71 National Advisory Council on Art Education for England and Wales

1972– Honorary editor, *Leonardo: Journal of the International Society for the Arts, Sciences and Technology*, MIT Press

1975–78 Board of directors, Union of Independent Colleges of Art, United States

1977 Curator, Social Criticism and Art Practice, San Francisco Art Institute Gallery, San Francisco

1978 Chair, 1st International Symposium, Center for Critical Inquiry, San Francisco Art Institute, San Francisco

1985–86 Chef de mission, Projet de Création d'un Centre de Formation et de Recherches visuelles dans la région Nord–Pas-de-Calais, France

1986 International Commissioner, Art, Technology and Informatics, XLII Biennale of Venice

1987 Vice-president, International UNESCO Seminar, Synthesis: Visual Arts in the Electronic Culture, Offenbach-am-Main, Germany

1988 Jury Member, PLEIAS, European Computer Art Concours, Sorbonne, Paris

1989 President, International UNESCO Seminar, Training of Creators in New Technologies, Université du Québec à Montréal

1989–98 Member, Comité international, CETEC, Le Centre Européen de Technoculture, Université Paris-Dauphine, Paris

1990, 1993, 1997, 2000

 Chair, Artists' Panel, Annual Conference, College Art Association of America

1990–95 Jury member, Interactive Art, Prix Ars Electronica, Linz, Austria

1990– Editorial advisor, *International Directory of the Electronic Arts / Guide international des Arts électroniques*, John Libby, London / CHAOS, Paris

1991 Guest editor, with Carl Loeffler, *Leonardo* 24, no. 2, *Connectivity: Art and Interactive Telecommunications*, MIT Press

1991–93 Editorial Board, *Time and Society*, Sage Publications, London

1991–94 Board member, European League of Institutes of the Arts

1991–95 Associate, Cyprès, Centre interculturel de Pratiques, Recherches et Échanges trans-disciplinaires, Aix-en-Provence

1992 Director of the Atelier "Connectivity," Differentiel/s, Aix-en-Provence

1992–95 International Committee, International Symposium on Electronic Art (Sydney, Minneapolis, Helsinki, Montreal)

1993 Consultant, art and technologies, Délégation aux Arts Plastiques, Ministère de la Culture, Paris

1993–94 Comité Asesor, Intermedia, Nuevas Tecnologías, Creación, Cultura, Madrid

1994 Consultant, Nippon Telephone and Telegraph (Paris Bureau) Inter-Communication Centre

1994–95 Advisory Board and Jury, Interactive Media Festival, Los Angeles

1994– Comitato Scientifico, *Epipháneia, Ricerca estetica e tecnologie*, Minervini, Naples

1994– Editorial Board, *Leonardo Electronic Almanac*, MIT Press

1994– Guest editor, "The Planetary Collegium: Towards the Radical Reconstruction of Art Education," *Leonardo: Journal of the International Society for the Arts, Sciences and Technology*, MIT Press

1995–96 Specialist, Audio-Visual Arts, Task Force of the Arts Education and Training Initiative DG XXII, Commission of European Communities, Brussels

1995–97 Mediateca, Fondació "La Caixa," Barcelona

1995– Editorial Board, *Convergence*, Journal of Research into New Media Technologies, Luton, England

1996 International Committee, 5th International Conference on Cyberspace, 5Cyberconf, Madrid

1996–99 Arts Council of England, Visual Arts Advisory Board

1996–99 Overseeing Committee, Multimedia Arts, European Commission (Tempus Programme), Bucharest

1997, 2000– Advisory Council, Nippon Telephone & Telegraph Co. Ltd. (NTT) InterCommunication Center, Tokyo

1997–2000 Advisory Panel, The Gallery of the Future, Loughborough University

1997– Editorial Board, *Digital Creativity*, Swets & Zeitlinger Publishers, Lisse, Netherlands

1997– Guest editor, "Art and Consciousness Research," *Leonardo: Journal of the International Society for the Arts, Sciences and Technology*, MIT Press

1998 STWEAG '98 Jury, Graz, Austria

1998 Guest editor, *Computers and Post-Biological Art*, special issue, *Digital Creativity* 9, no. 1 (Lisse, Netherlands: Swets & Zeitlinger)

1998–99 Jury Chamber, Biennale Exhibition, NTT InterCommunication Center, Tokyo

1999– Advisory Board, Skopje Center for Contemporary Art, Skopje, Macedonia

2000	Technical Committee, VISUAL-2000, 3d International Conference on Visual Computing, Mexico City
2000–2001	Advisory Board, CEM—Centro em Movimento, Lisbon
2000–2001	Advisory Board, Lugar Comum, Lisbon
2000–	Editorial Board, *Consciousness, Literature and the Arts,* University of Wales, Aberystwyth
2000–	Advisor, "Nabi" Media Art Center, Seoul
2001–	New media arts editor, <www.tom.com> online magazine, Beijing
2002–	Founding editor, *Technoetic Arts: International Journal of Speculative Research,* Intellect Books, Bristol, England
2002–	Advisory Board, Digi-Arts Project, UNESCO, Paris
2002–	Editorial Board, *Journal of Collective Intelligence,* University of Ottawa

Collections of Essays Authored by Roy Ascott

Art and Telematics: Toward the Construction of New Aesthetics. In Japanese. Translated with an introducion by Erimi Fujihara. Tokyo: Nippon Telephone and Telegraph Publishing Co., 1998.

Collections Edited by Roy Ascott

Art. Technology. Consciousness. Bristol, U.K.: Intellect Books, 2000.

Consciousness Reframed: Art and Consciousness in the Post-Biological Era. 1st International CAiiA Research Conference Proceedings. Newport: University of Wales College, Newport, 1997.

Reframing Consciousness. Exeter, U.K.: Intellect Books, 1999.

Commissioned Reports

Das AEC als Datapool. In *AEC, Ars Electronica Center Projectstudie,* ed. Hannes Leopold-seder, II/1–II/48. Linz: ORF, 1993.

Identity in Cyberspace: Pilot Project for a European Cyberspace Collegium. (Brussels: Commission of the European Communities, D.G. XXII, 1996).

Information Technology Assessment Report. Tate Gallery Application. Arts Council of England Lottery Department, 1998.

Projet de création d'un centre de formation et de récherches visuelles dans la région Nord–Pas-de-Calais. Project to create a centre for teaching and visual research in the Nord–Pas-de-Calais region of France. Report to the Conseil régional, Lille, 1986.

Essays in Books, Journals, Conference Proceedings, Exhibition Catalogues, and Other Publications

1964-69

"Artists on Their Art." *Art International* (Zurich) 12 (1968): 22.

"Behaviourist Art and the Cybernetic Vision." *Cybernetica: Journal of the International Association for Cybernetics* (Namur), pt. 1, "Behaviourist Art," 9 (1966): 247–64; pt. 2, "The Cybernetic Vision in Art," 10 (1967): 25–56. Excerpted in *Multimedia: From Wagner to Virtual Reality,* ed. Randall Packer and Ken Jordan (New York: Norton, 2001).

"The Construction of Change." *Cambridge Opinion* 37, *Modern Art in Britain* (January 1964): 37–42.

"The Cybernetic Stance: My Process and Purpose." *Leonardo* 1 (1968): 105–12. Reprinted in *Visual Art, Mathematics and Computers*, ed. Frank Malina, 135–42 (Oxford: Pergamon Press, 1979).

Diagram Boxes and Analogue Structures. Exhibition catalogue. London: Molton Gallery, 1964.

"Statement." *Control* (London) 1 (1966): n.p.

1970-79

"Art as an Alternative to Education, or, The Rise of the Jam Factory." *Art* (Society of Canadian Artists) 3, 1 (Spring–Summer, 1972): 14–16.

"Behaviourables and Futuribles." *Control* (London) 5 (1970): 3. Reprinted in *Theories and Documents of Contemporary Art*, ed. Kristine Stiles and Peter Selz, 396 (Berkeley and Los Angeles: University of California Press, 1996).

"The Psi-bernetic Arch." *Studio International* (April 1970): 181–82.

"Table." *House: The Journal of the London Architecture Club* 1, 1 (1975): n.p.

1980

"Towards a Field Theory for Postmodernist Art." *Leonardo* 13: 51–52.

1983

Ascott, Roy. "La Plissure du texte." In *Electra: L'Electricité et l'electronique dans l'art au XX siecle / Electricity and Electronics in the Art of the Twentieth Century*, 398–99. Paris: Musée d'Art Moderne de la Ville de Paris.

1984

"Art and Telematics: Towards a Network Consciousness / Kunst und Telematik / L'Art et le télématique." In *Art + Telecommunication*, ed. H. Grundmann, 25–67. Vancouver: Western Front.

"Behaviour at Table." In *Architectural Projects and Drawings from the Studio of Alsop, Barnett & Lyall*, 35. London: Architectural Association.

1985

"Concerning Nets and Spurs / Netze und Sporen." In *Artificial Intelligence in the Arts*, ed. Richard Kriesche, 44–51. Graz: Steirischer Herbst.

1986

"Arte, tecnologia e computer." In *Arte e scienza: Biologia, tecnologia e informatica*, ed. C. Pirovano, 187–88. Venice: Biennale internazionale d'arte.

"Art, Technology and Computer Science." In *XLII Esposizione internazionale d'arte: La Biennale di Venezia: Arte e scienza*, ed. M. Calvesi, 33–35. Venice: Biennale inter-

nazionale d'arte. Reprinted in *Cultura Digitalis*, ed. Z. Wiener, 6–7 (Vienna: Österreichische Wissenschaftsmesse, 1987).

"Le Moment télématique." *Inter* (Spring): 11. Reprinted in *L'estetica della comunicazione*, ed. M. Costa, 81–84. Salerno: Palladio Editrice, 1987.

1987

"Digitary-do." *Australian and International Art Monthly*, October, 21–22.

1988

"Art and Education in the Telematic Culture." *Leonardo*, supplemental issue (September): 7–11. Translated as "Kunst und Erziehung in der telematischen Kultur," *Bildende Kunst* (1988): 61–63. Reprinted as "Art and Education in the Telematic Culture / Kunst und Erziehung in der telematischen Kultur," in *Synthesis—Visual Arts in the Electronic Culture / Die visuellen Künst in der elektronischen Kultur*, ed. M. Eisenbeis and H. Hageböling, 184–203 (Offenbach am Main: Hochschule für Gestaltung, 1989).

"On Networking." *Leonardo* 21, 3: 231–32. Reprinted in *The Future Shape of Fine Art Education*, ed. G. Foster, 16–17 (Kingston on Thames, U.K.: Kingston on Thames Polytechnic, 1986).

"Supervernetzung in unendlichen Datenraum." In *Zwischen Null und Eins*, ed. P. Purgathofer, 53–59. Vienna: Technische Universität, 1988. Reprinted in *Anthologie Medienkunst, European Media Art Festival*, ed. J. Coldeway, 332–36 (Osnabrück, Ger., 1988).

1989

"Gesamtdatenwerk: Konnektivität, Transformation und Tranzendenz." *Kunstforum* (Cologne) 103 (September–October): 100–109. Translated as "Gesamtdatenwerk: Connectivity, Transformation and Transcendence," in *Ars Electronica: Facing the Future*, ed. Tim Druckrey, 86–89 (Cambridge, Mass.: MIT Press, 1999).

"Karte wird zum Territorium / A térkép területte lesz." In *Karten/Térképek*, 6–8. Budapest: Magyar Iparmuvészeti Foiskola, 1989.

"The Prospect of a Telematic Culture." In *Mutual Uses of Cybernetics and Science*, ed. G. de Zeeuw and R. Glanville, 13–18. Amsterdam: Thesis Publishers, 1989.

1990

"Beyond Time-Based Art: ESP, PDP, & PU." *Zeit: Sterz-Zeitschrift für Literatur, Kunst und Politik* (Graz) 48: 27–29. Reprinted in *New Observations*, special issue, *Navigating the Telmatic Sea*, ed. Bruce Breland, 76 (1990): 18–20.

"Global Vision." In *L'arte telematica per un'Europa più unita*, ed. G. Salerno. Borgo di Calcata, VT, Italy.

"Is There Love in the Telematic Embrace?" *Art Journal* 49, 3: 241–47. Reprinted in *Theories and Documents of Contemporary Art*, ed. Kristine Stiles and Peter Selz, 491–98 (Berkeley and Los Angeles: University of California Press, 1996).

1991

Art and Telecommunications, special issue, *Leonardo* 24, 2. Guest editor, with Carl Loeffler. Editorial statement, "Connectivity: Art and Interactive Telecommunications," 115–18.

"Art and Technology: Virtual Worlds." In *Virtuelle Werelden: Beeld Media & Technologie in de Kunst: Roy Ascott, Peter Beyls, Hugo Heyerman,* ed. G. Van Looy, 3. Antwerp: International Cultureel Centrum.

"Das Konnektivistische Paradigma: Kunst im Elektronischen Raum und in der molekularen Zeit." In *Die Geometrie des Schweigens,* ed. Heidi Grundmann, 24–27. Vienna: Museum Moderner Kunst Stiftung. Translated as "The Connectivist Paradigm," *Journal of Electroacoustic Music* (Aberdeen) 6 (1993): 4–9.

"Die Kunst Intelligenter Systeme / The Art of Intelligent Systems." In Der Prix Ars Electronica: Edition 91, ed. Hannes Leopoldseder, 25–33. Linz: Veritas-Verlag.

"Das Museum—neugedacht / In den Gärten der Hypothesen." In *UND: Das Buch zur Museumwelt und darüber hinaus,* ed. J. Baur, 63–75. Graz: Leykam Buchverlag.

"Reti di trasformazione e rinascita dell'arte." In *Artmedia,* ed. M. Costa, 75–80. Salerno: Relazioni.

1992

"Akademien: Im Rückzug oder am Neubeginn? Gedanken zur elektronisch-nanonischen Entwicklung." In *Die Elektronische Akademie,* ed. Richard Kriesche, 20–24. Offenbach: HfG.

"Declaración." *Mente Global* (Barcelona: Art Futura): 78–79.

"Keine einfache Materie: Der Künstler als Medienproduzent in einem Universum der komplexen Systeme." In *INTERFACE: Elektronische Medien und künstlerische Kreativität,* 75–79. Hamburg: Hans Brelaw Institut. Reprinted in English as "No Simple Matter: Artist as Media Producer in a Universe of Complex Systems," *AND: Journal of Art* (London) 28 (1993): 3.

"Mind City / Cité Cerveau." In *Art-Réseaux,* ed. Karen O'Rourke, 68–69. Paris: Éditions du C.E.R.A.P.

"La photographie à l'interface." In *Digital Photography,* ed. Annick Bureaud, 3–6. Paris: Centre National de la Photographie. Reprinted as "Photography at the Interface," in *Electronic Culture: Technology and Visual Representation,* ed. Tim Druckrey, 165–72 (New York: Aperture, 1996).

1993

"From Appearance to Apparition: Communications and Culture in the Cybersphere." In *FISEA: Fourth International Symposium on Electronic Arts,* ed. R. Verostko, 5–12 (Minneapolis: MCAD). Reprinted in *Leonardo* Electronic Almanac 1, 3 <http://mit press.mit.edu/e-journals/LEA> (1994). Translated as "De la apariencia a la aparición," *Intermedia: Nuevas tecnologías, creación, cultura* (Madrid) 1, 1 (1994): 73–77; "De l'apparence à l'apparition: Communication et conscience dans la cybersphère," *Terminal* (Paris) 63 (1994): 27–38; and "Dall'apparenza all'apparizione: Comuni-

cazione e cultura nella cybersfera / From Appearance to Apparition: Communications and Culture in the Cybersphere," in *Creativita alternativa e valori umani: Cani sciolti nella galassia*, ed. G. Broi, 125–45 (Florence: Edizione regione toscana, 1995). Revised and reprinted as "From Appearance to Apparition: Dark Fibre, Boxed Cats and Biocontrollers," *Intelligent Tutoring Media* (Oxford) 6, 1 (1994): 5–10. Translated by R. Kluszynski as "Od wygladu do zjawiskowosci: Komunikacja i kultura w cyberprzestrzeni," *Magazyn Sztuki* (Gdansk) 6–7, 2–3: 190–97.

"Heavenly Bodies." In *Teleskulptur III*, ed. Richard Kriesche, 13–15 (Graz: Kulturdata).

"Telenoia." In *On Line—Kunst im Netz*, ed. Robert Adrian, 135–46. Graz: Steirischen Kukturinitiative. Translated by E. Fujiwara, *InterCommunication* (Tokyo) 7 (1995): 114–23. Translated by S. Leblanc in *Esthétique des arts médiatiques*, ed. Louis Poissant, 1: 363–84 (Québec: Presses de l'Université du Québec, 1995).

"Telenoia: Art in the Age of Artificial Life." *Leonardo* 26, 3: 176–77.

"Telenoia: Mind-at-Large." In *Zero—The Art of Being Everywhere*, ed. H. Ranzenbacher, 102–5. Graz: Steirische Kulturinitiative.

"Zurück zur (künstlichen) Natur." In *Kultur und Technik im 21. Jahrhundert*, ed. G. Kaiser, D. Matejovski, and J. Fedrowitz, 341–55. Frankfurt: Campus Verlag. Translated as "El Retorno a la Naturaleza II," *Zehar, boletín de Arteluku* 31 (Summer): 8–15.

1994

"The Architecture of Cyberception." *Leonardo* Electronic Almanac 2, 8 <http://mitpress.mit.edu/ejournals/LEA> on-line publication. Reprinted in *Architects in Cyberspace*, ed. M. Toy, 38–41 (London: Academy Editions, 1994). Translated by A. Bourgeois as "L'architecture de la cyberception," in *Les cinq sens de la création: Art, technologie et sensorialité*, ed. Mario Borillo and Anne Sauvageot, 184–94 (Seysell, Fr.: Champ Vallon, 1996). Translated by Mela Dávila as "La arquitectura de la cibercepción," in *Ars telematica: Telecomunicación, Internet y ciberespacio*, ed. Claudia Giannetti, 95–101 (Barcelona: Associació de cultura contemporània L'Angelot, 1998). Translated by Lucia Leão as "Arquitectura da ciberpercepção," in *Interlab*, ed. L. Leão (São Paulo: Iluminuras, 1999). Translated by Sónia Marques as "A Arquitectura da Cibercepção," in *Ars telemática: Telecomunicação, Internet e ciberespaço*, ed. C. Giannetti, 163–178 (Lisbon: Relógio d'Agua, 1999).

"The Centre That Can Hold." *Times Higher Education Supplement* (London), 12 August, iii.

"Minute Manifesto." *Leonardo* Electronic Almanac 2, 8 <http://www.mitpress.mit.edu/LEA/home.html> on-line publication.

"La Mort de l'artifice et la naissance de la vie artificielle: Une Approche connectiviste / The Death of Artifice and the Birth of Artificial Life: A Connectivist Approach." In *Art/cognition: Pratiques artistiques et sciences cognitives*, ed. M. Partouche, 76–185. Aix-en-Provence: CYPRES: Ecole d'art d'Aix-en-Provence

"Time for a Planetary Collegium." *Times Higher Education Supplement* (London), 16 September, v. Reprinted in *ISEA '94: Catalogue and Proceedings of the Symposium*. Helsinki: UIAH.

1995

"Aesthetics Argued on a Phone Extension." *Times Higher Education Supplement* (London), 10 November, Multimedia section vi–vii.

"Die Ästhetik des Erscheinenden / Apparitional Aesthetics." In *Prix Ars Electronica 95: Internationales Kompendium der Computerkünste*, ed. Hannes Leopoldseder, 15–22. Linz: Österreichischer Rundfunk, Landesstudio Oberösterreich.

"Digital Arts Glossary." In *Digital Express*, ed. Roy Ascott, 1, 16. Bath, U.K.: f.StopMedi@Station. Reprinted in *Point: Art + Design Research Journal* (London) 1 (1996): 8–11.

"From Cyberspace to Our Space." In *Digital Creativity: Proceedings of the 1st Conference on Computers in Art & Design Education (CADE '95), University of Brighton 18–21 April 1995*, ed. Colin Beardon, 157–62. Brighton, U.K.: University of Brighton.

"Homo Telematicus in the Garden of A-Life." *Tightrope* (online journal) <http://www.geelhaar.de/tr/intro.html>.

"Interactive Terminology: An Interfacial Glossary." In *Interactive Media Festival*, ed. T. Druckrey and L. Goldman, 19. Los Angeles: Interactive Media Festival.

"Interattività/ Interactivity." In Ente autonomo La Triennale di Milano, *Oltre il villaggio globale / Beyond the Global Village*, 178–83. Catalogue of an exhibition held in the Palazzo dell'arte, Milan, 23 May–25 June 1995. Milan: Electa.

"Muzeum cyfrowe. Kultura telematyczna i sztuczne życie." Translated by R. Kluszynski. *Magazyn Sztuki* (Gdansk) 5, 1: 287–300.

"The Museum of the Third Kind." Translated by E. Fujiwara, *InterCommunication* (Tokyo) 15: 74–79.

"Nature II: Telematic Culture and Artificial Life." *Convergence: Journal of Research into New Media Technologies* (London) 1, 1: 23–30. Translated by S. Leblanc in *Esthétique des arts médiatiques*, ed. Louis Poissant, 2: 437–52. Québec: Presses de l'Université du Québec.

"Noetic Nodes." In *Viper '95: Internationales Film-Video-und Multimedia-Festival*, ed. M. Wepf, 171–74. Lucerne, Switzerland: Zyklop Verlag.

Untitled statement. In *La nuova Europa / A New Europe*, ed. C. Stano, 26–27. Palermo: L'Epos.

1996

"Art and Mind: The Technology of Transformation." *Actualité de France*, 1: 22–23.

"The A–Z of Interactive Art." *Leonardo* Electronic Almanac 3, 9 <http://mitpress.mit.edu/ejournals/LEA> online publication.

"Cyborg est un verbe / Cyborg Is a Verb." In *International Directory of the Electronic Arts / Guide International des Arts Electroniques*, ed. Annick Bureaud, 8–13. London: John Libby.

"Das digitale Museum / The Digital Museum." In *Perspektiven der Medienkunst / Media Art Perspectives*, ed. H. Schwartz, 76–83, 183–89. Karlsruhe: Cantz Verlag.

"L'Esthétique de la Cyberculture." Translated by S. LeBlanc. *Spirale* (Montréal), September–October, 24–25. Reprinted in *Atopie* (Neuilly sur Seine), no. 2 (1996): 1–4.

"The Gallery in the Net." In *Virtual Reality and the Gallery,* ed. K. Atherton. Compact disk. London: Chelsea College of Art & Design.

"Der Geist des Museums." Translated by Florian Roetzer. *Telepolis—Das Magazin der Netzkultur* (on-line publication), <http://www.heise.de/tp> 1995.

"Implicate Art: A Commentary on Accessing http://www.ntticc.or.jp/ic95/." In *On the Web,* 132–35. Tokyo: NTT ICC. Reprinted in *Leonardo* Electronic Almanac 4, 8 <http://mitpress.mit.edu/ejournals/LEA> on-line publication.

"Networks of the Mind: Art and the Emergent Noetic Culture." In *Creativity and Cognition, 1996: Proceedings of the Second International Symposium,* ed. L. Candy and E. Edmonds, 167–75. Loughborough, U.K.: LUTCHI Research Centre.

"Das Netz, das fühlen kann / The Sentient Net." In *Ars Electronica Center, Museum der Zukunft / Museum of the Future,* ed. Hannes Leopoldseder, 64–71. Linz: Ars Electronica Center.

"Noetic Aesthetics: Art and Telematic Consciousness." In *Consciousness Research Abstracts: Toward a Science of Consciousness 1996,* 171. Tucson: University of Arizona.

"The Planetary Collegium: Art and Education in the Post-Biological Era." *Artlink* (Sydney) 16, 2–3: 51–54.

"Reference Points in Cyberspace: A Glossary." *Epiphaneia* (Naples) 1: 26.

"Techno-Anxieties, Guilt and the Restoration of a Material World." *Times Higher Education Supplement* (London), 13 September, 36–37.

"Wormholing in Cyburbia, and Other Paranatural Pleasures." In *Proceedings, 6th International Symposium on Electronic Art,* 1–7. Montreal: ISEA.

1997

"Artists Teaching Artists: A New Paradigm." In *Proceedings, Seventh International Symposium on Electronic Art,* ed. M. Roetto, 45. Rotterdam: ISEA.

"Cultivando o hipercórtex." Translated by Flavia Saretta. In *A Arte no Século XXI: A humanização das tecnologias,* ed. Diana Domingues, 336–44. São Paulo: University of São Paulo.

"Discourse on Utopia." Translated by E. Fujiwara, *InterCommunication* (Tokyo) 21: 178.

"Entrevista." In *El Arte en las Redes,* ed J. A. Lleo, 139–46. Madrid: Ediciones Anaya Multimedia S.A.

"Intabyu." Translated by E. Fujiwara. In *The Multimedia and Cultural Evolution,* ed. M. Sekiguchi, 94–99. Tokyo: Nippon Telegraph and Telephone Publishing Co. Ltd.

"Der Tag, an dem der Computer seufzt." *Telepolis: Die Zeitschrift der Netzkultur* 3 (September): 32–39.

"The Technoetic Aesthetic: Art and the Matter of Consciousness." In *Consciousness Reframed: Art and Consciousness in the Post-Biological Era, Proceedings of the First International CAiiA Research Conference,* ed. Roy Ascott, unpaginated. University of Wales College, Newport. Translated by Diana Zamudio as "Estética de la Tecnoética: el arte y la construcción de la realidad," in *Arte virtual realidad plural,* ed. K. Ohlenschläger, 33–44 (Monterrey, Mexico: Museo de Monterrey, 1998).

"Turning on Technology." In *techno.seduction: An Exhibition of Multimedia Installation*

Work by Forty Artists, ed. Robert Rindler and Deborah Willis, 12–14. New York: Cooper Union.

1998

Cover artwork, *Leonardo* 31, 1.

"Enactment and Emergence in the Dramaturgy of Artificial Life." In *ACM and ATR Workshop on Technologies for Interactive Movies*, 30–34. New York: Association for Computing Machinery.

"Esthétique et politique de la cyberculture." Translated by Suzanne Leblanc. *Alliage* (Nice) 33–34: 19–24.

"The Shamantic Web: Art et technologie de la conscience." Translated by Myriam Bloedé. In *Pour une ecologie des media: Art, cinéma, vidéo, ordinateur*, ed. M. Klonaris and K. Thomadaki, 88–104. Paris: Astarti.

"The Technoetic Dimension of Art." In *Art@Science*, ed. Christa Sommerer and Laurent Mignonneau, 279–90. New York: Springer.

"Technoetic Structures." In *Architects in Cyberspace II*, ed. N. Spiller (London: Architectural Design); 68: 11/12: 30–32.

1999

"El arte y la materia de la consciencia." *Revista de Arte y Pensamiento* (Valencia) 2: 23–25.

"Dupla visão: Arte e a tecnologia da transcendência." *Revista de Psicanálise da Sociedade Psicanalítica de Porto Alegre* 6, 3: 553–60.

"Entrevista, glossário: Prétextos para discussão." *UNIFACS* (Salvador, Bahia, Brazil) 4, 7: 7–14.

"Judge's Review: A Set of Experiences to Be Celebrated." In *ICC Biennale '97*, ed. K. Nakamura, 33. Tokyo: Nippon Telegraph and Telephone Publishing Co Ltd.

"New Media Strategies." *Leonardo* Electronic Archive 7, 1.

"Technoetic Connectivity." In *Internet Art between the Interactivity, Void and Diss-Authorization*, ed. N. Vlic, 63–73. Skopje: Soros Center for Contemporary Arts.

"The Technoetic Predicate." *Leonardo* 32, 3: 219–20.

"Technoetic Theatre: Performance and Enactment in the Dramaturgy of Artificial Life." In *Proceedings of the 4th International Symposium on Artificial Life and Robotics*, ed. M. Sugisaka. Oita, Japan: University of Oita.

2000

"The Moist Manifesto." In *Kunst–Wissenschaft–Kommunikation. Comm.gr2000az*, ed. H. Konrad and R. Kriesche, 44–49. New York: Springer.

"La visión transformadora / The Transformative Vision." Translated by Antonio Fores. In *Futuros emergentes / Emergent Futures*, ed. Angela Molina and Kepa Landa. Valencia: Institució Alfons el Magnànim.

ART PROJECTS AND EXHIBITIONS

Telematic/Interactive Media Projects

1980-89

"Terminal Art." First U.S.–U.K. telematic art project. Directed by Roy Ascott. 1980.

"Four Wings (Planetary I Ching)." International telematic project. Contributed by Roy Ascott as part of Robert Adrian's "The World in 24 Hours," Ars Electronica Festival, Linz, Austria, 1982.

"La Plissure du texte (A Planetary Fairy Tale)." Telematic project between artists in Paris, Amsterdam, Vienna, Bristol, Sydney, Vancouver, Pittsburgh, Toronto, San Francisco, Honolulu, and Alma, Québec. Directed by Roy Ascott for the exhibition *Electra*, Musée d'Art Moderne, Paris, 1983.

"Organe et fonction d'Alice au Pays des Merveilles." Interactive videotex project (Minitel). Directed by Roy Ascott for the exhibition *Les Immatériaux*, Centre Pompidou, Paris, 1985.

"Sonart: L'Image à distance par son." Slowscan TV by short wave radio transmission, Alma, Québec; Pittsburgh. Directed by Roy Ascott and Robert Adrian. ANNPAC/RAC, Alma, Québec, 1985.

"Planetary Network: Laboratory UBIQUA." Artists in three continents interacting through computer networks, videotex, slowscan TV, fax. Directed by Roy Ascott, Don Foresta, and Tom Sherman. XLII Esposizione internazionale d'arte: La Biennale di Venezia, Venice, 1986.

"Digital Body Exchange." Digital image network between artists in Gwent (Wales), Perth, Sidney, Vienna, and Pittsburgh, 1987.

"Making the Invisible Visible." Telematic image/text exchange between artists at University of Applied Arts, Vienna, Carnegie-Mellon University, and University College London, 1988.

"Aspects of Gaia: Digital Pathways across the Whole Earth." Interactive art installation and telematic project with artists in three continents. Directed by Roy Ascott. Ars Electronica Festival of Art and Technology, Linz, Austria, 1989.

1990-2000

"Texts, Bombs and Videotape." Slowscan TV, digital image, and fax exchange between artists in Vancouver, Pittsburgh, Vienna, and Bristol. Directed by Roy Ascott in collaboration with Paul Sermon. Watershed Media Centre, Bristol, 1991.

"Virtuelle Werelden." Documentary exhibition of computer communication projects by Roy Ascott (also work by Peter Beyls and Hugo Heyrman). Internationaal Cultureel Centrum, Antwerp, 1991.

"Die Geometrie des Schweigens / The Geometry of Silence." Distributed sound installation. Directed by Roy Ascott in collaboration with Matthias Fuchs. Museum Moderner Kunst, Vienna; Ferdinandeum, Innsbruck, 1992.

"Telenoia: A Global Networking Project for the Eighth Day of the Week." Telematic project using vidphone, fax, BBS, and EARN. Directed by Roy Ascott. V2 Organization, 's-Hertogenbosch, Netherlands, 1992.

"Gasflow." Telematic project. Internet and walkie-talkies in a text/sound interchange. Directed by Roy Ascott. Mission Impossible, Gashouder, Amsterdam, 1994.

"Roy Ascott's Telematic Art Projects from 1984–94." Video documentation. Triennale di Milano, Milan, 1995.

"Identity in Cyberspace." WWW and CD-ROM project between artists in Newport, Barcelona, and Dublin. Directed by Roy Ascott. CAiiA, Newport, Wales, 1996.

"Apollo 13." Interactive elevator (Televator). Permanent installation. Concept design by Roy Ascott. Ars Electronica Center, Linz, Austria, 1996.

"Art-ID/Cyb-ID: Identities in Cyberspace." Installation / WWW project (mind-shift .net) by Roy Ascott and Josep Giribet. Biennal do Mercosul, Porto Alegre, Brazil, 1999.

"Art-ID/Cyb-ID: Identities in Cyberspace." WWW project (mind-shift.net) by Roy Ascott and Josep Giribet. European Media Art Festival 2000, Osnabrück, Ger., 3–7 May 2000.

"The Moistmedia Manifesto." Installation. gr2000az. Concept design by Roy Ascott. Graz, Austria, May–October 2000.

Solo Exhibitions of Paintings and Constructions

1960	Univision Gallery, Newcastle upon Tyne
1961	Artists International Association Gallery, London
1961	St. Johns Gallery, York
1963	Molton Gallery, London
1964	Gallerie Suzanne de Conninck, Paris
1965	Hamilton Galleries (Annely Juda), London
1965	Queen's University, Belfast
1968	Ikon Gallery, Birmingham
1968	Laing Art Gallery & Museum, Newcastle upon Tyne
1969	Exe Gallery, Exeter
1970	Angela Flowers Gallery, London
1972	University of Guelph, Ontario

1978 Anna Gardner Gallery, Stinson Beach, California

1980 Dartington Hall, Totnes

Paintings and constructions by Roy Ascott were shown in numerous group exhibitions in the United Kingdom, France, Spain, Sweden, and Germany between 1960 and 1970. Three works made by Roy Ascott in the 1960s were included in the exhibition *The Sixties Art Scene in Britain* at the Barbican Art Gallery, London, March–June 1993. See David Mellor, *The Sixties Art Scene in London* (London: Phaidon Press, 1993).

CAIIA-STAR RESEARCH CONFERENCES

Sensing the Future. Arthouse, Dublin, April 11–12, 1997.

Consciousness Reframed; Art and Consciousness in the Post-Biological Era, 1. University of Wales College, Newport, Caerleon, July 4–7, 1997.

Consciousness Reframed; Art and Consciousness in the Post-Biological Era, 2. University of Wales College, Newport, Caerleon, August 19–22, 1998.

Interstices: The Architecture of Consciousness, University of Plymouth, Port Eliot, August 23–25, 1998.

Emergent Futures. Centro Cultural La Beneficencia, Valencia, December 4–5, 1998.

Emergent Futures. Les Triches, Marseilles, April 12–13, 1999.

Emergent Futures. Federal University, Rio de Janeiro, August 22, 1999.

Invenção: Thinking the Future. Co-organized with ITAU, ISEA, and *Leonardo*. ITAU Cultural Center, São Paulo, August 26, 1999.

Interfacing the Future. Co-organized with Carol Flax for the third annual Digital Arts Symposium, College of Fine Arts, University of Arizona, Tucson. April 6, 2000.

L'Art à l'ère post-biologique. Co-organized with Annick Bureaud, École Nationale Supérieure des Beaux-Arts, Paris. December 12–13, 2000.

enaissance: New configurations of mind, body, and space. Galleria Civica d'Arte Moderna e Contemporanea, Via Magenta 31, Turin, March 28–29, 2001.

eXtreme parameters: new dimensions of interactivity. Universitat Oberta de Catalunya, Barcelona, July 11–12, 2001.

9/11-N2N: From Networking to Nanosystems, a Series of Digital Dialogues and Debates. Co-organized by the University of California Digital Arts Network (UCDARNet), Santa Cruz, Los Angeles, Irvine, November 8–14, 2001.

Remaking Reality. Co-organized by the Institute of Advanced Media Arts and Sciences (IAMAS), Ogaki City, Gifu, Japan, October 25, 2002.

REFERENCES

Adcock, Craig. 1981. *Marcel Duchamp's Notes from the Large Glass: An N-Dimensional Analysis.* Ann Arbor: UMI Research Press.

Adrian, Robert. 1979. "Decentralisation: Communications as Content." In *Zur Definition eines neuen Kunstbegriffes,* ed. Ursula Krinziger. Innsbruck: Forum für Aktuelle Kunst.

———. 1982. "The World in 24 Hours." In *Ars Electronica 1982* (exhibition catalogue). Linz: Liva.

———. 1995. "Art and Telecommunications 1979–1986: The Pioneer Years." <http://www.t0.or.at/~radrian/TEXTS/springer-e.html>.

Allport, Floyd Henry. 1955. *Theories of Perception and the Concept of Structure: A Review and Critical Analysis with an Introduction to a Dynamic-Structural Theory of Behavior.* New York: Wiley.

Anthology of Chance Operations. See Young 1963.

Antliff, Mark. 1993. *Inventing Bergson: Cultural Politics and the Parisian Avant-Garde.* Princeton: Princeton University Press.

Arnason, H. H. 1986. *History of Modern Art: Painting, Sculpture, Architecture, Photography.* 3d ed. Revised and updated by Daniel Wheeler. New York: Harry N. Abrams.

Ars Electronica. 1992. *Ars Electronica: Die Welt von Innen — ENDO & NANO = The World from Within — ENDO & NANO.* Edited by Karl Gerbel, Peter Weibel, and Katharina Gsöllpointner. Translated by Linda Altmisdört and Silvia Zendron. Linz, Austria: PVS Verleger.

Ascott, Roy. 1959. "Paul Cézanne: A Study of the Work of Paul Cézanne with Special Reference to the Period 1878–1906." B.A. Fine Art diss., King's College, University of Durham.

———. 1961. Artist's statement in K. G. Pontus Húlten, *Bewogen Beweging* (exhibition catalogue). Amsterdam: Stedelijk Museum.

———. 1963. *Diagram Boxes and Analogue Structures.* London: Molton Gallery.

———. 1983. "La Plissure du Texte." In *Electra: L'Electricite et l'electronique dans l'art au XX siecle / Electricity and Electronics in the Art of the Twentieth Century,* 398–99. Paris: Musée d'Art Moderne de la Ville de Paris.

———. 1986. "Art Technology and Computer Science." In *XLII Esposizione internazionale d'arte: La Biennale di Venezia: Arte e scienza,* ed. M. Calvesi, 33–35. Venice: Biennale internazionale d'arte.

———. 1998. *Art and Telematics: Towards the Construction of a New Aesthetics.* In Japa-

nese. Translated by Erimi Fujihara. Tokyo: Nippon Telephone and Telegraph Publishing Co.

——, ed. 1999. *Reframing Consciousness: Art and Consciousness in the Post-Biological Era.* Exeter, U.K.: Intellect Books.

Ashby, W. R. 1952. *Design for a Brain.* London: Chapman & Hall; New York: J. Wiley.

——. 1956. "Design for an Intelligence Amplifier." In *Automata Studies,* ed. C. E. Shannon and J. McCarthy. Annals of Mathematics Studies, no. 34. Princeton: Princeton University Press.

Barthes, Roland. 1975. *The Pleasure of the Text.* Translated by Richard Miller. New York: Hill & Wang. Originally published as *Le Plaisir du texte* (Paris: Éditions du Seuil, 1973).

——. 1977. "From Work to Text." In *Image, Music, Text,* trans. Stephen Heath. New York: Hill & Wang.

Bateson, Gregory. 1972. *Steps to an Ecology of Mind: Collected Essays in Anthropology, Psychiatry, Evolution, and Epistemology.* San Francisco: Chandler Publishing Co.

Baudrillard, Jean. 1981. *For a Critique of the Political Economy of the Sign.* Translated by Charles Levin. St. Louis, Mo.: Telos Press. Originally published as *Pour une critique de l'économie politique du signe* (Paris: Gallimard, 1972).

Baudry, Jean-Louis. 1974–75. "The Ideological Effects of the Basic Cinematographic Apparatus." Translated by Alan Williams. *Film Quarterly* 28, 2 (Winter): 39–47.

Baumgärtel, Tilman. 1997. "Immaterialien: Aus der Vor- und Frühgeschichte der Netzkunst." *Telepolis* 3 (September): 135–51. Also published online at <www.heise.de/tp/deutsch/special/ku/6151/1.html>.

BBC. 1993. Radio 4. "In Business," May 12.

Bell, Daniel. 1979. "The Information Society." In *The Computer Age,* ed. M. Dertouzos and J. Moses. Cambridge, Mass.: MIT Press.

Beniger, James R. 1986. *The Control Revolution: Technological and Economic Origins of the Information Society.* Cambridge, Mass.: Harvard University Press.

Benjamin, Walter. [1936] 1969. "The Work of Art in the Age of Mechanical Reproduction." In id., *Illuminations,* ed. Hannah Arendt. New York: Schocken Books.

Berenson, Bernard. [1897] 1903. *The Central Italian Painters of the Renaissance.* New York: G. P. Putnam's Sons.

Bergson, Henri. 1911. *Creative Evolution.* New York: Henry Holt. Translated by Arthur Mitchell. Originally published in 1907 as *L'Évolution créatrice* (156th ed., Paris: Presses universitaires de France, 1986).

Biederman, Charles Joseph. 1948. *Art as the Evolution of Visual Knowledge.* Red Wing, Minn.: n.p.

Blonsky, Marshall. 1985. *On Signs.* Baltimore: Johns Hopkins University Press.

Bohm, David. 1981. *Wholeness and the Implicate Order.* London: Routledge.

Bolter, J. David. 1984. *Turing's Man: Western Culture in the Computer Age.* Chapel Hill: University of North Carolina Press.

Bolter, Jay David, and Richard Grusin. 1999. *Remediation: Understanding New Media.* Cambridge, Mass.: MIT Press.

Brand, Stewart. 1987. *The Media Lab: Inventing the Future at MIT.* New York: Viking Penguin.

Brecht, Berthold. 1986. "The Radio as an Apparatus of Communication" (1932). In *Video Culture: A Critical Investigation,* ed. John G. Hanhardt. Layton, Utah: G. M. Smith, Peregrine Smith Books, in association with Visual Studies Workshop Press.

Brion-Guerry, Liliane. [1950] 1995. *Cézanne et l'expression de l'espace.* Reprint. Paris: Albin Michel.

Bronowski, J. 1961. *Science and Human Values.* London: Hutchinson.

Bull, Hank. 1993. "Notes towards a History of Telecommunications Art." Unpublished manuscript.

Bureaud, Annick, ed. 1992. *Digital Photography.* Exhibition catalogue. Paris: Centre national de la photographie.

Burnham, Jack. 1968. *Beyond Modern Sculpture: The Effects of Science and Technology on the Sculpture of This Century.* New York: George Braziller.

———. 1971. *The Structure of Art.* New York, George Braziller.

———. 1974. "Duchamp's Bride Stripped Bare: The Meaning of the Large Glass." In id., *Great Western Salt Works: Essays on the Meaning of Post-Formalist Art,* 89–117. New York: George Braziller.

Cage, John. 1961. *Silence: Lectures and Writings.* Middletown, Conn.: Wesleyan University Press.

Calder, Alexander. [1932] 1968. In *Abstraction, création, art non-figuratif,* no. 1. Reprint. Arno Series of Contemporary Art, 8. New York: Arno Press.

Capra, Fritjof. [1975] 1977. *The Tao of Physics: An Exploration of the Parallels between Modern Physics and Eastern Mysticism.* New York: Bantam Books.

Carey, John, and Pat Quarles. 1985. "Interactive Television." In *Transmission: Theory and Practice for a New Television Aesthetics,* ed. Peter D'Agostino. New York: Tanam Press.

Cavallaro, Dani. 2000. *Cyberpunk and Cyberculture: Science Fiction and the Work of William Gibson.* New Brunswick, N.J.: Athlone Press.

Cézanne, Paul. 1941. *Letters.* Edited by John Rewald. Oxford: B. Cassirer.

Chandessais, C. 1964. "Essai sur la formalisation dans les sciences du comportement." *Cybernetica* (International Association for Cybernetics, Namur), no. 1.

Chipp, Herschel B. 1968. *Theories of Modern Art: A Sourcebook by Artists and Critics.* Berkeley and Los Angeles: University of California Press.

Clark, Kenneth. [1953] 1979. *Landscape into Art.* New York: Harper & Row.

Clynes, Manfred, and Nathan S. Kline. 1960. "Cyborgs and Space," *Astronautics* 14 (September): 26–27, 74–75.

Coen, Ester. *Umberto Boccioni.* Translated by Robert Eric Wolf. New York: Metropolitan Museum of Art, 1988.

Couchot, Edmond. 1988. *Images: De l'optique au numérique.* Paris: Hermès.

Couffignal L. 1964. "Que peut apporter la cybernétique à la pédagogie." *Cybernetica* (International Association for Cybernetics, Namur), no. 1.

Curran, Paul J. 1985. *Principles of Remote Sensing.* New York: Longman.

D'Agostino, Peter. 1980. *TeleGuide. Including proposal for QUBE*. Published by the author.

Davis, Douglas. 1973. *Art and the Future: A History/Prophecy of the Collaboration between Science, Technology, and Art*. New York: Praeger.

Deleuze, Gilles. 1983. *Nietzsche and Philosophy*. Translated by Hugh Tomlinson. London: Athlone Press.

———. 1988. *Bergsonism*. Translated by Hugh Tomlinson and Barbara Habberjam. New York: Zone Books.

Derrida, Jacques. 1979. *Spurs: Nietzsche's Styles*. Translated by Barbara Harlow. Chicago: University of Chicago Press. Originally published as *Éperons: Les Styles de Nietzsche* (Venice: Corbo e Fiore, 1976).

———. 1986. *Glas*. Translated by John P. Leavey Jr. and Richard Rand. Lincoln: University of Nebraska Press. Originally published as *Glas* (Paris: Éditions Galilée, 1974).

DeWitt, Bryce S., and Neill Graham, eds. 1973. *The Many Worlds Interpretation of Quantum Mechanics: A Fundamental Exposition by Hugh Everett III, with Papers by J. A. Wheeler [and others]*. Princeton: Princeton University Press.

Diebold, J. 1958. "The Economic and Social Effects of Automation." In *Proceedings of the Second International Congress on Cybernetics*. Namur: International Association for Cybernetics.

Dreher, Thomas. 1995. "The Arts and Artists of Networking." In Ars Electronica 95, *Mythos Information: Welcome to the Wired World*, ed. Karl Gerbel and Peter Weibel, 54–67. New York: Springer.

Drexler, K. Eric. 1986. *Engines of Creation*. Garden City, N.Y.: Anchor/Doubleday.

Duchamp, Marcel. 1973. *Salt Seller: The Writings of Marcel Duchamp. Marchand du sel*. Edited by Michel Sanouillet and Elmer Peterson. New York: Oxford University Press.

Dunn, Robert, ed. 1962. *John Cage*. A catalogue of his work. New York: Henmar Press / C. F. Peters.

Durrell, Lawrence. [1957] 1961. *Justine*. Reprint. New York: Pocket Books.

Eco, Umberto. 1976. *A Theory of Semiotics*. Bloomington: Indiana University Press.

Edwards, Paul N. 1996. *The Closed World: Computers and the Politics of Discourse in Cold War America*. Cambridge, Mass.: MIT Press.

Egan, Greg. 1992. *Quarantine*. London: Legend.

———. 1995. *Permutation City*. New York: HarperPaperbacks.

Elliot, Sir Charles. 1933 [1969]. *Japanese Buddhism*. Reprint. New York: Barnes & Noble, 1969.

Eno, Brian, Russell Mills, and Rick Poynor. 1986. *More Dark than Shark*. London: Faber & Faber.

Feenberg, Andrew. 1995. *Alternative Modernity: The Technical Turn in Philosophy and Social Theory*. Berkeley and Los Angeles: University of California Press.

Feigenbaum, E. A., and Pamela McCorduck. 1983. *The Fifth Generation: Artificial Intelligence and Japan's Computer Challenge to the World*. Reading, Mass.: Addison-Wesley.

Feyerabend, Paul. 1991. *Three Dialogues on Knowledge*. Oxford: Oxford University Press.

Flynt, Henry. 1975. *Blueprint for a Higher Civilization*. Milan: Multhipla Edizioni.

Foerster, Heinz von. 1973. "On Constructing Reality." Lecture at the Fourth International Conference on Environmental Design Research, Virginia Polytechnic Institute, 15 April, 1973.

———. 1981. *Observing Systems*. Seaside, Calif.: Intersystems Publications.

Ford, John J. 1966. "Soviet Cybernetics and International Development." In *The Social Impact of Cybernetics*, ed. Charles R. Decher. New York: Simon & Schuster.

Foucault, Michel. 1970. *The Order of Things: An Archaeology of Human Sciences*. London: Tavistock Publications; New York: Pantheon Books. Originally published as *Les Mots et les choses: Une Archéologie des sciences humaines* (Paris: Gallimard, 1966).

———. 1971. *L'Ordre du discours: Leçon inaugurale au Collège de France prononcée le 2 décembre 1970*. Paris: Gallimard.

———. 1972. *The Archaeology of Knowledge and the Discourse of Language*. Translated by A. M. Sheridan Smith. New York: Pantheon Books.

Fourier, Charles. [1971] 1983. *The Utopian Vision of Charles Fourier: Selected Texts on Work, Love, and Passionate Attraction*. Edited and translated by Jonathan Beecher and Richard Bienvenu. Reprint. Columbia: University of Missouri Press.

———. 1996. *The Theory of the Four Movements*. Edited by Gareth Stedman Jones and Ian Patterson. New York: Cambridge University Press. Originally published as *Théorie des quatre mouvements et des destinées générales* (1841).

Frank, Elizabeth. 1983. *Jackson Pollock*. New York: Abbeville Press.

Fried, Michael. 1967. "Art and Objecthood." *Artforum* 5, 10 (June): 12–23.

Fry, Roger. [1927] 1952. *Cézanne: A Study of His Development*. London: Hogarth Press.

Furlong, Lucinda. 1983. "Big Bird Goes to the Museum." Review of exhibition "Video + Satellite," Museum of Modern Art, New York, September 23–October 26, 1982. *Afterimage*, January 1983, 15.

Gasquet, Joachim. 1921. *Paul Cézanne*. Paris: Galerie Bernheim jeune.

Gelernter, David. 1994. *The Muse in the Machine: Computerizing the Poetry of Human Thought*. New York: Free Press; Toronto: Maxwell Macmillan Canada; New York: Maxwell Macmillan International.

George, F. H. 1959. *Automation, Cybernetics and Society*. New York: Philosophical Library.

———. 1961. *The Brain as a Computer*. New York: Pergamon Press.

Gibson, William. 1984. *Neuromancer*. London: Gollanz.

Gidney, Eric. 1991. "Art and Telecommunications: 10 Years On." *Leonardo*, special issue, *Connectivity: Interactive Art and Telecommunications*, ed. Roy Ascott and Carl Eugene Loeffler, 24, 2: 311–15.

Gieryn, Thomas F. 1999. *Cultural Boundaries of Science: Credibility on the Line*. Chicago: University of Chicago Press.

Gigliotti, Carol A. 1993. "Aesthetics of a Virtual World: Ethical Issues in Interactive Technological Design." Ph.D. diss., Ohio State University.

Gilder, George. 1993. "The New Rules of Wireless." *Forbes ASAP,* March 29.

Gleick, James. 1987. *Chaos: Making a New Science.* New York: Viking.

Gordon, W. 1964. "Economic and Social Effects of Automation." *Cybernetica* (International Association for Cybernetics, Namur), no. 4.

Gowing, L. 1958. "Paint in America." *New Statesman* (London).

Graubard, Stephen R. 1988. *The Artificial Intelligence Debate: False Starts, Real Foundations.* Cambridge, Mass.: MIT Press.

Green, Paul E. 1993. *Fiber Optic Networks.* Englewood Cliffs, N.J.: Prentice Hall.

Hamilton, Richard. 1966. *The Almost Complete Works of Marcel Duchamp* [catalogue of an exhibition] *at the Tate Gallery, 18 June–31 July 1966.* London: Arts Council of Great Britain.

Haraway, Donna J. 1991. *Simians, Cyborgs, and Women: The Reinvention of Nature.* New York: Routledge.

Harrison, Charles. 1991. *Essays on Art and Language.* London: Blackwell.

———. 1996. "Modernism." In *Critical Terms for Art History,* ed. Robert S. Nelson and Richard Shiff, 142–55. Chicago: University of Chicago Press.

———. 1997. *Modernism.* New York: Cambridge University Press.

Hartmann, Geoffrey. 1981. *Saving the Text: Literature/Derrida/Philosophy.* Baltimore: Johns Hopkins University Press.

Hastings, Michael. 1963. "Michael Hastings on Roy Ascott, Who Uses Cybernetics as an Art Form Which Might Lead to a New Industrial Revolution." *Scene* 21 (March 23): 40.

Hayles, N. Katherine. 1999. *How We Became Posthuman: Virtual Bodies in Cybernetics, Literature, and Informatics.* Chicago: University of Chicago Press.

Heim, Michael. 1999. "The Cyberspace Dialectic." In *The Digital Dialectic: New Essays on New Media,* ed. Peter Lunenfeld, 24–45. Leonardo series. Cambridge, Mass.: MIT Press.

Heisenberg, Werner. 1958. *Physics and Philosophy: The Revolution in Modern Science.* New York: Harper & Row.

Henderson, Hazel. 1978. *Creating Alternative Futures.* New York: Berkeley Windhover.

Henderson, Linda Dalrymple. 1988. *Duchamp in Context: Science and Technology in the Large Glass and Related Works* (Princeton: Princeton University Press).

Herbert, Nick. 1985. *Quantum Reality: Beyond the New Physics.* Garden City, N.Y.: Anchor/Doubleday.

Hiltz, Starr Roxanne, and Murray Turoff. 1978. *The Network Nation: Human Communication via Computer.* Reading, Mass: Addison-Wesley.

Horne, Donald. 1984. *The Great Museum: The Re-Presentation of History.* London: Pluto Press.

The I Ching; or, Book of Changes: The Richard Wilhelm Translation Rendered into English. 1950. Translated by Cary F. Baynes. New York: Pantheon Books.

International Future Research Conference [1st, Oslo, 1967]. 1969. *Mankind 2000.* Edited by Robert Jungk and Johan Galtung. Oslo: Universitetsforlaget; London: Allen & Unwin.

Jarry, Alfred. [1911] 1996. *Exploits & Opinions of Doctor Faustroll, Pataphysician: A Neo-Scientific Novel*. Translated by Simon Watson Taylor. Boston: Exact Change.

Johansen, Robert, Jacques Vallée, and Kathleen Spangler. 1979. *Electronic Meetings: Technical Alternatives and Social Choices*. Reading, Mass: Addison-Wesley.

Jung, Carl. 1973. "Synchronicity: An Acausal Connecting Principle." In *The Nature of Human Consciousness*, ed. Robert Ornstein. San Francisco: W. H. Freeman.

Kac, Eduardo. 1992. "Aspects of the Aesthetics of Telecommunications." In SIGGRAPH [Special Interest Group, Graphics], *Visual Proceedings: SIGGRAPH '92*, ed. John Grimes and Gray Lorig, 47–57. New York: Association for Computing Machinery.

———. 1996. "Telematic and Telepresence Installations." In SIGGRAPH [Special Interest Group, Graphics], *Visual Proceedings: The Art and Interdisciplinary Programs of SIGGRAPH 96*, ed. by Brian Blau et al. New York: Association for Computing Machinery, 1996.

———. 1997. "The Internet and the Future of Art: Immateriality, Telematics, Video-conferencing, Hypermedia, Networking, VRML, Interactivity, Visual Telephony, Artist's Software, Telerobotics, Mbone, and Beyond." In *Mythos Internet*, ed. Stefan Münker and Alexander Roesler, 291–318. Frankfurt: Suhrkamp Verlag. In German. Published online in English in *Parol: quaderni d'arte e di epistemologia*. Bologna: University of Bologna, <www.unibo.it/Parol/files/internet.htm>.

Kahn, Douglas, and Gregory Whitehead, eds. 1992. *The Wireless Imagination: Sound, Radio, and the Avant-Garde*. Cambridge, Mass.: MIT Press.

Kahn, Herman, and Anthony J. Wiener. 1967. *The Year 2000*. New York: Macmillan.

Kaprow, Allan. 1993. *Essays on the Blurring of Art and Life*. Edited by Jeff Kelley. Berkeley and Los Angeles: University of California Press.

Kellner, Douglas. 1989a. *Jean Baudrillard: From Marxism to Postmodernism and Beyond*. Stanford, Calif.: Stanford University Press.

———. 1989b. "Resurrecting McLuhan? Jean Baudrillard and the Academy of Postmodernism." In *Communication for and against Democracy*, ed. Marc Raboy and Peter A. Bruck, 131–46. New York: Black Rose Books.

Kelly, Kevin. 1995. *Out of Control: The New Biology of Machines, Social Systems, and the Economic World*. Reading, Mass.: Addison-Wesley.

Kerr, Elaine B., and Starr Roxanne Hiltz. 1982. *Computer-Mediated Communication Systems: Status and Evaluation*. New York: Academic Press.

Kilpatrick, Franklin Peirce. 1961. *Explorations in Transactional Psychology*. New York: New York University Press.

Kirkpatrick, Diane. 1971. *Eduardo Paolozzi*. Greenwich, Conn.: New York Graphic Society.

Kiss-Pál, Klára. 1997. "Biography" (online biography of Ray Johnson). Budapest: Art Pool. <http://www.artpool.hu/Ray/RJ_curriculum.html>.

Klee, Paul. [1961] 1969. *Notebooks*. Edited by Jürg Spiller. London: L. Humphries; New York: G. Wittenborn.

Kobayashi, Koji. *Computers and Communications: A Vision of C&C*. 1986. Cambridge, Mass.: MIT Press.

Kosuth, Joseph. 1991. *Art after Philosophy and After: Collected Writing, 1966–1990*. Edited by Gabriele Guercio. Cambridge, Mass.: MIT Press.

———. 1996. "Writing (and) the History of Art—Intention(s)." *Art Bulletin* 77, 3 (September): 407–12.

Kriesche, Richard, ed. 1985. *Artificial Intelligence and the Arts*. Graz: Steirischer Herbst.

Langton, Christopher G., ed. 1989. *Artificial Life: The Proceedings of an Interdisciplinary Workshop on the Synthesis and Simulation of Living Systems, Held September 1987 in Los Alamos, New Mexico*. Santa Fe Institute Studies in the Sciences of Complexity, 6. Redwood City, Calif.: Addison-Wesley, Advanced Book Program.

Large, Peter. 1980. "Terminal Consciousness." *Guardian* (London), October 4.

Latil, Pierre de. 1952. *Introduction à la cybernétique: La Pensée artificielle*. Paris: Gallimard.

Lévi-Strauss, Claude. 1978. *The Origin of Table Manners*. Translated by John and Doreen Weightman. New York: Harper & Row.

Licklider, J. C. R., and Robert W. Taylor. 1968. "The Computer as Communication Device." *Science and Technology* (April): 21–31.

Lippard, Lucy R. [1973] 1997. *Six Years: The Dematerialization of the Art Object from 1966 to 1972. A Cross-Reference Book of Information on Some Esthetic Boundaries*. Berkeley and Los Angeles: University of California Press.

Littlewood, J. A. 1964. "Laboratory of Fun." *New Scientist* 22 (May 14): 432–33.

Lovejoy, Margot. [1989] 1997. *Postmodern Currents: Art and Artists in the Age of Electronic Media*. 2d ed. Upper Saddle River, N.J.: Prentice-Hall.

Lovelock, J. E. 1979. *Gaia: A New Look at Life on Earth*. Oxford: Oxford University Press.

Lyotard, Jean-François. 1985. "A Conversation with Jean-François Lyotard." Interview with Bernard Blistène. *Flash Art*, no. 121 (March): 32–39.

Lyotard, Jean-François, and Thierry Chaput. 1985. *Les Immatériaux*. Exhibition catalogue. Paris: Centre de création industrielle; Centre Georges Pompidou.

Maturana, Humberto R., and Francisco J. Varela. 1980. *Autopoiesis and Cognition: The Realization of the Living*. Boston: D. Reidel.

———. [1987] 1992. *The Tree of Knowledge: The Biological Roots of Human Understanding*. Translated by Robert Paolucci. Rev. ed. Boston: Shambhala.

McLuhan, Marshall. 1962. *The Gutenberg Galaxy: The Making of Typographic Man*. Toronto: University of Toronto Press.

———. 1964. *Understanding Media: The Extensions of Man*. New York: McGraw-Hill.

———. 1967. *The Medium Is the Message*. New York: Random House.

McLuhan, Marshall, and H. Parker. 1968. *Through the Vanishing Point*. New York: Harper & Row.

Mead, G. R. S. 1896. *Orpheus*. London: John M. Watkins.

Mellor, David. 1993. *The Sixties Art Scene in London*. London: Phaidon Press.

Mikulak, Maxim W. 1966. "Cybernetics and Marxist-Leninism." In *The Social Impact of Cybernetics*, ed. Charles R. Decher. New York: Simon & Schuster.

Mitchell, W. J. Thomas. 1994. *Picture Theory: Essays on Verbal and Visual Representation*. Chicago: University of Chicago Press.

Moholy-Nagy, László. 1934. "Painting with Light." In supplement to *Telehor* (Brno, Csr.).

———. 1947. *The New Vision and Abstract of an Artist.* New York: Wittenborn.

———. 1987. *Painting, Photography, Film.* Cambridge, Mass: MIT Press.

Moles, Abraham A. 1966. *Information Theory and Esthetic Perception.* Translated by Joel F. Cohen. Urbana: University of Illinois Press. Originally published as *Théorie de l'information et perception esthétique* (1958).

Montaigne, Michel de. 1958. *Essays.* Translated by J. M. Cohen. Harmondsworth, U.K.: Penguin Books.

Moravec, Hans P. 1988. *Mind Children: The Future of Robot and Human Intelligence.* Cambridge, Mass.: Harvard University Press.

Morgan, Robert C. 1996. *Art into Ideas: Essays on Conceptual Art.* New York: Cambridge University Press.

Morse, Margaret. 1998. *Virtualities: Television, Media Art, and Cyberculture.* Bloomington: Indiana University Press.

Myers, Brad A. 1996. "A Brief History of Human Computer Interaction Technology," <www.cs.cmu.edu/~amulet/papers/uihistory.tr.html>. Revised and reprinted in *ACM Interactions* 5, 2 (March 1998): 44–54.

Nietzsche, Friedrich. 1974. *Twighlight of the Idols* [1889] [and] *The Anti-Christ* [1895]. Translated and edited by R. J. Hollingdale. 1968. Baltimore: Penguin Books.

Nora, Simon, and Alain Minc. 1980. *The Computerization of Society: A Report to the President of France.* Cambridge, Mass.: MIT Press, 1980. Originally published as *L'Informatisation de la société: Rapport à M. le président de la République* (Paris: La Documentation française, 1978).

Norris, Christopher. 1982. *Deconstruction, Theory and Practice.* New York: Methuen.

Oettinger, A. G., P. J. Berman, and W. H. Read. 1977. *High and Low Politics: Information Resources for the 1980s.* Cambridge, Mass: Harvard University Press.

Ouspensky, P. D. [1950] 1974. *The Psychology of Man's Possible Evolution.* 2d rev. ed. New York: Knopf.

Paik, Nam June. 1966. "Cybernated Art." In *Manifestos.* Great Bear Pamphlets. New York: Something Else Press.

Pask, A. G. 1958. "The Growth Process inside the Cybernetic Machine." In *Proceedings of the Second International Congress on Cybernetics.* Namur: International Association for Cybernetics.

Penny, Simon, ed. 1995. *Critical Issues in Electronic Media.* Albany: State University of New York Press.

Photius [ca. 820–891? A.D.], patriarch of Constantinople. 1960. *Bibliothèque.* Translated and edited by René Henry. Collection Byzantine Guillaume Budé. Vols. 2 and 3. Paris: Les Belles Lettres.

Piercy, Marge. 1991. *Body of Glass.* New York: Penguin Books.

Pontus Hultén, Karl Gunnar. 1986. *Futurism & Futurisms = Futurismo & futurismi.* Catalogue of an exhibition at the Palazzo Grassi, Venice. New York: Abbeville Press.

Popper, Frank. 1968. *Origins and Development of Kinetic Art*. Translated from the French by Stephen Bann. Greenwich, Conn.: New York Graphic Society.

———. 1975. *Art—Action and Participation*. New York: New York University Press.

———. 1993. *Art of the Electronic Age*. New York: Harry N. Abrams.

Postman, Neil. 1985. *Amusing Ourselves to Death: Public Discourse in the Age of Show Business*. New York: Viking Penguin.

Raboy, Marc, and Peter A. Bruck, eds. 1989. *Communication for and against Democracy*. 1989. New York: Black Rose Books.

Reichardt, Jasia. 1968. *Cybernetic Serendipity: The Computer and the Arts*. London: Studio International.

Reynolds, Roger. 1962. "Interview" [with John Cage]. *Generation* (January).

Rogers, Everett M., and D. Lawrence Kincaid. 1981. *Communication Networks: Toward a New Paradigm for Research*. New York: Free Press.

Rorty, Richard. 1989. "The Contingency of Language." In id., *Contingency, Irony, and Solidarity*. New York: Cambridge University Press.

Ross, David. 1974. "Douglas Davis: Video Against Video." *Arts* 49 (December): 62.

———. 1975. "Interview with Douglas Davis." *Flash Art* (May): 54–55.

Rumelhart, David E., James L. McClelland, and the PDP Research Group. 1986. *Parallel Distributed Processing: Explorations in the Microstructure of Cognition*. 2 vols. Cambridge, Mass.: MIT Press.

Russell, Peter. 1982. *Awakening Earth: Our Next Evolutionary Leap*. London: Routledge & Kegan Paul.

———. 1983. *The Global Brain: Speculations on the Evolutionary Leap to Planetary Consciousness*. Los Angeles: J. P. Tarcher.

Santillana, Giorgio de, and Hertha von Dechend. 1969. *Hamlet's Mill: An Essay on Myth and the Frame of Time*. Boston: Gambit.

Sartre, Jean-Paul. 1948. *Existentialism and Humanism*. London: Methuen.

Schöffer, Nicolas. 1963. *Nicolas Schöffer*, ed. Marcel Joray, trans. Haakon Chevalier. Neuchâtel: Editions du Griffon.

Shanken, Edward A. 1998. "The House That Jack Built: Jack Burnham's Concept of Software as a Metaphor for Art." *Leonardo Electronic Almanac* 6:10 (November). <http://mitpress.mit.edu/e-journals/LEA/ARTICLES/jack.html>. Reprinted in Ascott, ed., 1999.

———. 2000. "Tele-Agency: Telematics, Telerobotics, and the Art of Meaning." *Art Journal* 59, 2 (Summer): 65–77.

———. 2001. "Art in the Information Age: Technology and Conceptual Art." In *SIGGRAPH 2001 Electronic Art and Animation Catalog*, 8–15. New York: ACM SIGGRAPH, 2001. Expanded and reprinted in *Leonardo* 35:3 (August 2002).

Shannon, Claude, and Warren Weaver. 1949. *The Mathematical Theory of Communication*. Originally published in *Bell System Technical Journal*, July and October 1948. Published in condensed form in *Scientific American*, July 1949. Republished in book form with the inclusion of Warren Weaver's "Recent Contributions to the Mathematical Theory of Communication." Urbana: University of Illinois Press.

Sharp, Willoughby. 1980. "The Artists'-Owned Satellite TV Network [ASTN]: Preliminary Assessment." *Video 80* 1, 1: 18–19.

Sheldrake, Rupert. 1981. *A New Science of Life: The Hypothesis of Formative Causation.* London: Blond & Briggs; Los Angeles: J. P. Tarcher.

SIGGRAPH [Special Interest Group, Graphics]. 1992. *Visual Proceedings: SIGGRAPH '92* [computer graphics conference, Chicago, 1992]. Edited by John Grimes and Gray Lorig. New York: Association for Computing Machinery.

———. 1996. *Visual Proceedings: The Art and Interdisciplinary Programs of SIGGRAPH '96* [computer graphics conference, New Orleans, 1996]. Edited by Brian Blau et al. New York: Association for Computing Machinery.

Simon, Sidney. 1999. "Allan Kaprow and Robert Watts Interviewed by Sidney Simon." In Benjamin H. D. Buchloh and Judith F. Rodenbeck. *Experiments in the Everyday: Allan Kaprow and Robert Watts, Events, Objects, Documents.* New York: Wallach Art Gallery, Columbia University.

Skinner, B. F. 1971. *Beyond Freedom and Dignity.* New York: Knopf.

Stafford, Barbara Maria. 1991. *Body Criticism: Imaging the Unseen in Enlightenment Art and Medicine.* Cambridge, Mass.: MIT Press.

Steinberg, Leo. 1972. *Other Criteria: Confrontations with Twentieth-Century Art.* New York: Oxford University Press.

Stelarc. 1997. *Metabody: From Cyborg to Symborg.* CD-ROM. Sydney: Merlin Integrated Media.

Stewart, D. J. 1959. "An Essay on the Origins of Cybernetics." <http://www.cybsoc.org/stewart/origins.htm>.

Stiles, Kristine. 1987. "The Destruction in Art Symposium (DIAS): The Radical Social Project of Event-Structured Art." Ph.D. diss., University of California, Berkeley.

———. 1998. "Uncorrupted Joy: International Art Actions." In *Out of Actions: Between Performance and the Object, 1949–1979,* 286–329. Los Angeles: Los Angeles Museum of Contemporary Art.

Stiles, Kristine, and Peter Selz, eds. 1996. *Theories and Documents of Contemporary Art: A Sourcebook of Artists' Writings.* Berkeley and Los Angeles: University of California Press.

Stiles, Kristine, and Edward A. Shanken. 2002. "Missing in Action: Agency and Meaning in Interactive Art." In *Context Providers: Context and Meaning in Digital Art,* ed. Margot Lovejoy, Christiane Paul, and Victoria Vesna. Cambridge, Mass: MIT Press.

Tansley, David V. 1977. *Subtle Body: Essence and Shadow.* London: Thames & Hudson.

Tate Gallery. 1965. *Victor Pasmore: Retrospective Exhibition, 1925–65.* Introduction by Ronald Alley. London: Tate Gallery.

Teilhard de Chardin, Pierre. 1955. *The Phenomenon of Man.* New York: Harper & Brothers.

———. 1964. *The Future of Man.* New York: Harper & Row.

Thorne, Kip S. 1994. *Black Holes and Time Warps: Einstein's Outrageous Legacy.* New York: Norton.

Uexküll, Jakob Johann von. 1934. *Streifzüge durch die Umwelten von Tieren und Menschen: Ein Bilderbuch unsichtbarer Welten.* Berlin: J. Springer.

Unger, Roberto Mangabeira. 1997. *Politics: The Central Texts, Theory against Fate.* Edited by Zhiyuan Cui. New York: Verso.

Vallée, Jacques, ed. 1981. *Saturn Encounter: Transcript of an International Computer Conference on Future Technology.* San Bruno, Calif.: Infomedia Corporation.

Varela, Francisco, Evan Thompson, and Eleanor Rosch. [1991] 1993. *The Embodied Mind: Cognitive Science and Human Experience.* Cambridge, Mass.: MIT Press.

Vasarely, Victor. 1955. *Exposition Vasarely: De l'invention à la re-création, par Victor Vasarely.* Exhibition catalogue. Paris: Galerie Denise René.

Vasiliev, L. L. 1976. *Experiments in Distant Influence.* New York: Dutton.

Vesna, Victoria. 1998. "Buckminster Fuller: Illusive Mutant Artist." *ArtByte* 1, 3 (August–September): 22–29.

Virilio, Paul. 1991. *The Aesthetics of Disappearance.* New York: Semiotext(e).

Virilio, Paul, and Sylvère Lotringer. 1983. *Pure War.* New York: Semiotext(e).

Wallis, Brian, ed. 1987. *Blasted Allegories: An Anthology of Writings by Contemporary Artists.* New York: New Museum of Contemporary Art; Cambridge, Mass.: MIT Press.

Watzlawick, Paul, ed. 1984. *The Invented Reality: How Do We Know What We Believe We Know? Contributions to Constructivism.* New York: Norton.

Wentworth Thompson, D'Arcy. [1942] 1968. *On Growth and Form.* 2d ed. 2 vols. Cambridge: Cambridge University Press.

Wheeler, John Archibald, and Wojciech Hubert Zurek, eds. 1983. *Quantum Theory and Measurement.* Princeton, N.J.: Princeton University Press.

Whorf, Benjamin Lee. 1967. *Language, Thought, and Reality: Selected Writings.* Edited by John B. Carroll. Cambridge, Mass.: MIT Press.

Wiener, Norbert. 1948. *Cybernetics; or, Control and Communication in the Animal and the Machine.* Actualités scientifiques et industrielles, 1053. Paris: Hermann; Cambridge, Mass.: MIT Press; New York: Wiley.

———. [1950] 1967. *The Human Use of Human Beings: Cybernetics and Society.* Reprint. New York: Avon Books, 1967.

Williams, Raymond. 1980. *Problems in Materialism and Culture: Selected Essays.* London: Verso.

Winograd, Terry. 1979. "Towards Convivial Computing." In *The Computer Age*, ed. M. Dertouzos and J. Moses. Cambridge, Mass.: MIT Press.

Wolf, Fred Alan. 1988. *Parallel Universes: The Search for Other Worlds.* New York: Simon & Schuster.

Wolfe, Morris. 1972. "Ascott in Wonderland: What Really Happened at the Ontario College of Art." *Toronto Life* (June): 33, 43–45.

———. 2001. *OCA 1967–1972: Five Turbulent Years.* Toronto: Grub Books.

Wolfram, Eddie. 1968. "The Ascott Galaxy." *Studio International* 175, 897 (February): 60–61.

Xenakis, Iannis. 1963. *Musiques formelles.* Paris: Stock.

Yalkut, Jud. 1984. "Electronic Zen: The Alternate Video Generation." Unpublished manuscript.

Young, La Monte, ed. 1963. *An Anthology of Chance Operations*, by George Brecht and others. Bronx, N.Y.: L. Young & J. MacLow.

Youngblood, Gene. 1970. *Expanded Cinema*. New York: Dutton.

———. 1986. "Virtual Space: The Electronic Environments of Mobile Image." *International Synergy* 1: 9–20.

Zukav, Gary. 1979. *The Dancing Wu Li Masters: An Overview of the New Physics*. New York: Morrow; London: Rider Hutchinson.

INDEX

*PAGE NUMBERS IN ITALIC
DENOTE ILLUSTRATIONS.*

Abe, Yoshiyuki, 305
Abstract expressionism, 9, 28, 89n4, 282
Abstraction, 9, 22, 23, 28, 165
Action painting, 121, 271, 282
Adams, Kenneth, 107n1
Adcock, Craig E., 206
Adrian, Robert, 64, 68, 83, 85, 92nn37,41, 183, 186
Agam, Yaacov, 21, 89n14, 118
Agis, Maurice, 119
Aleatory processes, 32, 35
Alienation, 168, 171, 215, 221, 257–58, 265, 341
Allen, Rebecca, 296
Allik, Kristi, 305
Allport, F. H., 180
Ampère, André-Marie, 163, 242
Analogue Table: Wiener-Rosenblueth (Ascott), 26
Anders, Peter, 374n3
Anderson, Laurie, 67
Andrevon, Philippe, 307
Animation, 237, 267, 291, 296, 298, 299, 300, 305, 336
Antin, Eleanor, 62
Antliff, Mark, 28
Apparition, aesthetics of, 157, 253, 277–81, 317–18, 320, 323, 325, 355, 380
Appleton, Peter, 246n5
Appropriation, as aesthetic strategy, 43, 48, 67
Architecture, 9, 45, 48, 119, 241, 323–26, 359, 371–73. *See also* Intelligent architecture
Arnason, H. H., 90n23

Arnatt, Keith, 62
Arp, Jean, 9, 28, 88n4, 121
ARPANET, 4, 52, 88n2
Ars Electronica, 64, 70, 183, 186, 241, 262, 270, 284–309, 340
Art & Language collective, 15, 25
ARTBOX, 64, 92n39, 183, 184, 186
Art Com / La Mamelle Inc., 60
Art criticism, 16–17, 23, 165, 234, 282, 310, 344
Art education, 6–7, 9–10, 49, 74, 102–7, 176–77, 286, 343; and cybernetics, 4, 11, 26, 34–35, 37–40, 42, 132, 133, 134–44, 152–55; and Planetary Collegium, 310–18; and telematics, 40, 196–97, 217–18. *See also* Didacticism
ARTEX, 64, 68, 92n39
Art history, 16–17, 90n20
Artificial consciousness, 268, 273, 340, 342, 343, 353, 354, 356
Artificial intelligence, 10, 18, 33, 196, 223, 224, 232, 244, 331, 332, 335
Artificial life: and apparition, 278, 279; and Ars Electronica Center (AEC), 291, 296; and artistic activity, 69, 73, 88, 265, 282, 311, 338, 353; and connectivity, 265, 311, 343; and consciousness, 356, 358, 365; and culture, 311, 353; and cyberbotany, 365; and cybernetics, 331; and garden of hypotheses, 353; and in-

teractivity, 311, 353; metaphors provided by, 271, 286, 310, 338; and moistmedia, 343, 354, 358, 365, 382; and museums, 271, 340, 341, 343, 345, 349, 353; and rematerialization, 337, 378; and second-order nature, 330, 337, 354, 379; and shamanism, 361; and technoetics, 343, 381; and telenoia, 259, 264, 265, 270; and urban planning, 324; and virtual reality, 259, 312
Art informel, 28
Art Journal, 232, 295
Art-Language: The Journal of Conceptual Art, 15
Art Pool (mail art group), 56
Arts and Crafts movement, 357, 376
Ascott, Roy: educational background of, 7, 9–10, 11; exhibitions of, 12, 20, 23, 26, 29, 67, 125, 151, 152, 153; military service of, 33, 81; teaching activity of, 6–7, 34–35, 37–40, 42, 98, 102–7, 152–55
—artworks: *Analogue Table: Wiener-Rosenblueth*, 26; *Bigelow*, 26; *Blackboard Notes*, 103; *Change Map*, 32, *32*; *Change Paintings*, 3, 29, *29*, 30, 97–98, *99*, 150; *Cloud Template*, 31, *153*; *Cognitive Map*, 317; *Cooking Chance*, 169; *Development*, 7, *8*, 27; *Diagram Boxes*, 33, 151; *Fourier*, 26, 152; *Hinged Relief*, 150, *162*; *Homage to*

Ascott, Roy *(continued)*
 C. E. Shannon, 26, 27, 150;
 For Kamynin, Lyubimskii
 and Shura-Bura, 31, 33;
 Kiosk, 151; *Locomotion Board*,
 151; *Love-Code*, *10*; "Moist
 Chart," *364*; *Parameter V*,
 33; *Shift*, 101; *Table-Top*
 Strategies, *34*; *Thesaurus*,
 12–13, *13*, 151; *Transaction*
 Set, 33, *33*; *Video Roget*, *12*,
 12–13, *13*, 30, 151
—projects: "Aspects of Gaia,"
 70–72, *71*, 85, 241–42, *243*,
 262–63; "Heavenly Bodies"
 proposal, 255–56; "Organe
 et Fonction d'Alice au Pays
 des Merveilles," 67, *68*,
 261–62; "La Plissure du
 Texte," 4, 40, 64–66, *65*,
 69, 85, 92–93n42, 189–90,
 191, 210, 240–41, 242, 261;
 "Telenoia," 259, *260*; "Ten
 Wings," 5–6, 53, 85, 183–
 84; "Terminal Art," 4, 62,
 63, 69
—writings: "The Architec-
 ture of Cyberception," 2,
 319–26; "The Ars Elec-
 tronica Center Datapool,"
 284–309; "Art and Educa-
 tion in the Telematic Cul-
 ture," 212–21; "Art and
 Telematics," 4, 55, 64, 81,
 185–200; "Art @ the Edge
 of the Net," 2, 74; "Back
 to Nature II," 2, 327–39;
 "Behaviourables and Fu-
 turibles," 14, 26, 157–60;
 "Behaviourist Art and the
 Cybernetic Vision," 3, 25,
 39, 42, 43, 44–50, 52, 77,
 84, 109–56; "Beyond Time-
 Based Art," 53, 227–31;
 "Concerning Nets and
 Spurs," 201–11; "Connec-
 tive Criticism," 174–75;
 "The Construction of
 Change," 3, 11, 26, 42,
 43–44, 81, 97–107, 154;
 "From Appearance to Ap-
 parition," 276–83; "Ge-
 samtdatenwerk," 222–26;
 "Heavenly Bodies," 255–

56; "Is There Love in the
 Telematic Embrace?" 72,
 74, 78, 80, 232–46; "The
 Mind of the Museum," 2,
 340–55; "Network as Art-
 work," 4, 176–77; "Photog-
 raphy at the Interface,"
 247–54; "The Planetary
 Collegium," 74, 310–18;
 "The Psibernetic Arch," 5,
 54, 161–66; "Statement,"
 13, 180; "Table," 168–73;
 "Telenoia," 2, 257–75;
 "Towards a Field Theory
 for Postmodern Art," 178–
 82; "Weaving the Shaman-
 tic Web," 6, 356–62
Ashby, W. Ross, 10, 18, 49,
 129, 185
Aspect, Alain, 224, 332
"Aspects of Gaia" project, 70–
 72, *71*, 85, 241–42, *243*,
 262–63
Asynchronicity, 53, 70, 83,
 193, 224, 228, 332. *See also*
 Timelessness
Atkinson, Terry, 15, 25
Authorship, 81, 86, 195, 199,
 209, 236, 249, 315, 336;
 dispersed, 189, 205, 208,
 213, 228, 241, 245n3; dis-
 tributed, 64, *65*, 66, 73,
 190–91, 238, 261, 330, 337
Automatic teller machines
 (ATMs), 1, 50
Autopoiesis, 242, 245, 343
Ayahuasca, 358, 359, 365,
 374n1, 377
Aycock, Alice, 62

Babiole, Cecile, 305
Bach, Gottfried, 92n39
Baldwin, Michael, 15, 25
Balla, Giacomo, 21, 116
Barthes, Roland, 4, 66, 187,
 189–90, 201, 208–9, 210,
 233, 261
Bartlett, Bill, 61, 92nn37,39,41
Barzyk, Fred, 57
Bateson, Gregory, 5, 76, 194,
 215, 236, 259, 325, 342,
 352
Baudrillard, Jean, 48, 84, 85,
 367

Baudry, Jean-Louis, 93n48
Bauer, Will, 305
Bauhaus, 2, 54, 118, 124, 318
Bayle, Laurent, 303
Bear, Liza, 60, 61
Beauty, 139, 207, 234, 348
Bec, Louis, 296
Bedau, Mark, 296
Bedworth, Jon, 374n3
Beer, Randell, 296
Beer, Stafford, 129
Behavior: and art education,
 34–35, 103, 105–6, 133;
 and cybernetic art, 26,
 34–35, 43, 44–46, 127–28,
 133, 157–60; and cyber-
 netics, 20, 75; and inter-
 activity, 1, 10, 35, 42, 45,
 46, 76, 280; and postmod-
 ern art, 178, 179; table-top,
 168, 170–73; and telematic
 art, 1, 4; and telematic cul-
 ture, 334, 338; triggers of,
 116, 117, 120, 128, 150,
 151, 157, 159, 175
Behaviorism, 45–46, 160
Behaviorist art, 44–46, 109–
 25, 127–28, 129, 150–52,
 157–60
Beholder discourse, 25
Bell, Daniel, 188
Bell, John Stewart, 224, 332
Bell, Mark, 305
Benayoun, Maurice, 300
Benjamin, Anthony, 107n1
Benjamin, Walter, 48, 252,
 347
Benton, Stephen, 305
Berenson, Bernard, 329
Berg, Adrian, 107n1
Berger, Paul, 248, 251, 252,
 272
Bergson, Henri, 21, 27–28,
 29, 30, 33, 43, 114, 224,
 333, 348
Berkhout, Rudie, 299
Bernard, Claude, 100
Bernecky, Bob, 92n37
"Bewogen Beweging" exhibit,
 20, 89, 150
Biederman, Charles, 9, 30,
 88n4
Bigelow (Ascott), 26
Bigelow, Julian, 20

Binary code, 18, 31
Binary opposition, 47, 78, 85, 327
Bindman, David, 107n1
Biological form, 7, 9, 27, 28, 29, 31, 73, 89n4
Bio-telematics, 338, 375
Bird's-eye view, 32, 33, 70, 171, 181, 195, 236, 241, 321, 350
Birge, Robert, 272–73
Blackboard Notes (Ascott), *103*
Black boxes, 45–46, 276, 336
Blake, William, 2
Blavatsky, Helena Petrova, 345
Blonsky, Marshall, 247
Boccioni, Umberto, 21, 329, 344, 357
Bochner, Mel, 14
Body: and architecture, 371; and art education, 217; and cyberception, 319, 322; and double consciousness, 358; and East-West relations, 263; extension of, 190, 332; and individuality, 265, 320; post-biological, 266, 278, 372, 375, 379; redefinition of, 264, 350–51; and virtual reality, 270. *See also* Disembodiment; Out-of-body experience
Bohm, David, 187, 205, 332, 333, 344
Boissier, Jean-Louis, 304
Boissonet, Philippe, 305
Bolter, J. David, 91n27, 228
Books, obsolescence of, 315, 336
Bowen, Dennis, 107n1
Boyle, Mark, 11
Brancusi, Constantin, 117
Brand, Stewart, 247, 296
Branson, Richard, 267
Braque, Georges, 116
Brecht, Bertolt, 55–56, 57, 61, 82
Brecht, George, 22, 56
Breck, Ren, 92n38
Bricken, William, 272
The Bride Stripped Bare by Her Bachelors, Even (Duchamp), *10*, 75, 78, 90n20, 117, 195, 206, 209, 235–36

Brion-Guerry, Liliane, 115, 155n1
Britten, Benjamin Jay, 307
Brooks, Rodney, 296
Brunner, Matthew, 305
Buchloh, Benjamin, 89n11
Buddhism, 24, 88n3, 187, 199, 205, 316, 317. *See also* Zen
Bué, Henri, 262
Buendia, Mario, 305
Bull, Hank, 58, 64–66, 92n41, 93n43
Burgy, Don, 62, 186
Burnett, Christopher, 307
Burnham, Jack, 17, 23, 28, 44, 58
Burroughs, William, 124
Bury, Pol, 120

Cable television, 59, 60–61, 62
Cadavre exquis, 66
Cage, John, 22, 24, 32, 67, 88n3, 122
CAiiA (Centre for Advanced Inquiry in the Interactive Arts), 6–7, 40, 42, 73–74, 263, 367–69
Calder, Alexander, 120, 155n3
Calibrators, *31*, 35, *36*, 105–6, 151, 154
Calvesi, Maurizio, 331
CAM (cybernetic art matrix), 44, 45, 48–49, 77, 109, 127, 129, 132–50, 152, 154, 166, 185
Cambridge Opinion (periodical), 97, 154
Capitalism, 6, 84, 210, 258, 293
Capra, Fritjof, 180, 187, 204–5
Carey, John, 59
Caro, Anthony, 119
Carroll, Lewis, 25, 67, 262
Cartesianism, 164, 202, 206, 227, 244, 263, 350, 353
Cartography, 33–34
Casti, John L., 374n2
Cato, 221
Center for Critical Inquiry, San Francisco, 174, 175
Center for New Art Activities, New York, 60

Centre d'Art cybernétique, Paris, 23, *125*, 151
Centre Pompidou, Paris, 204, 240, 262
Cézanne, Paul, 28, 30, 114–15, 158, 271, 328
Chance, 32, 33, 121, 123
Chand, Rajinder, 307
Change Map (Ascott), 32, *32*
Change Paintings (Ascott), 3, 29, *29*, 30, 97–98, *99*, 150
Chaos: and architectural space, 372; and museums, 345, 351; and Planetary Collegium, 314, 315; representation of, 222, 229, 231, 275, 345; and second-order nature, 328; and telematic art, 231, 235, 242, 271, 286; and telematic embrace, 245
Chaput, Thierry, 67, 204
Chicago Museum of Contemporary Art, 58
Cinema, 79, 124, 228, 271, 336, 347
City, concept of, 322–25, 327
Claridge, Peter, 307
Clark, Kenneth, 329
Classicism, 274, 339n1
Claudianus, 203
Clinton, Bill, 273
Cloud Template (Ascott), 31, *153*
Clynes, Manfred, 149
Co-Evolution Quarterly, 180
Cognitive Map (Ascott), 317
Cohen, Bernard, 17, 107n1
Cohen, Harold, 107n1, 298
Cold War, 20, 52, 81, 88n2
Collective unconscious, 187
Collins, Robert, 296
Commercial relations, 57, 58, 59, 61, 82, 83, 88, 126, 130–31, 133, 192, 289, 292–93, 313, 368. *See also* Capitalism
Commodification, 130–31
Complementarity, 5, 6, 24, 74
Computers: and animation, 237, 267, 291, 296, 298, 299, 300, 305, 336; and behaviorist art, 128–29; and binary code, 18, 31; and computer conferencing, 4,

Computers (continued)
6, 59, 61–64, 67, 69, 186,
188, 193, 239, 259, 301,
302; and connectionism,
332; and cybernetic art, 49;
and global consciousness,
77; and information theory,
18; and interfaces, 225–26,
239; and invisibility, 225,
229, 238, 244, 245; and
memory, 62–63, 202, 216,
272–73; molecular, 272–
73, 321, 330; and parallel
distributed processing, 54,
217, 227–30, 236, 244, 332;
and telematics, 1, 218, 221;
and transformative activity,
225, 238–39
Conceptual art, 4, 11, 13–16,
25, 26, 54, 86–87, 90n16
Concrete poetry, 11, 14
Connectionism, 332
Connective criticism, 174–75,
177, 178, 182, 244
Connectivism, 332, 333, 336–
37, 380
Connectivity: and Ars Elec-
tronica Center (AEC), 284,
285, 290, 292; and asyn-
chronicity, 228; and cyber-
ception, 319, 321, 323, 324,
325; and five-fold path,
267, 284, 311, 377; and
hyperconnectivity, 342–43,
382; and interfaces, 266;
and molecular revolution,
330; and museums, 341,
342, 345, 347, 353, 355;
and networking, 222;
and neural networks, 312;
and photography, 252; and
Planetary Collegium, 314,
315, 369, 373; and Pollock's
art, 281; and postmodern-
ism, 178, 182; and quantum
physics, 215; and second-
order nature, 332; and su-
perconnectivity, 223, 237;
and technoetics, 376; and
telematic art, 87, 216, 263,
274, 333, 336, 338–39n1;
and telematic culture, 267,
269, 279; and telematics,
73, 76, 228, 264, 265, 319,

334; and telematic space,
379; and telenoia, 371; and
telepresence, 265; and urban
planning, 324
Connell, Jonathan, 296
Conninck, Suzanne de, 23,
151
Consciousness: artificial, 268,
273, 340, 342, 343, 353,
354, 356; double, 357–58,
359, 361, 377; global, 1, 5,
6, 51–52, 74, 76–77, 83,
133, 146, 197, 216, 217,
230, 236; and moistmedia,
365; technoetic, 356, 357
"Consciousness Reframed"
conference, 42, 368
Constructivism, 9, 12, 22, 29,
30, 31, 54, 90n18, 118, 277,
286, 344; radical, 247, 251,
271, 280, 282, 316, 318,
349, 367, 380
Consumerism, 9, 24, 48, 131
Contact (Levine), 58
Content, aesthetic, 85–86,
112–13, 128, 152, 233–
35, 237, 239, 244, 351;
compared to context, 266,
269, 279, 312, 320, 352
Contingency, 19, 20, 75, 79,
99, 237, 242, 251, 351
Control (periodical), 13, 17,
108, 157
Conway, John, 296
Cooking Chance (Ascott), 169
Copyright law, 48
Cordier, Raymond, 23
Cosmic web, 204–5
Cosmology, 5, 24, 33, 53, 271,
286, 379
Couchot, Edmond, 66, 67, 304
Couffignal, L., 156n5
Courchesne, Luc, 304
Cox, Donna, 298, 374n3
Cox, Geoff, 374n3
Crane, Mike, 91n30
Creativity, 45, 49, 79, 97, 99,
108
Csuri, Charles, 305
Cubism, 27, 115, 116, 124,
271, 286
Cultural relations: and artistic
activity, 98–100; and deter-
minism, 45, 46, 80, 110,

113–14, 125, 126, 234,
242, 244, 322; and feed-
back loops, 27, 45, 242;
and post-biological sys-
tems, 248, 266, 284, 294,
367, 369; and table-top
behaviors, 168, 170–73.
See also Cyberculture; Tele-
matic culture
Curran, Paul J., 237
Cyberbotany, 365, 373
Cyberception, 2, 315, 319–
26, 342, 347, 350, 353,
359–62, 365, 374, 376
Cyberculture, 279–83, 325,
326
Cyber-estate, 315, 316
Cybernetica (periodical), 45,
109
Cybernetic art, 10–11, 17–
34, 42–50, 100–103, 109–
12, 126–29, 131–50; and
behavior, 26, 34–35, 43,
44–46, 127–28, 133, 157–
60; and CAM (cybernetic
art matrix), 44, 45, 48–49,
77, 109, 127, 129, 132–50,
152, 154, 160, 166, 185;
critique of, 25–26; and
education, 4, 11, 26, 34–35,
37–40, 42, 132, 133, 134–
44, 152–55; and feedback
loops, 24, 26, 30, 34–35,
43, 45, 46, 48, 72, 133; and
global consciousness, 133,
146; and information flow,
144–47; and interactivity,
3–4, 12, 21, 23, 26, 30, 45,
46, 77, 331; and interdisci-
plinary activity, 49, 153;
and music, 22, 24; and play,
132, 133, 135, 136, 137,
140, 141, 143, 144, 148,
149, 154; and sculpture, 17,
23–24; and social relations,
132–33, 147
The Cybernetic Art Work That
Nobody Broke (Hurrell), 25
Cybernetics: and art educa-
tion, 4, 11, 26, 34–35, 37–
40, 42, 132, 133, 134–44,
152–55; and behaviorist
art, 127–28, 157–60; and
Buddhism, 24; and feed-

back loops, 4, 11, 12, 18, 19, 34–35, 128; history of, 18–20; and information theory, 18–20; and interdisciplinary activity, 18, 19, 221; and military research, 20, 33; and parapsychology, 161, 163–67; and perception, 100–101; second-order, 75, 234, 237, 242, 331, 332; and social relations, 49, 126, 130–31, 132; and social theory, 19–20; and telematics, 6–7, 51–52, 197, 242

"Cybernetic Serendipity" exhibit, 17, 90n15

Cyberspace: and apparition, 278; and architecture, 371, 380; and Ars Electronica Center (AEC), 288, 289, 294, 301, 303; and art education, 312, 314, 318; and connectivity, 279; and cyberception, 320, 321, 323, 324, 325, 326; and double consciousness, 377; in Gibson's fiction, 51, 277, 337; and hierarchical relations, 93n50; and interactivity, 278; as matrix of human values, 283; and moistmedia, 372; and personality transfer, 337; and Planetary Collegium, 314, 367, 368, 369, 373; and shamanism, 358, 374n1; and telematic art, 69, 70, 78, 80, 86, 278; and telematics, 51–52, 243, 246n6; and teleprescience, 382; and telepresence, 345; and urban planning, 324

Cyborgs, 9, 77, 78, 149, 265, 268, 344, 380

Dada, 9, 32, 118, 124

D'Agostino, Peter, 55, 62, 85, 307

Dali, Salvador, 67

Dark fiber, 273, 279

Data foam, 354, 376

Datapool, 270, 284–309, 376

Data space, 235, 237, 238, 239, 241, 244, 284, 288, 296, 334, 352, 375; and *Gesamtdatenwerk*, 222, 225, 226; and photography, 247, 249, 252, 253; and quantum physics, 229; and telematic art, 241; and telenoia, 261, 262, 266, 267, 269, 275

Davies, Char, 42, 374n3

Davis, Douglas, 22, 57, 62

Decentralization, 51, 52, 55, 81–83, 199, 316

Dechend, Hertha von, 203

Decision trees, 33

Deconstruction, 43, 47, 74, 201, 209, 231, 247, 271, 286

Degas, Edgar, 114

Deleuze, Gilles, 333, 341

Dematerialization, 4, 26, 80, 221, 330, 348

Democracy, 57, 67, 84, 279, 289

Derrida, Jacques, 75, 201, 208–9

Deterministic culture, 45, 46, 80, 110, 113–14, 125, 126, 234, 242, 244, 322

Détournement, 22

Development (Ascott), 7, *8*, 27

DeWitt, Bryce, 230

Diagram Boxes (Ascott), 33, 151

Diagrams, 12, 13, 14, *14*, *15*, 30, 33, *41*, 90n20, 151, 152

Dialogical relations, 86, 111, 112, 170, 196, 355

Didacticism, 11, 35, 37, 43, 97–98, 102, 118

Diebold, J., 126

Différance, 75, 233, 352

Dionysios of Aegeae, 201, 211n1

Direct Media Association, 61

Disembodiment, 70, 314, 350–51, 358, 374n1

Disney, Walt, 296

Disneyland, 348, 352

Doesburg, Théo van, 118

Double consciousness, 357–58, 359, 361, 377

Drexler, K. Eric, 330, 332

Dubuffet, Jean, 195

Duchamp, Marcel, 9, 10, 21, 22, 32, 33, 82, 116–17, 121, 206–7, 215, 271, 281, 344, 357; *Large Glass* of, *10*, 75, 78, 90n20, 117, 195, 206, 209, 235–36

Duesing, James, 307

Duration, 3, 21, 22, 27, 28, 30, 43, 333

Durée, 21, 27, 28, 29

Durrell, Lawrence, 79

Duval, Xavier, 305

Dyens, Georges, 304

Eagle, David, 303

Ealing College of Art, London, 10, 11, 17, 34–35, 39, 43, 102, 153, 154, 155, 185

East-West relations, 5, 24, 88n3, 187, 263

E.A.T. (Experiments in Art and Technology), 58–59

Eco, Umberto, 179

Economic relations, 6, 48, 80, 82, 126, 130–31, 164, 210. *See also* Capitalism; Commercial relations

Éditions MAT (Multiplication d'Art Transformable), 22

Education. *See* Art education; Didacticism

Egan, Greg, 276–78, 347

Einstein, Albert, 19

Élan vital, 27, 28, 29

"Electra" exhibit, 189, 210, 240, 242, 261

Electronic Hokkadim (Davis), 57

E-mail, 1, 50, 69, 73, 82, 239, 241, 259, 262, 288, 291, 302

Emergence, 267, 269, 275, 277, 278, 285, 286, 287, 311, 312, 338, 353, 371, 377

Emshwiller, Ed, 304

Engelbart, Doug, 4

Enlightenment, 205, 232, 242, 351

Eno, Brian, 37–39, 299

Entropy, 105, 159, 163, 164, 179, 229

Epistemological models, 5, 19, 43, 47, 75, 78, 88

Equilibrium, aesthetic, 111, 115
Eroticism, 78–79, 190, 235, 265
ESP (extra-sensory perception), 159–60, 161, 163, 164, 165, 167, 227–28
Essentialism, 19
Estienne, Jerome, 305
Ethics, 81–82, 98
Euclidean space, 113, 335, 371
Evans, Bruce, 305
Everett, Hugh, 230, 339n2

Farman, Nola, 304
Fax machines, 54, 56, 64, 67, 68, 210, 237, 241, 259
Feedback loops, 4, 11, 12, 18, 19; and art education, 34–35; and behaviorist art, 110–11, 112, 128, 159; and cyberception, 321, 324; and cybernetic art, 24, 26, 30, 43, 45, 46, 48, 72, 133; and sociocultural relations, 27, 133, 242; and urban planning, 324
Feminism, 268
Feyerabend, Paul, 250, 251
Fiber optics, 273–74, 279
Field theory of art, 179, 180, 182
Five-fold path, 267, 284–85, 311, 377
Flax, Carol, 248, 249, 272
Fleischmann, Monika, 305
Fluxus, 22, 23, 43
Flynt, Henry, 14
Foerster, Heinz von, 75, 234, 280
Foresta, Don, 67, 246n4
For Kamynin, Lyubimskii and Shura-Bura (Ascott), 31, 33, 150
Formalist modernism, 178–81
Forster, Noel, 107n1
Foucault, Michel, 5, 190, 191, 193, 201, 351
Fountain (Duchamp), 82
Fourier (Ascott), 26, 152
Fourier, Charles, 6, 75, 235, 245n2
Fractals, 49, 222, 358, 380

Franklin Street Arts Center, New York, 60
Fremont-Smith, Charles, 89n12
French, B., 107n1
Freud, Sigmund, 265, 380
Fried, Michael, 23
Frye, Northrop, 175
Fuchs, Matthias, 246n5, 303
Fuller, Buckminster, 2, 372
Furlong, Lucinda, 60, 61
Furness, Tom, 272
Futuribles, 157, 158, 160, 161, 165, 166, 167
Futurism, 21, 115, 116, 124, 271, 286, 331
Futurology, 2, 76
Fuzzy systems, 236, 242, 252, 253, 268, 315, 319, 331, 333, 351

Gabo, Naum, 21, 119
Gabriel, Jean, 23
Gaia hypothesis, 70, 72, 76, 337. See also "Aspects of Gaia" project
Galántai, György, 56
Galloway, Kit, 60, 63, 275n1, 355
Garden of hypotheses, 352, 378
Gauguin, Paul, 114
Gelernter, David, 316–17
Genet, Jean, 209, 350
Genetic engineering, 127, 271, 273, 322, 333, 335
Geoffroy, Christiane, 300
George, F. H., 10, 18, 126, 129
Gerstner, Karl, 118
Gesamtdatenwerk, 226, 233, 242, 245n1, 304–5
Gestural abstraction, 22, 23, 28, 42
Giaccardi, Elisa, 374n3
Gibson, William, 51, 268, 277, 337
Gidney, Eric, 63
Gigliotti, Carol, 374n2
Gilder, George, 273, 279
Gillette, Frank, 58
Giotto, 329
Giscard d'Estaing, Valéry, 50
Gleick, James, 234

Gleizes, Albert, 27
Global consciousness, 1, 5, 6, 51–52, 74, 76–77, 83, 133, 146, 197, 216, 217, 230, 236
Gnosticism, 5
Godard, Jean-Luc, 124
Goethe, Johann Wolfgang von, 44, 98
Gogh, Vincent van, 114, 328
Goldberg, Steve, 305
Gordon, W., 132
Gore, Al, 273
Gowing, Lawrence, 28, 121
Grace, Sharon, 60
Graubard, Stephen R., 238
Green, Paul, 273
The Green Box (Duchamp), 117
Greene, Richard, 300
Griffith, David, 228
Gropius, Walter, 318
Groupe de Recherche d'Art Visuel (GRAV), 22, 119
Groupe Espace, 119
Grusin, Richard, 91n27
Gunn, Charlie, 298
Gurdijieff, G. I., 374n4
Gutai (art group), 122
Guzzetti, Ale, 303

Haacke, Hans, 58
Hamilton, Richard, 7, 9–10, 11, 91n24, 116
Happenings, 11, 22, 23, 28, 54, 56–57, 91n31, 122, 149
Haraway, Donna, 268
Harris, Ed, 283n1
Harrison, Charles, 25
Harrison, Dew, 42, 374n3
Hartmann, Geoffrey, 209
Hastings, Michael, 30
Haukeland, Arnold, 129
Hauser, Gustave M., 62
Hayles, N. Katherine, 18, 19
Healey, John, 120
Hegedus, Agnes, 304
Hegel, G. W. F., 209
Heisenberg, Werner, 19, 179, 206, 224, 229, 328
Hello (Kaprow), 57
Henderson, Hazel, 197–98
Henderson, Linda Dalrymple, 374n2

Hendrix, Jimi, 24
Henry, René, 21 1n1
Hepworth, Barbara, 28
Heraclitus, 230
Hershman, Lynn, 304
Heubler, Douglas, 62
Hierarchical relations, 51, 55, 81, 82, 93n50
Higgins, Dick, 58
Hill, Anthony, 118
Hill, Richard, 40
Hiller, Lejaren, 24
Hilton, Tim, 281
Hiltz, Starr Roxanne, 188, 193, 299
Hinged Relief (Ascott), 150, 162
Hoenich, P. K., 121
"Hole in Space" project, 63–64, 355
Holism, 5, 171, 172, 177, 181, 195, 196, 202, 215, 218, 223, 236, 237, 245, 281, 337–38, 350
Holography, 146, 148, 226, 253, 289, 291, 298, 299, 301, 305
Holomatic principle, 239, 262, 320, 378
Homage to C. E. Shannon (Ascott), 26, 27, 150
Hommage à Chrysler Corp. (Hamilton), 9
Hommage à New York (Tinguely), 121
Hopi cosmology, 5, 237, 380
Horizontality, 32, 33, 70, 170, 172, 180–82, 195–96, 236, 241
Horne, Donald, 351
Howe, Scott, 305
Hubris, 331–32
Hultén, K. G. Pontus, 89n14
Humanism, 47, 74
Hunt, Gillian, 374n3
Hunter, Keith, 298
Hurrell, Harold, 25
Hyperconnectivity, 342–43
Hypermedia, 69, 228, 233, 237, 242, 244, 280, 315, 352, 354, 357, 359, 361, 382; and Ars Electronica Center (AEC), 289, 291,

300, 306, 307; and photography, 249, 251, 252, 253, 254n2
Hypertext, 58, 69, 254n3, 315

I Ching, 5, 6, 31, *31*, 32, 33, 53, 64, 88n3, 123, 183–84, 186, 322
Immateriality, 27, 223, 233, 237, 251, 277, 321, 378; and museums, 341, 351, 355; and telematic art, 52, 204, 244
"Les Immatériaux" exhibit, 67, *68*, 204, 240, 262
Immersion, 223, 266, 267, 269, 274, 284, 285, 311, 377
Implicate order, 187, 205, 333
Impressionism, 21, 165
Indeterminacy, 124, 179, 224, 230, 231, 235, 348, 371
Individualism, 81, 258, 341
Individuality, 238, 264–65, 319
Infomedia Notepad System, 62, 186
Information: and cyberception, 2; and cybernetic art, 43, 46, 47, 144–47; exponential growth of, 197; and feedback loops, 4, 18, 45; and texts used in art, 13; theory of, 10, 18–20
Innocent, Troy, 298
Institute for the Future, 188
Institute of Contemporary Arts, London, 7, 28, 90nn15,17
Intellectual property law, 48
Intelligence amplifiers, 49, 129
Intelligent architecture, 2, 237, 270, 287, 324, 325, 334, 342, 345, 354, 372–73, 380, 381
Interactivity: and appropriation, 48; and Ars Electronica Center (AEC), 284, 285, 288, 292, 293, 294, 296, 299, 301, 303–8, *308*; and behavior, 1, 10, 35, 42, 45, 46, 76, 280; and behaviorist art, 110–12; and cy-

berculture, 279, 280; and cybernetic art, 3–4, 7, 21, 26, 30, 45, 46, 331; and cybernetics, 12, 23; and cyberspace, 278; and five-fold path, 267, 284, 311, 377; genealogy of, 42–43; and *Gesamtdatenwerk*, 226; interdisciplinary approach to, 3, 4; and interfaces, 266; and kinetic art, 22, 30; and moistmedia, 363, 365; and molecular revolution, 330; and museums, 344; and performance art, 28; and photography, 251, 252; and Planetary Collegium, 315; and Pollock's art, 281; and radio, 55; and shamanism, 360–61; and telematic art, 1, 10, 54, 59–62, 86, 87, 210, 233, 237, 239–41, 259, 261, 262, 263, 274, 323, 339n1, 357, 360–61; and telematic culture, 238, 266–67, 280; and telematics, 1, 10, 50, 59, 211, 212–13, 232, 238, 242, 257; and telenoia, 259; and teletype, 58–59; and urban planning, 324; and video art, 56–58
Interdisciplinary theory and practice, 3, 4, 7, 9, 18, 19, 40, 49, 50, 74, 153, 197, 221, 241, 242, 370
Interfaces, 225–26, 239, 266, 269, 278–79, 319, 320, 334, 352
Internet, 2, 4, 52, 60, 69, 73, 91n32, 273, 280, 302, 312, 314, 354, 357, 361, 365, 372; and museums, 341, 342, 343, 345, 346, 347, 353, 355. See also World Wide Web
Inter-reality, 315, 318
Intertextuality, 4, 336
Invisible made visible, 218, 225, 231, 235, 238, 281, 291, 314, 321, 334, 337
I. P. Sharp Associates (IPSA), 61, 64, 92nn37,39, 183, 186, 261

Ipswich Civic College, Suffolk, 37, 39, 153
Ishii, Setsuko, 299, 305
Ito, Hirofumi, 300

Jansenn, Zacharias, 329
Japan, 192, 219, 378
Jarry, Alfred, 345
Jefferson, David, 296
Jennings, Pamela, 374n3
Johansen, Robert, 188
Johns, Jasper, 118
Johnson, N., 107n1
Johnson, Ray, 56, 91n30
Jouffret, E.-P., 206
Jouissance, 190
Joyce, James, 124
Jung, C. G., 187, 200n1
Jung, Dieter, 299

Kac, Eduardo, 42, 56, 72, 83–84, 85, 374n3
Kahn, Herman, 164
Kamynin, V., 31, 33, 150
Kandinsky, Wassily, 2, 281, 357
Kaprow, Allan, 17, 22, 56–57, 91nn31–32
Kawaguchi, Yoichiro, 299
Kay, Alan, 298
Kellner, Douglas, 84–85
Kelly, Kevin, 312
Kent, Stan, 92n38
Kerouac, Jack, 378
Kerr, Elaine, 193
Kilpatrick, F. T., 180
Kincaid, D. Lawrence, 194, 213
Kinetic art, 21–22, 30, 31, 54, 271, 286
King's College, Newcastle upon Tyne, 7
Kiosk (Ascott), 151
Kiss-Pál, Klára, 91n30
Kitaj, R. B., 17, 107n1
Klaniczay, Júlia, 56
Klee, Paul, 98, 117, 318, 329, 357
Klein, Adrian, 120
Klein, Yves, 128
Klimt, Gustav, *208*
Kline, Nathan S., 149
Klüver, Billy, 59
Knapp, Benjamin, 266

Knowledge, alternative systems of, 1, 5, 10, 24, 31, 53
Kobayashi, Koji, 238
Koerner, Joseph, 90n23
Kohonen, Teuvo, 298
Kosuth, Joseph, 13, 15, 16, 17, 89n11
Krieg, Peter, 306
Krueger, Myron, 304, 343
Kunstforum (periodical), 222

"Laboratorio ubiqua" project, 67–68, 239, *240*, 242
Lacan, Jacques, 217
Landa, Kepa, 374n3
Langton, Christopher, 88, 296, 310–11, 338, 353
Language, 3, 13–16, 26, 85, 87, 174, 205, 207, 209, 230, 258, 268, 365–66
Large Glass. See The Bride Stripped Bare by Her Bachelors, Even
Lasseter, John, 305
Latham, John, 11, 28, 90n17, 122
Latham, William, 296
Latil, Pierre de, 128
Laukes, Jim, 374n3
Laurel, Brenda, 299
Lebel, Jean-Jacques, 23
Leber, Titus, 300, 307
Leisure, 45, 49, 113, 126, 132, 133, 135, 137, 143, 164, 324
Lenin, V. I., 163
Leonardo (periodical), 64, 178, 212, 295
Leonardo da Vinci, 98
Levine, Les, 58
Lévi-Strauss, Claude, 160, 196
Lewitt, Sol, 15
Liberalism, 47
Licklider, J. C. R., 93n50
"Line" (Rackham), 69
Lippard, Lucy, 26
Literature, 114, 124, 267, 268, 276–77, 378
Littlewood, Joan, 119
Livingstone, Dan, 374n3
Lloyd, Anthony, 266
Locomotion Board (Ascott), 151
Loeffler, Carl, 60, 87
Lotringer, Sylvère, 20

Love, 1, 6, 74, 75, 76, 78–79, 80, 86, 233, 235, 245, 356, 381
Love-Code (Ascott), *10*
Lovelock, James, 70, 76, 337
Luesebrink, Dirk, 304
Lusted, Hugh, 266
Lye, Len, 22
Lyons, Kieran, 374n3
Lyotard, Jean-François, 67, 204, 262
Lyubimskii, E., 31, 33, 150

MacMurtrie, Chico, 296
Macy Conferences, 18, 89n12
Madel, Mark, 306
Magnenat, N., 306
Mail art, 54, 56
Mairet, Philip, 114
Malevich, Kasimir, 116
Malina, Frank, 120
Malina, Roger, 64, 374n2
Manet, Édouard, 114
Mann, Thomas, 98, 99, 258
Manovich, Lev, 79, 93n48
Many-selves hypothesis, 265, 372, 374n4
Many-worlds hypothesis, 229, 339n2, 372
Marcuse, Herbert, 84
Marey, E.-J., 116
Marinetti, Filippo, 2, 331
Martin, Kenneth, 90n18, 120
Martin, Mary, 90n18
Marx, Karl, 84, 163
Mathematics, 14, 16, 26, 206
Mathieu, Georges, 28, 90n17
Matisse, Henri, 119
Matos, Jean-Marc, 296, 305
Matta, Roberto, 305
Maturana, Humberto R., 213, 233, 272, 343
Maxwell, Delle, 298
McCulloch, Warren, 89n12
McFadden, Robert, 303
McKenna, Stephen, 107n1
McLuhan, Marshall, 2, 4, 39, 50, 84, 124–25, 127, 187, 194–95, 330, 333, 346
Mead, Carver, 298
Mead, G. R. S., 203
Media Lab at MIT, 226, 296
Mellor, David, 17, 28, 90n17
Ménard, Philippe, 303

Merzbau, 119
Metaphors: and artificial life, 271, 286, 310, 338; biological, 7, 9; and computer conferencing, 63; and cybernetic art, 21, 26; and emergence, 312; and museums, 348, 349, 350, 352, 378; and nature, 327, 330; and networking, 201, 203, 215, 222, 235; new sources of, 180, 232, 234, 244, 257, 271, 286, 333, 334, 349, 365; and shamanism, 354; and telematic embrace, 245; and weaving, 187, 201, 206
Metaphysics, 24, 33, 43, 63, 74, 187, 224, 344
Metzger, Gustav, 11, 37, 121
Metzinger, Jean, 27
Mignonneau, Laurent, 42, 374n3
Military research, 4, 20, 33, 52, 88n2
Mimesis, 30, 247, 271, 287. *See also* Representation
Minc, Alain, 50–51, 66, 83, 188, 212, 232
Mind at large, 76, 201, 202, 215, 224, 236, 259, 265, 315, 325, 335, 341, 350, 352
Mindmap, 38, 154
Minimalism, 23
Minitel, 67, *68*, 212, 240, 261–62
Minneapolis College of Art & Design, 40
Minujin, Marta, 56, 91n31
MIT (Massachusetts Institute of Technology), 226, 296
Modernism, 25, 43, 47, 91n24, 178–81, 257, 274, 310, 323, 339n1
Moholy-Nagy, László, 21, 54–55, 58, 120
Mohr, Manfred, 305
Moistmedia, 2, 363–66, 369, 372–74
Molecular biology, 127, 268, 271, 328–30, 333, 335, 337
Molecular computers, 272–73, 321, 330

Molecular time, 329, 333, 336
Moles, Abraham, 17
Möller, Christian, 304
Molton Gallery, London, 12, 29, 151
Mondrian, Piet, 30, 118
Monet, Claude, 30, 114
Montaigne, Michel de, 167, 197
Moore, Henry, 28
Moorman, Charlotte, 67
Moral responsibility, 81–82, 98
Moravec, Hans, 265, 296, 332, 335
Morphic resonance, 337
Morphology, 3, 7, 27, 28, 31, 73, 89n4
Morris, J., 107n1
Morris, Robert, 17, 23
Morris, William, 357, 376
Mulder, Robert, 305
Mullican, Matt, 305
Multiculturalism, 6, 313, 323
Multimedia, 43, 48, 69, 71, 241, *243*, 254n2, 262, 263, 265, 271, 280, 311, 313, 323, 359, 365, 379; and Ars Electronica Center (AEC), 286, 288, 289, 301, 304, 306, *308*
Munari, Bruno, 118
Musée d'Art moderne, Paris, 64, 189, 211, 240, 261
Museum of Modern Art (MOMA), New York, 283n1
Museums, concept of, 2, 269, 271, 282, 285, 340–55, 376
Music, 22, 24, 32, 37, 48, 114, 123–24, 129, 158, 303
Myers, Brad A., 4
Mysticism, 2, 5, 34, 88n3
Mythology, 70, 158, 160, 175, 202, 203, 204, 224, 241, 244, 375, 380

Nakamae, Eihachiro, 305
Nakamura, Ikuo, 72
Nanotechnology, 2, 265, 298, 330, 332, 337, 338, 359, 366
Napster, 48

Narrative, 3, 66, 67, 124, 282, 310, 315, 371, 380; nonlinear, 4, 58, 69, 261, 342, 346
NASA (National Aeronautics and Space Administration), 60, 92n34, 186
National Endowment for the Arts, 186
Naturalism, 327–29
Nature, second-order, 330, 331, 332, 338, 379
Navajo sand painting, 236, 245, 282
Nechvatal, Joseph, 42, 374n3
Nelson, Ted, 58, 254n3
Neoclassical art, 90n23
Nerichov, J., 107n1
Network, metaphor of, 201, 203, 215, 222, 235
Networking: and Ars Electronica Center (AEC), 302–3; and art education, 176, 196–97; and connectivity, 222; and engagement, 224; experiential aspects of, 186–87, 198–99; and global consciousness, 77, 197; and interdisciplinary activity, 3; and nonlinearity, 224, 260; and postmodernism, 182, 224; and spirituality, 223, 347; and telematic art, 4, 51–52, 68, 69, 86, 185–86, 189, 192, 193–96, 334; and telematics, 185–200, 202, 238, 335; and telenoia, 260; and transcendence, 223
Network of Stoppages (Duchamp), 33, 206
Neural networks, 4, 18, 77, 260, 271, 286, 298, 312, 332, 354, 373
Newman, Barnett, 118
New Scientist (periodical), 164
Newtonianism, 19, 113, 179, 227, 335
Nicholson, Ben, 90n18
Nietzsche, Friedrich Wilhelm, 108, 191, 201, 207–9, 224, 341
Nieuwenhuys, Constant, 119
Noland, Kenneth, 118

Nonlinearity, 229, 244, 311, 314, 333; and identity, 379; and narrative, 4, 58, 69, 261, 342, 346; and networking, 224, 260
Noosphere, 76–77, 226, 236, 241, 243
Nora, Simon, 50–51, 66, 83, 188, 192, 212, 232
Nordheim, Arne, 129
Norris, Christopher, 209
Norton, Alan, 299, 300
Norwood, James, 374n3
Nouvelle Tendance, 22, 118
Novak, Marcos, 42, 374n3
Nude Descending a Staircase (Duchamp), 116

Obmokhu exhibition, 119
October (periodical), 89n11
Oettinger, Anthony, 188
Oldenburg, Claes, 118, 122
Oleschak, Eduard, 307
One-way communication, 46, 57, 67, 82, 111, 159, 172, 178, 216, 233, 258, 349
Onnen, Onno, 298
Ono, Yoko, 22
Ontario College of Art, Toronto, 39–40, *41*, 185, *191*
Open-endedness, 66, 111, 122, 173, 175, 181, 225, 248, 269, 280, 285, 337, 341, 345, 360, 371
Oppenheim, Dennis, 58
Oppenheimer, Peter, 296
Optical fiber, 273–74, 279
"Organe et Fonction d'Alice au Pays des Merveilles" (Ascott), 67, *68*, 261–62
Organic form, 7, 9, 29, 49, 88n4. *See also* Biological form
Originality, 43, 48, 67, 91n24, 98, 207
Orwell, George, 67
Ouspensky, P. D., 265, 374n4
Out-of-body experience, 160, 190, 193, 228, 244, 264, 321, 330, 335, 352, 380, 382

Packard, Norman, 296
Page, Michael, 305
Paik, Nam June, 24, 67

Painting, 9, 17, 21, 23, *166*, 171, 193, 195, 196, 214, 236, 245, 281, 282; and behaviorist art, 113, 114, 117, 118, 119, 121, 124; and Cézanne's practice, 28, 114–15, 328; and Duchamp's practice, 32–33, 116, 195; and horizontality, 32–33, 181–82; and naturalism, 328–29; and Pollock's practice, 28, 32, 121, 195–96, 236, 281–82
Pakesch, Gerhard, 305
Pallas, Jim, 296
Panama Canal, as cybernetic system, 19
Paolozzi, Eduardo, 17–18
Parada, Esther, 248, 249–50, 252, 272
Paradox, 5, 24, 75, 88, 108, 209, 227, 229, 276
Parallel distributed processing (PDP), 54, 217, 227–30, 236, 237, 244, 332
Parallel universes, 54, 223, 224, 229–31
Parameter V (Ascott), 33
Paranoia, 258, 265, 315, 341, 371
Parapsychology, 5, 54, 157, 160, 161, 163–67, 180, 200n1, 335
Pask, A. G., 119, 150
Pasmore, Victor, 7, 9, 10, 11, 28, 30, 90n18, 118, 119
Passionate attraction, 6, 75, 78, 79, 235, 245n2
Passive reception, 46, 82, 110, 111, 179, 207, 231, 234, 238, 239, 312, 331, 342, 360, 361, 379
Pataphysics, 345
Payne, David, 274
Pedagogy. *See* Art education
Pepper, Andrew, 305
Pepperell, Robert, 246n5
Perception, 2, 43–44, 74, 100–101, 104, 180, 229, 237, 238, 253, 320. *See also* Cyberception
Performance art, 28, 31, 37, 54, 73
Perry, John, 299

Personality transfer, 336, 337
Perspective, 113, 194, 214
Pevsner, Antoine, 119
Phenomenology, 114
Philippe, Jean-Marc, 298
Phillips, Mike, 374n3
Photius, 201, 211n1
Photography, 105, 114, 198, 247–53, 271, 272, 329
Physics. *See* Quantum physics; Relativity, theory of
Picasso, Pablo, 116
Piercy, Marge, 267, 268
Ping Body (Stelarc), 73
Pissarro, Camille, 114
Planetary Collegium, 74, 313–15, 318, 367–70, 373, 380
"Planetary Network" project, 67–68, 239, *240*, 242, 262
Plato, 201
Play, aesthetic, 44, 49, 99, 111, 258, 266, 346; and cybernetic art, 132, 133, 135, 136, 137, 140, 141, 143, 144, 148, 149, 154
"La Plissure du Texte" project, 4, 40, 64–66, *65*, 69, 85, 92–93n42, 189–90, *191*, 210, 240–41, 242, 261
Plunkett, Ed, 91
Pluralism, 214, 224, 238
Plutarch, 203
Poetry, 114, 124, 245, 262, 347–48; concrete, 11–14
Poincaré, Henri, 206
Political relations, 22, 52–53, 57, 81–84, 126, 130, 131, 156n4, 210, 242, 273, 278
Pollock, Jackson, 22, 28, 32, 121, 195–96, 236, 271, 281–82, 283n1
Pomeroy, Jim, 62
Pontus Hultén, K. G., 331
Pop art, 9, 91n24
Popper, Frank, 1, 20, 64, 261
Popperwell, George, 107n1
Popular culture, 9, 10, 37, 249
Porter, Edwin S., 228
Portholes, simulation, 289, 294, 307
Positivism, 242

Post-biological systems: and
Ars Electronica Center
(AEC), 284, 287, 291, 293,
294, 296; and art educa-
tion, 310; and artificial life,
353; and artistic activity, 2,
269, 271, 272, 286, 287,
318, 353, 361, 367, 368;
and body, 266, 278, 372,
375, 379; and construc-
tivism, 367, 380; and cul-
ture, 248, 266, 284, 294,
367, 369; and cybercep-
tion, 319, 322, 324; and
interfaces, 266, 278; and
museums, 345, 353, 376;
and poststructuralism,
380; and science fiction,
277; and shamanism, 357;
and social relations, 2, 368,
372
Postman, Neil, 250
Postmodernism, 6, 43, 45,
47–48, 67, 75, 208, 210,
291, 310, 323; and decon-
struction, 208, 231, 271,
286; and despair, 229,
234, 282, 366; and field
theory of art, 178–82; and
pessimism, 224, 229, 234;
and relativism, 224, 315;
and solipsism, 231, 282
Poststructuralism, 19, 43, 201,
207–10, 332, 336, 350
Poussin, Nicolas, 111
Poynor, Rick, 38–39
Pragmatism, 366, 367, 372
Prevot, Philippe, 304
Price, Cedric, 119
Prix Ars Electronica, 292–93,
294, 295, 306, 307
Probability, 18, 19, 20, 43,
129, 178, 179
Process, 11, 21, 26, 28, 42,
43, 52, 61, 86, 112, 116,
122, 139, 157, 279
Proclus, 203
Progress, 25, 47, 179
Prophet, Jane, 73
Psibernetics, 161, 163–67,
36In1
Psi-perception, 358, 362n1
Psychology, 45–46, 114, 118,
172, 187, 191, 265, 345, 380

Public Interest Satellite Asso-
ciation (PISA), 92n34
Punt, Michael, 374n3

Quantum physics: and alter-
native systems of knowl-
edge, 31, 74, 187, 199, 205;
and artistic activity, 31, 177,
180, 199, 227, 235, 271,
286, 344, 371; and disconti-
nuity, 224, 229, 333; and
interconnectedness, 187,
201, 204–5, 206, 215; and
many-worlds hypothesis,
229, 339n2; and observer's
participation, 76, 180, 199,
204, 206, 215, 223, 234–35,
276–77; and Schrödinger's
Cat, 276; and telematic
culture, 234; and telematic
embrace, 75; and transfor-
mation of energy, 224, 229;
and uncertainty principle,
19, 206, 224, 229, 231, 351,
371; and wormholes, 324,
354, 376
Quarles, Pat, 59
QUBE, 62
Queens University, Belfast,
151

Rabinowitz, Sherrie, 60, 63,
275n1, 355
Rackham, Linda, 69
Radio, 55–56, 57, 303
Rainer, Yvonne, 17
Rajah, Niranjan, 374n3
Ramsden, Mel, 13
Randomness, 33, 37, 67, 69,
73, 105, 164, 166, 262, 314;
and behaviorist art, 121, 122,
124, 151, 152; and CAM
(cybernetic art matrix), 145,
146
Rationalism, 43, 75, 88
Rauschenberg, Robert, 91n24,
195
Ray, Man, 22, 120
Ray, Tom, 353, 374n2
Read, Herbert, 28
Realism, 113
Reichardt, Jasia, 17, 90n15
Reinhard, Ad, 128
Reiser, Beverly, 307

Reiser, Hans, 307
Relativism, 43, 75, 202, 214,
224, 251, 312, 315, 322,
344
Relativity, theory of, 19,
229
Rematerialization, 263, 337,
361, 366, 378
Renaissance art, 78, 79,
90n23, 114, 194, 214,
215, 236
Representation: compared to
simulation, 231, 271, 349;
control of, 57, 258, 277,
281; decline of, 272, 275,
278, 282, 286–87, 317,
318, 323, 325, 333, 335,
345, 351, 375; traditional
modes of, 214, 217, 277,
328, 345, 355
Responsibility, 81–84, 98,
259
Reynolds, Roger, 123
Rhine, J. B., 163, 200n1
Riley, Bridget, 117
Rimington, Wallace, 120
Ritual, 358, 359, 380; and
artistic activity, 98, 99, 112,
116, 121–22, 149, 154, 157,
159, 160
Roberts, Sara, 304
Robotics, 45, 52, 69, 73, 265,
296, 298, 320, 332, 335
Rockeby, David, 304
Rogala, Miroslaw, 42, 374n3
Rogers, Everett M., 194, 213
Romanticism, 75, 102, 257,
274, 339n1
Rorty, Richard, 251, 268,
366
Rosch, Eleanor, 316
Rosenboom, David, 303
Ross, David, 57
Rotary Demisphere (Duchamp),
117
Rothko, Mark, 118
Russell, Peter, 5, 76–77, 197,
217, 236

San Francisco Art Institute,
40, 174
Santillana, Giorgio, 203
Santo Daime, 6, 358–59,
374n1

Satellites, 53, 56, 58–64, 87, 92n34, 210, 232, 239, 267, 301, 320
"Saturn Encounter" project, 63, 92n38, 186, 188
Sauter, Joachim, 304
Saxo Grammaticus, 203
Sayre, Rick, 296
Scher, Julia, 93n52
Schiller, Gretchen, 374n3
Schiphorst, Thecla, 374n3
Schizophrenia, 229, 265, 335, 376, 380
Schizo-time, 228, 230
Schlemmer, Oskar, 318
Schmidt, Arthur, 305
Schmidt, Helmut, 164
Schneeman, Carolee, 17
Schneider, Ira, 58
Schöffer, Nicolas, 17, 22, 23, 24, 30, 49, 52, 120, 129
Schrödinger, Erwin, 224; and Schrödinger's Cat, 230, 276
Schweniger, Duff, 60
Schwitters, Kurt, 119
Science: combined with esoteric knowledge, 5, 25; and consciousness, 356; epistemological shifts in, 19, 280–81; integrated with art, 1, 3–4, 5, 26, 30, 31, 34, 43, 75, 97–102, 244, 245. See also Mathematics; Quantum physics; Relativity, theory of
Science fiction, 51, 268, 276–78, 337, 347
Scientism, 17, 49, 102, 344
Scott, Jill, 42, 374n3
Sculpture, 9, 12, 17, 21–22, 23–24, 28, 30, 52, 78, 117, 118, 119, 120
Seaman, William, 42, 307, 374n3
Securityland (Scher), 93n52
See, Henry, 300
Selfishness, 263–64
Self-organizing systems, 2, 126, 128, 133, 373
Selz, Peter, 17
Semiotics, 13, 86, 189, 281
Sermon, Paul, 69, 305

Seurat, Georges, 98, 114
Sexuality, 10, 78–79, 80, 190, 235, 265
Seybold Digital Word Conference, 313
Shamanism, 6, 354, 357–59, 360–61, 365, 366; and shamantics, 359, 380
Shannon, Claude, 18, 150, 233
Sharp, Willoughby, 60–61
Shaw, Jeffrey, 304
$he (Hamilton), 9, 10
Sheldrake, Rupert, 337
Sherk, Bonnie, 299
Sherman, Tom, 67, 246n4, 272
Shift (Ascott), 101
Shura-Bura, M. R., 31, 33, 150
Sims, Carl, 296
Simulations, 69, 127, 231, 237, 247, 287, 291, 298, 334, 349, 365; and portholes, 289, 294, 307
Situationism, 22
Skinner, B. F., 45–46, 160
Slade School of Art, 9
Slow-scan video, 62, 64, 67, 208, 210, 239
Smith, David, 119
Snow, Michael, 299
Social class, 126, 344
Social relations: and art education, 35, 155; and behaviorist art, 158; and cybernetic art, 132–33, 147; and cybernetics, 49, 126, 130–31, 132; and cyberspace, 243; and feedback loops, 27, 133, 242; and interactive art, 23; and McLuhan's theory of media, 124–25; and post-biological systems, 2, 368, 372; and telematic art, 80–85, 87; and telematics, 51, 74, 191–94, 243; and telenoetics, 347; and telenoia, 341
Social responsibility, 81–84, 98, 259
Social theory, 19–20, 234
Socrates, 221

Sommerer, Christa, 42, 353, 374n3
Sonnier, Keith, 60, 61
Soto, Jesus Rafael, 118
Sound, 24, 72, 129, 303, 334
Soviet Union, 163, 165
Spanjaard, Martin, 306
Spirituality: and computers, 317, 381; and double consciousness, 359, 374n1; and integration of art and technoscience, 344–45; and moistmedia, 363, 366; and museums, 340; and networking, 223, 347; and Planetary Collegium, 367, 370; and postmodernism, 180; and shamanism, 358, 360; and technoetic culture, 341; and technosticism, 381; and Teilhard's philosophy, 93n47; and telematic culture, 236, 270; and telematic embrace, 6, 74; and telematics, 264
Spoerri, Daniel, 22, 89n14
Stafford, Barbara Maria, 316, 317
Stanford Research Laboratory (now SRI), 4
STAR (Science, Technology and Art Research) center, 42, 73–74
Startup, Peter, 107n1
Stedelijk Museum, Amsterdam, 89n14, 150
Steinberg, Leo, 195
Stelarc, 72, 73, 298
Stephenson, Ian, 7
Stiles, Kristine, 17, 23, 42, 374n2
Still, Clyfford, 118
Stills, Luv, 296
Stockhausen, Karlheinz, 24
Strauss, Wolfgang, 305
Structural coupling, 272, 273, 275, 280, 316
Structuralism, 9, 89n4
Studio International (periodical), 161
Subjectivity, 2, 76, 312, 344, 356

Suddaby, William, 107n1
Sufism, 170, 178, 359
Surrealism, 32, 63, 66, 118, 121, 124, 345
Suzuki, D. T., 88n3
Symbolism, 114
Syracuse University, 272

Table-tops, 33, *33, 34,* 168, *169,* 170–73, 180, 181, 196
Table-Top Strategies (Ascott), *34*
Takis (Panayotis Vassilakis), 22, 120
Tannenbaum, Ed, 307
Tansley, David V., 236
Taoism, 5, 180, 187, 205, 282, 322, 344
Tarot, 112, 159, 166, 170, 171
Tatlin, Vladimir, 118
Taylor, Robert W., 93n50
Technocracy, 25, 80
Technoetics, 6, 376, 378, 380, 381, 382; and consciousness, 356, 357, 361; and cultural relations, 341, 342, 344, 352; and cyberbotany, 373; and moistmedia, 363, 364, 366, 371, 374; and museums, 341, 342, 344, 352, 353; and shamanism, 365, 366
Technology: and capitalism, 6; integrated with art, 1, 5, 9, 16, 25, 43, 75, 79, 245, 357; integrated with esoteric knowledge, 6, 10, 75; language as, 258; and perception, 43–44; and social relations, 53; and utopianism, 86, 93n52
Techno-qualia, 360, 381
"TechnoSphere" (Prophet), 73
Teilhard de Chardin, Pierre, 5, 76–77, 93n47, 197, 236, 342
Telematic art, 5, 10, 40, 50–54, 185–86, 189, 192, 193–96, 210–11, 239–45; and artificial life, 338; and conceptual art, 86–87; and connectivism, 333, 336, 338–39n1; and connectivity, 87, 216, 274; and consciousness, 356, 357; content of, 85–86, 233–35, 237, 239, 244; critique of, 80–88; and cyberspace, 69, 70, 78, 80, 86, 278; history of, 54–68; and interactivity, 1, 10, 54, 59–62, 86, 87, 210, 233, 237, 239–41, 259, 261, 262, 263, 274, 323, 339n1, 357, 360–61; and interfaces, 239; and museums, 343; and simulation, 231; and social responsibility, 80–85, 259; and virtual reality, 335; and Web-based art, 69–74, 93n52
Telematic art projects: "Aspects of Gaia," 70–72, *71,* 85, 241–42, *243,* 262–63; "Heavenly Bodies" proposal, 255–56; "Hole in Space," 63–64, 355; "Laboratorio ubiqua," 67–68, 239, *240,* 242; "Organe et Fonction d'Alice au Pays des Merveilles," 67, *68,* 261–62; "Planetary Network," 67–68, 239, *240,* 242, 262; "La Plissure du Texte," 4, 40, 64–66, *65,* 69, 85, 92–93n42, 189–90, *191,* 210, 240–41, 242, 261; "Saturn Encounter," 63, 92n38, 186, 188; "Telenoia," 259, *260;* "Ten Wings," 5–6, 53, 85, 183–84; "Terminal Art," 4, 62, 63, 69; "The World in 24 Hours," 64, 183, 186
Telematic culture, 244, 294, 313–16, 325, 330, 338n1; and art education, 311, 313; and behavior, 334, 338; and connectivity, 267, 269, 279, 280; and difference, 216; and global consciousness, 236–37; and holism, 215; and interactivity, 238, 266–67, 269, 280; and love, 80; and networking, 236; and Planetary Collegium, 314; and quantum physics, 229, 234; and shamanism, 361; and spirituality, 236, 270; and telenoia, 257, 268–70; and virtual reality, 335
Telematic embrace, 1, 6, 74–76, 78–79, 80, 86, 88, 233, 244, 245, 371
Telematics: and accessibility, 215; and appropriation, 48; and Ars Electronica Center (AEC), 287, 288, 291, 294, 303; and art education, 40, 196–97, 217–18; and collective unconscious, 187; and connectivity, 73, 76, 228, 264, 319, 334; and cybernetics, 6–7, 51–52, 197, 242; and cyberspace, 51–52, 243, 246n6; definition of, 1, 202, 232; French government report on, 50–51, 188, 192, 212; and global consciousness, 1, 5, 6, 51–52, 74, 76, 77, 197; and interactivity, 1, 10, 50, 59, 211, 212–13, 232, 238, 242, 257; and interdisciplinary activity, 197, 242; and networking, 185–200, 202, 238, 335; and parallel distributed processing, 54; and parallel universes, 54; and parapsychology, 54; and poststructuralism, 207–10; and shamanism, 358; and social relations, 51, 74, 191–94, 243
"Telematic Vision" (Sermon), 69–70
Telenoia, 259–60, 265, 267, 275, 315, 325, 338, 341, 371, 374, 381
"Telenoia" project, 259, *260*
Telepathy, 160, 161, 330, 374n1, 380
Telephone Pictures (Moholy-Nagy), 54–55

Telephones, 54–55, 58, 61–62, 64, 68, 232, 240

Telepresence, 72, 263–65, 267, 269, 288, 301, 318, 330, 335, 337, 343, 345, 346, 354, 382; and cyberception, 320, 321, 326

Teletype, 59–60

Televator, 308, *308*

Telex, 50, 59, 62, 146, 148

"Ten Wings" project, 5–6, 53, 85, 183–84

"Terminal Art" project, 5–6, 62, 63, 69

Texts: artistic use of, 11–17, 30, 58–59, 69, 189–90, 241; Barthes's theory of, 187, 208; Foucault's theory of, 5, 190, 191; and telematic networking, 189–91

Thalman, Daniel, 306

Thesaurus (Ascott), 12–13, *13*, 151

Thompson, Evan, 316

Thorne, Kip, 354

3 Standard Stoppages (Duchamp), 33, 206

Time and temporality, 21, 26, 227, 228, 230–31, 347. *See also* Duration; Molecular time; Schizo-time

Timelessness, 188, 189, 190. *See also* Asynchronicity

Tinguely, Jean, 22, 89n14, 121

Tolson, Michael, 298

Townshend, Peter, 37

Transaction Set (Ascott), 33, *33*

Transcendence, 75, 223, 235, 257, 277, 330, 337, 380

Transformation, 225, 238–39, 267, 277, 280, 285, 311, 377

Transparency, 78, 90n20, 235, 251, 287, 324

Travers, Michael, 296

Treu, Barry, 304

Triggers, behavioral, 116, 117, 120, 128, 150, 151, 157, 159, 175

Trini, Tomasso, 67, 246n4

Truckenbrod, Joan, 304

Tsai Wen-Ying, 23

Turing, A. M., 228, 382

Turoff, Murray, 188

22 Predicates: The French Army (Atkinson and Baldwin), 25

Uexküll, Jakob von, 230, 268

Uncertainty, 151, 160, 172, 190, 202, 214, 233, 235, 237, 242, 248, 253, 341, 350, 361, 372; and behaviorist art, 110, 112, 117, 124; principle of, 19, 206, 224, 229, 231, 351, 371; sunrise of, 75, 80, 234

Unger, Roberto Mangabiera, 370

University of Applied Arts, Vienna, 40

University of Durham, 7

University of North Carolina, Chapel Hill, 358

University of Plymouth, 42

University of Wales, Newport, 40, 69, 263

University of Washington, Seattle, 272, 358

Utopianism, 2, 5, 17, 48, 49, 59, 75, 79, 80, 81, 84, 86, 87, 93n52

Vallée, Jacques, 62–63, 92n38, 180, 186, 188, 196–97

Vardanega, Gregorio, 120

Varela, Francisco J., 213, 233, 272, 316, 317, 343, 374n2

Vasarely, Victor, 22, 117, 132

Vasiliev, L. L., 163

Vasulka, Steina, 24

Vasulka, Woody, 24

Veeder, Jane, 304

Vesna, Victoria, 42, 374n3

Video art, 54, 56–58, 62, 69, 91n32, 172, 182, 271, 305

Video Roget (Ascott), *12*, 12–13, *13*, 30, 151

Vietnam war, 37

Vila, Doris, 305

Virilio, Paul, 20

Virtual presence, 239, 243, 262, 320, 335, 355, 378

Virtual reality: and Ars Electronica Center (AEC), 287, 291, 299, 302, 303, 305; and art education, 312; and cyberception, 320; and cyberpower, 376; and cyberspace, 278, 303, 312, 318, 320, 377; and *Gesamtdatenwerk*, 223, 224, 233, 242; and interactivity, 265; and interfaces, 239, 262, 270, 320, 378; and inter-reality, 315; and moistmedia, 363, 365; and museums, 344, 345, 351, 352, 353, 355; and nature, 327; and out-of-body experience, 330; and quantum reality, 224, 229, 230, 382; and shamanism, 358, 359; and telematic art, 69, 73, 218, 223, 224, 231, 243–44, 282; and telematics, 208, 335; and telenoia, 259; and trade exhibitions, 246n6; and urban planning, 324, 376; and virtualization, 247, 270, 330, 333, 335, 337

Virtual space, 224, 233, 243, 244, 249, 253, 263, 282, 335, 345, 352, 354, 382

Viseman, Miles, 246n5

Visionary theory and practice, 1, 2–3, 10, 18, 34, 59, 77, 342, 366, 367, 372

Vitalism, 9, 12, 27–28, 33

Vostell, Wolf, 56, 58, 122

Wagner, Richard, 114, 226, 245n1

Wall, Brian, 107n1, 119

Wallis, Brian, 17

Warhol, Andy, 91n24, 122

Watts, Bob, 43

Watzlawick, Paul, 252, 280

Weaver, Warren, 233

Wentworth Thompson, D'Arcy, 7, 27, 29, 88–89n4, 310, 345

Western Front art center, Vancouver, 64

Wheeler, John, 76, 230, 235–36, 344

White, Norman, 40, 92n37, 93n42, 298

The Who (rock group), 37

Whorf, Benjamin Lee, 230
Wiener, Norbert, 10, 18, 19–20, 33, 150, 163, 180, 185, 242, 310, 330
Wilfred, Thomas, 120
Willats, Stephen, 17, 120
Williams, Raymond, 250
Wilson, Stephen, 305
Wilson, Stuart, 296
Winograd, Terry, 190
Wipe Cycle (Gillette and Schneider), 58
Wolf, Fred Alan, 230

Wolfram, Eddie, 35
Wolverhampton Polytechnic, 39
Woodman, Ned, 58
Woodward, Bill, 305
World Future Society, 176
"The World in 24 Hours" project, 64, 183, 186
World War II, 20
World Wide Web, 2, 6, 40, 50, 58, 314, 344, 346; and Web-based art, 69–74, 93n52. *See also* Internet

Wormholes, 324, 354, 355, 382
Wright, Brian, 107n1

Xenakis, Iannis, 24, 129

Young, Pascal, 306
Youngblood, Gene, 57, 63, 82, 83, 85

Zen, 88n3, 342–43, 353, 382
ZERO (art group), 22
Zukav, Gary, 199
Zurek, Wojciech, 76

DESIGNER: NOLA BURGER

COMPOSITOR: INTEGRATED COMPOSITION SYSTEMS

TEXT: 9.5/13.75 JANSON

DISPLAY: INTERSTATE LIGHT AND BOLD

PRINTER AND BINDER: SHERIDAN BOOKS, INC.

INDEXER: ANDREW JORON